DEFIANT SPIRITS

DEFIANT

the MODERNIST REVOLUTION

of the GROUP OF SEVEN

SPIRITS

ROSS KING

McMichael Canadian Art Collection
Kleinburg, Ontario

DOUGLAS & MCINTYRE

To my three brothers: Bryan, Randy and Stephen

Douglas and McIntyre (2013) Ltd.
PO Box 219, Madeira Park
British Columbia, Canada V0N 2H0
www.douglas-mcintyre.com

McMichael Canadian Art Collection
10365 Islington Avenue, Kleinburg
Ontario, Canada L0J 1C0
www.mcmichael.com

Cataloguing data available from Library and Archives Canada
ISBN 978-1-55365-362-2 (cloth)
ISBN 978-1-55365-882-5 (pbk.)
ISBN 978-1-55365-807-8 (ebook)

Editing by David Staines
Copy editing by Ruth Gaskill
Cover and text design by Naomi MacDougall
Front cover illustration by Tom Thomson (Canadian, 1877–1917),
Twisted Maple (detail), 1914, oil on plywood, 26.7 × 20.9 cm, McMichael Canadian
Art Collection, Gift of Mrs. Margaret Thomson Tweedale, 1974.9.4
Back cover photo by Arthur Goss, courtesy of Arts & Letters Club
Photo of Lawren Harris on the title spread by M.O. Hammond,
Archives of Ontario, F 1075-16-0-0-200
Dimensions of artwork are given as height × width
An adaptation of "White Feathers and Tangled Gardens"
appeared in the Winter 2009 issue of *Canadian Art*.
Printed and bound in Canada by Friesens
Text printed on acid-free paper
Distributed in the U.S. by Publishers Group West

We gratefully acknowledge the financial support of the Canada Council for the
Arts, the British Columbia Arts Council, the Province of British Columbia
through the Book Publishing Tax Credit and the Government of Canada
through the Canada Book Fund for our publishing activities.

Now what shall be our word as we return,
What word of this curious country?

DOUGLAS LEPAN, "Canoe-Trip"

CONTENTS

ACKNOWLEDGEMENTS

NEVER BEFORE IN the course of writing a book have I received or required so much help from friends and strangers alike.

My deepest thanks and greatest obligation is to Tom Smart, executive director and CEO of the McMichael Canadian Art Collection. Tom nurtured and encouraged this project from its very beginnings (a lunch on a rainy day in Oxford in December 2006) and along the way became a close and valued friend. I'm also grateful for the support and friendship over the years of Noreen Taylor, chair of the McMichael's Board of Trustees during the time that I did the bulk of the work on the project. The third figure in this magical trinity has been Scott McIntyre, chairman, CEO and publisher of Douglas & McIntyre. All three have shown not only a belief in *Defiant Spirits* but also a dedication to Canadian art and Canadian publishing.

The team at the McMichael offered me a tremendous amount of wisdom and assistance—and treated me with much patience and understanding. Thanks to their efforts I feel I am in the position of an obese and undeserving tourist who has been escorted to the top of Mount Everest by an infinitely more worthy and capable team of Sherpas. Katerina Atanassova, the chief curator, and Chris Finn, assistant curator, have given me much advice and have put in more hours

of planning and detective work on my behalf than I can bear to think about. Linda Morita, the McMichael's indispensable librarian and archivist, was a constant source of help and wise counsel. She made my days in the archives pleasant and (I hope) productive, and she also located all of the archival images for the book. Janine Butler found all of the colour images and—in a task whose magnitude and frustration I cannot imagine—arranged all of the loan requests for the exhibition. Shelley Falconer and Shawna White, curators at the McMichael when I started the project, provided early encouragement, and Christine Lynett arranged my first visits to the McMichael and showed me her collection of papers from the Tweedale family, now in the McMichael's archives. I'm also obliged to Stephen Weir, the McMichael's inveterate publicist, for countless services. Among the introductions he orchestrated was a memorable one to James Mathias, for whom I am grateful for a fascinating tour of the Studio Building.

The Canadian Art Foundation gave me the chance to air earlier versions of the book, both in print (in *Canadian Art* magazine) and in lectures delivered in Toronto and Winnipeg. For these opportunities I'm grateful to Ann Webb, Melony Ward and Richard Rhodes. Another chance to think aloud in front of an audience came at the Interdisciplinary Centre for Culture and Creativity at the University of Saskatchewan, for which I thank David J. Parkinson and Peter Stoicheff. Teresa Howe arranged for me to give a preview of *Defiant Spirits* for the Canadian Women's Club in London, England; and Judy Craig at the Arts Society King, in King Township, Ontario.

Many people responded to my requests and provided valuable information in the course of my research: Susan Mavor, head of Special Collections, University of Waterloo Library; Cyndie Campbell, head of Archives, Documentation and Visual Resources in the National Gallery of Canada's Library and Archives; Cathryn Walter and the other members of the staff at Library and Archives Canada; Scott James, librarian at the Arts and Letters Club in Toronto; Nora Hague, senior cataloguer in the Notman Photographic Archives, McCord Museum, Montreal; Isobel MacLellan, librarian, Archives and Special Collections, Mitchell Library, Glasgow; Lisa Cole, assistant

curator, Gallery Records, Tate Gallery, London; Graeme Siddall in the Sheffield Archives; Laura Lamb in the Special Collections Department of the Hamilton Public Library; the periodicals and email reference staff of the Worcester Public Library in Massachusetts; Ken Dalgarno at the Moose Jaw Public Library; Damien Rostar at the Local History Department at the Hackley Public Library in Muskegon, Michigan; and Roberta Green at the Huntsville Public Library.

Other people generously responded to my queries or supplied other assistance. Angie Littlefield provided information on Tom Thomson's early years, Ron Hepworth on Ontario's flowers and vegetation, and Dr. Ken Reynolds on the fate of the 60th Battalion. I am grateful to Barb Curry, Rick Thompson and Jayne Huntley of the Sheddon Area Historical Society and to Annie Robertson, who shared with me her memories of Coboconk. Mary Gordon told me about Christina Bertram's dealings with A.Y. Jackson and Tom Thomson. Louis Gagliardi gave me a private view of paintings by J.W. Beatty and P.C. Sheppard. Dr. Bogomila Welsh-Ovcharov's tremendous support, along with that of Annie Smid, gave a great boost to the exhibition at a crucial point in its development.

I was fortunate to receive cooperation from the descendants of a number of the people mentioned in the book. William D. Addison granted permission for me to quote from Mark Robinson's diaries, now in the Trent University Archives in Peterborough; and Catharine Mastin allowed me to quote from Franklin Carmichael's letters, held in the McMichael's archives. Kim Bullock kindly gave me much information on her great-grandfather, Carl Ahrens. She also made available to me passages from Madonna Ahrens's unpublished memoirs and provided the photograph of Carl Ahrens reproduced in the book.

The formidable logistics of writing on Canadian history and Canadian art while living in England were solved thanks to help from a number of friends. Victor Shea offered me a bed in Toronto, and Tasha Shea photocopied journal articles that were unavailable to me in the U.K. I am also thankful for the generous hospitality in Toronto of John and Chris Currie, who on several occasions gave me the keys to their beautiful house.

Chris Labonté, Susan Rana and Peter Cocking—along with other of their colleagues at Douglas & McIntyre—made the process from manuscript to book efficient, enjoyable and remarkably painless. Ruth Gaskill expertly copyedited the manuscript.

Two people, both in Ottawa, went above and beyond the call of duty in their assistance. I was extremely fortunate in having as my wise editor Dr. David Staines of the University of Ottawa. He scrutinized the various iterations of the manuscript with a keen and rigorous eye, offering many editorial insights. I was also the happy recipient of a huge amount of help and advice from Charles Hill of the National Gallery of Canada. Despite his own busy schedule, Charlie read the manuscript in its entirety and gave me the benefit of his extraordinary knowledge of Canadian art in general and the Group of Seven in particular. He rescued me from numerous faux pas. As for any that remain, this thing of darkness I acknowledge mine.

Like anyone writing about the Group of Seven, I am indebted to a number of art historians who over the years have held high the torch for Canadian art. Besides that of Charlie Hill, I wish to acknowledge the work of Dennis Reid, David Silcox, Joan Murray and the late Robert Stacey. Many other scholars are cited in my notes. One of the numerous pleasures of researching *Defiant Spirits* was discovering the tremendous breadth and depth of recent writing on Canadian art and Canadian history—all of it testimony to the health and vigour of Canadian studies.

Two people in England were vital to the production of the book: my agent, Christopher Sinclair-Stevenson, and my wife, Melanie. Besides giving her love and support, Melanie patiently endured my frequent absences from home and, when I was at home, my long hours shut away in my studio with "the Canadians."

I must also thank my family in Canada: my mother, brothers, sisters, nephews and niece. Writing and thinking about Canadian art, after a decade of work on Italian and French art and history, took me back to my Canadian roots. For that reason the dedicatees of *Defiant Spirits* are three people—my brothers Bryan, Randy and Stephen—with whom I shared a happy boyhood on the Saskatchewan prairies.

BOOK **I**

1 A WILD DESERTED SPOT

IN MAY 1912 two men from Toronto arrived in Algonquin Provincial Park, armed with fishing rods and a letter of introduction to the superintendent. The park, an eight-thousand-square-kilometre fish and game preserve in Northern Ontario, was inaccessible by road, so the men made the 220-kilometre journey north from Toronto on the Grand Trunk Railway. They would have changed trains at Scotia Junction, north of Huntsville, before arriving via a single-track railway line at Canoe Lake.

For the past few years, the Grand Trunk Railway (whose president, Charles Melville Hays, perished on RMS *Titanic* less than a month earlier) had been transporting affluent tourists and overworked city dwellers into the Ontario hinterlands for what a 1910 issue of *Rod and Gun in Canada* called "a rest cure in a canoe."[1] Canoes and fishing rods were widely publicized antidotes for modern ills and anxieties at a time when the urban population of Ontario for the first time outnumbered the rural.[2] Promoting itself as the "Highway to Health and Happiness," the Grand Trunk advertised Algonquin Provincial Park in full-page spreads as one of "the beauty spots of the Dominion" that appealed to sportsmen, nature lovers and artists alike. "This country is increasing in popularity every year," declared one advertisement,

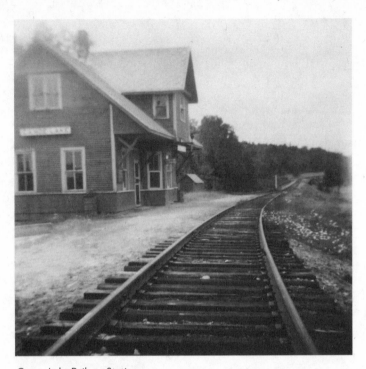

Canoe Lake Railway Station
McMichael Canadian Art Collection Archives

"and has become a favourite tourist resort of Britons and Americans who are flocking to this country for their vacation in increasing numbers."[3] The company already operated two lakefront hotels: the thirty-five-room Hotel Algonquin at Joe Lake Station and the seventy-five-room Highland Inn on Cache Lake. In 1912 there were plans for two more.

The two visitors who presented their letter of introduction to the park superintendent were typical of those who descended by the trainload on Algonquin Park. Tom Thomson and Harry B. Jackson were city dwellers lured north on a two-week fishing holiday by promises of lakes abundant with black bass and speckled trout. Both were graphic designers who worked at Grip Limited, a commercial art firm in downtown Toronto. Their modest salaries of $30 per week meant they declined the luxuries of the Highland Inn, which boasted hot and

cold running water, indoor washrooms, private baths and an elegant dining room. On the advice of one of the rangers, who assured them of "good meals and excellent beds,"[4] they availed themselves instead of the more rustic conveniences of Camp Mowat.

A former barracks for the mill workers of the bankrupt Gilmour Lumber Company, Camp Mowat was on the northwest shore of Canoe Lake, in the semi-derelict village of Mowat. Its air of decrepitude meant that even the Grand Trunk's most enthusiastic copywriter would have struggled for words. According to one visitor, it was "a wild deserted spot."[5] The village's population had shrunk from a high of five hundred at the turn of the century to a little more than one hundred. Camp Mowat itself was a bleak-looking warehouse of a building whose rows of windows faced what the daughter of a park ranger later described as "a treeless, desolate area of thirty acres or more covered with pine slabs and sawdust."[6]

The area immediately beyond Mowat was barely more inspiring. One Torontonian who owned a cottage on Canoe Lake described the park as "a paradise of virgin wilderness,"[7] but in fact much of the area around Mowat was neither paradisal nor virgin. Hundreds of acres of the surrounding forest were either clear-cut, flooded by dams or swept by fire. With the vast logging operation defunct, Mowat was left with an abandoned mill surrounded by decaying tree stumps and dunes of sawdust. There was also a deserted hospital and a cemetery with two inhabitants.

It was in these unpromising environs that Thomson and Jackson unpacked not only their brand-new fishing gear but also—since they had come to Canoe Lake for something more than black bass—a Kodak camera and their paintbrushes. They were not the first landscapists to paint in the park. A decade earlier three members of the Toronto Art Students' League had come north, clambered into canoes and, with the help of a guide, paddled the waterways in search of picturesque landscapes. More recently the park was visited by Tom McLean, a friend of Thomson and a fellow employee of Grip Limited. A specialist in scenes of canoes and voyageurs (those staples of Canadian landscape painting), the thirty-one-year-old McLean was a true

man of the woods. He had worked in Northern Ontario as a prospector, fire ranger and surveyor, and he was present in 1904 when his friend Neil McKechnie, another Toronto painter with a love of the outdoors, drowned while shooting the rapids on the Mattagami River.

Thomson and Jackson produced a number of oil sketches during their stay. Jackson commemorated their visit with a small portrait of Thomson smoking his pipe and wearing a hat festooned with trout flies, and Thomson painted several landscapes. One of them, *Old Lumber Dam, Algonquin Park,* showed, in an eerie adumbration of his none-too-distant fate, an overturned canoe. But these were fairly amateur efforts, because in 1912 Thomson was a painter of limited skill and no repute. Two months shy of his thirty-fifth birthday, he was more experienced in angling than in landscape painting, a technique in which he had little formal training. As Jackson later recalled, Thomson "used to chuckle over the idea" that his work would ever be taken seriously.[8]

THOMAS JOHN THOMSON was a striking man: slim, six feet tall, with black hair—"as black as midnight," according to a friend[9]—and fine, almost delicate features. According to one of his brothers, he was "always neatly attired in the best of clothes."[10] Portraits taken in his younger days showed him in waistcoats, bow ties and celluloid collars. In one photograph a plug hat is tipped back from his brow; in another, looking like a raffish undergraduate, he poses with a cigarette between his lips and sports a dapper moustache. One family photograph reveals him with his hair parted in the middle—a style that in Victorian Ontario, an age of close-cropping and side-parting, lay one open (as a newspaper reported) to charges of "dandyism" and "dudism."[11]

Sartorial flair belied Thomson's shy, self-effacing personality. "There was no atom of pretence about Tommy Thomson," a friend later recalled, "not the slightest swank or swagger."[12] According to another, he possessed "a quiet reserve, a reticence almost approaching bashfulness."[13] One of his closest friends noted how he was "a man of few words,"[14] and a woman with whom he would share studio space

Tom Thomson, c.1905
McMichael Canadian Art Collection Archives

found him "shy and unassuming."[15] This self-effacing personality masked a darker side. His mood swings could be alarming. He was by turns "jovial and jolly ready for a frolic of any kind" and then "quite melancholy and defeated in manner"; when one of these melancholy moods came upon him, he could turn "almost angry in appearance and action."[16] According to yet another acquaintance, he was subject to fits of depression, a condition he was suspected of self-dramatizing and sometimes intensifying with an excess of drink.[17]

The sixth of ten children, Thomson was raised on a hundred-acre farm at Leith, Ontario, ten kilometres northeast of Owen Sound, on the southern shore of Georgian Bay. His father was the son of a Scottish immigrant and his mother (in what gave him an unimpeachable Canadian pedigree) a distant relative of Sir John A. Macdonald.[18] The Thomsons were a talented and artistic family. Their brick farmhouse,

Rose Hill, was filled with books and music. Tom had sung in the choir of the local Presbyterian church and learned to play the trombone, the mandolin and the violin. In the evenings, according to a sister, "Tom usually was busy with a book."[19] He was a sickly child, suffering various ailments. An "inflammation of the lungs" kept him out of school for an entire year.[20] He nonetheless took to outdoor pursuits. In his youth he led what a friend later called (probably with some rose-tinted amplification) the "squirrel-hunting, apple-eating, cow-chasing, chore-drudging life of the farm boy."[21] An older sister would remember how he roamed the woods near Leith armed with a shotgun and wearing an old felt hat decorated with wildflowers and squirrel tails.[22] He often went fly-fishing with his father, John, an absent-minded and slightly delinquent farmer who escaped the drudgery of his turnip patch by loafing on a riverbank with a fishing rod.

Another inspiration for Thomson's love of the outdoors was his great-uncle, Dr. William Brodie, a former mentor of Ernest Thompson Seton, the wildlife painter and later founder of the Boy Scouts of America and the Woodcraft League. A self-taught naturalist who originally trained as a dentist, Dr. Brodie took the adolescent Thomson on expeditions along the Scarborough Bluffs, outside Toronto, to collect plant and insect specimens. Twenty new species of insect resulted from these forays, as well as a collection of nearly 100,000 biological specimens (many of which entered the Smithsonian). In 1903 Dr. Brodie was made director of the Biological Department of what would become the Royal Ontario Museum. His only son, a promising naturalist, drowned while crossing the Assiniboine River, and Dr. Brodie appears to have regarded Thomson (his sister's grandson) as a kind of surrogate. He passed on to Thomson his love of the Ontario landscape, which he praised for its "deep ravines" and "abrupt wooded hills . . . with the projected tops of stately pines."[23]

Thomson did not, as might have been expected of a literate young man with artistic talent, study at either university or an art school. Lack of funds was not the problem. In 1898, at the age of twenty-one, he inherited $2,000 from his grandfather's estate. Two thousand dollars was a large sum, far beyond the annual wage of the average

Canadian. In 1898 it would have been enough to either build a house in Toronto or purchase a 150-acre farm in most parts of the country.[24] What became of this sudden largesse is a complete mystery: it seems to have been either squandered outright or slowly but determinedly depleted over the course of many years. In either case, it had little bearing on his career. He began a humble apprenticeship at William Kennedy & Sons, a steel foundry in Owen Sound that produced water-wheels, propellers, mill gearings and other equipment for ships and sawmills. This career ended when, in an episode he later called the "most regrettable" in his life, he quarrelled with the foreman and left after only eight months.[25]

A stint at a business college in Chatham followed. Thomson studied ornamental penmanship and, perhaps subsidized by his legacy, developed a reputation for dancing and socializing. He tried to enlist for service in the Boer War (more than seven thousand other Canadians fought) but was rejected because of fallen arches and the condition of the big toe on his right foot, broken years earlier during a football match.[26] There followed a period of what a friend from the steel foundry, Alan Ross, called "drifting."[27] One night, during a drinking session, he unburdened himself to Ross, "lamenting his lack of success in life in terms that rather astonished me. I began to think then that he realized his powers and that he also had secret ambitions."[28]

In 1901 Thomson began pursuing these ambitions by following his older brother George across the continent to Seattle. At the time Seattle was still the transport and supply centre for prospectors heading north to the Yukon. Even the mayor of Seattle had resigned his post in 1897 and joined the gold rush. But Thomson had less intrepid plans, working as an elevator boy in the Diller Hotel on First Avenue and then studying decorative design at the Acme Business College. Owned by the enterprising George and his distant cousin F.R. McLaren, the college offered training in bookkeeping and shorthand. Diploma in hand, Thomson began working as a graphic designer—the trade he would practise for the rest of his life—in a Seattle firm of photoengravers. Once again his independent spirit and flashes of temperament caused friction with his superiors.[29]

Thomson's time in the United States ended abruptly in 1904, not owing to a quarrel with his manager but, more mysteriously, because of a love affair gone wrong. He left Seattle after an eighteen-year-old named Alice Lambert, the daughter of a former president of Willamette University in Oregon, spurned his marriage proposal.[30] Thirty years later, this interlude would be fictionalized by Lambert herself, who cast Thomson as the romantic lead in one of her novels—a "darkly morose" commercial artist with "thin, nervous hands and flashing eyes." This young artist (imaginatively named Tom) romanced the heroine with streetcar rides through Seattle and winter afternoons in the "musty dimness of the Public Library where he would pore over prints and reproductions of the Masters." The affair ended when Tom returned east, "determined to succeed" as a painter.[31]

Success did not appear imminent for Thomson. Moving back to Canada, first to Owen Sound and then to Toronto, he found employment in the art department of another photoengraving firm. He earned $11 a week and (in what was becoming a recurring pattern) a reputation as "an erratic and difficult man."[32] He was still drifting as he reached his thirtieth birthday in 1907, rooming in a succession of inexpensive boarding houses and remaining a bachelor. He joked to co-workers about hopping a freight train and travelling farther east, hobo-like, in a boxcar.[33]

So, we see Thomson at thirty: handsome; shy; moody; profligate; rebellious; dandyish; rootless; secretly ambitious; given to drink, depression and outbursts of temper. But he was also moving in new directions and making other plans. In 1906 he took night classes at the Central Ontario School of Art and Industrial Design (later rechristened the Ontario College of Art) from a famously cantankerous painter and illustrator named William Cruikshank, the grand-nephew of George Cruikshank, celebrated illustrator of Charles Dickens. Then, after four years in Toronto, he moved to Grip Limited, another commercial design firm.

At Grip Limited, Thomson came into contact with a vibrant group of young artists and designers. Many were frustrated by the mundane nature of their tasks, which included such inspiring commissions as

designing labels for Dr. Clarke's Stomach and Liver Tonic. A number of the young men in the art department—an "eager group of young fellows"[34]—harboured greater ambitions. As a friend later remembered, they hoped to "awaken artistic consciousness in this country."[35] By the summer of 1912, when Thomson made his first excursion into Algonquin Provincial Park, Grip Limited was fast becoming a nursery for a new kind of Canadian art. Thomson's drifting was about to be arrested.

2 THIS WEALTHY PROMISED LAND

GRIP LIMITED HAD its offices on Temperance Street, two blocks south of where Toronto's City Hall stood on Queen Street West. The firm's art department was situated in a high-ceilinged, open-plan, second-storey office. A photograph taken in the Grip office in about 1911 shows ten young men, all in waistcoats and neckties, gathered beneath the office's clerestory windows and behind a jumble of wooden desks; a framed print of Frans Hals's *The Laughing Cavalier* hangs on the wall behind them. Tom Thomson, wearing a jacket, puffs away at the pipe he always stuffed with Hudson Bay tobacco ("the rankest, reekingest, deadenest, most odiferous" on the market).[1]

The mood looks industrious but relaxed and good humoured. A visitor to the department later reported that the men's moments away from their desks were spent in "boxing and wrestling matches, playing horse or monkey with much stamping, kicking and swinging on the steam pipes."[2] Thomson on one occasion filled a photoengraver's tank with water and, after pulling a chair alongside and producing his paddle, "sat there gently paddling."[3] But a young man who joined the firm in 1910 had found their behaviour respectful and orderly: the men were "artistic and decent," and there was "no chewing, spitting or cursing... Their conversation is clean and interesting." He noted that "they all seem so very ambitious."[4]

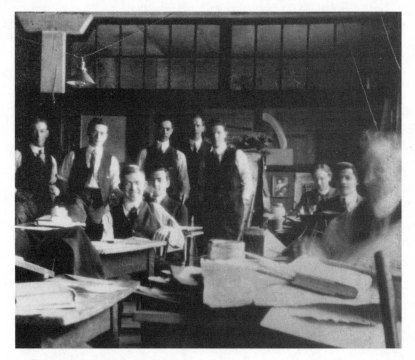

Art Room at Grip Limited, c.1911–12
National Gallery of Canada Archives, Ottawa

The firm took its name from an illustrated periodical, *Grip*, founded in 1873 by J.W. Bengough, a political caricaturist who named his weekly after the talking raven in Dickens's *Barnaby Rudge*. Bengough was a crusading moral reformer who wanted to turn Canada into a Christian republic and who used his barbs and outrageous puns ("the pun is mightier than the sword," he once declared) to "serve the state in its highest interests."[5] *Grip* ceased publication in 1892, with Bengough's dreams of a Christian republic unfulfilled, but the company that printed it survived. Known as the Grip Printing & Publishing Co. (shortened in 1901 to Grip Limited), it incorporated engraving, lithography and advertising departments. Gone was Bengough's Christian evangelizing. The firm now produced images advertising Canada's commercial prosperity: posters and pamphlets for hotels and railways, furniture warehouses, real-estate firms and mail-order catalogues.

Designing logos and pamphlets might have seemed a prosaic occupation for men, like Thomson, who harboured artistic ambitions. This, however, was the heroic age of commercial illustration. Many artists with international reputations were creating beautiful and innovative commercial work. Pierre Bonnard began his career designing posters for champagne, the Beggarstaff Brothers used their talents to sell corn flour and Rowntree's cocoa, and the Art Nouveau designer Alphonse Mucha did ads for bath salts, cigarette paper and baby food. Art and advertising had come happily together. In the 1890s the advertisements of designers like Mucha and Henri de Toulouse-Lautrec unleashed an *affichomanie,* or "poster craze," in Europe and America. Advertisements became so popular (and valuable) that enthusiasts stole them from billboards and kiosks. As an American advertising handbook exulted, people "obtain more genuine joy and satisfaction from a first-rate poster than they would from an old masterpiece."[6]

By the first decade of the twentieth century, Grip Limited was on the leading edge of this kind of commercial design. It had introduced into Canada not only the Art Nouveau style but also metal engraving and the four-colour process. A young Englishman, shown work by Grip designers in 1910, enthused that it was "equal if not better to anything I have seen in England."[7]

WITH ITS GROWING population and booming economy, Toronto offered much opportunity to Grip designers like Tom Thomson. It was the second-largest city in Canada, after Montreal. An English visitor in 1913, the poet Rupert Brooke, described "T'ranto" (as he was told to pronounce it) as the "soul of Canada . . . wealthy, busy, commercial, Scotch." He found it "a clean-shaven, pink-faced, respectably dressed, fairly energetic, unintellectual, passably social, well-to-do, public-school-and-'varsity sort of city"—though not lacking "its due share of destitution, misery, and slums."[8]

The city had been known since the 1880s as "Toronto the Good," thanks to a crusading mayor who shut down many brothels and gambling dens. Much-lamented shortcomings remained: muddy streets, wooden sidewalks, ugly buildings, garish signs and a lack of public

parks and squares. Its dearth of cultural amenities (its art museum had no premises) prompted one writer to call it "the most philistine city in the Dominion."[9] Nevertheless the city had a powerful sense of its own civic worth. "Torontonians used to say that Toronto was destined to become a great city," one commentator proudly declaimed. "We employ the present tense now. Toronto *is* a great city." According to another observer, measuring the city against its American neighbours in the anxious hobby that would engross Torontonians for at least another century, it "compared magnificently with many of the largest cities on the American continent."[10]

Toronto had grown immensely over the previous decade. Swollen by European immigration, mainly from Britain, its population had almost doubled to 382,000. Canada as a whole was booming and growing. A giddy optimism was in the air. Famously, on January 18, 1904, the Canadian prime minister, Sir Wilfrid Laurier, gave a speech at the first annual banquet of the Canadian Club of Ottawa. "The nineteenth century was the century of the United States," he declared. "I think that we can claim that it is Canada that shall fill the twentieth century."[11]

There were good reasons for this optimism. Canada seemed a land of untold resources and as-yet-untapped potential. A 1911 book on Canada by an English journalist bore the emphatic title *The Golden Land.* In the first decade of the twentieth century, Canada had the world's fastest-growing economy. The wheat boom that began in 1896 boosted the nation's exports and populated the Prairies as immigrants arrived from all over the world. A song called "The Sugar Maple Tree" included the lines, "All nations of the earth / Are now learning of its worth / And are flocking to this wealthy, promised land."[12] Canada's population rose from 5.3 million at the turn of the century to 7.2 million in 1911. Lured by the Laurier government's aggressive promotion of Canada abroad as "The Land of Milk and Honey," more than 2.5 million immigrants arrived in Canada between 1903 and 1913; 405,000 would come in the year 1913 alone. In 1911 the *Montreal Daily Star* called Canada "the richest, most promising, most prosperous country in the world." It predicted an eventual population of 80 million.[13]

There was some anxiety about how these hundreds of thousands of immigrants from all nations of the earth would be assimilated into Canadian society. Many of those moving to the West were not the pink-faced Protestants from Scotland, Ireland and England who settled Ontario but a more eclectic mix from the Galicia and Bukovina regions of the Austrian Empire and from Belarus, the Ukraine and the Punjab. By 1905 hundreds of Romanian Jews were homesteading in Saskatchewan, and thousands of Sikhs were arriving in British Columbia. Between 1909 and 1911 some 1,500 black settlers from Oklahoma moved onto the Prairies.[14] In 1912 more than 80,000 immigrants who spoke no English arrived in the country.[15] A Conservative MP from Ontario complained that Canada "is today the dumping ground for the refuse of every country in the world."[16] A 1909 book entitled *Strangers within Our Gates* lamented the "uncouth ways," "alien ideas" and "laxity of morals" of the "motley crowd of immigrants" moving to the Prairies.[17]

Laurier allowed that Canada was made up of "confused elements": "Our existence as a nation is the most anomalous as has yet existed. We are British subjects, but we are an autonomous nation; we are divided into provinces, we are divided into races."[18] What ballast was there to keep this strange vessel on an even keel? What encompassing interpretation of its history could be offered?

The Dominion of Canada was less than fifty years old. It knew no revolution, no grand battle; there was no legion of martyrs with whom to keep faith. The sedate progress from colony to nation robbed Canadians of the traumatic events that the leading sociologist of the day, Émile Durkheim, called "effervescences"—collective shocks that bind a people together by means of a shared body of rituals, myths, heroes and sacred objects.[19] Canada had no distinctive flag of its own, no official anthem, no great metropolis, no widely recognized body of literature, mythology or music. Colonized by Britain and France, it was founded on lands purchased (sometimes stolen) from the Natives, divided between French and English speakers, populated by immigrants and bordered by the United States, whose population of 92 million made it the continent's economic and cultural centre of gravity.

The Grip designers wished to "awaken artistic consciousness" in Canadians. But what did it mean to be Canadian? What, indeed, was Canada?

THE ONE THING Canadians had in common, it seemed obvious to anyone who travelled across the country on one of the two transcontinental railways, was a vast landscape and a northern geography. Canada was a land of mountains, frozen lakes and unending prairies and forests at the top of the world map. What made Canadians unique was their engagement with this hostile and unforgiving land that dictated the terms of human existence. If Canada had a national mythology, it involved arduous voyages of discovery and struggles for survival in the wilderness, from Jacques Cartier and Martin Frobisher to Samuel Hearne and David Thompson.

The Canadian wilderness was a place of great wealth—of Cartier's fabulous, ruby-rich "Kingdom of the Saguenay," or Skookum Jim Mason's gold nuggets panned in a Klondike tributary. But it was also a wild and dangerous place, where, as a chronicler soberly noted of Frobisher's voyages, "all is not gold that glistens."[20] The Canadian landscape inspired fear, mystery, wonder and often frustration and disappointment. One confronted not other people, or even oneself, so much as the forces of nature and the vastness of the universe. The English poet and philosopher T.E. Hulme, in Saskatchewan to help with the wheat harvest in 1906, experienced what he called the "fright of the mind before the unknown": a horrifying, agoraphobic vision of the insignificance of man before the oppressive and impossible immensity of Canada's physical landscape.[21] Hulme went on to become the English-speaking world's greatest philosopher of modernism, the man celebrated by T.S. Eliot as "the forerunner of a new attitude of mind."[22] This new attitude was shaped, Hulme himself believed, by his fright of the mind before the distended horizons of the Canadian Prairies—"the first time I ever felt the necessity or inevitability of verse."[23]

Others, gazing upon this robust grandeur, had felt the necessity and inevitability of pictures. At the opening of the Art Association of Montreal in 1879, the governor general, the Marquess of Lorne,

urged Canadian painters to turn for inspiration and the creation of a national "school" to "the foaming rush of . . . cascades, overhung by the mighty pines or branching maples" and "the sterile and savage rock scenery of the Saguenay."[24] By 1879 his injunction was already redundant. Almost every corner of the country had been captured on canvas. The habitants, waterfalls and Mohawk and Huron encampments of Quebec had appeared in the work of Cornelius Krieghoff. Paul Kane captured the remote frontiers of the West during a long odyssey across the continent in 1846–48, from Toronto to the Juan de Fuca Strait and back. Two decades later the English painter Frances Anne Hopkins canoed through the fur-trading routes of the Great Lakes with her husband, an inspector for the Hudson's Bay Company. Then in 1888 Lucius O'Brien, the first president of the Royal Canadian Academy of Arts, made a cross-country train journey to Vancouver. He spent the entire summer exploring Howe Sound in a sailing canoe navigated by Chinook guides.

Not even the Canadian Arctic was a territory uncharted by painters. The British midshipman Robert Hood, a member of Sir John Franklin's 1819–21 expedition, executed watercolours of animals and birds, his brush sometimes freezing to his paper as he worked. In 1859 Frederic Edwin Church, an American, journeyed to the southeastern tip of Labrador to paint icebergs. Two years later another American artist, William Bradford, donned sealskins, chartered a twenty-ton schooner and began producing hugely popular studies of the Labrador coast.

And yet, for all these thousand miles by canoe, train or whaling ship, and for all these canvases of jagged mountains and misty cascades, by the turn of the new century the accusation lingered that the "true North" had not yet been captured with a distinctively Canadian flavour, with a style adequate to the matchless geography. The point was made in 1908 by Harold Mortimer-Lamb, a British-born employee of the Canadian Mining Institute who became a pictorialist photographer and art critic. "No painter," Mortimer-Lamb contended in the *Canadian Magazine,* "has yet experienced the spirit of the great northland; none perhaps has possessed the power of insight which such a task would demand."[25]

THE PROBLEM WAS partly a matter of technique, of learning to see the particulars of the Canadian landscape—its flora, its geology, its clear and brittle atmosphere—through distinctively "Canadian" eyes in a way that would channel or interpret Hulme's fright of the mind. European travellers of the nineteenth century always compared the Canadian wilderness to the beauty spots of Europe: the area around Parry Sound to the hills of Killarney, the islands of Georgian Bay to the Hesperides. But if Canada's northern landscape was unique, then its depiction called for unique representational strategies. Yet O'Brien's paintings, with their burnished atmosphere and sense of hushed grandeur, hewed closely to the style of American painters such as Church and Albert Bierstadt.

Or again, the canvases of two of Canada's most renowned landscapists, Homer Watson and Horatio Walker, were resolutely European in style. Watson was even known as the "Canadian Constable," and Walker depicted Quebec farm life in a sentimentally heroic style recalling the peasant scenes of the French painter Jean-François Millet. Both men enjoyed enormous success, both in Canada and abroad. Watson's works were owned by both Oscar Wilde and Queen Victoria, and in 1902 a New York art critic hailed Walker (winner of numerous international prizes) as "the man to whom the first place among American painters should unanimously be conceded."[26] Yet they painted Canadian scenes with few concessions to the local conditions. A young art student, visiting Watson's studio near Berlin, Ontario, in 1910, was surprised to find his sombre works a complete contrast to "the country in which he lives. You would never recognize it from his work."[27]

The lack of an indigenous Canadian artistic style was noted by various foreign observers. An 1886 exhibition of Canadian paintings in London struck an English artist with its "evident traces of French influence," and a critic reviewing the same show could have believed himself in "a good European art gallery."[28] A generation later, the European imprint was as pronounced as ever. A critic for the *Morning Post,* surveying Canadian paintings at the Walker Art Gallery in Liverpool in 1910, saw "the beginning of a movement that will

produce great things in the future." But he lamented that the essence of the Canadian landscape was "crushed out by a foreign-begotten technique" because Canadian painters had been forced to seek their means of expression "in the ateliers of a foreign land."[29]

Tragically, one of the few artists celebrated for painting the landscape in a uniquely "Canadian" style—for painting the Canadian wilderness in a manner praised as "free, strong, untrammeled of convention"—had been Neil McKechnie, who drowned at the age of twenty-seven.[30] McKechnie's death on the Mattagami showed all too plainly how the Canadian painter's relationship to the landscape was fundamentally different from that of the French or English or Dutch to theirs. The Canadian landscape was not only vaster and less populous, but it was also more intractable and potentially dangerous. Life in many parts of the Dominion was more basic and elemental than in Europe, leading to a very different sense of place and—allegedly—calling for a different type of character. The Canadian landscape was, in history and legend, where people froze to death, drowned, starved or went mad from isolation. Even in an area as apparently colonized by trains and tourist hotels as Algonquin Provincial Park, it was still necessary, in the middle of winter, for cottagers to connect their doors to their woodsheds and outhouses by means of rope lines to avoid getting lost in blizzards and dying in what was literally their own backyard.[31]

Canadian landscape art had produced martyrs in both McKechnie and Robert Hood. The latter was shot through the head by one of his starving companions, a voyageur known as "Michel the Iroquois"; two other members of the expedition, driven mad by hunger, murdered Michel and stayed alive by eating Hood's buffalo robe.[32] Franklin, famously, ate his own boots. Clearly this was not a Dutch riverside or the sheep-clad Surrey hills. How could Canadian painters possibly respond to their physical environment in the same way the Dutch or British did to theirs? A new idiom of landscape was called for.

20

FOR SEVERAL YEARS Tom Thomson's supervisor at Grip Limited had been J.E.H. MacDonald. If Thomson clashed with his superiors in the past, his relationship with the gentle, retiring and slightly

shambolic Jim MacDonald was far more temperate and satisfying. MacDonald was called by friends "a wonderful poetic soul, full of humour and patience" and compared to a "secular monk" with the "simple mysticism of St. Francis of Assisi."[33] He was known for pouring oil on troubled waters. "Often a somewhat delicate situation, with possibilities of wrathful recrimination, would be saved," a friend later wrote, "by a flash of Jim's delightful humour which turned anger into laughter."[34] MacDonald (whom Thomson always addressed formally as "Mr. MacDonald") no doubt had many opportunities to quell Thomson's anger. He was also to become one of the most important influences on the younger man's art.

Four years older than Thomson, the red-haired MacDonald had been born in England, in Durham, to a Canadian father and a British mother. At fourteen he immigrated with his parents to Hamilton, apprenticing soon afterwards with a lithography company while attending evening classes at the Hamilton Art School. In 1890 he moved to Toronto, starting at Grip soon after the demise of Bengough's magazine. More art lessons followed. In 1898 he enrolled in Saturday classes at the Central Ontario School of Art and Industrial Design, where he, like Thomson a few years later, studied under Cruikshank. He also joined the Toronto Art Students' League, a group based on the Art Students' League of New York, founded in 1875 to provide tuition outside the more conservative art schools. In the Toronto version, nationalism came to the fore. "There was a great stirring of the Canadian ideal," MacDonald would later write.[35] The men gathered in the evening to sing canoeing songs. Determined to depict Canadian scenes, members embarked on cross-Canada sketching trips, the results of which were illustrated calendars published annually between 1893 and 1904. Although some members set off on daring voyages of the sort that cost one of their number, Neil McKechnie, his life, the frail, slender MacDonald generally stuck to Toronto's suburbs.

MacDonald had eventually returned to England for further employment and training. After marrying a primary school teacher in 1899 and becoming a father two years later, he moved with his

J.E.H. MacDonald at Grip Limited
McMichael Canadian Art Collection Archives

young family to London. For the next four years he worked with the

Carlton Studios, whose three Canadian founders were all gradu-
ates of the Central Ontario School of Art and Industrial Design and
former Grip employees. He spent much time in London's great art
museums. Although a wide range of paintings was on offer, the art of
Edwardian England had been dominated by landscapes. Each year the
exhibitions at the Royal Academy and other venues filled with images

of fields, pastures and groves—vistas offering agreeable flights from London's smoke and ever-inflating population (the city had increased by 900,000 people during the 1890s: its total population was almost 7 million). In 1906 MacDonald saw what he called "a little forest picture" by a painter of the Barbizon School, Narcisse-Virgile Diaz de la Peña. The work inspired in him the ambition to become a great painter: "I seemed to get a clear feeling, though faint and far off, that someday I, too, would be an artist and produce similar things." He saw himself, he claimed, "as a forest specialist."[36]

MacDonald returned to Canada in 1906 to become head designer at Grip. He continued to hone his skills as a forest specialist by painting landscapes in High Park, along the Humber River and occasionally in Muskoka. He made his first important sale early in 1911 when the Government of Ontario purchased *By the River, Early Spring*. In November of that year, in a fateful episode for Canadian art, he staged a solo exhibition of his work at the Arts and Letters Club.

Only a few blocks from Temperance Street, the Arts and Letters Club was founded in 1908 as a venue for staging plays and art exhibitions and otherwise facilitating creative interactions among Toronto artists and writers. Membership was open to all men (and it was exclusively a men's club) who had "artistic tastes and inclinations."[37] According to its founder, the journalist Augustus Bridle, the club was "a weird, delightful rendezvous! Absolute escape from all that otherwise made Toronto consumingly commercial."[38] One early member, Vincent Massey, enjoyed the company of the "weird geniuses" who made the club so different from "the complacent Philistinism of most Toronto drawing-rooms."[39] After eviction from its premises above the Brown Betty restaurant on King Street East, it had relocated to the second floor of a building housing the Court House of the County of York. The lease specified that members use the tradesmen's entrance, accessed only after members picked their way past the police horses' dollops of manure. It was a fitting metaphor for how Toronto's professional elite regarded those with artistic tastes and inclinations.

MacDonald's collection of landscapes received great acclaim from his fellow artists in the club. The noted Canadian landscapist

C.W. Jefferys was particularly struck. A painter who had made his name with panoramas of the Prairies, Jefferys detested how Canadian scenes were so often expressed through what he called "European formulas." On too many Canadian paintings, he wrote, "lay the blight of misty Holland, mellow England, the veiled sunlight of France."[40] But Jefferys believed he saw in MacDonald's works an original and uniquely Canadian approach. "Mr. MacDonald's art is native—native as the rocks, snow or pine trees that are so largely his theme. In these sketches there is a refreshing absence of Europe or anything else, save Canada."[41]

MacDonald's fondness for Narcisse Diaz indicates the extent of Jefferys's wishful thinking. Some of his early works certainly paid homage to distinctively Canadian subjects, with *By the River, Early Spring* (painted near the Muskoka cottage of his wife's aunt) featuring jamcrackers at work before a tumbling waterfall. But the "foreign-begotten technique" was still evident in his choice of sun-etched cloudscapes, a result of his close studies of John Constable at the Victoria & Albert Museum. The blue shadows in his early snowscapes, as well his broken brushwork, reveal his interest in French Impressionism (neatly characterized by one American critic as the "blue-shadow idea").[42]

Still, even if MacDonald's paintings did not live up to the patriotic rod-and-paddle machismo of the singalong gatherings at the Toronto Art Students' League, the aspiration to paint Canada on its own terms—and to "awaken artistic consciousness" in Canadians—at least was there.

THE SUCCESS OF MacDonald's exhibition at the Arts and Letters Club and the sale of his jamcracker painting to the Government of Ontario proved there was an appetite—albeit in refined circles—for northern scenes painted in an Impressionist style. Buoyed by the success of his solo exhibition, and frustrated by the drudgery of commercial work that meant he passed day after day, as he put it, "in the same old way . . . in the same old place, with my nose down to the same old work," MacDonald resigned from Grip at the end of 1911

to work full-time on his painting.[43] A few months later, he sold yet another painting. The National Gallery of Canada bought *In the Pine Shadows, Moonlight,* a dreamy winter scene that attempted to capture the effects of moonlight and shadows on fresh snow.

A few desks away from MacDonald in the office of Grip Limited, Tom Thomson had undoubtedly taken notice of his superior's success. Thus far Thomson had painted mostly in the Toronto environs. It was probably MacDonald's success, and perhaps also his "Canadian ideals," that inspired Thomson to pack his palette as well as his brand-new fishing rod when he went to Algonquin Park in 1912. By the time he returned to the Grip office at the end of May, he was already planning to take a leave of absence and, equipped with his camera and sketching materials, embark on another trip into Ontario's Shield country.

3 EIN TORONTO REALIST

ANOTHER MEMBER OF the Arts and Letters Club, besides C.W. Jefferys, took an interest in J.E.H. MacDonald's 1911 exhibition. Twenty-six-year-old Lawren Harris was intrigued by the same qualities in the paintings applauded by Jefferys. "These sketches," Harris would write in retrospect, "contained intimations of something new in painting in Canada, an indefinable spirit which seemed to express the country more clearly than any painting I had yet seen." He added that he saw in MacDonald's landscapes "the beginning of what I, myself, vaguely felt; what I was groping toward—Canada painted in her own spirit."[1]

Lawren Harris's background was different from either MacDonald's or Tom Thomson's. Always turned out impeccably in a silk shirt and a grey suit—flannel in summer, tweed in winter—he looked, a friend later wrote, "like a Bay Street stockbroker."[2] He had a neat moustache, crisp manner and fastidious dislike of clutter. A photograph taken in his mid-thirties would show him punctiliously adding paint to a canvas while wearing three-piece salt-and-pepper tweeds.

The patrician manner was genuine. Harris's grandfather Alanson had founded a wealthy Brantford dynasty whose fortune came from the "Brantford Light Binder," a horse-drawn reaper that competed

with Daniel Massey's "Toronto Light Binder" until the two firms merged in 1891 to form Massey-Harris, Canada's largest corporation. A year later Harris's father died of Bright's disease, and as the eldest of two brothers, Lawren might have been expected to join the family business. But he had little interest in farm implements. After studying at St. Andrew's College, a newly opened boys' school in Rosedale, he enrolled in 1903 at the University of Toronto. His mathematics professor persuaded his mother that the young man was better suited to studying art.

Aspiring young Canadian artists usually set sail for Paris. One Canadian, arriving in Paris in the mid-1890s, discovered "quite a colony of Canadian art students."[3] Harris, though, went to Berlin. The choice was based less on artistic than on domestic motives, because his thirty-year-old uncle, Dr. William Kilborne Stewart, a Harvard PhD and German instructor at Dartmouth College in New Hampshire, was pursuing post-doctoral studies there. Arriving in Berlin in 1905, Harris enrolled in private lessons with three different teachers. One of them, Franz Skarbina, was among the city's most prominent painters.

For the twenty-year-old Harris, Berlin was a wholly new experience. He would later describe the Ontario of his youth as a place where the people were "submerged in the severest orthodoxy, divided and blinded and sustained by sectarian views, comfortably warped by provincialism and remote from all cultural centres."[4] Religion certainly ran in the Harris family. His maternal grandfather had been a Presbyterian minister, and his paternal great-grandfather, "Elder John," a circuit-riding preacher commemorated by a stained glass window in the Baptist church in Boston, Ontario. His uncle Elmore Harris, a premillennialist, served as pastor of the Walmer Road Baptist Church in Toronto and as president of the Toronto Bible Training School. An uncle by marriage was minister of the Bloor Street Presbyterian Church. Harris himself had been raised a Baptist, attending church three times a day on Sunday.

Berlin exposed the young Harris to a world very different from this claustrophobic provincialism. In 1905 it had a population of more than 2 million; in Europe, only London and Paris were larger. An

English visitor described it as the "chief pleasure town of Germany and the great centre for wealthy persons in search of amusement and dissipation."[5] Whereas Toronto still did not have a single art museum, for a young student in Berlin an enormous range of paintings from every European school could be seen in large art museums such as the Altes Museum, the Neues Museum, the Nationalgalerie and the newly opened (in 1904) Kaiser Friedrich Museum. There was also the Great Berlin Art Exhibition, held each summer at a large exhibition hall in which thousands of paintings and pieces of sculpture went on show. The city was teeming with other art students, with the Royal Art School and the Berlin Academy of Arts turning out rigorously trained young painters.

PIONEERING MOVEMENTS WERE well under way in the German art world by the time Lawren Harris arrived in Berlin in 1905. The previous decade had been a period of rapid intellectual and technological innovation. Radical new proofs were emerging about the nature of both the self and the visible world. The realm of dreams, somnambulism, hypnotism and hallucinations was being explored and described by the new discipline of psychology. French scientists were studying the effects of shapes and colours on the nervous system and unconscious mind. Physics was demonstrating a series of dynamic processes—invisible waves, force fields, electrically charged particles. X-rays were discovered in 1896, and in the following year a British physicist destroyed the concept of the atom as an indivisible unity by demonstrating the electron to be a subatomic particle.

New forms of artistic expression developed as the European art world responded to these discoveries. Conventions established and perfected in the Renaissance were replaced by more personal strategies of representation. Tradition and parochialism came under assault as young painters, believing a breach with the past necessary for art to move forward, seceded from official art academies. Manifestos flew and new journals were founded. In 1898 the architect August Endell, a Berliner, had prophetically declared, "To those with understanding... we are not only at the beginning of a new stylistic phase,

28

but at the same time on the threshold of the development of a completely new Art."[6]

Berlin had been in the vanguard of the new approach to art for more than a decade. By the early 1890s the city was home to an avant-garde led by the Norwegian painter Edvard Munch and the Swedish writer August Strindberg. Munch was one of the great bellwethers of European modernism. In 1892, then twenty-nine and known in his native Norway as "Bizzarro," he was invited by the Society of Berlin Artists, a private association, to exhibit fifty-five of his paintings and etchings at their autumn exhibition at the Architektenhaus. Bitter controversy ensued over Munch's obsessive meditations on love, sex, melancholia and death: a Frankfurt newspaper called on "true believers" to rise up and condemn "that Nordic dauber and poisoner of Art."[7] The members of Berlin's Academy of Arts, a more conservative body of professional artists, ordered the show to be closed down after only a week—an edict that prompted Munch to mock his enemies as "a lot of terrible old painters who are beside themselves at the new trend."[8]

One of Munch's strongest supporters proved to be Franz Skarbina, then forty-three. A Berlin native, Skarbina had taught anatomical drawing and the science of perspective at the Academy of Arts but resigned his post in protest against Munch's treatment. With a number of other disgruntled artists he founded the Gruppe der Elf (Group of Eleven), a collective that staged independent exhibitions and tried to foster a more understanding public for modern art. Its members were accused by Emperor Wilhelm II—an arch-conservative when it came to matters artistic—of "poisoning the soul of the German nation."[9] In 1896, however, a critic for the avant-garde journal *Pan* declared that the Group of Eleven had "helped the cause of modern art more than anything else that has been done to introduce modernity to Berlin—no small achievement, considering the lazy and stupid trust in the conventional that resists anything new, young and forceful."[10]

Two years later, in 1898, the Group of Eleven expanded to become the Berlin Secession, a revitalizing force in German art that attracted many young painters into the city and staged controversial exhibitions. Over the next few years the Secession introduced Berliners to

29

the work of Paul Cézanne, Paul Gauguin, Wassily Kandinsky and Vincent Van Gogh. In 1902 Munch joined the Secession and exhibited, for the first time, the entirety of his *Frieze of Life*.

Harris was undoubtedly aware of developments within the Continental avant-garde thanks to his studies with Munch's champion Skarbina, who served on the executive committee of the Berlin Secession. He also saw their works, since by his own account he "went the rounds of the public and dealers' galleries."[11] During Harris's time in Berlin, Munch would exhibit five times with the Berlin Secession and another six in private galleries around the city, and seventy-two works by Van Gogh were shown in Berlin between 1904 and 1907.[12]

Harris did not entirely comprehend these new currents in European art. His small acquaintance with Canadian art had little prepared him for the galleries of Europe. "Modern paintings interested me most," he wrote later of his years in Berlin. "I remember, however, while I was strongly attracted to them I did not understand Gauguin, Van Gogh and Cézanne."[13] This same baffled fascination would be experienced a few years later by another young Canadian art student, Emily Carr, who arrived in Paris in the summer of 1910. "Something in it stirred me," she later wrote of the art she saw, "but I could not at first make head or tail of what it was about."[14]

What neither Harris nor Carr understood at first was how these painters were exploring new visual modes. Many younger European painters were abandoning the techniques taught in the academies: the varnished surfaces, delicate brushwork and modulated tones of the Old Masters. They renounced efforts to create convincing illusions of three-dimensional space through shading, modelling and perspective; they emphasized instead the flatness of the picture plane and the sensuous manipulation of their materials. Brush marks and even the weave of the canvases were often left visible. Colours became more strident, and the more experimental added their pigments in small, separate touches. Gauguin worked with flat planes of bright colour thickly outlined in black, and Van Gogh sometimes applied paint in an impasto so thick that he might have been (and sometimes was) squeezing pigment onto his canvas straight from the tube. Such

experimental and individualistic styles were sharply at odds with the tried-and-true modus operandi of the art academies.

IF HE HAD little comprehension of these ideas and techniques at this early point in his career, Harris did absorb one aspect of modern art passed on to him by Franz Skarbina. An English writer described Berlin as a modern city that showed "the most complete application of science, order and method . . . to public life."[15] But Skarbina did not see the city, least of all Berlin, as a utopia. He was among the German artists and intellectuals who deplored the poverty and inhumanity of the modern metropolis. A number of prominent European thinkers—Ferdinand Tönnies, Émile Durkheim, Max Weber, Georg Simmel—were writing about the alienating effects of the urban environment. Tönnies distinguished between the *Gemeinschaft* (a community based on personal ties and fellow feeling) and the *Gesellschaft* (the rootlessness and impersonality of modern industrial society). Durkheim believed rural life was characterized by a unity of values, beliefs and sentiments that produced what he called "collective consciousness"—a cohesiveness that he believed could not exist in a large city.[16]

Skarbina specialized in depictions of this rootlessness, showing downtrodden workers against the background of soot-and-steam cityscapes. He won a reputation for showing the poor and industrial areas unknown to the German middle classes and for rendering them in a style combining Realism with an Impressionist concern for light and atmosphere (he was widely praised by the critics for his ability to paint artificial light). One of his best-known works, *The Matthiasstrasse in Hamburg* (1891), featured a woman clutching a baby in a claustrophobic and ramshackle alley in the middle of a slum. In 1895 he exhibited *Gleisanlage des Güterbahnhofs Weißensee* (known as *Railway Tracks in North Berlin*—see plate 2), depicting an exhausted couple crossing the steam-filled rail yards outside Berlin's Anhalter Station. Such works saw him celebrated as "Ein Berliner Realist."[17]

Influenced by Skarbina's choice of subject, as well as by his Impressionist technique and view of the metropolis as a place of poverty and despair, Harris sketched and painted a number of urban scenes

in Berlin. He concentrated on the houses beside the River Spree and the shabby, sunless alleys that attracted Skarbina. In one of his watercolours, *Buildings on the River Spree,* a cart horse stands before the facades of riverside buildings whose picturesque details—shutters, dormer windows and steeply pitched, snow-covered roofs—are offset by the grey sky and an air of desertion. The work shows obvious parallels with Skarbina's *Hof im Schnee* (Courtyard in the Snow), painted in 1905 and undoubtedly seen by Harris in Skarbina's studio. Like Skarbina, he painted his houses in a vertical rather than a horizontal format, exploring the effects of snow and failing light on the warm brown tones of the buildings.

Dissatisfaction with the ugly and overcrowded metropolis led many German intellectuals to escape into the countryside to experience what one Berlin city planner extolled as "the incomparable joys of Mother Nature."[18] The beauty of the German landscape was the subject of a loose group of artists known as Heimatkunstlers, or regional painters. Among them was one of Harris's other teachers, Fritz von Wille, who concentrated his efforts on the Eifel region of Germany, portraying what one critic called "Nature with her vastness and grandeur."[19] Harris was to discover this vastness and grandeur first-hand in the summer of 1906, when he went on a hiking holiday in the Austrian Alps, and then again the following summer in Bavaria, with his third instructor, Adolf Gustav Schlabitz. Harris found Schlabitz, then in his early fifties, "an interesting character" (Schlabitz played the flute as they hiked).[20] He was, however, less adventurous as a painter than Skarbina. A member of neither the Group of Eleven nor the Berlin Secession, he painted mainly placid mountain landscapes of sunbathed, flora-covered alpine meadows.

In Bavaria, Schlabitz introduced Harris to the German poet and landscapist Paul Thiem, whose unorthodox religious views (he was probably a theosophist) the young Canadian found "shocking and stirring."[21] Thiem's outrageous opinions were offset by his rather docile landscapes. Providing a counterpoint to the gritty urban subjects favoured by Skarbina, he painted the German countryside in a style intended to evoke what a review of one of his Berlin exhibitions

called a "quiet German *Heimatgefühl*," or sense of home.[22] Thiem and other landscapists believed this sense of place and belonging, drastically eroded in a metropolis such as Berlin, could still be experienced among Germany's forests and mountains.

Many of these painters were influenced by the work of the great German landscapist Caspar David Friedrich. Forgotten for many decades, Friedrich was dramatically rediscovered in 1890, fifty years after his death, when a Norwegian art historian found many of his canvases gathering dust in a Dresden warehouse; in 1906 thirty-two of them went on show at the Nationalgalerie in Berlin, a landmark exhibition that Harris almost certainly would have seen.[23] Friedrich's paintings typically projected a sense of the divine onto both natural and man-made phenomena—mountains, sunsets, ruined abbeys, solitary pine trees—in haunting and often austere landscapes. The fact that these remarkable canvases, with their lonely alpine peaks, Gothic churches and bleak Baltic shorelines, were seen as characteristically German (Friedrich was an ardent patriot who conveyed political symbolism through his landscapes) meant he was quickly celebrated as the foremost exponent of a national tradition: one critic called him "the most German of Germany's painters."[24]

Much later, Harris would claim that when he returned to Toronto from Germany, "my whole interest was in the Canadian scene. It was, in truth, as though I had never been to Europe. Any paintings, drawings or sketches I saw with a Canadian tang excited me more than anything I had seen in Europe."[25] To a friend he later wrote that he "forgot the indoor studio-learning of Europe" virtually as soon as he returned to Canadian shores.[26] Years after the fact he would claim that MacDonald's little display of works in the Arts and Letters Club affected him more than "any paintings I had seen in Europe."[27]

These were retrospective constructions that greatly overstated the case. Harris was eager, later in his career, to shake the dust of Europe from his shoes, to cover his artistic tracks and present himself as a wholly indigenous talent who was (as his letter put it) "simply dictated to by the environment and life I was born and brought up in."[28] He would make no public acknowledgement of his debt to the modern

33

styles and movements, or important teachers such as Skarbina, to which his years in Berlin had exposed him.

But Harris took away from Berlin, when he finished his studies there in 1907, considerably more than his arduously acquired techniques in drawing and painting. He was exposed, in particular, to the contrast between the urban alienation painted by Skarbina and the more sacred life of the countryside, where both a stronger sense of belonging and (as Friedrich had shown) an idea of the supernatural could be discovered and cultivated. His two years in Berlin had also revealed to him the bitter rivalry between the "new, young and forceful" artists—exemplified by Skarbina's Group of Eleven—and the "lazy and stupid trust in the conventional" that so many young German artists wished to overturn. They were lessons that, acknowledged or not, he would carry forth in the years ahead.

BY THE END of 1911, when he first met J.E.H. MacDonald, Harris had been back in Toronto for three years. By this time he too was a family man struggling to earn a reputation as a painter. In 1910 he married an heiress named Trixie Phillips ("a nice, gay little thing," according to a friend).[29] Their son, also named Lawren, was born within the year. Determined to make his way as an artist, he was renting a studio above a grocery store at Yonge and Cumberland.

Harris went on sketching expeditions to the Laurentians, the Haliburton Highlands and Lac Memphrémagog in Quebec. But his true passion after he returned from Berlin was cityscapes—images of urban poverty of the sort painted by Franz Skarbina. Toronto certainly had plenty of scenes of ugliness and destitution. Residents and visitors alike deplored the unsightly appearance of its poorer neighbourhoods. The lack of parks and the ill-favoured streets and buildings, together with the winter slush and summer dust, made Toronto, according to various observers, "squalid" and "contemptible." The English-born landscapist F.M. Bell-Smith called it "third-rate" and "quite out of the race of modern cities."[30]

Bell-Smith, ironically, had done one of the few compelling Toronto cityscapes. Better known as a painter of the Rockies, in 1894 he

created his marvellous *Lights of a City Street,* a snapshot of the rain-slicked and newsboy-clamouring corner of King and Yonge. First shown to high acclaim in 1897, it was purchased by Simpsons and placed on display in the Palm Room of their department store at Queen and Yonge. For the most part, however, Toronto scenes were rare. Visitors to the city's art exhibitions could feel they had closed the door behind them on their mundane urban world and entered a pleasingly rural wonderland of Muskoka shorelines, English cottages and Quebec sugar camps.

Harris found artistic inspiration in the "squalid" and "contemptible" parts of Toronto. Although he was raised in a stately late-Victorian mansion on St. George Street, and although Toronto's finest architect, Eden Smith, was building a large and comfortable Arts and Crafts house for him on Clarendon Avenue, it was districts such as the Ward, a notoriously poor enclave immediately south of Queen's Park, that held a special fascination for him.

The Ward was home to many Jewish and Italian immigrants who ran small businesses or worked in the sweatshops along Spadina Avenue. It was bounded on the east by Yonge Street and on the south by City Hall. In 1909 Augustus Bridle called it "the most cosmopolitan part of Toronto," with "rows of blinking little modern shops" and "everywhere the shuffling, gabbling crowd." A report in the *Toronto Daily Star* described it less appealingly as a place of "filth and disorder."[31] Another writer remarked that it was "generally regarded by the respectable citizens of Toronto as a strange and fearful place into which it is unwise to enter even in daylight."[32] The neighbourhood had long attracted the attention of social reformers—though never before that of an artist.

In a reprise of his Berlin experiments, Harris made pencil sketches and paintings in the Ward. Urban painters such as The Eight, a group of American artists who specialized in gritty New York street scenes, used plunging perspectives and strong diagonals to emphasize the speed and vitality of the large modern metropolis. Harris, however, approached his subject differently. He depicted Toronto's terraces of houses flat to the picture plane, with no swirling crowds and no

35

slashing perspectives. Toronto certainly possessed little of the dash and vitality of either New York or European capitals, and Harris was interested in offering a more intimate, meditative view of streets all but empty of traffic and inhabitants. The shuffling crowd mentioned by Bridle was absent, along with any social comment it might have broached. His interest, at least at this stage, was primarily aesthetic. In a work such as *A Row of Houses, Wellington Street,* he was merely attempting, he explained, "to depict the clear, hard sunlight of a Canadian noon in winter."[33]

THE RENDERING OF the transient effects of these impalpable phenomena such as sunlight and shadows, together with their "Canadian tang," was what had apparently attracted Harris to MacDonald's paintings at the Arts and Letters Club. Harris was greatly exaggerating when he claimed that MacDonald's works at this point showed "something new in painting in Canada." For the past two decades, many Canadian artists (especially those who spent time in Paris) had been sketching out of doors and depicting the Canadian landscape in an Impressionistic style.[34] But his admiration for MacDonald clearly extended to the personal level, and the two men quickly became friends. They already had a number of mutual acquaintances, since Harris knew Grip employees such as Fergus Kyle and J.W. "Bill" Beatty. Harris had previously gone on sketching expeditions with both Kyle and Beatty, and so it was natural that he and MacDonald should likewise begin working together.

The two men's first expedition, sometime early in 1912, appears to have been one to the Toronto waterfront near the foot of Bathurst Street, near Fort York. This industrial zone, bisected by the railway and its sidings, was home to a silver-plate company and a stove foundry. Nearby, on land where Lake Ontario had been infilled, were lumberyards, a cattle market and the premises of Consumers Gas Company, with its two gasometers. These great cylindrical monoliths distilled and stored coal gas.

MacDonald had no real enthusiasm for urban scenes, least of all ones of Toronto, which he disparaged as "this grey town."[35] The choice

of location was almost certainly Harris's. The subject matter was probably inspired by Skarbina's twilight masterpiece *Railway Tracks in North Berlin,* an industrial landscape featuring a gasometer flanked by chimney stacks in a haze of smoke and steam. Harris was no doubt also aware of cries of modernists such as the English poet and art critic Laurence Binyon, who wanted artists to turn away from "subjects from the past" and instead paint images of modern life. "We are to celebrate the sublime geometry of gasworks," Binyon wrote in 1910, "the hubbub of arsenals, the intoxicating swiftness of aeroplanes."[36] What better way for Harris and MacDonald to proclaim themselves modernists than by depicting icons of the contemporary industrial city such as smokestacks, locomotives and gasometers?

There might have also been another motive for choosing this location. Toronto industrialized around the time of Confederation, after which its steam-powered factories and foundries became sources of local pride. The first few decades after Confederation were the heroic age of factories and machines—of locomotives puffing through Crowsnest Pass and Massey-Harris reapers fanning out across the Prairies. Indeed, one of the first films ever shot in Canada, by the Edison Company in 1898, starred a new Massey-Harris binder. The pages of the *Canadian Illustrated News* were filled with inspiring engravings of Toronto's busy factories, and a nineteenth-century catalogue for Hart Massey's farm implements proudly featured an illustration of a factory blackening the sky with smoke.[37] Steam and smoke meant jobs and signalled prosperity. As late as 1912 a new Toronto subdivision called the Silverthorn Park Addition hoped to lure homebuyers with a newspaper advertisement that showed smoke-belching factories. It proudly declared Silverthorn to be "right in the heart of the factory district."[38]

Canadian industry was prominent in the news in the months before MacDonald and Harris took themselves down to the waterfront. Toronto's industries had vigorously expanded over the previous decade,[39] and a good deal of MacDonald's professional career had been spent producing images of Canadian commercial prosperity (including, in 1911, a poster for Canadian Northern Steamships showing black smoke billowing from a steamer's funnels).[40] But in 1911 all

of that prosperity had been threatened. The country had just fought an election on the issue of free trade with the United States. The reciprocity proposals called for free exchange in both natural resources and a wide variety of manufactured goods: everything from pocket knives and surgical gauze, to musical instruments, motor vehicles and urinals. Reciprocity was popular in the resource-rich West but bitterly opposed by Ontario's captains of industry. Arguments about the national interest were rolled out to defend the owners of private fortunes. "Canadian nationality is now threatened with a more serious blow than any it has heretofore met with," declared the manifesto of a group of protectionist magnates known as the Toronto Eighteen. The Conservative leader, Robert Borden, wrote a letter in a Toronto newspaper claiming the treaty would cause "the disintegration of Canada."[41] Anti-American sentiment was unleashed in pamphlets and cartoons; the Stars and Stripes was even censored in Ontario cinemas. On September 21, 1911, Borden's Conservatives won the election by 132 seats to Laurier's 85.

It seems too much of a coincidence that Harris should have been drawn to Toronto's industrial zone at such a time. Already stirred by nationalist sentiments, he must have noticed how the treaty had provided for the importing of American harvesters, reapers and threshing machines. He would also have known that Sir Lyman Melvin-Jones, president and general manager of Massey-Harris, though personally loyal to the Liberals, opposed the deal, which would have seen farmers in the West able to buy more affordable farm machinery.

If MacDonald's work for Grip Limited involved him in the design of publicity for steamship lines and ambitious new Toronto subdivisions, Harris had already done his own hymn to industrial endeavour and commercial abundance. In 1911 he painted *The Eaton Manufacturing Building* (see plate 3). This twelve-storey factory on Queen Street West was built two years earlier, the latest addition to the handful of skyscrapers on the urban landscape and a glass-and-steel testimony to Toronto's prosperity and modernity. Harris produced a remarkable picture in which the Eaton building looms like an apparition over the Ward's nondescript houses and sheds. Chimney smoke, shadows and

38

industrial steam are set off by an ethereal sunset shimmering in the monolith's windows.

Harris was no doubt hoping for a similar evocation of the city's industrial sublime when he and MacDonald set up their easels in the snow beside the lakefront. They were probably accompanied by another Toronto painter, thirty-year-old Peter Clapham Sheppard, a graphic designer and a student of Cruikshank (MacDonald's former teacher) at the Central Ontario School of Art and Industrial Design. Each produced a painting of a gasometer, concentrating on the inter-actions of atmosphere and colour to create Canadian versions of the "tinted steam" paintings of nineteenth-century landscapists such as J.M.W. Turner and Claude Monet.[42] The example of Skarbina, at least for Harris, was paramount. For Skarbina railway tracks and chimney stacks were motifs by which the brutality of the modern metropo-lis, mercilessly shaped by industry and hostile to its inhabitants, was most graphically expressed.[43] Skarbina, however, was also mesmer-ized by the visual effects of the bustling metropolis—its electric light, its swirling smoke and rising steam. *Railway Tracks in North Berlin* was a *Stimmungsbild,* or "atmosphere painting," intended to capture the spectacle of the metropolis and evoke a mood of reverie.[44]

The Toronto painters likewise beautified their city's industrialized urban landscape. Sheppard's *Toronto Gasworks with Locomotives,* a fif-teen-by-twenty-centimetre oil sketch (no doubt painted on the spot), and MacDonald's finished painting, *Tracks and Traffic* (see plate 4), both showed a black CPR locomotive powering through the snow-covered premises of the Consumers Gas Company, steam billowing from the smokestack into an overcast sky. Harris's *The Gas Works* (see plate 5) approached the subject from a different angle. Unlike MacDonald, who painted the gasholders from the south, he positioned himself on their north side, in what appears to be a vacant lot overlook-ing the backs of houses on Niagara Street. From this vantage point he concentrated on the larger of the two gasometers, a monstrous, rust-brown shadow. Only MacDonald offered a human touch: two workmen, one with a shovel slung over his shoulder, crossing the cedar-block pavement that stretches through the foreground.

Already the differences in MacDonald's and Harris's approaches are evident. MacDonald added a profusion of distracting detail—a caboose, stacks of lumber in the yard, telephone poles—and gave volume to the locomotive steam through an intricate manipulation of light and shade. Harris simplified his composition: detail was eliminated and forms flattened as he concentrated on the profile of the gasometer, which he turned into the kind of distant but looming presence that would appear in so many of his later paintings of mountains. His interest in geometric forms indicates his movement away from Impressionism and its transient effects in search of more solid volumes.

Anyone seeing these paintings in 1912 could have believed an urban realist school, mixed with tinctures of French Impressionism and German *Stimmungsbild,* was on the brink of developing in Toronto. Harris certainly maintained an interest in urban subjects, and in future years Sheppard would create ambitious and magically beautiful Toronto cityscapes. But the experiment at the foot of Bathurst Street would never be repeated. Harris and MacDonald seem to have concluded that there was no real "Canadian tang" in paintings of chimney stacks and gasometers: such works could as easily have been done in Berlin or Amsterdam or London.

There was, of course, only one direction to go in order to paint Canada "in her own spirit." Soon afterwards, with snow still on the ground, the two men set off for the bush.

4 EERIE WILDERNESSES

I N 1884 A Montreal surgeon named William Hales Hingston published a treatise called *The Climate of Canada and Its Relation to Life and Health.* The relation, as Hingston saw it, was a happy one: the country's northerly latitudes gave its citizens good health, long life and "increased muscular development."[1] The Grand Trunk Railway may well have been justified, therefore, in promoting itself as the "Highway to Health and Happiness." For many people, however, Canadians and immigrants alike, the physical benefits of a northerly climate were offset by some inconvenient realities. For them the Canadian north presented a more discouraging prospect.

North is, of course, a relative term. From Algonquin Provincial Park, situated between the 45th and 46th parallels of latitude, the North Pole and the equator are virtually equidistant. The park shares the same latitude as Venice, Milan and the wine-growing region of Bordeaux in southwest France, and it is only a few degrees of latitude higher than Provence, extolled by French writers at exactly the same time as a "southern" Eden.[2]

But the Canadian "north" is a concept concerned less with degrees of latitude than perceptions of remoteness, underpopulation, lack of cultivation and, above all, harsh winter weather. Whatever its

beauty and grandeur, whatever its appeal for boating enthusiasts, fly-fishermen and ozone-gasping valetudinarians, the forested wilderness beyond the bounds of Ontario's cities and towns was regarded by many who visited it, especially in winter, as alien and dangerous. Even Grey Owl, a man who lived closely and apparently harmoniously with nature, wrote of the "brooding relentless evil spirit of the Northland" that sought "the destruction of all travellers."[3]

Many volumes of writing affirmed this bleak view of the Canadian north, from early stories of the despairing Portuguese explorer's lament, *Cà nada* ("here nothing"), to the numerous accounts of Franklin's failed quest to find the Northwest Passage. The popular adventure stories of Robert M. Ballantyne and J. Macdonald Oxley catalogued with gusto the ever-present dangers of Canada's northlands. Oxley's 1897 novel *The Young Woodsman, or Life in the Forests of Canada* confirms the hero's mother's "dread of the woods" with references to people freezing to death or getting dashed against the rocks or eaten by wolves.[4]

At the opposite end of the literary spectrum, equally harrowing portraits of spectral woods and frigid winds came from the pens of the Confederation poets Wilfred Campbell and Archibald Lampman. Campbell, who finished high school in Owen Sound in 1879, two years after Tom Thomson's birth, was known as the "laureate of the lakes" (and he would become one of Thomson's favourite writers). In 1905 he wrote that the cure for "our modern ills and problems" was "a return to the land," and five years later he published a guidebook, *The Beauty, History, Romance and Mystery of the Canadian Lake Region.*[5] Anyone reading his poetry would wish to reconsider plans for a return to the land or a visit to the Ontario lake region. His 1889 poem "The Winter Lakes" piled up relentless images of Northern Ontario as a "world of winter and death" where "the mighty surf is grinding / Death and hate on the rocks." Lampman offered no more irresistible a view, with many of his poems evoking the bitter cold: "winds that touch like steel" (in "Winter Evening") and "frost that stings like fire upon my cheek" ("Winter Uplands").

Worse than the cold, according to the poets, was the loneliness and isolation—the lack of any other human presence. Lampman's poem "Winter–Solitude" sums up the Canadian experience of "a world so

mystically fair, / So deathly silent—I so utterly alone." Another of his works, "Storm," describes "eerie wildernesses / Whose hidden life no living shape confesses / Nor any human sound." It is usual to point out that the Ojibwa lived in this supposedly empty wilderness, but the theme of the "vanishing Indian" had been common in Canadian writing for at least a half a century. Catharine Parr Traill noted as early as the 1850s that the "poor Indians" in her part of Ontario (the Kawartha Lakes) were "dying out fast" thanks to the white man, who had brought them "disease and whiskey and death."[6] The Native population of Ontario was no doubt also growing scarcer because their ancestral lands in the Georgian Bay watershed had been ceded to the Crown in the 1850 Robinson Treaties. Then, in 1905, the James Bay Treaty (also known as Treaty No. 9) stated with brutal pragmatism that "activity in mining and railway construction" in Northern Ontario "rendered it advisable to extinguish the Indian title." The Aboriginal people still accounted, however, for some three-quarters of the population of Northern Ontario.[7]

Empty of people or not, the northland was something whose terrors and intractability—as well as its paradoxical nearness to civilization's fragile stretches of road and rail—haunted Canadians. Even Stephen Leacock's sense of humour deserted him when he turned his attention northwards. "Here in this vast territory," he wrote in 1914, "civilization has no part and man no place."[8] The statistics seemed to bear out this observation: the Government of Ontario reported in 1909 that, of the province's 116 million acres, 40 million remained "virgin forest."[9]

Perhaps the most disturbing presentation of these barren lands was found in Lampman's 1888 poem "Midnight," in which the wilderness instills in the poet a cosmic terror similar to that felt on the Prairies by T.E. Hulme. Five years before Edvard Munch painted *The Scream,* Lampman describes "some wild thing" that calls from the depths of the snowy night, an unsettling "crying in the dark" that is neither man nor beast nor wind. This unnerving sound pervades the wilderness and resounds in the poet's head in a Canadian version of what Munch (another northerner) would soon call "nature's great scream."[10]

IT WAS FROM these "eerie wildernesses" that Lawren Harris and J.E.H. MacDonald—like so many others before them—were hoping to forge their vision of Canada. They entered this frozen and supposedly menacing hinterland in January or February of 1912. The two men pressed north through the fashionable Muskoka Lakes, sensible, perhaps, that this region, with its picturesque shorelines and quaint mills, had been well represented over the years in Canadian art exhibitions. Nor was Muskoka either eerie or a wilderness. For the best part of four decades, Canadian and American nabobs of finance and industry, such as Harris's father-in-law, Frank Phillips, had been building ever more grandiose estates for themselves along its lakefronts. (In an illustration of the dangers lurking in the eerie wilderness, Phillips drowned in a lake in 1910—though in Michigan rather than in Ontario). By the turn of the century, heavily promoted by the businessman Alexander Cockburn, the district had mushroomed with more than fifty summer resorts. The grandest of these was the Royal Muskoka Hotel on Lake Rosseau. It came complete with its own golf course and billed itself with no undue hyperbole as "The Grandest Spot in all America."[11]

Harris and MacDonald moved northward into an area less touched by summer tourism. It appears the two men made their base at the home of MacDonald's wife's aunt, Esther Prior, in Burk's Falls, forty kilometres north of Huntsville on the Magnetawan River, not far beyond the western boundary of Algonquin Park.

The journey between Huntsville and Burk's Falls, made on the Grand Trunk Railway through tracts of land heavily logged by the lumber baron J.R. Booth, would have been an unprepossessing panorama of slash and deadfall, primitive settlers' shanties, and trails for skidding timber cut into the dense bush. Burk's Falls itself was an old lumber town, with dirt streets and wooden sidewalks scarred by the cleats of the loggers' boots. At the end of their journey were the rapids and falls of the Magnetawan River, described by the English painter and teacher Ada Kinton as a "boiling, broken tumbling tumult of fall and swirling rapids . . . bubbling and seething, dancing a mad, frantic waltz in dazzling circles."[12]

Although MacDonald would paint these rapids and falls on later journeys, on this particular visit the two men were taken more with the winter landscape, including the activities of the lumber industry (a favourite subject of the Toronto Art Students' League). Winter was a busy time for logging companies, with trees cut almost exclusively in the colder weather because felling was easier with no sap flowing. Most drives had to wait for spring, but the swift flow of the Magnetawan evidently meant it was still possible to float sawlogs downstream to the mill. Harris witnessed one of these midwinter log drives and, inspired by the sight, as well as by MacDonald's *By the River, Early Spring*, made studies of drivers in the middle of the river.

This visit to Burk's Falls was not Harris's first experience of the lumber industry. He might have looked the part of a tweedy patrician, but he had fairly impressive experiences of outdoor life. After leaving Berlin he had ridden a camel four hundred kilometres across the desert from Jerusalem to Cairo. He had been accompanying another Brantford expatriate, Norman Duncan, the thirty-six-year-old author of two successful novels, *Dr. Luke of the Labrador* and *The Cruise of the Shining Light*, based on his travels in Newfoundland and Labrador. In 1907, contracted to write an account of his journey through the desert for *Harper's Monthly Magazine*, Duncan invited Harris along to prepare illustrations. For three weeks the two men travelled the old caravan route south from Jerusalem, enduring blistering heat and passing through windstorms and settlements of (as Duncan did not scruple to express it) "evil faith and monstrous reputation."[13] After returning to Canada in 1908, the pair was dispatched by *Harper's* to a Minnesota lumber camp, in the middle of winter, for a similar assignment.

Harris's sojourn in the Minnesota lumber camp inspired a scene of back-breaking hibernal toil not unlike Horatio Walker's paintings of rural labour in half-lit agrarian landscapes. In 1911 he painted a large canvas called *A Load of Fence Posts* depicting a horse-drawn wagon crossing an iced-over lake against the backdrop of a radiant sunset. In this rural companion-piece of sorts to the urban *The Eaton Manufacturing Building*, the northern bush was envisaged as a place of hard physical work as well as gorgeous visual effects.

Returning to Toronto following his visit with MacDonald to Burk's Falls, he turned his hand to another such scene, a composition called *The Drive*, at 91 centimetres high by 138 centimetres wide, his largest work to date. It too took the theme of rural labour beloved of Barbizon and Hague School painters but transplanted it from an agricultural landscape of peasant ploughmen and their beasts of burden to a more distinctively Canadian location in the Ontario bush. The limited colour scale revealed less of a departure from the Hague School tradition. With the exception of the brightly dressed lumberjacks, the tone was still muted and dark, with an umber and russet landscape beneath a lowering sky providing the background for the men's exertions. The way he lit his composition—darkened edges giving way to a patch of sunlight in the distant central plane—was suggestive of the Barbizon-influenced American painter Henry Ward Ranger, known as the leader of the "Tonal School of America."[14]

Harris must have painted the work quickly because, despite its size, it was ready for the annual exhibition of the Ontario Society of Artists, Toronto's most important art show, which opened in early March.

MOST MIDDLE-CLASS Torontonians wanting to look at paintings or decorate the walls of their homes made their way to the intersection of Yonge and Queen streets. The Robert Simpson Company had a picture gallery on its sixth floor (and Bell-Smith's *Lights of a City Street* in its Palm Room), and across the street the T. Eaton Company displayed framed paintings in its windows along Yonge. The publicity for Eaton's boasted that its upstairs picture gallery had "stacks and stacks" of paintings. It sold both reproductions of famous works of art and original oils and watercolours of "beautiful bits of landscape, delightful spots in the woods, lovely women, animals, home scenes, and children at play." The original works were priced between $10 and $50, often heavily discounted in clearance sales.

Eaton's even had a Canadian Gallery on its fourth floor to cater to those interested in Canadian scenes and Canadian painters. One artist regularly featured in the Canadian Gallery was C.M. Manly, a teacher at the Central Ontario School of Art and Industrial Design and

a former member of the Toronto Art Students' League. His landscapes of Nova Scotia were advertised (in his 1913 exhibition) at between $20 and $125. These prices were not especially cheap in a world where a mohair suit cost $15, a wolf stole $25 and a diamond in a ten-carat gold band $75. But because Toronto had no permanent art museum, the picture galleries in the two department stores probably did more than anything else both to shape and to reflect the general public's aesthetic tastes.[15]

Another place to see art, though less frequently and in smaller doses, was in the Public Reference Library. Each March, the Ontario Society of Artists staged a public exhibition of painting, drawing and sculpture in the Beaux Arts–style building at College and St. George. Founded in 1872, the OSA was intended to foster (as the prefatory note to one of its exhibition catalogues stated) "original and native art in the Province of Ontario."[16] Public attendance at its annual exhibitions was comparatively light, usually in the low thousands over the course of the three-week run (the exhibition was open Mondays through Saturdays). Almost all of the works were for sale, but few members of the public ever bought them, even though many were priced in the same $20–$50 range as those at Simpsons and Eaton's. Stalwarts of Eaton's Canadian Gallery such as C.M. Manly (an active OSA member) and the French-born Georges Chavignaud regularly appeared at OSA exhibitions, though here some of their paintings were offered at the upper end of the scale, with price tags of $300 to $400—the cost of a fur coat from Simpsons.[17]

A more reliable patron for artists exhibiting at the OSA was the Government of Ontario. It purchased works (generally to decorate government offices) after taking advice from the Toronto Guild of Civic Art, a committee of artists and laymen. Despite a limited budget, the National Gallery too bought paintings for the collection in Ottawa. Almost as important as the sales were the reviews. Most of Toronto's six newspapers, as well as magazines such as *Saturday Night* and *Canadian Courier,* gave the exhibition a write-up. However modest, it was therefore the city's most prestigious venue for painters and sculptors to make their names.

Just as advertisements for Eaton's repeatedly drew attention to the stock of "beautiful bits of landscape" and "delightful spots in the woods," most paintings in OSA exhibitions were landscapes. In 1911 some 120 of the 200 paintings were landscapes or European street scenes. Interiors, still lifes, genre paintings and portraits were in a distinct minority, done for the most part, though not exclusively, by the thirty women who showed work in 1911.[18] The landscapes at the OSA always included a number of European subjects—the Normandy and Cornish coasts, views of St. Paul's, the Pont-Neuf—but mostly they were Canadian scenes because foreign landscapes required the expense of a ticket on a transatlantic liner. The 1910 exhibition had included pictures of Nova Scotia, New Brunswick, Quebec, the Rockies and rural Ontario. One year later visitors could see paintings with titles such as *Northern Ontario Homestead, April in Manitoba, Magnetawan, In the Pine Woods* and *In the University Parks, Toronto.* Toronto's most distinguished landscapist, C.W. Jefferys, offered *The Plains of Saskatchewan, Virgin Prairie* and *The Qu'Appelle Valley.*

As their titles suggest, many of these landscapes represented Canada in a state of pastoral bliss. OSA exhibitions abounded with images of snake fences and picturesque barns. It had long been axiomatic that Canadian landscapes should be agricultural scenes. "Canada is essentially an agricultural country," proclaimed a writer in the *Canadian Magazine* in 1904, "and any picture distinctively Canadian in subject must include the painting of animals." Another writer in the same magazine agreed that Canada's artistic destiny lay with scenes of beef-on-the-hoof, though he was willing to entertain another subject too, since Canada was notable for "handsome women" as well as cows.[19]

There was another reason for these serial pictures of cows and barns. In Canada as elsewhere, pictures destined for the domestic interior were meant to provide notes of calm and order—to give the occupant respite from the chaotic world outside. Doctors of the day, following the "new psychology," claimed pictures could be an emotional emollient, the next best thing to a rest cure in a canoe. Contemplation of landscape paintings, preferably ones with distant views and sombre tones, provided relief to the overworked and overstimulated. "Lines

and hues," according to one French critic, "exert as considerable an influence as that of pure air, spectacles of nature and flowers." He no doubt voiced the aspiration of many a middle-class Canadian picture-buyer when he wrote, "Oh, to forget the ugliness of the street when we stand before an idealized landscape."[20]

Augustus Bridle believed that at the 1912 OSA exhibition the country was not only better represented than ever before but also represented in a way that put less stress on this kind of idealized pastoral landscape. "There is an exhilaration, almost an abandon," he wrote, "that convinces any average beholder of the vitality of Canadian art." He claimed the painters were not only depicting "farm landscapes and pastorals and smug interiors, and pretty women"—the sort of work to be found, in other words, in the department stores. They were also capturing "Canada of the east and west, north and south, of railways and traffic, and city streets; of types of people . . . and phases of development." He claimed that "to a Canadian, scenes in this country are of vastly more interest than all the fishing smacks and brass kettles and seaweed sonatas of north Europe."[21]

Bridle was overstating his claims about the "first satisfying depicture" of Canada, since in 1912 Canada was no better or more abundantly served by artists than in most previous years, and there were still "farm landscapes" aplenty. But the partnership of Harris and MacDonald, with their stabs at urban realism, produced impressive results. They were the most prolific artists at the exhibition. Each showed six paintings, and Harris included a number of pencil sketches of Toronto's neighbourhoods. He did not exhibit *The Gas Works* (the painting was probably not yet complete) but showed scenes of houses and buildings in downtown Toronto, a barn in the Laurentians (from his trip with Kyle several years earlier), and *The Drive*. Besides *Tracks and Traffic, Frosty Morning* (as the work was called in the catalogue), MacDonald exhibited winter scenes set mainly in the High Park area of Toronto, such as *The Sleighing Party* and *Ski-ing*.

Both painters were rewarded for their efforts. The Government of Ontario purchased one of MacDonald's six canvases, *Morning Shadows,* and the National Gallery of Canada bought *The Drive* from

49

Harris. MacDonald would get a further boost when *Tracks and Traffic* was praised in the international art journal *The Studio* as "a *tour de force* of the effects of steam and snow." The review, written by a Canadian critic, went on to make a surprising claim: "No such scenes may be held anywhere but in Canada, where every manufacturing and transporting enterprise is hustle-bustle evermore."[22]

This strange hyperbole, along with that of Augustus Bridle, could not hide the fact that the sought-after "Canadian tang" was still not as sharp as it might have been. Harris and MacDonald were seeking what the former called "the varied moods, character and spirit of this country."[23] But paintings such as *The Drive* or MacDonald's vignettes of suburban snow marked no great advances over the dozens of other Ontario scenes hung each March on the walls of the Public Reference Library. The two painters, MacDonald especially, were working in a technique that, with its light palette and concise brushwork, still owed much to French Impressionism. Several other painters at the OSA exhibition also worked in this style, including Helen McNicoll and Elizabeth McGillivray Knowles. But if Impressionism was adept at catching the transient and delicate effects of filtered sunlight or shadowed snow, it offered little in the way of strength or grandeur. Highly derivative of European models and attacked by some critics as superficial glitter, it was probably regarded by Harris and MacDonald as too effete for their ambitious plans to capture the harsh realities of the Canadian north.

Harold Mortimer-Lamb's remarks from 1908, that no one yet possessed the "power of insight" to interpret "the spirit of the great northland," still appeared to hold dismayingly true.[24] Where, then, could this power of insight be found? The answer, oddly enough, would be in Buffalo.

IN LATE JULY 1912, two months after returning from Algonquin Park, Tom Thomson departed on another canoeing and painting expedition. This time he would spend not two weeks, but two months, in the bush. His destination was the Mississagi Forest Reserve, eight thousand square kilometres of land north of Lake Huron that had been set aside by the Ontario government in 1903.

Thomson's companion this time was a twenty-three-year-old York-shireman named William Smithson Broadhead. After immigrating to Canada from Sheffield almost three years earlier, Broadhead had begun working with Thomson at Grip Limited at the end of 1910. By 1911 the pair were sharing the same lodgings, a boarding house on Summerhill Avenue, on the northern fringe of Rosedale. Broadhead too was an aspiring painter, but whereas Thomson was diffident and insecure, the ambitious and self-assured young Englishman wrote letters home to Sheffield proclaiming himself "by far the best designer in Canada" and "cock of the walk" among Toronto's painters. "I could knock the spots off half the so-called big guns here," he brashly declared.[1] His accomplishments hardly justified such self-regard. He showed several works at the 1912 OSA exhibition, including a painting called *Boy with Goldfish* and a drawing of Lady Macbeth. These

works collected no prizes or critical attention, nor were they the kind of works Augustus Bridle had praised for giving a "satisfying depicture" of Canada.

Despite his clamorous *amour-propre,* Broadhead evidently made an agreeable roommate, co-worker and travelling companion for Thomson. The two men caught the train from Toronto to Biscotasing, on the shores of Biscotasi Lake, 140 kilometres northwest of Sudbury and almost 500 kilometres from Toronto. Although on the CPR line, this area was more remote than Algonquin Park, with slightly fewer chances of encountering American fishermen or weekending Torontonians. The local fur-trading post, La Cloche, had shut down several decades earlier, but trappers, fur traders and canoe brigades still worked the area around Bisco (as the town was known) and along the Spanish River, and each spring the Spanish River Lumber Company drove sawlog timber downriver. These men who took to the lakes and rivers were no recreational canoeists in search of a rest cure. One of the rangers working in the Mississagi Forest Reserve in 1912 later described these rivermen as "hard-bitten bush-wackers, nurtured in hardship," with "barbed, gritty humour" and an "unparalleled skill in profanity."[2]

This particular ranger was a hard-drinking Englishman, born the same year as Broadhead, named Archie Belaney, later to become famous as Grey Owl. He would soon be run out of Bisco for demonstrating his marksmanship on the bell of the local church while a Sunday service was in progress. In the summer of 1912, however, he was working for the Ontario Department of Lands, Forests and Mines, his face burned "as black as the arse of a tea kettle" by the summer sun.[3] Legend has him meeting Thomson and Broadhead in Bisco. Thomson supposedly impressed Grey Owl with his skill in making doughnuts, though the Englishman was later distinctly ambiguous in his memories of the encounter.[4] Still, a meeting is not unlikely, given how it would have been prudent for relatively inexperienced canoeists like Thomson and Broadhead to check in with the local ranger (as Thomson had done in Algonquin Park) before paddling into the maze of woods and waterways. But what, if anything, passed between these

Jimmy Sanders, Donat Legace, Archie Belaney, Raphel Legace and Marie Woodworth, Biscotasing, 1913. Archives of Ontario, C 273-1-0-46-2

two icons-in-the-making—besides a plate of doughnuts—has long since been lost to history.

The Treaty No. 9 commissioners (among whom were the poet Duncan Campbell Scott and the painter Edmund Morris) had noted in Biscotasing a "considerable Indian population" who "make their living by acting as guides and canoeists for sportsmen."[5] It is unclear if Thomson and Broadhead hired an official guide: once again, a prudent recourse for a pair of relatively inexperienced canoeists, if only to keep them from getting lost in unfamiliar territory. But Thomson

might have felt his experience in Algonquin Park held him in good stead, and Broadhead was typically proud of his expertise in the bush: "I am an expert with a canoe now," he boasted to the folks back home two years earlier, after paddling a stretch of the Humber River.[6] In any case, after provisioning themselves in Bisco, they began making their way in a Peterborough canoe west across Biscotasi Lake to Ramsey Lake and then along the Spanish River, through a great wilderness of red and white pine.

Canoeing would have been difficult, with their passage impeded throughout their journey by rapids, dams and dead logs left over from the drives. What Grey Owl's "hard-bitten bush-wackers" might have made of these two would-be painters up from Toronto, had they met on the lake, one can hardly guess. But Thomson and Broadhead were not the first landscape painters to dip their paddles in a Canadian river. In the 1840s Paul Kane had travelled with the Hudson's Bay Company canoe brigades, and in 1869 Frances Anne Hopkins voyaged along the Ottawa and Mattawa rivers and through the Great Lakes. More recently, in the summer of 1903 Tom McLean and Neil McKechnie, both described by the *Toronto Globe* as "expert boatsmen," had paddled through the Abitibi district and then the following year, with tragic consequences, on the Mattagami.[7]

Artists, along with sportsmen and tourists taking a rest cure, were only the latest in a long line of Canadians for whom the canoe had proved important. It had been used for many centuries both by the Aboriginal peoples and the European explorers, fur traders and surveyors. Canada's geography as well as its industry were shaped by its waterways and consequently by vessels such as the birchbark canoes of the Algonquin peoples and the ten-man *canots du maître* of the North West Company. By the early twentieth century the canoe had become a romantic symbol of the country that encompassed and included—as little else did—First Nations, French-Canadian and English-Canadian cultures. Ole Evinrude built the first outboard motor in 1909, but Samuel de Champlain's wonder at the canoes of the Aboriginal peoples at Lachine in 1603 ("in the canoes of the savages one can go without restraint, and quickly, everywhere")[8] could still be experienced by anyone, like Thomson and Broadhead, who

wished to travel the more remote and inaccessible routes through the Canadian hinterlands.

Thomson and Broadhead spent their nights in makeshift campsites. Their meals were trout and smallmouth bass caught and then cooked in a reflector oven, sometimes after Thomson, like a big-game hunter, photographed them. He took great pride in his skills as a fly-fisherman, tying his own flies and casting his line in perfect figures of eight.[9] But although canoeing in these parts called for great skill, he regretted that an expert fisherman was hardly called for to extract pike from the waters in the forest reserve, since "they are so thick there is no fun in it."[10]

Thomson clearly fished for reasons beyond putting something on his dinner plate. Fishing was part of his communion with nature, an escape from civilization into what the publicity for the Grand Trunk Railway constantly emphasized was a more salubrious and elemental world. Fishing seems to have exemplified for Thomson what the novelist J. Macdonald Oxley had called "wise idleness," which he defined as "quietly absorbing something through the eye or ear that for the time at least drowns the petty business and worries of life."[11] It is probably revealing that Thomson took with him on fishing expeditions a copy of Izaak Walton's *The Compleat Angler,* first published in 1653. Presumably he read the book not for Walton's advice on how to keep live bait or catch trout at night, but rather for the work's poetic celebrations of the contemplative life. The book is subtitled *The Contemplative Man's Recreation,* and for Walton the "art of angling" was a "pleasant labour which you enjoy when you give rest to your mind and divest yourself of your more serious business." For the careworn scholar of the seventeenth century, angling was "a cheerer of his spirits, a divertion of sadness, a calmer of unquiet thoughts, a moderator of passions, a procurer of contentedness."[12]

Angling was a cure-all, in other words, for what another of Thomson's favourite writers, Wilfred Campbell, called "our modern ills and problems"—the enervation caused by a life spent amid the bustle and smoke of the city. Like the lean-and-draw motion of the paddle, fly-casting into a flowing stream brought Thomson into touch with the rigours and rhythms of a more natural way of life.

FOLLOWING A BRANCH of the Mississagi River, Thomson and Broadhead eventually reached Aubrey Falls, a series of cataracts the highest of which, cascading over pinkish granite, is an imposing fifty-three metres. From Aubrey Falls they made their way south along the Mississagi to Squaw Chute, near Thessalon on the North Channel of Georgian Bay. Altogether, their journey was some 160 kilometres by canoe and portage through an area whose thunderous rapids and brooding granite hillsides Grey Owl later described so vividly in *Tales of an Empty Cabin.*

Thomson boasted to a friend that the Mississagi Forest Reserve provided "the finest canoe trip in the world."[13] Although suitably impressive, their voyage was dwarfed by those of Paul Kane and Frances Anne Hopkins. It was also less audacious than one made in 1907 by another Canadian painter, the wildlife artist Ernest Thompson Seton. He and a companion had rowed more than 3,000 kilometres through northern Canada in a thirty-foot Peterborough canoe, from the old fur-trading post at Athabaska Landing (150 kilometres north of Edmonton) to Great Slave Lake. Thomson was probably aware of Seton's feat, not merely because the painter recounted the journey in *The Arctic Prairies,* published in 1911, but because Seton's natural history mentor had been Thomson's friend, relative and own natural history mentor Dr. William Brodie. Seton was good friends with Dr. Brodie's son (Thomson's first cousin, once removed), and he was present when the young man drowned in the Assiniboine. Although based in Connecticut for the previous dozen years, he may well have met Thomson at some point, courtesy of Dr. Brodie. In any case, Seton could have provided inspiration for the younger man, since he was far and away Canada's most famous artist, naturalist and woodsman.

Near Bruce Mines, on the North Channel of Georgian Bay, Thomson and Broadhead caught a steamer that took them to Owen Sound. Reaching his family on September 23, after a journey of almost two months, Thomson wrote to a friend that he had "got back to civilization."[14] If he had not been a skilled canoeist when he left Bisco, then two months later, as his canoe nosed into the waters of the North Channel, he and Broadhead could legitimately claim to be something

more than the amateurs disparaged by Grey Owl as "kitchen-garden woodsmen."[15]

THOMSON PHOTOGRAPHED more than he painted during his voyage through the Mississagi Forest Reserve. The weather through August and into September was not conducive to *plein-air* painting. Constant rains caused the rivers to swell dangerously. Thomson wrote about his experiences to a friend in Huntsville, Dr. John McRuer, a fellow fisherman whose best man he had been in 1909: "The weather has been very rotton [*sic*] all through our trip never dry for more than 24 hours at a time and some times raining for a week steady." He added details of a mishap recalling the accidents that claimed the lives of both Neil McKechnie and Dr. Brodie's son, as well as an upset in the Athabaska that cost Seton his journal. "We got a great many good snapshots of game—mostly moose and some sketching," he explained, "but we had a dump in the forty mile rapids which is near the end of our trip and lost most of our stuff—we only saved 2 rolls of films out of about 14 dozen."[16] Broadhead soon afterwards recounted details of this "narrow escape" to Thomson's brother-in-law, describing how they had been shooting rapids in a fully laden canoe when they struck a submerged rock and came close to "losing their lives." He claimed that if Thomson had not been "such an expert canoesman, they would both have been lost."[17]

McRuer commiserated over the loss of the photographs but alluded to an earlier mishap: "You might have drowned, you devil, and that was not the first time you were dumped, eh?"[18] Thomson had been taking the photographs (a total of fourteen rolls of a dozen exposures each) as a record of his journey and perhaps to use for future paintings. With most of these lost or damaged, he asked McRuer to find the friend of a mutual acquaintance named Hicks—"a man who was through the trip last year and who had a fine lot of photos"—to ask if he might borrow them. "If Dr. Hicks can remember that man with the photos he may save a life."

But McRuer and Hicks had fallen out ("he acted very unkind...so that we 'bounced him,'" reported McRuer), and so it was another

James MacCallum portrait
National Gallery of Canada Archives, Ottawa

doctor who would come to the rescue. Besides the two rolls of film, Thomson also salvaged some of his paintings. After he showed them to his friends at Grip Limited, word reached Dr. James M. MacCallum, a friend of Lawren Harris.

Dr. MacCallum might have seemed an unlikely hero for Canadian art. The fifty-two-year-old ophthalmologist was a professor of materia medica, pharmacology and therapeutics at the University of Toronto and the author of the treatise "Recurrent Fugitive Swellings of the Eyelids."[19] He came by his love of art through a passion for the Canadian wilderness. His father had been a Methodist minister whose parish included the east coast of Georgian Bay, an area MacCallum had come to love deeply. He had recently purchased a twenty-seven-acre island—"Island 158"—in Georgian Bay, fifty kilometres north of Penetanguishene; in 1911 he added to it an Arts and Crafts cottage designed by C.H.C. Wright, head of the University of Toronto's Department of Architecture and Drawing.

MacCallum's Toronto residence was on Warren Road, only a block or two from where Harris lived, but it seems to have been West Wind Island (as Island 158 would more romantically be christened) where MacCallum and Harris met. Harris had spent the summer of 1911 in a nearby cottage owned by Dr. David Gibb Wishart, a professor of otolaryngology at the University of Toronto. Dr. Gibb Wishart may even have introduced the two men: and so it was that an ophthalmologist and an otolaryngologist (a specialist on the diseases of the ear, nose and throat) came to play vital roles in Canadian art.

Dr. MacCallum, a bald man with a waxed moustache, was already friends with an artist, Curtis Williamson. A Brampton-born painter who had lived in Barbizon, France, in the early 1890s and spent time in the Netherlands, Williamson was known for gloomily atmospheric paintings that earned him the nickname the "Canadian Rembrandt." MacCallum had also met J.E.H. MacDonald. After seeing Mac-Donald's 1911 exhibition at the Arts and Letters Club, he not only purchased several of his works but also invited him to paint on West Wind Island. The works produced there, including *View from Split Rock, Sunlit Water,* and *Clouds and Rock, Split Rock,* he either purchased or else received as recompense for hosting the artist. It was to be the start of a faithful and generous patronage.

Since leaving Grip Limited, MacDonald had been sharing a studio on Adelaide Street East with Bill Beatty, and it was here, one day in the autumn of 1912, soon after returning from the Mississagi Forest Reserve, that Thomson met Dr. MacCallum. MacCallum was shown some of the works that had been, as he put it, "fished up from the foot of the rapids."[20] Thomson's paintings at this point were considerably less sophisticated than MacDonald's: it would have been fair to say that Thomson was, capsize notwithstanding, a better outdoorsman than a painter. His works were sombre in colour and barely a cut above the average Sunday-afternoon dauber in oils. They were characterized by distant views, low horizons, largely unbroken bands of muted colour and a general absence of detail. Still, Mac-Callum believed they had a feeling "for the grim, fascinating northland. Dark they were, muddy in colour, tight, and not wanting in

technical defects; but they made me feel that the north had gripped Thomson as it had gripped me when, as a boy of eleven, I first sailed and paddled through its silent places."[21]

A short time later, interested in adding a few Thomsons to his collection, MacCallum looked up the painter at home. Not having the exact address—Thomson was still leading a peripatetic existence— he was forced to ring every doorbell on Summerhill Avenue until he found the boarding house. Although Thomson was out, the proprietor admitted MacCallum to his room in the attic, where he studied the Mississagi sketches as he waited. When he returned at last, Thomson told the doctor, in his usual self-deprecating way, "Take them home with you. They're no good."[22]

WILL BROADHEAD'S FIRST few years in Canada were marked by a heedless optimism of the sort that infected so many Canadians. His letters home to his family in Sheffield described the boundless possibilities of his newly adopted country. "I see nothing but sunshine and prosperity," he wrote in one letter. "Everything in Canada seems to be booming," he declared in another. He assured his friends and family that he was "doing wonders," that Canada was "a great place," and that his bosses "think I am a rapid worker, but as a matter of fact I just take it easy & try to do good work, there is absolutely no hustling here."

Word of this promised land for designers soon reached the ears of Arthur Lismer, a friend from their days together at the Sheffield School of Art. Lismer wrote to Broadhead that he was "sick of Sheffield" and wanted a change. Broadhead was enthusiastic, because he regarded Lismer, then twenty-five, as "a real fine fellow, just the fellow for a companion." He tried to ease Lismer's path to Canada, late in 1910, by taking samples of his design work to Grip Limited (Lismer was self-employed in Sheffield as a photoengraver and "specialist in pictorial publicity"). Alas, as Broadhead wrote confidentially to his father, "The truth is—his work is not good enough." But it was too late: in January 1911 Lismer boarded s s *Corsican* in Liverpool.[23]

The extroverted and ambitious Lismer (a friend would later describe him as "an ardent spirit suffering no restraint")[24] was a spare

Arthur Lismer at Grip Limited, c.1911–12

Gift of Marjorie Lismer Bridges, McMichael Canadian Art Collection Archives

six-footer with red hair and piercing green eyes. The son of a Sheffield draper, he had begun studies at the Sheffield School of Art at the age of thirteen; two years later, while still a student, he went to work as an illustrator for the *Sheffield Independent,* doing sketches of what he later called "the spot where the body was found,"[25] as well as portraits of visiting luminaries such as George Bernard Shaw and a fledgling MP and former war correspondent named Winston Churchill. He joined the Heeley Art Club, a working-men's sketch club not unlike the Toronto Art Students' League; its members went on sketching excursions on the moors outside Sheffield before retiring to the local

hostelries for refreshment. Some of them, Lismer included, were members of a group called the Eclectics who gathered to discuss theosophy as well as writers such as Edward Carpenter, the sandal-wearing apostle of "cosmic consciousness."

In 1906, at the age of twenty-one, Lismer enrolled in the Royal Academy of Fine Arts in Antwerp. Founded in 1664, the Royal Academy was one of the finest teaching institutions in Europe, in a city that was once the artistic centre of the continent. Discipline was rigorous. A journal of the day reported how the students toiled for seven days a week. Smoking was forbidden, and breaches of the regulations resulted in "compulsory holidays for two or three days or sometimes weeks" (one of the more illustrious but troublesome pupils, Vincent Van Gogh, had been expelled some twenty years earlier). The products of this regime were young artists of "breadth and manliness" whose "technique and feeling" could, in the opinion of the journal's critic, "cope with any on the continent."[26]

Besides formal instruction at the school, there were museums and galleries in Antwerp for the students to visit, in particular the Koninklijk Museum voor Schone Kunsten. This royal museum held fine examples of Netherlandish landscapes that included several works by Joachim Patinir, the "father of landscape painting" who had specialized in panoramic views of rugged coastal terrain. Lismer also made side trips to see the galleries in Paris and into the French countryside to study the landscape where Camille Corot and Charles-François Daubigny had painted.[27]

Lismer survived under his stringent Antwerp tutelage for eighteen months. Back in Sheffield, he found himself unable to earn a decent living or offer prospects to his fiancée, Esther Mawson. "It was a cold world for artists in those days in northern England," he later wrote.[28] He therefore set sail for Canada with $5 in his pocket and his few worldly possessions (which included a parting gift from his fellow Eclectics, a copy of Carpenter's *The Art of Creation*) crammed inside a travelling trunk made from his chopped-up writing desk. Weeks later, after a winter transatlantic crossing that finished with ss *Corsican* encased in ice, the effusive Yorkshireman was working at Grip

(Broadhead's appraisal had clearly been too pessimistic) and rooming on Summerhill Avenue with the reticent and self-effacing Thomson.

TORONTO PROVED AS lucrative and welcoming to Lismer as it had to Broadhead. Within a year of his arrival, he had enough money in his bank account to return to Sheffield to marry Esther and then to bring her to Canada and install the pair of them in a small house near Christie Pits. The streets of Toronto, he jubilantly informed a Sheffield acquaintance in a letter, "were practically paved with gold."[29]

That acquaintance was Frederick Horsman Varley, the next son of Sheffield to immigrate to Toronto. Varley was a thirty-year-old commercial artist and Lismer's fellow graduate of both the Sheffield School of Art and Antwerp's Royal Academy. Varley too had been struggling to earn a living in Sheffield, a city he would later dismiss as "a back alley for art."[30] For much of the previous decade he had led a hand-to-mouth existence in both Sheffield and London as a newspaper illustrator, but by 1908 his bleak prospects had forced him to take work as a stevedore on the docks of the North Sea port of Hull and then as a clerk in a railway office in Doncaster. In the summer of 1912, with a wife and young daughter to support, he was prepared to listen to his old friend's tales of Canada as a land of artistic opportunity. That summer, leaving behind his family and borrowing money from Lismer's brother-in-law, he sailed from Liverpool aboard ss *Corsican*. Arriving first in Montreal, he tossed a dime into the air: heads meant New York, tails Toronto. Although the coin came up heads, he went to Toronto, no doubt owing to the presence of Lismer. Within days he, too, had landed on his feet, finding work at Grip and a bed on Summerhill Avenue.

Thomson and Varley immediately became friends. The red-haired, craggy-featured Varley was a loner with a mercurial temperament and—almost unheard of even among artists in Toronto the Good— bohemian appetites. He had spent several years in London, by his own account, "drifting in the underworld."[31] He drank copiously and chain-smoked cigarettes, and beneath his corduroy trousers (the choice of Parisian aesthetes and bohemians from Théophile Gautier

63

F.H. Varley paddling near his home on Toronto Island, c.1913

Photographer: Maud Varley; Courtesy of Christopher Varley, McMichael Canadian Art Collection Archives

to Leo Stein) he wore silk underwear. Thomson too liked to drink and, when not in the bush, could be something of a dandy. He was a "connoisseur of good tobacco," according to one Grip colleague, and he wore what Lismer called "silk shirts of a fairly loud pattern."[32] When in funds, he dined at the fashionable McConkey's Restaurant on King Street West, an elegant establishment whose Palm Room was the home of Toronto's beau monde. His mackinaw-clad forays into the

bush notwithstanding, Thomson had, according to one of his sisters, a "hunger for the refinements and niceties of life."[33]

Thomson and Varley got along so well that soon Varley began acting as a matchmaker, trying to engineer a relationship between Thomson and his sister-in-law Dora, the half-sister of his wife, Maud: the two Englishwomen were expected to arrive in Canada by spring. Thomson declined the offer. He "wasn't fit for a girl," he told Varley, because he was "a wild man."[34]

Painting was the two men's greatest passion. Weekends found them sketching in the outskirts of Toronto and on Centre Island, in Toronto Harbour. Thomson evidently regaled his new friend with tales of life on the Mississagi, because before long Varley was writing to his sister in England that he was "aching" to express the landscape of what he called "this . . . outdoor country."[35]

6 WILD MEN OF THE NORTH

IN JANUARY 1913 Lawren Harris and J.E.H. MacDonald caught a train from Union Station in Toronto. On this occasion they were going not north but south, 150 kilometres around Lake Ontario to Buffalo, New York.

Buffalo was a far more impressive city than Toronto. The eighth-largest city in the United States, it had a population of more than 420,000. Buffalonians could boast spacious boulevards built on a radial plan, houses by Frank Lloyd Wright, and the United States' largest office block, the Ellicott Square Building. They also enjoyed more than a thousand acres of beautiful parkland designed by Frederick Law Olmsted, America's greatest landscape architect; one of the parks, Delaware Park, had been the site of the Pan-American Exposition, which in 1901 attracted nearly 8 million people to the city. Whereas Toronto still had no permanent public art collection, Buffalo could take pride in the neoclassical Albright Art Gallery. The gallery was begun in 1900 and completed five years later. Its 5,000 tons of marble, 102 Ionic columns and eight-foot-high caryatids all announced Buffalo's triumphant commitment to the arts.

The Albright had already mounted several major exhibitions. Recent shows were devoted to modernist artists such as the Russian

Prince Paolo Troubetzkoy, the Spanish Post-Impressionist Ignacio Zuloaga, the Art Nouveau designer Aubrey Beardsley and the photographer Alfred Stieglitz. Two separate exhibitions had been dedicated to James McNeill Whistler. In 1911 the Albright had hosted yet another important exhibition, the first showing outside Paris of the Société des peintres et sculpteurs (formerly the Société nouvelle). According to a *New York Times* review, this exhibition revealed the "intelligent zest" of the "new forms of expression" in France.[1] It included bronzes by Auguste Rodin and paintings by the expatriate Canadian J.W. Morrice, a Montreal native who had lived for many years in Paris. Members of the Arts and Letters Club, Harris and MacDonald among them, chartered a CPR carriage to transport them to the exhibition. A friend later said that Harris "deplored our neglect of the artist in Canada,"[2] and so it must have been chastening for him to realize that, in order to see works of such quality and variety, one needed to catch the train to Buffalo.

The exhibition that opened on January 4, 1913, entitled *Contemporary Scandinavian Art,* was yet another impressive international show. Harris and MacDonald would already have known Scandinavian art by reputation because Canadian artists had long taken an interest in Nordic painting. Twenty years earlier, in 1893, paintings from Norway, Sweden and Denmark struck a resonant chord with several young Canadian artists at the World's Columbian Exposition in Chicago. C.W. Jefferys, twenty-four years old at the time, noted that "their painters were grappling with a landscape and climate similar to our own." He felt "a natural affinity to them, rather than to the London, Paris, Munich and Dusseldorf Schools. We became northern-minded."[3]

In 1913 there was still much in Scandinavian art to make impressionable young Canadian painters turn northern-minded. "You will see here," the Swedish-American curator Christian Brinton announced on opening night, "the fantastic forms which the snow assumes, the freshness of the fields in springtime, the flow of water, and the contour of the clouds mirrored in the shining face of the sea."[4] The forty-two-year-old Brinton, author of *Modern Artists,* was a tireless promoter in America of contemporary European painting. For

the Albright he had assembled a collection of 165 works by some of Scandinavia's most prominent modern painters. Although no contributions came from the Swedish avant-garde collective De Åtta (The Eight), Brinton did pay tribute in the exhibition catalogue to what he called these "earnest disciples of progress"—students of Henri Matisse led by Isaac Grünewald.[5]

The Eight were Scandinavia's only most recent disciples of progress. For the previous thirty years Scandinavian art had been enjoying a golden period. Young Swedish, Danish and Norwegian painters, trained in Italy, France and Germany, had returned to their countries to interpret their northern landscapes in adventurous new styles that made them among the most celebrated painters in Europe. "After us, the Scandinavians," the French painter Ernest Meissonier had predicted shortly before his death in 1891.[6] Optimism about the power of Scandinavian art was related to a widespread conviction that the civilization of Western Europe—urban, industrialized, rootless—was entering a decline. For an apostle of progress such as Brinton, Scandinavia's virtue was "its remoteness, its scenic picturesqueness, and the comparative lateness with which its inhabitants entered the concert of so-called European civilization."[7] The decadent and enfeebled culture of Europe could be invigorated (so proponents of Northern European art believed) by a half-civilized race of poets and artists from Europe's rugged northern latitudes—what one critic celebrated as the "wild men of the North."[8]

This philosophy, as well as Brinton's poeticizing about Scandinavia's "perpetual snow" and "grandiose and eccentric meteorological phenomena," had obvious parallels to the American and, even more especially, the Canadian situation. For was not Canada, too, a remote northern land of perpetual snow and spectacular scenery, with a vigorous stock of people not yet domesticated by the bonds of culture? Since Confederation, many Canadians had been identifying themselves—in sharp distinction to the races and nations of supposedly softer and lazier latitudes—as a hardy northern race. They were, in the words of Robert Grant Haliburton, the "Northmen of the New World."[9] If the northern wilderness was to preserve and progress culture

through its health and vigour, where could it be found in greater abundance than in Canada?

Canada had intriguing parallels with Norway in particular, a country that, as Brinton observed, was emerging from the "early, formative years of her artistic development."[10] Both nations had until recently been ruled by others. Norway was a province of Denmark for more than four centuries until, in 1814, it achieved partial independence thanks to a political union with the Kingdom of Sweden; parliamentary rule was achieved in 1884 and independence from Sweden only in 1905. Such prolonged political subservience naturally led Norwegian artists to explore national identity—and this identity was constructed around their northern landscape. A movement known as "National Romanticism" developed in the 1840s, followed forty years later by the "New Romanticism" of nationalist-minded painters, led by Gerhard Munthe, based at a farm named Fleskum in Bærum, near Oslo. Founding the Lysakerkretsen (Lysaker Society) to promote Norwegian nationalist values, Munthe had even launched the idea of a special Norwegian palette of colours—blue-green, bright reds, deep violets, indigo, bold yellows—that he believed reflected the unique Norwegian landscape.[11] Although none of Munthe's works was on show in Buffalo, nationalism was one of the keynotes of the Albright exhibition, with Brinton evaluating the paintings through the lens of the perceived national characteristics of the different Scandinavian countries.

Harris would later call his trip to the Albright with MacDonald "one of the most rewarding and exciting experiences either of us had."[12] Accustomed to misty paintings of French riversides and Dutch coasts, the two men were enthralled by the vivid images of the boreal forest, the vast biome that encircles the top of the globe like a coniferous crown, encompassing Canada as well as Scandinavia. They were particularly struck by the work of landscapists such as the Symbolist painter Harald Sohlberg, a Norwegian, and the Swede Gustaf Fjaestad (a former speed skater who in 1891 set the world record for the English mile). Snow was unexpectedly rare in Scandinavian paintings prior to the 1890s, but Sohlberg and Fjaestad had turned to wintry images to convey specific national characters and a distinctive

Nordic symbolism.[13] These razor-sharp images of hoarfrost, pristine snow and bristling pines against steel-blue skies struck the Canadians as fresh and new after the mellow, beeswaxed glow so prominent in Toronto exhibitions.

Harris and MacDonald began to envision the possibilities of an art that would emphasize what Harris later called "the power and clarity and rugged elemental beauty of our own land."[14] Or as Mac-Donald prolixly enthused, the "feelings of height and breadth and depth and colour and sunshine and solemnity" raised by these paintings of "the soil and woods and waters and rocks" meant both artists became determined to do much the same thing with the Canadian landscape.[15]

THERE WAS MORE in the Albright exhibition to intrigue Harris and MacDonald than depictions of forests, mountains and snow. After all, for the better part of a century Canadian painters in great profusion had been depicting forests, mountains and (less frequently) snow: the walls of the OSA exhibitions had been thronged with images of Muskoka and the Rockies. It was, rather, the particular *style* of some of the Scandinavian painters that excited the two Canadian artists. The clear light, jagged peaks and pinnacled pines of the northern latitudes evidently called for a style different from the misty riverbanks and cultivated fields of Europe's more southerly regions. A number of the Scandinavians used strong colours and expressive, rhythmic forms taken from 1890s artistic movements such as Synthetism, Symbolism and Art Nouveau. The Danish painter J.F. Willumsen had been a friend and disciple of Paul Gauguin, and many of his canvases (eight were at the Albright) showed the influence of Gauguin's saturated colours and distorted perspectives.

70 The purpose of these startling compositions and bright, seemingly arbitrary colours was an emotional effect. European art movements of the previous decades had emphasized the importance of the painter's emotional and psychological responses. Van Gogh stressed that he painted what he felt rather than what he saw, writing to his brother Theo that "instead of trying to reproduce exactly what I see

before me, I make more arbitrary use of colour to express myself more forcefully."[16]

A number of the Scandinavian painters at the Albright likewise wished to capture and express emotional states in their landscapes. Their motto was expressed by the Swedish painter and critic Richard Bergh: "Every landscape is a state of mind."[17] Sohlberg, a Symbolist, hoped to create, in the words of an American reviewer, "nothing less than a new form . . . that shall express with greater intensity the new feelings and emotions aroused in man by all the objects of the natural world."[18] He was not interested in offering photographic images of the Norwegian countryside: he specialized in what Brinton called "emotionally intense landscapes."[19] He experimented with glazing techniques in order to create heightened colours and intense feelings.

Another Norwegian Symbolist, Edvard Munch, offered even more emphatic emotions and visions. He too believed a physical landscape produced a set of feelings that he then attempted to capture in pigment: "It is these feelings which are crucial," he once wrote, "nature is merely the means of conveying them."[20] Harris must have taken a special interest in Munch's six paintings, since he was the man for whom Franz Skarbina had resigned his post and then founded the Group of Eleven. In 1913 Munch claimed he was "quite faded and classic," no longer among "the wildest things of Europe."[21] He was living in Norway with his beloved fox terrier, Mr. Phipps, and enjoying excursions through the fjords on his motorboat. An outcast no more, he was a Knight of the Royal Order of Saint Olav and by far the most renowned and financially successful of the Scandinavian painters on display at the Albright. He was in fact, as Brinton acknowledged, one of the most famous artists in the world, his reputation "second to that of no living contemporary."[22] Although scarcely appreciated by everyone (his name "still rankles in the memory of many an outraged patron of art," noted one reviewer),[23] he was a salutary example of how controversy and notoriety could coalesce, in the short space of a decade or two, into acceptance and fame.

Something more than Munch's celebrity must have drawn Harris and MacDonald to his works. There was in much Scandinavian art,

and in Northern European art in general, an attitude towards nature quite different from, say, the French art of the previous fifty or sixty years. By the nineteenth century, natural scientists had unwoven the rainbow (as John Keats lamented). Following in their wake, Realist and Impressionist painters such as Gustave Courbet or Claude Monet drained the natural world of any transcendent dimension. Many French painters in the second half of the nineteenth century regarded the landscape as a setting for social recreations such as picnics and promenades, or as a site on which to examine—like a scientist on a field trip—atmospheric or meteorological effects in the changing seasons and at various times throughout the day.

Courbet and Monet both painted seascapes at Étretat on the Normandy coast, but their pictures of remarkable geological formations such as Needle Rock—as in Courbet's *Cliff at Étretat after the Storm* or Monet's *Étretat, Gate of Aval: Fishing Boats Leaving the Harbour*— were descriptive images of sunlight, water, reflections and human activities such as fishing or sailing. No attempt was made, despite the appearance of the looming rocks or the fact that Monet often worked in gales of wind and rain, to convey a sense of the awesome majesty of nature. Interest was in the specific and the momentary. "For me," Monet once claimed, "a landscape does not exist in its own right, because its appearance changes at every moment; but it is brought to life through the air and the light, which continually vary."[24] The English painter and critic Roger Fry wittily paraphrased this kind of statement when he characterized the Impressionist as someone who believed he could not paint the same river twice.[25]

In contrast, a later generation of European artists concentrated on the more timeless and objective features of a landscape. They sought something more than the sun-sparkled surface pursued by the Impressionists. The Cubist Robert Delaunay spoke for many when he wrote that beneath the "contingent and obvious" features of the landscape painted by the Impressionists lay a "universal reality with the most profound effect of depth."[26] The painter was to communicate with these depths—to seek the "universal reality" beyond the superficial visual phenomena of the natural world.

For more than twenty years Munch had been struggling to dis-
cover an artistic means by which to express the mysteries—what
he called the "sanctity" and the "grandeur"[27]—beyond the world of
appearances, which in his case often included the coastal landscape
at Åsgårdstrand, a small beach resort near Oslo. Rather than merely
capturing the external forms of the natural world, he wished to pen-
etrate its primal mysteries. He used the Nordic landscape as a setting
for psychological dramas, and his tortured images disturbed many
Scandinavian-American visitors to the Albright who had hoped to see
pretty pictures of their faraway homeland. "No one can say that these
visions of sickness, these passionate wild longings, high notes in paint,
are there to please the mob," observed one critic.[28]

Munch's powerful forms of expression appear to have intrigued
Harris and MacDonald almost as much as the pictures of mountains
and snow. Munch's response to the landscape in his paintings was not
unlike the experience of the visitor to the "eerie wildernesses" of the
Canadian northlands: "A profound awe, a cosmic fear, is the keynote
of these canvases," as Brinton observed. "He is as a child who sees ter-
ror in the most familiar shapes, or a man who shudders on the brink
of an abyss."[29] MacDonald recognized how Munch's objective was not
fidelity to nature but emotional truths and a deep symbolism. "He
aims to paint the soul of things," MacDonald would later remark, "the
inner feeling rather than the outward form." The result was that he
created, in MacDonald's words, a "remarkable, painful and yet irradi-
ating art."[30]

One of Munch's most famous paintings was on show at the
Albright—*The Sick Child,* an unsettling recapitulation of the death of
his older sister from tuberculosis when he was thirteen. MacDonald
praised this "beautifully composed" work as "feeling enveloped in a
veil of colour."[31] Also on view were a number of Munch's landscapes,
such as *Starry Night,* first shown at a Berlin gallery in 1893 and then
again at the 1902 exhibition of the Berlin Secession. Showing the coast
at Åsgårdstrand, this nocturnal scene reveals Munch's passionate
empathy with the northern landscape and his unsurpassed ability to
capture what MacDonald, describing Munch's landscapes, called the

"mystical quality" of the northern summer evening.[32] It evokes emotion through colour and dramatic line rather than merely recording, through close attention to visual detail, the effects of stars reflecting in the black water. Mysterious forms and reflections haunt the inky, blue-black landscape, turning geography into a mental state—an obscurely menaced loneliness and isolation.

EDVARD MUNCH'S PAINTINGS were precisely the kind of work, full of "lyric exaltation" and "passionate unrest," that Brinton referred to when he wrote of the "peculiarly Northern" aspects of the Scandinavian paintings at the Albright.[33] But it was Gustaf Fjaestad, then in his mid-forties, whose work most impressed MacDonald: his paintings were, MacDonald wrote, "perhaps the most attractive of all."[34] Fjaestad specialized in eerily beautiful northern landscapes that were at once both meticulous observations of nature and stylized decorative designs (see plate 6). If his photographic illusionism made him one of the most popular painters in the Albright exhibition, what appealed to MacDonald was his application of ornamental patterns to what seemed a familiar northern landscape: the "decorative foliage of his snow-hung boughs" possessed, MacDonald claimed, "a delicate charm we had never seen in art before."[35]

Fjaestad's stylized landscape designs (some of which were woven into tapestries by his sisters Anna and Amelie) featured sinuous lines of vegetation or ripples of water that owed much to Art Nouveau, the popular and elegant international style of illustration developed in the 1890s and described by a German art historian in 1901 as "the cult of the line."[36] For the previous two decades, Art Nouveau designs had adorned everything from architecture, posters and spoons to Émile Gallé's mushroom-shaped lamps and Hector Guimard's iron and glass signs for the Paris Métro. Fjaestad, who also worked as a cabinetmaker, applied them, like many other designers, to furniture, often incorporating Scandinavian motifs.

Art Nouveau was a stock-in-trade of any commercial designer of the age, and an 1898 press advertisement for Grip Limited was done in a distinctive Art Nouveau style.[37] MacDonald himself was one of the

style's most accomplished practitioners in Canada, having done many such designs in his commercial work both at Grip in Toronto and at the Carlton Studios in London. Not until January 1913 did it occur to him to apply its hallmarks—stylized vegetative shapes, blocks of colour, sweeping curves and meandering outlines—to the Canadian landscape. These "true souvenirs of that mystic north," as he later called Fjaestad's paintings, "had a great Canadian inspiration for us."[38]

The example of Fjaestad might have served Harris and MacDonald in one more important way. In 1897 Fjaestad had become a member of the Rackenmålarna, or the Racken Group, a colony of artists and craftsmen (including his wife, Maja) living near Lake Racken in Sweden. This cooperative effort, combined with the similar examples of The Eight in Sweden and the Group of Eleven in Berlin, no doubt made the two Canadians realize that a national art movement, attempting to forge a new style, would need to be a group effort. If the Scandinavian painters gave them an inkling of a style, what remained was to find new members for a group. And so began what Harris would later call "an all-engrossing adventure."[39]

TWO MONTHS AFTER visiting the exhibition of Scandinavian art in Buffalo, Lawren Harris and J.E.H. MacDonald received American exposure of their own. In March 1913 a small selection of their works was included in an exhibition of Canadian painting staged at the MacDowell Club in New York City. The somewhat ambiguous reception given these Canadian works may well have served as a further prompt for the two young painters to become "northern-minded."

The MacDowell Club, at 108 West 55th Street, was founded in 1905 with the plan—rather like Toronto's Arts and Letters Club—of staging plays, readings, musical recitals, art exhibitions and occasional displays of morris dancing. According to the *New York Times,* its aim was "to nurture the fine arts and protect them against the coldness of a commercial age," and to "seek out embryo Millets, Beethovens, Shakespeares, and help them along the thorny path which leads to Parnassus."[40] Into this bonhomous den of artistic goodwill came, in the first week of March, paintings by some of Canada's most renowned

artists: Bill Beatty, William Brymner, William Clapp, Maurice Cullen, Clarence Gagnon, E. Wyly Grier and C.W. Jefferys, together with ones by Harris and MacDonald.

Americans were not disposed to hold Canadian cultural productions in any esteem. The arrogance and antipathy with which New Yorkers regarded Canada would be demonstrated a few months later when Rupert Brooke, visiting the city and eagerly anticipating his impending trip through Canada, was warned by New York friends to give the country a wide berth: they spoke scornfully of the "Philistine bleakness" of the "country without a soul" lying somewhere to the north.[41] For many Americans Canada was a place to slay deer, catch salmon and build lakefront monstrosities, but not to find artistic innovation. Their prejudices appeared to be confirmed by the fact that so many Canadian artists, exasperated by poor prospects in their homeland, had fetched up hopefully in New York, "drawn thither," as Brooke observed, "for the better companionship and the higher rates of pay."[42]

The reviews of the Canadian paintings at the MacDowell Club were sparse and mixed. The most resonant remarks were made by a reviewer for the *New York Sun*. In an article entitled "Softer Aspects of Northern Country at the MacDowell Club," the critic found himself perplexed that, with the exception of "one or two wintry aspects by J.E.H. MacDonald," the savagery of the Canadian wilderness—what he called "the essence of the Dominion"—was largely unrepresented. Having had his idea of Canada nurtured, perhaps, by the poems of Lampman and Campbell, he lamented that there was "nothing that bears out the traditional fierceness of the climate of the country above the St. Lawrence and the Great Lakes." The only paintings that came anywhere close to capturing this essence, he believed, were Jefferys's Saskatchewan landscapes, though these, with their thin and meticulous applications of paint, were executed in an outmoded style. "No one," he concluded, "has quite conveyed that sense of boundless breadth and solitude that so readily stirs the visitor in Canada."[43]

Given how they were hoping to convey exactly this kind of eerie grandeur, the reproach must have stung Harris and MacDonald. The critic's observations echoed Harold Mortimer-Lamb's five-year-old

lament that "the spirit of the great northland" continued to elude Canadian painters. In contrast to the Scandinavian display at the Albright, there was nothing in the MacDowell Club exhibition that showed either the rugged elemental beauty of the land or a formal experimentation capable of conveying it. Much work still needed to be done to capture the savage heart of the Dominion.

WHATEVER ITS EFFECT on Harris and MacDonald, the exhibition at the Albright Art Gallery in Buffalo was far from the most important or influential art exhibition staged in the United States in 1913. Of vastly more consequence was the International Exhibition of Modern Art in New York City. Opening on February 17 in the 69th Regiment Armory Building, it quickly came to be known as the Armory Show. As one critic at the Albright exhibition predicted, the "wildest and most incomprehensible flights" of the painters in Buffalo, such as Edvard Munch, "will appear mild and quite orderly by comparison with what you will see in the forthcoming International Exhibition of Modern Art."[1]

The Armory Show ran in New York until March 15, before moving on to Chicago and then Boston. Organized by the newly formed Association of American Painters and Sculptors, it introduced the American public to many of the latest developments in European painting and sculpture, including works by Henri Matisse, Pablo Picasso, Wassily Kandinsky and Marcel Duchamp. On opening night one of the organizers, John Quinn, declared, "The members of this association have shown you that American artists—young American artists, that is—do not dread, and have no need to dread, the ideas or the culture of Europe." He made what turned out to be a prophetic

announcement: "Tonight will be a red-letter night in the history not only of American but of all modern art."[2]

Young American artists might have been ready to embrace the ideas and culture of Europe, but not so the public and many critics. The Continental avant-garde had in the previous few years developed a fearsome reputation. Just over two years earlier, in the autumn of 1910, an exhibition called *Manet and the Post-Impressionists* caused huge controversy in London. The exhibition's curator, Roger Fry, coined the term Post-Impressionism to describe the styles of exhibited artists such as Georges Seurat, Van Gogh, Gauguin and Matisse—men who, Fry explained in his catalogue, celebrated "individuality" and "self-expression" over a literal representation of nature.[3] Much of the British press responded to these works with an astonishing fear and hostility. One newspaper denounced the artists as "the analogue of the anarchical movements in the political world." Others attacked the paintings as "hysterical daubs," "crude intolerable outrages," "childish rubbish" and "sickening aberrations." A doctor at Bedlam, the lunatic asylum, wrote a paper arguing that Post-Impressionism was the result of "degenerates," "hysterics" and "paranoiacs" who had managed to "turn their unhealthy impulses towards art."[4]

The even more challenging works that crossed the Atlantic in 1913 received an equally belligerent reception. The critics and the public alike were appalled at the apparently childlike drawing, distorted shapes and carelessly vigorous brushwork, all executed in shockingly bright or unnatural colours. Royal Cortissoz, the influential critic for the *New York Herald Tribune* and author of *Art and Common Sense,* called the paintings "freakish things" and denounced Post-Impressionism as "a gospel of stupid license and self-assertion."[5] Another critic complained that Kandinsky's work looked like "fragments of refuse thrown out of a butcher's shop." Matisse was denounced as "essentially epileptic," and Duchamp's *Nude Descending a Staircase, No. 2* was said to resemble an explosion in a slat factory.[6] Teddy Roosevelt stomped through the building, waving his arms and shouting, "That is not art!" The Metropolitan Opera star Enrico Caruso mocked the artists by doing postcard caricatures of their works and handing them out as souvenirs. An effigy of Matisse was stabbed, beaten and burned by

enraged American art students, and in Chicago the Vice Commission was summoned to investigate the canvases for moral turpitude.

Although rare enough in the United States, such scenes were unheard of in Canada. Canadian art criticism had traditionally been respectful and constructive, with little of the vitriol or doltish scoffing that marked so much of that in Europe, especially in France. There had been no real *succès de scandale,* no critical rumpus, in the history of Canadian art. Canadian painters inspired apathy rather than outrage. Shocking new European movements, such as Cubism or Futurism, seemed a world away.

Reverberations of the hysteria over Post-Impressionism were soon felt in Montreal, a city as conservative and unadventurous in its artistic tastes as Toronto. A month after the Armory Show opened in New York, the same heated rhetoric was heard at the annual spring exhibition of the Art Association of Montreal, one of the most important showcases for contemporary Canadian art. Canadian decency and propriety were under attack, the critics appeared to believe, from dangerous and debased foreign influences. "Post-Impressionists Shock Local Art Lovers at the Spring Exhibition," blared the *Montreal Daily Witness,* a Protestant newspaper founded in 1860 to promote temperance. The headline continued: "Screaming Colours and Weird Drawing Cause Much Derisive Comment." The paper's reviewer proceeded to attack a landscape entitled *Assisi from the Plain* (see plate 7) for its "prodigality of paint and studied carelessness of handling."[7] On the same day, the critic for the *Montreal Daily Herald* called the painter of *Assisi from the Plain* a member of the "Infanticist School," claiming (with gross overstatement) that his works were "as contemptuous of all precedent as the most advanced of the Futurists."[8]

Canadian art had found its *bête noire,* its own shocking equivalent of Matisse or Picasso. He was a thirty-year-old Montreal native named Alexander Young Jackson.

A.Y. JACKSON HAD returned from prolonged studies in France only a few weeks earlier. Another artist might have been shaken by such an unfriendly reception in his hometown, but the pugnacious

Jackson ("outwardly rather gruff and blunt," according to a friend)[9] was not one to be cowed by insults or abuse. He would later write that his father, who abandoned his wife and six children following various unsuccessful business ventures, was "lacking in initiative."[10] Lack of initiative did not run in the family, and throughout his life A.Y. Jackson—"a mixture of vaulting ambition and remarkable amiability"[11]—would show himself to be courageous, combative, persevering, resourceful and, on occasion, overbearing and unjust.

Jackson's father's failed businesses and abrupt departure had plunged the respectable middle-class family into financial distress. Alex Jackson was therefore expected to work from a young age. His mother took him to a phrenologist to discover what occupation might suit: after feeling the boy's head, the phrenologist believed he had discovered a lawyer. At thirteen, however, Jackson began his career more humbly as an office boy in a lithography firm; after six years and a transfer into the art department he was taking home $6 a week. Because his time was spent designing labels for beer bottles and cans of tomatoes, he began studying painting in night classes, including at the Council of Arts and Manufactures and the Art Association of Montreal. One of his instructors at the latter was the dean of Montreal art instruction, William Brymner, who had studied in Paris for seven years in the 1880s and (a rare thing in Montreal) took a liberal view of modern developments in painting. "If a man wants to paint a woman with green hair and red eyes," he once told a student, "he jolly well can."[12] Probably inspired by Brymner's example, Jackson made his first trip to Europe in 1905, aged twenty-three. In a passage coinciding almost exactly with that of Lawren Harris on his way to Berlin, he crossed the Atlantic on a steamship with his brother Harry. On board was a crew of drunken deckhands, a consignment of Canadian cheddar, and four hundred head of livestock.

Jackson spent several weeks touring England, France and Belgium before returning to Montreal. Soon afterwards, a strike in the lithography business persuaded him to try his luck in Chicago, to which his feckless father had absconded to work as a salesman for a company specializing in Masonic regalia. The younger Jackson quickly found

employment with a firm of commercial designers, "drawing corned beef labels and all that kind of truck at $15 a week."[13] He studied four nights a week at the Art Institute, where one of his teachers was the well-known illustrator Frederick Richardson and where a student the previous year had been Georgia O'Keeffe. He also attended lectures by visiting luminaries such as the Art Nouveau designer Alphonse Mucha, a friend of Gauguin.[14] In March 1907 Jackson went to the exhibition staged at the Art Institute, *Painting by Contemporary German Artists,* featuring work by members of the Berlin Secession such as Lovis Corinth, Walter Leistikow and Franz Skarbina. "Some very powerful paintings," he wrote his mother. "I will go several times and study them out."[15]

Although thrilled by the work on show at the Art Institute, Jackson regarded his time in Chicago as "a kind of necessary exile to prepare my way to Paris."[16] In September 1907, when he was twenty-four, his exile ended. He had earned enough money making labels for corned beef that he was able to return to Europe to study at the Académie Julian in Paris, a private art school where a month's worth of lessons cost $5.

Founded in 1868 by a circus wrestler and sometime painter, the Académie Julian offered instruction as rigorous as that in the conservative École des beaux-arts, with a strong emphasis on draughtsmanship and the nude.[17] Jackson's teacher, Jean-Paul Laurens, then in his late sixties, was a figure from another age. A member of the prestigious Académie des beaux-arts, he enjoyed a long career painting grandiose historical subjects—heroic victims committing suicide or resigning themselves to their executions in authentic period costume—of the sort that for much of the nineteenth century had covered the walls of the Paris Salon by the acre. Although ferociously republican and anticlerical in his politics, he was rigidly orthodox in his aesthetic beliefs. Realism and Impressionism had passed him by, and he favoured "established tradition" (as Jackson later noted) and strongly disapproved of Cézanne.[18] One of the lessons he set for his students was a composition called *Dante and Virgil in the Inferno, Watching the Lost Souls Drift By.* "We have over a week yet to do it," Jackson reported to his mother, "but it isn't exactly in my line somehow."[19]

As in Chicago, Jackson sought out extramural inspiration, becoming so fanatical that he sometimes skipped classes to visit galleries, museums and special exhibitions. More art could be seen in Paris than anywhere else in the world. The English painter C.R.W. Nevinson, studying in Paris around the same time, described how he was able to see "literally hundreds and hundreds of pictures" merely by peering in gallery windows as he walked the streets.[20] Numerous exhibitions were also to be seen. A few days after arriving in Paris, Jackson went to the Grandes Serres de l'Alma for an exhibition of the Seurat-inspired Italian Neo-Impressionists known as the Divisionists and touted in the catalogue as "a group of painters that is one of the living forces of Italian art today."[21]

Following six months at the Académie Julian, Jackson embarked on an artistic pilgrimage to Florence, Venice and Rome. The summer of 1908 he spent painting seascapes and sand dunes among a colony of expatriate artists at the fishing port of Étaples on the English Channel near Le Touquet. It offered, he wrote his mother, "old houses, canals, woods, seashore, fishing boats, sand dunes and any variety of subjects."[22] He translated this seaside atmosphere into a painting called *Paysage embrumé* (Misty Landscape). Although accepted for exhibition at the annual Paris Salon, it attracted little attention.

Jackson next spent several months in a village south of Fontaine-bleau in the heart of Barbizon country (from which he made regular trips into Paris to see new exhibitions). In the summer of 1909 he travelled to Holland and Belgium, sketching windmills and cathedrals. He also visited the Rijksmuseum in Amsterdam, "one of the finest picture galleries in the world," he told his mother, adding effusively that besides Rembrandt it had work by Hague School artists such as the Maris brothers and Anton Mauve, whose works were so popular in Montreal.[23] Back in Canada in 1910, he used his sketches from the Low Countries to create on the bedroom wall of his aunt's home in Berlin, Ontario, a Dutch-themed mural: sheep, steeply pitched roofs and Antwerp Cathedral. This frieze was, along with a portrait of his Aunt Geneva's dog, his first commission.

Jackson was less enamoured of the painters of the Hague School when he returned from Europe following a third tour of duty in

1911–13. He found himself laden with canvases impossible to sell to the Dutch-mad Montreal collectors. His lack of success stemmed from the fact that by 1913 he was moving dramatically away from the style favoured by these collectors. On this third trip to Europe, Jackson had discovered colour and been even more definitively exposed to the Continental avant-garde. If somehow he had not already studied them during earlier visits to Europe, by 1912 he was certainly absorbing the influences of what he later called his "gods in art": painters such as "Cézanne, Van Gogh and other moderns."[24]

CÉZANNE AND Van Gogh were as important for Jackson as for so many other painters working in Europe in the first dozen years of the twentieth century. Van Gogh's posthumous fame and influence were dramatically increasing at this time thanks to regular exhibitions in Vienna and Berlin, a 1905 exhibition at the Stedelijk Museum in Amsterdam, and the landmark 1910 show *Manet and the Post-Impressionists* at the Grafton Galleries in London; this latter exhibition had included twenty-one works by Cézanne, twenty-two by Van Gogh and thirty-seven by Gauguin. Jackson was not in Europe for the London exhibition (which Arthur Lismer made a point of attending: he travelled from Sheffield down to London to see it). He probably saw Van Gogh's work in Paris as early as January 1908, when a hundred of his works went on display at the Galerie Bernheim-Jeune, along with, simultaneously, another thirty-five at the Galerie Eugène Druet.[25]

Likewise, although he missed by a month the Cézanne exhibition at the Galerie Bernheim-Jeune in January 1910, Jackson almost certainly saw fifty-six of Cézanne's paintings and drawings at the retrospective of his career staged at the 1907 Salon d'Automne. This was a landmark exhibition, a hugely important moment in modern art when Cézanne became, in the words of Gertrude Stein's brother Leo, "the man of the moment" who was "important for everybody."[26] Laurens might have disapproved of Cézanne, but it is difficult to imagine a young painter like Jackson, only a few weeks in Paris, missing such an important event. Other painters whose works Jackson could have seen at the 1907 Salon d'Automne—which featured 1,748 works by 571 artists—were Matisse, who showed 7 paintings, and Maurice de Vlaminck.

A.Y. Jackson in his studio in Assisi, Italy, 1912
Courtesy of the Estate of the late Dr. Naomi Jackson Groves

Jackson would have taken away from these painters new tech-
niques and new visions of the world. Van Gogh, especially, was
revelatory for many young painters, with his intense, often clash-
ing colours, his spontaneous brushwork, and his fluid patterns and
skewed perspectives. The impulse behind the radical styles of Van
Gogh and other moderns was described by the art critic Laurence
Binyon in his defence of Fry's exhibition: the aim of these painters, he
claimed, was "to get behind the appearance of things, to render the
dynamic forces of life and nature, the emotional significance of things.
Away with imitation, let us get to primal energies and realities."[27]

Van Gogh and Cézanne were only two of the "moderns" to whom
Jackson could have looked for inspiration. His sixteenth-month stint
in Europe between the autumn of 1911 and early 1913 coincided with
radical and far-reaching developments in the art world. These were
the years the American art historian Meyer Schapiro would later
call "the heroic period in which the most astonishing innovations

had occurred."[28] Jackson would not necessarily have been aware of all these innovations, but some, as a young artist rubbing shoulders with other young artists, he could hardly have avoided. During his third interlude in Europe, Cubist works appeared at the 1911 Salon d'Automne, and Pablo Picasso and Georges Braque began experimenting with collages and developing Synthetic Cubism. Italian Futurism arrived in Paris, two exhibitions of the group Der Blaue Reiter (The Blue Rider) toured Europe, and a second Post-Impressionist exhibition was staged in London. In Cologne the Sonderbund-Ausstellung devoted an entire room to the work of Edvard Munch. Wassily Kandinsky published the profoundly significant *Concerning the Spiritual in Art,* whose account of the "language of form and colour" outlined the principles on which much modern art was beginning to develop. Perhaps most innovative of all, during this time both Kandinsky and Robert Delaunay achieved total abstraction.

Jackson, like Lawren Harris, was coy about his European influences, but it is revealing that he spent his second sojourn in Paris, early in 1912, in a studio on the west side of the Jardin du Luxembourg. His address was 26 rue de Fleurus; his neighbours directly across the narrow street, at number 27, were Gertrude and Leo Stein, the two great American enthusiasts for European modernist art. The pair hosted Saturday salons for both expatriates and Parisians in rooms bedecked with Picassos and Matisses. According to one visitor in 1912, the young American painter Marsden Hartley, the walls of "27" (as the apartment was known) were "all afire with epoch-making ideas and at least two vivid people under them."[29]

Jackson, in Paris at the same time as Hartley, might likewise have been invited into "27" to meet some of these vivid people, because in the pre-war years the Steins were generous hosts who welcomed many young artists.[30] If so, he would not have been the first Canadian art student to cross the threshold. In 1909 the painter John Goodwin Lyman, from Montreal, was introduced to the Steins by his American cousin.[31] Even without a similar entree or invitation, Jackson certainly would have known about these painters and intellectuals with their epoch-making ideas.

Leaving Paris in the spring, Jackson once again made his way to the fishing village of Étaples, two hundred kilometres north of Paris. Nestled among the sand dunes and thick fogs of the Côte d'Opale, Étaples had been the site since the 1880s of a thriving American artistic colony whose members at various times included the American Impressionist Frederick Carl Freiseke and the African-American painters Henry O. Tanner and William Edouard Scott. Numerous expatriate Australians, such as Hilda Rix Nicholas, also painted at Étaples. In the summer of 1912 Jackson worked there with the Australian landscapist Arthur Baker-Clack, known for his brilliant colours: according to Jackson, Baker-Clack "revelled in colours he could not afford."[32] From Étaples, Jackson crossed the Channel to visit cousins in the north of England before returning to the Continent with them for a group expedition to Italy. It was there, in the autumn of 1912, inspired by the bright palette of Baker-Clack as well as the bold examples of Post-Impressionism, that he painted *Assisi from the Plain*.

BY THE TIME he returned to Canada at the beginning of 1913, A.Y. Jackson had therefore developed a personal mode of expression, indebted to both Impressionism and Van Gogh, in which he painted with vivid colours in a loose, sketchy manner, eliminating detail and applying his paint in thick layers.

Jackson was coming to believe that this style was the appropriate one for depicting the Canadian landscape, but his results were drastically at odds with the glossy surfaces, suffused light and harmonious blending of subtle tones found in the works favoured by Montreal collectors. From France in May 1912 he had written a letter to the *Montreal Herald* deploring how Canadian connoisseurs, despite living in a "brilliant atmosphere, surrounded by colour," inexplicably preferred the "low-toned" and "gloomy" paintings of the Hague School.[33] "I hope it pokes someone in the eye," he wrote to his mother of his letter. "It's time someone did a little kicking and made a noise."[34]

Jackson also bemoaned these tastes in a letter to another relative, pointing out that as wealthy Canadians "buy only the works of dead artists, it's kind of hard on the ones still living."[35] He did manage to

sell one of his paintings to a Montreal architect, but within weeks the work was returned after an ultimatum from the architect's wife: "either she or the canvas had to go."[36] Jackson's fortunes were about to change, however, as a more sympathetic patron for his work suddenly stepped forward.

Revolted by the hostile reception of his work at the Art Association of Montreal, Jackson retreated to Émileville, sixty-five kilometres east of Montreal, with a painter friend, Randolph Hewton, a Montrealer and former student at the Académie Julian whom he met the year before in Paris. The twenty-five-year-old Hewton worked, like Jackson, in a modern style of flattened forms and, in works such as *Afternoon, Cameret,* checkerboard patterns of colour. Here, in maple sugar country, the two men painted landscapes and earned money helping the farmers in the sugaring-off season. Works Jackson produced included *Early Spring, Émileville, Quebec* and *Morning after Sleet,* the latter showing blue and aquamarine shadows on the snow, with birch trees in the middle ground.

While in Émileville, Jackson received a letter from J.E.H. MacDonald, whom he seems never to have met, though with whom he had been corresponding.[37] MacDonald reported that a Toronto painter named Lawren Harris wished to buy a work of his called *The Edge of the Maple Wood* (see plate 8), painted in 1910 and seen by Harris at the 1911 OSA exhibition. Harris was probably less interested in the painting than he was in Jackson. He could, after all, have tried to purchase the work at any point in the preceding two years. It was an accomplished piece, Impressionist in its broken brushwork but not atypical, in its restricted range of sepia and umber, of many other works offered for display at OSA exhibitions. It included a tumbledown farmhouse and even a snake fence of the sort that crawled picturesquely through so many Canadian landscape paintings of the period.

While painting *The Edge of the Maple Wood* in March 1910, Jackson had written despondently to his mother: "Nothing doing in the way of selling pictures. So I guess it's really all over now."[38] But this painting was to be, in so many ways, the most important of his entire career. Whatever impression the work made on him in 1911, two years later Harris had no doubt been made aware of Jackson through the

reviews in the Montreal newspapers. News of a Post-Impressionist suddenly appearing in Montreal, a painter whose work bore comparison to "the most advanced of the Futurists," would certainly have caused Harris to take notice. He clearly regarded Jackson, on the basis of the panicked responses in the Montreal press and the quality of *The Edge of the Maple Wood,* as a potential recruit. For when Jackson replied to MacDonald, telling him that the work, like all his paintings, was still for sale, Harris sent him a cheque along with a letter reporting that a Canadian art movement was under way in Toronto.

Jackson wrote back with enthusiasm: "It really looks as though the sacred fires were going to burst into flame in Toronto by the faithful efforts of yourself and MacDonald." He added, "It seems like a dream. So scared I'll wake up."[39]

THERE DID INDEED appear to be reason for optimism in Toronto. Among other things, in 1913 the city finally opened its first public art gallery, the Art Museum of Toronto. The museum had been incorporated by the Government of Ontario in 1900, but because of the lack of both a venue and holdings (William Cruikshank's sketchbook, donated in 1909, was its first acquisition) it had no material existence for a dozen years. The problem of space was finally solved thanks to the will of Goldwin Smith, one-time Regius Professor of History at Oxford and author in 1891 of *Canada and the Canadian Question,* a book that argued for Canada's union with the United States. When Dr. Smith died in Toronto in June 1910, without having achieved the desired American union apart from, on a personal level, an advantageous marriage to a wealthy American-born widow, he left a fortune of more than $800,000. The bulk of the money migrated south to Cornell University, where he had taught for a mere two years in the 1870s (he left when he belatedly noticed the presence on campus of female students). His library went to the University of Toronto, and the house, one of the grandest in the city, a stately brick mansion known as The Grange, to the Art Museum of Toronto.[40]

Since the new museum would not officially open until June, the 1913 OSA exhibition took place, as it had for the previous few years, at the Public Reference Library. Shortly before it opened, the director

89

The Grange, Toronto, c.1908
Photographer: C.G. Begg, Archives of Ontario, F 4436-0-0-0-125

of the National Gallery in Ottawa, Eric Brown, published an article in a book called *Canadian National Problems.* Brown was an Englishman who arrived in Canada in 1910 to become the National Gallery's first full-time curator. Although he wore tweeds and a monocle, he was an eager outdoorsman who loved camping, canoeing and (as his wife later wrote) "leaving behind civilization to explore the bush, lakes and mountains."[41] These outdoor pursuits disposed him favourably towards paintings of Canada's rugged landscape. His piece for *Canadian National Problems,* entitled "Canada and her Art," was remarkably upbeat, making confident pronouncements about Canadian art: "A national spirit is being slowly born ... There are painters who are finding expression of their thought in the vast prairies of the far West, in the silent spaces of the North, by the side of torrent and tarn, and in the mighty solitudes of the winter woods."[42]

The 1913 OSA exhibition included many examples of these "silent spaces" and "mighty solitudes" that Brown implied were synonymous

with the Canadian national spirit (but that the critic for the *New York Sun* had found singularly lacking at the MacDowell Club). Among the plentiful Canadian landscapes were C.W. Jefferys's *A Bright Day in Saskatchewan* and *A Prairie Trail,* Tom McLean's *Through the Pines* and *North Country,* and Fred Brigden Jr.'s *In the Hardwood Bush, Northern Ontario.* There was even a contribution from Princess Patricia, the twenty-seven-year-old granddaughter of Queen Victoria and the daughter of the Duke of Connaught, governor general of Canada since 1911: she exhibited a view of Lake Louise.

MacDonald and Harris were, for the second year running, the two most prolific painters, with MacDonald showing several of his Georgian Bay paintings—one called *The Lonely North*—along with views of rapids along the Magnetawan River. Harris exhibited four paintings; one of them, an urban scene entitled *The Corner Store,* proved the most popular in the entire show. Less popular, perhaps, but drawing none of the hostile comment they had received in Montreal, were four canvases by A.Y. Jackson. These works had been sent to the exhibition before Jackson retired to Émileville. Probably the sight of them, as much as for *The Edge of the Maple Wood,* excited Harris, for they were painted in the vigorous modern style that so appalled the Montreal critics. They were, however, European rather than Canadian scenes: two views of Assisi, one of sand dunes near Cucq, France, and a fourth called *The Yellow Tree.* By purchasing *The Edge of the Maple Wood* rather than these European canvases, Harris was trying to wean Jackson from Continental subject matter—though not the Continental avant-garde—and point him in the direction of more indigenous scenes.

The work of these three young painters caught the attention of the reviewer for the *Toronto Daily Star,* Margaret L. Fairbairn, who was struck by the forcefulness of their work. A knowledgeable commentator on the arts, she wrote that the exhibition was "dominated almost entirely by the younger men, who, casting aside formulas, start out to record only what are their own individual impressions. The result is virile work, fearless brushing, strange, crude colour."[43]

This was something of an embellishment: the brushwork and "strange, crude colour" were nothing like as bold as what had been

on offer at the Armory Show. The reviewer for the *Toronto Daily Mail & Empire* noted, in fact, how the "wave of artistic excitement" that swept over the United States in the previous few weeks had "scarcely touched Toronto."[44] But Fairbairn's comments note perceptively how MacDonald and Harris, along with Jackson, were beginning to experiment with a more audacious and "virile" style of painting that would move away from the muzzy tones and gentle pastoral beauty of many Canadian landscape paintings.

BY 1913 THE new Canadian art movement in Toronto had another recruit: Tom Thomson exhibited one of his works in public for the first time. That he should have exhibited nothing before reaching his mid-thirties indicates both a lack of confidence and a desire for perfection. He had few illusions about his talent as a painter. In Seattle, any designs failing to meet with his approval he would "burn up," according to his brother Ralph, "or smear with cigar ashes or the ends of burned matches."[45] He took a similarly incendiary attitude towards his paintings. Harris claimed he would sometimes sit in disgust before a freshly painted picture and "flick burnt matches at it in a kind of whimsical scorn."[46] He once made a bonfire of his paintings in Algonquin Park. The proceedings were witnessed by a twelve-year-old girl who found herself impressed by the "beautiful" effect of the burning oil paints.[47]

A loner by nature, Thomson nonetheless thrived in the encouraging atmosphere of a group. MacDonald, Varley, Harris and Lismer all urged him to develop his talent, and early in 1913 he painted *A Northern Lake* for exhibition at the annual OSA show. A restrained effort, thinly painted in murky tones, it featured a composition to which Thomson would return many times in the years to come: a foreground of boulders, a horizontal band of water in the middle ground and a shore in the distance, all framed by the rigid, vertical trunks of bare trees.

The canvas had none of the fearless brushing or crude colour Fairbairn noted in the canvases of some of the other young painters. But it suitably impressed the Government of Ontario's selection committee, which purchased it for $250. Thomson benefited from the

fact that this three-man committee consisted of his old teacher William Cruikshank and—possibly even more decisive—two members of the Madawaska Club, a group of University of Toronto professors, all fishing and canoeing enthusiasts, who in 1898 purchased land and then built a clubhouse for their outdoor recreations at the mouth of Go Home River on Georgian Bay. Their leader was the physicist W.J. Loudon, a keen outdoorsman who had followed up his *Notes on Elementary Mechanics* (1909) with *The Small-Mouthed Bass* (1910). In 1913 Dr. Loudon served on the Government of Ontario's selection committee, and he was no doubt as favourably disposed to northern scenes as the third member, Dr. John Seath, a former teacher and inspector of schools who had been Ontario's superintendent of education since 1906. Dr. Seath was a charter member of the Madawaska Club. Like Loudon, he was a friend of Dr. James MacCallum, who had purchased Island 158 because of its proximity to the club and who might have done some string pulling in order to see his young protege represented in a public collection.

Questions of influence peddling aside, to have sold his first exhibited painting to the provincial government was a tremendous boost to a painter lacking in self-assurance. In purely practical terms, the $250 Thomson earned from his painting was the equivalent of almost two months' wages. It gave him the courage, like MacDonald a year earlier, to quit full-time paid employment (he had recently been part of an exodus from Grip Limited to a rival firm, Rous and Mann). He cashed his government cheque in $1-bills and, visited later that day by Arthur Lismer at his latest boarding house, on Wellesley Street, tossed the bills into the air in an uncharacteristic fit of exuberance. Later he pinned the money to the wainscotting of his attic room so that he could see it all at once. Such behaviour was slightly odd from a man who had inherited $2,000 from his paternal grandfather, but presumably he felt that his $250, unlike the legacy, had been properly earned. It was, in any case, to mark the beginning of a new stage in his life.

8 THE HAPPY ISLES

Arthur Lismer had reasons of his own for celebrating: the Government of Ontario had likewise purchased one of his works from the 1913 OSA exhibition. Featuring tree stumps and waste ground surrounded by a fringe of pine trees, *The Clearing* looked like a scene from the heavily logged areas of Northern Ontario. In fact, it was painted in the Toronto suburbs, in York Mills, on the site where ground was being cleared for a new subdivision. Although Lismer received $250 for the work, he could hardly afford Thomson's heedlessness, since he had a wife and, from the middle of May, a daughter to support. Part of his money was spent on a cot and a baby carriage.[1] To earn extra money, he took a summer job at the Ontario College of Art (as the Central Ontario School of Art and Industrial Design was rechristened in September 1912). It was the start of a teaching career at which he would excel throughout his life.

Lismer, like Varley, was hoping to paint farther afield than the Toronto suburbs. Sheffield was a dismal industrial city described by one resident as an "enduring cloud of smoke" occupied by a "pale-faced teeming population."[2] But Toronto, for Lismer, was scarcely an improvement. Like MacDonald, he found it drab and grey. "Toronto is a good place," he once said. "Good to get out of!"[3] So far he had

painted at York Mills and on the banks of the Don River, but he was mesmerized by Thomson's accounts of Algonquin Park and the Mississagi Forest Reserve—and mystified that most Torontonians seemed uninterested in such places. "If the country's half as stirring as Tom's sketches seem to indicate," he wrote to a friend, "in Heaven's name why are so many of Canadians always talking about their stomachs, their money, etc.?"[4] He found Torontonians obsessed with getting and spending. "They can argue and discourse for hours on the dollar and the ways and means of getting it," he wrote, "but they can't talk on any other subject intelligently. My present opinion is that they are all 'swank,' to put it broadly."[5]

Lismer's distaste for the mercenary acquisitiveness of Canadians was shared by others. Catharine Parr Traill's decades-old plea to Canadians—"set not your heart too much on riches!"[6]—seemed to have gone largely unheeded. Many believed the country's enormous resources and fast-growing economy meant spiritual matters were being neglected in a Klondike-style rush for wealth and possessions. A Protestant minister lamented that people immigrated to Canada not for educational advantages or religious privileges but rather "to make money—and the material side of life is uppermost in their thoughts—wheat and lands, dollars and acres, the thirst to have, the rush to get, these are the things that are absorbing the lives of men to the exclusion of other and higher things."[7]

Lismer's dismay at this materialism and his belief in "other and higher things" were shaped in a large part by his admiration for Edward Carpenter, the English mystic and social reformer whose book *The Art of Creation* accompanied him to Canada in 1911. Born in 1844, Carpenter was a Cambridge graduate, ordained Anglican priest, associate of William Morris (with whom he formed the Socialist League in 1884), and enthusiastic disciple of Walt Whitman. He had studied Eastern religions in India and Ceylon and since the early 1880s lived in the Derbyshire village of Millthorpe, ten kilometres south of Sheffield. Here he grew his own vegetables and manufactured sandals. He shocked Victorian society by living with his working-class male lover and wearing open-necked shirts.

Carpenter wrote numerous books, from works on homosexuality such as the pamphlet *Homogenic Love* and a collection of essays called *The Intermediate Sex,* to philosophical treatises steeped in Eastern mysticism. Of these latter, *The Art of Creation,* published in 1904, was typical. Carpenter married up-to-date science and psychology with what he called "the world-old wisdom of the Upanishads" to argue that the "materialistic view of the world"—the notion that the world around us is merely dead matter—was passing out of favour. For Carpenter, as for much Eastern philosophy, the physical world was instead to be understood as "the outcome and expression of the mental," with "a vast unity underlying all." Carpenter was influenced by Whitman's famous line from *Leaves of Grass* (another book that found its way into Lismer's luggage for his transatlantic voyage): "Objects gross and the unseen soul are one."[8] It was the duty of the artist to explore this underlying connection between the mind of man and the "other world of the mountains and the trees and the mighty ocean and the sunset sky."[9] He therefore advocated in one of his other books, *Civilisation: Its Cause and Cure,* a "return to nature . . . This is the way back to the lost Eden, or rather forward to the new Eden, of which the old was only a figure."[10]

Besides discussing these writings with other members of the Eclectics, Lismer used to attend Carpenter's lectures on Sunday mornings at a Unitarian church in Sheffield. He was suitably impressed by the man known as the "Noble Savage." "I would listen with my mouth open," he later claimed.[11] He may even have visited Millthorpe with his fellow Eclectics, because Carpenter kept an open house and regularly entertained visitors from far and wide. In any case, arriving in Canada and hearing Thomson describe the wonders of places such as the Mississagi Forest Reserve sparked in Lismer a desire to escape "civilization"—which Carpenter regarded as a disease through which humanity must pass—and see for himself the "other world" of nature.

THE OPPORTUNITY PRESENTED itself in September 1913, when Dr. MacCallum invited Lismer, his wife, Esther, and four-month-old daughter, Marjorie, to his cottage in Go Home Bay. Laden with sketching equipment and baby bottles, they were transported across

open waters towards the island, over three kilometres from shore, in a small motor launch piloted by a "sinewy youth."[12]

The Lismers quickly experienced nature red in tooth and claw. A storm—appropriately for Lismer, a September gale—blew in across Georgian Bay, a body of water so vast that Champlain, arriving on its shores in search of the sea route to China, had called it *La Mer douce* (the Freshwater Sea). The journey became hazardous, the youth having to navigate the small craft through choppy waters past the island known as Giant's Tomb, where a Huron legend held that Ki-chi-ki-wa-na, or Rockman, lay buried. Much larger vessels had come to grief in the area. Only two years earlier, the *Thomas Cranage*, a 305-foot freighter that was once the largest ship in the American fleet, went aground on Watcher Reef, northeast of Giant's Tomb, breaking up and sinking in waters almost seventeen metres deep. Over the years, the number of wrecks, including those of the *Imperial* and the *Lottie Wolf*, helped earn Georgian Bay the nickname "Graveyard of the Great Lakes."

Although Lismer probably knew little of these maritime disasters, as the gale mounted he might have reflected that death by water was something of an occupational hazard for a Canadian painter: less than a month earlier, Edmund Morris, one of Canada's finest landscapists and a subtle and sympathetic painter of First Nations portraits, drowned in the St. Lawrence near Quebec City at the age of forty-one. Little more than a year earlier, in August 1912, Go Home Bay was itself the scene of tragedy as one of Canada's most distinguished philosophers, thirty-eight-year-old George Blewett, Ryerson Professor of Moral Philosophy at Victoria University, drowned while swimming near Dr. MacCallum's cottage. Their deaths, like Neil McKechnie's, were poignant reminders of the dangers lurking in Canada's lakes and waterways.

The party eventually found refuge on a small island where a Yorkshireman named Billy France lived. Following some hastily improvised sleeping arrangements, they made their way safely to Dr. MacCallum's cottage on the following day. West Wind Island was in Monument Channel, northeast of Split Rock, views of which

MacDonald had painted the previous summer. The house was fairly typical of the summer cottages that had been appearing on the shores of Georgian Bay islands for the previous few decades. Built on a rocky point, it was Y-shaped, with a wing of bedrooms facing the water and a high-ceilinged, wood-panelled living room with an open fire and a massive stone chimney breast; a wide veranda ran around the perimeter, and nearby a houseboat was moored in a sheltered cove.

Whereas Tom Thomson preferred a primitive sojourn in the woods that harked back to the experiences of the explorers and fur traders, Lismer's first taste of the Canadian "wilderness" was much the same as that enjoyed by the cottagers who each summer packed their croquet mallets and water wings and descended by the hundreds on Muskoka and Georgian Bay. Living in well-appointed houses with verandas, balconies and even turrets, they often enjoyed much the same standard of comfort as they did at home: one Torontonian, William Elliott, president of the Mendelssohn Choir, had built himself a beautiful Arts and Crafts cottage on Lake Joseph, to which each summer he transported a cow from his Rosedale residence. Already popular with Americans, Ontario's cottage country received international attention in the summer of 1913 owing to the presence on Lake Rosseau of a vacationing President Woodrow Wilson, elected only the previous March. The publicity surrounding his visit caused even more Americans to buy property in the area.[13]

Lismer was less experienced and, understandably therefore, less adventurous than Thomson when it came to paddling a canoe. Nonetheless, each morning he would set off from Dr. MacCallum's wharf, pass the slash and sawdust heaps of the defunct lumber company town of Muskoka Mills, and enter the Musquash River, collecting milk and other supplies from a farm before paddling back to the island. The landscape through which he passed did not disappoint. The Wisconsin glacier had sculpted the area, exposing the bedrock and leaving only rocky outcrops and a thin soil in which only the hardiest vegetation could flourish. Also left behind was the archipelago known as the 30,000 Islands, a maze of inlets and islands so bewildering that even David Thompson got lost as he surveyed the area.

Lismer almost believed he had discovered the "new Eden" promised by Edward Carpenter: "Georgian Bay!" he would later write, "Thousands of islands, little and big, some of them mere rocks breaking the surface of the waters of the Bay—others great, high rocks tumbled in confused masses and crowned with leaning pines, turned away in ragged disarray from the west wind." He called them the "happy isles, all different, but bound together in a common unity of form, colour, and design. It is a paradise for painters."[14]

Altogether Lismer spent several weeks in these "happy isles," painting and exploring near the MacCallum cottage. Despite the fact that he had seen the controversial 1910 exhibition *Manet and the Post-Impressionists*—his interest possibly sparked by the fact that the curator Roger Fry was a protege of Edward Carpenter—his style was still fairly conventional. Regardless of how dramatic he found the scenery, he used an Impressionistic style to catch the effects of light dappled on the waters in Georgian Bay, as in a painting called *Georgian Bay*. Although beautiful and accomplished in its own way, it showed no attempt to explore the underlying connections between the mind of man and the "other world" of mountains and trees.

AT THE END of September, as Arthur Lismer and his family waited for transport to take them back to Penetanguishene, a motor launch appeared on the island's dock. Out stepped A.Y. Jackson, ready to begin his own sojourn at the cottage.

Lismer and Jackson had met briefly several months earlier, in Toronto, after Jackson used the money Lawren Harris paid for *The Edge of the Maple Wood* to fund a trip to Ontario. Harris had been away at the time on yet another sketching expedition with MacDonald: first at Mattawa, the site of an old Hudson's Bay Company trading post on the Ottawa River that closed only in 1908; and then at Témiscaming, fifty kilometres farther north on the Ottawa. Returning to Toronto and realizing he had missed Jackson, Harris sought him out in Berlin, where Jackson had gone in June to visit his two paternal aunts.

The fateful meeting between Harris and Jackson appears to have taken place at Geneva Lodge, the antique-crammed, servant-filled

home of A.Y.'s aunt Geneva Jackson. She was a grand old lady whose father, Henry F.J. Jackson, of Jackson & Flowers, had constructed, in association with Sir Casimir Gzowski, the stretch of the Grand Trunk Railway between Breslau and New Hamburg.[15] On the triangle bounded by King, Water and Francis streets in Berlin, Henry Jackson had built himself a large home that he named in honour of his daughter. Here the unmarried Geneva lived in somewhat distressed gentility. She owned a Krieghoff and what she mistakenly believed to be a Caravaggio. A dabbler in oil paints, she regarded her nephew's productions as "pictures no sane person could understand."[16]

Jackson had listened to Harris's optimism about the burgeoning Canadian art movement in Toronto, and he may also have been reassured by the more sympathetic reception given his paintings at the OSA. But in the spring of 1913 he was already making plans to try his fortune, like so many other Canadians, in New York. Before departing for the United States, he went north to Georgian Bay to spend time with some distant relations, the Breithaupts, members of a prominent Berlin family (the father had served as both mayor and MPP) who owned a cottage and houseboat near Penetanguishene.

Jackson was no stranger to what, during his time in France, he nostalgically called "the good Canuck wild woods." As a young man, especially in Paris, he had adopted the self-consciously bohemian air of the Left Bank artiste or *flâneur*, wearing a corduroy suit and celluloid collar and dosing his head with coal oil to preserve what remained of his vanishing and prematurely greying hair. But he claimed to be at home in the bush as well as on the boulevard. "I have passed so much time out in the woods by myself," he boasted as a student, "that I can get all the company I need out of a pencil and a piece of paper."[17]

Jackson had already visited Georgian Bay three years earlier, in the summer of 1910. On that occasion he had been in the company of the three artistic Breithaupt girls—Edna, Rosa and Catherine—and another set of distant Berlin relations, the Clements. The Clement family owned a cottage on the southern tip of Portage Island, and while staying with them Jackson would take a canoe and paddle over to the Breithaupt property.[18] His short voyage might have been

motivated by more than a need for fresh air or exercise on the open water, since he was apparently in love with Rosa Breithaupt, recently graduated from her art studies at the Ontario Ladies' College in Whitby.[19] In the summer of 1913 Jackson did a painting of twenty-two-year-old Rosa posing at her easel on Chippewa Island.

Like Lismer, Jackson would likewise call the 30,000 Islands of Georgian Bay the "happy isles." In 1910 he and his cousins had enjoyed the usual cottage-country delights. They took to the water in dinghies, enjoyed marshmallow roasts and ice cream, and picnicked on Giant's Tomb.[20] Yet he did not find the area encouraging as far as painting went. Georgian Bay was no stranger to artists: that inveterate painter and traveller Lucius O'Brien had already worked there in the 1880s, creating works such as *Among the Islands of Georgian Bay.* But Jackson could see few pictorial possibilities. With his head full of European cathedrals and Dutch scenery of the sort he had just depicted on the wall of his Aunt Geneva's bedroom, he disdained the area as a place for artists. "It's a great country to have a holiday in . . . but it's nothing but little islands covered with scrub and pine trees, and not quite paintable . . . Sketching simply won't go."[21] The Canuck wild woods of Georgian Bay did not, at least in 1910, seem worth the pencil and paper.

In the summer of 1913 Jackson was more favourably disposed to the scrubby boulder-and-water landscape. He had no doubt been influenced by the enthusiasm of the Toronto painters he met a short while earlier, as well as by some of the art he had recently seen in Europe. Georgian Bay's wind-sculpted pine trees, clear atmosphere, expanses of water and masses of Precambrian rock seemed to call for the strong outlines, broad patches of colour and dynamic forms that Van Gogh, for example, had used to capture the clear light and gesticulating cypresses in the south of France, or that had served Gauguin when he painted Brittany's weather-beaten granite churches and whitewashed cottages.

Jackson remained on the bay after his cousins returned to Berlin, occupying the Clement family's old boathouse on Portage Island and—as he was accustomed to doing from his days in Fontainebleau or on the Brittany coast—making numerous *plein-air* sketches in the

woods and on the shore. Portage Island, as it happened, was only a few kilometres south of West Wind Island. Dr. MacCallum had been planning to close the cottage for the winter following Lismer's visit when he received a letter from Lawren Harris describing how a Montreal artist named Jackson was working in the area. "We want to get him to come to Toronto," Harris wrote, "but he's hard up and talks about going to New York. If you see him, have a talk with him about it."[22]

HARRIS AND Dr. MacCallum were only too aware that, for lack of opportunity, many Canadian artists had been forced to base themselves more or less permanently abroad. Sometime after returning from the Mississagi Forest Reserve, Will Broadhead joined the exodus to seek his fortune in New York City. His initial optimism about his adopted country had rapidly faded. "I feel that I can do some real good work, if only I get the proper opportunity," he wrote home to his parents, "and I can see that that opportunity will not come in this city."[23] Around the same time, Tom Thomson's other canoeing companion, Harry B. Jackson, likewise left town for greener American pastures. Their attitude was summed up by A.Y. Jackson in a letter of October 1910. "As far as Canadian Art concerns me, it can go to——. There never will be a school of Canadian art. The natural centre for Eastern Canadian artists will be New York, and it will be better for themselves and their art when they realize it."[24]

The climate in Canada was indeed inhospitable for an aspiring artist. The collectors were apathetic, the public oblivious and the critics benightedly conservative. Daniel Wilkie, a banker who served as honorary president of the Canadian Art Club, despaired that a Canadian artist returning to his native land after studying abroad "experienced a shock in realizing the lack of sympathy with his aims and objects, the lack of artistic facilities of every kind, the lack of intelligent critics, the lack of suitable buildings where works of art can be properly shown, and, above all, the lack of any apparent desire to see things change for the better."[25]

Even artists with international reputations, such as Maurice Cullen and J.W. Morrice, found Canadian sales difficult. The

Montreal-born Morrice sold paintings to the French government and the wealthy Russian collector Ivan Morozov, but his sales in Canada (apart from a few to connoisseurs) were few and far between. In 1911 he refused to send his paintings for exhibition in Toronto: "Nothing is sold... nobody understands them."[26] Since 1890 he had lived in Paris. Many other Canadian painters worked in London or New York. Hamilton-born William Blair Bruce, who died prematurely in Sweden in 1906, spent most of his working life in France and then on the Swedish island of Gotland. Halifax-born Ernest Lawson, founder of the Harlem River School and the inspiration for the painter Frederick Lawson in Somerset Maugham's *Of Human Bondage,* lived for so long in the United States that he took to denying his Canadian roots: he told everyone he came from San Francisco.

MacCallum and Harris were probably aware of how yet another promising artist had just been lost in this great diaspora. The painter besides Jackson condemned by the *Montreal Daily Herald* as a member of the "Infanticist School" was twenty-seven-year-old John Goodwin Lyman. Lyman left Montreal in 1907 to study in Europe: first at the Royal College of Art in London and then the Académie Julian in Paris (where he studied under Laurens one year after Jackson). Haunted by the "summary intensity" of a Matisse painting at the 1909 Salon des Indépendants, he enrolled in the Académie Matisse, which he called a "nest of heretical fledglings."[27] Early in 1913 he returned to Canada to show work at the Art Association of Montreal. Braving the poor reviews, he staged a solo exhibition of forty-two paintings in May, with catalogue copy composed by his wife that read, "Art is not an imitation of nature... Art that has an air of the natural is a nonsense; art must be artificial."[28] The response was even more savage. In the *Montreal Daily Star* Samuel Morgan-Powell attacked his canvases as examples of the dreaded Post-Impressionism, haughtily dismissed as "a fad, an inartistic fetish for the amusement of bad draughtsmanship, incompetent colourists, and others who find themselves unqualified to paint pictures."[29] In the kind of intemperate language used in not even the most acrimonious political debate, he condemned Lyman's works as "travesties, abortions, sensual and hideous malformations"

whose creation "would shame a school boy. His composition would disgrace an artist of the stone age."[30] At least Lyman was in good company: Morgan-Powell had denounced Van Gogh as a "raving maniac" and Gauguin a "Post-Impressionist mountebank."[31] But the result of this critical mauling was that Lyman immediately left Montreal in disgust: he would spend the next eighteen years in Europe.

Another painter badly shaken by the critics in 1913 MacCallum and Harris almost certainly would not have known about. In the summer of 1912, when Tom Thomson and Will Broadhead were paddling through the Mississagi Forest Reserve, another aspiring artist, Emily Carr, was travelling along the Skeena River and through the Queen Charlotte Islands of British Columbia. Earlier that year, following her studies in France and San Francisco, she exhibited some of her Fauve-inspired French canvases—to critical alarm—in her studio at 1465 West Broadway in Vancouver. In 1913 she rented space at Drummond Hall in Vancouver to show two hundred of the works painted in northern British Columbia. Like Harris and MacDonald, she hoped to forge a new style appropriate to the Canadian landscape, in her case by combining the vibrant colours of Post-Impressionism with the designs of totem poles and ceremonial masks of the First Nations peoples. "More than ever I was convinced," she later wrote, "that the old way of seeing was inadequate to express this big country of ours, her depth, her height, her unbounded wideness, silences too strong to be broken—nor could ten million cameras, through their mechanical boxes, ever show real Canada. It had to be sensed, passed through live minds, sensed and loved."[32] But the lack of support for her work in Vancouver, both critical and financial, obliged her to close her studio and move back to Victoria. She would live for many years in artistic isolation and, like Lyman, no longer disturb the sensibilities of the Canadian critics.

104

MacCallum and Harris were determined that Jackson should not join the ongoing exodus of Canadian painters. Seeking him out on Portage Island, MacCallum found the painter gamely trying to insulate his quarters by stuffing birchbark and moss into the gaps in the walls. Inviting him to spend the winter at the cottage on Go Home Bay,

Emily Carr with dog and parrot
National Gallery of Canada Archives, Ottawa

he also made Jackson another even more generous offer: he would pay the painter's expenses for a year, relieving him of his need to work at anything other than painting.

JACKSON STAYED IN Dr. MacCallum's cottage for a month before returning to Toronto and accepting further hospitality from Lawren Harris, who gave him space to work in his own studio above the Bank of Commerce at Bloor and Yonge.

Harris also tried to woo Jackson by getting his work into the National Gallery. Although founded in 1882, for many years the gallery was woefully neglected by the Dominion government. Until recently its small collection (in 1913 it held some four hundred paintings) shared space in a mansard-roofed building on O'Connor Street in Ottawa with the Government Fish Hatcheries Exhibit: stuffed salmon were displayed on the ground floor, art a floor above. In 1911 the

collection moved into the newly opened Victoria Memorial Museum, this time sharing accommodation with the Department of Mines and the Geological Survey. The building was to prove structurally unsound, and in 1915 the central tower would need to be removed to stabilize the shaky foundations that served as an all too apt metaphor for the state of the national collection.

Found among these mineral samples and dinosaur bones was a painting collection of what Harris derided in a letter to a newspaper as "second-rate foreign pictures."[33] Eager to have his new friend represented in the national collection (to which *The Drive* had recently been added), he convinced nineteen Toronto artists—most of them members of the Arts and Letters Club—to invest in one of Jackson's paintings, a French landscape entitled *Autumn in Picardy* (see plate 9). Then, without troubling to consult either the director, Eric Brown, or the majority of his subscribers, he announced in a newspaper article that the painting was to be donated to the National Gallery. Brown was taken aback by the offer, and some subscribers felt conned. The eminent portraitist E. Wyly Grier was angered that until he read Harris's "preposterous article" he had not been informed of the "monstrous suggestion" that such a "microscopic sketch"—it was only twenty-one centimetres high by twenty-seven centimetres wide— should be sent to the National Gallery.[34] Grier was probably objecting to the style of Jackson's painting as much as he was to its minuscule size. *Autumn in Picardy* was a blur of bright colour and dissipating form, a *plein-air* sketch with dabs of pigment thickly and energetically applied with a wide brush.

Autumn in Picardy was one of the works Jackson displayed in Toronto in December 1913, when Harris—in another effort to keep him in Canada—arranged for an exhibition of his paintings at the Arts and Letters Club. The critical waters proved little better in Toronto than in Montreal, and Jackson received a facetious rebuke in the *Toronto Daily Star* in a review entitled "The Hot Mush School."

With more than eighty thousand readers, the *Daily Star* was Toronto's largest-circulation newspaper by some margin.[35] A few months earlier its regular art reviewer, Margaret L. Fairbairn, responded

favourably to the "virile" style of the "younger men." But it was not Fairbairn but a man named Henry Gadsby who strolled through the doors of the Arts and Letters Club to survey the paintings. Gadsby freely admitted his lack of qualifications to speak knowledgeably about art: he was a parliamentary reporter more accustomed to penning affectionately mocking portraits of politicians. His persona in the article was that of the befuddled member of the public confronted by strange and incomprehensible images. Mystified by Jackson's experimental style, with its urgent colours and liberal paint handling, he claimed the works looked as if someone had sprayed a tube of paint at the canvases. One of them he described as looking like "a plesiosaurus in a fit," another as "Dutch head cheese having a quarrel with a chunk of French nougat." The works, he claimed, looked more like "a gob of porridge than a work of art." The "younger set," he wrote, "believes in Explosions, Outbursts and Acute Congestions of Pigments." He even suggested that many of these "Hot Mushers" were under the influence of opiates or other hallucinogens.[36]

Gadsby's comments were a harmless pastiche of the outraged moral panic that had greeted the Post-Impressionist works at the Grafton Galleries and the Armory Show. But Jackson's new Toronto friends were not prepared to let these insults go unpunished. MacDonald leapt swiftly to his defence with his own article in the *Toronto Daily Star,* published a week later.

MacDonald took an interesting tack to defend Jackson. Various clear explanations and robust defences of this kind of paint slinging had recently been offered in both Britain and America. Such was the topicality of Post-Impressionism following the scandal of the Armory Show that in November 1913 even *Popular Science* published an article explaining the optical theories that underpinned it. Many other statements of purpose could have helped unscramble Gadsby's confused thoughts. In an essay published in 1909, Roger Fry had argued that "likeness to Nature" was no longer important to the modern artist: what counted were the "emotional elements" of a painting.[37] Or as the catalogue for his 1910 exhibition *Manet and the Post-Impressionists* stated, "There comes a point when the accumulations

of an increasing skill in mere representation begin to destroy the expressiveness of the design."[38]

MacDonald could easily have defended Jackson along these lines. But aligning Jackson with a coterie of dreaded Post-Impressionists would have done the painter few critical favours in Canada, and so his support for Jackson was based not on the integrity of his experimental modern style so much as on the nationality—the "Canadianness"—of his paintings. He urged Gadsby and his fellow critics to respond to such works "with an open eye and perhaps a little receptivity of mind," and to "support our distinctly Native art."[39] In what would become a familiar refrain, he appealed to the patriotism of the critics and the public, arguing that a new Canadian style could not emerge so long as the country's young painters were forced to maintain the shopworn conventions of the past.

MacDonald therefore swaddled their art in the flag of the Dominion. He was sincere in his desire to forge a new Canadian style, but his manoeuvre was disingenuous: patriotism was used as a stalking horse for an international style of art that, as reactions at both the Armory Show and the Art Association of Montreal revealed, the North American public was not prepared to accept. Anything that might be disparaged as a French fancy needed to be garbed in mackinaw.

This kind of artistic flag hoisting was not regarded by everyone as the highest ideal for art. The best painting was supposed to aspire to timelessness and universality, not nationalist concerns. Even Ralph Waldo Emerson, who called for a distinctively American art, admitted that the "highest charm" of masterpieces was "the universal language they speak."[40] Good art was meant to cut across national boundaries. When that most deracinated painter, James McNeill Whistler, founded the International Society of Sculptors, Painters and Gravers in 1898, he disparaged the idea of "nationality in Art." He wished to occupy instead what he called the "cosmopolitan ground of International Art."[41]

Yet not everyone wished to join Whistler on his cosmopolitan terrain. Modernist art is often seen—thanks to Whistler and others—as loftily international, at odds with narrowly regional or nationalist

concerns. But MacDonald and his friends were far from alone in their desire to forge an indigenous culture based on the land. Many European modernists openly appealed to nationalist sentiments or were inspired by their love for a homeland.[42] Modernism's three greatest innovators, Cézanne, Gauguin and Picasso, were deeply rooted in either their provincial homelands or (in the case of Gauguin's South Sea paintings) the particular features of a specific locale, rural and remote. Many of their paintings, however formally adventurous, can be seen as "ethno-scapes"—celebrations of geographical patrimonies.[43]

Cézanne, for example, was thoroughly imbued with the terroir of Provence. After his permanent return to Aix-en-Provence in 1886 he described his passionate attachment to "our native soil, so vibrant, so harsh and so reverberant with light."[44] Picasso's landscapes from the area around Horta de Ebro, painted in 1909 and declared by Gertrude Stein to be the first examples of Cubism, were inspired by both Cézanne's example and his own Catalan nationalism.[45] For Picasso's friend, Guillaume Apollinaire, all art was inescapably national. This influential apostle of modernism believed art always expressed "a milieu, a nation," and that artists were inevitably the products of their environments. "Art will only cease being national," he wrote, "the day that the whole universe, living in the same climate, in houses built in the same style, speaks the same language with the same accent—that is to say, never."[46]

MacDonald and his friends wished to produce a "distinctly Native art" that could do for Canada what Cézanne's self-conscious *provençalisme* did for his homeland, or Picasso's paintings for the hilly Catalan landscape. They hoped to produce works that would be both artistically audacious and (in the old phrase beloved of cultural nationalists everywhere) "racy of the soil."[47]

Whether the public and the critics would show any "receptivity" and support for these painters was still an open question. But Jackson at least paid heed to the injunctions of MacDonald and the blandishments of Harris and MacCallum: by the end of the year he had decided to remain in Toronto rather than follow the path of so many other artists south to New York.

9 RITES OF *PAYSAGE*

LAWREN HARRIS AND Dr. MacCallum had another idea, besides their sponsorship of A.Y. Jackson, about how to kindle the "sacred fires" of Canadian art. In the autumn of 1913, construction began on a three-storey brick and concrete building on Severn Street, a few hundred metres east of Yonge and Bloor, on the southwestern-most fringe of Rosedale, one of Toronto's most affluent neighbourhoods. "The Studio Building for Canadian Art," as it was known, would offer workspace, and even some limited living quarters, for at least six artists. Harris paid more than three-quarters of the building costs, with MacCallum contributing the rest. The total layout, including the land, was $60,000. It was an enormous sum considering that the average assessed value of a house in Toronto at the time was $1,600.[1]

With fourteen-foot-high ceilings and six north-facing windows, the Studio Building was intended as a Toronto version of the hospitable and inspiring MacCallum cottage on West Wind Island. It was designed by Eden Smith, the architect of Harris's new home on Clarendon Avenue. Smith was a co-founder in 1903 of the Arts and Crafts Society of Canada and, since his arrival in Toronto from England in the 1880s, one of the country's leading architects. Dozens of his stylish Arts and Crafts houses, occupied by barristers, businessmen and

The Studio Building, Toronto, c.1950
Photographer: Charles McFadden, National Gallery of Canada Archives, Ottawa

university professors, adorned the city's boskier neighbourhoods, such
as Wychwood Park, the artistic community where he had built his
own home.[2]

The hallmarks of Smith's usual William Morris–inspired style—
dormers, hipped roofs, multi-paned sash windows—were largely
absent from the more utilitarian Studio Building. A visiting journalist
described it as a "factory-looking building."[3] The premises nonethe-
less showed the pervading influence of the Arts and Crafts ideal of a
cooperative community.[4] Its name and purpose furthermore revealed
familiarity with the Tenth Street Studio Building in New York, a
three-storey structure opened in 1858 and still offering studio space
to artists in 1914. New York's Studio Building had housed prominent
American painters such as Winslow Homer and William Merritt
Chase, as well as Canadians like Horatio Walker. It had provided win-
ter quarters for many landscapists, from the Hudson River School to

American Impressionists, who in the summer flocked to the Catskills or the Connecticut coast in an attempt to create a distinctively American idiom.

The Studio Building's Toronto counterpart (whose originators scrupulously avoided all reference to their model in New York) was aimed at creating a uniquely Canadian style of art, or what Harris was later to call "a modern conception which suited this country."[5] The Studio Building, Canadian-style, would therefore become (as Jackson wrote) "a lively centre for new ideas, experiments, discussions, plans for the future and visions of an art inspired by the Canadian countryside."[6] Visions of art inspired by the Canadian landscape were an important criterion for anyone hoping to claim one of the six studios, since Harris specifically reserved space "for artists doing distinctly Canadian work."[7]

THE STUDIO BUILDING filled with tenants as soon as it opened in January 1914. Jackson and Tom Thomson began sharing an atelier on the ground floor, splitting the monthly rent of $22. Two more studios were occupied by MacDonald and Harris himself.

Some of the other occupants likewise had an interest in northern landscapes. One of them, forty-four-year-old Bill Beatty, was a friend of both Harris and MacDonald. Although he, like Jackson, had spent much time studying and painting in Europe, he was a brawny outdoorsman heralded as the first to "attempt to paint into this northern wilderness the quality of its trackless immensity."[8] An adolescent during the 1885 Riel Rebellion, Beatty went west to Batoche as a bugler in the 10th Royal Grenadiers. Afterwards he worked as a house painter and firefighter, astounding co-workers at the Hook and Ladder Company of the Lombard Street Firehall with feats such as sliding headfirst down the brass pole or with a man clinging to his back. Following his return from his studies in Europe in 1909, he painted with Harris in the Haliburton Highlands and a year later travelled with Tom McLean to Fort Mattagami on the Abitibi River. Since 1912 he had been teaching, like Arthur Lismer, at the Ontario College of Art.

Another occupant of the Studio Building, forty-three-year-old Arthur Heming, known as "the chronicler of the north," also seemed

to fit the bill as a combination of artist and outdoorsman. As a youth in Hamilton he was a prodigy at lacrosse, football, rowing and wrestling. His first trip into the Canadian wilderness, at the age of sixteen, was followed over the next two decades by more than a dozen treks through the northlands. He even crossed the Rockies with a Royal Northwest Mounted Police pack train. According to his own meticulous accounting, he had chalked up 550 miles by raft, 1,100 miles by dog sled, 1,700 miles on snowshoes and 3,300 by canoe. Legend had him pitching teepees, knocking together rafts and toboggans, even harpooning whales. Augustus Bridle viewed him with exhilarated reverence. He celebrated him in a 1912 *Toronto Globe* article: Heming had "seen more," boasted Bridle, "and found out more about the wild life and the outpost edges of the Canadian north than any other artist or writer alive."[9] The article was illustrated with a photograph of Heming striding through the snow, a slit-eyed lynx cap on his head and a rifle in the crook of his arm. Those who met this husky-mushing, pemmican-munching paragon of northern get-up-and-go were invariably surprised to find him extremely "citified" and "curiously over-refined"—for Heming was fastidious to the point of prissiness and (according to one observer) a "popinjay."[10]

Although he "disdained social life" and "arty circles," Heming was a member of the Arts and Letters Club.[11] It was probably there that he came to know Harris, who in 1911 praised his paintings for the "masterly way" they captured the "mystery and bigness" of the North and the "cold crispness" of its snow.[12] This was to err on the side of generosity. The (literally) colour-blind Heming's outdoor scenes of Canadiana were traditional in execution and similar in subject matter to the northern adventure stories of Robert M. Ballantyne or J. Macdonald Oxley: square-jawed Mounties collaring renegades, fur-hatted hunters taking beads on their quarries.

Heming first made his reputation with illustrations for James Williams Tyrrell's 1897 classic of northern travel literature, *Across the Sub-Arctics of Canada: A Journey of 3,200 Miles by Canoe and Snowshoe through the Barren Lands*. He was also a writer and in 1907 illustrated his own novel, *Spirit Lake,* based on his travels near Hudson Bay. "It was generally believed that Heming knew more about the

Arthur Heming, 1912

Photographer: M.O. Hammond, Archives of Ontario, F 1075-16-0-0-80

north country than anyone else in Canada," Jackson later wrote, "and Harris hoped he would inspire a northern movement." He added, "I do not remember that he ever mentioned the north country or expressed a desire to go there."[13] Some of Heming's hardbitten northern exploits undoubtedly erred on the side of myth, but Jackson's observation showed his wish to claim for himself and his friends the role of pioneers of the Canadian north. There is no doubt that, however

dandified his appearance, Heming saw vast tracts of northerly Canadian latitudes long before Jackson.

The final atelier was taken by someone with, at first blush, slightly less impressive credentials for doing "distinctly Canadian work." Curtis Williamson, born in the year of Confederation, was the portrait painter known as the "Canadian Rembrandt" for a dark and moody tonal style he had developed in Holland. In this sense he made a strange studiomate for Jackson and Harris, considering their antipathy towards the Hague School. But Williamson had travelled and painted the coast of Labrador, returning with works that, according to one writer, "struck the Scandinavian note."[14] His place in the Studio Building may also have been assured thanks to his close friendship with Dr. MacCallum, who had fast become one of the driving forces in Canadian art.

That the Studio Building was meant to give Canadian painters a place in which to depict their country—and to gain what Harold Mortimer-Lamb had called the "power of insight" demanded by the Canadian landscape—was affirmed in an article printed in the *Toronto Daily Star* several weeks after the building opened. According to the writer, in a piece called "Where Artists Work by Northern Lights," it was a venue for painters to produce "pictures which partake of the larger, bigger feeling which abounds in Canada—conveying to the minds of people something broader, grander, more noble, even, of the aspects of life which come to artists who are permeated with the virility and enthusiasm of the freer atmosphere of a new country—freed from the conservatism and staid ways of older countries of Europe."[15]

Within these walls, the band of painters—what Beatty called "men with good red blood in their veins"—would flex their artistic muscles and begin to create their "virile" interpretations of the Canadian landscape. They would make, as Beatty confidently predicted, "the future of Canadian art."[16]

IF A MUTUAL shortage of funds originally prompted them to share a ground-floor atelier in the Studio Building, A.Y. Jackson and Tom Thomson soon discovered they had much else in common.

The two men first met in the late autumn of 1913, after Thomson returned from his latest expedition into the bush. He had spent the summer canoeing through Algonquin Provincial Park and then working as a fire ranger north of Biscotasing on the Mattagami Reserve, the area through which Neil McKechnie and Tom McLean canoed in the summer of 1904 when they too worked as fire rangers.

Thomson was probably drawn to this particular area of Ontario in part because one of his sisters lived in Timmins and also because Lawren Harris and Bill Beatty went there in 1910. But he almost seemed to be following the trail of the doomed McKechnie, born in the same year, 1877, and celebrated as a "real Canadian" who captured the "granite-ribbed" wilderness and the "mystery of the North."[17] Thomson probably never met McKechnie, but his memory was kept alive in Toronto almost a decade after his death. He lay buried near Gogama, southwest of Mattagami Lake, beneath a wooden cross designed by friends who included J.E.H. MacDonald. His remote and primitive burial (a newspaper reporting his death described the impossibility of finding "even a plain deal coffin within 200 miles of the scene of the disaster")[18] probably inspired Duncan Campbell Scott to compose "Night Burial in the Forest." Scott, who travelled to Mattagami Lake the year after McKechnie's death, described the inhumation of a young man "in his secret ferny tomb" in the middle of a mossy forest.

Thomson evidently decided that his artistic destiny, like McKechnie's, lay along these same lakes and rivers. But although he had found a subject in Ontario's forested regions, he still needed a personal style—what Harris called a "modern conception"—with which to capture the wild vitality of the Ontario northlands. Help was fortuitously at hand.

Like Jackson, Thomson became a beneficiary of Dr. MacCallum's patronage. The ophthalmologist made Thomson the same offer: he would underwrite his expenses for a year as he concentrated on his work. But if MacCallum was impressed with Thomson's skills, Jackson was not. He found his paintings, he later claimed, sombre and colourless. Thomson's hesitancy and lack of chromatic panache were hardly surprising. He was the least experienced and most untutored of the painters in the "northern movement" being fostered by Dr. MacCallum

and Lawren Harris. Apart from his classes from William Cruikshank, he had not studied in a recognized school or academy, nor had he visited Europe or had the opportunity to see, except in reproduction, works of art by modern masters such as Cézanne, Gauguin or Matisse.

The only place Thomson might possibly have been exposed to international artistic trends was in Connecticut. The art colony based at Florence Griswold's boarding house in Old Lyme, on the Connecticut coast, was the most famous in America. The first art colony in the United States to experiment with Impressionism, it was founded in 1899 by Henry Ward Ranger, who worked in muted tones and hoped to create an "American Barbizon." The colony, however, soon came to be dominated (after his arrival in 1903) by Childe Hassam. Painting in bright colours and occupying a shack-like studio christened "Bonero Terrace," Hassam turned Old Lyme into an "American Giverny." Arthur Heming had been a member of the "School of Lyme" for much of the previous decade, spending each summer there between 1902 and 1910. By about 1907 another member of Old Lyme's art colony was Tom Thomson's older brother George, who had sold his share in the Acme Business College and moved from Seattle to New York to study under Frank Vincent DuMond at the Art Students' League. Each summer, DuMond taught outdoor painting classes in Old Lyme, and in 1907 George's *Lyme Pastures* was accepted at the National Academy of Design's annual exhibition in New York. Since 1908 he had been living in New Haven, fifty kilometres west of Old Lyme.

If Tom Thomson visited his brother in New York or Old Lyme, he left no trace: Heming mentions neither George nor Tom in his memoir of Old Lyme. Still, it almost seems inconceivable that Thomson should have followed his brother across the continent to Seattle but not made the much shorter journey to Connecticut. If he did visit the art colony, the impact on his painting was limited. By 1913 his land- scapes revealed none of the splashy colour or animated brushwork of Old Lyme's resident American Impressionists—but nor, for that matter, did the work of either Heming or George Thomson.[19]

Jackson, by contrast, had already absorbed numerous influences during his travels. His exposure to European art, both Old Masters

and the avant-garde, was extensive. He was also steeped in modern painting theories and techniques. Much of this exposure came through his dedicated—almost maniacal—extramural efforts. As a young art student in Chicago and then Paris, he had been desperate to learn the technique of painting. "I must learn to paint or my name is mud," he wrote to his mother from Paris in 1908. Since he was taught painting and colour theory at neither the Art Institute of Chicago nor the Académie Julian, he knew that to become what he called a "paint-slinger" he needed to read as many books and magazines, and to attend as many art exhibitions, as possible. He became an artistic omnivore, gourmandizing on lectures, exhibitions, books, periodicals and, presumably, conversations with other students. In Chicago he went to the library of the Art Institute and "read all the magazines," even telling his mother of his plan to spend the 1906 Christmas holidays in the library, "where they have all the Art Magazines and books on art that you could wish for."[20]

In Paris these studies continued unabated. Jackson joined the American Art Association of Paris (the headquarters of English-speaking art students) because "it's the cheapest way of seeing all the art magazines. Besides they have quite a library." He soon buried himself in a "big, long serious" book on the history of art. He also visited numerous art museums and attended multiple exhibitions (on a quick trip to London in 1908 he visited five museums in two days). "My painting is still pretty punk," he complained to his mother in 1908, before announcing he was off to see the Franco-British Exhibition— "one of the finest art exhibits ever brought together." Four years later, "Have been seeing lots of exhibitions," he wrote breathlessly from Paris, "which is very necessary."[21]

118 EVIDENTLY RECOGNIZING THE sheer raw talent of his studiomate, Jackson began tutoring Thomson in the first weeks of 1914. Clearly the two men got along on a personal level. Jackson called Thomson "a good companion" and "a friendly chap."[22] He even invited Thomson to accompany him on visits to a family friend, Christina Bertram, the widow of a wealthy Toronto industrialist. Mrs. Bertram, a patron of the

arts, lived in La Plaza Apartments at the corner of Charles and Jarvis, a short walk from the Studio Building. She fed the two men and mended their clothing. They gave her some of their sketches in return.[23]

Thomson no doubt realized there was much to be learned from his self-confident new studiomate. Jackson began describing to Thomson some of the trends in modern art, in particular the techniques of the Neo-Impressionist painter Georges Seurat and his use of what Jackson called "clean-cut dots of colour."[24] Seurat and his followers took up the optical theories of scientists such as the American Ogden N. Rood, a physicist (and part-time painter) who believed that light was the product of an oscillation of adjoining colours. The Neo-Impressionists (as an 1886 review christened them) abandoned broad, blended strokes to apply their paint in separate dots or dashes of unmixed pigment (the "clean-cut dots") in the belief that the mosaic-like blobs would blend in the eye of the viewer to produce pulsatingly vibrant canvases.

Jackson had first-hand experience of these works. Besides the exhibition of the Italian Divisionists, he probably saw the Seurat exhibition in December 1908 at the Galerie Bernheim-Jeune, which featured one of his most famous works, *A Sunday on La Grande Jatte.* He could likewise have seen the work of Seurat's disciple Paul Signac at numerous Paris exhibitions, such as one at the Galerie Druet in the summer of 1911 that included paintings by another Neo-Impressionist, Henri-Edmond Cross. By this time, Cross and Signac, in search of more expressive powers, had enlarged their dots and begun using coarser, thicker brushstrokes to create separate squares of colour—what Signac called a "divided touch" and an English critic "large brick-like rectangles."[25] This broader and looser touch, sometimes known as the second phase of Neo-Impressionism, was the ne plus ultra of Parisian painting at the time of Jackson's first sojourn in Europe.[26]

Thomson not only heard about various new trends in European art, but he also saw his new studiomate in action. The two men were probably first introduced in Harris's studio at Bloor and Yonge in November 1913, at the time when Jackson, using sketches done on Georgian Bay, was painting *Terre sauvage,* one of his first important canvases (see plate 10). Thomson would therefore have seen

taking shape on Jackson's easel something very different from many of the "second-rate paintings" on show each summer at the Canadian National Exhibition.

In *Terre sauvage* (initially known as either *The North Country* or *The Northland*), Jackson worked the Shield landscape that he once believed resistant to pictorial composition into a haunting vision of backwoods remoteness: black spruce rising above a foreground of Precambrian rock into a steel-blue sky. These rocks and trees became the building blocks of his artistic experimentation. Georgian Bay's sharp colours, smooth contours of granite and statuesque vegetation allowed him to explore elements of the new styles he had seen in Europe. His determination to paint in this manner, despite his lack of sales and the vociferous attacks in Montreal, showed both his strength of character and the value of the support established by MacCallum and Harris. He continued working in the Hot Mush style, using a bold palette and simplified but expressive forms, such as distended trees and swirls of cloud.

The final title of the painting (adopted in 1920) seems to allude to the "eerie wildernesses" described by the Confederation poets—the hostile and untamed land of forest and snow beyond the bounds of civilization. Yet *Terre sauvage* is no straightforward depiction of the harsh Canadian barrens. Topographical veracity was less important to many modern painters than emotional values and visual effects. "Sitting down in nature and copying what you see is not the way to make a painting," Signac once cautioned.[27] If the Impressionists tried to give objective depictions of the natural world by means of an almost scientific study of the chromatic effects of light and shade, by the end of the nineteenth century their successors—the "paint-slingers" whose work Jackson so admired—were freely manipulating the visual data of the landscape. The process was described by Matisse's friend Simon Bussy: "I draw from nature the elements necessary to my composition, I reassemble them, I simplify them . . . I transform and twist them." Unlike the Impressionists, Bussy was not concerned to render effects of light and atmosphere. He sought instead, he claimed, "the equilibrium of volumes" and "the rhythm of lines."[28]

In *Terre sauvage,* Jackson ignored atmospheric effects and deliberately distorted the forms of the landscape. That he was not merely transcribing the scene as he actually saw it can be seen from the fact that he did not paint the sky beneath the rainbow darker than that above—the well-known meteorological phenomenon shown in Joseph Wright of Derby's 1795 painting *Landscape with Rainbow.* In Jackson's painting, the swell of the earth and the arrangement of the trees have little to do with arboreal precision or the rules of single-point perspective. The warped-looking jack pine, the indistinct foreground, the weirdly elongated spruce that recall the flame-like cypresses in Van Gogh's 1889 paintings such as *A Wheatfield with Cypresses* and *The Starry Night*—together with the rainbow on the left, these dreamlike effects show Jackson translating the raw data of nature in order to communicate aesthetic emotions. The result is a unique and personal vision of the "primal energies and realities" beyond the physical world of rocks and trees.

THE STUDIO BUILDING quickly became a smaller and more exclusive version of the Arts and Letters Club, a place for lively exchanges of opinion. According to Jackson, "There was the stimulus of comparison and frank discussion on aims and ideals and technical problems which resulted in various experiments."[29]

Lawren Harris was inevitably at the centre of these discussions. He was painting his own experimental work as Jackson worked on *Terre sauvage.* Using a sketch of fire-swept hills done on a trip to the Laurentians with Fergus Kyle five years earlier, he began a canvas nicknamed "Tomato Soup" by the others because, Jackson claimed, he would drag his brush through several pigments and then "slap it on the canvas" in hopes of achieving vibrant colours.[30] The actual process was probably more measured, since the end result, *Laurentian Landscape,* made use of a technique known (after its inventor Giovanni Segantini) as the "Segantini stitch." Segantini had adapted Seurat's brushwork in the 1890s to create narrow, stitch-like hatchings that gave his Alpine landscapes a moiré effect, like a phosphorescent tweed.

121

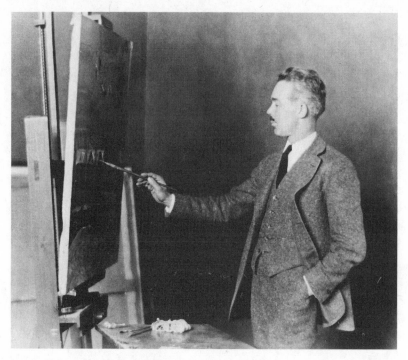

Lawren Harris in the Studio Building

Where exactly Harris learned this technique remains unclear, but before his premature death from peritonitis in 1899 Segantini had been one of the most famous painters of his day (Austria, Italy and Switzerland all claimed him as their own). An English catalogue of his works was published in 1901, and leading journals such as *International Studio, Scribner's* and *The Artist* carried studies and reproductions of his paintings. Americans such as Marsden Hartley (who saw Segantini's work reproduced in the January 1903 issue of *Jugend*) revealed his influence. Harris could easily have learned about Segantini through this kind of "graphic traffic" (as art historians call such exchanges of images), and it is likely that he also heard about him from Jackson. Thirty-seven of Segantini's works had gone on display at the Italian Divisionist exhibition seen by Jackson in Paris in 1907.

Segantini probably held a special fascination for Canadians like Harris, Jackson and Thomson, obsessed as they were with painting

remote locations in inclement weather. Living in a hut high above St. Moritz, he had painted the surrounding mountains in the most bitter conditions, wearing furs in winter and even a custom-made body-warmer, a tin-plated receptacle filled with hot coals. This kind of performance—which won him a reputation as a kind of Nietzschean Superman—was bound to appeal to the "men with good red blood in their veins" searching for virile interpretations of their own rugged landscape.[31]

TOM THOMSON MAY still have had, as an acquaintance later claimed, a "disbelief in himself," "fits of unreasonable despondency" and an "erratic and sensitive" temperament.[32] But his faith in his abilities as an artist began to grow under the tutelage of Jackson and Harris. One indication of his growing self-confidence was the fact that in February 1914, within a month of moving into the Studio Building, he chose to exhibit five paintings in the exhibition *Little Pictures by Canadian Artists* staged in the Public Reference Library.

The annual *Little Pictures* exhibitions were inaugurated a year earlier. According to a report in *The Studio,* the aim was to popularize the work of younger painters "in the homes of middle-class citizens, where wall space is insufficient for the display of large canvases."[33] Middle-class citizens might have had neither the money nor the wall space for the large and expensive paintings of established artists, but the modestly sized and even more modestly priced canvases of little-known painters such as Thomson (whose price tags at the exhibition ranged from $20 to $25) were within reach of most middle-class Torontonians. His paintings were therefore priced roughly the same as many of the least expensive ones in the picture galleries in Eaton's and Simpsons. In fact the *Little Pictures* exhibition in some ways marked an attempt by Toronto artists to steal a march on the department stores by appealing to much the same clientele.

Thomson's paintings nevertheless failed to sell. Undeterred, he submitted one of his other paintings, a nocturne called *Moonlight,* to the 1914 OSA exhibition. It carried a considerably higher price tag of $150. This canvas showed how his sense of form was sharpening and his technique proving more impetuous as he used staccato

brushwork to capture the effect of moonlight on the broken surface of a lake. A correspondent for *The Studio* praised his work as "striking in treatment," and *Moonlight* was purchased by the National Gallery. Thomson was soon afterwards elected to membership in the Ontario Society of Artists.[34]

There was encouragement for other painters in the Studio Building as well. The "Post-Impressionist" style of the Hot Mushers showed few signs of causing the same hysteria as elsewhere. The *Toronto Daily Star* took a lenient view of the younger painters at the OSA exhibition. "Young Canada," wrote its critic, Margaret L. Fairbairn, was represented by "rising artists" who shocked the conservatives and "the average person" with canvases "covered in daubs of paint apparently put on with a shovel." She urged her readers, "Never mind. Some shocks are extremely beneficial."[35]

Even more rewarding was a review in *The Studio.* The Toronto correspondent for the prestigious international journal reported that under the leadership of A.Y. Jackson, "some six or seven rising men" had begun experimenting with crude form and emphatic illumination in order to evoke the Canadian landscape. He perceptively noted that the painters were following "Norwegian-French protagonists"—that is, their expressive landscapists were redolent of the ateliers of Munch, Cézanne and Gauguin. Pointing out how they used coarse canvas and painted with flat brushes, he claimed the effect of their work was "that of raised embroidery, or *appliqué* work, with sharp contrasts of light and shade and crashing bars of colour."

However enthusiastic he might have been, the critic for *The Studio* was cautious about their chances for commercial success: "Whether this style of painting will become popular," he concluded, "it is impossible to say: anyhow, as a feeling after forcible expression it is worthy of attention."[36]

IF HE WAS the beneficiary of A.Y. Jackson's tutelage, Tom Thomson returned the favour by firing his studiomate's enthusiasm for the Ontario northlands.

Early in February Jackson left Toronto to paint and snowshoe in Algonquin Provincial Park. He would later describe the park as

"hacked up many years ago by a lumber company that went broke. It is fire-swept, dammed by both man and beaver, and overrun with wolves."[37] But, like Thomson, he was exhilarated by these surroundings and the possibilities for painting them. The woods, he wrote to MacDonald, were "full of 'decoratif motifs.'"[38] He remained there for several months, enduring deep snow and frigid temperatures. In the middle of February he wrote to MacDonald from Canoe Lake Station, where temperatures plunging to –45 degrees Fahrenheit meant "all you notice is your breath dropping down and splintering on the scintillating ground."[39] The population of Canoe Lake, he reported, was "eight, including me . . . Our only means of locomotion are snow shoes. There is only one road, to the station a mile away, and it stops there. However, the snowshoeing is good—there are lots of lakes and all frozen, so you can walk for miles on the level. As soon as you get off the lakes you are in the bush, which is very rough, a very tangle of birch and spruce."[40]

For Jackson these stimulating hibernal adversities were all part of what it meant to be a Canadian. "The Canadian who does not love keen bracing air," he wrote to another friend at this time, "sunlight making shadows that vie with the sky, the wooden hills and frozen lakes. Well, he must be a poor patriot."[41] Patriotic love for bracing air and frozen lakes was an essential requirement for a Canadian artist, since the task of Canadian painters was, he now believed, to capture on canvas these wintry effects in remote areas of wilderness. In a letter to Dr. MacCallum from Algonquin Park, he wrote, only half-jokingly, of how the tenants of the Studio Building could forge a new Canadian art simply by taking themselves off to the country's most inhospitable and far-flung regions: "Heming up in the Barren Lands. Thomson West of Ungava. MacDonald Georgian Bay Rocky Island. Beatty Rocky Mountains. Harris those Godforsaken Laurentian Hills. I'll look after the Labrador Coast . . . Then we would have a Canadian School for sure."[42]

A "Canadian School," for Jackson, was linked to explorations of these geographically remote areas of the Dominion. Artists were to be latter-day versions of Champlain and David Thompson, armed with canvases and brushes in place of maps and compasses, the value

of their art measured in degrees of latitude and Fahrenheit. He was apparently unaware that all these isolated domains and many more besides had already been painted with no sign of a Canadian School developing. The Labrador coast for which he jocularly volunteered himself had been painted fifty years earlier by William Bradford and more recently by Curtis Williamson—but their sealskin-and-snowshoe expeditions had not produced anything approaching a distinctly Canadian school of painting (and anyway the Labrador coast was not even part of Canada: it belonged to the self-governing Dominion of Newfoundland).

Jackson's belief that reaching and then painting these far-off regions could create a national school is all the stranger considering how these lands were hardly *terrae incognitae* to most Canadians. They had already been interpreted countless times, not only in pigment but also in literature (not least by Arthur Heming) and more recently through the new medium of moving pictures. Over the previous decade virtually every region of Canada had been captured on celluloid and then flickeringly played back in nickelodeons (of which Canada already had more than a thousand). It must have been difficult to venture far into the Canadian wilderness without bumping into filmmakers wielding hand-cranked cameras in front of waterfalls or beside frozen lakes. The country's entire geography was mapped in the silent-picturegoer's imagination—everything from the Canadian Bioscope Company's rendering of Nova Scotia in 1913's *Evangeline* and the Vancouver Island of Edward S. Curtis's 1914 six-reeler *In the Land of the War Canoes,* to the barren lands in the Edison Company's 1911 *Eskimos in Labrador.*

Merely dogsledding or snowshoeing into the wild, then hunkering down to paint ice floes or pine trees, would not be enough. A new vision, a new technique, was required. The most promising prospects for the development of a Canadian School were, as the critic for *The Studio* had noted, the techniques of the Continental avant-garde that Jackson had used to such striking effect in *Terre sauvage*—a work that owed as much to the galleries and ateliers of France as it did to the bracing air of the Canadian barrens.

AS JACKSON POINTED out, Algonquin Park, with its beaver swamps and swaths of clear-cut timber, was by no means conventionally beautiful or even, in many parts, particularly majestic. But such was Tom Thomson's enthusiasm that in 1914 the park became the rural centre of operations for the new Canadian School, the "men with good red blood in their veins" based in the Studio Building.

If the studios were intended for distinctly Canadian work, then the "Canada" most of the artists had in mind was Ontario's Shield country. Its granite outcrops and krummholz-formation pine trees were easy to see as the markers of a uniquely northern landscape different from the lusher and gentler countrysides of France, England or even southern Ontario. Rupert Brooke had found southern Ontario—"rolling country, thickets of trees, little hills green and grey in the distance, decorous small fields"—almost indistinguishable from rural England.[43] But clearly something more singular met the eye as one ventured into the spruce-and-moose hinterland of the boreal forest.

A journey north on the Grand Trunk Railway therefore became a rite of *paysage* for Canadian artists. In March Jackson was joined in Algonquin Park by J.E.H. MacDonald and Bill Beatty. The Toronto press soon began making reference to an "Algonquin Park School."[44]

Late in April 1914, with snow still on the ground, Thomson returned to Canoe Lake. He took up residence, as in the previous two years, at Camp Mowat, the former boarding house of the Gilmour Lumber Company that had recently been expanded and rechristened "Mowat Lodge." As soon as the snow melted, Thomson moved out of the lodge and into his tent. He camped in a grove of birch trees next to a pile of lumber nearby the disused mill, a red-brick structure with a galvanized iron roof. Here, equipped with Hudson's Bay Company blankets, cooking pots and a sack of flour, he lived in a tent with his painting equipment and his sixteen-foot Chestnut canoe at the ready. A visitor to Canoe Lake in 1914 recalled how he looked like a woodsman in his mackinaw trousers.[45] There was, however, a touch of flamboyance and profligacy amid this scene of rusticity. He painted his canoe a distinctive blue-grey, achieved by mixing into the standard grey canoe paint a brilliant cobalt blue—an expensive pigment costing $2 per tube.[46]

127

Thomson had become a well-known figure to the sparse inhabitants at Canoe Lake. "It appears that Tom Thomson is some fisherman, quite noted round here," Jackson wrote to MacDonald in February.[47] Well acquainted with several of the park rangers, Thomson had also become friends with Shannon Fraser, the freckled, red-haired proprietor of Mowat Lodge who also served as Canoe Lake's postmaster. Thomson was often drafted into service to patch the roof of the boarding house, plant vegetables or even dry the dishes for Fraser's wife, Annie. He further made himself useful by performing services for other guests at Mowat Lodge, such as carving oars for them and catching the fish that Annie Fraser then cooked for dinner.[48]

Besides his angling, Thomson also developed a reputation for eccentricity. Passing railwaymen were puzzled by the sight of him dabbing paint on bits of board ("What kind of thing is that?" asked an incredulous section foreman when informed that Thomson was an artist). Other visitors to the area sometimes saw him sitting above a rapids near Joe Creek, staring dreamily at the sky and occasionally tossing a rock into the rushing water. Once a young woman staying at the Algonquin Hotel expressed an interest in what she called the "strange-looking chap" who haunted the area. Despite the fact that the guest was, according to the ranger Mark Robinson, "rather an attractive looking lady . . . bright, intelligent in every way," she failed to make a conquest. "I've spoken to him two or three times," she explained in exasperation to Robinson, "and he won't as much as look my way or answer." Robinson himself sometimes encountered Thomson staring so intently at a pine stump that he "never looked sideways at me or anything" when the ranger greeted him.[49]

Robinson's wife found such behaviour "slightly demented," but at other times, Robinson stressed, Thomson could be "all smiles" and "as nice . . . as you could wish him to be, in every way." One of his most characteristic traits was generosity with money. A fellow Grip employee, Stanley Kemp, once claimed Thomson "would share his last dollar with a friend in need."[50] One beneficiary of this kindheartedness was a boy in Kearney, a small logging town north of Huntsville. Before returning to Toronto in the late autumn of 1913,

Thomson had gone into Kearney for a haircut when he noticed a boy with holes in his rubber boots. According to Robinson, he proceeded to buy the boy not only a new pair of boots but also stockings, mittens, a knitted toque, underwear and, for good measure, a whole new suit of clothes. "Go home and tell your Dad you met Tom Thomson," he instructed the newly outfitted child.[51] The reference to himself in the third person suggests something of his secret ambitions.

THOMSON HAD BEEN at Mowat Lodge for several weeks in the spring of 1914 when Arthur Lismer arrived from Toronto for a canoe and sketching excursion. Although Lismer was not a tenant of the Studio Building, his passion for the "happy isles" and his friendship with Thomson were enough to have him counted among the red-blooded men among whom there was, according to Bill Beatty, a "bond of sympathy."[52]

The Englishman was met by Thomson at the train station. If he was collected by the macabre form of transport with which Fraser usually greeted visitors—a black carriage, purchased from a local undertaker and known as "The Hearse"—he failed to mention it.[53] The pair spent the night at Mowat Lodge before setting out the next afternoon in Thomson's canoe, laden with supplies: a pup tent, blankets, food for several weeks, a reflector oven, plates and utensils, an axe, fishing tackle and, not least, as Lismer wrote, "sketching impedimenta, this last consisting (for me) of two dozen $12\frac{1}{2} \times 9\frac{1}{2}$ three-ply veneer boards."[54] When fully laden, the canoe's gunwale cleared the waterline by a dangerously scant three inches.

The two men camped on Molly's Island on Smoke Lake before making excursions through the maze of pine- and boulder-fringed waterways, passing through Ragged, Crown and Wolf lakes; altogether they spent some three weeks under canvas.

Thomson's other companions in the bush, Harry Jackson and Will Broadhead, seem not to have held his bushcraft in any regard. Lismer, though, was hugely impressed—in retrospect, at least—by Thomson's abilities. He was later moved to describe his friend's skills in the most hyperbolic terms: "He saw a thousand things—animals and birds,

Arthur Lismer and Tom Thomson, Algonquin Park, May 1914
Photographer: H.A. Callighen, McMichael Canadian Art Collection Archives

and signs along the trail that others missed. He knew where to find subjects—a stretch of muskeg, a fine stand of pine with possibilities for the kind of thing he wanted to paint. He could drop a line in places, and catch a fish where other experienced fishermen failed. He identified a bird song, and noted changes in the weather. He could find his way over open water to a portage of a camp on a night as black as ink." These astute powers of observation—his "sense of awareness and significance of simple sights"—served Thomson well when he sat down at his easel, because his "uncanny sensitivity carried over into his paintings and sketching."[55]

Lismer was exaggerating Thomson's affinity with nature in the interests of myth. Even so, the acute observation of the natural world required by a good woodsman or fisherman no doubt paid dividends when Thomson put down his fishing rod and took up his paintbrush. Many of his landscapes were sketched on the banks of lakes or rivers,

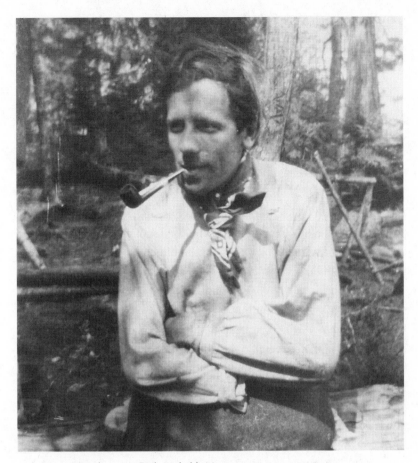

Arthur Lismer in Algonquin Park, probably May 1914

Gift of Marjorie Lismer Bridges, McMichael Canadian Art Collection Archives

in spots where he might have fished as easily as he painted. But he was at least as well served in his art by his astute observations of Jackson's Hot Mush technique and Lismer's own accomplished *plein-air* style. Following the example of Beatty and Jackson, he fashioned himself a variant of the kind of field easel used by French painters, notably the Impressionists, for carrying art supplies on their outdoor sketching trips. Like theirs, Thomson's box-easel served as a palette, a small easel and a place in which to separate and store his finished sketches. Working on small canvases as well as boards, he began

using freer brushstrokes than a year earlier, applying his paint thickly and unevenly, sometimes allowing the weave of the canvas to show through his brusque strokes.

Thomson also extended the range of his palette at this time. In one of his sketches, *Larry Dickson's Shack,* a painting of one of the rangers' cabins, swabs of cerulean appear in the sky, with sapphire and pale-blue shadows stretching across the snow. His approach to the wilderness likewise altered. Lismer taught him to turn his panel 90 degrees and paint the scene before him—as he himself was doing in sketches such as *Tom Thomson's Camp*—in a portrait rather than a landscape format. Thomson abandoned his earlier distant and murky panoramas in favour of close-ups of enclosed spaces, as though he was becoming ever more intimate with the landscape, observing it more minutely and painting it in more forceful detail.

One of Thomson's sketches, done before Lismer's visit, showed a continuing interest in panoramas as well as his "uncanny sensitivity" to the landscape. At some point in the early spring he had travelled to the Petawawa River, in the northeastern corner of the park. Here, standing on the bank beside a rapids, the river swollen and broad before him, he painted the spring breakup and, in the distance, the monumental forms of the Petawawa gorges. With its stratifications of water, land and sky, the composition was not much different from the work he did two years earlier on the Mississagi River—but the assertive brushwork and innovative use of colour showed exactly how far he had come. Called *Petawawa Gorges,* the sketch was signed in the mauve-coloured paint he had used in the shadows of the gorge. Thomson himself was beginning to come out of the shadows, ready to take his place at the forefront of Canadian art.

PLATE 1 | LAWREN S. HARRIS
(Canadian, 1885–1970)
Houses Richmond Street, 1911
oil on canvas, 61.1 × 66.6 cm

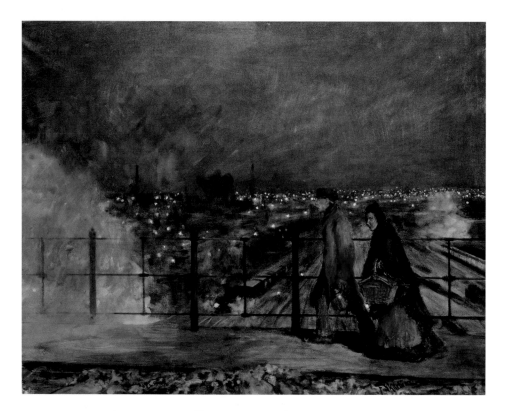

PLATE 2 | FRANZ SKARBINA (German, 1849–1910)

Railway Tracks in North Berlin, 1895

watercolour on paper, 71.7 × 91 cm

Stiftung Stadtmuseum Berlin

Reproduction: Hans-Joachim Bartsch, Berlin

PLATE 3 | LAWREN S. HARRIS (Canadian, 1885–1970)
The Eaton Manufacturing Building, 1911
oil on canvas, 76.2 × 75 cm
Private Collection

PLATE 4 | J.E.H. MACDONALD (Canadian, 1873–1932)
Tracks and Traffic, 1912
oil on canvas, 71.1 × 101.6 cm
Art Gallery of Ontario, Gift of Walter C. Laidlaw, Toronto, 1937

PLATE 5 | LAWREN S. HARRIS

(Canadian, 1885–1970)

The Gas Works, c.1912

oil on canvas, 58.6 × 56.4 cm

Art Gallery of Ontario, Gift from the McLean Foundation, 1959

PLATE 6 | GUSTAF FJAESTAD
(Swedish, 1868–1948)
Winter Moonlight, 1895
oil on canvas, 100 × 134 cm
© the Nationalmuseum, Stockholm

PLATE 7 | A.Y. JACKSON (Canadian, 1882–1974)
Assisi from the Plain, 1912
oil on canvas, 64.7 × 80.6 cm
Art Gallery of Ontario, Purchase, 1946

PLATE 8 | A.Y. JACKSON (Canadian, 1882–1974)
The Edge of the Maple Wood, 1910
oil on canvas, 54.6 × 65.4 cm
National Gallery of Canada, Ottawa

PLATE 9 | A.Y. JACKSON (Canadian, 1882–1974)

Autumn in Picardy, 1912

oil on wood, 21.2 × 27 cm

National Gallery of Canada, Ottawa,
Gift of members of the Arts & Letters Club, Toronto, 1914

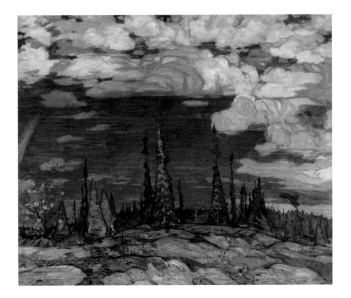

PLATE 10 | A.Y. JACKSON (Canadian, 1882–1974)

Terre sauvage, 1913

oil on canvas, 128.8 × 154.4 cm

National Gallery of Canada, Ottawa, Acquired 1936

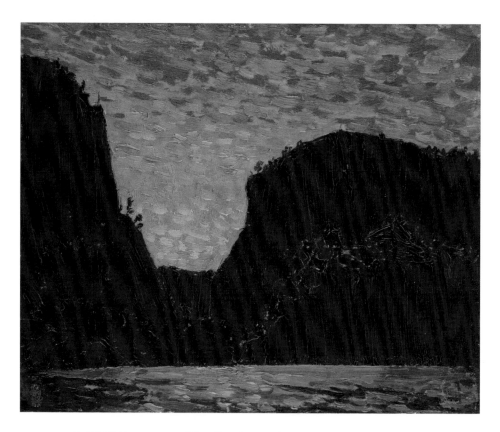

PLATE 11 | TOM THOMSON (Canadian, 1877–1917)
Petawawa Gorges, Night, fall 1916
oil on wood, 21.1 × 26.7 cm

10 THE YOUNG SCHOOL

IN THE SUMMER of 1914 the Studio Building for Canadian Art entertained a distinguished visitor. Sir Edmund Walker was, in the words one admirer, "a tall majestic figure, alert and radiant, with far-seeing kindly blue eyes, ample grey beard, and well-cut clothes."[1] The sixty-five-year-old Sir Edmund was president of the Canadian Bank of Commerce and one of the wealthiest and most powerful men in the country.

Sir Edmund was also a man of culture and learning. He lectured on Italian art at the University of Toronto, on whose board of governors he presided as chairman. His influence and patronage were decisive in the founding of the Mendelssohn Choir, the Royal Ontario Museum and the Art Museum of Toronto. He was a collector of discerning if predictable tastes. His skills as a connoisseur were honed, according to legend, in his first job: spotting counterfeit bills at his uncle's bureau de change in Hamilton. Long Garth, his elegant residence on St. George Street, had fine collections of etchings, bronzes, ivories and more than a thousand Japanese woodblock prints. It featured murals by the Canadian artists Gustav Hahn and George A. Reid, along with several hundred European paintings. The collection included works by Dürer and Rembrandt.

Sir Edmund Walker, collector and first president of the Art Museum of Toronto, c.1923

From the original photograph by Ashley and Crippen, ©2010 Art Gallery of Ontario

Sir Edmund visited the Studio Building in his capacity as chairman of the board of trustees of the National Gallery. A short while earlier Lawren Harris had published an angry letter in the *Toronto Globe* decrying the National Gallery's supposed practice of filling its rooms with what he called second-rate European pictures. This policy was detrimental to Canadian painters, he claimed, because it endorsed the "snobbishness" of collectors (he might have had Sir Edmund in mind) who bought only "foreign work." He ended with an angry blast: "Out

of touch, with no sympathy or enthusiasm or any belief in the future of Canadian art save that it ape the past and severely copy European standards, it with its stupid policy is merely helping the dealer to blind the people whom the Canadian artists must depend on for a living."[2]

Harris's letter was overstated and in many respects unjustified. Although Canadian collectors steered clear of Canadian paintings, the same could not be said of the National Gallery. Its director, Eric Brown, had recently written about how Canada had "a strong and forceful art which only needs to be fostered and encouraged in order to become a great factor in her development as a nation."[3] He was making it his business to make certain the National Gallery fostered Canadian art, with particular attention to what he called "the younger men." One of Harris's own works, *The Drive,* had been added to the collection in 1912, and Tom Thomson's *Moonlight* was purchased only weeks earlier. The gallery included works by most Canadian artists of any repute whatsoever, many of them Canadian-themed landscapes. Its confined quarters could boast (to name only a few) Maurice Cullen's winter landscapes *First Snow* and *The Ice Harvest,* Fred Brigden Jr.'s *A Muskoka Highway,* C.W. Jefferys's Prairie landscape *Western Sunlight, Last Mountain Lake,* Marc-Aurèle de Foy Suzor-Coté's *Autumn Landscape, Evening,* Edmund Morris's coastal view *Cap Tourmente,* Horatio Walker's moody rural scene *Oxen Drinking* and Homer Watson's pastoral *A Hillside Gorge.*

Some of these painters might well have been guilty of trying to "ape the past" and imitate European standards. But the accusation that the National Gallery was neglecting homegrown art in favour of European paintings was such a gross exaggeration that one suspects Harris either had not set foot in the Victoria Memorial Museum or else (more likely) he was being deliberately and provocatively disingenuous in the interests of further promoting himself and his friends.

Harris's strident letter produced the effect of luring Sir Edmund Walker—"a strong man with a liking for his own way of doing things"[4]—into the Studio Building. The times must certainly have seemed auspicious for Harris and his fellow "rising men." During the 1911 election campaign, Sir Edmund, as leader of the Toronto Eighteen,

135

had been one of the most powerful and effective opponents of reciprocity. Harris and his friends were protectionists in the art world: they hoped, as the *Toronto Daily Star* reported, to "counteract the effect of the importation of European pictures."[5] Would Sir Edmund now defend and support Canadian painters as he had Canadian businessmen?

The meeting passed cordially and peacefully. Walker proved sympathetic to Harris's arguments. Despite his personal taste for Japanese prints and Old Masters, Walker recognized that the National Gallery needed to collect representative samples of Canadian art. As early as 1909 he had instructed his fellow trustees that they must consider purchasing for the collection works of art "which may not be attractive to us as individuals, but would be fair expositions of the condition of art in Canada."[6] According to A.Y. Jackson, he asked Harris "what all the fuss was about. Harris told him of our intention to paint our own country and to put life into Canadian art. Sir Edmund said that was just what the National Gallery wanted to see happen; if it did, the Gallery would back us up."[7]

Walker must have been by taken aback by the fervency with which the painters expressed a desire to paint their own country, since Canadian landscapes were hardly in any short supply. But he must have been shown some of the paintings that Harris and his friends had recently finished or were executing at the time—works that, like *Terre sauvage* or *Laurentian Landscape,* did indeed show that the tenants of the Studio Building were attempting to "put life into Canadian art" by expressing themselves in a style different from earlier generations of landscapists such as Homer Watson. Although Walker might have little wished to see such works on the walls of Long Garth, he could appreciate the need to put them in the National Gallery.

136

FOLLOWING HIS CANOE expedition in Algonquin Park, Arthur Lismer returned to Toronto, to his job and his domestic obligations, in the third week of May. Tom Thomson, with neither work nor a wife to detain him, remained in Northern Ontario for the rest of the summer. After Lismer's departure he travelled west by train from Algonquin

Park to Parry Sound, at the mouth of the Seguin River. Here, on the eastern edge of Georgian Bay, he continued to pursue the leisure that Dr. James MacCallum's patronage offered him.

Some 240 kilometres north of Toronto, Parry Sound was a bustling port, logging town and railway terminus. It had several sawmills, a shingle mill and two grain elevators built by J.R. Booth. There was also a deep, well-protected harbour for steamships, many owned by the endlessly enterprising Booth. Yet when he sat down with his box-easel on the last day of May, Thomson chose not to record any of this industry and activity. Instead he produced a remarkable sketch, *Parry Sound Harbour,* which showed the more elemental forces of wind and wave. As Thomson knew, Georgian Bay was renowned for its wrathful storms. Wilfred Campbell had written in his guidebook of the "iron surfs" and the "maddened fear" of the waves on this "inhospitable coast."[8] Thomson no doubt knew how tempests in this area had claimed steamers such as the *Waubuno* and the *Asia,* the latter, in 1882, at the cost of more than a hundred lives. The *Asia,* which had set off from Thomson's hometown of Owen Sound, even became the subject of the popular ballad "The Wreck of the *Asia.*"

It was this destructive power that Thomson hoped to capture. The composition of his sketch—horizontal bands of lake and sky in panorama—he had done many times already, but *Parry Sound Harbour* showed evidence of rapid progress as he deployed his new-found skills, texturing his paint to give turbulence and menace to the white-capped water and wind-blown sky. In the bottom right-hand corner, in blood-red pigment, he confidently inscribed his name.

A few days later, after travelling north along Georgian Bay, probably by steamship, Thomson camped with Dr. MacCallum near the delta of the French River. Here the doctor was able to see the latest fruits of Thomson's industry. Unlike Sir Edmund Walker, Dr. MacCallum was hardly a knowledgeable connoisseur. Jackson claimed the ophthalmologist knew astonishingly little about art. His virtue, to Jackson, was that he had a great passion for the Ontario northlands and "looked for the feel of it in pictures."[9] Yet Dr. MacCallum, to his credit, had more advanced tastes than many other collectors, and

Thomson's latest paintings, with their gestural brushwork and exuberant colours, seem to have left him reassured about his decision to fund the artist. He acquired (either then or later) Algonquin sketches such as *Larry Dickson's Shack* as well as both *Parry Sound Harbour* and a sketch Thomson made a short distance from their campsite, *Spring, French River*. Executed on plywood with the same robust brushwork, this latter painting showed a stand of trees, including a twisted jack pine, huddled on an outcrop of rock.

In the past few years, Jackson, Harris, MacDonald and Lismer had all visited Dr. MacCallum's cottage on West Wind Island. In the summer of 1914 it was Thomson's turn to enjoy the doctor's hospitality. He spent much of June and all July at the cottage, canoeing among the islands and making numerous sketches. He gave painting lessons to Dr. MacCallum's ten-year-old daughter, Helen, and presented her with a painting called *Boathouse, Go Home Bay,* one of several sketches he did of the area's numerous summer cottages. She inscribed on the back, "Given to me by Tom Thomson the summer he taught me to paint."[10]

Although the landscape of the "happy isles" appealed to Thomson no less than to Jackson and Lismer, he was less than impressed with his fellow visitors to Go Home Bay. Jackson later wrote that on Georgian Bay everything was still "pretty much as it had been when Champlain passed through its thousands of rock islands three hundred years before."[11] But this was to turn a blind eye to the effects of industry and, especially, tourism. Thomson wrote to Fred Varley in July that the area was "too much like North Rosedale . . . all birthday cakes and water ice."[12] This disdain was evidently for people like Jackson's friends the Clements—affluent urbanites who each summer descended on the "wilderness" for a few weeks of marshmallow roasting and dinghy rowing.

138 Deprived of the guidance of Jackson, Harris and Lismer, Thomson found himself unable to paint.[13] Soon he began yearning for the relative isolation of Algonquin Park, whose deeper reaches were as yet untrammelled by the same kind of tourism and whose landscape offered so much inspiration a few months earlier. At the beginning of July he wrote a letter trying to persuade Varley and his wife, Maud

(who had arrived in Canada the previous summer), to join him for a canoeing and camping excursion. He hoped to be back in Algonquin Park "about a week from today."[14] However, it was not until the beginning of August 1914—when the lamps were going out all over Europe—that he finally set off by himself for Algonquin Park.

THE PRECISE DETAILS of Thomson's remarkable solo voyage—one that has entered the realms of Canadian myth—are vague. He probably took a steamer the hundred kilometres north from Go Home Bay to the French River, from which point he began canoeing and portaging northeast to Lake Nipissing.[15]

This was a daring voyage through mythic waters. Exactly a year earlier Rupert Brooke, struck by the apparent lack of history or habitation as he travelled through this area, wrote that the pools of water and cliffs of rock were "dumbly awaiting their Wordsworth or their Acropolis . . . The air is unbreathed, the earth untrodden."[16] But Brooke was almost as ignorant of Canada as his graceless New York friends. This was by no means a pathless and anonymous wilderness, because these waterways, as Wilfred Campbell had noted, were replete "with history and legend."[17] Thomson undoubtedly knew the histories and legends, not only from reading Campbell but also through discussions with Dr. MacCallum. It was no accident the two men met to camp along the French River, at the spot where Champlain, in search of the sea route to China, had arrived on Georgian Bay. The Madawaska Club was planning celebrations for the three hundredth anniversary of Champlain's voyage, and MacCallum was probably scouting locations for the proposed pageant. Festivities were to include actors rowing a canoe ashore and playing the parts of Champlain, the Hurons and Father Le Caron.[18]

In traversing the 110 kilometres along the French River between Georgian Bay and Lake Nipissing, Thomson was tracing earlier voyages by both the Algonquin peoples and the explorers, fur traders and Récollet friars who followed them. For many years the French River had been part of the main fur-trade route to the Great Lakes, and by the end of the nineteenth century, as lumber replaced fur as a staple, tens of millions of board feet of timber were driven down the river

each year to the sawmills on Georgian Bay. More recently, fishermen had come to the river in search of smallmouth bass and northern pike.

However commercialized, the French River was still undeniably treacherous, especially for a lone canoeist. Passing through the undulating, glaciated granite of the Canadian Shield, it offered stretches of whitewater and sheer cliff. Alexander Henry, navigating the river in the summer of 1761, described "many rapids, full of danger to the canoes and the men."[19] Jennet Roy's *The History of Canada,* published in 1850, reported that beside a single set of its rapids thirteen wooden crosses had been erected "to commemorate an equal number of fatal accidents."[20] It was almost as if in undertaking this foolhardily perilous voyage Thomson was measuring his abilities against all those who had come before him—including Neil McKechnie, the "expert canoeist" and "real Canadian" who had captured the country's savage beauty in paint.

There is probably a good reason why Thomson's solo voyage has become legendary. Besides placing him alongside near-mythical vagabonds of the Canadian wilderness such as voyageurs and coureurs de bois, it gives a uniquely Canadian twist to the age-old myth of the solitary quester, which has been called "the single most pervasive literary plot in western literature."[21] In this myth, the hero, in a time of need, goes forth from his homeland and into an underworld of dangerous wonders. Here he contends against mighty forces and undergoes a series of trials before returning home, armed with special powers that give vitality to his community. Anthropologists and literary historians find this motif everywhere, from Homer and the Bible, to Grail legends and the Native American *hanblecheya,* or vision quest. The myth was particularly cherished during the Age of Discovery.[22] As such, it bore a special relevance to Canada, with its history of European seamen-adventurers such as Champlain or Martin Frobisher navigating into an underworld of treacherous northern straits in hopes of returning home laden with fabulous riches.

In the tale of Tom Thomson as the epic quest–hero, the setting (the Shield country) and means of transport (the canoe) set him alongside these other heroes of the Canadian national epic. His victory in the

green deeps of the wilderness over what Grey Owl called the "brooding relentless evil spirit of the Northland" grants him insights into this harsh geography, as well as special artistic powers with which to interpret it for his countrymen.[23]

A.Y. JACKSON WAS undertaking adventures of his own at this time, as he spent the summer of 1914 with Bill Beatty in the Rocky Mountains. The pair had received a commission to accompany work crews of the Canadian Northern Railway as they laid steel through the Yellowhead Pass. They therefore became the latest in a long line of landscapists, beginning with John A. Fraser, F.M. Bell-Smith and Lucius O'Brien a quarter century earlier, who journeyed west on passes issued by railway companies anxious to promote the Rockies as a tourist destination.

More accustomed to the beaches of Picardy than the Canadian wilderness, Jackson enjoyed the rigours of his mountain adventure. He described in a letter to Dr. MacCallum the hazards and exertions of painting in the Rockies: "We took too many chances, sliding down snow slopes with only a stick for a brake, climbing over glaciers without ropes, crossing rivers too swift to wade by felling trees across them."[24] This rough-and-ready approach to the task of landscape painting anticipated a friend's comment, made years later, that Jackson's painting expeditions were forays into a world of "nature-as-enemy as known to the explorer . . . an affair of Jackson-against-nature and vice-versa."[25] Even so, Jackson was hardly an explorer of the calibre of some of his fellow painters. His frolics in the CNR camps in the Rockies pale beside the feats of an American contemporary, the painter Belmore Browne, another product of the Académie Julian. Between 1906 and 1912, Browne made three attempts on the summit of Mount McKinley in Alaska, established the altitude record for North America and made the first ascent of Mount Olympus.

Whereas Browne's adventures led to finely observed paintings of wildlife and glacial peaks, Jackson proved unable to translate his enthusiasm for the Rockies into successful canvases. The brief to create beautiful works that might attract tourists and immigrants to the

Rockies was not one for which the painter of *Terre sauvage* was ideally suited. He came to the conclusion that "mountains were not in my line" and consigned most of his sketches to the flames.[26] Making matters worse, he did not find Beatty a stimulating companion. "He can look after the business end of a trip and is a good man to travel with in that respect," he confided to MacDonald, "but he isn't an artistic inspiration. I don't know what he thinks of me, and care less."[27] Beatty's admiration for William-Adolphe Bouguereau—the French academic painter of glossily erotic nymphs and shepherdesses—disgusted Jackson.[28] Nor could Beatty keep up with Jackson, who was thirteen years younger. The man whose feats once astonished colleagues at the Lombard Street Firehall was now forty-five and not the physical specimen he used to be. "We'd start to climb a mountain, but about halfway up Old Bill would have to lie down panting, so I'd go on alone."[29] It was to Algonquin Park and Tom Thomson that Jackson now looked for inspiration and companionship. As soon as he returned to Ontario he made his way to Canoe Lake.

THOMSON HAD ULTIMATELY reached Lake Nipissing after his solo voyage and, after navigating its southern shore, turned into the South River and paddled another eighty kilometres south, reaching Canoe Lake in the middle of September. He and Jackson immersed themselves in the grim beauty of the Algonquin wilderness. Taking along their sketching equipment, they canoed and camped at Smoke Lake and then on its southern neighbour, Ragged Lake.

The experiences of paddling a canoe and sleeping in a tent were as novel for Jackson as for Lismer on these same waters four months earlier, and he took to it with a similar delight. Like Lismer, he was impressed by Thomson's abilities in the canoe. A friend at Grip Limited described Thomson as "tall and big and strong,"[30] and Jackson was struck by the physical strength that allowed him to row for an entire day without fatigue while Jackson—a bantamweight a full six inches shorter—idled in the bow and kept a lookout for likely subjects. Besides berries and fish, Thomson was fuelled by a carbohydrate-rich diet of bannock, flapjacks and doughnuts.[31]

142

Jackson was equally impressed by his fellow traveller's paintings. Not having seen the sketches Thomson produced in Algonquin Park and Georgian Bay, he was struck by the vibrancy of his friend's new style. If Thomson had suffered an artistic block in Georgian Bay, his creative energies were released in Jackson's company in Algonquin Park. His bold new style was achieved in part by creating furrows and other textures on his panels by dragging a dry brush or even the point of the wooden handle through his paint to produce works that were, Jackson informed Dr. MacCallum in a letter, "very different from last year's stuff."[32]

To MacDonald he reported, "Tom is doing some exciting stuff. He keeps one up to time. Very often I have to figure out if I am leading or following. He plasters on the paint and gets fine quality."[33] He even joked to Dr. MacCallum that Thomson was developing "decided cubistical tendencies and I may have to use a restraining influence on him."[34] This was to lay it on rather thick, but in Thomson's latest sketches, such as the gloriously ablaze *Twisted Maple* (see plate 12) and *Soft Maple in Autumn,* the forms in the Algonquin landscape dissipated into bright colours—deep reds, primrose yellows, burnt oranges—that were a far cry from his low-keyed works from the autumn of 1912. He was also, as Jackson noted, adding his pigment in a lavish impasto whose texture revealed the deftly confident sweep of his brush.

These works showed Thomson's enthusiasm for capturing raw visual effects with a startlingly sensuous technique—the kind of "fearless brushing" and "crude colour" Margaret Fairbairn had already noted in the works of painters of "Young Canada" such as Harris and MacDonald. Even so, sketching did not always go well. Thomson still became frustrated and discouraged, and on one occasion, enraged at a poor day's work, he hurled his box-easel into the bushes and vowed never to paint again. The next morning, following a change of heart, he and Jackson crawled through the brush in search of it. Once found, the box needed to be taken to one of the rangers for repair.[35]

143

Despite Thomson's example and the rude beauty of the surroundings, Jackson still found himself unable to paint anything worthwhile. "I am not in the mood to produce at all," he wrote to J.E.H. MacDonald.

The problem was partly that the failure of his Rocky Mountain paintings prevented him from working spontaneously. His problems were also related to the grim shadow that had fallen across Europe in the summer of 1914. He had learned of the outbreak of war while in the Rockies and since then had painted little of worth. "I think if the Germans got a good walloping I might brace up," he told MacDonald.[36]

THAT THE WAR in Europe should have been on Jackson's mind was hardly surprising. For the previous few weeks the Toronto newspapers were emblazoned with headlines about the "Battle of Belgium." It was clear that Canada, unable because of her constitutional position either to declare war or to conclude peace, would not escape the conflict. Three days before Britain declared war on Germany, the Duke of Connaught, the governor general, cabled the British secretary of state for the colonies to affirm that "the Canadian people will be united in a common resolve to put forth every effort and to make every sacrifice necessary to ensure the integrity and maintain the honour of the Empire."[37] Torontonians eagerly affirmed the statement, with news of Britain's declaration of war against Germany greeted by crowds pouring into the streets to sing "Rule Britannia."

By the end of August, optimism that the war would be over by Christmas—as so many statesmen initially predicted—was fading rapidly. The *Toronto Daily Star* began printing long lists of British casualties (1,600 died at the Battle of Mons on August 22) as well as hair-raising tales of German atrocities in Belgium. On August 25 one of its reports quoted Lord Kitchener's ominous forecast that the "disastrous war" might well endure for as long as three years.[38] In Ottawa, two orders-in-council were made to raise a Canadian fighting force for service overseas. No shortage of volunteers came forward. In Toronto, crowds besieged the city's armouries, including many ex-servicemen hoping to rejoin their old regiments.[39] By the beginning of September, two Toronto regiments alone, the 48th Highlanders and the Queen's Own Rifles, had shipped more than 2,000 men east to the training camp at Valcartier near Quebec City. In the first week of October, 33,000 Canadian troops—many of them raw recruits with only the most basic training—departed for Europe.

There was as yet no special urgency among the recruiters. So numerous were the volunteers that married men were turned away, along with those who (as the *Toronto Daily Star* reported) had "a foot not properly arched."[40] For this reason, it was not unusual that in the first week of October two married men with jobs and children, Arthur Lismer and Fred Varley, joined Jackson and Thomson in Algonquin Park. They brought with them their wives and another Toronto painter, Beatrice Hagarty Robertson, a former studiomate of Mac-Donald and Bill Beatty who had exhibited flower paintings at the OSA. Jackson, a veteran of the prolific art colony at Étaples, was impressed by their industry. "Art is raging round here now," he wrote to MacDonald. "No less than five OSA exhibitors on the job."[41]

Mowat Lodge quickly became an impromptu exhibition gallery in October 1914.[42] The painters propped their works against the wall for appraisal, turning the premises into a Canadian version of the Buvette de la plage, the boarding house in Le Pouldu decorated by Gauguin and Paul Sérusier in 1899, or the Hôtel Baudy in Giverny, where the dining room was filled with paintings by the resident Impressionists. Mowat Lodge did not, however, turn into a mutual admiration society. Bill Beatty had boasted to a journalist of a "bond of sympathy" between the artists, making them "encourage one another" in their efforts.[43] But with so many red-blooded men jockeying for position, rivalries and differences were bound to show (as Beatty himself had discovered with Jackson).

In Algonquin Park, it was Varley who frustrated the obstreperous Jackson. Varley had taken readily to life in Canada, and within days of arriving he wrote back to his wife: "I am already a Canadian." He also wrote to his sister in England about how there was "a small party of us here, the young school, just 5 or 6 of us, and we are working to one big end."[44] But despite his friendship with Thomson and his passion for "this outdoor country," he was not as convincing as some of the other artists in his commitment to what Harris called "distinctly Canadian work." Working full-time as a designer at Rous and Mann, and with a wife and two young children to support, he had little time for the lengthy canoe expeditions undertaken by Thomson or the railway journeys of Jackson and Beatty. Nor had he, like the others in the

"young school," journeyed into the Ontario backcountry. Before his trip to Canoe Lake, his experience of rural Canada barely extended beyond the Toronto Islands. His real preference was for figure paintings and portraits rather than landscapes. His most ambitious work to date—painted in Sheffield early in 1912—had been a dramatic female nude entitled *Eden*.

For Jackson, who wished painters of the "Canadian School" to prospect the farthest-flung regions of the Dominion, Varley's metropolitanism and his interest in the human figure were hindrances. The two men had little in common beyond their friendship with Thomson, and Jackson was contemptuous of Varley's lack of experience in the bush. "Varley is most excited over the sketches which are the least suggestive of the north country, and as for my stuff," he pouted to MacDonald, "he doesn't like it at all."[45] Jackson even sniffed at Varley's decision to spend his nights with Maud in the comfort of Mowat Lodge rather than under the stars. "Varley would be a hot musher in a few weeks," he complained to Dr. MacCallum, "if he would live outside."[46]

In Jackson's view, authentic landscapes required such canoe-and-sleeping-roll communions with nature. Thomson's progress as a painter, which had coincided with his progress as a canoeist and outdoorsman, seemed to confirm his opinion. Although the "excellent beds" were available in Mowat Lodge, Thomson and Jackson pointedly pitched their tent a short distance away, in the middle of a birch grove beside the old mill. The two bachelors might have felt like outsiders in any case, since both the Lismers and the Varleys had brought their children with them, and Beatrice Hagarty Robertson was newly married. With their backwoods snobbishness, Thomson and Jackson might have used their tent to retreat from the "birthday cakes and water ice" effervescence that had recently driven Thomson from Go Home Bay.

Whatever the tensions or rivalries, all concerned were awed by Algonquin in full autumn colour. Varley and Lismer, especially, were astonished by the blaze of colour. Varley, who was learning from Thomson how to paddle a canoe, wrote to Dr. MacCallum, "The Country is a revelation to me—and completely bowled me over at first."[47]

146

Lismer wrote of the "glorious week of colour" but admitted how he found it "far from easy to express the riot of colour and still keep the landscape in a high key... Varley and I are struggling to create something out of it all."[48]

The crimsons and yellows of the sumac and birch, in combination with the lucid atmosphere and expanses of clear water, created scenes quite different from the tonsured hedgerows and gorse-covered fells of the moorlands outside Sheffield, or for that matter from the vaporous hues and mellow orchards and pastures of Holland or France that had served so many landscapists in the past. Jackson, Harris and MacDonald all were stressing that a different approach to the landscape—something akin to the style of the "Norwegian-French protagonists"—was required to do the Shield country justice. Jackson and Thomson, following the Post-Impressionists, and Harris and MacDonald, taking their cue from the Scandinavian painters, were abandoning the colour harmonies and cursory brushwork of Impressionism in favour of bold lines and broad planes of clashing colours. If the intensely bright sunlight of the Midi inspired the chromatic outbursts of Van Gogh, Matisse and André Derain, the palettes of the Studio Building painters took their cue from the sumacs, tamaracks and maples.

Varley wrote to his sister, "We are endeavouring to knock out of us all the preconceived ideas, emptying ourselves of everything except that nature is here in all its greatness."[49] The desire to rid oneself of all influences and see the world anew was common among painters, especially modernists. Cézanne claimed he wanted to do paintings of the sort produced by someone who had never seen a work of art. Piet Mondrian wished to erase the history of art from his imagination, and Picasso, Vuillard and Bonnard all sought to recapture the freshness of a child's eye, untainted by other pictures.[50] Yet the painter's mind can never be wiped clean. Every artist, no matter how original, is an amalgamation of influences. Despite their fantasies of artistic tabulae rasae, Bonnard was influenced by the Impressionists and Japanese prints, Mondrian (in his early works) by the painters of the Hague School and (in his later ones) by Picasso and Braque. Picasso, the most brilliantly

innovative painter of the twentieth century, assimilated such prede-
cessors as Velázquez, El Greco, Goya and Titian.

It is hardly surprising that Varley failed to rid himself of his own
preconceived ideas about what made a work of art. The product of
his visit to the park was *Indian Summer,* a portrait of Maud against a
background of birch trees. The bold pattern of flattened shapes shows
the influence of Augustus John, one of his favourite painters, who was
inspired in turn by Gauguin and Matisse.

Lismer likewise revealed the imprint of previous painters, in
his case the French Impressionists. Later he would claim—in what
became a mantra for these painters of the Canadian north—that
Impressionism "does not transplant well to Canada. It is emotion-
ally unstable . . . in our clear air and amid our solid form of land and
water."[51] But this remark does disservice to his work in Algonquin
Park in 1914. *The Guide's Home, Algonquin* (see plate 13), however
indebted to Impressionism with its dappled light, mauve shadows and
stabs of colour, is a stunningly beautiful showstopper of a painting
whose crystal-clear blue sky and stand of shimmering birch trees (one
can almost hear the gentle applause of the leaves) suggest the Cana-
dian autumn as vividly and powerfully as anything yet to come from
the easels of his companions.

THE LISMERS AND Varleys returned to Toronto in the middle
of October, followed a week later by Jackson. With the onset of war,
financial prospects for the painters looked bleak. Earlier in the year,
the country began experiencing an economic slowdown as more than
a decade of prosperous and expanding commercial activity gave way
to inactivity in the exchanges and a contraction of the money mar-
kets. Now the war threatened to make the situation even worse. "I
guess there is not much commercial work to do in Toronto," Jackson
wrote to Dr. MacCallum. Orders for brochures and posters for hotels
and real-estate companies evaporated, others were cancelled, and the
staffs of engraving houses drastically reduced. "If the war keeps on,"
Jackson glumly mused, "conditions can only get worse. The only job
will be handling guns."[52]

Jackson's artist friend Randolph Hewton was already preparing to do exactly that. In 1913 Hewton had been denounced in the Montreal press as a Post-Impressionist but then defended by Harold Mortimer-Lamb as an artist of "original outlook" and "unusual promise."[53] Now he was enlisting with the Victoria Rifles and, along with the sixty thousand other Canadians who were in uniform by the end of 1914, preparing to ship overseas with the Canadian Expeditionary Force. He was anxious for Jackson, his old sketching companion at Émile-ville, to join him. "I am not in any desperate hurry," Jackson wrote to MacCallum. "The hero's job is a pretty thankless one. There are a lot of institutions and big fat heads in this country not worth laying down one's life to preserve."[54]

Nor was Tom Thomson eager to enlist. After another month in Algonquin Park, he returned to Toronto in the middle of November. One day soon afterwards, he stood at the corner of Bloor and Yonge with Fred and Maud Varley watching as twelve thousand men marched by eight abreast. According to Varley, Thomson was "really upset" about what he took to be the dire fate of the young soldiers: "Gun fodder for a day." He was equally pessimistic about the prospects for a swift end to the war, predicting it would last for three or four years.[55]

Thomson's pessimism about the war and his disillusionment with the flag-waving crowds were shaped in part by a book he read a year or two earlier, Norman Angell's *The Great Illusion: A Study of the Relation of Military Power in Nations to Their Economic and Social Advantage.* Angell was an Englishman who immigrated to California in 1889 at the age of seventeen. He worked at a series of frontier-style jobs—ditch digger, prospector, buckaroo—before turning to journalism. In 1903, revolted by the age's patriotism and jingoism, he published *Patriotism under Three Flags: A Plea for Rationalism in Politics.* It was followed six years later by another attack on jingoism and empire building, *Europe's Optical Illusion,* a pamphlet expanded into a book the following year and retitled *The Great Illusion.* The "great illusion," he argued, was the belief that a nation's financial and industrial stability relied on its ability to defend itself against the aggression of other nations who would invade because they believed—in another great illusion—that

they would thereby "increase their power, prosperity and well-being, at the cost of the weaker and vanquished."[56] One economic fallacy was therefore being used to combat another, and such logical blunders were leading to a militarism that threatened the stability of the entire world.

Praised by reviewers as "one of the most profound, as well as the most acute, pleas against war and armaments that has ever appeared,"[57] *The Great Illusion* ultimately sold more than 2 million copies. In about 1912, according to Stanley Kemp, it became a topic of discussion among the designers at Grip Limited. Angell's view of the contradictions and absurdities of militarists and empire builders—Jackson's "big fat heads"—won a sympathetic audience in Thomson even before the Great War. According to Kemp, Thomson "was of the opinion that war was a snare and a delusion" and that "militarism" and "preparedness" were "quite wrong."[58]

Kemp claimed Thomson was not alone in his views, but as the artist stood with Varley and his wife among the cheering crowds at the corner of Bloor and Yonge, watching the young Torontonians marching in lockstep towards their doom, he must have felt in very much of a minority. He must also have realized that his group of fellow painters, who had so recently come together and offered him such advice and support, were now threatened with dispersal or extinction as "Young Canada" was drawn into the lunatic and dangerous quarrels of the Old World.

BOOK **II**

1 MEN WITH GOOD
RED BLOOD IN THEIR VEINS

ALTHOUGH THE WAR in Europe meant that artists such as Randolph Hewton were shipping overseas, the hostilities brought one young Canadian painter back home.

Franklin Carmichael was the red-haired son of an Orillia carriage maker. After taking art lessons in Orillia from Canon Richard W. Greene (reputedly the model for Dean Drone in Stephen Leacock's *Sunshine Sketches of a Little Town*),[1] he had arrived in Toronto in 1911, at the age of twenty-one, to further an artistic career limited until then to painting crests and racing stripes on the vehicles manufactured by his father. For the next two years he worked at Grip Limited as an office boy and apprentice designer while taking lessons from those stalwarts of Toronto art education, William Cruikshank and George A. Reid. He frugally put away $5 a week (his salary was $15 per week) until in the summer of 1913 he had saved enough to begin studies, on their advice, at the alma mater of Arthur Lismer and Fred Varley, the Royal Academy of Fine Arts in Antwerp. He spent nine months in Belgium (whose neutrality wrongly suggested it would be a safe destination) before travelling to England in the summer of 1914. He was in England when Germany invaded Belgium and so returned to Toronto, to the design firm of Rous and Mann, in October. Soon afterwards he became a tenant in the Studio Building.

Franklin Carmichael at Grip Limited, 1911
McMichael Canadian Art Collection Archives

Carmichael's arrival in the Studio Building was a welcome one for Tom Thomson, Bill Beatty and Arthur Heming. "We really have an enjoyable time as we visit one another and gab away like so many geese," Carmichael wrote to his girlfriend.[2] He was valued for other reasons as well. With painting commissions and the demand for graphic design in short supply, some Studio Building tenants were embarrassed for funds. To the cash-strapped artists, the state-of-the-art Rosedale studios, with their kitchens and bathrooms and enormous windows, suddenly seemed a costly and unnecessary extravagance. As early as October 1914 Jackson was hoping to have the responsibility for paying the rent taken off his hands. He was

planning to return for reasons of economy to his mother's house in Montreal but feared leaving Thomson—who was "getting to the end of his tether" financially—responsible for the rent on their shared studio.[3] The arrival of Carmichael meant a replacement had been found. Before the end of the year Jackson had cleared out of the Studio Building and returned home.

Jackson did one final painting before leaving Toronto. On the first night of his stay with Thomson in Algonquin Park, the two men had camped below Tea Lake Dam, a sixty-foot-long timber construction built by the Gilmour Lumber Company to raise the water level so that logs could be driven more easily along the Oxtongue River. He might not have been in the "mood to produce" during this trip, but here, Jackson made a quick sketch of a maple sapling beside the rushing river. The scene was, as he must have realized as he returned to Toronto, quintessentially Canadian. Back in the Studio Building, he began working up his small sketch into an oil painting. On a canvas eighty-two centimetres high and a metre wide he depicted, from the low point of view of someone seated on the riverbank, rapids in the Oxtongue as seen through the delicate screen of the maple sapling. The painting showed Jackson approaching the summit of his powers and confirmed his position as the most creative and daring landscapist working in Canada. Using deep blues, ochres and, to tinge the boulders, mauve, he contrasted the stillness and fragility of the young maple with the turbulence of the churning waters beyond. Most striking of all in this, yet another of his brilliantly keyed canvases, was the flaming crimson of the maple leaves elegantly flecked across the artist's field of vision.

The Red Maple is an astonishing image of the beauty, frailty and power of the natural world (see plate 14). But for Jackson, troubled by thoughts of war, the painting must have had a significance beyond his visit to Tea Lake Dam. By 1914 the maple leaf had long been a symbol of Canadian identity. In 1867 Alexander Muir wrote "The Maple Leaf Forever" (with its line "The Maple Leaf, our emblem dear") as the Confederation song. The maple leaf was included on the flag of the governor general as well as on the coats of arms of Ontario and Quebec, and between 1876 and 1901 it appeared on all Canadian

coins. Most poignantly of all, in 1914 the maple leaf was on the badge of members of the Canadian Expeditionary Force, such as Jackson's friend Randolph Hewton, who were shipping overseas.

It is not difficult to see symbolic meaning in a maple sapling perched on the brink of a violent torrent. In this depiction of promise and threat, fragility and power, Jackson poetically captured the terrible predicament in which all young Canadians of his generation suddenly found themselves.

JACKSON'S MOVE TO Montreal at the end of 1914 was a great loss to Tom Thomson. Jackson, with his extensive European training and experience, had begun to foster Thomson's talent, recognizing his raw skills and helping to refine them. When for two months the previous summer Thomson was unable to paint, it was Jackson's company that unleashed his creative abilities. The two men spent only a matter of months together, but over the course of that time Thomson began developing artistic gifts the depth and power of which his earlier works had given scant hint.

Jackson did not exaggerate when he said Thomson was getting to the end of his tether financially. With his year-long patronage from Dr. MacCallum at an end, and with discouraging prospects of earning a comfortable living through commercial design, he was forced to make economies. At the end of the year he moved out of his latest lodgings— a boarding house at Wellesley and Church—and into a tumbledown shack behind the Studio Building. Situated on sloping ground and surrounded by saplings, the shack had formerly served as the workshop of a cabinetmaker and even for a time as a henhouse. Lawren Harris and Dr. MacCallum paid $176 to have the modest structure re-roofed and insulated with beaverboard. An east window was added for light, and the shack was furnished with a bunk and a box stove. Thomson was then allowed to occupy it for the peppercorn rent of $1 per month.

Harris had an affection for this primitive kind of jerry-built, lumber-and-tarpaper shack; many examples would later appear in his art. Although the exact origins of this particular shack are unclear, it was probably one of the many self-builds that mushroomed in Toronto

Thomson Shack behind the Studio Building, Toronto
McMichael Canadian Art Collection Archives

over the previous decade as immigration soared and many poor British immigrants built themselves two- and three-room shacks with no plumbing or electricity. Thomson's new home was probably technically illegal as a residence, as efforts to clean up Toronto saw the city council pass Bylaw 6691 in 1913 "to regulate the installation of sanitary conveniences under the Public Health Act."[4] He nonetheless made himself happily at home, spending his leisure moments carving axe handles and decorating the walls with paddles, lures and trolling spoons—mementos of the self-sufficient life in the bush. The shack represented an attempt to replicate, in the heart of Toronto, his primitive living conditions in Algonquin Park. Its unadorned decrepitude evoked the humble shelter-houses occupied by the park's rangers and loggers.[5]

If the shack provided him with cheap living quarters, Thomson spent the winter of 1914–15 sharing workspace in the Studio Building with Frank Carmichael. Despite the age difference (Thomson was

thirteen years older) the two men had much in common. Both came from Scottish Presbyterian backgrounds in rural Ontario; both were avid readers and accomplished musicians (Carmichael played the violin, cello, bassoon, piano and flute); and both were instinctive loners.[6] Carmichael's experiences studying in Europe, however abbreviated, keened all the more Thomson's appetite for modern art, already whetted by Jackson and Harris over the previous year.

Although lacking Jackson's or Harris's wide experiences, during his brief stay Carmichael probably saw the 1913 World Exhibition in Ghent, and in England he admired the work of Constable and Turner. Belgium had numerous examples of Jugendstil design (Brussels billed itself as the "capital of Art Nouveau"), and at some point Carmichael developed an appreciation of Japanese woodblock prints. He was not the first of Thomson's friends to share this enthusiasm, since Will Broadhead had been another aficionado: he had books on Japanese art shipped to him from England.[7] Japanese prints had been in vogue in Europe since at least the 1890s. Their curvilinearity and organic forms inspired both Art Nouveau (Siegfried Bing, proprietor of the Paris gallery L'Art Nouveau, spent two years in China and Japan in the 1880s) and painters such as Toulouse-Lautrec and Pierre Bonnard.

The studio shared by Thomson and Carmichael took on the carefree and disarrayed air of bachelordom. It was cluttered with easels bearing half-finished canvases, and on the floor, as Carmichael wrote to his girlfriend, Ada Went, lay "canvases and frames in great array, and not without disorder. The table too is covered with half-used tubes of paint, brushes, bottles of oil, turpentine, bottles, sketches, colour boxes with sketches standing up against the wall. Under it are colour boxes and tubes with a pile of sketches at one end, looking not unlike a bunch of shingles broken open." Their cooking was equally chaotic, including mishaps and "queer sights . . . when a finger is burnt or some stuff boils over." They often ate with Bill Beatty, who treated them to fried potatoes and oyster stew. Thomson's specialty was mulligan stew, and he also made preserves from the berries he picked in the north. He seems to have been something of an impromptu chef: MacDonald's son, Thoreau, remembered seeing him mash potatoes with an empty bottle.[8]

Away from their easels, the two men played chess, often in the company of Heming. Recreations became livelier with the arrival in the building of Alex G. Cumming, the manager of Art Metropole on Temperance Street, where most of the artists bought their materials. The financial plight of the painters persuaded Harris to rent space to a non-artist. He lived to rue the arrangement, since Cumming proved a "lively and frolicsome fellow" who threw parties in his studio. Dance tunes from his gramophone blared down the corridors. Thomson may not have been troubled by the introduction of wine, women and song into the Studio Building. Cumming's wild ways, however, soon began to chafe some of the more abstemious artists, such as the fastidious Heming, who "never smoked or drank" and was "shy with women."[9]

More calm and well-behaved visitors were welcomed onto the premises, such as Dr. MacCallum, whom Carmichael called the "patron saint" of the Studio Building. According to Carmichael, the doctor "comes in, flops down on a chair, throws matches on the floor and talks in an intelligent way about our work, taking as keen an interest as one's self. His very attitude makes one feel at ease, and as though one had known him for years."[10]

Although several women were eventually to work in the Studio Building, the *Toronto Daily Star* had stressed that it was "not a place for pink teas or tango"[11]—the recreations of well-heeled Rosedale women. The emphasis on what Beatty called "men with good red blood in their veins" made it a decidedly—and even self-consciously—masculine environment. At least one tenant was aware that a nation characterized by physically demanding and exclusively masculine occupations such as mining and lumberjacking might view an artist with suspicion. "I always had the juvenile illusion," Heming confessed in a 1912 interview, "that an artist was some long-haired effeminate freak."[12] For many Canadians Oscar Wilde's 1895 trial forged the image of the artist as a homosexual.[13] Some Studio Building painters hoped to sever this link by having the artist bunk down—metaphorically speaking—with Canadian machos such as Mounties and river drivers. Like his near-namesake Ernest Hemingway's own hairy-chested posturings, Heming's strenuous exertions with canoes and snowshoes were in part attempts to disabuse the suspicious (most of

all, perhaps, himself) of the notion that artists were what Canadians euphemistically called "Oscar Wilde types."

The concern for manly vigour was hardly unique to Canada or Canadian artists. The first decade of the twentieth century witnessed Lord Baden-Powell trying to instill manliness in the youth of England, while the most frequent adjective on the lips of an English school-master was "manly." Not only Boy Scouts and schoolboys but artists, too, required manliness. The most famous art instructor in America, Robert Henri, told his students that the artist must be "a real man" (a category for which he qualified by dint of a boyhood among cow-boys and a surname that was not French—so he insisted—but rhymed with "Buckeye"). Meanwhile, London's Slade School of Fine Art was drumming out of its students the perceived effeminacies of the 1890s Aesthetic Movement—whose cynosure was Oscar Wilde—by feeding them a diet of Friedrich Nietzsche. The Slade course could boast its successes. England's most renowned painter, Augustus John, a Slade graduate, when not painting raw and remote scenery, was bedding his models, downing pints of beer and getting into scrapes that culmi-nated in police pursuits and county court summonses.[14]

The artists of the Studio Building took their manly pleasures more innocently. Thomson, Carmichael, MacCallum and Heming often attended boxing matches. Although the sport had recently been taken to task for attracting to ringside "a great many turbulent and otherwise undesirable persons,"[15] Carmichael was anxious to assure Ada that the matches in Toronto the Good were, relatively speaking, wholesome performances. "It was of course amateur sport, and as clean as could be," he told her after attending a series of bouts. "True, some boxers were knocked out, but that is to be expected. They were fine specimens of men physically, and I must say I have never seen such fine action. Altogether, it was an enjoyable evening, and we came home refreshed."[16] Carmichael might have underplayed the vio-lence, because the report of the matches in the *Toronto Daily Star* was a brutal catalogue of boxers "knocked dizzy" and dispatched "into Dreamland," and a graphic description was offered of a "husky, gritty boy" named Martin who took a "right smash" to the head and was "dragged to the corner inert."[17]

This enthusiasm for pugilism did not translate into paintings, even though the young American artist George Bellows, himself a star athlete, had recently achieved success with action-packed fight scenes such as *Stag at Sharkey's* and *Both Members of This Club*. But if Bellows captured the brawny dynamism of the American character with his bloodstained boxers, for Thomson and his fellow painters the essence of Canada was to be found not in its people but in the landscape.

THE GREAT WAR brought another young Canadian painter back to Toronto, this time from New York. Frank Johnston was a burly twenty-seven-year-old painter and designer, the son of Irish immigrants.* He and Thomson had known each other since 1909, when both began working at Grip Limited. Three years later, as Thomson was discovering artistic inspiration in the Ontario backcountry, Johnston enrolled at the Pennsylvania Academy of the Fine Arts in Philadelphia.

The Pennsylvania Academy was one of the finest and most famous art schools in America. Five members of the most vital and original art movement in America—the group of urban realists known as The Eight—had recently been students there. Johnston studied under the American Impressionists Philip Leslie Hale and Daniel Garber and then worked briefly in New York as a graphic designer at Carlton Studios. In New York he continued his studies under Robert Henri, leader of The Eight. Although Henri was famous for encouraging his students—his "real men"—to frequent New York's bars and billiard halls in search of low-life subjects, Johnston preferred landscapes. Returning to Toronto in 1915 he began work at Rous and Mann with Frank Carmichael and Fred Varley.

Johnston took a studio above the Arts and Letters Club rather than renting space in the Studio Building. He was a frequent enough visitor to Severn Street, however, for Arthur Lismer to commemorate him in a series of cartoons called "Frank Johnston in T.T.'s Shack." He

* Christened Francis Hans Johnston, he was known as Frank or (in some catalogues) as "Francis H. Johnston" until 1927, when, influenced by numerology, he adopted the name Franz.

was good friends with Heming as well as with Harris and MacDonald, and by 1915 he may well have taken over from Jackson in guiding Thomson's artistic education. He was arguably the most impressively trained of all the painters around the Studio Building. His teachers in Philadelphia were in the front rank of American artists, with Garber a leading figure among the Pennsylvania Impressionists, a group of artists acclaimed by one American critic as "our first truly national expression."[18] A revered teacher and the most accomplished technician of the New Hope colony of painters, Garber specialized in poetic and meticulously painted scenes of the Delaware River and the tranquil countryside surrounding New Hope.

An even more intriguing teacher was Philip Leslie Hale. Born in Boston in 1865, Hale was one of the first Americans to experiment with Impressionism, working at Giverny in the late 1880s and early 1890s. He ultimately developed a style in which he adapted some of the most progressive aspects of French art of the 1890s to produce Pointillist-inspired landscapes of disintegrating forms and shimmering light. A sharp-eyed commentator on artistic trends, he was familiar to some Canadians thanks to a series of articles he wrote in the early 1890s on Symbolism and Neo-Impressionism for the Montreal-based journal *Arcadia.* He was especially interested in the Nabis, the school of French painters such as Pierre Bonnard and Maurice Denis who wished their art, with its bright colours and flat patterns, to be decorative rather than descriptive. Johnston might have known one of Hale's most adventurous works, the Nabi-influenced *Landscape,* painted in the early 1890s and still in the artist's studio in 1915. The simple design of the landscape—a screen of mauve tree trunks against horizontal bands of luminous yellow ground—veered tantalizingly towards abstraction.

Johnston's years in Philadelphia and New York therefore made him *au courant* with Neo-Impressionist styles of painting such as Pointillism and their American interpreters like Hale. If Thomson found Seurat and Pointillism as appealing as Jackson claimed, he must have been intrigued by Johnston's explanations. His old friend, thanks to his studies at the Pennsylvania Academy, had at least as firm a theoretical grip on these techniques as Jackson.

AROUND THE TIME of Johnston's return to Toronto, Thomson was at work on a painting called *Northern River* (see plate 15). The title seems to allude to Wilfred Campbell's poem "A Northern River," which describes the "shining music" of a river winding through the "dusk and dim" of a forest. Showing the silver arc of a river behind the bristling silhouettes of bare spruce trees, Thomson's painting featured clarified forms, flat planes of colour and an arrangement to which he would return many times in the years to come. Using the motif of an interrupted vision, he showed a screen of vertical trees parting like a veil or stage curtain to allow a revelatory glimpse of the reflective surface of a body of water and, beyond, the indistinct features of a distant shore. The impression is one not only of a communion with nature but also of a mystery on the brink of disclosure—or what Campbell's poem calls "the under-dreams that throng and bless, / The unspoken, swift imaginings."

Northern River was partly the product of Thomson's observation of the natural world. The inspiration was probably the Oxtongue River, the setting for Jackson's *The Red Maple*. Yet this haunting image of the Canadian northlands owed much to the sinuous lines of Art Nouveau and the reduced forms and bright colours of Post-Impressionism. It owed a debt, in particular, to a colour illustration published two years earlier in *The Studio*. This English journal, first published in 1893, appears to have been read avidly by the artists in the Studio Building, not least because of its regular mentions of their efforts. Thomson clearly regarded the journal as a source of artistic inspiration. He once adapted a Harry van der Weyden landscape reproduced in a 1904 issue, turning it into a work called *Northern Shore*.[19]

A 1913 article in *The Studio* entitled "Modern Tapestry-Work in Sweden" reproduced images of a number of Swedish tapestry designs, among them one by Gustaf Fjaestad, whose paintings at the Albright Art Gallery had so impressed MacDonald and Harris. Thomson seems to have been taken with a tapestry called *Woodland Scene* (see plate 16), designed by Henrik Krogh and reproduced by the journal in full colour.[20] Owned by the Swedish sawmill owner Hjalmar Wijk, it was a stylized representation of a spruce wood, with ruler-straight ranks of vertical trunks festooned with chartreuse and yellow foliage.

Thomson transformed this decorative design of a dense northern wood into his own pattern of branches drooping in elegant tracery across an enfilade of tree trunks. The S-shaped tree leaning diagonally through the foreground—what was to become a classic Thomson motif—clearly reflects the curvilinear motifs of Art Nouveau as well as the arabesques of the Fauves.

The March 1913 issue of *The Studio* was therefore among the paddles and axe-handles in Thomson's shack. This same issue included articles on the art of the Italian landscapist Paolo Sala, the Camille Corot paintings in the recently auctioned collection of Henri Rouart, and an exhibition in Berlin devoted to the work of the Berlin Secessionist Lovis Corinth. There were also reviews and reports of various other art shows in Vienna, Budapest, London, Moscow, Munich, Copenhagen and Philadelphia.

The fact that Thomson was leafing through the pages of such a journal—and discussing topics such as Neo-Impressionism with Jackson and then Frank Johnston—should complicate his image as a "wild man" of the bush closed off from the world and ignorant of the ways of modern art. Lismer was grossly underrating him when, in the interests of turning him into the brute poet of Canadian art, he claimed that "outside of fishing and his canoe he had few other interests."[21] The claim was patently false: Thomson certainly had interests outside of fishing and his canoe—art and music being two of them. Conversation at Grip and in the Studio Building did not focus exclusively on canoes and the north country. Will Broadhead, who collected books and considered himself "highly intellectual," described the environment at Grip as "refined and cultured."[22] Among this "bunch of gentlemen" (as Broadhead called them) was Stanley Kemp, the man with whom Thomson discussed *The Great Illusion*. Before starting work at Grip, Kemp had studied for the Anglican ministry at Wycliffe College and in 1908 completed an MA thesis at the University of Toronto entitled "The Life of Palladio and His Place in the Evolution of Architecture." He was, among other things, the future father-in-law of Northrop Frye.[23]

Thomson's discussions with Kemp indicate the wide range of his reading. Raised among shelves of books (works of literature were as

164

basic to his mother's house "as curtains on her windows or carpet on her floors"),[24] Thomson continued to read through adulthood. Walton's *Compleat Angler* and works by Wilfred Campbell were favourites. He also kept abreast of the more progressive trends in literature. One of the authors he appears to have studied was Maurice Maeterlinck, the Symbolist dramatist and poet celebrated as the "Belgian Shakespeare." He might have seen Roy Mitchell's direction of Maeterlinck's 1891 play *Interior* at the Arts and Letters Club in 1911, the year Maeterlinck won the Nobel Prize in Literature. By then he was already familiar with Maeterlinck. About the time he started work at Grip Limited he illustrated a line from Maeterlinck's *Wisdom and Destiny*, which had been translated into English in 1899: "It is well to have visions of a better life than that of every day, but it is the life of every day from which elements of a better life must come."

Thomson's interest in Maeterlinck shows his awareness of wider cultural trends both in Canada and abroad. The Belgian Symbolist's mysticism was hugely influential in Canada at the turn of the twentieth century. His Canadian translator Richard Hovey, a friend and champion of the Confederation poets, believed Maeterlinck's work marked the passing of realism in favour of "esoteric meaning" and "the adumbration of greater things." Duncan Campbell Scott shared this enthusiasm, calling Maeterlinck's work revelatory "for the mystical side of life . . . He is endeavouring to awaken the wonder-element in a modern way, constantly expressing the almost unknowable things which we all feel. His is the work of the modern Mystic."[25]

Maeterlinck's mysticism inspired, besides Scott, the painter Wassily Kandinsky: for the Russian he was an "artist of the soul" and "one of the first prophets" whose work heralded the end of the "nightmare of materialism" and the "soulless life of the present."[26] One of Lismer's favourite writers, Edward Carpenter (another scourge of soulless materialism), had friends in common with Maeterlinck and would later quote his work.[27] It is not difficult to imagine Lismer and Thomson discussing mysticism and Symbolist art and poetry as they sat together in the shack. But this was not the Thomson—erudite, philosophical, *au fait* with the latest European thought—that Lismer and other members of the group wished to advertise to posterity.

THOMSON SENT *Northern River* and two Georgian Bay scenes to the 1915 OSA exhibition that opened on March 13. Despite the war, there was no shortage of works for the public to see, with 138 paintings on display in the exhibition rooms of the Public Reference Library. A notable feature of the show was the strong presence of the painters from the Studio Building. Arthur Lismer had recently begun using one of the ateliers, and so seven painters listing their address in the catalogue as the Studio Building—Beatty, Carmichael, Harris, Jackson, Lismer, MacDonald and Thomson—accounted for twenty-three paintings, or almost one in five of the works in the entire exhibition.

They also accounted for many of the highest asking prices. A striking aspect of the Studio Building contributions was their eye-popping price tags. Established artists such as F.M. Bell-Smith and C.W. Jefferys priced their major works in the exhibition at $400, while Clarence Gagnon, subject of a successful solo show in Paris in 1913, had work on offer for $250. The artists from the Studio Building demanded steeper tariffs: Beatty, Thomson and Lismer all were asking $500 for various of their works. The $600 price tag on MacDonald's *Canada's Morning* made it the second-dearest work in the exhibition; only George A. Reid, at $700 for *An Idyll,* was marked higher.[28]

Prices aside, the other notable aspect of their contribution was the emphasis on winter scenes. Carmichael showed *Winter Evening,* Harris *Snow Pattern,* Jackson *Winter Afternoon* and MacDonald *Snow-Bound.* This much snow was a rarity in a Toronto art exhibition. Although Quebec painters such as Gagnon, Cullen and Suzor-Coté had tackled snow and ice before, landscapists in English Canada generally steered clear. They recognized, as one critic observed, that to paint a Canadian landscape under snow was "unpatriotic, untactful, and unwise." Canada's cold climate and deep snow had been a sore point at least since Voltaire mocked the country as "a few acres of snow." As Jefferys put it, "Our climate, winter especially, was regarded as a sort of family skeleton."[29]

Although winter scenes left most English Canadians cold, they were enjoying a remarkable vogue elsewhere. The Studio Building painters would certainly have known of the great success enjoyed

by Gagnon with his solo exhibition, *Winter Landscapes in the Lau-rentians,* staged at Adrien M. Reitlinger's prestigious Paris gallery at the end of 1913. A former student, like Jackson, of both Brymner and then Jean-Paul Laurens at the Académie Julian, Gagnon had displayed seventy-five paintings, the bulk of them winter scenes of the Baie-Saint-Paul region of Quebec. Unanimously glowing reviews in the French press led to an invitation to show further work at Reitlinger's 1914 exhibition *Painters of Snow* and a recognition, in France and Canada both, of his talents as a brilliant interpreter of the snowy ter-roir of Charlevoix country.

Even more to the point, many Scandinavian painters, as Har-ris and MacDonald noted in Buffalo, had turned unapologetically to winter scenes of frozen lakes and snow-blanketed forests to convey what they regarded as their particular national characters. By 1914 the influence of the exhibition of Scandinavian art on the painters of the "young school" was unmistakable. The snow-laden fir branches painted by Harris and MacDonald, in particular, revealed their efforts to imitate the style of Gustaf Fjaestad, whose "snow-hung boughs" MacDonald had so admired two years earlier.

The reviews of the OSA exhibition were generally positive, with the *Toronto Daily Mail & Empire* commending the "power and poetry" of the artists and Hector Charlesworth, in *Saturday Night,* praising their "pigmentary enthusiasm." Perhaps most enthusiastic was Lismer's *Sunglow,* a work whose clashing colours, applied in thick dabs and divided brushstrokes, confirmed his involvement in the Studio Build-ing's Neo-Impressionist discussions and experiments. Charlesworth singled out Thomson's *Northern River* as "fine, vigorous and colourful" and "a most effective composition."[30] *Northern River* was then bought by the National Gallery for its asking price of $500. The recognition was welcome, and the sum promised to end Thomson's financial wor-ries for the next few months at least—though he once claimed that each year he spent $500 (the equivalent of almost five hundred tubes of paint) on pigment alone.[31]

Also purchased by the National Gallery was Beatty's *Morning, Algonquin Park* and, though it had not appeared at the OSA exhibition,

Jackson's *The Red Maple*. The director, Eric Brown, was holding true to his promise, made in 1913, that there would be a "constant addition" to the collection as "the claims of the younger men become strong and urge recognition."[32]

ALTHOUGH THEY FAILED to find anything in the way of private buyers other than Dr. MacCallum, by 1915 most members of Algonquin Park School were represented in public collections, either in the National Gallery or in the collections of the Government of Ontario. The one member of the group whom this kind of success still eluded was Fred Varley. At the 1915 OSA exhibition he showed a single painting, an Algonquin scene entitled *Autumn* that attracted little attention. An irascible loner, Varley was something of an outsider to the group. He had no quarters in the Studio Building, possibly owing to his chronic lack of funds. Like the other painters, he was in straitened circumstances. Early in 1915, dunned by creditors, he moved house for the fifth time since Maud's arrival in Toronto two and a half years earlier. The couple was now living with their two young children on Pacific Avenue, north of High Park. Maud had become pregnant during their stay at Mowat Lodge, and a third child was now on the way.

Varley was comfortable only with Thomson and Lismer, and sometimes he fell out even with them. In what was becoming a regular habit, he caused a disturbance at a party hosted by Lismer and his wife in the third week of March. The Lismers had invited Varley and Maud, together with Thomson and Carmichael, to their house on Delaware Avenue, north of Bloor. "It was not quite as enjoyable an evening as I have spent there before," Carmichael observed in rueful understatement a day or two later. "Through no fault of ours, or Arthur's, Fred is again showing a side of his nature which does not always make for sociability." No sooner had Varley arrived through the door than he said "a few words"—an insult that Carmichael had no wish to repeat—that caused deep offence to Thomson in particular. "I have never seen Tom so angry," Carmichael told Ada. He added, "It is rotten and I feel as if I want to chuck Fred entirely."[33]

Although the exact details of the transgression went unrecorded, it is easy to imagine the conversation straying onto controversial topics,

such as the war, about which Thomson held firm opinions. Another possibility is that Varley insulted Jackson, whose reputation and rewards—for paintings Varley did not admire—far outstripped those of the belligerent Yorkshireman.

One result of the argument was that Varley did not go north with Thomson, despite his expressed wish to return to Algonquin Park and "paint the out-door figure."[34] Thomson travelled alone into the park at the end of March, laden with sketching equipment and camping gear. First, however, he spent a few days in Huntsville, a logging town on the Muskoka River.

THOMSON HAD A number of friends in Huntsville, including John McRuer, the local doctor and a fellow fishing enthusiast who had opened a practice in the town in 1908. But the "Doc," as Thomson called him, was seriously ill with tuberculosis, and at the end of 1913 he and his wife had moved to Denver, Colorado (possibly a somewhat unexpected move considering the volumes of tourist publicity extolling the pure air of Muskoka as a tonic for respiratory ailments). In 1915 Thomson was probably visiting Winnifred Trainor, the eldest daughter of Hugh Trainor, a foreman for the Huntsville Lumber Company. Thomson and the thirty-one-year-old Winnie, who worked as a bookkeeper, might have been introduced during one of Thomson's visits to Dr. McRuer, or else they might have met at the Trainors' house, which offered itself to paying guests as a boarding house. It is more probable, though, that they met at Canoe Lake, possibly as early as 1912 or 1913, since for the previous three years Hugh Trainor had leased a small summer cottage, known as The Manse, which stood only a short distance from Mowat Lodge.

Thomson's relations with women were ambiguous and obscure. He appears to have shared the same timidity or reticence towards women as his fellow bachelors Arthur Heming and Will Broadhead. Heming never married, so the explanation went, "because he could never summon up enough courage to ask a woman to marry him."[35] Broadhead was strongly averse to the idea of marriage: "The last thing on earth I dream of is being anchored to any female," he once wrote to his mother. He did, however, enjoy a romantic interlude in Bisco with

what he called a "little half-breed girl . . . the only girl who has ever sto-len my affections for any time."[36]

Thomson seemed equally disinclined to marry. He regarded him-self as a "wild man" unfit for female company, though his cultured upbringing and expensive tastes should have marred this self-image. More likely a combination of bashfulness and awkwardness were behind his maladroit courtship of Alice Lambert, his rejection of Var-ley's sister-in-law and his discourtesy towards the "attractive looking lady" who tried to engage him in conversation at Canoe Lake. Win-nie Trainor appears to have been one of the few women with whom he sustained a relationship of any length or significance. Yet even the most basic details of their affair, such as how and when they met, are strangely scarce.

Whatever its eventual state, in the spring of 1915 the relationship was neither serious nor rewarding for Thomson, because in the mid-dle of May he wrote Carmichael a distressed and slightly self-pitying letter about his lack of female companionship. He worked as a fishing guide after leaving Huntsville, and following his return from escort-ing American tourists he learned of Carmichael's engagement to Ada Went (the two were to be married in September). Clearly his young friend's wedding plans—and Carmichael's unfeigned and touching happiness—set Thomson to thinking about his own marital status as he approached his thirty-eighth birthday. It was unusual for a man of his age to remain a bachelor: the average Canadian man of his genera-tion married at twenty-eight. Bachelordom was even rarer as a man got older, since 91 per cent of Canadian men ultimately tied the knot.[37]

Thomson sent his congratulations to Carmichael, offering the couple as a wedding present anything in the way of "wall decora-tion" (as he put it) from his shack. Carmichael wrote to Ada, "It may sound hoggish, but I have such a deep admiration for his work I would like to clear the place out." But he also told Ada how Thomson's let-ter was "not untinged with a certain bitterness" towards anyone who claimed that bachelordom and what Carmichael called "the state of celibacy" were the ideal existence for an artist. He did "a little moraliz-ing on his own account about a bachelor's life . . . giving me the benefit

of what seems to be his own personal experience." Carmichael was slightly alarmed by the unhappy temper of the letter, which revealed his friend's essential loneliness. "Poor old boy," he wrote to his fiancée, "the whole tone of his letter seemed to be so blue—I wanted to rush up to the park just to have a chat with him, and cheer him up a bit. He has these streaks occasionally."[38]

Thomson ended his letter to Carmichael by saying he was planning a long canoe trip through Algonquin Park. Soon afterwards, he bought a new Chestnut canoe, silk tent and other camping supplies and started out from Canoe Lake on another long solo voyage.

2 THE GREAT EXPLOSION

IN THE THIRD week of April in 1915, Canadian troops were engaged in some of the most notorious battles of the Great War. Late in the radiantly sunny afternoon of April 22, German soldiers seven kilometres north of Ypres released onto a northeast wind 168 tons of chlorine gas. Within minutes, the 3rd Canadian Brigade was reporting "a cloud of green vapour several hundred yards in length" approaching the French trenches to their left.[1] The Battle of Gravenstafel Ridge—later known as the Second Battle of Ypres—had begun.

Over the next few hours, as French and Algerian troops died in the trenches or staggered away in retreat, the Germans advanced four kilometres south into Allied territory. Late that evening, the 10th and 16th Canadian Battalions received orders to stop the Germans with a counterattack: they were to clear the enemy from an oak plantation called the Bois des cuisiniers and known to the English as Kitchener's Wood. The plantation with its captured British battery was retaken after a heroic charge under moonlight and machine-gun fire, but at a cost of more than six hundred Canadian lives.[2]

Two days later, more horror and more heroism. At four o'clock in the morning of April 24 the Germans released poison gas directly into the Canadian line northeast of Ypres at St. Julien. Realizing the

only place of safety was towards the German trenches, the Canadians rushed forward, urine-drenched cotton bandoliers serving as rudimentary gas masks. This latest confirmation of the ferocity of the Canadian troops was achieved at the cost of a thousand dead and almost five thousand wounded.

The use of poison gas, together with the Zeppelin raids over the English coast, the torpedoing of the unarmed British luxury liner R M S *Lusitania,* the deployment of "Big Bertha" artillery with shells weighing 820 kilograms, all served as brutal testament to the horrors of a war of unprecedented savagery. Stories abounded of German atrocities. In the middle of May *The Times* reported a crime of "insensate rage and hate," claiming a Canadian sergeant had been crucified against a fence by the Germans during fighting at Ypres: "Bayonets were thrust through the palms of his hands and his feet, pinning him to the fence. He had been repeatedly stabbed with bayonets, and there were many punctured wounds on his body."[3] A few days later a Canadian soldier wrote home claiming that not one but six Canadian soldiers had been crucified, their corpses marked with plaques warning other Canadians to stay at home.[4]

The course of these events was followed closely by A.Y. Jackson. A few months earlier he had been in no hurry to enlist, but by the spring of 1915 he was beginning to change his mind. Since returning to Montreal several months earlier he had taught an art class at the Art Association of Montreal and then gone to Émileville for some *plein-air* sketching. After the excitement of the "young school" developing in Toronto, however, Montreal was a disappointment. A letter to Arthur Lismer proclaimed him to be "out of sympathy with the art world here. Their whole outlook is so puny and narrow." Events in Europe, furthermore, had left him increasingly unsettled. "The war is not giving me much inspiration to paint," he lamented.[5]

Not only had Jackson's friend Randolph Hewton volunteered, but so too had his brother as well as Arthur Nantel, his former boss at the lithography firm where he had begun his career. Besides the radio reports and the newspapers, there were posters on every street corner urging people to purchase war bonds, donate to the Patriotic

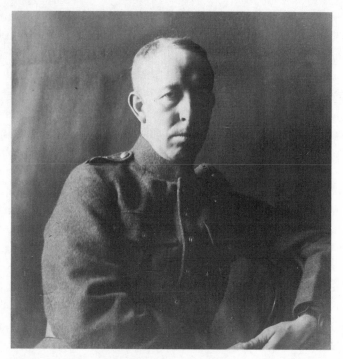

Private A.Y. Jackson, c.1915
McMichael Canadian Art Collection Archives

Fund, increase productivity, support the Canadian Red Cross (the wife of whose founder perished on the *Lusitania*) and, of course, enlist. At first Jackson disparaged such patriotic appeals. "The Canadian spirit which one hears so much about won't stand very close inspection," he predicted to Lismer at the beginning of February. He found it inconsistent and richly ironic that in peacetime, newspapers force-fed Canadians a constant diet of American news and entertainment—"divorce scandals, stock comic pages"—but now suddenly they began urging Canadians to "be British" and fight for their heritage.[6] But news of the Canadian heroism at Kitchener's Wood and St. Julien forced him to reconsider. Nantel, who had joined the 14th Royal Montreal Battalion at the age of forty-one, was captured by the Germans at the Second Battle of Ypres. Jackson learned of the battle, and of the poison gas attacks, one morning in late April. "I knew then that all

the wishful thinking about the war being of short duration was over."[7] By the middle of June he had enlisted in the 60th Canadian Infantry Battalion (Victoria Rifles of Canada). He was not alone: 35,000 other Canadians joined up in the weeks after the Second Battle of Ypres, virtually doubling the number of Canadians under arms.[8]

Jackson's height was recorded as five foot six inches, and he was given the regimental number 457316. Lawren Harris, in a characteristic gesture of generosity, urged Jackson to apply for an officer's commission, offering to defray all expenses. "But I knew nothing about soldiering," Jackson later wrote, "and decided to start at the bottom as a private in the infantry."[9]

Jackson went with the thousand other men of the "Silent Sixtieth," as the battalion was known, to Camp Valcartier, twenty kilometres northwest of Quebec City. Here, on a twelve-thousand-acre site, he and his fellow recruits began learning the art of handling guns.

ALTHOUGH TWO-THIRDS OF those who enlisted in the Canadian Expeditionary Force in the first months of the war were British immigrants, the three English-born members of the "young school"— MacDonald, Lismer and Varley, all with wives and young children to support—remained in or near Toronto. In the spring of 1913 MacDonald had moved with his wife and twelve-year-old son, Thoreau, to Thornhill, twenty kilometres north of downtown Toronto. For the best part of a year they rented a red-brick house before moving in the spring of 1914 to a clapboard farmhouse with a stable and four acres of land. MacDonald paid $6,500 for the property, promptly christened Four Elms. From here he commuted down Yonge Street, on the Toronto and York Radial Railway, to work at the Studio Building.

There was increasingly little commercial work for MacDonald. One of his few sources of income was the $500 first prize in a contest to design a colour poster for the Patriotic Fund, which offered financial support to the wives and families of Canadian soldiers overseas. For *Canada and the Call,* he depicted a white-robed figure of Britannia holding a Union flag and resting her hand on the shoulder of a coverall-clad ploughboy as the pair gazed at a troop of Canadian

soldiers marching determinedly past. Behind them, in a delicate spray reminiscent of A.Y. Jackson's *The Red Maple,* were the crimson leaves of a maple sapling.

Even with the prize money, MacDonald, forced to meet hefty mortgage payments on Four Elms, was suffering financially. "The hard times are hitting Jimmie pretty badly," Frank Carmichael wrote to Ada Went, "perhaps worse than any of the rest of us." (Carmichael too was having financial woes: on the eve of his marriage, he was preparing to move to Bolton and take work decorating hearses for the local undertaker.) Compounding MacDonald's problem was the fact that his wife, Joan, suffered health problems: she was, according to Carmichael, "invalided most of the time."[10] Her parents soon moved into the farmhouse to help MacDonald care for her.[11]

Although the National Gallery made a timely purchase of *Snow-Bound,* MacDonald's earnings nonetheless dropped so drastically in 1915 (he would earn only $624 for the entire year)[12] that in the spring he and Joan took in lodgers: Arthur Lismer and his wife and daughter. The Lismers were likewise in dire financial straits. Lismer had even abandoned his space in the Studio Building and—much to the dismay of Thomson, who hated to see his private sanctum invaded—moved his painting gear temporarily into the shack.[13] He moved his family into Four Elms and, with the help of MacDonald and his son, tried to ease their mutual plight by growing vegetables both for their own dinner plates and for ready cash.

The asperities of the war had forced MacDonald into the kind of self-sufficiency practised by the man after whom he named his son. MacDonald had always admired Henry David Thoreau. According to his old boss at Grip Limited, Albert H. Robson, his favourite authors were Thoreau and Walt Whitman.[14] What he admired in *Walden,* first published in 1854, seems to have been the same thing that Lismer esteemed in one of his own idols, Edward Carpenter: a critique of a society in which wealth and material possessions caused a deterioration of the human spirit. Thoreau was distressed by such "improvements" to nineteenth-century life as the telegraph, the railroad and the "quack vials" of modern medicine. He wished human beings to become a harmonious part of nature rather than, as many

believed themselves to be by the middle of the nineteenth century, a distinct and domineering force. It was an appealing philosophy for many of the Algonquin Park painters and one that might have provided some consolation for the frail MacDonald as he leaned on his hoe in the garden at Four Elms.

Four Elms included on its west side a garden planted with sunflowers, asters and chrysanthemums, beyond which lay an apple orchard and an old stable. MacDonald's first winter in the house had seen him painting the view of his snow-laden spruce trees; in the summer of 1915 he made sketches of his new garden. Reaching for the brightest pigments in his paintbox, he depicted large sunflowers drooping amid the dazzling colour of the purple asters and blood-red chrysanthemums. Lack of funds meant he worked on pieces of fibreboard—used by bookbinders—rather than wooden panels or canvas.

Around the same time, MacDonald painted a work of a different sort, a poster designed for the war effort but apparently never printed. Already he had done a stark image of warfare for the December issue of the *Canadian Magazine,* the original of which he exhibited at the 1915 OSA exhibition. Satirically entitled *Forward with God,* it portrayed a sword-wielding Kaiser Wilhelm astride a white horse being led by a skeleton across a field sewn with corpses and skulls. His poster *Belgium* was equally graphic: a menacing-looking black bird perched on a bare tree above a hooded woman with her head sorrowfully bowed (see plate 17). If these figures were inspired by Symbolist images such as those in Carlos Schwabe's classic *The Gravedigger's Death,* in the background MacDonald offered a vivid portrayal of no man's land: pools of stagnant water, the spectral silhouettes of trees, a ruinous purple sky. Both it and *Forward with God* were what a friend of MacDonald, the painter Estelle Kerr, called his "suggestive war-paintings."[15] Although MacDonald might have done these works on commission, there is no mistaking his revulsion at the abominations of modern warfare that had plunged the world into destruction.

TOM THOMSON WAS likewise troubled by the Great War in the summer of 1915. He was deeply distressed to learn in July that Jackson had enlisted. "I can't get used to the idea of Jackson being in the machine,"

he wrote to MacDonald the week after Jackson was sent to Valcartier, "and it is rotten that in this so-called civilized age such things can exist."[16]

Thomson's comments reveal a horror at the war consistent with his reading of Norman Angell. But two rangers working in Algonquin Park in 1915 claimed that he tried to volunteer for service. Bud Callighen, with whom Thomson transported tourists by canoe from Joe Lake Station to Smoke Lake, told a visitor that in the spring of 1915 Thomson "was lamenting the fact that he could not enlist in the Army" and vowing to "get over yet" despite the fact that, as Callighen put it, "certain persons interested in Tom objected to his abandoning his art career to go overseas."[17] The truth of this story, related three decades after the fact, is impossible to confirm. It is plausible that Dr. MacCallum—who clearly regarded Thomson as the most adept and promising of the Canadian School—should have tried to talk his protege out of enlistment. Less plausible is the fact that a thirty-eight-year-old man who wished to serve overseas would have bowed to such pressure.

A different version was provided by the park ranger Mark Robinson. He later claimed that Thomson did attempt to enlist in the Canadian Expeditionary Force at a station in Kearney but "was turned down and felt very keenly about it." He then apparently tried again in Toronto, with the same result, and finally "went to some outside point in the country" (possibly Owen Sound, where the 147th Grey Overseas Battalion was recruiting in 1915) only to be rejected for a third time.[18] One of his sisters, visiting from Saskatchewan, likewise believed he had made at least one unsuccessful attempt to enlist.[19]

It is possible that, despite his abhorrence of the "machine" of war, Thomson volunteered for service in 1915 only to be rejected, possibly because of "a foot not properly arched" or the broken toe from that long-ago football game (the reason he was supposedly turned down for service in the Boer War). Certainly fit and able men were sometimes declined for no apparent reason. Frank Carmichael was declined on minor medical grounds, and a future Victoria Cross winner, G.B. McKean of the Royal Montreal Regiment, was rejected for service three times before he was able to enlist in January 1915. At

most recruiting offices, the failure rate for medical reasons was as high as 70 per cent. Potential recruits could be turned away because of bad teeth, poor eyesight, a lack of height or a chest of inadequate circumference.[20]

With heavy casualties sustained in the spring of 1915, with recruitment dwindling after the initial euphoria and with Prime Minister Borden preparing to commit Canada to raising a force of 500,000 troops, the authorities could ill afford to be so selective with their exemptions and rejections. In the summer of 1915 some of the physical requirements were relaxed, making eligible for service those previously turned down because of bad teeth or short stature. In such times an able-bodied outdoorsman, even one nearing his fortieth birthday, would not have been spurned without good reason. In any case, rejection by the military authorities seems unlikely given how Thomson impressed almost everyone with his physical prowess. A doctor whom he met in 1915 was astounded at how he could hoist a heavily laden canoe to his shoulder "without help, and seemingly without effort."[21]

Another of the park rangers claimed that he and Thomson discussed the war many times and that Thomson did "not think that Canada should be involved." He was adamant that Thomson would never have offered himself for service.[22] It seems more likely that Thomson was kept out of uniform by his pacifist beliefs, not by either Dr. MacCallum or fallen arches.

AS IN 1914, Thomson spent the whole of the summer in Algonquin Provincial Park. The park had changed dramatically since the previous year. The war was good for the lumber industry, because the curtailment of Britain's supply of pulp and paper from the Baltic meant Ontario's mills were working around the clock and timber cutting continued, as the *Toronto Daily Star* reported, on a more "vigorous scale than ever."[23] But the Grand Trunk's full-page advertisements had disappeared from British newspapers, and the hotels and campsites were depleted of tourists.

Despite these adverse conditions, Thomson lent $250—half of what he received for *Northern River*—to Shannon Fraser. Undaunted

by the dwindling tourist traffic, the Mowat Lodge proprietor was expanding his enterprise and to that end was hoping to purchase a fleet of new canoes to rent to fishermen and other visitors. Turned down by a bank in Huntsville, he appealed to Thomson, who, ever open-hearted and generous, if sorely lacking in financial acumen, handed over the money.[24]

Thomson had cause to regret his generosity, because finding work as a fishing guide proved difficult. As he wrote to J.E.H. MacDonald, "there are more guides than jobs."[25] These jobs were potentially lucrative, with wealthy Americans willing to pay handsomely for the best angling guides. The most renowned guide in Algonquin was a man known as "Nipper." The prestige of securing Nipper's services was deemed worthy of inclusion in the society columns of the *Toronto Daily Star* as an indication of social standing (Thomson's name failed to appear in these pages: evidence that his reputation as a woodsman was not as lofty as Lismer and others suggested).[26] In the lean summer of 1915 the presence of a Toronto artist, a latecomer to the bush, was not endearing to the seasoned regular guides. They resented Thomson's presence because he provided unwanted competition for the few existing jobs: one of the guides, according to Mark Robinson, "made a kind of a slighting remark about Thomson."[27]

Feeling unwelcome in the park, Thomson began contemplating a trip to the Prairies for the annual harvest excursion; two of his sisters lived in Saskatchewan. But in the end he decided against the expedition and remained in the park, painting as best he could. Even the weather conspired against him. "We have had an awful lot of rain this summer," he complained to Dr. MacCallum, "and it has been to some extent disagreeable in the tent, even with a new one, the very best, you get your blankets wet and if you spread them out to dry it is sure to rain again."[28] He managed to keep active, hiking as well as canoeing. His sister Louise recalled that he was a "great lad to walk": on one occasion, she claimed, he had walked ten miles through a blizzard.[29] One day in the summer of 1915—as if to dispel any doubts about fallen arches or broken toes—he hiked fourteen miles through the bush carrying a sketchbox and a rifle. He returned to his campsite with a fox, seven partridges and a brace of sketches.[30]

At the beginning of September Thomson arrived in South River, a small town of dirt streets and wooden sidewalks midway between Huntsville and North Bay. It had a sawmill, a gristmill, a hydroelectric power station and a hotel, the New Queen's, where he took a room. He visited one of his friends from the park, a ranger named Tom Wattie, for whom he made a partridge and dumpling stew. He was planning another long voyage back into the park, but by this point the solitude of the bush was becoming too much even for a loner like Thomson. "If Lismer or any of the boys can come," he wrote to Dr. MacCallum, "get them to write me at South River. I should like awfully well to have some company."[31]

But Thomson was unable to tempt his friends in the Studio Building to join him, so he paddled alone to North Tea Lake. He was aiming, he informed Dr. MacCallum, to make it to Mattawa, almost a hundred kilometres distant.[32] Harris and MacDonald had visited Mattawa, a former fur-trading post at the junction of the Ottawa and Mattawa rivers, in the spring of 1913. They travelled via the CPR from North Bay and stayed in the comfort of the Mattawa House Hotel.

If Thomson reached Mattawa by canoe, his journey was more hazardous, comparable with the one he took in the summer of 1914. Alexander Henry, the eighteenth-century traveller, described "extremely difficult" portages and walls of rock on either side of the Mattawa River, with the corpses of drowned Indians placed on the narrow ledges of the chasm.[33]

THERE ARE INTRIGUING parallels, at this point in their careers, between Thomson and his exact contemporary, the English poet Edward Thomas. Both were late bloomers, both were dogged by self-doubt, both expressed themselves most powerfully and prolifically after war was declared in 1914. The onset of war caused Thomas to lose his paying job (penning literary reviews) and then to anguish over whether or not to enlist and become, at the advanced age of thirty-seven, "the oldest bald head in the battalion." A remarkable burst of creative energy in the first year of the war—partly inspired by his friend and mentor, the American poet Robert Frost—saw him produce more than a hundred poems that would later win him (in

the words of Lloyd George) "triumph and renown." The Great War, according to Frost, turned Thomas into "some sort of a new man and a poet."[34] It was as if he sensed the end was near, and indeed it was. In July 1915 he enlisted in the Artists' Rifles, and in April 1917 he was killed at the Battle of Arras.

Thomson, too, took powerful artistic strides through 1915, as if his fears, anguish and uncertainty, together with the inspiration of a fellow artist, unleashed imaginative intensities. He painted more than a hundred sketches during the summer and early autumn of 1915. Many he sent in a trunkful to MacDonald with instructions to "spread them around in the shack as I'm afraid they will stick together a good deal."[35]

Just as MacDonald was making sketches of his garden at this time, several of Thomson's works were brilliantly coloured close-ups of Ontario wildflowers—marguerites, wood lilies, vetch and water irises.[36] His interest in botanical subjects no doubt went back to the influence of his great-uncle, Dr. William Brodie, the great naturalist with whom he used to collect specimens along the bluffs and in ravines around Toronto. He painted with enough detail that the species of the individual flowers were identifiable, though his strong patterning and decorative style—the bright patchworks of colour—indicate an interest in visual effects rather than horticultural particulars.

These tranquil images of wildflowers were atypical of Thomson's work in the summer of 1915. He was continuing to work in radiant colour, but the peaceful panoramas of previous years—the calm, reflective lakes and distant shores in silhouette—had been replaced by agitated images of tumultuous clouds and churning waters. Works such as *Evening* (see plate 18), *Hot Summer Moonlight* and (especially) *Sunset* showed spectacles of ebullient colour, with great breakers of cloud tinged puce, gold and (in the case of the last painting) mercurochrome red.

There were probably geological and meteorological reasons for these molten sunsets. On May 22, 1915, in what became known as "The Great Explosion," Lassen Peak erupted in California, showering volcanic ash for hundreds of miles and veiling the northern hemisphere in stratospheric aerosols that caused the spectacular sunsets

seen by Thomson a short while later. He was only the latest artist whose sunset paintings recorded the after-effects of volcanic eruptions. Turner painted some of his trademark incandescent skies following eruptions in the Philippines and Nicaragua in the 1830s, and the blood-red sky of *The Scream* was influenced by "tongues of fire" seen by Munch in the sky above Christiania a few months after Krakatoa's 1883 eruption.[37]

Another of Thomson's sketches, *Fire-Swept Hills,* a moonscape of livid purples, mauves and pinks, showed an even clearer environmental influence: the aftermath of one of the forest fires that regularly swept through the Canadian woods in summer. The sketch undoubtedly illustrates a scene witnessed by Thomson, but in this eerie image of scorched earth and burned trees it is not difficult to see an allusion to the Great War not unlike MacDonald's more straightforward depictions in *Forward with God* or *Belgium*. Reports of the horrors of the war filled the newspapers in the summer of 1915, with Canadian troops seeing further action at the Battle of Festubert in May and the Battle of Givenchy in June.

One of his sketches was particularly haunting. Thomson painted a number of logging scenes in the summer of 1915. The lumber industry was traditionally hazardous, with the Mattawa having once claimed the lives of seven men as they tried to clear a logjam.[38] Innovations such as timber slides and caulked boots with quarter-inch spikes lessened the death toll, but logging was still a risky occupation, and its violence and tragedy were captured by Thomson in *Crib and Rapids*. A timber crib was a large raft assembled, for ease of transporting lumber, from as many as two dozen squared logs. The crib, typically thirty-two feet long, would be floated along the river and, in one of the industry's most treacherous procedures, steered down wide timber slides by a pole-wielding raftsman—a manoeuvre likened by the plucky hero of Oxley's *The Young Woodsman* to "tobogganing on water."[39] A raftsman missing the slide would find himself and his crib going through rapids or over a falls, causing the crib to break up and the raftsman to become a statistic.[40]

Thomson's *Crib and Rapids* shows the aftermath of such an incident. As logs from a disintegrated crib eddy in the churning waters,

two are forced upright and intersect to form a Latin cross.[41] The sketch is an image of peril and death, a testimonial to the hazards of the lumber industry and—with the thirteen crosses beside the French River in mind—rapids in general. The air of mortality about the painting also suggests anxieties about the war. How Canadians who fell in foreign lands should be commemorated was a topic of much debate at the time. In Canada and Britain both, patriotic faith in the "sacred cause" of the war meant that, despite the massive casualties, the elaborate mourning rituals of the Victorian era were abandoned, and mothers were urged not to mourn their lost sons. Sir Edmund Walker even balked at plans for the government to present a Latin cross to the mothers of fallen soldiers, saying that such funereal symbols would not "serve the purpose."[42]

But Latin crosses did make their way into the public consciousness. In early May 1915, John McCrae composed "In Flanders Fields," with its description of "the crosses, row on row, / That mark our place." The poem was not published in *Punch* until early December, but by the autumn Thomson must have known how the temporary grave marker for a casualty of the Great War was a simple wooden cross with a painted inscription, usually done by surviving members of the regiment. A front-page report in the *Toronto Daily Star* in early May, for example, reported how the graves of Canadian soldiers in Belgium and France were marked with "nothing but a little wooden cross," to which chaplains and surviving members of the regiment sometimes added "little flags with a maple leaf."[43]

At first an emblem of death, the wooden cross quickly became a symbol of the war itself, reinforced by such things as the giant wooden calvary at Ypres that miraculously survived German shelling, and ultimately by Roland Dorgèles's novel *Les Croix de bois.*[44] Although wayside crosses appeared as votive symbols all over Britain during the Great War, in some parts of Canada these crossroad calvaries possessed a different meaning: many Québécois erected wayside crosses to ask protection from the army's recruiters.[45] It was a gesture with which Thomson, conflicted in his feelings about the war, would have been in some sympathy.

THE "SILENT SIXTIETH" trained at Camp Valcartier for four months. Along with the 1,024 other men in the battalion, A.Y. Jackson learned how to march, shoot and fight hand-to-hand with bayonets. His daily rations included an ounce of cheese, an ounce of tea, two ounces of sugar and, as the weather cooled in autumn, a cubic foot of wood. The "ill-assorted, motley crowd of civilians" recruited in Montreal was gradually transformed into a "sunburned, hardened, disciplined" battalion.[1] On November 6, 1915, the men boarded ss *Scandinavian* to ship overseas.

The war on the Western Front was proceeding miserably as the Allies failed drastically in their autumn offensive against the Germans. The French suffered massive casualties of nearly 150,000 men in the Battle of Artois, while the British fared little better in their efforts at Loos, with 50,000 dead or wounded. With ever more troops needed in the trenches, the British secretary of state for war, the Earl of Derby, began threatening unmarried men with compulsion should they fail to volunteer by the end of November.

Arriving in England, the 60th Battalion was detached to the 9th Infantry Brigade of the newly formed Canadian 3rd Division. Jackson began further training "in the mud and rain" at Bramshott Camp in

Hampshire, sixty kilometres southwest of London.[2] He was among the first Canadian arrivals, since Bramshott Camp—known as "Mudsplosh Camp"—opened to Canadian troops only in October. It featured wooden huts for barracks, a corrugated-iron YMCA and a recreational facility dubbed "Funland," complete with billiard tables and a rifle range. There was also a cockney bayonet instructor who urged his students to "Fink it's yer muvver-in-law" as they lunged at sack dummies.[3] The men were forced to rise at 4:30 in the morning and march ten kilometres to the rifle range before marching back to camp. "It's very interesting," Jackson wrote pluckily to his mother, "but also very strenuous."[4] To MacDonald he was less doughty: "Someday it may seem heroic but at close range it seems to be made up of filth, irreverence, booze, and petty authority."[5] A natural rebel like Jackson must have chafed under this petty authority, especially since, according to one of Jackson's fellow recruits, the future economic historian Harold Innis, the British officers treated their Canadian underlings with "insolence and brutality."[6]

These lessons lasted three months. In the third week of February 1916, after a "rather chilly trip across the Channel," lashed by sleet and snow, Jackson and his battalion landed in France.[7] They joined the fifty thousand other Canadian troops serving in the field. One day earlier, a million German troops had begun their assault on Verdun.

THE SITUATION FOR Canadian artists was made ever more discouraging when on February 3, 1916, a fire on Parliament Hill destroyed the Centre Block. Reconstruction began almost immediately, but in the meantime Parliament took over the space in the Victoria Memorial Museum occupied by the National Gallery. As Eric Brown lamented, in 1916 the National Gallery "passed out of existence."[8]

186 With the National Gallery's quarters commandeered and its budget slashed, the artists in the Studio Building could at least count on their other faithful patron. In the autumn of 1915 Dr. James MacCallum commissioned MacDonald, Thomson and Lismer to paint murals for his cottage on Go Home Bay. Dr. MacCallum envisaged, as a surprise for his wife and children, a series of murals running in a

metre-high frieze around the top of the living room walls. The wall space was broken up by windows, a door and, on the west wall, a large stone fireplace topped by a stone chimney breast. In the middle of October the three painters went to Georgian Bay to take measurements (slightly inaccurately, as it turned out) and sketch the layout of the living room.

The three men were busy in the Studio Building over the next few months as they worked on the commission, for which MacDonald (recently forced to borrow money from his father-in-law) received a much-needed $140. Thomson and Lismer worked together in near-indigence in the shack. Lismer did several lighthearted cartoons illustrating their life. One showed Thomson smoking a corncob pipe and stirring a steaming pot on a cast-iron stove as Lismer looked on. Another, called *"Too Much Mulligan,"* featured the pair looking dazed and replete, with Thomson sprawled on a chair and Lismer sitting head in hands. But the men's luxuries were few. When M.O. Hammond, city editor of the *Toronto Globe*, visited the shack in December, he found the premises "awfully bare." The two men, he wrote, "work together and are about bankrupt." They did without a fire, Thomson explaining that the stove did not draw well for want of a longer pipe. "But I perceive the real reason is no money for fuel."[9] Tellingly, *"Too Much Mulligan"* showed Thomson wrapped for warmth in a greatcoat.

All three men painted their murals on beaverboard, a material used for insulation (Harris had lined the walls of Thomson's shack with beaverboard). MacDonald executed two large panels, each almost 2.5 metres high, to go on either side of the chimney breast. Rather than landscapes, they were vignettes of Canadian history. He already had experience at historical scenes, since in 1912 he and C.W. Jefferys produced illustrations for *The Index and Dictionary of Canadian History*, part of the twenty-volume "Makers of Canada" series published by George N. Morang (who regarded his work as "an exercise in nation-building").[10] For MacCallum's cottage, MacDonald chose historical scenes of local importance, showing both the past and the present inhabitants of Go Home Bay. One mural featured Hurons, a French explorer and a Catholic missionary beneath arching

Arthur Lismer (Canadian, 1885–1969), *Too Much Mulligan,*" 1915
graphite on wove paper, 19.7 × 25.4 cm
National Gallery of Canada, Ottawa, Gift of the artist, Montreal, before 1946

jack pines, the other a trapper, a fisherman and a lumberjack. The lumberjack, a sturdy if gloomy fellow grimly clutching an axe, a kind of saturnine Paul Bunyan, was a portrait of Thomson, whom Hammond had found a "well built chap with . . . the hands of a woodsman."[11]

MacDonald also paid a tribute to another of his friends in a small panel called *A.Y. Jackson Sketching.* The work showed Jackson, booted and wearing a hat, standing before a pine-topped cliff, busy at his sketchbook as a mass of threatening storm clouds rolls in. The small scene was an acknowledgement of the artistic inspiration provided by Go Home Bay as well as a tribute to his friend who had gone overseas.

Lismer painted two panels that memorialized his own first visit to the "happy isles" two years earlier. *The "Skinny Dip"* and *The Picnic* were idyllic scenes from summer holidays played out under blue skies and white cumulus clouds—the kind of Georgian Bay scenes, in other words, that Thomson had belittled as "North Rosedale." More

J.E.H. MacDonald (Canadian, 1873–1932), *Inhabitants of Go-Home Bay,*
Times Past, 1915–16, and *Inhabitants of Go-Home Bay, The Present*, 1915–16,
oil on beaverboard (four irregular panels assembled), 243.2 × 174.3 cm and
242.6 × 161.3 cm National Gallery of Canada, Ottawa, Gift of Mr. and Mrs. H.R. Jackman, Toronto, 1967

fancifully, Lismer painted a dragon for the gable of the doctor's
boathouse.

Thomson's contribution to the effort was more modest than that
of his colleagues: seven panels showing trees and undergrowth (the
incorrect measurements meant four of them were too big and were
therefore never installed). These presented, in thick outlines and
bright autumn colours, a series of stylized images of profuse, inter-
twining plants (see plate 19). The heavy outlining of the clusters and
stems—an effect recalling the lead joints in stained glass windows—
reveals a debt not only to the "cult of the line" of Art Nouveau but
also to European movements such as Cloisonnism, developed by the
Gauguin-inspired Pont-Aven School in the 1890s and characterized by
one practitioner, Paul Sérusier, as "this craze for using large dark-blue
outlines to emphasize the form."[12] It was a style to which Thomson
would return in one of his larger paintings.

BESIDES THEIR MURALS, the painters were busy on other works in the winter of 1915–16. Thomson was able, despite his straitened circumstances, to purchase several large canvases on which to work. In the last weeks of 1915 he painted *In the Northland,* a kind of reworking of *Northern River* showing a lake through a screen of birch trees. It was a study in clashing colours, the chill blue of the lake contrasting with the school-bus yellow of the birch leaves. Thomson probably knew how the yellow-against-blue combination had been a trademark of Van Gogh, who used these complementary colours to enhance the brilliancy and visual dynamism of his canvases.

These same contrasts show up in other works Thomson was painting at the time, such as *Spring Ice* (yellow rocks against a blue lake) and *Autumn's Garland.* The latter canvas was almost as stylized in design as the vegetation panels for Dr. MacCallum's murals. A rich feast of shades of yellow and orange—persimmon, gamboge, burnt orange—it featured swags of crimson foliage draped across a forest of blue-trunked trees and (more clashing colours) vivid planes of orange. Like *Northern River,* with its allusion to Henrik Krogh's tapestry, *Autumn's Garland* revealed how Thomson did not approach nature with a blank mind as well as a blank canvas. The scene was self-consciously composed, from the flattened background with its lack of spatial recession to the choice of colour and the application of paint with a wide brush. It was not the work of a traditional landscapist so much as the confection of a theatrical set designer.

In his atelier at the top of the Studio Building, MacDonald was likewise preparing works for the 1916 OSA exhibition. One of them, *The Elements,* was a striking portrait of an eerie wilderness. Based on a sketch done on Georgian Bay the previous October, it was dramatically different from a prettified work like *Autumn's Garland* in its approach to the landscape of the Precambrian Shield. The work shows the harsh contours of rock overhung by an equally forbidding tower of thundercloud. Two figures (probably Thomson and Lismer) huddle before a campfire, their small forms dwarfed and seemingly menaced by a pair of looming jack pines. The fact that these scarecrow pines resemble the spectral tree silhouettes in the background of *Belgium*

suggests that this image of human vulnerability in the face of powerful and oblivious forces had another significance for MacDonald as he painted it during some of the bleakest days of the Great War.

Another painting MacDonald was completing for the exhibition was a large version of the sketches made the previous summer in his garden at Four Elms. Called *The Tangled Garden,* it was painted on the same kind of beaverboard used for the MacCallum murals—an indication of how MacDonald was forced to economize with his materials (see plate 21). Showing sunflowers drooping in arabesques over a bright blaze of asters, the painting promised to be one of the most chromatically adventurous paintings ever put on show in a Toronto exhibition. More spumes of colour were found in another of his entries, *Rock and Maple.* This latter work, based on sketches done in the Haliburton Highlands, exhibited daring brushwork and, if anything, an even more audacious use of colour—a giddying rush of water streaked with rust, yellow, green and cobalt blue. Above this multicoloured stream, among green-tinged boulders, MacDonald added foliage of intense yellows and oranges.

MacDonald must have worried about the possible reception of these paintings. Reviewers had so far shown sympathy for what he called the "distinctly Native art" emerging from the Studio Building. But would Torontonians, nourished on snuff-brown landscapes, be ready for *The Tangled Garden* or *Rock and Maple?*

Visitors to Canadian art galleries did not expect to be assailed by bright colours. In Canada as elsewhere, traditionalists regarded colour as less important than design, drawing, perspective and subject matter. A connoisseur once lectured John Constable, "A good picture, like a good fiddle, should be brown."[13] Colour was viewed as decadent and meretricious, addressing the baser senses rather than the intellect. The French Impressionists introduced brighter colours into their canvases, thanks in part to the advances in chemistry that resulted in new pigments such as coal-tar mauve and alizarin red. Still, as recently as 1905 a group of painters led by Matisse and Maurice de Vlaminck caused outrage when their brilliantly hued works appeared in Paris. The point of their garish and often unexpected uses of colour was a

visual and emotional impact they believed Old Master hues could not deliver. "The chief function of colour," as Matisse proclaimed, "should be to serve expression as well as possible."[14] They quickly became derided as *les fauves* (wild beasts).

Those who regarded landscapes as a pictorial balm for weary eyes and shattered nerves were shocked by the savage colours and tentacular lines of the Fauves and other Post-Impressionists. French critics claimed—probably quite sincerely—that the swirls and colours left them overstimulated and seasick. A critic for the conservative journal *Le Figaro* once reeled out of a display of paintings by the Nabis feeling "exhausted, sick, exasperated, my nerves on edge."[15]

Most of Toronto's critics and picture buyers believed good paintings were meant to mollify, not induce, this kind of nerve-shredding overstimulation. Like the work of the Nabis or the Fauves, the vivid tones of MacDonald's paintings almost seemed guaranteed to cause alarm.

THE TANGLED GARDEN and *The Elements* appeared along with 136 other paintings when the 1916 OSA exhibition opened on March 11. MacDonald might have been reassured about his position when, on the eve of the exhibition, he was elected vice-president of the OSA. The office of president was filled by C.W. Jefferys, one of his earliest supporters.

These good omens proved to be a false dawn for the Algonquin Park School. The *Toronto Daily Mail & Empire* gave the show a positive review, headlining its article "Ontario Artists do Daring Work." Commenting on *The Elements,* the *Mail & Empire* reviewer noted that the work was "almost post-impressionistic in its lack of realism... All the lines are grotesque, the artist having apparently laboured to secure this effect, and the colours of the various elements are challenging in the extreme. Although the picture is not realistic, it does suggest a driving gale."[16]

Not everyone was pleased with these garish exploits. Although recently full of praise for their "virile" style, Margaret Fairbairn expressed reservations about "their use of strong, even violent, colour." *The Tangled Garden* seemed to her, at first glance, nothing more than

"a purposeless medley of crude colours," and *The Elements* resembled "a whirl of chaotic shapes." She believed Thomson, too, was in danger of overreaching himself with his "fearless use of violent colour which can scarcely be called pleasing."[17]

A week later the assistant editor of *Saturday Night*, Hector Charlesworth, expressed even greater reservations. Charlesworth had previously praised the "pigmentary enthusiasm" of the painters, but in a review headlined "Pictures That Can be Heard" he claimed to dislike the "experimental pictures" on show in 1916. MacDonald was, he believed, the "chief offender." He made a self-conscious repetition of the famous 1877 attack by John Ruskin on Whistler: MacDonald was guilty of "throwing his paint pots in the face of the public." In a repeat of the sophomoric Hot Mush insults from 1913, he dubbed MacDonald's paintings "A Hungarian Goulash" and "A Drunkard's Stomach."[18]

The forty-three-year-old Charlesworth, known by MacDonald, a fellow redhead, as "Copper-head Hector," was a former music critic with the *Mail & Empire*.[19] He knew little about and cared less for modern painting. His magazine, *Saturday Night*, was a deeply conservative and sometimes blatantly racist organ. A 1906 article entitled "Chinamen" had denounced the "slant-eyed Asiatic" with his "yellow skin" and "unmanly humility" as a "yellow stain" on "a white man's country" such as Canada. Five years later, another article attacked "the Negro" as "indolent, prodigal, and shiftless." French Canadians meanwhile were "insular," "bigoted," "ignorant" and "narrow."[20] Although Charlesworth himself probably did not subscribe to these repellent views, he was writing for a magazine whose readership by and large feared change, whether the "yellow stain" appearing in British Columbia or the bright stains of colour appearing in modern art.

Charlesworth's malicious assault was exactly the kind of response MacDonald had been dreading ever since his 1913 plea with the critics to show "an open eye and perhaps a little receptivity of mind." Charlesworth did not even represent the nadir of opinion. An even more mean-spirited attack came from the painter Carl Ahrens, a friend of Charlesworth. In an interview with the *Toronto Daily Star*, Ahrens deplored the "blustering spirit of post-Impressionism" on show

at the OSA in 1916. The exhibition featured, he lamented, "samples of that rough, splashy, meaningless, blatant, plastering and massing of unpleasant colours which seems to be a necessary evil in all Canadian art exhibitions these days... Nobody visiting the exhibition is likely to miss having his or her sense of colour, composition, proportion and good taste affronted by some of these canvases."[21]

The fifty-four-year-old Ahrens was an interesting character.[22] A native of Winfield, Ontario, he specialized in soft, elegant landscapes painted in close tones that belied his turbulent nature and adventurous past. The grandson of a German nobleman, he followed up youthful escapades in Lesser Slave Lake and the Dakota Territory with stints as a button-dyer in Waterloo and a dentist in Nebraska. In 1887 he downed his dentist's drill and a few years later moved to New York City to study painting under William Merritt Chase. He had exhibited his work since the 1890s, specializing in woodland interiors whose idyllic moods and narrow tonal range suggested the prevailing taste for Barbizon and Hague School landscapes. According to his second wife, he regarded the act of painting as "an intensely sober and even mathematical problem... The laying on of color in flat masses in the modern manner was an anathema to him."[23] He had found a generous patron in the Toronto barrister Malcolm Mercer, but in 1916, with Mercer in uniform overseas, Ahrens, like so many other artists, had fallen on hard times. In the spring of 1916 he was preparing to take up a post as a game warden at Kawartha Lakes.

Ahrens possessed a wanderlust and a love of the outdoors, and the previous three summers he had lived and painted in Leith, Thomson's hometown on Georgian Bay. But the artists in the Studio Building found his works too tepid for their tastes. His comments in the *Daily Star* might have been revenge for a 1911 review by Lawren Harris that disdained his works as "docile and inoffensive."[24] Ahrens himself proved anything but docile and inoffensive. His wife described him as a "virile masculine figure" with a "cruel streak." Those who had felt the force of his wrath, she claimed, "did not quickly forget."[25] His interview with the *Daily Star* concluded on a note of astonishing malice: he claimed the paintings showed not only "an absolute lack of knowledge

Carl Ahrens, 1911
Collection of Kim Bullock

of drawing, colour, and design" but also "a hermaphroditic condition of the mind." He then concluded, "I feel that these young persons who are indulging in these pastimes would gain a much higher standing before men if they gave their now mis-spent efforts to the destruction of the Hun."

"Hermaphrodite" had long been a euphemism for homosexual.[26] The obvious implication was that the use of bright and "unpleasant" colours was an indication of effeminacy, a sign that the artist was an "Oscar Wilde type." This was not the first time modernist painters saw aspersions cast on their masculinity or sexuality, since in 1910 reviewers of Roger Fry's *Manet and the Post-Impressionists* dismissed the French painters as "unmanly" and "girlish," and the term sometimes used to describe Post-Impressionism—"greenery-yallery"—became synonymous with homosexuality.[27]

For the Canadian artists recently celebrated for their "virility"—for their brawny boulders and priapic pines—this challenge to their masculinity must have been unexpected. Some of them, Thomson in particular, seemed to offer examples of the sort of paddle-and-axe-wielding masculinity that MacDonald was busy depicting in his murals for Dr. MacCallum's cottage. Indeed, within a few weeks of Ahrens's vitriol, *Saturday Night* published an article by its resident sketch writer and satirist, Peter Donovan, jocularly recounting how the typical Canadian artist was now a "husky beggar" who pulled on a pair of Strathcona boots and set off into the "northern woods" with a rifle, a paddle and enough baked beans for three months. "He can't work in peace," wrote Donovan, "unless he has a bear trying to steal his bacon or a moose breathing heavily down his neck."[28] But Ahrens, with his reference to hermaphrodites, conjured for readers of the *Daily Star* clichés of a different nature: images of "long-haired effeminate freaks" in velvet suits and silk cravats.

THOMSON'S EXPLOITS WITH paddles and axes might have proclaimed a northwoods masculinity, but he had failed to fulfill society's most important criteria for manhood. These were succinctly described in 1919 by Franz Kafka (who also failed to fulfill them) as "marrying, founding a family, accepting all the children that come."[29] Thomson had also, of course, failed another important test of manhood: he had not enlisted in the Canadian armed forces.

Carl Ahrens, in his attack on the Studio Building painters, did not scruple to raise the controversial issue of enlistment. He implied that they were cowardly as well as epicene, since his injunction for them to fight the Hun contrasted their "mis-spent efforts" with the dangers being faced by young Canadians on the Western Front.

196 The suggestion that the painters should be shouldering rifles in the trenches of Europe was a timely one. Eighteen months into the war, Toronto and other Canadian cities were still stickered with recruitment posters, while gramophones in the armouries and other recruiting offices blared hastily composed patriotic songs such as "Your King and Country Want You" and "Canada Fall In!" Three

hundred thousand Canadians had fallen in by the start of 1916, and Prime Minister Borden was promising to raise the country's manpower commitment to half a million. Britain enacted conscription with the passing of the Military Service Act in January 1916, but with fierce opposition, especially in Quebec, Borden was reluctant to introduce such a measure to Canada.

Tactics turned more desperate as recruitment stalled in the face of long casualty lists and seemingly endless battles. Recruiting offices mushroomed all over Toronto, while sergeants wearing red, white and blue rosettes stalked the streets in search of likely young men. Recruitment drives were held at Massey Hall, and in August 1915, more than 100,000 people gathered in Riverdale Park to watch fireworks and hear marching bands play "Rule Britannia," "Tipperary" and "The Maple Leaf Forever." The festivities were punctuated by an event becoming increasingly common. The *Daily Star* reported how "two gay young ladies" had made their way through the crowd, "each carrying a small sofa cushion, the ends of which they had opened. And to the astonished and outraged young men standing around the girls were joyously doling out the white chicken feathers that stuffed their cushions."[30]

These gay young ladies were members of the Order of the White Feather, first instituted in Britain in the early weeks of the war when Admiral Charles Penrose Fitzgerald deputized thirty women in Folkestone to place white feathers—symbols of cowardice—in the lapels and hatbands of men not in uniform.[*] The *Toronto Daily Star* began reporting this "quaint" treatment of "slackers" (as it called them) before the end of September 1914.[31] Life soon proved difficult for young men in Canada as well. A December 1915 front-page headline in the *Toronto Daily Star* referred darkly to "unmarried slackers."[32] A popular song by Muriel Bruce called "Kitchener's Question" blared

[*] The symbol of the white feather comes from a 1902 novel by A.E.W. Mason, *The Four Feathers*, in which the hero receives the contemptuous gift of white ostrich feathers from his fiancée and his fellow soldiers after he resigns his commission rather than ship out to fight in Sudan. In 1915 the book was turned into a silent film directed by J. Searle Dawley.

Your Chums are Fighting, Why aren't You? : recruitment campaign
Library and Archives Canada, Acc. No. 1983-28-897

out from recruiting stations. It included the lines: "Why aren't you in Khaki? / This means you! / Any old excuse won't do..."[33] Even children got into the act, using yellow chalk to draw stripes down the backs of unsuspecting men.[34]

By the spring of 1916, around the time of Ahrens's accusations of cowardice and effeminacy, the rhetoric was becoming increasingly heated. A speaker at a mass rally in Toronto described as "degraded," "cruel" and "selfish" the voluntary system that saw some men "do

their duty" in Europe while others stayed at home.[35] A young art critic and journalist named Helen Ball—who panned the Algonquin Park painters in a *Toronto Daily News* review—wrote that a husband lying in a "rough grave in France" was easier to bear than "a shirker by your side."[36] Hoping to get more young Canadian men into khaki, Emmeline Pankhurst, the British suffragette turned arch-imperialist, embarked on a cross-country tour in 1916. Her main ploy was to use young women to chastise the so-called slackers and shirkers, often using the language of sexual shame. "How will you like to think," she asked a Vancouver audience, "that the man you love has allowed other men to do his duty for him while he sheltered himself behind the sacrifice of other men?"[37]

Ahrens's own white feather to the painters, delivered in the columns of the *Toronto Daily Star,* must have been particularly wounding to Thomson. As a six-foot-tall, physically fit, unmarried man with no dependents, he must have already attracted the attention of the women in the Order of the White Feather. The incessant chorus from posters, recruiting offices and newspapers would also have been difficult to avoid or ignore. According to Fred Varley, everyone was "worrying" Thomson about enlisting.[38] For a man of physical strength and personal courage to have his bravery and masculinity challenged—whether by young women on Toronto streetcars or by Ahrens in the *Daily Star*—would have been distressing and infuriating in the extreme, and no quotations from Norman Angell could have offset the humiliation.

Thomson left Toronto at the end of March, within days of Ahrens's published comments in the *Daily Star.* He set off for another long sojourn in Algonquin Park, his place of sanctuary and renewal.

MACDONALD WAS THE one who took up the cudgels on behalf of the "hermaphroditic" painters insulted by Ahrens. On March 17, the day after the article appeared, he wrote a long and angry letter to the *Toronto Daily Star.* The letter was never published, or else MacDonald, in a moment of sober reflection, thought better of committing such intemperate language to print.[39]

MacDonald began his letter by stating that the Canadian land-scape required from painters "courageous and thorough experiment." He admitted that inspiration for the experimental style of the paint-ers in the Studio Building had come from "French innovators" as well as from Constable and Turner (no mention was made of the Scandi-navians). He then rounded on Ahrens, calling his paintings "droning hurdy-gurdy repetitions . . . The merit of an Ahrens' picture is its 'tone,' no problems of difficult drawing are attempted, the colour is feebly limited, the design may be described as putting a hole in the carpet, its only variation being in placing the hole." Pointing out that Ahrens painted in an outdated Barbizon style, he loftily declared, "Our coun-try requires more than this for its expression and the artist who does not recognize the fact is not worthy of the name."

MacDonald concluded his letter by addressing Ahrens's suggestion that the painters should be fighting the Hun. He pointed out that A.Y. Jackson was serving in France and then, ignoring the case of Thom-son, claimed the others had "domestic obligations . . . They are doing what they can for the cause, even though," he finished with a sharp ad hominem thrust, "they may resent being prodded on by critics with foreign names."

Ahrens's name was indeed "foreign." His German grandfather, Carl von Ahrens, immigrated to Berlin, Ontario, in the 1830s. He dropped the aristocratic "von" and became a successful member of the com-munity, working as a millwright, opening a general store and buying a foundry that made stoves and threshing machines.[40] In pointing out his critic's foreign name at a time when the businesses of German-Canadians were being ransacked across the country, when Jackson's friends the Breithaupts were facing suspicion and recrimination because of their German ancestry, and when thousands of "enemy aliens" were interned in camps, the ordinarily wise and gentle Mac-Donald had stooped to Ahrens's own level of debate.[41] It was possibly this remark that gave him second thoughts about posting the letter to the *Daily Star*.

A week later, MacDonald published an article, equally spirited though showing more self-restraint, in the *Toronto Globe*. Lamenting the low standard of journalism in Toronto, he attacked critics with

their "windy bladders" who offered a "ribald and slashing condemnation without justifying analysis." After a swipe at Charlesworth ("better acquainted with the footlights than with the sunlight") he ended, as usual, by playing the patriotism card. His paintings were, he declared, "but items in a big idea, the spirit of our native land." He promised that he and his colleagues would "keep on striving to enlarge their own conception of that spirit." As in his defence of Jackson during the Hot Mush controversy in 1913, patriotism and fidelity to the "dramatical elementalism" of the Canadian landscape were used to justify a style of art that, ironically, owed much to foreign lands.[42]

THE CONTROVERSY OVER the 1916 OSA exhibition boosted the number of visitors. Some four thousand people filed through the galleries before the exhibition closed in the middle of April, almost a thousand more than in previous years. There is no indication that any of the tumultuous scenes sometimes played out in the Paris Salon—puce-faced men brandishing walking sticks at canvases or else doubling up in paroxysms of forced laughter—took place at the Public Reference Library. Sales, though, were slight. MacDonald had priced *The Tangled Garden* at an ambitious $500, the most he had ever asked for a painting—but it remained conspicuously unsold. Despite the severe restrictions to both its budget and its exhibition space, the National Gallery did, however, buy six paintings from the exhibition, including *Spring Ice,* for which Thomson received $300.

Another of the works purchased by the National Gallery was a landscape by Lawren Harris, who was making his own experiments with colour. After seeing the exhibition at the Albright three years earlier, Harris dedicated himself to reproducing the ornately beautiful landscapes and dazzling snows of Gustaf Fjaestad's canvases. The introduction to Fjaestad's entry in the Albright's exhibition catalogue stated that he painted "the fantastic and varied shades and shapes the snow can assume."[43] In his own copy of the catalogue, MacDonald wrote, next to a black and white reproduction of Fjaestad's *Hoarfrost,* the phrases "blue purple" and "warm pink," as if marvelling at the daring touches of colour added by the Swede to the snow.[44]

Sometime in 1915, likewise inspired by Fjaestad's blue- and purple-tinged snow, Harris painted two almost impossibly luminous snowscapes, simply entitled *Snow* and *Snow II*. Both showed fir trees with their boughs weighted down by fresh snow that Harris painted with strokes of azure, mauve and cornflower blue, highlighted with touches of salmon pink. Radiantly decorative—not to say somewhat artificial—portraits of the winter woods, they showed "courageous and thorough experiment" but little of the dramatical elementalism that MacDonald claimed the painters were seeking to depict. But for one critic at least, Harris had moved to the forefront of snow painters. In 1912 the editor of the *Canadian Magazine,* Newton MacTavish, had praised Maurice Cullen as the interpreter par excellence of the Canadian winter. But now Harris exceeded even Cullen, attacking the winter landscape, MacTavish exulted, with "more brilliant, even prismatic colours."[45]

Harris received $600 from the National Gallery for *Snow II*. His personal wealth meant he did not share the financial hardships of the other painters in the Studio Building, but in 1916 he was facing the same quandary as every other young Canadian. His younger brother, Howard, a University of Toronto graduate, had already volunteered for service. After resigning his job with a firm of bond traders in April 1915, Howard sailed for England and obtained a commission in the 11th Battalion the Essex Regiment; in the spring of 1916 he was preparing to cross the Channel into France. Meanwhile, their twice-widowed mother, a devout Christian Scientist, was establishing a convalescent home in London, the "Massey-Harris Convalescent Hospital," intended to treat wounded Canadian soldiers.

Despite his domestic obligations—he and his wife, Trixie, had a young son—Harris decided that he too would join the war effort. In the spring of 1916 he joined the Canadian Officers Training Corps (COTC) as a private. Three weeks after the OSA exhibition closed, on May 5, he received his "Infantry Certificate." It recommended him for an appointment as a lieutenant in the 10th Regiment the Royal Grenadiers.

THROUGHOUT THE SPRING of 1916, the Canadian 3rd Division was engaged in trench warfare in defence of Ypres. Their position, marking the deepest penetration of the Ypres salient into

German territory, included ridges allowing them to observe the enemy trenches. Determined to capture this high ground, at six o'clock in the morning of June 2 the Germans began a ferocious bombardment of Canadians occupying a knoll called Mount Sorrel. A German eyewitness described the complete annihilation of the Canadian trenches: "The whole enemy position was a cloud of dust and dirt, into which timber, tree trunks, weapons and equipment were continuously hurled up, and occasionally human bodies."[46] Among the dead, killed by shrapnel as he lay wounded from a bullet, his eardrums shattered from the heavy bombardment, was the 3rd Division's commander, Major General Malcolm Mercer, the patron of Carl Ahrens.

That same day, A.Y. Jackson's 60th Battalion took part in the counterattack as the Canadians tried to recapture the territory taken by German troops. Thus far, like many soldiers, Jackson had been finding life in the trenches more tedious than anything else. "It isn't exciting," he told his mother. "Not half as much so as painting a Georgian Bay squall or climbing up eight thousand feet to get a sketch of Mt. Robson." The trenches were so foul smelling that, although habitually abstemious in matters of alcohol and tobacco, he told his mother he took up smoking to "counter attack the trench odors."[47] He was probably not telling the full story. Harold Innis wrote of his own experiences that many soldiers turned to alcohol and tobacco to combat the terrible stress. "A heavy bombardment of an hour's duration," he reflected, "immeasurably increases the consumption of cigarettes."[48]

Jackson and his company were five miles from the front line when they received their orders to move forward. "Early in the afternoon," he later wrote, "we got orders to move up a couple of miles and await further orders. We didn't take things very seriously. We had often been told to hold ourselves in readiness before. But after eating a few biscuits for supper we moved off in small parties."[49]

The roads were full of other Allied troops also moving forward. Airplanes passed overhead and guns burst in the distance as Jackson and his company crossed open fields, using the young crops as cover. As darkness fell and they came to within a mile and a half of the front line, the Germans released tear gas. "The Huns were dropping tear

shells at random, and as there was no breeze the beastly stuff just hung around and got us all weeping." They took shelter in a reserve trench, and at midnight, after "an infernal noise" of machine guns, "the whole place burst into light, and the rattle of rifles and machine guns became a prolonged roar."

When the noise and showers of flares and shrapnel died down, Jackson's company was ordered to advance. Following a bombed-out railway track, they reached a zigzagging sandbag fortification known as the "China Wall"; once there, they were instructed to continue along its length to reach and support a trench some distance away. They made the crowded trench at dawn, dodging machine-gun bursts and passing the bodies of soldiers killed hours earlier. As on the previous day, at 6 A M the Germans unleashed another fierce bombardment. "I saw our lieutenant turn pale and fall in a huddled heap, and then the boy beside me looking in dismay at a great spurt of blood coming from his arm, which was only hanging by a few shreds of flesh . . . We lost over sixty men in those few minutes."

Ordered to proceed along the reserve trench, what was left of Jackson's company advanced slowly towards the front line. "In places the parapet was so beaten down we had to crawl to avoid being seen, other places to dash quickly across the open. Then when the shelling got very severe we would crouch down and wait." The men reached the front line at exactly the same time that "the Huns started in to blow the place to pieces . . . Again and again we were nearly buried in dirt, the shells just skimming the parapet and bursting about twenty or thirty feet behind us, till we were deaf with the awful roar. Then the whole parapet suddenly jumped right at us."

The man beside Jackson, a signaller named Doyle, was killed instantly, his body never recovered from the debris. Jackson himself emerged miraculously unscathed until another mortar round struck the trench. "I got a smash on the back that knocked me senseless. I really thought I was blown all to pieces, and was much relieved to find that my arms and legs were still on." Wounded in the hip and shoulder, he managed to return along the trench to a dressing station. He was bandaged and given hot cocoa and a sandwich, "and among a whole

lot of other poor wretches I rolled up in a couple of blankets and went to sleep on the floor. And thus ended the 3rd of June."

Jackson was one of eight thousand Canadians killed or wounded during the first two weeks of June. He was evacuated from Belgium on a hospital train. He endured a "long, miserable" journey to the French coast, where he was treated at the No. 1 Canadian General Hospital. The brown canvas tents of the hospital, with its operating theatres and dozens of nurses, were situated among sand dunes and clumps of pine.[50] Jackson recognized his location immediately: he had arrived in the resort of Étaples-sur-mer where, in another life, he had painted his misty landscapes.

4 THE LINE OF BEAUTY

LAWREN HARRIS WAS sent, along with thirty thousand other new recruits, to Camp Borden, a large training base newly established in Simcoe County, seventy-five kilometres north of Toronto. The primitive camp, with its dirt roads and rough-sawn huts, looked like a sprawling shantytown. One recruit called it "a terrible place—nothing but sand."[1] Conditions were so harsh that it was quickly dubbed "Camp Horror," and in July 1916, at the official opening, the recruits jeered the visiting minister of militia and defence, Sir Sam Hughes: "Take us out of this rotten hole!" There followed a riot in which a major general was struck by a brick. Two battalions of the Simcoe Foresters were required to suppress the mutiny.[2]

Tom Thomson must have been dismayed that Harris, like Jackson, was now "in the machine." The two men did manage to spend time together before Harris was sent to Camp Borden. In April Harris and Dr. James MacCallum, along with Harris's forty-one-year-old cousin Chester, visited Thomson in Algonquin Park. Harris regularly travelled and painted in the Laurentians and the Haliburton Highlands, usually with MacDonald. This was his first-known trip to Algonquin as well as his first-known sketching expedition with Thomson. Rather than meeting Thomson at Canoe Lake, Harris, his cousin and

Dr. MacCallum probably caught the train from North Bay and disembarked at the small town of Brent, a divisional point on the main line of the Canadian Northern Railway. With Thomson, the party then canoed westward through Aura Lee Lake, Laurel Lake, Little Cauchon Lake and Cauchon Lake.

On one of the smaller lakes in this labyrinthine waterway, Thomson commemorated his friend in a rare figure drawing. *Little Cauchon Lake* featured a small grey-clad figure casting his fishing line near the foot of a tumbling waterfall. The tiny figure—almost certainly Harris—was positioned at the centre of the falls as a kind of reprise, whether consciously or not, of Jackson's contrast of force and fragility in *The Red Maple*. The war, an inescapable subject in 1916, must have been on the minds of all the men as they travelled through the park, not least because by this point Harris had undergone his training as a cadet in the COTC.

Thomson did another sketch on Little Cauchon Lake. According to Harris, the pair was painting beside the lake when a thunderstorm forced them to take refuge in an abandoned lumber shack. "There was a wild rush of wind across the lake," Harris wrote, "and all nature was tossed in a turmoil." Undaunted by these conditions, Thomson "grabbed his sketch box, ran out into the gale, squatted behind a big stump and commenced to paint in a fury." Artists had previously put themselves in peril to get a good picture. The best example was J.M.W. Turner, who once lashed himself to the mast of a storm-tossed ship off the Suffolk coast to make sketches for his 1842 painting *Snowstorm— Steamboat off a Harbour's Mouth*. Turner claimed he "did not expect to escape," and Thomson, too, might have thought he was painting his last sketch when, according to Dr. MacCallum, a pine tree, the subject of the sketch, was "blown down" on him. Harris at first thought Thomson had been killed, but "he soon sprang up, waved his hand to him and went on painting."[3]

As narrated by Harris and Dr. MacCallum, Thomson's actions beside Little Cauchon Lake—scrambling from primitive cover to complete his task in hostile and hazardous conditions, nearly losing his life in the process—read like one of the citations for "conspicuous

bravery" being awarded to Canadian soldiers for their heroics on the Western Front. If Thomson was abused in Toronto as a shirker and a hermaphrodite, Algonquin Park, for Harris and MacCallum, was the place where he could attest his true courage and masculinity.

THOMSON REMAINED IN the park after his friends returned south. Rather than risk the wrath of the regulars by seeking work as a fishing guide, he took a job as a fire ranger in the eastern end of the park. Ontario had first established fire rangers in 1885 in response to the fires, caused by the increasing habitation of the bush, that regularly decimated the province's timber wealth. Work was difficult, since the rangers patrolled the bush on foot and climbed trees or built "crow's nests"—elevated platforms in the forest—to scour the horizons for smoke. Firefighting was primitive, since the men were equipped only with shovels, axes and canvas water pails. The gravity of the task was made clear that July when a forest fire burned 500,000 acres of land and killed 250 people near Lake Abitibi, 220 kilometres north of Sudbury.

Thomson reported to the park station at Achray, one of the stops on the Canadian Northern line. He shared with another fire ranger, Edward "Ned" Godin, a log cabin known as the "Out-Side Inn" that Godin built some years earlier on the north side of Grand Lake. Thomson painted above the primitive veranda a signboard in Gothic lettering. Godin might not have appreciated all of Thomson's artistic efforts (the natives of the park, he complained to Dr. MacCallum, "can't see what we paint for"),[4] but otherwise the two men seem to have become good friends. Godin described Thomson as "a very fine fellow. Easy to get along with and always in good humor. He was very fond of fishing and spent quite a lot of time at this sport."[5]

208 This annual retreat into the bush offered Thomson not only subjects for his painting but also, in the soothing and reverential rituals of pitching camp and catching fish—the "pleasant labour" praised by Izaak Walton—the tranquility, order and simplicity missing from his life in the city. He felt at ease in the company of the rangers, outdoorsmen such as Ned Godin, Mark Robinson and Tom Wattie, who shared

Tom Thomson, c.1915–16
McMichael Canadian Art Collection Archives

his love of "masculine" pursuits such as fishing and canoeing. Their campfire cookouts and fishing lines draped over gurgling streams conjure images of Hemingwayesque bonds between men disillusioned by, and fleeing from, the complications of modern civilization.

In August Thomson and Godin canoed along the south branch of the Petawawa River—scene of his sketching in the spring of 1914—to the Barron Canyon, then along the north branch to Lake Traverse. Thomson complained to Dr. MacCallum that he was unable to do much sketching because "there's no place for a sketch outfit when you're fireranging."[6] At least there were no fires, and in fact he did

manage some sketches of the spectacular gorges through which he and Godin passed. "This is a great place for sketching," he wrote to MacDonald, "one part of the river (south Branch Petawawa) runs between walls of rock about 300 feet straight up."[7]

Thomson painted remarkable sketches of these flanks of rock towering above the river. His sketch *Petawawa Gorges* was an attempt to capture the physical majesty of the gorge, but these rearing, claustrophobic presences between which he passed in his frail canoe were a reminder of other menacing forces that loomed large in his mind. Thomson must have known that this voyage took him within a few miles of Camp Petawawa, a large military base that for the previous eighteen months had housed hundreds of German and Austrian prisoners of war. In the summer of 1916 the base had begun training thousands of Canadian recruits for service overseas. The Great War was casting its shadow even across Thomson's beloved park.

BY THE END of the summer of 1916, the "young school" fragmented still further as yet another member left Toronto. When the post of principal came open at the Victoria School of Art and Design in Halifax, both Lismer and MacDonald became candidates to fill it. Lismer already had experience in art education, having worked the previous year as an instructor at the Ontario College of Art's summer school in York Mills. MacDonald, though, was easily the more qualified. He served on the OCA's examination committee and ran its summer school in 1914 and 1916. He also did low-paid work as supervisor of the art department for the Shaw Correspondence School, for which he designed a course and graded examinations in commercial design. Furthermore, unlike Lismer, he had a strong connection in the Maritimes. One of his oldest friends, Lewis Smith, a former Grip colleague and the principal of the Victoria School of Art and Design between 1910 and 1912, lived in Halifax.

No doubt MacDonald would have welcomed the regular (if slightly stingy) salary of $900 per year as well as the chance for a reunion with Smith, whom he called "the best friend I ever knew."[8] In the end, owing to his upbeat and garrulous personality, the job went to Lismer.

Sir Edmund Walker's doubts about MacDonald's suitability for the post scuppered the older man's chances. "J.E.H. MacDonald is a more accomplished artist at the moment and, I should think, a more interesting man," he wrote in a letter of reference. "He is, however, a shy eccentric person and would not be as useful in a community as Mr Lismer."[9] Calling MacDonald an "accomplished artist" in the aftermath of the lacerating reviews of *The Elements* and *The Tangled Garden* indicated a rare open-mindedness. And if Walker made an overly harsh appraisal of MacDonald's fitness to teach, his choice of Lismer would at least prove wise and worthy.

Halifax, with a population of some fifty thousand people, was an important seaport and rail terminus. Freighters laden with lumber, fish and apples ordinarily steamed out of its harbour. But with Halifax an embarkation point for Canadian troops bound for Europe, the ships were now exporting young soldiers. Halifax was vitally important to the wartime effort. In October 1916, within a month of Lismer's arrival, a single German U-boat a few miles off Nantucket torpedoed six Allied ships. Henceforth all Europe-bound merchant ships would assemble in Halifax to cross the Atlantic in convoys. A flotilla of a dozen ships constantly patrolled the harbour, which was also protected by a quick-fire battery and a floating anti-submarine net that each night was lowered into place. Meanwhile the vast shipyard was busy with the construction of a dozen anti-submarine trawlers.

The Victoria School of Art and Design stood on Argyle Street, a few streets west of the dockyards and a few streets east of the massive, star-shaped Citadel, heavily garrisoned with troops. The school had been founded in 1887 by benefactors that included Anna Leonowens, otherwise notable for her six-year spell in Bangkok as English teacher to the children of King Mongkut of Siam (her 1870 memoir *The English Governess at the Siamese Court* would inspire the Rodgers and Hammerstein musical *The King and I*). The school presented an unprepossessing aspect. A one-hundred-year-old former schoolhouse, it was a four-storey clapboard building that Lismer found "dull, dirty and sordid."[10] Enrolment stood modestly at twelve students. The previous principal, Georges Chavignaud, found their efforts so haphazard

and incompetent he began teaching them boxing instead.[11] The governors, who included a bank manager and a Presbyterian minister, Lismer thought "dead in spirit" and, like almost everyone else in Halifax, "stuffy and chilly."[12] If Toronto was a drab city of materialistic philistines, Halifax, on first impression, was considerably worse.

The dearth of students at the Victoria School of Art and Design indicated no lack of interest or enthusiasm on the part of Halifax youth. Enrolment was intentionally kept low because, as Lismer complained to Eric Brown, the governors believed art to be "an exclusive & cultured subject for the edification of the few."[13] Lismer certainly did not regard art as the exclusive domain of an elite class. He was a product of the English tradition of John Ruskin and William Morris that believed art could dignify and exalt all members of society, especially the poorer classes in a time of mechanization and industrialization. Art education, for Ruskin, was absolutely crucial to the health and happiness of a society. He wrote that "every man in a Christian kingdom ought to be equally well educated,"[14] and to that end Ruskin gave art lessons to labourers at the Working Men's College in London and to the girls of Winnington Hall, a finishing school in Cheshire.

Although enormously influential across Britain and America, Ruskin's ideas were especially powerful and popular in the Sheffield of Lismer's youth. In 1871 Ruskin had founded the Guild of St. George to provide working-class men with a liberal education as well as what he called a "beautiful, peaceful, and fruitful" way of living.[15] In 1875 the guild's museum, ultimately known as the Ruskin Museum, was established in a Sheffield suburb. It housed Ruskin's collection of paintings, drawings and manuscripts, but also minerals, ornithological prints and architectural mouldings—all assembled by Ruskin to stimulate the eyes and minds of working-class men and women.

Lismer owned copies of Ruskin's works,[16] and as a young man he must have visited the Ruskin Museum. In any case, he approached his task in Halifax with the same evangelical zeal as Ruskin, making himself, as Sir Edmund Walker correctly predicted, "useful in a community." Within a few months he was reporting to Dr. MacCallum that things were "going pretty fair," and that the school was

"shaping a little into some recognized appearance of an art school." He missed the comradeship and excitement of the school of artists coming together in Toronto, however, and quickly realized the scale of his mission in a city that seemed to care little for the arts, particularly in wartime. As he repined to Dr. MacCallum, "The town is provincial and wholly inartistic."[17]

In fairness, wartime Toronto scarcely offered better prospects. Lismer's nostalgia for Toronto must have been jolted when he received a letter from MacDonald at Christmas. Unable to sell his paintings and still in the financial doldrums, the controversial author of *The Tangled Garden* was reduced to designing an exhibit for Simpsons on the theme of "Mother Goose's Village." He was planning and painting, he told Lismer, 280 feet of "quaint house fronts" to go around the store's toy section. The task involved designing fifty figures from Mother Goose: painted wooden cut-outs with moveable arms and legs attached. The display would include "a windmill in motion" and "a waterfall of real water." He explained how he had pressed his son, Thoreau, into service, and how Roy Mitchell—the "Prankmeister" of the Arts and Letters Club who specialized in directing avant-garde drama—was arranging for an actress dressed as Mother Goose to recite nursery rhymes to passing Christmas shoppers.[18]

MacDonald was (no doubt justifiably) proud of his handiwork. But that the painter of *The Tangled Garden* should be expending his efforts on Little Bo-Peep and Georgie Porgie plainly announced how hard times had befallen Canada's artists.

THOMSON REMAINED IN Algonquin Park until late October or early November 1916, returning to Toronto only after the snow fell. Altogether he had spent seven months in the bush, sketching and working as a fire ranger. This protracted spell in the northlands—the longest he is known to have spent away from "civilization"—suggests that he was deliberately avoiding Toronto, with its recruiting sergeants and other reminders of war.

Soon after returning to the shack behind the Studio Building, he began his usual process of painting canvases based on small oil

sketches done in the previous months. Jackson later wrote that at this time, with Lismer in Halifax and Harris in the Royal Grenadiers, Thomson was "very much alone" in Toronto.[19] That was not exactly true, since Thomson still had not only Carmichael, Johnston and Heming for company but also a number of visitors to the shack. At some point during the winter he hosted Florence McGillivray, a landscape painter from Whitby. Until 1911 McGillivray taught art at the Ontario Ladies' College in Whitby, where one of her students was Rosa Breithaupt. Thomson might have come to know her through Jackson's Breithaupt connections because McGillivray was friends with the family, once giving them a painting as a gift.[20] But he might have known her through his own connections in Whitby, where his father was born and his grandmother lived.

Thomson had a tremendous admiration for McGillivray's work. "Quite confidentially," he told a friend, "she is one of the best."[21] The fact that Thomson's esteem needed to be confidential suggests that other painters in the Studio Building either did not appreciate her work or else—given the prevailing masculine environment—did not believe a woman capable of serious or important artistic achievements. There was something else about McGillivray that Thomson no doubt kept secret from his friends in the Algonquin Park School: "She was the only one who understood immediately what I was trying to do," he told a friend.[22]

McGillivray was therefore an important mentor to Thomson. At some point she gave him her calling card and an invitation to her forthcoming exhibition in Toronto. He placed both, like cherished billets-doux, in his paintbox. No evidence exists for any romantic attachment between the pair, but their admiration was clearly mutual and sincere. Unfortunately, most details about their relationship have—like so many other details of Thomson's life—slipped into the historical vacuum.

There is little doubt that McGillivray, who was fifty-two years old in 1916, was an accomplished painter. She originally studied with Thomson's old instructor William Cruikshank, and in 1913 she went to Paris to study under Émile-René Ménard at the Académie de la

Florence H. McGillivray , Trafalgar Castle School, formerly known as Ontario Ladies' College, from an *Ontario Ladies College Viewbook* circa early 1900s

Grande Chaumière, an *atelier libre* opened in Montparnasse in 1904 (Matisse was an early student). Ménard specialized in dreamy pastoral scenes inspired by classical antiquity, but McGillivray worked in a more adventurous Post-Impressionist style. Her avant-garde technique was developed partly from her familiarity with work by the Gauguin-inspired School of Pont-Aven (she travelled and painted in Brittany in 1915) and partly, no doubt, from her extramural studies in Paris. She came into contact with many young painters in Paris thanks to her position as president of the International Art Union (she was only the second woman to hold the post). This union staged exhibitions of young painters, awarded them prizes, bought their works to donate to institutions, and in general promoted their careers both in Paris and abroad. As her interest in Thomson indicates, this mentoring continued when she returned to Canada.

One of McGillivray's paintings, *Contentment*, appeared at the Salon de la Société nationale des beaux-arts and then, after her return to Whitby in 1916, at the OSA. It conjured the Pont-Aven painters in both its subject matter (a rosary-clutching nun whose habit recalls the costumes of Gauguin's Breton peasants) and its heavily painted planes of blacks and whites. She even used a palette knife à la Cézanne to apply some passages. The painting failed to sell in either Paris or Toronto, but another, *Afterglow*, the National Gallery purchased in 1914. It too revealed her French experiences. It featured a stand of bare trees, their trunks accentuated with Cloisonnist-style outlines. In the background, using divided touches, she painted a goldenrod sunset.

McGillivray probably gave Thomson advice and encouragement as he tackled his latest paintings. Several were simple but dramatic scenes of jack pines and maple trees on the edge of a lake. The first, *The West Wind* (see plate 22), was inspired by the sketch executed during the fierce thunderstorm on Little Cauchon Lake. It is the dynamic and potentially destructive force that (according to legend) nearly killed him, as well the violence and fragility of nature, that Thomson captures. With its threatening sky, white-capped waves and scarecrow shapes, *The West Wind*, like Jackson's *Terre sauvage*, is an image of the Canadian north as an eerie wilderness. The lake and sky are painted naturalistically, a legacy of Thomson's vigorous *plein-air* pursuits and supposedly near-death experience beside Little Cauchon Lake. The three pines in the foreground receive a different treatment. They are two-dimensional, their foliage thickly outlined in crimson and their krummholz trunks and branches (like the trees in McGillivray's *Afterglow*) with black. The middle tree reprises in more compressed form the S-shape of the leaning spruce in *Northern River*, and the stylized outlines recall Thomson's decorative designs of forest undergrowth for Dr. MacCallum's cottage.

Like his murals for the cottage, *The West Wind* is decorative rather than naturalistic or descriptive. Anyone believing Thomson always simply "painted what he saw"—the bromide used by so many painters to defend their techniques—should be disabused of this notion by the sight of this trio of whiplashing pines. Thomson and his companions

were not going into lands unfamiliar to most Canadians and then returning with "realistic" images of the barrens. Instead, they were venturing into lands familiar to many Canadians—through tourism, industry, painting, literature and film—and returning with paintings done in what was to most Canadians an unfamiliar style.

Thomson's icon of the Canadian landscape owes a good deal to contemporary ideas about the nature of easel painting and the purpose of art—ideas he would have absorbed from Jackson, Harris and McGillivray, or through his reading of art journals such as *The Studio*. For the modernist artist, as Signac noted, painting a landscape was not a matter of sitting down in nature and faithfully transcribing the view. In 1891 a critic took Monet to task for doing precisely that—for, in effect, pointing his easel almost randomly at a landscape and taking a picture. The critic put this approach down to a misplaced honesty that made the painter say, "The place was like that, and I had no right to alter it." Such scrupulousness, though admirable in legal testimony, was a "negation of art."[23]

The Post-Impressionists, by contrast, composed their views self-consciously and artificially, using the landscape as a jumping-off point for more floridly imaginative compositions. The operative word was "decorative." Roger Fry defined Post-Impressionism as a conception of art in which "the decorative elements preponderate at the expense of the representative."[24] A few years earlier, at the 1906 Salon des Indépendants, the critic Louis Vauxcelles wrote, "Our young landscapists see truthfully because they see decoratively. The site is for them a pretext, a setting in which the figures are to be enclosed by arabesques." Another critic at the same exhibition praised painters (he was thinking of the Fauves) who "ask of the spectacle of nature pretexts to realize decorative compositions."[25]

Following Gauguin and Van Gogh, young French painters rejected faithful transcriptions of nature in favour of simplification and transformation. They created what were known as *paysages décoratifs,* or "decorative landscapes," where topographical accuracy was happily sacrificed for dazzling ornamental effects of line and colour. Signac compared decorative landscapes—which he defined as the creation

of "pure colour within rhythmic lines"—to tapestries and oriental rugs, which served the same ornamental function in the household.[26] Another painter claimed the word *décoratif* was the *tarte à la crème,* or catchphrase, among modern French artists.[27]

Jackson's observation to MacDonald in February 1914 that Algonquin Park was "full of 'decoratif motifs'" proves the phrase was a *tarte à la crème* in the Studio Building too.[28] Jackson also stated the aim and technique of the Canadian painters in terms that echoed the precepts of Signac and other French avant-gardists: "We felt that there was a rich field for landscape motives in the North Country if we frankly abandoned any attempt after literal painting, and treated our subjects with the freedom of the decorative designer ... We tried to emphasize colour, line, and pattern ... It seemed the only way to make a right use of the wealth of motives the country offered."[29]

Like the motifs on oriental tapestries and rugs, these landscapes sometimes tended towards abstraction. Vauxcelles claimed the Fauve painter André Derain, in his quest for pure decoration, "turns his back upon nature" and "plunges into the abstract."[30] The abstract figure on which the decorative landscape was based was the kind of arabesque—the wavy line—so prominent in *The West Wind.* As the painter and sculptor André Lhote (a teacher at the Académie de la Grande Chaumière who began his long career working in a Fauvist style) described his method of landscape painting in 1907, "The general rhythm of nature ... I will express in a fictional way, by arabesques that intertwine, that bisect one another harmoniously, that divide up musically."[31]

The arabesque, or *figura serpentinata,* has a long artistic history. It stretches back to classical antiquity and Islamic decorative art, and runs forward through the corkscrewing poses of Italian Mannerist sculpture and William Hogarth's "line of beauty." At the end of the nineteenth century, it reappeared in the fluent lines of Gauguin and Van Gogh, and in the spiraloid designs of Art Nouveau. But for some artists, these sinuous flourishes were not meant to be merely pleasing and decorative. In the Islamic world, arabesques were symbols of the Gardens of Paradise in the afterlife and therefore representations of a

permanence and eternity beyond the transient visible world.[32] Signac used them in the same way, as an expression of an authentic reality transcending the material world. In 1890 a critic wrote that Signac's work "sacrifices anecdote to the arabesque."[33]

Matisse put the arabesque to self-conscious use in early masterpieces such as *Luxe, calme et volupté* (1904) and *Le Bonheur de vivre* (1905–6). The arabesque represented what he called an "impassioned impulse" and "the most synthetic way to express oneself in all one's aspects."[34] Its expressive form not only gave elegance to objects in his paintings—the tendrils of the nasturtium in *The Red Studio* (1911), the wrought-iron grillwork in *The Piano Lesson* (1916)—but also conveyed certain emotions and abstract ideas, such as vitality and voluptuous pleasure. Some critics saw darker emotions at work. When Matisse showed *Harmony in Red* at the 1908 Salon d'Automne, one writer believed he glimpsed in the tortuous patterns on the tablecloth and wallpaper "an expression, acute to the point of tragedy, of modern torment."[35]

THE WHIPLASHING CURVES of *The West Wind* certainly express more modern torment than voluptuous pleasure. The scene is one of struggle, of an elemental tug-of-war for existence. Thomson was a reserved and inarticulate man who gave little away in his letters or his conversation. He expressed himself through his paintings instead, and these windblown jack pines suggest his own turmoil—the emotional tumult caused by his financial and artistic struggles as well as the horror and pointlessness of the war, the "machine" that had swallowed both Jackson and Harris, along with tens of thousands of other young Canadians.

The war was impossible to escape or ignore in Toronto at the end of 1916. If Thomson managed to avoid the news reports in Algonquin Park, reminders would have been ever-present when he returned to the city and began painting *The West Wind*. The papers and newsreels were filled with reports on the twenty-week-long Battle of the Somme, an Allied offensive that finally ended in the middle of November. Letters from soldiers describing the horrors of the battle appeared in

the Toronto newspapers. Beginning in October, 14,000 people a day packed the 1,600-seat Regent Theatre in Adelaide Street to watch the British documentary *The Battle of the Somme,* screened virtually around the clock for weeks on end. "The whole panorama is one nerve-straining spectacle," wrote the reviewer in the *Toronto Globe.* "The spectators watch men moving along communication trenches with fixed bayonets, alive and healthy, and the next moment we see them emerge on the sky line silhouetted in death."[36]

The dreadful war of attrition along the Somme cost more than 620,000 Allied casualties, including, on the first day alone, two out of every three men from the Royal Newfoundland Regiment. Tales of Canadian heroism abounded, acts of bravery and fortitude such as the assault on the French town of Courcelette and the capture of Desire Trench. In the words of a United Press correspondent, the Canadians "fought like bearcats" at the Somme.[37] Such was their ferocity and determination that they were now marked out as storm troops: henceforth the Canadian battalions would be in the vanguard of every Allied attack on the Western Front.

This heroism came at a terrible price, with 24,029 casualties. In the eleven weeks between early September and mid-November, 8,500 Canadians died at Courcelette. Long lists of the dead and the wounded appeared in the Toronto newspapers. Almost 3,000 Toronto men were killed or wounded in October alone. The papers of October 24 recorded the names of 200 local men—Toronto's worst day yet.[38] One casualty of war that Thomson certainly would have known about was A.Y. Jackson, since in September 1916, while recuperating with relatives in England, Jackson wrote a long letter to MacDonald describing in full the horrors of Sanctuary Wood.

By the end of the year, with the Somme offensive a costly failure for the Allies, the war had reached a horrific stalemate. Much of the early jingoism had evaporated. No longer was it so easy for Canadian newspapers and politicians to claim, as they did after the Second Battle of Ypres, that the dead had "something heroic and almost divine about them," or that "there rose steady and clear the voice of thankfulness to God . . . that they were permitted in their death to make so splendid a

sacrifice."[39] Even the new British prime minister, David Lloyd George, questioned the point of such horrendous loss of life, accusing General Douglas Haig of "squandering" the lives of the soldiers. As one young British officer glumly observed at the beginning of 1917, "the war seemed likely to go on for ever."[40]

IF THIS TRAGEDY and pessimism about the war found expression in the turbulent sky, ruffled waters and fragile, struggling pines of *The West Wind,* another painting Thomson did at this time, although almost identical in subject, was different in composition and mood. *The Jack Pine* presents the elegiac symbol of a tree sharply silhouetted against a glowing sunset. If Thomson was derided as unpatriotic by contemporaries because of his failure to enlist, *The Jack Pine,* with its near-mythical reverence for the beauty of the Canadian landscape, could be seen as his riposte.

The pine tree is offered as an emblem of Canada and its defiant spirit in the same way that Jackson, two years earlier, suggested the maple. Thomson probably knew from park rangers and perhaps also loggers that the jack pine had unique properties of survival. It was a tree that quite literally rose from the flames. Its cones, coated in resin, were opened by forest fires, and as the seeds were released, new growth arose phoenix-like from the devastation.[41] This idea of regeneration and endurance, of the burned earth scattered with vital seeds, would have been a comforting one to contemplate at the end of 1916, when Canada bore such terrible scars of conflagration.

Thomson painted *The Jack Pine* (see plate 23) from a sketch done the previous spring on Grand Lake, near Achray. The atmosphere is one of transcendent repose, with the arabesques of *The West Wind* resolving into horizontal bands of lake and sky. With its outspread and drooping branches making it a lakeside calvary, the tree is anthropomorphized into an image of loneliness, suffering and endurance. If the central motif of Canadian art and life is survival—staying alive amid the fierce, beautiful and uncaring forces of nature[42]—then Thomson's painting more than any other image stamps this symbol on the Canadian imagination.

221

For *The Jack Pine,* Thomson made use of a technique he is not known to have used before. The horizontal strokes of paint in the sky and water were added over an undercoat of crimson visible in the blood-red tracery of the languid branches. The undercoat gives this painting its wonderfully luminous, almost incandescent sunset. The Impressionists achieved luminosity by using pale undercoats, but the technique of working over a reddish ground had a precedent, intriguingly, in medieval and Renaissance painting. Reddish outlines were often used in icon painting,[43] and Italian artists used grounds of Armenian bole when gilding altarpieces and other panel paintings. Bole was a red clay that, mixed with parchment size, served as an adhesive for the gold leaf. Its rich colour, showing through the tissue-paper-thin foil, gave the gold an added lustre.

Where and how Thomson learned about this method—if indeed he was deliberately copying the earlier techniques—is unknown. The best description of Armenian bole was found in Cennino Cennini's fifteenth-century handbook *Il Libro dell'Arte,* a work not translated into English until the early 1930s. Whatever the case, Thomson's use of a crimson undercoat not only gave an eerily lambent, blood-red silhouette to the jack pine but also turned the tree—a coniferous symbol of trial-by-fire and resurrection—into a kind of votive image. This painting, soon to become such an emblem of Canada, was perhaps conceived and executed quite literally as an icon.

DESPITE HIS PERSONAL worries, Thomson seemed uncharacteristically pleased with his efforts in these and other paintings. Gone were the match-flinging frustrations of a few years before. Early in 1917 he wrote to his father, "For myself I have been first rate and am getting considerable work done." A few weeks later, more optimism as he reported that he had "some pretty good stuff."[44] His new self-confidence probably had something to do with the encouragement of Florence McGillivray. In any case, the discouragements of past years seemed behind him as he experimented heedlessly on canvas.

Around this time, Thomson probably enjoyed the benefits of another tutor. During visits to Algonquin Park he was introduced by

the ranger Bud Callighen to the painter and art instructor John Sloan Gordon. Gordon was a friend of Arthur Heming, with whom he had trekked the Canadian tundra. He spent part of each summer at Camp Nominigan with the Hamilton photographer A.M. Cunningham (who in 1915 bought A.Y. Jackson's *Near Canoe Lake* and donated it to the Art Gallery of Hamilton). Gordon was a Canadian combination of the backwoods and the boulevards. He studied in Paris for several years in the 1890s before returning to Hamilton to become, in 1909, principal of the Hamilton Art School. His landscapes, such as *Niagara Falls* and *Old Mill, Brantford* (the latter bought by the National Gallery in 1909), showed the influence of the broken-colour techniques of Seurat and Signac absorbed during his years in Paris. He would later be celebrated as the first man in Canada "to use the class of technique termed 'Pointillism' in Europe."[45]

Gordon's influence and example may be behind *The Pointers*, one of Thomson's most striking and experimental works (see plate 24). Originally named (by Dr. MacCallum) *Pageant of the North*, it depicted the activities of the logging industry. It shows a "crib and cage" and a trio of eight-man "pointer boats" (shallow-draft vessels with red-lacquered, V-shaped hulls) making their way across a calm lake. The crib and cage was used by lumber companies to move booms of logs across calm waters. A large raft harnessed to the logs, it was propelled over the water by means of a horse-powered capstan anchored to the far shore.

Although his subject matter in *The Pointers* was the industry of rural Ontario, for his style of representation Thomson looked farther afield. The painting was created from broken touches of exaggerated (though not non-naturalistic) colour that revealed his continued interest in Divisionism and Fauvism. It is witness to his sheer joy of colour and technique, with sky and water created with broad hyphens of orange and purple applied in brushstrokes of unmixed pigment juxtaposed like the platelets of a mosaic—the same "brick-like rectangles" used by Signac and Cross. The lack of shadows, a hallmark of Fauve canvases, gives the painting not only brilliance but also a flatness. This surface flatness is further emphasized by the fact that the

entirety of the canvas was painted with the same brushstrokes and an equal colour saturation. Artists traditionally used larger and broader brushstrokes, as well as more intense colours, for the foreground, adding background details (to suggest recession and depth) in thinner, paler tones, and with a finer brush. Thomson did away with this sort of perspective. The result was not a faithful and naturalistic transcription of the landscape but a decorative work of art that rejoiced in delicious agonies of colour.

Despite his new self-confidence of expression, Thomson sent nothing to the 1917 OSA exhibition. His reluctance may have been due to the fierce attack by Carl Ahrens a year earlier: the coruscating Fauvism of a work such as *The Pointers* would surely have attracted the ire of Ahrens and Charlesworth. Evidently he was unwilling to risk further "white feather" and "hermaphrodite" jibes even for the sake of unveiling his remarkable new works.

Thomson nonetheless attracted some media attention, this time more favourable. In the spring of 1917 he was interviewed in the Studio Building by his hometown newspaper, the *Owen Sound Sun*. The reporter was taken slightly aback when shown some of the painter's latest canvases, noting that "at first the brilliancy rather daunts one" and that the colours seemed to "scream." He proudly declared, however, that Thomson was "a young artist ... on the threshold of an exceptionally brilliant career."[46]

5 IMPERISHABLE SPLENDOUR

"I'M OUT OF it for a few weeks and I'm not sorry," A.Y. Jackson wrote to Arthur Lismer at the end of June 1916, three weeks after his wounding at Sanctuary Wood. He had received what was known in the trenches as a "blighty" wound—one severe enough to get him sent back across the Channel. "At present," he told Lismer, "I'm convalescing along with forty other Canadians in an old house overlooking the Yare."[1]

Jackson was shipped from the Canadian field hospital in Étaples-sur-mer to Brundall House Hospital, a large brick mansion on the River Yare outside Norwich. Besides the wounded hip, he had shrapnel in his left shoulder. "Luckily it missed the bone," he wrote to Lismer, "or it would have made an awful mess as it was about the size of a thimble and rather ragged." He offered to send the "odd junk" to his mother for use as a hatpin.[2] Although his sense of humour remained intact, Jackson had no illusions about how close he had come to death. "It was luck to come out of that business alive . . . No," he told Lismer, "war does not improve by coming into closer contact with it."

Like so many veterans, Jackson almost never spoke or wrote of his experiences in the trenches. MacDonald was the first and, apparently, the only person to whom he gave a full account of the trauma. One

of his fellow soldiers wrote of the difficulty of communicating with those back home: "I had been trying to imagine how I would express my feelings when I got home, and now I knew I never could, none of us could. We could no more make ourselves articulate than those who would not return; we were in a world apart, prisoners, in chains that would never loosen till death freed us."[3]

Jackson undoubtedly bore psychological scars much deeper than those from his shrapnel wounds. As Harold Innis, wounded in France in 1917, later reflected, "There remains the fact that no one who has been wounded, or no one for that matter who has seen a great deal of front line service, is physically or mentally better for the experience." In his opinion, soldiers suffered psychological damage "from which only the strongest survive."[4] A French doctor who served at a clearing station such as the one to which Jackson was first evacuated observed that "the brave soldier becomes a coward" after suffering a wound at the front: "He is shorn of his warrior courage."[5] Jackson was certainly one of the stronger and braver ones, but his silence makes difficult the task of understanding how severely he was affected. His response to the horrors of war would be found not in words but in his paintings.

From Brundall House, Jackson was sent, in August, to Horton Manor, a former lunatic asylum near Epsom commandeered by the War Office as a convalescent camp for Commonwealth soldiers. Here, he told Lismer, he was supposed "to get into shape for the front again."[6] But he did not immediately return to the front or take part in the Battle of the Somme. From Epsom he was sent for duty in the Army Post Office near Hastings, on the Sussex coast. He found the work "very dull... with little to do. Some of the boys relieved the tedium by steaming open letters of an intimate nature, which, they had learned, were being received by some of their comrades, and reading them aloud for the entertainment of the rest of us."[7] Other recreations included visits to the local circus to see the tattooed lady and to the cinema to watch serials such as *The Iron Claw*. What Jackson wanted to do, however, was paint, though both opportunity and inspiration eluded him. "I have not been storing up much material for making pictures later," he had lamented to Lismer from Brundall

House Hospital. "I suppose it is pretty hard for you chaps to go on painting with this horror going on," he added, "and there seems to be little chance of it ending. We can bungle along longer than they can. That seems to be our principal hope."[8]

During his long months of convalescence he was, unsurprisingly, homesick for Canada. In the spring of 1917 he received a package from two of the Breithaupt sisters, his distant cousins from Berlin, Ontario (recently renamed Kitchener after much vigorous debate). The twenty-one-year-old Catherine, a music student, had knitted him pairs of socks and gloves, and twenty-nine-year-old Rosa made him a pot of maple cream.[9]

Jackson had a great affection for the vivacious and artistic Breithaupt sisters, not least because they were the ones who first introduced him to Georgian Bay. He once claimed to be in love with Rosa, a talented painter and the recipient of a gold medal in art at the Ontario Ladies' College. The pair exchanged canvases as tokens of their mutual admiration, and in the summer of 1913 he had painted her portrait on Chippewa Island: a true sign of devotion, perhaps, in a man who otherwise shunned portraiture.[10] But in 1917 Rosa married A. Russell Hewetson, the son of a Brampton shoe merchant. Possibilities for romance between the pair, such as they ever might have been, reached an end.

Jackson's letter of thanks to Catherine ended with an exasperated comment about the war: "It's a grim business," he told her, "but it must be gone through. Either we break them or they break us. After what they have done it is impossible to come to any agreement, and yet it's very cruel to see such magnificent boys sacrifice themselves."[11]

Many more magnificent boys were destined to sacrifice themselves. On the day Jackson wrote these words, April 9, 1917, Easter Monday, the Canadian Corps was beginning its attack on the German Sixth Army at Vimy Ridge.

IN THE WORDS of a correspondent for *The Times*, Vimy Ridge was the "most bitterly contested and blood-stained area of the whole Western Front."[12] A series of promontories running diagonally northwest

to southeast near the village of Vimy, ten kilometres north of Arras, it was a formidable bastion protecting the Flanders plain. Captured by the Germans in the first months of the war, it became the keystone of their defences, an impregnable fortification with concrete machine-gun nests and three rows of deep trenches, all woven with barbed-wire fencing. For more than two years it had defied attacks that cost the French army 120,000 casualties; many of the dead lay beneath its heights in unmarked graves.

By the end of 1916, following the Battle of the Somme, all four Canadian divisions had assembled on the line below the Vimy Ridge in preparation for an offensive. The attack was part of a plan by the French commander-in-chief, General Robert-Georges Nivelle, to cut off the German salient in France and win the war in 1917. The assault began at 5:30 AM on Easter Monday, at first light and in driving sleet and snow. Twenty-one battalions crossed the frost-hardened grave-yard of no man's land and fought, in the words of one history book, as a "terrible, efficient machine of death."[13] A few hours later, as 15,000 Canadian infantry attacked the German positions, sometimes with bayonet charges into withering machine-gun fire, the snow stopped and the sun appeared. In the sudden light the entrenched Germans witnessed the heights covered with advancing Canadian soldiers. Although the outcome was no longer in doubt, battle continued for three more days, at the end of which the whole of the ridge was cap-tured along with 4,000 German prisoners. Four Canadians received the Victoria Cross, among them Private William Milne, a twenty-four-year-old farmer from Moose Jaw who single-handedly captured two machine-gun emplacements. Killed later that day, he was one of 3,598 Canadian dead.

Despite the victory, such horrendous losses, felt in every Cana-dian city, were all the more tragic given how the British and French offensives against the Germans quickly bogged down at Arras (where the poet Edward Thomas died) and on the Aisne. By the end of April, General Nivelle was relieved of his command. A month later, French troops were in open revolt against their generals. The war, it was only too clear, would not be won in 1917.

THE CANADIAN DEAD of Vimy Ridge were remembered in London almost three months after the battle. At a special service in Westminster Abbey, Herbert Ryle, the dean of Westminster, addressed an enormous congregation that included King George v, soon to make his own official visit to Vimy Ridge. Also present were hundreds of Canadian soldiers, many recovering from wounds. "Not in vain, not forgotten, not unhonoured have they laid down their lives," Dean Ryle declared from the sanctuary steps. "Ypres, Vimy Ridge, and a hundred other fights have crowned with imperishable splendour the glory of Canadian nationhood." The service then concluded with, in the words of one newspaper, a "lusty" rendition of "The Maple Leaf Forever."[14]

This service, held on Monday, July 2, commemorated fifty years of Confederation, or what was awkwardly known in the press as the "semi-centennial." Similar celebrations, with an equal mixture of reverence and rejoicing, were held across Canada, all of them, since the actual anniversary of Confederation fell inconveniently on a Sunday, one day late. In Ottawa, soldiers paraded to Parliament Hill with members of the police and fire brigades and troops of Boy Scouts and Girl Guides. The new Parliament building—still under construction after the 1916 fire—was dedicated to (as a plaque unveiled on a central pillar in Confederation Hall proclaimed) "the Fathers of Confederation and to the Canadians fighting in Europe." Outside, British, French and American flags fluttered in the breeze. Sir Robert Borden and the governor general, the Duke of Devonshire, delivered speeches. Afterwards a choir sang the Dominion's unofficial anthem, "O Canada."[15]

These celebrations, like the euphoria over the victory at Vimy Ridge, did not last. Four days after the Ottawa ceremony, the House of Commons passed the Conscription Bill. The controversial legislation was made necessary, Borden believed, by the simple and inescapable fact that Canada was unable to replace through volunteers the large numbers of soldiers killed or wounded on the Western Front. In April 1917, when the Canadian Corps sustained 23,939 casualties, only 4,761 men volunteered for service to replace them.[16] A.Y. Jackson's battalion was in the process of being disbanded because recruitment problems in Montreal meant the casualties of Sanctuary Wood could not be

replaced. Clearly the Canadian divisions could not be maintained at strength or raised to the promised number of 500,000 without the government resorting to more drastic methods of recruitment.

On July 6, after an all-night sitting that concluded with the singing of "God Save the King" at five o'clock in the morning, the Commons affirmed the principle of conscription by 118 votes to 55. The vote, and the heated debate preceding it, revealed stark divisions that served as a reproach to anyone who believed Canadian heroics at the Somme and Vimy Ridge, or the nationwide celebrations of the semi-centennial, could unite the country or confirm its identity. Every single Ontario MP, whether Liberal or Conservative, supported the bill, which was unanimously opposed by francophone MPs in Quebec. There was likewise strong opposition in the West, which, as sharp-eyed foreign correspondents noted, was grossly underrepresented in Parliament by some twenty seats.[17] An amendment to the bill, introduced by Sir Wilfrid Laurier and providing for a referendum on the issue, was defeated by a virtually identical pattern of voting. The bill was therefore due to be sent before the Senate at the beginning of August, after which it would receive royal assent and come into force as the Military Service Act. This selective draft aimed to make eligible for compulsory military duty all men between the ages of twenty and forty-five, in particular those who were unmarried and without children.

In the summer of 1917, debate over the controversial legislation filled Canadian newspapers and sometimes—with anti-conscription parades and protests in Quebec—the streets of Canadian cities. A Montreal journal called *L'Idéal Catholique* published an article entitled "Down with Confederation"; it was quickly reprinted in three hundred other newspapers.[18] Stories reached the papers of "preparations for revolt" in Quebec, while the New Brunswick–born R.B. Bennett, a Conservative MP for Calgary and future prime minister, warned that compulsion could not be introduced in French Canada without "riot and bloodshed."[19] A foreign correspondent, in an article headlined "Canada at the Cross-ways," observed this bleak political landscape and sorrowfully observed, "The clouds are still low

over the political horizon of Canada, and the prospect of their break-
ing to a clearing sky seems remote."[20]

In the midst of this furor there appeared in the *Toronto Daily Star,*
on Wednesday, July 18, beneath a long list of Canadian soldiers killed
in action, a report that the body of a "landscape artist of rare charm
and promise" had been recovered from Canoe Lake.

6 SHADES OF GREY

W HEN TOM THOMSON arrived at Mowat Lodge early in April 1917, snow still covered the ground. For the first few weeks he spent his time painting and ice fishing. In the middle of the month, he wrote to his father that, with three feet of snow in the bush, he was anticipating "a lot more winter sketches."[1] But he was unsure of his plans for the coming months and not certain if he would remain in Algonquin for the whole summer. He had already decided against working as a fire ranger because, as he wrote to his brother-in-law, "it interferes with sketching to the point of stopping it altogether, so in my case it does not pay." The job might have earned him a certificate of exemption from conscription, had he wanted one, on the grounds that it could be deemed (in the words of the Military Service Act) "expedient in the national interest." But as he told his brother-in-law, "I can have a much better time sketching and fishing and be farther ahead in the end."[2]

There was apparently another reason why Thomson decided to remain at Canoe Lake rather than work as a fire ranger. Mark Robinson believed Thomson wished to stay close to one of the summer cottagers, Charlie Scrim, a twenty-nine-year-old florist from Ottawa. Scrim had been an active member of the Rideau Canoe Club, but by

J. Shannon Fraser, Tom Thomson and Mr. Charles Robert Edwards Robinson
at Mowat Lodge, Algonquin Park, May 1917

Photographer: Mrs. Emily C. Robinson, Gift of the Family of Charles R. and Emily C. Robinson,
McMichael Canadian Art Collection Archives

1917 he was suffering from a physical infirmity, probably tuberculosis, the disease that in a few months would claim Thomson's friend Dr. John McRuer. Thomson believed the ailing Scrim was "not long to be with us," so he resolved "to stay down here on Charlie's account" and make what was left of his life "as happy as can be."[3]

This devotion to Scrim reveals the strong bonds of attachment Thomson felt to the small community on Canoe Lake, and to some extent it belies his reputation as a taciturn solitary. In the early spring and late autumn, when the snow prevented him from pitching his tent, he lived, according to one Canoe Lake resident, "with the Frasers as one of the family."[4] He was likewise friends with the rangers, not only Mark Robinson but also Larry Dickson and George Rowe. Dickson, a former shantyman, and Rowe, a one-time typesetter and mill worker, shared a small log cabin (painted several times by Thomson) on the north end of Canoe Lake, near the Algonquin Hotel. He also became close to the less robust residents, such as Scrim. Many of those who

visited Canoe Lake were semi-invalids who came for the sake of their health. Thomson took an interest in their welfare, rowing "many a sick friend" around the lake until they were "growing strong and back to health again."[5]

A visitor to Canoe Lake with whom he formed a much-debated romantic attachment was Winnie Trainor. A Mowat Lodge resident in 1917 later claimed that Thomson was "with her all the time."[6] According to the testimony of another regular visitor, an American named Robert Little, Thomson and Winnie were "frequently seen together."[7] Described by Little as "comely," the tall and slim Winnie was known at Canoe Lake as a "Belle of the Ball."[8] What must have appealed most to Thomson was her love of the outdoors and her interest in his paintings. Mark Robinson's daughter wrote that Winnie took "a great interest in Thomson and his work. Tom visited her in Huntsville and gave her some of his sketches."[9] Altogether he gave her about a dozen of his works—though none painted after 1914[10]—and also decorated a set of her crockery with northern scenes. Frequent letters passed between them when she was in Huntsville.

At some point, using the camera he always packed for his canoeing expeditions, Thomson took two photographs of a woman generally presumed to be Winnie. Both show her standing in the bush on a sunny summer's day, a bamboo fly-fishing rod in one hand and her catch of bass in the other. She wears an ankle-length flannel dress with a high collar and down-to-business, rolled-back sleeves. She is smiling but her eyes are shyly downcast, or else Thomson caught her at the moment she blinked or squinted in the sunlight. She looks to be a young woman at home in the bush, an updated version of that uniquely Canadian female character type, the industrious and prudent pioneer woman of the sort described by Catharine Parr Traill in *The Backwoods of Canada* and *The Canadian Settler's Guide*. The photographs suggest that Thomson was able to share his passion for fishing and the outdoors with a woman as well as with men like Mark Robinson or Ned Godin.

The most tantalizing thing about Thomson's photographs is that Winnie (if she is indeed the woman in the pictures) wears three rings

Miss Winnifred Trainor
Tom Thomson / Library and Archives Canada / PA-193570

on the third finger of her left hand.[11] Whether or not Thomson and
Winnie were engaged—and, if so, whether their engagement was the
result of a pregnancy—has been the subject of much inconclusive
debate. Annie Fraser, Shannon Fraser's wife, later claimed the pair
was to be married. She based her evidence, according to Robinson's
daughter, on a letter "carelessly lying on a dresser" in Thomson's room
at Mowat Lodge. This letter supposedly urged Thomson to "get a new
suit, because we'll have to be married"[12]—the hasty trip down the
aisle necessitated (so the inference goes) by Winnie's pregnancy. Yet
Thomson would hardly have left a letter of such import lying "care-
lessly" on a dresser: he was suspicious of the Frasers' interest in his

affairs, warning Winnie never to put anything personal in her letters because the Frasers "always seemed to know his business." He suspected the Frasers of steaming his letters open in the post office or else removing them from his overcoat pocket.[13] Even if Winnie committed such sensitive information to print, Thomson would not have been so indiscreet as to leave the letter vulnerable to the snooping eyes of his landlady.

Not everyone believed the relationship between Thomson and Winnie was destined to end in marriage. Mark Robinson learned from an unnamed friend that Winnie claimed she was engaged to Thomson. The ranger had his doubts: "Perhaps so, but I did not see anything to indicate more than ordinary friendship."[14] He too read the correspondence between Thomson and Winnie (there were few secrets at Canoe Lake) but dismissed it as "just ordinary boy and girl letters, there was nothing extraordinary about them."[15] An adolescent acquaintance of Winnie later remarked that she knew nothing of the engagement and that the relationship between the two supposed lovers was "all a mystery."[16]

Even so, the rings in the photograph and the testimony of Robert Little indicate something more than ordinary friendship. After more than three years, Thomson's relationship with Winnie appears to have reached a critical stage—though not necessarily as a result of a pregnancy. Thomson certainly hoped to find domestic happiness: that much he indicated in his letter to Frank Carmichael deploring those who believed that bachelordom and celibacy were ideal for an artist. He undoubtedly agreed with his friend Will Broadhead that the life of a bachelor was "unnatural and disappointing."[17] But marriage would have brought its own problems. Thomson wrote to his father in the spring of 1917 that he hoped to live exclusively by his art "for another year at least . . . I will stick to painting as long as I can."[18] Marriage would inevitably threaten his artistic independence. Would he be able to support Winnie and a family? Or would he be forced to work as a fire ranger or—provided he could find a job—a commercial designer?

The decision did not, to all outward appearances, weigh heavily on Thomson. A fellow resident of Mowat Lodge that spring found him "a rather moody, quiet chap, and rather withdrawn," but Little

believed him to be "in excellent spirits."[19] He was also productive with his brush. Each day through April and May he painted, according to Robinson, at least one sketch (or "board," as Thomson called them), creating "a record of the weather for sixty-two days, rain or shine or snow, dark or bright."[20] Once again Mowat Lodge turned into an exhibition gallery as dozens of Thomson's sketches were spread around the dining room. One was given by Thomson as a wedding present to Robert and Daphne Crombie, a couple honeymooning at Canoe Lake.

One sketch Thomson completed was a small but ambitious nocturnal scene, *Northern Lights.* The possibility of painting nocturnal landscapes fascinated and frustrated painters. "It often seems to me," wrote Van Gogh in September 1888, "that the night is more alive and more richly coloured than the day."[21] But how did one use colour to depict darkness? *The Starry Night,* with its superabundant variegation of swirling blues and yellows, was Van Gogh's triumphant experiment. Thomson was equally daring. He attempted to depict the aurora borealis, something so fleeting that most artists considered it impossible to paint. Late one "intensely cold" evening Thomson had been watching the northern lights outside Mark Robinson's house when he declared, "I believe I can put that on canvas." Robinson's property near the Algonquin Hotel failed to provide a striking background to the lights, so he went to Larry Dickson's cabin and lit a fire. He then spent the entire night dashing in and out of the cabin, studying the lights for a few minutes before returning inside to warm his hands beside the fire and paint by lamplight.[22] Only twenty-two centimetres high by twenty-seven wide, the sketch showed the newly self-confident painter in full artistic flight. Yet Thomson was still assailed by self-doubts. Evidence of his ongoing frustrations was a pile of smashed-up boards along Potter Creek.[23]

Thomson became less prolific as summer arrived. On July 7 he wrote to Dr. MacCallum that he had not been able to work "since the flies started. The weather has been wet and cold all spring and the flies and mosquitoes much worse than I have seen them any year and fly dope doesn't have any effect on them." He kept busy nonetheless, taking temporary work as a fishing guide and planting vegetable plots at both Mowat Lodge and the cottage known as The Manse. But with

the weather finally warming in the first week of July he was optimistic about producing more work. "Will send my winter sketches down in a day or two," he wrote to Dr. MacCallum, "and have every intention of making some more."[24] That evening found him drinking with a group of men in Larry Dickson's cabin.

LIKE MANY MEN who lived in the bush, Larry Dickson and George Rowe were hard drinkers. Dickson resorted to doses of horse liniment to treat his frequent hangovers. Their fondness for liquor meant they were regularly fired (and then long-sufferingly rehired) by Shannon Fraser, who used them, like Tom Thomson, to carry the mail and perform odd jobs around Mowat Lodge. Thomson, at least as a young man, also enjoyed a drink. "I have been with him on several occasions when I am now sorry to say that neither of us was very sober," reported a friend from Owen Sound.[25] Getting drunk in Ontario in 1917 was not the easiest proposition. Prohibition arrived in September 1916, when the Ontario Temperance Act closed all bars and liquor stores in a supposed effort to make the province more economically productive. The only legal place to consume alcohol was a private house, provided it could be obtained in the first place from either a reliable bootlegger or a sympathetic physician.

Alcoholic beverages were served, however, in the tiny cabin that Rowe, a man in his sixties, shared with Dickson. Besides Thomson and Rowe, those present that Saturday evening, July 7, were Shannon Fraser and a married American named Martin Bletcher Jr., a private detective from Buffalo whose family owned a cottage close to The Manse. Heavy drinking ensued. "They were all pretty good drinkers," Daphne Crombie later reported. "Tom as well . . . They were all tight."[26]

Daphne Crombie and her husband were not actually present at Canoe Lake in July 1917, and reports of what happened over the next twelve hours would vary widely. Thomson and Bletcher soon began to argue. Certain investigators, following the usually reliable maxim *cherchez la femme,* have been anxious to draw Winnie Trainor into their dispute.[27] More likely the cause of the argument (if in fact a drunken argument requires a rational *casus belli*) was the war. The United States had finally entered the Great War in April 1917, with

Congress approving conscription on May 18 and requiring all American men between the ages of twenty-one and thirty (Bletcher was a few days shy of his twenty-sixth birthday) to register for the draft. Later it was claimed that Thomson accused Bletcher of evading the draft.[28] It seems unlikely, though, that Thomson, with his hatred of war and probable humiliation by the Order of the White Feather, would have berated the young man as a slacker.

Americans were extremely unpopular in Canada during the war years. They were regarded as having sat on the sideline for more than two years, profiteering on war orders and bank loans as Canadians died in their thousands on the Western Front. Their belated entry was marked with a typical bravado and much insensitive flag-waving. Propaganda movies and war songs playing up America's (hitherto non-existent) role in the war flowed across the border with no regard for Canadian sensibilities or sacrifices. Harold Innis spoke for many Canadians when he wrote to his mother in July 1917: "The Americans never get tired of talking about the things they do or the things they are going to do . . . I never heard such a line of bragging and boasting in my life. It was really disgusting, at least to Canadians."[29] When an American musical, *The Passing Show of 1917,* was performed at Toronto's Gaiety Theatre, entire audiences booed or stormed out as the Stars and Stripes was waved onstage.[30]

Canadians also resented the hysterically anti-British tone of German-American propaganda. Bletcher, a German-American who spoke with a slight accent, was therefore almost guaranteed to raise hackles at Canoe Lake. He had already attracted suspicion and hostility. Feelings against Germany and German immigrants ran so high in Canada that the teaching of German literature was banned in schools, orchestras refused to play German music, and soldiers of the 118th Infantry Battalion, based in Waterloo, vandalized German-owned local businesses. Thousands of "enemy aliens" were interned in camps across the country, including (until the spring of 1916) at nearby Camp Petawawa.

Bletcher fell foul of these anti-German sentiments. Mark Robinson, newly returned from Europe after being wounded while serving with the Peterborough Rangers, believed him to be a German spy.[31]

239

The suspicion, however unfounded, was not completely unreasonable. Under Count Johann von Bernstorff, the German ambassador to the United States, members of the German Foreign Office in Washington were recruiting and organizing German-born Americans for missions in Canada as saboteurs. In 1914 British intelligence warned the Canadian government of a German plan to bomb the Welland Canal. Although that attack never took place, soon afterwards a CPR bridge in New Brunswick was destroyed by dynamite on orders from Arthur Zimmermann, undersecretary at the Foreign Office in Washington (and future author of the infamous "Zimmermann Telegram"). Then in June 1915 a German agent from Detroit named Karl Respa, a one-time homesteader in Alberta, planted dynamite at a factory in Walkerville, Ontario, and at an armoury in Windsor. Only the former detonated, but within a few days more dynamite was found on the premises of both a Windsor truck company and a machine works due to be transformed into a munitions factory. Respa was apprehended and, in March 1916, sentenced to life imprisonment in Kingston Penitentiary.[32]

Whatever the exact nature of their disagreement, cottagers at Canoe Lake had already noticed "some ill feeling" between Thomson and Bletcher, and on the night of July 7 it erupted into open hostility.[33] Insults were traded, and the altercation stopped shy of an exchange of physical discourtesies only thanks to the intervention of Fraser and Rowe. One account described the aggrieved Bletcher storming from the cabin with a final drunken threat to Thomson: "Don't get in my way if you know what's good for you!"[34]

Thomson returned to his room at Mowat Lodge (he was not sleeping in his tent at this point) and the next morning, in heavy rain, went fishing on the north end of Canoe Lake. Later in the morning, at the Algonquin Hotel, he had a cup of tea, as well as "a piece of cake and pie and so on," with the owner, Molly Colson.[35] Shortly before one o'clock he went to The Manse, not to visit Winnie, who was in Huntsville, but to collect his fishing gear. He was planning a longer fishing expedition, probably to Gill Lake. He asked Shannon Fraser to load his canoe—his distinctive blue-grey Chestnut—with supplies such as bread, bacon,

maple syrup and pancake flour. He did not pack his sketching equipment. Fraser wrapped the provisions in a rubber groundsheet and placed them in the bow.

In the summer of 1916 Thomson had positioned himself on Hayhurst Point, a peninsula on the north end of Canoe Lake. Here, occasionally cleaning his brush on the rocks, he painted the waters and islands spread below him. *Islands, Canoe Lake* shows a stretch of gloriously prismatic water—soothing licks of salmon pink, lavender, ultramarine—beneath a teal-coloured sky (see plate 25). One year later he paddled onto this shimmering lake, navigating into the middle because the passage along the shoreline was blocked by sawlogs. He was wearing a grey lumberjack shirt, khaki trousers and canvas shoes. The last Fraser saw of him, he was already fishing, trolling with his copper fishing line in the middle of the lake. By Fraser's fob watch it was 12:50 PM. The temperature was in the upper teens, the morning's heavy rain turning into a light drizzle.

TWO HOURS LATER, a few minutes after three o'clock, Martin Bletcher and his sister Bessie, crossing the lake in their small motor launch, spotted a capsized canoe near one of the islands, Little Wapomeo, in the middle of the lake. Not recognizing it as Thomson's, despite the unique colour, they assumed it was one that had come loose from its moorings at the Algonquin Hotel. Rogue canoes, like stray logs, were not an uncommon sight: earlier that morning Thomson and Shannon Fraser rescued an abandoned canoe from the north end of the lake.[36]

When the Bletchers returned a short while later, intending to tow it back to the hotel, the canoe had disappeared. No one realized Thomson was missing until the next morning when the Bletchers finally reported their sighting to Shannon Fraser. Mark Robinson and the park superintendent, G.W. Bartlett, were immediately alerted, and the search began on both water and land. Robinson assumed that Thomson, while portaging, "must have broken a limb . . . or fallen someplace and injured himself."[37] Gunshots were fired and whistles blown. On Tuesday, two days after Thomson disappeared, the capsized canoe

was spotted by Charlie Scrim and brought ashore. The portage paddles were lashed into place and a few provisions stashed in the bow, but Thomson's handmade black-cherry paddle, axe, fishing rod and dunnage bag all were missing. A telegram reporting the discovery was sent to Thomson's parents in Owen Sound. The *Owen Sound Sun* reported that the state of the canoe meant it could have drifted from its moorings, leaving Thomson marooned, but alive and well, on one of the islands.[38]

On Thursday, July 12, Robinson wrote Dr. MacCallum to inform him that Thomson was missing but that "everything is being done that can be done."[39] That same morning Thomson's older brother George arrived at Canoe Lake from where he had been holidaying in Owen Sound. He remained in Mowat for two days before returning to comfort his elderly parents. By then the *Toronto Globe* was reporting that "one of the most talented of the younger landscapists" was thought to have been drowned or "the victim of foul play." The suggestion of foul play may have surprised the paper's readers given the drownings that routinely occurred in the region every summer. In the same week Thomson went missing the papers were reporting the drowning of a seventeen-year-old boy after a canoeing mishap on a lake near Bobcaygeon and the death of two men after a capsize on Drag Lake in the Haliburton Highlands. Foul play was not mentioned in connection with either case.[40] The *Globe* ended its story on a gloomy note: "There is still a chance that Mr. Thomson may be alive, but this is considered doubtful as four days' search has failed to find a trace of him."[41]

Thomson's body was finally found on Monday, July 16, more than a week after he went missing. It was spotted at ten o'clock in the morning by a vacationing Toronto neurologist named Goldwin Howland. Dr. Howland had impressive medical credentials, not to mention an alluring Canadian pedigree. His grandfather had been one of the Fathers of Confederation, and his father, William Holmes Howland, was the reforming mayor of Toronto whose zeal for shutting down bars and brothels in the late 1880s had earned the city its nickname Toronto the Good. Dr. Howland was himself a distinguished figure, the country's first consulting neurologist and a pioneer in the treatment and rehabilitation of wounded soldiers.

In the summer of 1917 Dr. Howland was renting Little Wapomeo Island and its cottage from Taylor Statten, future founder of Camp Ahmek. He was sitting on the veranda (or, other sources claim, fishing with his daughter in a boat) when he saw a body floating on the lake. He immediately summoned Larry Dickson and George Rowe, who recognized Thomson from his clothing. Securing it with, presumably, a fishing line, the two rangers towed the body several hundred yards through the lake to Big Wapomeo Island. Here they tethered the dead artist to, poignantly, the roots of a pine tree.

TOM THOMSON WAS buried twice: first in Canoe Lake, and then again, in a metaphor for how he would never truly be laid to rest, four days later, after exhumation, in his hometown of Leith.

The Canoe Lake ceremony, performed on July 17, was a forlorn and improvised affair. "The sky was overcast and the rain was falling," recalled a visitor from Toronto enlisted as a pallbearer even though he was utterly oblivious to Thomson's identity and reputation. "It had all the earmarks of a backwoods funeral."[42]

The funeral was held, on the advice of Dr. Howland and with the permission of G.W. Bartlett, because of the deterioration of the body. The coroner had not yet arrived, nor were any of Thomson's family or friends from Toronto present. The brief telegram sent by Shannon Fraser to the Thomson family—"Found Tom this morning"—had failed to indicate whether he was alive or dead, painfully prolonging their suspense. An ensuing telephone message, received, according to the local newspaper, "in a roundabout way," did little to clarify.[43] The family would not learn positively of his death until the day after his funeral.

However hasty and irregular these proceedings may seem to posterity, swift burials were the norm in Ontario at this time. The deceased was almost always buried within a day or two of death. When Professor George Blewett drowned under similarly inexplicable circumstances at Go Home Bay on August 15, 1912, his body was returned to Toronto on the Muskoka Express on the sixteenth and then buried at the Necropolis on the seventeenth, a Saturday.[44]

A horse-driven cart carried Thomson's wooden coffin along a logging road to the tiny cemetery, encircled by a picket fence, that stood

on a knoll behind Mowat. The location was eerily similar to the "secret ferny tomb" near Mattagami Lake where Neil McKechnie had been laid to rest almost exactly thirteen years earlier. Thomson knew the Mowat cemetery well. He had photographed one of the two graves, that of James Watson, a twenty-one-year-old Gilmour employee killed by a falling tree in 1897. Watson was, according to his grave marker, "the first white person to be buried at Canoe Lake." His gravestone included a pair of couplets legible in Thomson's photograph:

Remember, comrade, when passing by
As you are now so once was I,
As I am now so you will be;
Prepare thyself to follow me.

Thomson was interred some twenty-five feet from Watson's grave, with Martin Bletcher Sr. reading the service. Several hours later a coroner named Arthur Ranney, summoned from North Bay but delayed by medical emergencies, opened the inquest. The body had been examined by Dr. Howland, who observed a bruise on the right temple—what the coroner concluded was consistent with "striking some obstacle, like a stone"[45]—and some bleeding from the right ear. Dr. Howland believed from his observations that Thomson died by drowning. The verdict was accepted by the coroner, a less distinguished medical practitioner than Dr. Howland. He concluded the inquest at 1:30 AM on the eighteenth and then, later that morning, caught the train back to North Bay.

Thomson remained in the Canoe Lake cemetery for less than two days. At eight o'clock on the evening of the eighteenth, an undertaker, a bowler-hatted man named Churchill, arrived from Huntsville with a metal casket and instructions to exhume the body and return with it to Owen Sound. He worked late into the night, literally prosecuting the resurrection that would be performed, figuratively, many times thereafter. On the following evening the casket was placed on a train that carried Thomson for the last time from his beloved Algonquin Provincial Park.

244

The second funeral service was performed on Saturday, July 21, at the Presbyterian church in Owen Sound. Interment followed in the family plot at the church in Leith. In the Burial Register of Owen Sound church, the Reverend P.T. Pilkey inscribed a strange clerihew: "Talented and with many friends, and no enemies, a mystery."[46]

TOM THOMSON, DESPITE painting in vibrant hues, once told Mark Robinson that "grey is one of the hardest colours I have to manage."[47] It is cruelly appropriate that his life should have ended in shades of grey, the answers to what exactly happened on the afternoon of July 8, 1917, as elusive as the yellow-jerkinned phantom who local legend claims paddles through the veils of Canoe Lake mist: an insistent rejoinder to the poet Earle Birney's famous quip that Canada is haunted by a lack of ghosts.

The Reverend Pilkey was far from alone in his bafflement over Thomson's death. The mysterious disappearance, the rushed inquest, the simple verdict from a coroner who failed to view the body; such proceedings caused disquiet. By 1917 Thomson was an experienced canoeist who had shot the rapids of the Mississagi, paddled the gorges of the Petawawa, conquered the strenuous portages of the Mattawa. How could he possibly have drowned, not in one of these eerie wildernesses, but on a calm lake, in broad daylight, only a short distance from his lodgings and where the neat cottages of wealthy Torontonians sat perched on private islands?

As Arthur Lismer observed from Halifax, the circumstances were "strange enough for any amount of speculation."[48] No sooner had the coroner departed on the eighteenth than Mark Robinson wrote in his diary, "There is considerable adverse comment regarding the way evidence had been taken at the meeting among the residents on the Lake."[49] To a number of Mowat residents, Thomson's death seemed not to have received a proper investigation. Charles Plewman, the pallbearer, noted how there was "considerable speculation" as to how a man with Thomson's skill in handling a canoe could have drowned.[50] Most distressed and suspicious was Winnie Trainor, who, after the body was found, "appeared on the scene," according to Plewman, "and

demanded the right to see the remains, saying that there must have been foul play as she was certain that Tom didn't drown by accident in a small lake like Canoe Lake."[51]

Some speculation involved suicide. Thomson certainly seems to have suffered from bouts of depression—what Carmichael called his "blue streaks." But might he have killed himself? Shannon Fraser wrote to Dr. MacCallum on July 24, in garbled English, that Thomson "must of taking a cramp or got out on shore and slip of a log or something."[52] But to Plewman he told a different story, suggesting the "shy and sensitive" Thomson, facing a "showdown" with Winnie regarding their impending marriage, decided "that a settled, married life was not for him, but that he just could not say so to Miss Trainor."[53] When his theory reached the ears of the Thomson family, Fraser emphatically retracted: "No one ever mentioned such a thing as suicide at the inquest," he assured George Thomson. "The verdict was death due to drowning. I am feeling very badly about this terrible thing as I thought so much of Tom & would be the very last to even mention such a thing."[54]

One of the people who knew Thomson best, Frank Carmichael, found the suicide theory unconvincing. Two days after the Canoe Lake funeral he wrote to Lismer, "The idea of Tom himself being responsible for it (which seems to have entered into some of the discussions) hardly strikes me as being probable. It is hardly fair to presume on his eccentricities to that extent."[55]

Suspicions lingered of foul play, some implicating Fraser, possibly because of his swiftness in promoting the suicide theory. Fraser's true crime seems to have been his petty and unseemly greed. Winnie Trainor regarded him as "money grabbing,"[56] and his conduct in the weeks following Thomson's death led to a falling-out with the Thomson family. Fraser seems to have been guilty of sharp practice. He tried to sell Thomson's shoes after his death, he undervalued Thomson's two canoes by claiming they were "full of holes" and therefore worth only $10 each, and he charged both the Thomsons and Dr. MacCallum for the services of the rangers. "I tell you frankly, Mr. Fraser," Thomson's brother-in-law wrote in a stern letter, "I am suspicious that you are not dealing square and I hope you will be able to give a satisfactory

explanation of everything." The family was understandably concerned about the $250 loan from Thomson to Fraser in 1915, though Winnie assured them it had been repaid in full. Even so, Thomson's sister Margaret began to wonder if Fraser was guilty of more than minor irregularities in dealing with Thomson's estate: "Sometimes I wonder if the man did do anything to harm Tom," she wrote to Dr. MacCallum. "I suppose it is wicked to think such a thing, but if anyone did harm him, it was for the little money they could pocket."[57]

It hardly seems convincing that Fraser, however avaricious, should have ambushed and murdered, in broad daylight, for the price of two canoes and a pair of shoes, the man who was such an asset to Canoe Lake and Mowat Lodge. Nor would Fraser have done away with his friend to get his hands on his paintings: Thomson was only too happy to give away his sketches. Little claimed he "often gave away his panels for the asking or to pay for some minor obligation," and Plewman believed that in the summer of 1917 he, if he so wished, "could have had them for about a dime a dozen."[58]

Sixty years later, Fraser was blamed for Thomson's death by Daphne Crombie, the newlywed who came to Canoe Lake with her tubercular husband. In 1977 she gave two interviews incriminating Fraser, one for the Algonquin Park Museum Archives, the other to the journalist Roy MacGregor, a distant relation by marriage of Winnie Trainor and the author of the 1980 novel *Shorelines* (later retitled *Canoe Lake*).

Although not at Canoe Lake in July 1917, Crombie claimed that when she returned four months later Annie Fraser told her that Thomson's drunken altercation on the night of July 7 was not with Martin Bletcher but with Shannon Fraser. Fraser and Thomson, both the worse for drink, had argued over money. Thomson needed Fraser to repay him because Winnie was pregnant and he needed a new suit for their forthcoming wedding. After an exchange of blows, Thomson fell to the floor and struck his head on a fire grate. He either died outright or—as Crombie believed more likely—was knocked senseless. The panicked Fraser roused his wife, and the pair disposed of the body in the lake. "My conception," claimed Crombie, "is that he took Tom's body and put it into a canoe and dropped it in the lake. That's how he died."[59]

Crombie's story, with its sketchy, second-hand details related long after the fact, has the obvious flaw that Thomson was still alive—and seen by witnesses like Mark Robinson and Molly Colson—on the morning after his supposed death. MacGregor suggests the fight might have taken place not on the evening of the seventh but on the eighth. Thomson's overturned canoe, however, was spotted by the Bletchers on the afternoon of the eighth, whereas Crombie's description of a drunken Fraser rousing his wife implies a late-night drinking session: hence her insistence on the seventh. The cause of the fight—the money owed by Fraser—was contradicted by Winnie, who claimed the debt had been discharged. Other puzzles abound in this version of events. Why would the Frasers dump a still-breathing Thomson into the lake? Why did Annie Fraser confess these details to Crombie? And why did Crombie, once in possession of them, not inform the police?

The case against Martin Bletcher Jr., the other prime suspect, is even less persuasive. Much later it would be reported that a gunshot was heard on Canoe Lake around the time Thomson was last seen.[60] This melodramatic addition to the story, together with Bletcher's B-movie threat against Thomson and his supposed role as a Boche agent lurking in the Canadian backwoods, consigns the tragedy of Thomson's death to the realms of John Buchan's spy fiction.

ONE REASON FOR continued suspicions of foul play is a piece of evidence that came to light almost forty years after Thomson's death. Mark Robinson mentioned in 1956 a fact that appeared nowhere in contemporary accounts of Thomson's death, least of all in either Dr. Howland's affidavit or the coroner's report: around Thomson's left ankle, claimed Robinson, "there was a fishing line wrapped sixteen or seventeen times."[61] The fishing line has been offered as proof that Thomson's assailant, after striking the lethal blow, tethered his body to a rock or other weight so he would, in mafia-victim style, sleep with the fishes. It also supposedly explains why Thomson's body took so long to find: it was anchored to the bottom of the lake for perhaps as long as a week.

Yet there is a more plausible and innocent explanation for the coiled fishing line. Robinson spotted the suspicious tether when Thomson's body was still on Big Wapomeo Island, resting on boards and undergoing an examination by Dr. Howland. Larry Dickson, present for the makeshift autopsy, asked Robinson if he had a sharp knife to cut through the fishing line. According to Robinson, "I said I had ... and I did, and I counted them, that's why I know there were sixteen or seventeen."[62] Why Dickson should have requested Robinson to remove this incriminating and surely significant piece of evidence in the middle of an autopsy, in the presence of a distinguished medical professional, is a mystery unless one considers that Dickson wound it around Thomson's ankle in the first place: he and George Rowe were the ones who towed the body through the water to Big Wapomeo Island and tethered it to the tree.

Thomson's body would have required no anchor to remain beneath the surface of the lake for a full eight days. Dr. Howland probably entertained no suspicions of foul play because the medical literature of the period taught that a drowned corpse always remained underwater for eight to ten days before floating. That, at any rate, was the sworn testimony, in a case heard before the Supreme Court of the State of New York, of a coroner who examined some four hundred drowning victims. Two assistant coroners from New York City and a medical doctor corroborated his evidence. Only when the water temperature is 70 degrees Fahrenheit or above—certainly not the case at Canoe Lake in the cool spring and summer of 1917—will a corpse rise in less than a week. Thomson's body therefore appeared on the surface of Canoe Lake exactly when medical science would have predicted.[63]

Another supposed murder clue—the air reportedly in Thomson's lungs—may also have an innocent explanation. Air in the lungs would mean, so the theory goes, that Thomson was dead before he entered the water, struck on the head by a paddle-wielding assailant who then, in the words of one melodramatic reconstruction, "watched him crumple up and topple over the side of the canoe and sink slowly out of sight without a struggle."[64] As many as 10 to 15 per cent of drowning victims, however, are found to have air in their lungs. This

249

condition, known as "dry drowning," results from a laryngospasm, an involuntary muscular contraction of the vocal chords caused by a small amount of water entering the airways. This reflex shuts the windpipe, creating a seal that prevents more water from entering the lungs but in the process stops the victim's breathing. The result is that he or she "drowns" with only a small amount of water aspirated and air still in the lungs.[65]

Neither a gunshot nor a blow from a paddle would have been necessary for a death on Canoe Lake. Plenty of hazards and obstacles could be found: deadheads, submerged rocks, rogue sawlogs. Thomson could easily have come to grief on any of them, and he is known to have had spills in rivers such as the Mississagi. But such an accident would have cruelly put the lie to the myth of how, in Lismer's glowing report, Thomson could find his way over open water "on a night as black as ink," or how, as Eric Brown wrote, he was "the best guide, fisherman and canoe man in the district."[66] Perils such as tree stumps and hidden rocks were too random and too mundane to satisfy either curiosity or legend.

THE SCALE OF the nation's loss in the waters of Algonquin Provincial Park, in a year when so many other young Canadians died overseas, was appreciated at first by only a select group of people. Arthur Lismer was in Halifax, at the Victoria School of Art and Design, when he learned of his friend's death. He wrote immediately to Dr. MacCallum: "We've lost a big man—both as an artist and a fine character . . . When one recalls the few years that he had been painting, it is remarkable what he achieved."[67]

Thomson's achievement was indeed remarkable. He had been painting in the Studio Building for less than four years, but during that time he made such astonishing progress that Lismer, Jackson, MacDonald, Carmichael and Varley must all have recognized how he possessed an extraordinary talent that the rest of them could try to emulate but never match. One of the few indisputable facts about his mysterious death on Canoe Lake was that he died just as he was approaching the summit of his artistic powers. His sketches of the

night sky suggest he was planning a large canvas of the aurora bore-alis—a lost masterpiece it is now almost unbearable to contemplate.

At the end of September, Thomson was commemorated by a cairn at Hayhurst Point, on Canoe Lake. This was the age of these sad com-memorations, as the traditional mementos of war—statues of generals and other heroes—gave way to monuments dedicated to sorrow and remembrance. Over the next few years, cenotaphs and plaques hon-ouring the Canadian war dead would appear in virtually every Canadian city and town. A bronze plaque listing more than a hundred of Massey-Harris's fallen employees would be fixed to the facade of the company's head office on King Street West in Toronto; nearby stood a statue honouring eighteen employees of Borden's Dairy.

Thomson's cairn was a similar tribute to a fallen hero.[68] A trun-cated pyramid of rose-grey stones cemented into place, it was financed by Dr. MacCallum and featured a brass plaque designed by MacDonald. The cenotaph was placed against a background of spruce trees a short distance from rocks showing smears of paint made by Thomson as he cleaned his palette. The stones had to be lugged some sixty feet up a cliff, with the sand for the cement brought by boat and then likewise raised to the top. The work was overseen by Bill Beatty with help from Shannon Fraser, George Rowe and (as MacDonald told Thomson's father) some "soft-handed city men, who had not known Tom, but were holidaying at the Lake and cheerfully offered their ser-vices."[69] MacDonald arrived towards the end of their labours with a brass plate commemorating the "artist, woodsman and guide" (as Thomson was identified). The inscription continued: "He lived humbly but passionately with the wild. It made him brother to all untamed things of nature. It drew him apart and revealed itself wonderfully to him. It sent him out from the woods only to show these revelations through his art. And it took him to itself at last." At the bottom of the plaque, MacDonald wrote that Thomson's friends and fellow artists had joined in this tribute to his "character and genius."

The memorial on Hayhurst Point marked the second time Mac-Donald joined with a small group of artists to pay tribute to a fallen comrade, since in 1904 MacDonald was one of those who

commemorated Neil McKechnie in the tiny cemetery near Matta-
gami Lake with a bronze plaque and what an article in *Saturday Night*
described as an "axe-hewn cross."[70] Thomson's tragic death recalled
to MacDonald his other drowned friend. A short time later he wrote
a poem, "Below the Rapids," originally dedicated to McKechnie but
equally evocative of Thomson's death:

> He'll follow no more the sun
> Portage and rapid are one
> Night brings no need of camping place
> The end of the trail is run.[71]

Although deeply grieved by everyone in the Studio Building, Thom-
son's death affected MacDonald most, since he had known and worked
with him for almost ten years. "I know how keenly you will feel his loss,"
A.Y. Jackson wrote to him from England.[72] The stress of Thomson's
death and continued financial hardships took a severe toll on MacDon-
ald's health. In November he and his family were forced to move from
Four Elms to a smaller property—what his son Thoreau called "a small
and rotten rickety house"—across from a gristmill in York Mills.[73] The
evening following the move, with their possessions still unpacked,
MacDonald suffered a stroke. The Studio Building's latest casualty
would be left bedridden for many months, unable to work.

PLATE 12 | TOM THOMSON (Canadian, 1877–1917)
Twisted Maple, 1914
oil on plywood, 26.7 × 20.9 cm

McMichael Canadian Art Collection,
Gift of Mrs. Margaret Thomson Tweedale, 1974.9.4

PLATE 13 | ARTHUR LISMER
(Canadian, 1885–1969)
The Guide's Home, Algonquin, 1914
oil on canvas, 102.6 × 114.4 cm
National Gallery of Canada, Ottawa

PLATE 14 | A.Y. JACKSON
(Canadian, 1882–1974)
The Red Maple, November 1914
oil on canvas, 82 × 99.5 cm
National Gallery of Canada, Ottawa

PLATE 15 | TOM THOMSON (Canadian, 1877–1917)
Northern River, 1915
oil on canvas, 115.1 × 102 cm
National Gallery of Canada, Ottawa

PLATE 16 | *Woodland Scene* 1911/1913
tapestry, linen and wool, 285 × 247 cm
Designed by Henrik Krogh / woven by Märta Måås-Fjetterström,
Röhsska Museet, Göteborg, Sweden

PLATE 17 | J.E.H. MACDONALD (Canadian, 1873–1932)

Belgium, 1915

oil on cardboard, 52.7 × 74.9 cm

Art Gallery of Ontario, Purchase, 1963

PLATE 18 | Tom Thomson (Canadian, 1877–1917)

Evening, 1915

oil on board, 21.6 × 26.7 cm

McMichael Canadian Art Collection, Gift of Mr. R.A. Laidlaw , 1966.15.20

PLATE 19 | TOM THOMSON (Canadian, 1877–1917)

Forest Undergrowth III, 1915–1916

oil on beaverboard, 121.4 × 91 cm

National Gallery of Canada, Ottawa,
Gift of Mr. and Mrs. H.R. Jackman, Toronto, 1967

PLATE 20 | LAWREN S. HARRIS (Canadian, 1885–1970)

Snow Fantasy, c. 1917

oil on canvas, 71 × 110.1 cm

McMichael Canadian Art Collection, Gift of Keith and Edith MacIver, 1966.16.88

PLATE 21 | J.E.H. MACDONALD (Canadian, 1873–1932)

The Tangled Garden, 1916

oil on beaverboard, 121.4 × 152.4 cm

National Gallery of Canada, Ottawa, Gift of W.M. Southam, F.N. Southam
and H.S. Southam, 1937, in memory of their brother Richard Southam

PLATE 22 | TOM THOMSON (Canadian, 1877–1917)

The West Wind, c.1917

oil on canvas, 120.7 × 137.9 cm

Art Gallery of Ontario, Gift of the Canadian Club, Toronto, 1926

PLATE 23 | TOM THOMSON (Canadian, 1877–1917)

The Jack Pine, 1916–1917

oil on canvas, 127.9 × 139.8 cm

National Gallery of Canada, Ottawa

FURTHER TRAGEDY AND death followed at the close of the *annus horribilis* that was 1917. On the morning of December 6, in Halifax Harbour, an explosives-laden French munitions ship, the *Mont Blanc,* collided with a Norwegian steamer carrying Belgian relief supplies and burst into flames. Twenty minutes later, as the French crew scrambled ashore and onlookers gathered to watch oily smoke pour from the decks, the fire ignited the *Mont Blanc*'s cargo of over two hundred tonnes of TNT and more than two thousand tonnes of explosive picric acid. What followed was the largest man-made explosion ever known. Nearly two thousand people were killed, thousands more injured, and twenty thousand left homeless. The blast was followed by an eighteen-metre-high tsunami and a white cloud that rose six kilometres into the sky.

Arthur Lismer was fortunate to escape death or injury. Unable in 1916 to find accommodation in Halifax owing to the presence of so many naval personnel, he had taken lodgings in Bedford, fifteen kilometres northwest. Here, despite a frugality imposed by wartime restrictions and a modest salary, he and his family had been enjoying an idyllic year. Their house stood on an acre of sloping land at the mouth of the Sackville River, and Lismer's leisure hours were spent

gardening, picnicking, boating, sledding and swimming with his wife and young daughter. He had even taken up photography, developing his prints in the darkened family bathroom.[1]

On a professional level, Lismer devoted much energy to the previously moribund artistic life of Halifax. He aggressively recruited students for the school. "I've gathered 'em in from the byways and hedges," he wrote to MacDonald.[2] Enrolment was raised to a respectable seventy-two, and twenty-five scholarships were established. He revived the inactive Nova Scotia Museum of Fine Arts, staging a year-long exhibition of Canadian landscapes on loan from the National Gallery. He also executed a series of twelve murals for the Green Lantern, a popular Keith Street restaurant that featured a soda fountain, fish pond, orchestra gallery and ice cream parlour.* In the midst of these efforts he even found time to paint landscapes, though he found his abilities to make *plein-air* sketches hampered by the war: early in 1917, while sketching near the Halifax waterfront, he was arrested as a spy and briefly detained. Haligonians were evidently unaccustomed to the sight of men bearing easels and paintbrushes. He did manage one canvas of the waterfront, *Halifax Harbour, Time of War,* which showed the kind of harbour traffic that would result in tragedy a few months later.

On the morning of December 6, Lismer missed his usual train from Bedford to Halifax and "so escaped—some who took the train didn't."[3] He made it into Halifax later in the day, getting past a military cordon and, in a throwback to his days on the *Sheffield Independent,* executing on-the-spot pen-and-ink sketches. He discovered that most of the paintings in the museum had survived the blast, even though a retaining wall had collapsed and a selection of prints on loan from the National Gallery—including ones by Whistler and Henri Fantin-Latour—"were flung everywhere."[4] The school, too, was miraculously intact, though one of his students was killed. The building was soon requisitioned for sad and grisly duty as a morgue. The

254

* These murals were overpainted in the 1940s and later destroyed when the restaurant burned down.

Green Lantern Restaurant, where Lismer's murals were unveiled only a week earlier, became a distribution depot for clothing and footwear. The bloodstained survivors who climbed the stairs to collect shoes and overcoats did so beneath Lismer's visions of clapboard fishing villages, bucolic farms and wide expanses of tranquil ocean.

SOME OF LISMER'S pen-and-ink sketches of Halifax's devastation were published later in the month in the *Canadian Courier.* A short time later, early in 1918, he wrote to Eric Brown asking for help getting permission to gather material to chronicle Halifax's contribution to the Canadian war effort: "Halifax is of vital interest as a war city & there is a tremendous amount of activity that I'd like to record—the departure & arrival of troopships, convoys, hospital ships, troopships from Australia & New Zealand & the States—camouflaged men-of-war of different nationalities—it's intensely interesting & graphic and no one is painting it."[5]

Lismer was inspired by the fact that elsewhere painters and photographers were already active in documenting Canada's role in the Great War. In December 1916 the Grafton Galleries in London—once the venue for Roger Fry's Post-Impressionist exhibitions—had staged a remarkable series of photographs showing Canadian soldiers fighting at the Somme. William Ivor Castle, Canada's official war photographer, documented the Canadian Corps' role in the offensive, then returned to London to mount his first exhibition of more than 200 pictures, many enlarged to three metres wide and mounted in heavy oak frames. The *Daily Mirror* pronounced it "one of the most remarkable exhibitions of photographs ever." Six months later, in July 1917, the Grafton Galleries showed 188 more of Castle's photographs, this time capturing the Canadian exploits at Vimy Ridge. One of them, a picture of no man's land, was billed as "the largest photograph in the world."[6]

255

These oak-framed pictures attracted eighty thousand people through the gallery doors in the summer of 1917. So successful was the exhibition that the head of the British Department of Information, John Buchan, a future governor general of Canada, found his

own efforts at propaganda outclassed and overwhelmed. He peevishly lamented that it seemed "Canada is running the war."[7] An English newspaper, accustomed to casting only the British in the roles of heroes, griped that it was "open doubt whether there was anybody but Canadians fighting in France."[8]

That the Canadians, hitherto political and cultural wallflowers usually safely ridiculed or ignored, should have stolen a march on the British was thanks largely to one man. The exhibitions at the Grafton Galleries were part of the mission of the Canadian War Records Office. The cwro had been established at the end of 1915 by the force of nature that was Sir Max Aitken, the expatriate Canadian newspaper baron ennobled in 1917 as Lord Beaverbrook. The British press routinely refused to distinguish between British and Dominion troops, which meant they failed to report the hugely significant Canadian contributions *as* Canadian contributions. British reports almost never mentioned the Canadian Corps, and the press's imperious disregard for Canada was such that John McCrae, author of "In Flanders Fields," was never identified in British newspapers as a Canadian.

Efforts, Beaverbrook reasoned, needed to be made to document for posterity Canada's contributions and sacrifices. The cwro produced inspirational books such as *Canada in Khaki* and Beaverbrook's own two-volume *Canada in Flanders.* The latter was written with help from Beaverbrook's friend Rudyard Kipling, who nonetheless wrote witheringly to another friend—with exactly the sort of disdain that Beaverbrook was hoping to counter—that the Canadians "do not yet realize how small an item is their contingent."[9]

Because photograph and film were believed to have a lifespan of only twenty-five years, and because he desired a more permanent visual record of Canadian heroics, Beaverbrook turned to painters. He founded a spin-off organization called the Canadian War Memorials Fund (cwmf) and commissioned the British society painter Richard Jack—known for his portraits of Edward vii and George v—to begin a grand panorama of Canadians at the Second Battle of Ypres. By 1917 the ranks of the cwmf numbered some of Britain's most famous artists: Augustus John, Percy Wyndham Lewis and Paul Nash. They were

charged with creating a record of Canadian achievements during the war in a series of paintings that would in the fullness of time be placed in a museum to be constructed on Sussex Drive in Ottawa.[10]

Both Eric Brown and Sir Edmund Walker approved of Lord Beaverbrook's efforts, but they wished to see the involvement of Canadian as well as British painters. Although happy enough to entertain the idea, Beaverbrook admitted that Canadian artists were a species about whom he knew nothing at all. Walker therefore cabled to London a list of candidates whom Beaverbrook ordered to report in person to his office. Included on the list was A.Y. Jackson, described by Walker's telegram as "an able Impressionist."[11]

The summons by Lord Beaverbrook was a timely one for Jackson. From Hastings he had been moved along the Sussex coast to Shoreham Camp to await reassignment after the disbanding of the 60th Battalion. Although he was reunited with his friend Randolph Hewton, conditions in this latest base, improvised over a golf course on Slonk Hill, were scarcely an improvement on "Mudsplosh Camp." By 1917 the submarine blockade was causing food shortages in Britain. The dispirited soldiers turned mutinous, with many (including Jackson) arrested for "kicking about the poor grub we were getting," as he explained to his mother.[12] Morale among the troops plunged lower as more and more convalescents arrived at the camp, and as Old Shoreham churchyard filled with those who had died of their wounds.[13] But Jackson himself claimed to be inoculated against tragedy. "I have seen so much of death over here," he wrote to MacDonald, "that I hear without emotion of boys I marched with, slept beside and went through rainy and sunny days with being killed. It makes me almost callous."[14]

The one death about which he could not feel indifferent was, of course, Thomson's. "I could sit down and cry," he wrote to MacDonald at the beginning of August, "to think that while in all this turmoil over here there is a ray of light and that the peace and quietness of the north country should be the scene of such a tragedy." He and Thomson had worked together as partners, he believed, in the "new movement" in Canadian painting: while Jackson supplied the "school learning and

Lord Beaverbrook as Minister of Information, 1918

Beaverbrook Art Gallery

practical methods of working," Thomson offered the experience of "a new world, the north country, and a truer artist's vision." But now, with Thomson dead, the north country seemed, he wrote sorrowfully to MacDonald, "a desolation of bush and rocks."[15]

He told MacDonald that he hoped to forget himself in painting "if only they give me freedom enough," though the freedom was not yet forthcoming. His application for promotion to lieutenant had been turned down, and artistic opportunities were limited to making diagrams and enlargements from maps of the front (worse assignments existed: the English artist Stanley Spencer, serving with the 68th Field Ambulancemen in Salonika, was reduced to painting the lettering on latrines). In the summer of 1917, after a fourteen-month convalescence, he was passed fit to return to battle. He was therefore

facing the prospect of joining the British offensive in Flanders when his summons to the Canadian War Records Office arrived in August.

LORD BEAVERBROOK, thirty-eight years old in 1917, was a man of enormous energy and enterprise. Born to a Presbyterian clergyman in Maple, Ontario, north of Toronto, he was raised in Newcastle, New Brunswick. As a young man he sold insurance, flirted with legal studies and worked in a Calgary bowling alley. In 1900 he began selling bonds, and by twenty-five he was a millionaire. In 1910 "Maximillion" (as he called himself) moved to England, and within the year he had acquired a seat in Parliament, a knighthood, a country house in Surrey and friends such as Kipling and the future prime minister Andrew Bonar Law (a fellow New Brunswicker). By 1917, as owner of the *Daily Express,* he was a powerful press baron and an English milord: he grandly took ermine as 1st Baron Beaverbrook. Impish-looking and asthmatic, he was well on his way to becoming the contumelious, sycophant-begirded megalomaniac that Evelyn Waugh would lampoon in his novels as Lord Monomark.

Jackson and Beaverbrook met at the CWRO's offices in Tudor Street, a few blocks south of where Beaverbrook bestrode Fleet Street as proprietor of the *Express.* Jackson found his lordship "certainly very kind though very businesslike."[16] "So you are an artist?" inquired Beaverbrook. "Are you a good artist?" To establish his credentials, Jackson produced a clipping from *The Studio* ("*The Studio?* What's that?" demanded Beaverbrook) that lauded him as "a coming man" with a "largeness of vision" and "something worthwhile to say."[17] Since Jackson neglected to mention that these flattering words were composed by his friend Harold Mortimer-Lamb, Beaverbrook was suitably impressed. On August 13 Jackson found himself promoted to the rank of "honorary lieutenant" and armed with a paintbrush instead of a gun.[18]

Jackson received his first commission soon afterwards, a portrait of a Victoria Cross winner, Corporal John Kerr of the 49th Battalion. He wrote to MacDonald that he "would rather be excused" from the job, but this portrait, he realized, stood between him and a hasty

return to the trenches.[19] Unfortunately he possessed extremely limited experience as a portraitist. Leaving aside the portrait of his Aunt Geneva's dog and the sketch of Rosa Breithaupt, he really had only a single one under his belt, a 1910 portrait of the Berlin headmaster Jeremiah Suddaby, done from a photograph.* This painting, commissioned by the Berlin School Board after Suddaby's death, had been arranged by his Aunt Geneva and earned him $400.[20]

If painting Corporal Kerr held little appeal to a landscapist like Jackson, the young soldier's story was at least a remarkable one. Jackson jocularly called him "the boy who took 62 Huns hisself."[21] A former lumberjack in Kootenay and homesteader in Spirit River, Alberta, Kerr had trekked fifty miles to Edmonton in the middle of winter in order to enlist. During the Battle of the Somme in September 1916, in a mind-boggling feat of toughness and daring, he single-handedly seized sixty-two German prisoners at Courcelette, having penetrated enemy lines and assaulted the entrenched Germans with grenades and a rifle before rounding them up in their dug-out. He told Jackson that if he had also been armed with a bottle of rum "he could have induced a whole battalion to come over."[22]

Jackson apologized to the corporal that a landscapist had been sent to execute his portrait. He then began painting at the CWMF's Earl's Court studio with "considerable trepidation . . . I drew in the head and rubbed it out many times; later I scraped out the painting until finally I got a passable likeness and took no more chances."[23]

AS JACKSON PAINTED the young man's portrait, the Canadian Corps was back in action in France, capturing Hill 70, a supposedly impregnable bastion above the French city of Lens. They then defended it against counterattacking Germans armed with mustard gas and flame-throwers. The valour of Ypres and Vimy Ridge was

260

* Jeremiah Suddaby had been for many years the principal of the Berlin Central School, renamed the Suddaby School after his death in 1910. Jackson received the commission thanks to a degree of nepotism: his grandfather, Alexander Young, was the Berlin Central School's first principal when its doors opened in 1857.

reprised, with six soldiers receiving the Victoria Cross.* Jackson was in the vicinity soon afterwards, doing his first work in the field (and taking the leisure to visit Baker-Clack and other friends in Étaples: all were doing a roaring trade selling their landscapes as souvenirs to the soldiers).[24] As an artist he received a chilly reception from the troops "until they found that earlier I had been in the line with the infantry. Then they could not do enough for me."[25]

A more insuperable problem was what to paint. The Second Battle of Ypres was being reconstructed in Richard Jack's studio by rifle-toting uniformed veterans of the Western Front. "Nothing was left undone to secure accuracy," an official for the CWMF later wrote.[26] But creating this kind of multi-figure action scene was unappealing to Jackson, though he did consider, apparently seriously, "a big composition of *General Currie Crossing the Rhine*."[27] Such a painting, however "accurate" on the surface, would not capture what Jackson believed to be the unique horror of modern warfare. His time in the trenches had drummed out of him any notions of martial glory. "This trench warfare," he wrote to MacDonald in 1916, "is exasperating . . . It don't feel heroic in the least."[28] Or as he later observed, "War had gone underground, and there was little to see. The old heroics, the death and glory stuff were gone for ever." Taking his sketches back to London in the autumn, to a studio he began renting in Charlotte Street, he produced only "charming landscapes."[29]

Another chance for Jackson to see action on the Western Front arrived in November when twenty thousand men from the Canadian Corps, fighting on muddy reclaimed marshland, captured the Belgian village of Passchendaele. There was death and glory aplenty,

* The necessity of the CWRO's efforts can be appreciated when one considers how two accounts of the Great War by British historians, Martin Gilbert's 640-page *The First World War: A Complete History* (1994) and John Keegan's 496-page *The First World War* (1998), make not a single mention of the Battle of Hill 70. As Beaverbrook realized, British and American military historians, eager to promote their own countrymen as protagonists, would inevitably downplay or disregard the Canadian contribution.

with sixteen thousand casualties and nine Victoria Crosses. But the capture of the shattered village was a strategically meaningless exercise. It had been rigidly promoted by Field Marshal Haig against the wishes of the commander of the Canadian Corps, General Sir Arthur Currie, who correctly predicted the massive casualties: the New Zealand Division had already suffered terrible losses in their own failed assault. The futility of capturing Passchendaele at such horrendous cost would be made painfully evident in the spring of 1918 when Haig blithely gave orders to abandon the village to the Germans in order to reinforce units elsewhere in Flanders.

Jackson crossed the Channel with the rest of the CWRO in November, coming within a few miles of where he had been wounded at Sanctuary Wood. He made only pencil sketches because he "found it hard to manage a sketch box while shells were dropping here and there."[30] He at least avoided the notorious Passchendaele mud, lodging in a house near the railway station at Poperinghe, a small town, known to the soldiers as "Pop," that served British and Commonwealth troops as a place of rest and recreation. Reminders of the war were plentiful, as German airplanes tried every night to bomb the railway station, "and if there were bombs left over they dumped them in our vicinity."[31]

After more than three years of war, few charming landscapes remained to be painted in this muddy, cratered, burned-out part of Flanders. Jackson once again found himself struggling as he toured the battlefields, like the other war artists, in a chauffeur-driven staff car. "Drizzle, rain and mud and the costly and useless offensive at Passchendaele took the heart out of everyone," he wrote.[32] He was relieved both to return to his studio in London and then to receive a commission to paint not scenes of death and glory but two more VC winners. Soon after he began work on these portraits, he learned that he was to be joined in London by another member of the Algonquin Park School, F.H. Varley.

ALTHOUGH SHORT OF money as usual, Varley had been one of the few Toronto painters not to suffer too drastically during the war. Still

working as a designer at Rous and Mann, he was supplementing his slender means with freelance work for the *Canadian Courier,* doing front-cover portraits of such as Lloyd George, Sir Robert Borden and Woodrow Wilson. He was also illustrating short stories in the *Canadian Magazine* and designing a recruiting manual for the Imperial Royal Flying Corps. His work with his paintbrush was, as ever, sporadic, devoted to portraits rather than landscapes, but in February 1916 he had completed enough to stage a solo exhibition at the Arts and Letters Club.

Despite his interest in figure painting, Varley had still been eager to paint the "outdoor country" of Canada. In the summer of 1916, financed by Dr. MacCallum, who covered the cost of his train fare from Toronto to Honey Harbour, he painted landscapes on Georgian Bay. Here he produced sketches that in the next few months he would turn into *Squally Weather, Georgian Bay,* by far his most ambitious and arresting landscape to date.[33] Painted at the same time as Thomson's *The West Wind* and *The Jack Pine*—and with the two men probably comparing notes as they worked—Varley's canvas used the motif of a lone, wind-twisted pine tree on a rocky shoreline to show the power of nature "in all its greatness." A high horizon line and elevated vantage point on a blustery cliff allowed him to present a broad expanse of the bay, with its eddying inlets and scything whitecaps. Varley's talents lay primarily in portraiture, and in many ways *Squally Weather,* with its jack pine posed dramatically in the foreground, dominating the design, was, like Thomson's two paintings, a portrait of solitude and fortitude in a beautiful, destructive wilderness. It was also, like *The West Wind* and other of Thomson's landscapes, a kind of self-portrait, a "landscape of the mind" that expressed the fierce convolutions of the painter's spirits.

Varley had written to his sister in 1914 that in painting the Canadian landscape he was endeavouring to rid himself of all "preconceived ideas." But no one ever sees a landscape, let alone paints one, without imposing preconceived ideas, whether consciously or not. Varley would have seen many landscapes as an art student, and it is intriguing that in tackling the subject he looked back to his days at

263

the Royal Academy of Fine Arts in Antwerp. The tradition of Western landscape painting had begun—ironically, considering the flat and featureless topography—in the Low Countries. The first Western painter known to have specialized in landscapes was the Flemish artist Joachim Patinir (or Patenier), an exact contemporary of Raphael. Varley could have been familiar with his work from his years in Antwerp, since *Landscape with the Flight into Egypt* and *St. Christopher Bearing the Christ Child* were both held in Antwerp museums, and another of his works, *Landscape with St. John the Baptist Preaching*, was nearby in the Musées royaux des beaux-arts in Brussels.[34]

Patinir's particular style of composition set a standard for landscapes. He and the many painters who followed him, including Pieter Bruegel the Elder and Jan van Amstel, painted atmospheric bird's-eye-view panoramas looking out across reaches of water interrupted by gnarled trees and jagged rocks.* Called "northern expressionists" by one art historian, they suggested with their distorted, corkscrewing trees and rocks not only a wonder at untamed nature but also the mysterious and malevolent forces of the universe in an era when Western Europe was convulsed by violent disorder. Almost three centuries later, their pierced rocks and frenzied trees would reappear in the landscapes of another artist from the Low Countries, Vincent Van Gogh, who likewise studied in Antwerp. Thus, although *Squally Weather* is a faithful portrait of an inlet on Georgian Bay, in composing his work Varley took from these Flemish works his elevated perspective and expansive view, as well as the fury and the menace of a nature agitated and unsubdued.[35]

Squally Weather appeared at the 1917 OSA exhibition with another of Varley's Georgian Bay landscapes. His work impressed Augustus Bridle, who later wrote of Varley that he "goes after the big, essential virilities," showing "strength and realism" and a "strong massing of forms and colours." The virility of these paintings was, Bridle believed, an extension of Varley's own sinewy nature. In Bridle's excited

* One of the more famous examples of this genre, Bruegel's *The Fall of Icarus*, entered the Musées royaux des beaux-arts only in 1912, after Varley left Belgium.

account, Varley was one of the reddest of Canadian art's red-blooded men: a brawny stevedore with a hobo's wanderlust and a poet's soul. "He has had a lot of experience that knocks the guff out of any man," wrote Bridle. "He knows what it is to be a wayside man without enough to eat, a dock walloper, a companion to those who never see three meals straight ahead in a row, the knights of the empty pocket and the full soul." Some parts of Bridle's account, had he seen it, may well have caused Jackson to shake his head in disbelief as he recalled Varley's reluctance to abandon Mowat Lodge and sleep under canvas: "He believes in the splash of rain on the pelt, the bite of the hard wind, the glint of a naked, hot sun."[36]

The point of this flattering hyperbole (which echoed Bridle's treatment of Heming a few years earlier) was that early in 1918 the CWRO announced that Varley would sail to Europe to begin work was a war artist. By this time more than fifty artists were at work for the CWMF, with artists from Belgium, Australia, Denmark and even Serbia scattered in studios all over London.[37] Believing Canadian painters still to be underrepresented, the OSA in combination with the Royal Canadian Academy recommended a number of artists to Sir Edmund Walker, who duly passed their names to Lord Beaverbrook. Consent was quickly granted. At the end of March, Varley left behind Maud and his three children (forced into yet another move, the family was now living on the edge of the Humber Marshes) and departed for Europe. He was given the rank of captain, a salary of $1,900 per year and an allowance of $600 for art materials.[38]

Joining Varley on the voyage were Bill Beatty and two artists from Montreal, Maurice Cullen and Charles W. Simpson. Varley was easily the least known of the quartet (and he was selected only when C.W. Jefferys declined). The fifty-two-year-old Cullen, a one-time friend of Whistler and Henri Rousseau, had enjoyed an international reputation for more than two decades. His Impressionist-inspired work had appeared at the Paris Salon, and in 1899 he became the first Canadian to be elected an associate member of the Société nationale des beaux-arts. Beatty taught at the Ontario College of Art and regularly exhibited in both Toronto and Montreal. The forty-year-old Simpson,

a former student of both Cullen and William Brymner, specialized in Impressionist-inspired scenes of Montreal's harbour in winter and was represented in the National Gallery of Canada by no fewer than three paintings. Varley appears to have been given the nod in part because of his supposed hardscrabble tenacity. That and the fact that Beatty, the original painter with "good red blood" in his veins, was also selected, suggest that Tom Thomson, had he lived, might have been one of the painters selected for duty.

At the end of March the painters left the ravages of Halifax Harbour on the troopship RMS *Grampian,* bound for Glasgow. Varley did not enjoy himself owing to the noise from artillery practice and the presence of a ukulele player, but the voyage was made tolerable thanks to fifty-six young women on their way to work as cooks and maids for the Voluntary Aid Detachment in London. He lived up to his reputation for being hardbitten by energetically promenading the decks, disdaining a lifebelt while his fellow passengers were laid low in their berths or lolling queasily on deck.

Arriving in Britain, he and the other Canadian artists were accommodated in considerable style and expense at the Strand Palace Hotel in London, described at its 1909 opening as "the last word in luxury," with marble wash basins in every room and a telephone on each of its ten floors.[39] The "knight of the empty pocket" encountered no difficulties adjusting to such extravagance. "We travel 1st class & swank and tip the plebeians as if we were lords," he wrote to Maud. "What a life, eh what? I've never swanked so much in all my life."[40]

VARLEY WAS LEFT to repose in this luxury for several weeks. His voyage across the Atlantic coincided with a German offensive, named by General Erich Ludendorff the Kaiserschlacht, the "Emperor's Battle"—a last desperate push to win the war before the full weight of Allied resources, which now included the Americans, could be brought to bear. The offensive temporarily brought to a halt the efforts in the field of the CWMF, and so Varley and the others found themselves "kicking our heels" in London.[41]

During this hiatus, Varley seized the opportunity to see the work being done for the CWMF by the other painters. He was taken round

a number of West End galleries by Paul Konody, Lord Beaverbrook's art adviser. The Hungarian-born Konody had served as the art critic for both the *Daily Mail* and the *Observer* as well as the editor of the journals *Artist* and *Connoisseur*. He advised Beaverbrook on which paintings to purchase for his own personal collection, and his influence over the cwmf, of which he was the director, became such that he was lampooned in an anonymous verse as the all-powerful leader of "the great Konodian army":

> I'm a judge of ancient and modern Art.
> In Art I take the leading part.
> Of a great concern I am the start;
> For I am the brain, the mind, the heart
> Of the great Konodian Army.
> Men of genius great and small
> Wield their brush at my beck and call
> I hire the greatest men in Town;
> I raise them up or I dash them down
> With a friendly nod or haughty frown
> In my great Konodian Army.[42]

Konody wished to show Varley the work of some of these "greatest men in Town." There was certainly much in the London art world that was new for Varley to see. He had left England fewer than six years earlier, but in that time the country's artistic climate had changed dramatically as London became the home of a distinctive avant-garde. In 1916 Ezra Pound wrote that "new masses of unexplored arts and facts are pouring into the vortex of London," bringing about "changes as great as the Renaissance changes."[43]

The best examples of these changes were Italian Futurism and its homegrown English version, Vorticism. The Futurists vehemently rejected all art of the past as "fetid gangrene," celebrating instead what they called the "overwhelming vortex of modernity," with its "crowds, its automobiles, its telegraphs, its bare lower-class neighbourhoods, its sounds, its shrieks, its violence, its cruelties, its cynicism."[44] In October 1913 the Doré Gallery in London hosted the *Post-Impressionist and*

Futurist Exhibition, followed in the spring of 1914 by an exhibition of *Works of the Italian Futurist Painters and Sculptors.* This latter exhibition, which caused a riot, included a poetry recitation by Filippo Marinetti ("peculiarly blood-thirsty concoctions," in the opinion of one audience member) accompanied by the cannon-like booming of drums.[45]

Italian Futurism involved a good deal of ludicrous posturing, but English artists began responding with their own equivalent. Christened "Vorticism" by Pound, its most boisterous adherents were Percy Wyndham Lewis and C.R.W. Nevinson. Just as the painters in the Algonquin Park School claimed the Canadian landscape called for new artistic forms, so Wyndham Lewis believed the "vortex" of a city like London demanded the dynamism of Futurism and Vorticism: a man passing his days "amid the rigid lines of houses, a plague of cheap ornamentation, noisy street locomotion, the Bedlam of the press, will evidently possess a different habit of vision to a man living amongst the lines of a landscape."[46] The results were paintings with abstracted geometrical images and Cubist-style planes that interlocked like the teeth of sprocket wheels or shattered in violent, clangorous colour. Wyndham Lewis further sounded the murkier fathoms of modern art by creating for a Soho club a sculpture made entirely from raw meat.

Although he wrote books on Raphael and Filippo Lippi, as well as guides to the Louvre and the Uffizi, Konody was sympathetic to new artistic movements such as Vorticism. In fact, he had recruited both Wyndham Lewis and Nevinson into the cwmf, along with David Bomberg and Paul Nash, two audaciously talented and experimental young graduates of the Slade School of Fine Art. Like A.Y. Jackson, Konody had realized that the "death and glory stuff" painted by war artists of the previous century was woefully inadequate to capture the intensity of modern industrial warfare. Early optimism about the war's suitability for poetry and pictures—"Oh God! what a lovely war," wrote Guillaume Apollinaire in "The Cavalier's Farewell"[47]—swiftly faded in the face of the bleak and unromantic reality. Heroic cavalry charges had been supplanted by muddy battles in the trenches. As early as 1915 *The Times* published an article entitled "The Passing

of the Battle Painter" in which the correspondent lamented how war had been "robbed of its beauty."[48] Modern war, like modern life, was ugly and impersonal, a vortex of speed, brutality and mechanical paraphernalia.

Konody believed that anyone trying to paint the Great War needed to approach his subject differently from previous war artists. He stressed that he did not want "visions of winged figures with laurel leaves" or "long rows of imaginary battle pictures invented or reconstructed by the professional battle painters in the undisturbed comfort of their studios" (which was, however, exactly what Richard Jack was doing). The CWMF was, in his opinion, about art as much as war: he wanted not only a record of Canada's contribution to the war but also "as complete as possible a picture of all the artistic currents and tendencies in vogue at the time of the world's war."[49] The only painter who could successfully grapple with what he called "the unprecedented conditions of modern warfare" was "an adherent of the modern school."[50] He therefore took Varley to see the work of other painters under his wing, giving him a viewing of some of London's most progressive art.

An art critic for the *Sunday Times* wrote that by 1917 it was clear that the two artists who had most to say about the Great War, and who said it most eloquently and innovatively, were Nash and Nevinson.[51] When Varley arrived in London, Nash had a solo exhibition, *War Paintings and Drawings,* on display at the Leicester Galleries. The twenty-eight-year-old Nash began his career as a landscapist, producing, in the years before the war, haunting and symbol-charged watercolours of the English countryside. In 1912 he wrote dreamily to a friend that he painted his landscapes "not for the landscape's sake, but for 'the things behind,' the dwellers in the innermost: whose light shines through sometimes."[52] Seeing the Home Counties through this idealizing lens was easy enough; the battlefields of Flanders were another matter. Dispatched to the front as a war artist in November 1917, he discovered these dwellers in the innermost, at least at Passchendaele, to be horrifying entities. In a letter to his wife he described the Western Front as "the most frightful nightmare . . . unspeakable,

utterly undescribable." His sketches of the nightmarish landscape gave, he told her, only "a vague idea of its horror," but *The Times* reviewer was astonished at the facility with which Nash captured "utter chaos" and showed "a world dead for a million years, frozen and without atmosphere . . . It is waste—a waste of worlds, of ages, which looks as if it had been made by some indifferent world of Nature."[53]

Nevinson, whose work Varley was also shown, arrived back from the Western Front with equally disconcerting images. Likewise only twenty-eight, he had been one England's most notorious artists at the outset of the war, a friend of Italian Futurists such as Marinetti and a former studiomate in Paris of Amedeo Modigliani. With Marinetti he composed a manifesto for English art that (in a long list of pungent dicta) denounced "effeminacy" and the "worship of tradition," and called instead for a "strong, virile and anti-sentimental" art.[54] His most famous painting, *Tum-tiddly-um-tum-pom-pom,* tried to capture the frenzied motion of a London crowd. In 1914 Nevinson believed that war was "the world's only hygiene," and that it would be, as he enthusiastically predicted early in 1915, "a violent incentive to Futurism, for we believe that there is no beauty except in strife, no masterpiece without aggressiveness."[55] Service in Flanders as a mechanic and ambulance driver quickly dampened his enthusiasm for strife and aggressiveness, and a nervous breakdown followed. His artistic style remained intact: Futurism offered, he maintained, "the only possible medium to express the crudeness, violence, and brutality of the emotions seen and felt."[56]

Nevinson was attached to the CWMF in July 1917. The following spring he, like Nash, showed work in the Leicester Galleries at an exhibition opened by Beaverbrook himself. A newspaper reported that Nevinson "stated the facts of the war without the slightest attempt to gloss over the inevitable horrors."[57] Paintings included *After a Push,* purchased by the Imperial War Museum and described in another newspaper as "a desolate collection of shell-holes filled with water and as large as ponds."[58] Another of his works, *Paths of Glory,* showing two dead British soldiers facedown in the mud, was deemed too terrible for public viewing. It provoked the ire of the military authorities, so

Nevinson pasted over it a sheet of brown paper chalked with the word "Censored" (for which he received an additional rebuke from the War Office: the word "censored," he was informed, was censored). An art critic managed to peel back enough of the paper to see barbed wire, the butt of a rifle and a khaki cap.[59]

Varley was impressed by the efforts of Nash and Nevinson. He realized the necessity of approaching his task with a modern technique similar to theirs. It would not be possible, he wrote to Maud, to produce "lovely tones and lovely colours and lovely drawing and all that bunkum when... the disembowelled earth is festering and flinging off an abortive stench." Reiterating what the Algonquin Park School had been saying about the Canadian landscape, he told her that "no art conceived in the past can express the hugeness of the present."[60] Modern warfare, like the vast and inhospitable landscape of Canada, called for new artistic forms.

VARLEY WAS TAKEN with the work of another artist whose work he saw in London. Jackson was back in London in April, having spent the early spring with an artillery brigade at Liévin, near Lens, in northern France. The sight of the war-ravaged countryside enthralled and appalled him in equal measures. The misty atmosphere and idyllic landscape of this region of northern France were once celebrated in paintings such as Camille Corot's *A Pond in Picardy*, not to mention the work of the École d'Étaples with which Jackson was so familiar. But now it was, he wrote, a "seemingly empty country, cut up by old trench lines, gun pits, old shell holes, ruins of villages and farmhouses."[61]

At one point, in the company of Augustus John, who was glorying in a major's uniform and tackling a huge canvas for the CWMF called *The Pageant of War,* Jackson had witnessed an Allied gas attack on the German line. Artists like Apollinaire were able to detach themselves— however briefly and temporarily—from the horrors of warfare in order to appreciate its aesthetic effects. After seeing rocket flares soaring through the night sky, Apollinaire began his poem "Wonder of War" with the lines: "How lovely these flares are that light up the dark / They

climb their own peak and lean down to look / They are dancing ladies whose glances become eyes, arms and hearts."[62] Despite his horrific first-hand experience at Sanctuary Wood, Jackson too was spellbound by the sight of coloured lights coursing through the fog bank of gas. "It was like a wonderful display of fireworks," he wrote, "with the clouds of gas and the German flares and rockets of all colours."[63]

Back in London, in an attempt to capture this macabre beauty, he painted *Gas Attack, Liévin,* showing an undulating foreground reminiscent of *Terre sauvage* and a sky aglow with flares. Another painting from this period was *Springtime in Picardy,* which presents a tree in bloom against the backdrop of a devastated village through which two soldiers nonchalantly stroll, oblivious to beauty and horror alike (see plate 26). Once again there are poetic analogues. The work features the same juxtaposition of the pastoral and the infernal found in several Great War poems, such as Wilfred Owen's "Exposure," which describes soldiers hunkered down in foxholes briefly imagining the benevolence of nature: "So we drowse, sun-dozed, / Littered with blossoms trickling where the blackbird fusses." The same play on the absurdly incongruous fit between mechanized warfare and the beauty of nature can also be found in John McCrae's "In Flanders Fields," with its roar of artillery set against a shattered idyll of poppies, larks and glowing sunsets.[64]

If *Springtime in Picardy* suggests the possibility of peace and renewal, or at least the continuation of the natural cycle despite mankind's devastation, Jackson's most powerful and expressive work from this time offered no such promise. Called *Liévin, March 1918,* it featured a distant watchtower and a foreground of shattered, windowless houses and the slithering lines of a battlefield that included barbed wire and two white crosses. The colours were bloody and brooding—greys, blacks, reds and oranges—and the painting filled with tortuous lines suggesting quagmire and collapse. If some of the English avant-garde painters were expressing the "waste of worlds" with jagged edges and sharp planes—as Paul Nash did in his remarkable *Void*—Jackson, at least in *Liévin, March 1918,* did so with writhing and distorted lines that make their way like tentacles across the picture plane.

Jackson and Varley spent much time together in Jackson's studio. The two men discussed Thomson and plans for future sketching expeditions into the bush, to places such as Canoe Lake. Varley confided to Maud that although Jackson was not "such a man as Tom," he believed that "we two would manage and pull along well." His newly favourable opinion came from the fact that he found Jackson changed from the man he last saw more than three years ago. He was now "more sensitive," chastened by his experiences on the Western Front. "I'm sure if he had to go through the fight anymore," he wrote to Maud, "he would be broken."

Earlier differences of opinion were set aside as Jackson regaled the new recruit about the difficulty of painting at the front and Varley expressed sincere admiration for his comrade's work. He wrote to Maud that Jackson was painting "impassive desolate scenes of the country which once was." In doing so, he had become, Varley believed, "a great artist." He was inspired but also daunted by the fact that he needed to accomplish similar things. "I realize more clearly what I must do," he wrote to Maud on May 10, as he awaited his orders to cross the Channel and experience for himself the horrors of modern warfare.[65]

8 THE DWELLER ON THE THRESHOLD

MORALE AT "Camp Horror" had improved since Lawren Harris arrived in time for the riot in the hot summer of 1916. There was now a YMCA canteen selling cigarettes, and a wooden shed, known as "The Strand," that showed silent films. But the base was still, for many recruits, a place of "dirt, dust, and loneliness."[1]

Most recruits spent only three weeks before shipping overseas. Harris, though, stayed at Camp Borden for twice as long as the average recruit. He served as a musketry instructor, using his artistic talents to devise European cityscapes and realistic moving targets— "Fritzies that popped up and disappeared"—on which the recruits could practise their marksmanship.[2] By the end of 1916 he was transferred to Toronto, where he gave instruction at the District School of Musketry, a rifle range improvised on the campus of the University of Toronto. The university had taken on the appearance of a military encampment, with tents sprouting on the lawns, soldiers and cadets everywhere, and the Royal Flying School occupying parts of Convocation Hall and Wycliffe College. In the newly built Hart House, wounded and shell-shocked soldiers were treated with hydrotherapy and massage.

If Harris was unable to forget the war, his new posting at least allowed him to paint in the evenings and during his periods of leave.

He even managed to exhibit a work at the OSA exhibition in 1917, a daringly vibrant canvas called (in an allusion to that favourite artistic *tarte à la crème*) *Decorative Landscape.* Another of his remarkable snow-and-fir compositions, it was the most adventurously decorative work he had ever produced. Painted around the same time that Thomson worked on *The Jack Pine,* it showed the blue silhouettes of pine trees in vivid relief against a sky painted with dabs of primrose yellow. In the foreground of this clangorous interplay of complementaries were swirls of blue and purple snow. Charlesworth dismissed it as a "garish poster."[3]

Although living in Toronto and able to paint, Harris was deeply troubled through much of 1917, owing partly to his despair over the war and the death of Tom Thomson. He was also suffering from a spiritual malaise that made him doubt his artistic direction as well as his purpose in life. In the midst of his crisis he wrote a letter to MacDonald, describing his ailment in curiously abstract terms. He claimed he "felt curiously shifty as if in an element that was making great sport of me." He found himself torn between "alluring impermanencies" and "even-more-attractive-at-the-time permanent things and nothings," and he told MacDonald he did not feel "soul-steadied" and that he had "built everything . . . on sand."[4]

One of the few other glimpses into his restless psychological condition can be found in some of the poems he began writing around this time. One of them, called "The Age," expressed his gloomy attitude about society's obsession with the material and the immediate at the expense of the eternal: "This is the age of the soul's degradation, / Of tossing into the sun's light / The dross and slime of life." The vulgar celebrations of the superficially beautiful material world—what his poem called "glorying in the miserable glitter"—was not enough to compensate for "the soul's great sadness."[5]

Harris was the most religious of the painters in the Studio Building. He had been raised a devout Baptist by a mother who had since converted to Christian Science, a religion of "healthy-mindedness" that saw patients treated by "mental practitioners" rather than medical doctors. Although Harris did not convert to Christian Science, he too became more heterodox in his religious views, sharing Christian

Science's disillusionment with the materialism of the age and its desire for spiritual replenishment. The tension he felt between the material world's "alluring impermanencies" and the "permanent things and nothings" of the spiritual world was one with which artists and writers had been grappling for the previous few decades. Edward Carpenter and Wassily Kandinsky both opposed the material view of the world—what Kandinsky condemned in 1911 as the "nightmare of materialism"—and predicted the coming of a spiritual revolution.[6] But hopes for this new world of the spirit seemed to have died on the battlefields of the Great War.

Perhaps as a prescription for his malaise, Harris used a week's leave from the army in the first week of 1918 to visit New York. The city's art galleries at this time offered, according to the *New York Times,* "innumerable entertainments."[7] Which galleries and museums Harris visited is not known, but at the Modern Gallery he could have seen an exhibition of etchings, drawings and lithographs by Cézanne, Matisse, Raoul Dufy and Vlaminck. New York's main attraction for him at this time, though, might have been the many works on show by members of The Eight (later known as the "Ashcan School").[8] One member, George Luks, had a solo exhibition at the Kraushaar Galleries on Fifth Avenue, while the Macbeth Gallery (where The Eight first showed their work together in 1908) featured a retrospective of the paintings and drawings of Arthur B. Davies. Another large display of the group's work could be seen at the Bourgeois Galleries, where a benefit for American War Relief included work by both Luks as well as other members such as Robert Henri, William Glackens, John Sloan and Everett Shinn.

If his trip to New York was timed to coincide with these exhibitions by members of The Eight, Harris would have returned to Toronto with a renewed interest in scenes of modern urban life. He must also have noted how, through aggressive self-promotion, the *enfants terribles* of American art were steadily winning over both the public and the critics less than a decade after their first group exhibition attracted bitterly hostile reviews ("Bah! The whole thing creates a distinct feeling of nausea," a critic had snorted at their 1908 show).[9] He would

furthermore have been sympathetic to Robert Henri's avowed aim to take art to the masses (many of The Eight even published illustrations in a journal called *The Masses*) by democratizing a love of art and turning America into what he called "an art country."[10]

While Harris was in New York, the *New York Times* devoted a long and laudatory article to Arthur B. Davies, one of the masterminds of the 1913 Armory Show and the painter possibly of most interest to Harris at this point. Unlike other members of The Eight, Davies expressed not the speed and cacophony of the city but silence and tranquility. His specialty, as in *The Dweller on the Threshold,* was ethereal female nudes dancing beside reflective lakes in mountain landscapes. The reviewer for the *New York Times* praised these canvases for their "long, continuous, linear rhythms," their "grace of movement," and their "ceaseless flow of beauty."[11] Another critic celebrated Davies as a "seer of visions" and a "poet who would penetrate this earthly envelope and surprise the secret fervors of the soul."[12]

These paintings of what Harris might have called "permanent things and nothings" were inspired by Davies's longstanding interest in mysticism and the occult. He was, along with Gauguin, Kandinsky, Mondrian, Nicholas Roerich and Gustaf Fjaestad, one of the many artistic followers of theosophy. Davies once met the Theosophical Society's founder, H.P. Blavatsky, a photograph of whom he afterwards carried as a charm in the case of his pocket watch.[13] Madame Blavatsky developed theosophy as a reaction against the stalemate reached by scientific materialism and orthodox religion, rejecting their dogmas and emphasizing the existence of a deeper spiritual reality beyond the world of matter. One of their objectives was "to investigate the hidden mysteries of nature . . . and the psychic and spiritual powers latent in man."[14] It was these deeper realities and hidden mysteries that artists like Mondrian and Kandinsky, abandoning representational art in favour of abstractions, sought to communicate through their paintings.

Harris might first have been exposed to this exotic philosophy— what a Canadian minister called "that extravaganza of religion"[15]— during his studies in Germany. The German Theosophical Society was

active under the leadership of Rudolf Steiner, who, beginning in 1904, gave a series of lectures in Berlin on spiritualism and the "destructiveness of materialist science in respect to the soul."[16] Theosophists were a rarer breed in Canada, numbering under a thousand, though in 1891 the first Theosophical Society Lodge opened in Toronto and by 1918 two more had appeared. The painter and educator George A. Reid was an early member, hosting meetings in his studio in the Arcade building on Yonge Street.[17]

Harris already had connections in Toronto's theosophical community. A friend from the Arts and Letters Club, the theatre director Roy Mitchell, was a prominent member who would found the Blavatsky Institute of Canada in 1924. Mitchell had moved to New York in 1916 to become technical director of the newly founded Greenwich Village Theatre. Harris's trip to New York might well have been timed to coincide with the theatre's maiden production, the Danish playwright Hjalmar Bergstrøm's *Karen Borneman*, which opened in the first week of January 1918.[18]

Harris also had other theosophical connections. An older and even closer friend, Fred Housser, a schoolmate from St. Andrew's College and the financial editor of the *Toronto Daily Star*, was likewise a theosophist. Inspired and perhaps counselled by these friends, and in the midst of his spiritual crisis, Harris too began to turn to theosophy as a way of penetrating the alluring impermanencies of the material world.

HARRIS'S MENTAL DISTURBANCE worsened dramatically with the news in February 1918 of the death of his only brother, Howard, a captain in the Essex Regiment. A decorated veteran of the Somme and Passchendaele, thirty-one-year-old Captain Harris was killed during a reconnaissance mission near Bapaume.[19] This devastating loss, combined with the death of Thomson less than a year earlier, left Harris extremely anxious and depressed. He began suffering from a sleep disorder, what he later described as "troublous, somewhat terrified tossings and turnings and apprehensive opening of the eyes."[20] By the spring he had suffered a complete nervous breakdown, and on the first of May he received a medical discharge from the army.

One of the first things Harris did following his discharge was to wander through Toronto's neighbourhoods with his sketchbook. As always, he had no interest in painting what Rupert Brooke called the "public-school-and-'varsity" aspect of Toronto—the parts of the city in which he himself was raised. He sought instead the picturesque squalor of more down-at-heel precincts. Since most of his old sketching ground, the Ward, was demolished in 1913 to make way for the Toronto General Hospital, he went north to the area around Dufferin and St. Clair. In this mushrooming neighbourhood he found a suitable bedragglement. The poor suburb had been settled a decade earlier by working-class English immigrants who christened it "Earl's Court" (soon condensed to Earlscourt) in an ironic reference to West London's upscale Victorian suburb. To more well-heeled and well-housed Torontonians it was "shacktown," because it consisted of dozens of small, ramshackle houses—many similar in design to Tom Thomson's shack—built by their owners on narrow plots of land. Many had no water, sewer, gas, electricity or sidewalks, and the first paved roads arrived only in 1913.

Harris described Earlscourt as a "picturesque semi-slum."[21] He might have known of it from a 1914 *Saturday Night* article that described these squatters' dwellings as "toy houses...ludicrous in size and shape."[22] But he could also have heard about Earlscourt from many of the young men who passed through Camp Borden or the District School of Musketry, because the area had one of the highest enlistment rates per capita in the British Empire: one English newspaper called it a "colony of soldiers."[23] It had suffered, noted the paper, "very heavy casualties," with many men returning home maimed both physically and psychologically. In 1917 a special Veterans' Burial Plot was opened in nearby Prospect Cemetery, and so famous was the area for its sacrifices that in 1919 the Prince of Wales would visit the cemetery to plant a silver maple in honour of Earlscourt's dead.

Harris made a number of oil sketches in the area, eventually producing a larger canvas in his studio, *Outskirts of Toronto*. The work shows a small clutch of houses at the foot of a hill, with another row of higgledy-piggledy shacks perched on the horizon. Like so many

of the Algonquin Park School's paintings of the Shield country, *Outskirts of Toronto* shows a place of solitude. There are no lively crowds or dramatic perspectives, only the faintly downtrodden stillness of his downtown urban scenes. The duckboards placed across the churned-up yellow mud and the woman stooped beside a washing line in the treeless landscape testify to the poverty and grimness of this part of Toronto. They also allude to the ooze and slime of the trenches in places such as Passchendaele—whose "evilly yellow" mud Paul Nash had graphically described in a letter to his wife[24]—that claimed the lives of so many Earlscourt residents.

IF THE SHACKS of Earlscourt were alluring impermanencies, Harris also sought more enduring things. In this time of crisis he sought solace in what he would later call "the ample replenishing North," which he regarded as a "source of spiritual flow" and "eternal values."[25]

Sometime in May 1918, he and Dr. MacCallum set off by train for the North. Avoiding Algonquin Park because of its painful reminders of Tom Thomson, they travelled to Manitoulin Island on Lake Huron. Wilfred Campbell in his 1910 guidebook described the island as "rugged, lofty, and precipitous . . . The scenery is magnificent."[26] But Harris was unimpressed, and so he and Dr. MacCallum pressed restlessly northwards, crossing the North Channel by boat and then catching a westbound CPR train to Sault Ste. Marie. On the following day the two men boarded the Algoma Central Railway and travelled into the Algoma district, swinging inland from Lake Superior and journeying north along a trestle-bridged line completed only a few years earlier.

Harris probably first learned of Algoma and its remarkable railway from Frank Johnston, who in 1916 took the ACR to the end of the line at Hearst, a small town 370 kilometres north of Sault Ste. Marie. In any case, Harris found in this land of moose and muskeg the replenishment he craved. His friend Fred Housser described Algoma a few years later as country "charted on a grand scale, slashed by ravines and canyons through which run rivers, streams, and springs . . . Granite rocks rise to noble heights—their sides and tops solidly covered with hardwood, spruce and pine, a perfect glory to the autumn."[27]

Harris wrote enthusiastically to MacDonald that on leaving Sault Ste. Marie and "climbing into that paradise" it was possible to "forget entirely to give your health or state of mind even a passing thought." The only thing necessary for peace of mind was to "give up to drinking in gorgeousness with your eyes, sweet, woodsy sounds with your ears and crisp, clean air with your lungs."[28]

If Algoma was a paradise, it was a typically Canadian one whose beauties had been harvested for many decades by commerce and industry. There were sawmills and fisheries, and each spring timber was herded down the Magpie and Michipicoten rivers into booms on Lake Superior. Hydroelectric plants on both rivers supplied the iron ore and gold mines near Wawa. Algoma Steel used the pig iron from the Helen Mine to make rails and, during the war, artillery shells. Near Goudreau, an American chemical company operated a pyrite mine. Despite these activities, the area was far from populous. Although ACR officials had hoped to promote agricultural and settlements along the line, the land was unsuited to farming and towns of any size had failed to develop. Still, the area had long been visited by city slickers like Harris and Dr. MacCallum. American tourists had made their way to Sault Ste. Marie since the 1850s to shoot the rapids in canoes, and Superior's eastern shore was so popular with visitors that Rupert Brooke, passing through Algoma in 1913, spotted bathing and boating parties along the shorelines, along with picnickers and campers "who rushed down the beach in various deshabille . . . Everyone seemed cheerful, merry and mildly raucous."[29]

Harris and Dr. MacCallum eventually travelled nearly two hundred kilometres north of Sault Ste. Marie on the ACR, staying for a few days in a lumber camp and visiting Michipicoten Harbour, near Wawa on Superior's eastern shore. By the time they returned south, Harris's recuperation had truly begun. He reported in July that he was "irritatingly healthy" and "extremely busy." He spent much of the rest of the summer at Woodend, his family's summer property at Allandale, on Kempenfelt Bay near Barrie. He felled trees, fitted the house with screen doors and windows, and reassembled the dock. He also began designing a 120-yard-long urban landscape for raw U.S. Army

recruits—almost 700,000 of whom were called up in 1917—to use in target practice. It comprised, he wrote to MacDonald, "a ruined village, trenches, shell holes, wire and general junk," for which he was "giving all thinkable details."[30]

Harris was also trying to paint landscapes but found the agricultural countryside around Kempenfelt Bay uninspiring: he complained to MacDonald of "the meagreness of material at hand." What he wanted was to return to paint in Algoma. Meeting Dr. MacCallum by chance on the platform at Allandale Station, he began planning another expedition. He invited MacDonald along: "If you can possibly arrange to get away for two weeks nothing would delight me more and I hope & pray you can make the grade." Knowing that MacDonald, too, was convalescing, he promised they would not exactly be roughing it: they would stay in either an ACR caboose or one of "several quite cosy log cabins scattered along their line." He explained, in case MacDonald was unfamiliar with rolling stock, that a caboose was "a most comfortable box. Pleasant bunks, stove, tables, chairs, and all the solid, essential comforts of home save all outdoors acts as the plumbing." Dr. MacCallum would be happy to tackle the domestic duties "and leave us free to paint. So long as we are painting it will be a pleasure to him to care for our tummies and the utensils, fire and food required to provide us with fuel." The idyllic arrangement had only a single drawback: "The Doc. snores on occasion."[31]

A few weeks later, at the end of August, Harris wrote MacDonald with good news. "Well James, me boy, down on your knees and give great gobs of thanks to Allah!—sing his praises, yell terrific hallelujahs that they may reach even unto His ears—we have a car waiting us on the Algoma Central!!! A car to live in, eat in and work out of. They will move us about as we desire and leave us on auspicious sidings that we may proceed to biff the landscape into a cocked hat at our sweet will."

Harris had indeed planned for everything. Besides a stove and cooking utensils, this "movable home" would even have one bunk separated from the others so that "the Doc. may snore in arrogant seclusion."[32]

HARRIS'S PROMISES ABOUT the comforts and conveniences of the boxcar journey into Algoma must have been welcome to MacDonald. Still recovering from his stroke the previous November, he was also nursing a delicate financial condition that early in 1918 required him to move his family from the "small and rotten rickety house" in York Mills and into the Studio Building. He was also obliged to move from his top-floor studio—whose fifty-step climb he could no longer manage—and into one on the ground level.

The first months of his recuperation MacDonald spent not painting or designing but, on the advice of its editor, Barker Fairley, composing articles on Canadian art for *The Rebel,* a University of Toronto publication. Unable to paint, he could at least propagandize. In their exasperation and asperity, many of his pieces were worthy of A.Y. Jackson. One of them, "A Whack at Dutch Art," lampooned the typical Canadian collector who spurned Canadian landscapes because the clear light of Georgian Bay was "too crude and clear for him in pictures, although he actually enjoys such things in his fine yacht, the *Flim-Flam.*" He deplored how this kind of connoisseur would happily part with $700 for a foreign work while Canadian paintings with more modest prices remained unsold. The upshot was that "men of great talent," discouraged by the poor prospects and slight esteem, were turning their efforts elsewhere. His article ended on a positive note, comparing lovers of Canadian art to the early Christians in the catacombs beneath the streets of pagan Rome: "They are developing the faith of the future in secret, and the ground will open with them some day."[33]

MACDONALD WAS FINALLY well enough to paint by the early summer of 1918. He sketched on the waterfront of Lake Ontario and in York Mills, and later in the summer he travelled north to Muskoka. On Moon River, near the village of Bala, he painted a sketch for *Cattle by the Creek,* revealing a palette magnificently undimmed by either illness or the reproaches of the critics.

MacDonald was persuaded to join the boxcar expedition to Algoma despite his worries that his physical condition would hamper

the efforts of the others. Also present for the journey, besides Harris and Dr. MacCallum, was Frank Johnston, now thirty years old. He had received a perfunctory invitation from Harris several weeks earlier: "Jim informs me that he has informed you that we intend going North a-sketching this fall. We would be delighted to have you join us."[34]

Harris jokingly called Johnston "the anemic, doddering Frank,"[35] but in fact Johnston fitted the profile of the husky, red-blooded Canadian painter. He had been athletic as a child growing up on Shaw Street, playing baseball and excelling on the sports field.[36] His beefy physique was offset by his flamboyant dress and manner. A Lismer caricature, done about 1915, showed him wearing an extravagant bow tie and wideawake hat à la Oscar Wilde. He cultivated a Van-dyke beard and a thick forelock. On social occasions he donned the claret-coloured velvet smoking jackets and flowing ties of a Victorian aesthete. ("That kind of outfit made Lawren wince," a friend later recalled.)[37] He was rarely without a cigarette, smoking as many as a hundred a day. A lover of theatre, he attended vaudeville at Shea's Hippodrome and gave star turns at the Arts and Letters Club's dramatic evenings, cartwheeling across the stage and performing burlesque stripteases.

This florid behaviour belied a sedate and satisfying domestic life. Johnston had married in 1910, was deliriously in love with his wife, and quickly produced four children, the youngest of whom was named for Lawren Harris. He was (like MacDonald's wife, Joan) a devout Christian Scientist. He attended the First Church of Christ, Scientist on St. George Street and, after the service, used to "stand on the church steps and powwow about art."[38]

Johnston's dandyish comportment also belied his love of the coun-tryside. Although he studied under Robert Henri, famous for his New York scenes, Johnston ignored Toronto's streets in favour of land-scapes in the Don and Humber valleys. In the summer of 1915, urged by Dr. MacCallum to explore the province's more northerly latitudes, he travelled to Bon Echo, a resort on Mazinaw Lake, in the Kawar-tha Lakes district of eastern Ontario. A year later he journeyed much farther north, taking the ACR in the middle of winter to Hearst. This

Frank H. Johnston
McMichael Canadian Art Collection Archives

expedition gave him certain bragging rights: none of the painters in the Studio Building, not even Thomson, had ventured to such a remote and northerly location in Ontario. The journey resulted in his first major sale. Since returning to Toronto in 1915 he regularly showed land-scapes at the annual OSA exhibitions, albeit without attracting the same attention or ire as Jackson or MacDonald. In 1917, however, the National Gallery paid $250 for *A Northern Night* (see plate 27), based on studies of the aurora borealis made at Hearst. Its scrupulous handling and poetic calm suggest the influence of his teacher Daniel Garber.

Johnston was turned down by the Canadian army for service in the war—the reason is unknown—but in the summer of 1918 he, like Jackson and Varley, became a war artist. The CWMF wished to document events on the home front as well as overseas, and so Johnston received an assignment to record the manoeuvres of the Royal Flying Corps at their training bases around Toronto. Since the remuneration was slight,

he kept his job at Rous and Mann, making sketches on evenings and weekends at the airfields in Armour Heights and Leaside. At the end of the summer, the man who recruited him into the CWMF, Sir Edmund Walker, supported his appeal to take leave from his duties at the airfields to travel to Algoma.[39] Walker had obviously earmarked Johnston as one of Canadian art's coming men and, like Dr. MacCallum, he believed that Canada's artistic destiny lay to the north.

THE FOUR MEN, accompanied by Harris's dog Prince, departed from Union Station early in September on an overnight CPR train to Sault Ste. Marie. At the Soo a specially equipped boxcar awaited them, a mobile studio conveniently fitted, as promised by Harris, with bunks, windows and lamps, cupboards, a stove, a sink and a water tank. The men also had use of a canoe and a jigger, a three-wheeled vehicle with which they could propel themselves along the tracks until, as Mac-Donald wrote, "some attractive composition of spruce tops or rock and maple" called for sketching.[40]

Their boxcar was hitched to a northbound ACR train and then uncoupled 180 kilometres later on a siding near Canyon, where the steel was laid as recently as the winter of 1911–12. After several days of sketching near the Agawa River they were collected by a southbound train and shunted onto sidings 30 kilometres later at Hubert. A second southbound train then took them 25 kilometres to their final stop at Batchawana.

The painters were mesmerized by the sight of winding rivers, thundering waterfalls and vertiginous granite canyons covered in radiant autumn colour. Harris found in the scenery "a richness and clarity of colour" that made everything in southern Ontario seem "grey and subdued."[41] MacDonald was even more smitten. "It is a land after Dante's heart," he wrote to Joan on September 11, describing how Algoma had "all the attributes of an imagined Paradise," with the sky and "that smooth shimmering infinity of waters" resembling "a glimpse of God himself." To describe his helpless feelings of wonder he used a metaphor from (and here we get some of his erudition) the Revelation of St. Paul, one of the Apocrypha that describes how the

apostle was swept into the third heaven to witness a series of visions: "It reminds one of Paul," he told Joan, "being caught up and hearing unutterable things."[42]

Even accounting for hyperbole, this response was remarkable. MacDonald's quasi-religious experience in Algoma duplicated the awe with which so many poets, painters and mystics had gazed on the rugged beauties of the natural world. The question of St. Hilary of Poitiers—"Who can look on nature and not see God?"—had resounded down the centuries. For many years the answer was, very few. The vast scale of natural wonders such as Mont Blanc or Niagara Falls was enough to create in sensitive beholders a kind of religious fervour. The Irish poet Thomas Moore, after visiting Niagara in 1804, wrote to his mother in language MacDonald would echo a century later: "I felt as if approaching the very residence of the Deity; the tears started into my eyes; and I remained, for moments after we had lost sight of the scene, in that delicious absorption which pious enthusiasm alone can produce . . . Oh! bring the atheist here, and he cannot return an atheist."[43]

The century that separated Moore and MacDonald had brought science intrusively into the equation. Suddenly it was possible to look on nature and *not* see God or feel pious enthusiasm. Early in his life, John Ruskin believed nature to be "animated by the sense of Divine presence" but ended his days complaining (in a classic statement of the Victorian "crisis of faith") that in every biblical verse he could hear the clink of geologists' hammers.[44]

If conventional religion crumbled under these hammer blows, a kind of Romantic pantheism, a belief in the divinity lurking in nature, continued undiminished. Even Van Gogh believed he could draw near to "Something on High" through "long years of intercourse with nature in the country." An American disciple of Walt Whitman named John Burroughs succinctly summed up this attitude: "Amid the decay of creeds, love of nature has high religious value." For such people, he claimed, nature "is their church, and the rocks and hills are their altars." Whitman himself was responsible for much of this "spilt religion" (as the philosopher T.E. Hulme derisively called it). Revered by many painters, including both Gauguin and Van Gogh, Whitman was

also one of MacDonald's (as well as one of Lismer's) favourite writers: MacDonald called him the "liberator of the soul" and the "patron saint of the modern artist." He must have felt on arriving in Algoma that he had been transported into "these skies and stars, these mountain peaks . . . / These huge precipitous cliffs, this amplitude, these valleys" celebrated by Whitman in his account of the "virgin land" of the American continent (which generously included what he called "Kanada").[45]

MacDonald was not certain at first what to make of his Algoma rapture. "I have not assimilated this experience yet," he wrote to Joan. "It is something to be quiet about and think over." But he was not at a loss over what to do with his palette and brush, making a number of remarkable sketches. One, *Leaves in the Brook,* he would several months later turn into a larger painting of the same name. Rather than mystic amplitude, these sketches present exultant hubbubs of colour akin to *Rock and Maple* of 1916, this time done in crimson, purples and orange. Depicting leaf-strewn boulders in the middle of a stream, they are, like *Rock and Maple,* wonderfully scintillating images of moving water. Another compelling sketch of rushing water, done near the falls of the Montreal River, he would turn into *The Wild River.*

MacDonald's ecstatic response to the Algoma landscape eclipsed for a time his personal worries about health and finances. But as the party prepared to return to Toronto at the beginning of October, the worries revived. He wrote to his wife about an unnamed problem, probably financial: "I am concerned about the problem. It seems as though such things had no existence here, but I suppose they must be faced some day. I hope to get back in good condition to help in their resolution, and in the meantime will do what I can in having the right attitude towards them. I hope you will not be too worried about such things."[46]

288 The war provided MacDonald with some employment, however grim. Back in Toronto, he found himself busy illuminating honour rolls and—in a poignant reprise of his work on Tom Thomson's cairn—designing memorial tablets for companies who had lost employees overseas.

9 THE GREAT KONODIAN ARMY

FRED VARLEY FINALLY reached the Western Front in early September 1918, at almost exactly the same time the boxcar expedition arrived in Algoma. After touring the London galleries with Paul Konody in April, he had spent six weeks at North Camp in Seaford, ninety kilometres south of London on the Sussex coast. The camp provided the soldiers with, among other things, anti-gas training. In preparation for the Western Front, they donned primitive respirators and protective masks, and then stumbled through huts and trenches filled with poison gas.

Varley recorded this exercise when, in one of his first efforts for the CWMF, he painted *Gas Chamber at Seaford*. But his real interest at this point lay in the landscape outside the camp. He found himself entranced by the chalk cliffs and rolling hills of the South Downs. The "pearly atmosphere" was entirely unlike the harsh clarity of Ontario that—as the painters in the Studio Building insisted—took a special style to paint; but to Varley it was no less beautiful for that. He walked as much as fifteen kilometres a day through the chalk downlands and along the Cuckmere River to the sea, enjoying the more feminine contours of the English countryside. "Every time I look at those marvels of hills with their great white sides facing the sea," he wrote to Maud, "I wonder if the scene is real."[1]

Varley enjoyed other aspects of the posting. He was "pampered & made a fuss of" during his stay at North Camp. Officers wore collars and neckties, dined in an officers' mess and were given the luxury of a "batman," a soldier-cum-servant from the Princess Patricia's Canadian Light Infantry. Officers also received generous periods of leave, and Varley found himself with enough money for regular excursions into London. He and his friends were "constantly trying new things & living like princes."[2] His prodigality was such that soon he was required to borrow money from Beatty and Charles Simpson. Little of his pay packet found its way back to his family in Canada. "It's those weekends and those days in London that take your money," he explained sheepishly to Maud.[3] She could hardly have been sympathetic about this galloping consumption of the purse. She was forced to ask her landlord for extra time to pay the rent on her small house in Thornhill—the latest in a long succession of Varley residences—and to appeal for assistance to Dr. MacCallum.

Varley's chances of economizing did not look promising when he was posted back to London at the end of May. With Beatty and Simpson drawn by lot for duties at the front, he installed himself in a studio in Hampstead, a bohemian suburb of artists and émigrés that boasted plenty of watering holes filled with roisterous company. "Wherever one goes," he exulted to Maud, "there are friends."[4] The temptations for a uniformed officer in London were spelled out in a popular song, "There's a Girl for Every Soldier." However, Varley mostly kept out of trouble by going to the cinema with Jackson, entertaining his sister Lilian, and working his way through weighty reading material such as *Anna Karenina* and volumes of poetry by Shelley and the Nobel Prize–winning Bengali writer Rabindranath Tagore (whose work he had probably seen performed at the Arts and Letters Club). He paid his dues to the CWMF by painting several portraits of Victoria Cross winners.

Varley's orders to join the "great Konodian army" in France finally arrived in September. A month earlier, August 8, marked the beginning of the Hundred Days Offensive, or what would become known to Canadians as "Canada's Hundred Days." The Canadian Corps was once more the spearhead of the offensive that would ultimately end

the war; over the next few months the Canadian Corps added to its illustrious roster of victories. On August 26 it breached the Hindenburg Line at Arras, a feat praised by General Currie as the finest moment in Canadian history. Even the British newspapers began to take notice, the *Daily News* reporting that the Canadian Corps was "simply irresistible."[5] Altogether the Canadian Corps in the last months of the war would defeat thirty-four German divisions, take 21,000 prisoners, and liberate more than fifty towns and villages across almost eight hundred square kilometres of French soil. Besides these heroics, Canadians offered remarkable individual accomplishments, with twenty-five-year-old Captain Roy Brown, from Carleton Place, Ontario, given credit for shooting down the Red Baron in April 1918, and Billy Bishop—from Tom Thomson's hometown of Owen Sound—credited with seventy-two kills, the highest of any British Empire pilot.

Like Jackson before him, Varley was witness to horror as well as heroism on the Western Front. Travelling behind the fast-moving Canadian divisions, he came upon muddy battlefields, destroyed towns and mass graves. In the middle of October he wrote to Maud of this bleak and hideous landscape of death. "You in Canada... cannot realize at all what war is like. You must see it and live it. You must see the barren deserts war has made of once fertile country... see the turned up graves, see the dead on the field, freakishly mutilated—headless, legless, stomachless, a perfect body and a passive face and a broken empty skull."[6]

To Lismer he was equally unsparing of the gory details. His duties as an artist took him across "festering ground" with shell holes "filled with dark unholy water. You pass over swamps on rotting duckboards, past bleached bones of horses with their harness still on—past isolated rude crosses sticking up from the filth, and the stink of decay is flung over all. There was a lovely wood there once with a stream running thro' it, but now the trees are powdered up and mingle with the soil. One or two silly maimed stumps are left, ghostly mockeries of what they were... I tell you, Arthur," he finished, "your wildest nightmares pale before reality. How the devil can one paint anything to express such is beyond me."[7]

VARLEY SOON WENT to work painting these barren deserts. He arrived back in England a short time before the armistice. London went wild with celebrations when the peace was announced. Huge crowds gathered in Trafalgar Square and in front of Buckingham Palace, and honking motorcars piled with passengers cruised the streets. But Varley had seen too many "piteous sights" to "flagwave or get drunk."[8] Shutting himself away in his Hampstead studio, he began a number of paintings, taking as his subject what Wilfred Owen had called "the pity of war."

One day at the front Varley made a quick sketch of a piteous sight he had witnessed near the front: a soldier from the Canadian Scottish Regiment taking a break from the task of digging a grave for his fallen comrades. The Canadian Scottish was a regiment extraordinary even by the standards of the Canadian Corps, having fought at Ypres, the Somme, Vimy Ridge, Hill 70 and Passchendaele. Four of its soldiers had been awarded the Victoria Cross. Yet nothing of the regiment's bravery and lustre appeared as Varley began turning his sketch into what he called his "horror picture." On a canvas 1.5 metres high by 1.8 metres wide he tried to capture "mud & dirty water and limbs & hopeless skulls full of rain."[9] The result was *For What?*—an image as chastening as anything painted by Nevinson or Nash: dead bodies heaped in a cart, two rows of white crosses in the mud, a storm gathering in the distance. Overseeing it all with grim nonchalance was the beret-wearing gravedigger (see plate 28).

The most alarming aspect of the painting was its title. Varley was broaching the disturbing question that few dared ask even at this late stage: for what had these young men sacrificed themselves? It was a bold and potentially controversial challenge. To question the point of these sacrifices, and of the war effort in general, was to risk the wrath of the authorities. Following the horrors of Passchendaele, the British government in November 1917 took strong measures to suppress what one MP called the "flood of poisonous stuff" flowing from the pens of pacifists. Scotland Yard immediately began a series of raids on the premises of suspect printers and the offices of such undesirables as the Fellowship of Reconciliation and the No-Conscription Fellowship.

Vanloads of pamphlets were seized and those held responsible for distributing them sent to prison.[10]

To dispute the purpose of the war was to risk, too, the violent wrath of soldiers and members of the public. Pacifist meetings in London regularly ended in assaults. Delegates to a meeting in a Congregational church in Hackney, East London, were attacked by a three-hundred-strong crowd of soldiers and locals bellowing "Rule Britannia." One of the mob's leaders was a Canadian corporal who gave an impassioned speech in the wreckage of the church, the windows and pews of which had been smashed. "In breaking up this meeting," he told his cheering companions, "we have done one of the finest things we possibly could do." When the pacifists returned to Hackney two months later, the church was set ablaze and the delegates thrashed in what the press called a "pacifist riot." Charges were laid against some of the bruised and bloodied pacifists, but none against their attackers.[11]

Evidently undaunted by the possible responses, Varley continued with further stark pictorial reportage. In the weeks following the armistice, he painted a large canvas called *Some Day the People Will Return* (see plate 29). The hopefulness of the work's title was undermined by both the painting itself and a gloss he wrote on it: "Some day the people will return to their village which is not. They will look for their little church which is not; and they will go to the cemetery and look for their own dear dead, and even they are not."[12]

Based on a small sketch made in France, the painting showed a churchyard destroyed by shelling, the coffins of the ravaged graves exposed in a grotesque resurrection. Not even the dead had escaped the carnage and violence; not even the grave was safe from devastation. If these suggestions were not grim enough, Varley's main point was even bleaker. In the mid-1880s Van Gogh expressed his loss of faith and the crumbling of religion in a series of paintings of the progressive dilapidation of the church tower and abandoned peasants' graveyard at Nuenen. For Varley, the decline of Christianity was captured by this more violent and dramatic scene. The toppled gravestones and upturned coffins of the French churchyard represented how, in his opinion, the war—the sheer brutality of mankind—had

brought the cultural values of Christianity to an end. In an obvious piece of symbolism he depicted in the foreground an overturned gravestone, its cross tipped sideways. "Christianity," he wrote bitterly to Maud, "is as dead as the graveyard I'm painting."[13]

It was a desolate and arresting vision. While Harris, MacDonald and Johnston were enjoying their rhapsodic experiences in the earthly paradise of Algoma, Varley, like Jackson, had been confronting the horror and nihilism of the Western Front.

VARLEY WAS CONVINCED that in works such as *Some Day the People Will Return* he was painting "something worthwhile . . . something strange & marvellous."[14] Others were soon able to pass their own judgment. On January 4, 1919, an exhibition of four hundred paintings commissioned by the Canadian War Memorials Fund opened at the galleries of the Royal Academy at Burlington House in London. Varley had been so determined to have his paintings completed on time for the exhibition that he spent the Christmas holidays working diligently in his studio.

The *Canadian War Memorials Fund Exhibition* was officially opened by Sir Robert Borden, who was in London to prepare for the Paris Peace Conference. Fears of influenza (almost fifty thousand people had died in Britain since October) did not stop more than two thousand visitors passing through the turnstiles on the first day. They filed through the courtyard of Burlington House to be greeted by marching songs from the band of the 17th Canadian Reserve Battalion. Upstairs in the exhibition rooms they were witness to what Paul Konody, writing in the *Observer,* called "the most important artistic event that has happened in England for many a year."[15]

Acclimatized to Post-Impressionism, Futurism and Vorticism, the British public required little education about modern artistic trends. They did need enlightening about Canada's role in the war. Images of Canadian troops in transport, in training and in battle covered the walls. Every aspect of the effort was documented, from Gerald E. Moira's painting of the Canadian Forestry Corps at work in Windsor Great Park to Anna Airy's *Cookhouse of 156th Battalion at Witley Camp.*

The central gallery featured Richard Jack's *The Second Battle of Ypres* along with a bronze sculpture by Francis Derwent Wood, *Canada's Golgotha,* a work showing the controversial (and probably apocryphal) episode of the crucified Canadian soldier.

The prize exhibit was Augustus John's three-metre-high by twelve-metre-wide charcoal-drawn cartoon for *The Canadians opposite Lens.* Konody praised this work in *Colour Magazine* as "an epitome of modern war" that caught the "destruction and desolation" of battle "with a sense of style unrivalled by any other living painter."[16] Probably not even Konody believed this humbug. Colossal reputation notwithstanding, the galloping major proved a bust as a war artist: he was court-martialled after a drunken brawl with a fellow officer, escaping military punishment only as a result of Lord Beaverbrook's intervention. His work would never progress from charcoal to pigment.[17]

Although Canadian soldiers were the stars of the show, Canadian artists were less conspicuous. No Canadian artist was deemed well-known enough to the British public to merit a place in the central gallery (it would still be possible, five years later, for an English journalist to remark that Canadian painters were "practically unknown" in Britain).[18] Jackson and Varley were well represented nonetheless. More significant, they were well reviewed. With thirty-five oil panels on display, Jackson was the most prolific artist of all those working for the CWMF. Besides *Springtime in Picardy* he showed another work with a deliberately ironic name, *A Copse, Evening.* The painting's mischievously Barbizon-like title was bluntly offset by its depiction of scorched trees and criss-crossing searchlights. The deeply undulating lines of *Liévin, March 1918* reappeared in the cadaverous trees of the "copse" and the quagmire over which soldiers filed on zigzagging duckboards.

These landscapes earned Jackson comparisons to Van Gogh and praise from an American critic as "one of the most successful artists of the entire exhibition" whose work "justifies the hopes of a more world-wide appreciation of the aims of the artist freed from the traditions of the academies."[19] Another reviewer would later pronounce *A Copse, Evening* "one of the most enduring pictures in the collection." It possessed, claimed the critic, "a phosphorescent beauty and almost

a fascination that yet in no way detracts from the grimness of the conception."[20]

Jackson was not in London to enjoy the acclaim because he had been sent back to Canada in October. Varley, though, was able to bask in the critical ovations. The *Observer* celebrated him as "the most distinguished and forceful of the Canadian official artists," and in the *Nation* he was commended for having conveyed to spectators "the original effect of horror." In the *Daily Telegraph* the distinguished art historian Sir Claude Phillips, a one-time keeper of the Wallace Collection, called him an "ultra-modernist" and praised *For What?* and *Some Day the People Will Return* for their "genuine power. There is nothing here of sentiment, nothing indeed of personal passion. We find a massive objectivity, a sense of all-pervading tragedy, of human will overpowered by Fate."[21]

Varley quickly became the toast of London. He was given honorary membership in the Chelsea Arts Club, the legendary institution founded in 1891 by James McNeill Whistler. Its reputation for decadent bohemianism (the annual Chelsea Arts Ball was the most notorious event in the social calendar) appealed to Varley. Here within the famous white walls he received a "very warm greeting" from Augustus John and "quite enjoyed gassing" with his fellow painters.[22] More work quickly came his way. The Canadian War Records Office commissioned him to paint an eleven-foot-wide panel and Lord Beaverbrook requested a portrait of his ten-year-old daughter, Janet. So great was Varley's success that he began contemplating a permanent move back to England. He wrote to Dr. MacCallum asking for two of his works—*Indian Summer* and *Squally Weather, Georgian Bay*—to be shipped to England so they might be included in the Royal Academy's annual summer exhibition. He informed Maud that he planned to take "full advantage of the tide" that was flowing in his direction.[23]

The promise of the Algonquin Park School, checked by the war, finally appeared on the verge of fulfilling itself. Back in Toronto, J.E.H. MacDonald, for one, was optimistic. "They will return," he wrote of the two triumphant war artists. "They will interpret for us with deeper insight the distinctive beauty of the land they have served. May their

countrymen leave their old apathy behind them, the old condescension, the old ridicule ... and arouse themselves to an appreciation of their efforts!"[24]

But if the promise was soon fulfilled, the old apathy would not be laid to rest so easily.

JACKSON WAS AWAITING passage to Siberia when the CWMF exhibition opened in London. He had returned to Canada to prepare for embarkation to Vladivostok to chronicle in paint the Canadian army's fight against the Bolsheviks. Provisioned with twenty tubes of white paint to depict the Siberian snows, he awaited his orders in vain. "I have been in readiness to proceed to Siberia for the last six weeks," he wrote to Eric Brown in early January, "and as practically the whole expedition has gone and left me here with no further orders it looks as though they do not intend to have an artist with the force."[25] He managed instead to get sent to Halifax to work, like Frank Johnston and more than a dozen other painters, on the Home Work Section of the Canadian War Memorials Fund. His task was to paint the troopships as they returned from Europe laden with Canadian soldiers.

In Halifax, Jackson was reunited with Arthur Lismer, likewise working for the Home Work Section. Lismer was officially commissioned by the Canadian War Records Office in June 1918, soon after which he contributed *Convoy in Bedford Basin*. He was intrigued by the zigzag patterns on the ships, a style of camouflage known as "dazzle painting" recently developed by the British marine painter Norman Wilkinson. Cubist experiments with colour and form had influenced its abstract patterns: "We did that!" Picasso, according to legend, exclaimed to Gertrude Stein on seeing camouflaged military vehicles rolling through Paris in 1915.[26] Dazzle-painted ships were regarded to be of sufficient artistic merit to warrant an article in *The Studio*. Enthusing over the patterns as if over a Cubist or Vorticist masterpiece, the journal's correspondent commended the stripes and curves "in black and white or pale blue and deep ultramarine" and the appearance of "hopeless confusion" that was in reality a "perfect order."[27] Although Lismer faithfully recorded the dazzle-painted

convoy, these harlequin patterns were as close as he would come to Cubism or abstraction in his own art.

Lismer took his duties seriously, placing himself in some peril to get his sketches. He went to sea on both a minesweeper and the 225-ton torpedo boat HMCS *Grilse*. He visited a seaplane station and even took a trip underwater in one of the Royal Canadian Navy's two submarines. In doing so he defied German U-boats, rough seas and possible collisions. Six of the *Grilse*'s crewmen had been washed overboard in a storm in 1916, and collisions and groundings claimed two Halifax minesweepers.[28] He also braved the new danger arriving at Canadian seaports. Halifax was on the front line of the influenza pandemic, and on the day he boarded the minesweeper in October 1918 the newspapers were reporting four deaths from the Spanish influenza in Halifax (including three returned soldiers), together with a dozen new cases.[29]

Lismer was delighted to be reunited with Jackson. If Varley had found Jackson subdued and chastened, to Lismer he was as obstinate and peppery as ever. "You may guess Alex & I have been having some great old 'chins' on all kinds of subjects," he wrote to MacDonald. "He is of course just as stubborn an old knocker as ever & every blessed individual & subject that comes under his consideration gets either a raking or a wee modicum of praise."[30]

Jackson for his part claimed the two men spent their time "swapping experiences . . . considering plans for the future, and looking for subjects to paint."[31] If they had plenty of plans for the future, there were few subjects to paint. By the time Jackson arrived in Halifax in February, most of the troopships were diverting to other ports. He therefore spent his time sketching in Nova Scotia villages such as Herring Cove. "I think you'll find that Algoma has a rival when you hear him," Lismer wrote to MacDonald.[32] Jackson finally got a chance to paint a subject for the CWMF when the dazzle-painted RMS *Olympic*—sister ship of the *Titanic*—arrived in Halifax Harbour in March, carrying hundreds of Canadian soldiers.

Jackson was discharged from the army in the middle of April. "After an absence of four and a half years," he later wrote, "I set about

trying to revive my interest in painting the Canadian scene, and to regain the excitement which had sustained me in the months before the war."[33] He returned first to Montreal, where he saw an exhibition of Tom Thomson's paintings curated by Harold Mortimer-Lamb at the Arts Club. Although he was able to see the tremendous strides taken by his former protege in the last two years of his life, his pleasure at the sheer brilliance of the works was mitigated by what he saw as the lukewarm reaction of the Montreal critics. He wrote a dispirited letter to Eric Brown complaining that Thomson's works had failed to "wake them up" in Montreal: "It has been a revelation to many of the younger artists but rather frowned upon by the academics who call it crude and fail to see its tremendous vitality."[34] Disgusted, as ever, by the conservatism of Montreal, he soon returned to Toronto and reclaimed in the Studio Building the space he had once shared with Thomson.

"Some day if we are not all broken down old war horses," he had written to MacDonald from London a year earlier, "we will push the movement on. Poor old Tommy, he should have lived to be the grand old man of the school. But tho' life is full of sad disappointments we'll play the game and go treasure hunting yet in the north land."[35]

BOOK **III**

1 THE SPIRIT OF YOUNG CANADA

SPEAKING OF THE invention of Cubism, Georges Braque once referred to himself and Picasso as two mountain climbers joined by a safety rope.[1] After the war, the Canadian painters likewise decided to hitch themselves together for mutual protection. One of the "plans for the future" discussed in Halifax by Jackson and Lismer no doubt included the launch of a group of Canadian artists. "The only way we will ever get anywhere," Jackson had insisted to Lismer in a letter of May 1918, "will be by a group of us working together."[2]

The previous fifty years had witnessed many artists in Europe and America forming groups and staging exhibitions independent of officially recognized art associations. The most famous case was that of the group of French painters, spurned by buyers and scorned by critics, who exhibited together in Paris in April 1874 and, thanks to a satirical review, earned the name "Impressionists." Many other artists since then had realized the most effective way to confront and perhaps overcome ossified academies and dyspeptic critics was by collective action. Groups banding together in France to lobby the public and collectors had included the Nabis and the Salon de la Rose + Croix, and in Germany the Berlin Secession and the Munich Secession both broke loose from conservative academies (and in the case of the Munich Secession

fragmented even further into Der Blaue Reiter). The pattern was repeated in America as, led by Childe Hassam, the group that became the Ten American Painters resigned from the Society of American Artists in late 1897 and the following spring staged their own exhibitions at the Durand-Ruel Gallery in New York. A decade later Robert Henri resigned from the selection committee of the National Academy of Design and launched The Eight at the Macbeth Gallery.

Canada got its own breakaway group in 1907, when a number of painters resigned from the OSA and formed an invitation-only exhibiting society called the Canadian Art Club. It ultimately grew to thirty-five members and included Curtis Williamson, William Brymner, Horatio Walker and Edmund Morris. The club lost momentum and direction after Morris drowned in 1913, folding two years later. Despite its members' professed aim to "produce something that shall be Canadian in spirit, something strong and vital and big,"[3] little was intrinsically Canadian about the Canadian Art Club beyond, perhaps, Morris's portraits of the indigenous peoples of the Prairies. Nor was it (in distinction to so many of the age's other breakaway collectives) especially modern. Several members who joined after 1913—notably Suzor-Coté and William H. Clapp—used Impressionist brushwork and high-keyed colours; most other members favoured the muddy and vaporous Dutch or Barbizon styles that were the dernier cri among wealthy Toronto and Montreal collectors in the first decades of the twentieth century.

As Jackson and Lismer discussed plans for a group exhibition, early in 1919 matters of rivalry and secession were once again brewing within the OSA. Lawren Harris and Frank Johnston had been chosen, along with the portraitist E. Wyly Grier, to serve on the OSA's three-man selection committee for the society's 1919 exhibition. These selection committees (unlike so many of those on the Continent) always conducted themselves without reproach or scandal. Although occasionally roasted by the critics and perennially underappreciated by the public, no member of the Algonquin Park School was ever denied a place on the walls of the OSA's annual exhibitions. But in 1919 Harris and Johnston sparked controversy by rejecting a pair of paintings by Elizabeth McGillivray Knowles.

304

This rejection was a deliberately provocative act, a gauntlet tossed at the feet of Toronto's artistic old guard. The fifty-three-year-old McGillivray Knowles was a prominent figure in the art worlds of both Canada and the United States. She was a member of both the Royal Canadian Academy and, in New York, the National Association of Women Painters and Sculptors. Her paintings regularly featured in both the OSA and New York exhibitions; two of them hung on the walls of the National Gallery in Ottawa. Her uncle was F.M. Bell-Smith, former president of the OSA and a specialist in Rocky Mountain landscapes. Her husband, Farquhar McGillivray Knowles, was equally redoubtable: a one-time student of William Merritt Chase, he had served as vice-president of the OSA between 1905 and 1908. His success with commissions from Toronto's financial aristocracy (he painted murals for the Eaton family's music room) meant he was able to furnish his studio with oriental carpets and other extravagant exotica. The couple regularly hosted a salon in their house at Spadina and Bloor.

Snubbing so eminent an artist was bound to cause controversy, the flames of which Harris took the opportunity to fan in an interview with the *Toronto Daily Star*. He explained that since artistic tastes had "changed more in the last ten years than in the four hundred years previously," the only way to avoid "squabbles" was for the OSA to hold two separate exhibitions: one for the work that "the older men consider meritorious," the other for "what pleases the younger men," who were more apt to "produce something really significant."[4]

Harris had no desire to avoid squabbles, and his proposal for a schism within the OSA was frankly absurd: the purpose of an art exhibition was not to impose on artists a single house style or highly selective range of subjects. His wish to clamp down on artistic dissent by banning offending works from exhibitions smacked of some of the worst excesses of the Continental juries of the previous century. Harris's high sense of his artistic mission was expressed around this time by Jackson in a letter sent to (but never published in) the *Montreal Daily Star*. An art exhibition should be a place, Jackson declaimed under the pseudonym "Rough Stuff," "where artists searching for truths not yet interpreted show us their efforts, experiments and

discoveries"; it was not a "showroom where artists who yearly repeat themselves send samples of the wares to be had in their studios."[5]

The rejection of Elizabeth McGillivray Knowles's paintings could not exactly be justified on stylistic grounds. Her subjects might have been tame—she specialized in small pictures of barnyard animals—but she had moved beyond a muzzy, Barbizon-influenced style to broken-brushwork explorations in light and colour that owed much to what Farquhar (her former teacher) had learned from William Merritt Chase. By 1919 this style of Impressionism was several decades out of date in most parts of Europe, but there would have been many empty stretches of wall at the annual OSA exhibitions had Harris managed to get all of it banned from view.

Harris's rebuff to McGillivray Knowles was discreditable for another reason. Women faced difficulties in the Canadian art world far more insuperable than those experienced by Harris and his friends in the Algonquin Park School. Although contributing from a quarter to a third of the paintings at Canadian exhibitions, women had no voting rights in societies such as the OSA or the Art Association of Montreal. They were denied membership in the Arts and Letters Club and its Montreal equivalent, the Pen and Pencil Club. The Canadian Art Club had been almost as exclusive: only one woman, Laura Muntz Lyall, ever had her work hung at its exhibitions. Finally, the Royal Canadian Academy might have elected McGillivray Knowles to an associate membership, but only a single woman, Charlotte Schreiber, elected in 1880, held full academician status. More than fifty years would pass before a second female artist, Marion Long, received the same honour in 1933.

McGillivray Knowles was the perfect target for Harris. She was a woman who painted successfully in a "foreign" style favoured and practised by "older men." She made few concessions to Canadian subjects and even lived abroad for part of the year in New York. By denying her a chance to show her work at the OSA, he and Johnston were sending a clear message about the direction that they—the "younger men" (the use of the gender-specific noun was revealing)—wished Canadian art to take in the years following the war.

HARRIS'S PUBLICITY OVER the McGillivray Knowles affair did him little harm when the 1919 OSA exhibition opened at the Art Gallery of Toronto (as the museum had been newly christened) in the first week of March. If Jackson drew the critical attention in 1913 and MacDonald in 1916, by 1919 it was Harris's turn to be both extolled as leader of the new movement in Canadian painting and castigated as a purveyor of crude and tasteless canvases.

Although he blocked Elizabeth McGillivray Knowles from showing two small paintings, Harris elected to exhibit no fewer than eight of his own. Two of them, *Snow V* and *Snow VI*, were from his series of Fjaestad-inspired snowy landscapes. He also exhibited six urban scenes, including *Outskirts of Toronto* and a second view of Earlscourt called *Shacks, Earlscourt.* The sheer volume of wall space devoted to Harris, together with the eye-catching colour of his works, meant he inevitably attracted a good deal of critical attention. The photographer Lewis W. Clemens, writing for *Toronto Sunday World,* believed the raw power of these works emphatically announced Harris's position as the "most important leader" of the modernist movement in Canadian art. His work "possesses strength in colour composition and tone," wrote Clemens. "Anyone who is at all interested in the art of Canada should not under any circumstances miss seeing this exhibition."[6]

Not everyone was so enthralled. Harris's bright colours and scenes of urban destitution unsettled the reviewer for the *Toronto Telegram,* who wrote an article entitled "Noisy Chaos of Colour in OSA Exhibition." He found the exhibition to be "dominated by the astonishing canvases from the workshop of Lawren Harris . . . This year Mr. Harris has pressed the very brightest tubes upon his palette, and has let his brush, knife, trowel, shovel or whatever tool he has used run away with itself. The pictures shout from the walls, and quite disturb the equanimity of the show." The reviewer for *The Weekly Sun* was likewise taken aback by their gaudiness. Perplexed by the brazen and seemingly eccentric use of colour, he attempted to describe *Snow VI* to his readers: "The trees are mauve with patches of yellow—road mauve—houses orange with yellow snow on roofs. Sky green. Now I know that snow under strong sunlight is yellow, and that the shadows are mauve, and

so are tree trunks . . . But certainly the colours are exaggerated."[7] More than five years after the Hot Mush controversy and three years on from *The Tangled Garden,* some in Toronto were still dumbfounded and affronted by a few strokes of chrome yellow and cobalt violet.

HARRIS SHOWED NONE of his Algoma paintings at the OSA in 1919. The reason was that, three weeks after the exhibition closed, the Art Gallery hosted a special exhibition for the "younger men" who were trying to "produce something really significant." Arranged through the offices of Sir Edmund Walker, the gallery's president, the special exhibition, prosaically entitled *Algoma Sketches and Pictures by J.E.H. MacDonald, A.R.C.A., Lawren Harris, Frank H. Johnston,* was staged at the Art Gallery of Toronto from April 26 to May 19.

The three-man show numbered 145 works, almost as many as the entire OSA exhibition. MacDonald presented 2 large canvases and 36 studies, Harris 2 canvases and 45 oil sketches, and Johnston, a tireless worker with a prolific output, offered 60 works. A dozen of Johnston's paintings were large canvases, all completed over the previous six months. His speed of execution might have been the result of his studies in Robert Henri's studio: Henri encouraged his students to produce colour sketches at great speed. Man Ray, one of his students in 1912, later recalled: "One had to make a drawing and even a colour sketch in twenty minutes."[8]

Whereas Harris and MacDonald (if not Johnston) were known well enough to Toronto gallery-goers in 1919, the name Algoma probably meant little. But this far-off land of steelworks and iron mines was presented to curious visitors to the Art Gallery of Toronto as the new proving ground of modern art in Canada. They were greeted by a series of manifesto-like sayings called "Algomaxims" inscribed on placards and strategically placed along the central hall.

Avant-garde collectives often issued manifestos to drive home their philosophies. The most famous was the "manifesto of ruinous and incendiary violence" unleashed in 1909 by the Italian Futurists. The Algomaxims, by contrast, were a series of mild pleas for understanding that lacked the punch and vitriol of many earlier manifestos.

"The blue glasses of Prejudice spoil all colour-schemes," read one. "If you never saw anything like that in nature do not despair," urged another. "The more you know the less you condemn," a third primly admonished. Others were more gnomic: "Even the artist has not seen all there is." One Algomaxim succinctly epitomized the philosophy of the painters in the Studio Building: "The great purpose of landscape art is to make us at home in our own country."[9]

The three men were no doubt braced for bad reviews as the show opened. One Algoma painting already unveiled to the public at the OSA, MacDonald's *The Wild River*, had drawn hostile notices across the board. MacDonald used short brushstrokes similar to Cézanne's "constructive-stroke" method to create flattened surfaces of rusty reds and forest greens in camouflage-like patterns. The experiment was not deemed a success. *The Wild River* was panned as a "large colour riot," a "chaotic composition," the victim of a "distorted colour scheme," and a work "badly in need of sorting and tidying up."[10] Even two people highly sympathetic to MacDonald, Eric Brown and Barker Fairley, failed to find anything to appreciate. Such reviews must have been dispiriting for MacDonald at a time when he was hoping to recover his health and repair his finances.

The Algoma paintings, hung a month later, received a better audience. Even Hector Charlesworth, evidently removing his blue glasses of Prejudice, commended them in *Saturday Night,* calling them "vital and experimental"—not qualities he was necessarily known to plump for. The reviewer for the *Mail & Empire* regarded their work as a continuation of the project of the Confederation poets. He proselytized enthusiastically on the painters' behalf, gallantly pushing for public acceptance: "The work of these young artists deserves enthusiastic recognition and support. In their work the spirit of young Canada has found itself."[11]

The painters did not delight in the enthusiastic support of the public. Visitors kept their chequebooks safely in their pockets, and not one of the 145 works was sold. But a successful precedent had at least been set for "a group of us working together": a small band of like-minded artists showing their visions inspired by the "spirit of young Canada."

IN 1916, WHILE based at Shoreham Camp, Jackson wrote longingly of the end of the war and a "grand reunion of all the revolutionaries."[12] That reunion, tragically minus Thomson, was finally happening. Fragmented and dispersed by the war, the Algonquin Park School began reassembling in the spring and summer of 1919, following a hiatus of almost five years. Suddenly it became possible to begin planning a group effort larger than the Algoma exhibition.

The Studio Building gradually filled with its former inhabitants. To make room for Jackson, the gramophone-loving manager of Art Metropole, Alex G. Cumming, was evicted from the building (taking with him several Thomson paintings acquired from the artist in a direct barter for pigments).[13] By the end of the summer of 1919, Lismer and Varley, too, were back in Toronto, the former as vice-principal of the Ontario College of Art. When the vacancy for this position was announced in April 1919, MacDonald urged him to "sit down and write a poetic letter of resignation" to the board in Halifax so that he could "get back to the front line trenches here."[14] Only in Toronto, he believed, could a Canadian school of painting be established. Lismer was happy to oblige. The visit from the voluble Jackson made him realize how isolated he was in Halifax. "I've profited greatly," he wrote to MacDonald, "but the situation here is really too apathetic . . . I really want to get back to Toronto and amongst the crowd again."[15] He duly resigned and, after curating a valedictory exhibition at the Victoria School of Art and Design—fifty-three of his own works, arrived in Toronto in August. Shrewd and sensible as ever, he used his payment of $2,250 from the CWMF to purchase a "little home" in Bedford Park, a suburb near Yonge and Lawrence.[16]

Fred Varley was not so prudent, and the usual indigence marked his return. Although he was still on the army payroll, his high living in London, including the $715 he paid on his Hampstead studio, meant he arrived home poorer than when he left Toronto sixteen months earlier.[17] His plans to establish himself in England had quickly unravelled. He had returned to Belgium and France for a second tour of duty in March, four months after the armistice. Still in uniform, he visited Arras, Sanctuary Wood, Ypres and Vimy Ridge to get material for his new commission, *Night Before a Barrage,* the eleven-foot-wide

panel for the prospective museum of war art in Ottawa. Returning to his Hampstead studio in May he painted *German Prisoners* and *The Sunken Road*—further examples of the shocking reportage that won over the London critics. But his success in London was not reprised. His offering for the Royal Academy's summer exhibition, *Indian Summer*—the work painted after his visit to Algonquin Park in 1914— failed to attract notice. Restless and discouraged, he began dreaming of a return to Canada. "The boys here can't understand why I want to go to Canada again," he wrote to Lismer in May, "but then they haven't been there and they don't know about the hundred bigger chances for progression out there than here. It's no use telling them."[18]

Varley on the loose in London, restless and discouraged, was a prescription for trouble. A dozen years earlier, in 1907, he fell on desperate times while trying to support himself as a newspaper illustrator. Homeless and deprived of all possessions but a cat that perched on his shoulder as he roamed the streets, he once went three days without eating. For several months, neither Maud (whom he had met the year before) nor his family knew his whereabouts.[19] Although not reduced to such beggary in 1919, he had once again disappeared from view. For two months Maud grew increasingly desperate until he resurfaced in the middle of July with the dubious explanation that he had "nothing to say."[20] In fact he had been having an affair with a twenty-seven-year-old Londoner named Florence Ann Fretton. If for Varley the affair was the result of boredom and the fact that he was, as the long-suffering Maud put it, "fond of the ladies," for Florence it was a desperately passionate attachment. What she called her "fatal fascination" with Varley drove her to the edge of a nervous breakdown.[21] However intense, the relationship lasted only a matter of weeks. On the first of August, in Liverpool, Varley boarded the *Lapland* for his return passage to Canada and a reunion with Maud. Florence was unwisely encouraged to continue her fatal fascination by writing to him in Toronto.

311

VARLEY ARRIVED IN Toronto in time for the CWMF exhibition at the Canadian National Exhibition. The first CNE since the end of the war called for great celebrations—what was advertised as "an epoch-making event."[22] The Prince of Wales was in attendance, the band of

the British Grenadier Guards played and a captured U-boat was on display. Visitors were treated to a spectacular pageant called the "Festival of Triumph" and the sight of Billy Bishop performing aerobatics over the exhibition grounds.

Dog shows and displays of livestock and tractors usually took centre stage at the CNE, while "second-rate paintings" (as Jackson called them) stayed in the background. But art featured much more prominently in 1919, with 447 works from the CWMF on display. The paintings had already appeared in June at the Anderson Galleries in New York. The show was politely received by the Americans. Nash, Nevinson and Wyndham Lewis, along with two other "Futurists" (as the *New York Times* called them), Edward Wadsworth and William Roberts, attracted most of the commentary and carried away the laurels as the "most immediately arresting" and "most persistently interesting."[23] The positive reviews and the large numbers pressing through the turnstiles proved New Yorkers had come a long way since the dark days of the Armory Show six years earlier—though Nevinson, visiting the city, caused an uproar by taking the opportunity to denigrate American painting as a thing of "little importance" and America itself a place of "mental sterility."[24] Of Jackson and Varley, not a word appeared in the American press. Even Paul Konody saw no need to mention them in a lengthy piece he wrote in the *New York Times Sunday Magazine,* though he did find space enough to puff Richard Jack's "vividly rendered battle episode."[25]

Some Canadian critics, viewing the paintings for the first time two months later at the CNE, were less sympathetic than those in New York. Never before had examples of Cubism and Vorticism been exposed to the Canadian public. Augustus John once scoffed at what he saw as the laughable incongruity of Vorticists in the Canadian War Memorials Fund doing work for a country as backward and benighted as Canada. Wyndham Lewis was obliged to reduce Vorticism, sneered John, "to a level of Canadian intelligibility—a hopeless task I fear."[26] Alas, John's remarks about Canadian ignorance proved accurate when one of the works produced for the CWMF, David Bomberg's *Sappers at Work,* was rejected. The young painter was sent back to his studio

to produce a tamer version. And while the British press praised the cwmf exhibition at the Royal Academy, the man who opened the show, Sir Robert Borden, grumbled that many of the works were "so modern and advanced that one could neither understand nor appreciate them."[27]

Bomberg, Nevinson and Wyndham Lewis were virtually guaranteed to put the frighteners on certain elements of Toronto's population. "Cubist monstrosities," declared the *Toronto Globe*, whose critic expressed the hope that Canada would not "provide a permanent home for such rubbish." Hector Charlesworth likewise bemoaned the approach of the avant-garde British painters, complaining that "the experimental themes of the up-to-the-minute painters are unsuitable to heroic themes"[28]—which rather missed the point. The exhibition at least was popular with the public: in the first two weeks, more than 100,000 people visited the art exhibition, attendance figures that in some ways justified Sir Edmund Walker's boast that the exhibition was "one of the greatest events in Canadian history."[29]

The most popular work in the exhibition, in terms of crowds drawn and reproductions ordered, was the Pre-Raphaelite painter John Byam Shaw's *The Flag*. Byam Shaw produced a sentimental work straight out of the Victorian era. Expressing the grief and loss felt by so many Canadians, it showed a dead soldier clutching the Red Ensign (Byam Shaw's title was a misnomer: technically, Canada had no official flag). Stretched beneath the paws of the statue of a pedestalled lion, the soldier is ringed by the mourning families for whom his sacrifice was made: beshawled mothers, bravely resolute children, widows prostrate with grief, grim and bearded patresfamilias. Byam Shaw even quoted in the left-hand corner of the work one of the most famous of all Victorian paintings of grief, Frank Bramley's 1888 *A Hopeless Dawn*.

However poignantly and eloquently Byam Shaw spoke to the pride and grief of the nation, *The Flag* was a work that, artistically speaking, looked backward instead of forward. Neither it nor any of the other large-scale battle scenes were, in Jackson's opinion, faithful documents of trench warfare. Nor did he believe them to be examples of good art. Writing in *The Lamps*, he complained of "the futility of fine

313

craftsmanship used without passion or dramatic conception." For Lismer, they were "posthumous pictures of battlefields, frozen in action" and showed "detail without fervour . . . incident without intensity."[30]

NEITHER JACKSON NOR Lismer, nor anyone else, seems to have taken much notice of the work of a Canadian painter of both fervour and intensity on display at the CNE in 1919.

At thirty-seven, David Milne was a year younger than Varley, three years older than Lismer and Harris, and the same age as Jackson. He was born five years after Tom Thomson, in a weather-beaten log farmhouse near Burgoyne, Ontario, thirty kilometres southwest of Owen Sound. A descendant, like Thomson, of Scottish Presbyterians, he enjoyed the same "apple-eating, cow-chasing" childhood in rural Ontario: fishing, catching frogs, collecting and drawing plants. Sensitive and introverted as a child, he later described himself as a "slow ripener"[31]—yet another trait shared with Thomson. After graduating from high school, he took a teaching course at the Model School in nearby Walkerton and in 1900 began his career as a teacher in a one-room schoolhouse near Paisley. But Milne was too talented and ambitious to remain in schoolmasterly obscurity. Three years later, with a correspondence art course and a handful of freelance illustrations for Canadian magazines under his belt, he moved to New York City. There he began three years of study at the Art Students' League under Frank Vincent DuMond (soon to teach Thomson's older brother George) and Robert Henri (later to teach Frank Johnston).

Milne's education continued in New York's numerous museums and galleries. Regular visits to Alfred Stieglitz's Little Galleries of the Photo-Secession at 291 Fifth Avenue—later known simply as 291—exposed him to the latest European trends. "In those little rooms under the skylights," he later wrote, "we met Cézanne . . . Matisse, Picasso, Brancusi."[32] He began showing his own work at the Montross Gallery, whose owner hoped to give exposure to "the men who have something fresh to say."[33] In 1913 a critic for the *Christian Science Monitor* condemned him as an "extremist," but the *New York Times* praised his "brilliant, daring and successful modernity."[34] His

David B. Milne in Toronto
Library and Archives Canada / C-057194

reputation as a talented member of the avant-garde was confirmed
when he became one of only three Canadians who exhibited work
at the Armory Show (the others were Ernest Lawson and a twenty-
five-year-old native of London, Ontario, named Edward Middleton
Manigault). He painted scenes of urban life and embarked on painting
excursions into the Pennsylvania woods and along the Hudson Val-
ley, to which he moved in 1916. He returned to Canada early in 1918
to serve with the Canadian army, shipping overseas in September. He
was stationed at Kinmel Park Camp, near Rhyl in north Wales, an area
made famous by the work of the British watercolourist David Cox.

The panjandrums of the Canadian War Records Office were
blissfully ignorant of Milne and his reputation. He learned of the
organization only when he spotted a picture of a dazzle-painted
troopship in the window of a London art dealer, complete with a card
announcing its purchase by the cwro for 200 guineas, "or some such

unbelievable sum."[35] Immediately he made his way to the CWRO's Tudor Street offices, where he quickly impressed Konody as "a provocative designer of the rarest distinction."[36] A number of his watercolour sketches of Kinmel Park Camp were hastily added to the Canadian War Memorial Fund exhibition in London and then included in the showings at the Anderson Galleries and the CNE.

Milne spent the summer of 1919 on the Continent, painting battlefields at Vimy Ridge and Passchendaele. He seems not to have crossed paths in London with either Varley or Beatty, though he shared many of the aesthetic concerns and techniques as the painters in the Studio Building. By 1911 he had adopted a style in which he abandoned atmospheric effects in favour of exploring decorative forms in the landscape through side-by-side dabs of bright Fauvist colour—what a critic for the *New York Times* admired as "extremely effective, intensely modern and competent blots and splashes of colour."[37] One of his works at the Armory Show, *Distorted Tree,* showed a leaning evergreen with crisscrossed branches perched on a rocky hillside blanketed in scintillating snow. With its cool blues clashing with bright oranges, it was a coruscating Hot Mush vision of the winter landscape. Appraising such work in 1912, an American critic celebrated his "genuine effort . . . toward cutting loose from formulas that have served for twenty or more years for the purposes of finding newer and more effective methods of reporting the facts of the natural world."[38]

If Milne's search for new and effective methods of reporting the natural world seemed perfect for the Matisse-and-mackinaw world of the Studio Building, the chance to join the Canadian painters slipped quietly away. After arriving back in Canada aboard ss *Belgic* in late September 1919, he was demobilized in the grounds of the CNE a month after the CWMF exhibition closed. He and his American wife, Patsy, stayed for several days at the Walker House Hotel on Front Street. Milne briefly considered living and working in Toronto, though it was a city he barely knew and one in which he had no contacts or connections. The Canadian War Memorial Fund's champion in Canada, Sir Edmund Walker, was either unaware or unconcerned that Milne was in the city. That he, Eric Brown and Lawren Harris

would not have interested themselves in an expatriate painter who was unrepresented in any Canadian public collections, and who used daringly modern methods in his landscapes and urban scenes, seems incomprehensible. But Milne met none of the painters from the Studio Building, and his prospects in Toronto, a city with no equivalent of galleries such as the Montross, discouraged him. In November, six weeks after his demobilization, he returned with Patsy to their former home in Boston Corner, New York. There, with apparently little knowledge of the activities and aspirations of Young Canada, he began roaming the Taconic Mountains armed with sandwiches and a Thermos bottle, in search of "hills to sit on while painting other hills."[39]

2 A SEPTENARY FATALITY

THE LAST SOLDIER killed in the Great War was a Canadian. Two minutes before the guns fell silent on the Western Front, a German sniper killed Private George Pierce in the Belgian village of Ville-sur-Haine. Private Pierce's cruelly pointless death emphasized the enormous Canadian sacrifices: 60,661 dead and many tens of thousands more wounded.

The Great War was by far the most traumatic event endured by the country since Confederation. Many believed the heroism and sacrifices of the war years could cement a foundation for the elusive national identity. "Canada is only just finding herself," Lucy Maud Montgomery had written in 1910. "She has not yet fused her varying elements into a harmonious whole. Perhaps she will not do so until they are welded together by some great crisis of storm and stress."[1] That crisis of storm and stress had come at Ypres, at Vimy Ridge, at Passchendaele.

By the end of the war it had become axiomatic that "a true Canadian nation" (as Talbot Papineau called it) was being born on the battlefields of Europe. A charismatic Montreal lawyer and decorated officer in the Princess Patricia's Canadian Light Infantry, Papineau wrote in 1916 that the Second Battle of Ypres represented "the birth-pangs of our nationality." He himself died at Passchendaele, joining the ranks of

those whose deaths in a distant land would, he believed, help Canada become "a nation respected and self-respecting."[2]

Papineau's hopes seemed to be fulfilling themselves as Canada took its first tentative steps towards sovereignty and self-respect in the months following the armistice. Sir Robert Borden had been the principal author of Resolution IX at the Imperial War Conference in 1917. Its objective for Canada to become an autonomous nation and gain a voice in foreign policy was realized two years later when Borden led a delegation at the Paris Peace Conference and then when Canada became a member of the League of Nations. This new role in global politics was undeniably the result of Canada's participation in the war. When the United States Secretary of State Robert Lansing (a one-time supporter of American neutrality) tried to veto Canadian representation at Versailles, he was bluntly reminded by Lloyd George that Canada lost more men in the war than the United States.[3]

Any optimism about a new Canadian nationhood was tempered by the profound social, political and racial divisions exposed by the war. Borden wrote gloomily in his private diary on the day the armistice was signed: "The world has drifted from its old anchorage, and no man can with certainty prophesy what the outcome will be."[4] The immediate outcome, in Canada at least, was unemployment, inflation, industrial unrest and riots. Waves of industrial action in the months following the armistice climaxed with the Winnipeg Trades and Labour Council calling a general strike on May 15, 1919. On June 21 a non-violent protest ended with a charge by the Royal Northwest Mounted Police that left one striker dead and the streets of Winnipeg occupied by federal troops. The authorities hastily turned their attention from pacifists to the perceived threat from Bolshevism. Borden believed there existed in Canada what he called "a deliberate attempt to overthrow the existing organization of Government and to supersede it by crude, fantastic methods founded upon absurd conceptions of what has been accomplished in Russia."[5] Police raided labour temples in Vancouver, Regina and Winnipeg. Printing presses were seized and the houses of foreigners searched. Anyone suspected of anarchist or communist sympathies was swiftly deported.

Political as well as industrial unrest divided the country. The violent clashes in Winnipeg tragically reprised the anti-conscription riot in Quebec City in the spring of 1918, when a crowd ransacked and burned the office of the military registrar after a twenty-three-year-old named Joseph Mercier was arrested at a bowling alley for failing to produce his conscription papers. The crowd broke into a hardware store in hopes of finding firearms and attacked the offices of the *Quebec Chronicle,* whose owner, Sir David Watson, was a veteran of Vimy Ridge and Commander of the Canadian 4th Division. The Easter Monday anniversary of Vimy Ridge arrived with Quebec City under military rule and soldiers on horseback charging through fogbound streets with swords drawn. Shots from the crowd were met with machine-gun fire, leaving four civilians dead, sixty-five under arrest, and relations between English and French Canada smouldering in ruins.[6]

Four months later, there had been further unrest and more military rule, this time in Toronto. On the night of August 1, 1918, Greek waiters forcibly ejected a disabled and inebriated veteran from the premises of the White Cafe at Yonge and College. For the next three days, mobs in their thousands, led by returned war veterans, ran riot through the streets, fighting the police and demolishing more than forty Greek-owned businesses. One of the country's finest achievements, Canada's Hundred Days, began with Toronto under martial law and the city's downtown core a shambles of shattered glass and looted shops and restaurants.

This ugly and shameful display of xenophobia raised wider questions about the place in Canada of the many tens of thousands of non-British immigrants who had arrived over the previous two decades. Pink-faced Canadians were still in the majority in Toronto, but the Prairie provinces and British Columbia offered a more multi-hued complexion. The Prince of Wales voiced the fears of the Toronto rioters when, alarmed at the number of recent immigrants from all lands in Western Canada, he wrote to his father, King George V, that Canada must be kept British: "It is up to the Empire and particularly the UK to see that its population is British and not alien!!"[7]

Poverty, unemployment, strikes, riots, class polarization, enmity between French and English, hostility to immigrants—what, if anything, could heal Canada's scarred and broken body politic?

A.Y. JACKSON, FOR one, believed that artists could serve a palliative function in society during such troubled times. Two months after the end of the Winnipeg General Strike, he published an article in the *Canadian Courier* entitled "The Vital Necessity of the Fine Arts." The fine arts were not a side issue, he wrote, since they could serve as "the common meeting ground for all classes" and become "one of the most potent factors in overcoming the problems of social unrest."[8]

How was this artist-led transformation of society to come about? Jackson believed the unrest could be quelled if the fine arts were allowed to provide society, from top to bottom, with a visual makeover. Cities such as Toronto were notoriously unlovely, but all that could be changed. The ugly manifestations of crass and uneducated tastes—"silly furniture, badly proportioned houses, worse pictures and tiresome wallpapers"—would be transformed into things of beauty as artists and designers made beautiful "what before was only dull and pretentious. Instead of going to museums to peer at dim darkened old masters we will see beauty all about us." Those who saw beauty all about them did not, presumably, riot in the streets.

Jackson's appeal was neither new nor original. Many others believed the fine arts could play an active role in creating a better and healthier society. For the previous two decades, social and moral reformers in Canada, Britain and America had been hoping to tame violent passions, improve morals, inspire patriotism and uplift the spirits of their populations—especially the more downtrodden and aggrieved enclaves—through a provident use of everything from architecture and monuments to music and public murals.

This type of civic reform (known in the United States as the City Beautiful Movement) had a strong advocate in Canada in the painter and architect George A. Reid, principal of the Ontario College of Art and former president of the OSA. Reid was a founding member of the Arts and Crafts Society of Canada, the Toronto Guild of Civic Art and

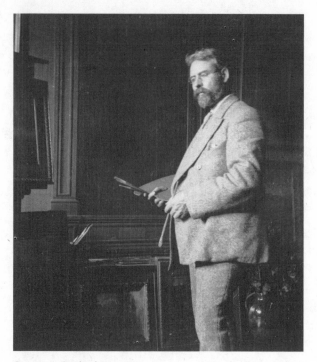

George A. Reid at home, 1907

Photographer: M.O. Hammond, Archives of Ontario, F 1075-16-0-0-9

the Toronto Theosophical Society. He had been promoting the beau-
tification of Toronto since the 1890s, donating two of his murals to
adorn the entry hall of City Hall when a full program was rejected
owing to lack of funds. In 1909 he was involved with Sir Edmund
Walker and others in drafting the *Report on a Comprehensive Plan
of Systematic Civic Improvements in Toronto,* an elaborate plan to
transform the city's visual appearance and moral complexion. It
championed turning the unsightly metropolis into a miniature Paris:

wide boulevards, attractive government buildings, opera houses, con-
cert halls, art museums, public murals, a waterfront, a system of parks
and other green spaces.

The philosophy of the City Beautiful Movement conveniently over-
looked the fact that social disaffection and moral decay thrived in
Paris despite the Beaux Arts architecture, spacious boulevards and

thronging art museums. But the point was that art was not an ivory-tower pursuit removed from the everyday life of society. Art was too important, Jackson believed, to become "a rich man's hobby."[9] In one of his public lectures Reid spoke of his wish "to cultivate a taste and appreciation for art" among the people of Toronto and to make it "a part of everyday life."[10] This democratic view put them at odds with some avant-garde theorists, such as the American Symbolist poet and self-styled "King of the Bohemians," Sadakichi Hartmann. In 1910 Hartmann proclaimed that "art is by the few and for the few." It was preposterous, he claimed, to believe "a pale seamstress or a fatted tradesman" could experience the same joy in contemplating a work of art as a critic or a connoisseur.[11] But Reid and Jackson wanted to reach out to pale seamstresses, fatted tradesmen and indeed everyone else. The health of Canadian society, they believed, depended on it.

Although Toronto's bureaucrats paid little heed to Reid's 1909 report, painters in the Studio Building besides Jackson shared his ideas. Reid was Lismer's superior at the Ontario College of Art and both a former teacher of MacDonald and, with his City Hall murals, one of his first sources of artistic inspiration.[12] Lismer's indoctrination in the ideas of John Ruskin meant he shared Reid's aspirations to educate and enlighten the socially disenfranchised. In Halifax Lismer took art out of the galleries and into the community, bucking the school governors who believed the fine arts were "an exclusive & cultured subject for the edification of the few." As he remarked in one of his own public lectures, if the "art impulses of a nation" were stirred, people would be able to rise above their "trivialities and differences."[13]

These "art impulses," in other words, would promote a cohesive national identity and a healthy society. Trivialities and differences existed because Canadians, even after the shared sacrifices of the war, still possessed no strong or agreed sense of themselves as a nation. The country's "confused elements" (in Laurier's phrase) stubbornly frustrated any broad definition of nationhood.

The familiar obsessions of Canadian art—the desire to capture or produce something distinctively Canadian in spirit—therefore returned with a new urgency after the war. Canada needed men and

women who could communicate with a wide audience and tell what Lismer called "the Canadian story" in a way that would enrich the "national consciousness."[14] Reid's plan to do the job with public murals came to naught, but the Canadian War Memorials Fund demonstrated how effectively art could begin to foster a national identity by telling this Canadian story. What Lord Beaverbrook did for Canadian soldiers now needed to be done, in paint and print, for the Canadian people as a whole. As Lismer later wrote, many artists and writers in Canada "began to have a guilty feeling that Canada was as yet unwritten, unpainted, unsung . . . In 1920 there was a job to be done."[15]

If the painters in the CWMF provided the inspiration for a new program of national self-definition, so too did the men commemorated in their works. Canadian soldiers had distinguished themselves in Flanders, MacDonald believed, in a way exemplary of the national character. "In initiative, energy, and stamina, they have established a distinctive Canadian character," he wrote a few months after the armistice. "They have made new inroads of achievement in a no man's land of tradition and precedent." The same qualities could now be used by artists. As Jackson expressed this idea in his usual breviloquent style: "We are no longer humble colonials. We've made armies, we can also make artists, historians and poets."[16]

THE CWMF EXHIBITION at the CNE closed on September 6, 1919. Little more than a week later, several painters from the Studio Building returned to paint in Algoma for the second successive autumn. Jackson was now part of the expedition, which again included Harris, MacDonald and Johnston but not, on this occasion, the group's cook and general skivvy, Dr. MacCallum. Lismer was unavailable because of duties at the Ontario College of Art and Carmichael because of his job at Rous and Mann and the demands of a young family. Varley, now renting premises in the Studio Building, was either uninvited or, busy with his other projects, chose not to participate.

The expedition followed almost exactly the same itinerary as 1918. The men took the train to Sault Ste. Marie and once again hired a specially adapted carriage from the Algoma Central Railway. This year

the car was the fabled ACR 10557, previously used as an office for the company's work crews. It was comfortably outfitted with a table and chairs, a stove, a water tank, a sink, cupboards and shelves, a coal box and, of course, bunks. The exterior, freshly painted in a bright red, was decorated by the artists with the skull of a moose, sprigs of holly and the painted motto *Ars longa, vita brevis.* Their meals were a campsite menu of pork and beans, scrambled eggs and bacon, porridge, and toast and marmalade.[17]

The painters might have known that danger lurked along the tracks; an "organized gang of bandits" (as a newspaper described them) was operating in the area. Only days before the painters arrived in Algoma, an ACR crew was bound, gagged and robbed by the gang. The area was also a scene of tragedy. Most of the miners at the pyrite mine at Goudreau, connected by a spur to the ACR mainline, had died in the influenza epidemic.[18]

The only problem encountered by the painters, however, was the weather. Continual rain made outdoor sketching difficult. "All the waterproofs, umbrellas, and weatherproofs have proven their worth on a dozen occasions," Johnston wrote to his wife, Florence, "and many a sketch of mine has been saved by my oilskin slicker and the umbrella." He reported that despite these conditions he and MacDonald were each managing three sketches per day, Jackson and Harris four. He was impressed with the efforts of his companions when they spread their work out for appraisal in the boxcar each evening. "Mac is doing some very nice work, very much finer than what he did last year," while "Lawren's four sketches today were very very beautiful. I think quite the finest things of his I have seen—and that is saying a good deal." He was even pleased with his own work, telling Florence how he and MacDonald had gone under the trestle bridge "down by the falls and I think I made one of the best sketches I have made up here." His one regret—no doubt kept to himself—was that Florence was not there with him. When the others were in bed, he wrote letters to her by lamplight. "I feel quite homesick when I think of you all and what I am missing being away from you all." As for his companions, "These chaps don't seem to miss their womenfolk much."[19]

THE TORONTO PAINTERS were not the only group venturing by
train into the Ontario hinterlands in September 1919. A few days
before the party left Toronto, a nine-carriage Royal Train transported
the Prince of Wales along the same track through Algoma from Sault
Ste. Marie. The twenty-five-year-old Prince Edward, who had visited
Earlscourt a few days earlier, was three weeks into his three-month-
long tour of Canada. Like so many others in search of an authentically
Canadian outdoor experience, the prince and his entourage headed for
the lakes and rivers of Northern Ontario. Leaving Toronto, the royal
party made its way along the North Shore of Lake Superior to the
southern fringe of Lake Nipigon. The prince spent three days camp-
ing and fishing on the Nipigon River, living, according to an American
reporter, "the rough-and-ready life of a woodsman." With the help of
Aboriginal guides, he even navigated a length of rapids in a birchbark
canoe. The hazards of the bush became evident when a fierce hail-
storm snapped the flagpole bearing the Royal Standard and sent a
pine tree crashing into his tent.[20]

Anyone pondering the Canadian task of self-definition and the
uphill struggle of the country's artists could have done worse than
follow Prince Edward's cross-country itinerary. Besides his exploits
on the Nipigon, he rode a bronco at a Saskatoon rodeo, gazed on the
Rockies at Lake Louise and bought a four-thousand-acre cattle ranch
in Pekisko, Alberta. In Saint John he passed through a triumphal arch
made from drums of cod-liver oil festooned with the carcasses of
dried codfish. Cultural events were largely absent from his schedule.
When culture did intrude, it came from what must have been, to the
prince at least, an unexpected direction. In a gesture that must have
galled Canadian artists, the prince's visit to Western Canada was
commemorated with the presentation to him of a painting by Charles
M. Russell, the American "cowboy artist" from Montana. Russell
was a popular painter with an international reputation. His nostal-
gic scenes of cowboys and buffalo hunts earned him high prices (his
works changed hands for as much as $10,000 each) and solo exhibi-
tions in New York and London. Will Rogers collected his paintings,
and among Russell's friends was the Hollywood cowboy star William

S. Hart. The Prince of Wales must nevertheless have been taken aback when his Canadian hosts in High River gave him a painting of a Canadian scene—two Mounties arresting horse thieves—done by this famous American artist.[21]

The gesture spoke volumes about the esteem in which Canadian politicians and businessmen held the country's artists. It must also have confirmed in the prince's mind the prejudice, held by so many others, that Canada was a land merely of canoes, ranches and cod-fish—an outdoor country untouched and untroubled by the trappings of higher culture.

IN THE MIDDLE of November, less than two months after returning from their latest Algoma trip, Harris, MacDonald and Johnston applied to the Art Gallery of Toronto for permission for another exhibition. This time they envisaged a more encompassing show than the recent Algoma one. Scheduled for the following spring, it was projected to feature the work of nine artists.[22] This exhibition would take to a new level Jackson's plan to confront timid collectors and unfriendly reviewers by gathering together a band of like-minded painters of Canada.

Details were refined over the next few months. Early in 1920, while on his way to Georgian Bay for some winter sketching, Jackson met with Harris in Allandale to discuss matters. He hoped to widen the franchise beyond the walls of the Studio Building by recruiting painters from Quebec. Soon afterwards, he wrote a letter instructing his sister Catherine, in Montreal, to arrange for works by three Quebec artists—including his friends Randolph Hewton and Albert Robinson—to be sent to the Art Gallery of Toronto for what he called "a special group show in May... about six of us with one or two specially invited ones."[23] The third Quebec painter would be Robert Pilot, a stepson of Maurice Cullen recently returned from studies at the Académie Julian in Paris after serving in the Canadian army. Cullen himself would not be invited.

A second meeting was held in March 1920. Present on this occasion were Harris, MacDonald, Lismer, Varley, Johnston and

Carmichael (Jackson would certainly have joined them were he not still snowshoeing around Georgian Bay). The venue was 63 Queen's Park, the Romanesque-revival mansion that Harris and his wife inherited following the death of Trixie's mother in 1917. A stone's throw from the Ontario Legislature, this castle-like building, with its round tower and coach house, made an improbably opulent location for disaffected artists to deplore their lot and lay their plans. These were not hand-to-mouth rebels living in cold-water flats and artistic isolation. Neither were they youths. Carmichael was the youngest, at almost thirty, while Johnston was approaching his thirty-second birthday, Harris and Lismer were both thirty-four and Varley thirty-nine. MacDonald, a few weeks from his forty-seventh birthday, was the elder statesman.

These men, along with Jackson, had dominated the art scene in Toronto for much of the previous decade. The National Gallery held more than a dozen of their paintings. They had friends in high places, notably Eric Brown and Sir Edmund Walker. Several occupied positions of power themselves: Lismer was vice-principal of the Ontario College of Art and, along with MacDonald and Johnston, a member of the OSA's executive committee. The spirit of the meeting was captured by Lismer, an incessant doodler and caricaturist, who marked the occasion with a pencil sketch of Harris. He portrayed him in a jacket and tie, casually sprawled in an armchair, with a cigarette on the go and his feet perched on an ottoman: the self-confident leader informally presiding over a meeting of friends.

Altogether, ten artists would be invited to show their work at this special exhibition: the three Quebec painters plus Jackson and the six men who plotted strategy at Harris's house. Conspicuous by his absence was Bill Beatty. A one-time leader of the group determined to produce what he called a "national art," Beatty had since been sidelined. Part of the problem was undoubtedly his obnoxious personality: Augustus Bridle called him a "glorious, truculent bigot, ready for action with either fist or vocabulary."[24] More to the point, perhaps, was his refusal or inability to adopt the Hot Mush style regarded by Jackson as essential to capturing the Canadian landscape. Both

Arthur Lismer (Canadian, 1885–1969), *Lawren Harris*, 1920
charcoal on paper, 25.4 × 20.2 cm
Art Gallery of Ontario , Gift of Mrs. R.M. Tovell, 1953
transferred from the Edward P. Taylor Reference Library, September 1983

Jackson (after the trip to the Rockies in 1914) and Varley (after his tour of duty as a war artist) were dismissive of what they regarded as Beatty's moonshine-and-mist idiom. Beatty also confessed a strange—and, to Jackson, atrocious—admiration for the French painters William-Adolphe Bouguereau and Pierre Puvis de Chavannes.[25]

There was, of course, another more poignant absence. Tom Thomson, had he lived, would certainly have been involved in the exhibition. He, more than any of the other painters in the Studio Building, had demonstrated the new spirit of painting in Canada. His attachment to the northern woods, the dramatic power of his compositions, his teeming brushwork and sumptuous colour—all revealed his passion for painting the Canadian landscape in a resoundingly modern style.

THE MATTER OF a name for the new group was settled either at the meeting in Harris's house or very soon afterwards. The seven Toronto-based painters, with the exception of Lismer and Varley, were all Ontario regionalists, concentrating almost exclusively on Georgian Bay, Muskoka and Algoma. But their ambitions to bestride the national stage meant they needed to brand themselves with a title less geographically limited than the designation—the Algonquin Park School—by which they were occasionally known in the press. They also needed a name to evoke the fact that they were, as Harris boasted a year earlier, "younger men" destined to "produce something really significant."

Harris and several of the others were familiar with the secessionist movements launched over the previous quarter century by the groups of young modernists responsible for so much controversial innovation. Starting with the Belgian group Les x x in the 1880s, most had plumped, rather unimaginatively, for numerical appellations summing up the number of members. There had been the Society of Six, formed in California in 1917 with the former Montrealer William H. Clapp as a leader, and no fewer than three avant-garde collectives named themselves, after head counts, for the number eight: The Eight (Henri's group in New York), De Åtta (Isaac Grünewald's group in Sweden) and the Nyolcak in Hungary (a "Group of Eight" formed in 1910 and influenced by Cézanne and Expressionism). There had also been the Ten American Painters and, of course, Franz Skarbina's Group of Eleven in Berlin. With these various integers already claimed, and with what appeared to be a core of seven Toronto painters, the name the "Group of Seven" naturally suggested itself.

There might have been, at least for Harris, certain satisfyingly mystical connotations to the number seven. His involvement in theosophy had deepened by the time he hosted the other painters at his home. In the summer of 1919 he expressed to MacDonald his admiration for "dear mystics" such as the Irish theosophist A E (a.k.a. George Russell), Annie Besant and "a whole flock of old Eastern Johnnies."[26] The mystical importance of the number seven was repeatedly stressed in theosophical writings. In *The Secret Doctrine* H.P. Blavatsky

Members of the Group of Seven at the Arts & Letters Club in Toronto, c.1920

From left to right: F.H. Varley, A.Y. Jackson, Lawren Harris, Barker Fairley
(not a Group member), Frank Johnston, Arthur Lismer and J.E.H. MacDonald

Photographer: Arthur Goss / Courtesy of the Arts & Letters Club

declared, "Everything in the metaphysical as in the physical Universe is septenary."[27] Elsewhere she observed that "a peculiar solemnity and mystical significance has been given the Number Seven among all people, at all times." This essay went on to elaborate, with absurd precision and dubious logic, the vital role played by this number in shaping the fortunes of the Theosophical Society. Everything from her street address in New York (17) and the day she sailed for India (December 17, 1879), to the moment the engines started (7:07 A M) on her voyage from Bombay to Ceylon, was triumphantly produced as evidence of a "septenary fatality" ensuring the success of the society and the proof of its teachings. This numerological obsession survived Blavatsky's death. Harris undoubtedly knew Annie Besant's 1909 work *The Seven Principles of Man,* as well as the various articles on the "seven worlds" and the "seven periods of evolution" published by A E in the *Irish Theosophist.*[28] The septenary fatality probably had a less secure and less preposterous hold on Harris than on Madam

Blavatsky and other theosophists—though it might have been no accident that the exhibition was scheduled to begin on May 7 and close on May 27, a total of twenty-one days.

Lismer was worried, however, about certain other connotations of the number seven. A name echoing famous secessionist movements might suggest a schism within the OSA and deep divisions in Toronto's artistic community. Jackson and Harris enjoyed and even courted controversy, but Lismer, like MacDonald, was more temperate and diplomatic, ever ready to pour oil on troubled waters. He was swift to reassure his friend Eric Brown. "We are having a show at the Toronto Art Gallery in May," he wrote to him a short time after the meeting at Harris's house. "It will be a group show . . . The 'Group of Seven' is the idea. There is to be no feeling of secession or antagonism in any way, but we hope to get a show together that will demonstrate the 'spirit' of painting in Canada."[29] There was to be none of the incendiary rhetoric and malice-aforethought provocation of the Futurists. It would be a straightforward appeal to what one of the Algomaxims had called the "broadminded people" of Canada.

3 ARE THESE NEW CANADIAN PAINTERS CRAZY?

A.Y. JACKSON WROTE that, after the Great War, Canada's climate was hostile to art. "There had never been," he claimed, "less interest in painting."[1] That was not strictly true, not least because of the perennial void of public interest in painting in Canada over the previous fifty years. The year 1920 was hardly an auspicious moment, however, to launch a modernist exhibition in Canada or anywhere else.

The Great War had taken a terrible toll on modernist artists. The Toronto painter Estelle Kerr was not exaggerating when she wrote at the end of 1916 that "ultra-modern art" had been "killed by the war."[2] Some of Europe's most innovative artists died on the battlefield; many others were physically or psychologically damaged. August Macke, a member of Der Blaue Reiter, was killed in the first month of the war. "How much is lost for all of us," lamented his friend and fellow painter Franz Marc. "It is like a murder."[3] Marc himself died eighteen months later at Verdun. Other casualties included the Vorticist sculptor Henri Gaudier-Brzeska, the English painter Isaac Rosenberg and the Italian Futurists Umberto Boccioni, Carlo Erba and Ugo Tommei. The Cubist pioneer Georges Braque was severely wounded, Ernst Ludwig Kirchner suffered a mental breakdown and the Expressionist Max Beckmann what he called "injuries of the soul."[4] Countless other young artists

died in obscurity, denied the chance to develop their talents and make their names. The Montreal-born painter Percyval Tudor-Hart, who operated a progressive school of painting in Hampstead, lost sixteen former students.[5]

Those who came through the war more or less unscathed adopted tamer styles. In 1920 Paul Konody wrote in the *Toronto Globe* that people on both sides of the Atlantic equated modernism—much of which had come out of Germany—with "the spirit of unrest" that led to the Great War.[6] Appalled by the technological horrors of the war, neither the public nor the artists themselves showed much appetite for modernist innovation. Wyndham Lewis claimed the shattered geometrics of Vorticism felt "bleak and empty" after the war.[7] Rejecting abstract art, he turned to novels and journalism. David Bomberg travelled to Palestine and painted restful landscapes. Marsden Hartley abandoned abstract portraits of German soldiers in favour of pastel sketches of New Mexico. Braque and Picasso forsook Cubism, Picasso opting for a more classical three-dimensional style that took its inspiration from, among others, Ingres. Leading Futurist Gino Severini renounced Futurism and turned to Giotto. Beckmann painted religious scenes. French journals resounded with condemnations of the avant-garde, and in England any painting that tried to recapture the daringly experimental spirit of the pre-war years was anathematized as "Junkerism" or "Prussian in spirit."[8]

The only place where modernist art could still be seen—in what appeared to be its strange and unsightly death throes—was in Germany. In June 1920 the First International Dada Fair opened its doors in Berlin. Dadaism responded to the horrors of the Great War not with a revival of classicism but with outrage, rebellion and a self-conscious and theatrical absurdity. "Art is dead," declared a sign at the Berlin exhibition. The provocative works on display—a wooden head stuck with metal debris, the effigy of a German officer with a pig's head—seemed a grotesque parody of modernist aesthetics, a calculated affront to art and art lovers alike. In an inversion of the usual artist-critic relationship, one of the exhibitors, the Austrian Raoul Hausmann, casually dismissed their work. "Straight away one must

First Group of Seven exhibition at the Art Gallery of Toronto, May 1920
McMichael Canadian Art Collection Archives

emphasize," he wrote in the catalogue, "that this Dada exhibition consists of the usual bluff, a cheap speculation preying upon the public's curiosity—it is not worth visiting."[9] Many critics were inclined to agree.

In comparison with the First International Dada Fair, the exhibition that opened a month earlier at the Art Gallery of Toronto was subdued and wholesome. It did not preach nihilism or the death of art but declared instead that Canadian art was alive and well. In any case, anyone who feared an outbreak of radicalism or revolution would have been reassured by the sight of tailcoats and strings of pearls on opening night. A stiff formality prevailed, the atmosphere akin to a wedding reception or the first night of an opera. One young visitor described the opening as a white-tie event with a receiving line and "ladies with evening dresses and white gloves." Everyone was "terribly polite" even though "nobody had any idea what some of these paintings were all about."[10]

The works were nowhere near as baffling to the audience as this visitor, A.J. Casson, insisted. Anyone puzzled by the works could purchase for 15¢ a mimeographed leaflet with a logo designed by Carmichael and a list of the works on display. This improvised catalogue included a foreword, an Algomaxim-style manifesto that declared—in terms hardly subtle or new—the aims and ideals of the artists. This piece might have been composed by Barker Fairley: he at least had been proposed for the task at the March meeting.[11] The thirty-three-year-old Yorkshire-born professor of German literature at the University of Toronto, whose expertise was the poetry of Goethe and Heine, made an unlikely champion of Canadian art. But apart from his academic specialization he was the editor of *The Rebel* (undergoing its relaunch as *Canadian Forum*) and a friend of several members of the new group. He was an admirer and promoter of Varley in particular, regarding it as his life's mission "to make Varley known to the world."[12]

If Fairley composed the foreword, he did so in close consultation with members of the group, since it rehashed many of their usual arguments. It declared that the Group of Seven held "a like vision" concerning Canadian art: "They are all imbued with the idea that an Art must grow and flower in the land before the country will be a real home for its people." A unique style of art was needed, one differing not merely from "the Art of the past" but likewise from "the present day Art of any people." This new Canadian art was therefore to be fresh and unprecedented, beholden to no tradition. This claim did not entirely bear the weight of evidence, but at least the painters were sincere in their ambition to interpret "the spirit of a nation's growth" by using a defiant style of painting.

In the midst of these passages of optimism and idealism a bitter note was sounded. The painters expected to be greeted, the foreword announced, "by ridicule, abuse or indifference" because their work differed so drastically from "the commercialized, imported standard of the picture-sale room." These debased tastes among "so-called Art lovers" had queered the pitch for the members of the group and their vibrant new style of painting. Although they cleaved to a democratic

view of art—it was "an essential quality in human existence," not the preserve of an elite—the painters expected to find little favour among the wider public at which their art was supposedly aimed. Their paintings would be understood and accepted, sighed the foreword, only by a "very small group of intelligent individuals."[13]

A contradiction therefore stood at the heart of their venture. The group saw themselves as patriots and populists whose landscapes were meant to appeal to all Canadians *as* Canadians and to foster a sense of beauty in everyone from captains of industry to pale seamstresses and fatted tradesmen. They believed, however, that their experimental modernist style would find favour only among the most discerning critics and collectors, those uncontaminated by the corrupt tastes of the many. In its pessimism that the group's efforts at nation building would be appreciated by only a small elite, the foreword veered dangerously close to Sadakichi Hartmann's claim that the fine arts were by the few and for the few.

From this daunting challenge, visitors moved to the works themselves, more than 140 of them. Anyone expecting a straightforward reprise of the Algoma exhibition, with its unremitting sequence of landscapes, would have been taken aback by the variety of work on offer: portraits, war pictures, fishing villages and (in the case of Harris) scenes of Toronto's slums. As Augustus Bridle wrote in an enthusiastic review, visitors were treated to "plateaus of brûlé and Laurentian hills; battlefields and dead men; Hebrew shacks and Italian cottages; old barns and ploughed fields; spring blossoms and gorgeous autumn; cold winterscapes and trails; ships and harbours; woodland tapestries and rainbows."[14]

As in the Algoma exhibition, Johnston, with eighteen canvases, was the most prolific. The most versatile was Harris, who, as Bridle pointed out, refused "to be identified solely by one type of picture."[15] Besides Algoma landscapes such as *Autumn, Algoma,* he exhibited eight portraits (including one of his friend Fred Housser's wife, Bess) and five urban scenes. Among the latter was another in his Earlscourt series, *Shacks,* in which the shabbiness of the tightly packed, jerry-built homes of "shacktown" was offset by a pigmentary gusto and

lively brushwork. The ebullience was captured by the prose of Bridle, who described how the canvas "shouts in reds, greens and blues. Harris . . . revels in gorgonesque blobs of broken and patched roughcast. He delights to swat himself in the eye with pink fence-boards, yellow windows and blue doorways that zip out of the naked plaster like poppies stuck in skulls."[16]

The reference to poppies and skulls indicates how, to Bridle and many other visitors, the exhibition must almost have been as redolent of the Great War as the CWMF exhibition eight months earlier. Varley submitted his arresting *The Sunken Road*—a corpse-strewn battlefield scene called by Bridle a "cadaver picture . . . an epic of necrosis"—and many of his other works likewise evoked the scars and torment of battle. These emphatic echoes were hardly surprising considering both the immediacy of the war in the spring of 1920 and the service record of the Group of Seven: four had worked for the CWMF, and a fifth, Harris, spent almost two years in uniform. Of the invitees, Hewton and Pilot both served overseas, and Robinson worked in a munitions factory at Longue Pointe.

The trauma of war haunted even the Algoma paintings. At some point on the 1919 Algoma expedition the painters had come across the aftermath of a forest fire. Johnston's *Fire-Swept, Algoma* (see plate 30) and *Beaver Haunts,* with their charred, naked trees in sharp silhouette, evoked the brutalized landscape of Flanders at least as readily as the Canadian wilderness Elysium that was supposedly Algoma. *Fire-Swept* called to Bridle's mind, not unreasonably, "a Hunswept village."

Jackson too painted this no man's land of scorched earth. He claimed that after returning from the battlefields of Europe he "wasn't satisfied to paint anything that was serene" and wanted instead "to paint storms . . . things that had been smashed up."[17] One of his first compositions since his return to Ontario, *First Snow, Algoma* (see plate 31), revealed his enthusiasm for this wrathful, tormented style born of the war and influenced by the work of other war artists such as Paul Nash. If Lismer was right that Jackson's success in catching the desolation of Flanders came from his excursions into "the rugged north country of Canada,"[18] his paintings of the rugged north

were now suffused with his experience of the Western Front. Even the maple saplings in the foreground—spatterings of poppy-coloured red—seemed to recall the Great War.

Bridle's review in the *Canadian Courier* was provocatively entitled "Are These New Canadian Painters Crazy?" A supporter and enthusiast, Bridle concluded they were not: "They are not decadent, but creative. They go direct to nature. Their aim in art is greater virility"—(Bridle's favourite word)—"and they have got it." But if the painters were not crazy, neither were they new. For much of the past decade, their work had been copious and eye catching; anyone setting foot inside an OSA exhibition since 1912 or 1913 could not have escaped it. Sixteen of the works had already hung on the walls of other exhibitions, including Jackson's *Terre sauvage* (shown under the title *The Northland*) and MacDonald's *The Tangled Garden*. MacDonald also showed *The Wild River*, already doubly exposed in Toronto, once at the 1919 OSA exhibition and then again at the Algoma exhibition two months later.

Familiarity did not breed contempt. A growing acquaintance with these works and their Hot Mush style, together with exposure to progressive painters such as Bomberg, Nash, Nevinson and Wyndham Lewis, meant the reviews and the public reactions were not what (judging from their manifesto) the members of the Group of Seven expected and possibly even desired. Jackson wrote to his mother that the exhibition was "attracting quite a lot of attention even if it is not understood."[19] In fact, with Hector Charlesworth failing to pass comment in *Saturday Night*, the reviews were full of both understanding and praise. "Seven Painters Show Some Excellent Work," declared the headline in the *Daily Star*. Its reviewer, Margaret Fairbairn, was sympathetic as always to their cause. She commended the "vitality" of Varley's portraits, the "brilliant passages of colour" in Carmichael's landscapes and the "Japanesy effect" of Jackson's Nova Scotia scenes. The review in the *Mail & Empire* proved equally gratifying. "Young men seeking to interpret Canada in original manner," read its headline. If *The Tangled Garden* was included as an incitement to critical riot, the riot failed to ignite. After the CWMF exhibition, the object

of such outrage and insult in 1916 no longer seemed subversive and shocking. *The Tangled Garden,* noted the *Mail & Empire,* "does not seem radical at all. It is gorgeously decorative." For Fairbairn, Mac-Donald's "riot of colour" was to be praised for its "intense feeling."[20]

FRED VARLEY WAS, for many people, the biggest revelation at the 1920 exhibition. Hitherto little known in Toronto, he continued his ascent through the ranks of Canadian painters with a clutch of glowing reviews for his portrait of Vincent Massey (see plate 32), evidently the most widely admired work in the show.

Varley's portrait was commissioned to hang in Hart House, named for Massey's grandfather and officially opened in November 1919 as a place of culture and recreation exclusively for male undergraduates within the University of Toronto (Vincent Massey railed against the "evils of co-education").[21] Hart House's committee originally balked at the thought of a "modernist" like Varley painting Massey's portrait. The commission was secured thanks only to the efforts of Barker Fairley and Massey himself, an enlightened patron who in 1918 purchased fourteen paintings from Tom Thomson's estate. He paid $25 for each sketch after spending a day going through what he called the "brilliant little panels" painted by Thomson in the open air.[22]

Varley spent many weeks on the portrait in the winter of 1919–20. After renting space in the Studio Building following his return from Europe, he moved his studio, late in 1919, into Tom Thomson's shack. Empty for almost three years, the "shack-studio," as Varley called it, was "not very presentable...I want Harris to get busy and make it habitable and fit for visitors as well as work," he had written impatiently to Eric Brown at the end of November.[23] Harris was in no special hurry to repair the shack: Varley was already three months in arrears with his rent for the Studio Building. But the refurbishment took place in due course, and Vincent Massey, the thirty-three-year-old Oxford-educated professor of history and scion of the Massey-Harris dynasty who had been reared in the "Mansion District" on Jarvis Street, found himself sitting for his portrait in the primitive shack. The humble setting might well have contributed to the mood celebrated by the critics:

they praised the expressiveness and informality of the work, which, as Bridle enthused, displayed an "intense emotionalism" projected onto the subject.[24]

Frank Johnston likewise garnered enviable reviews. Jackson, though, was little impressed. "The two weakest men in the Group, Johnston and Carmichael, they like most," he griped to his mother. "They really should be in a different sort of show."[25] Many of Johnston's works did show a delicacy and precision at odds with the paint-slinging efforts of his peers. Even *Fire-Swept, Algoma,* despite its vision of a tree-stump Golgotha, was vigilant in its colour harmonies: the despoiled woodland was portrayed in an adroit symphony of violets, greys, mauves and camouflage green. *Fire-Swept, Algoma* was painted in oil, but one reason for Johnston's finespun technique was that his preferred medium was actually egg tempera instead of oil paint. Tempera did not readily lend itself to the Hot Mush technique. Its quick-drying properties meant it was brushed thinly and evenly onto the canvas or panel, making impasto and other such "painterly" techniques impossible. The deep saturations of oil paintings were replaced by more subtle variations of tone.

Johnston owed this more exquisite approach to his Philadelphia teacher Daniel Garber, a virtuoso in carefully blended pigments and dexterous integrations of colour quite different from the straight-from-the-tube style of many Post-Impressionists. Atmospheric effects were not completely forsaken, and like Garber he aimed to produce poetically evocative works. The style, as Jackson caustically noted, won over both the public and the critics. Whereas in past years the unrestrained palettes of MacDonald and Harris drew mordant reviews, in 1920 a critic commended Johnston for his "lovely colours" and "imaginative quality," and Bridle praised his "prodigious fancy" and "wonderful eye."[26] Added to this acclaim was the fact that the National Gallery of Canada purchased *Fire-Swept, Algoma* for $750.

341

The National Gallery still remained one of the few patrons for the painters. Eric Brown purchased two other works, Jackson's *Night, Georgian Bay* (painted in 1913) for $200 and Harris's *Shacks* for $1,000. Brown had hoped to buy three more but faced resistance from one of

the gallery's trustees, a Montreal senator named Arthur Boyer. The son of a foodstuffs merchant who became one of Montreal's largest landowners, Boyer protested at Brown's efforts to buy work from the Group of Seven exhibition. According to Brown, he objected "violently" to all of the paintings.[27]

The members of the Group might have been expecting ridicule or abuse or indifference, but in 1920 Senator Boyer was a rare detractor. Among the wider public the response was a mild indifference: little more than two thousand people attended the exhibition during its three-week run. Although the painters could attract good critical notices and possessed friends in high places such as Eric Brown and Sir Edmund Walker, they still needed to win over the collectors and captivate the public imagination. Only three works sold apart from those destined for the collection of the National Gallery: two sketches by Carmichael and one pastel by Robert Pilot. The remainder, removed from the walls at the end of the three-week run, were returned to the painters' studios.

THE GROUP OF Seven's exhibition was still under way when yet another expedition set off for Algoma in the middle of May. This time the party was made up by Harris, Jackson, Dr. MacCallum and (making his first visit) Lismer. They travelled by ACR to Mongoose Lake, 120 kilometres north of Sault Ste. Marie, staying in a cottage on the lake rather than, as on past trips, in a boxcar. The end of the month saw them back in Toronto.

The sluggish sales of their work meant the painters needed to occupy themselves with what Jackson called "the bothersome business of earning a living."[28] (He once complained that Canadian painters were forced to subsist on "remuneration on which a street car conductor would starve.")[29] If few Torontonians took interest in their paintings, the Group of Seven was at least in demand as designers. Over the next few months the painters turned their hands to a variety of commissions. Some designed Christmas cards, and Mac-Donald produced artful ex libris, including one for the library of Hart House and another for the headmaster of Upper Canada College.

Jackson took a commission for $200 to paint a 150-foot-long mural of a northern landscape in the Toronto factory of Kent-McClain, a large company selling bookcases and store fixtures. Jackson's wooded hills looked down on the carpenters as—ironically—they began turning boards of timber into shelves and cabinets. The firm's owner, R. Watson McClain, was so delighted with the result that Jackson received a $100 bonus.[30]

One of the more intriguing projects diverting the painters from their oil paintings was the design of stage sets for the theatre at Hart House. Besides its gymnasium, squash courts, library and "swimming bath," Hart House boasted a handsome 450-seat theatre. Vincent Massey was determined to free Canadian drama from what he called "alien influences"[31]—the American and British touring companies whose productions filled Toronto's theatres. He also hoped to introduce a European-style "Little Theatre" akin to Dublin's Abbey Theatre or New York's Washington Square Players. His wish to provide more recondite and experimental drama was fulfilled when Roy Mitchell returned to Toronto to became the theatre's director in 1919 following his tenure as technical director at the avant-garde Greenwich Village Theatre. In Toronto he had staged experimental productions at the Arts and Letters Club between 1911 and 1916. A theosophist since 1909, he often directed works—Maeterlinck's *Interior,* W.B. Yeats's *The Shadowy Waters,* Rabindranath Tagore's *The Post Office*—whose authors were themselves inspired by theosophy.

Mitchell's debut Hart House production, in November 1919, was the Irish playwright Lord Dunsany's *The Queen's Enemies.* Jackson designed the stage set soon after returning from his first trip to Algoma: an underground Egyptian temple whose details he researched at the Royal Ontario Museum. Lismer was busy a few weeks later painting those for the second production, *Master Pierre Patelin,* a fifteenth-century French farce. Christmas 1919 saw the curtain rise on Harris and MacDonald's set (which incorporated an eight-foot-high stained glass window) for *The Chester Mysteries.* During the Group of Seven exhibition in 1920, Mitchell presented Euripides' *The Trojan Women,* with Lismer again working as set designer. Harris then set to

343

work on the staging for Basil Macdonald Hastings's controversial 1912 play *The New Sin,* a sardonic tale of inheritance, suicide and capital punishment.

A newspaper was soon enthusing that the Hart House Theatre was rivalled in its technical prowess only by the Metropolitan Opera House in New York. The claim might have been exaggerated, though the theatre did indeed boast "absolutely the last word in staging effects and electrical equipment."[32] The only thing lacking in the enterprise was Canadian content in the plays themselves. A 1920 article in the *Canadian Bookman* lamented that "suitable pieces were not available . . . The supply of Canadian material, of even a passable sort, has been so small as to prevent a genuine Canadian dramatic offering."[33]

This lack of Canadian scripts was not down to a lack of talent. Indigenous Canadian drama faced conditions far more difficult than indigenous Canadian painting. The walls of Canadian exhibitions (if not the walls of Canadian collectors) were at least filled with Canadian paintings. Canadian theatres, by contrast, were filled with British and, especially, American productions. In 1911 the Montreal theatre critic B.K. Sandwell wrote "The Annexation of Our Stage," a manifesto-like article calling for Canadian theatres to be liberated from American monopolistic control. "Canada is the only nation in the world," he pointed out, "whose stage is entirely controlled by aliens."[34] How could a national drama ever develop with such a barrier in place? A few months before Hart House Theatre opened its doors, an article in the *Canadian Bookman* echoed Sandwell with a call for "our own plays in our own theatres." The author asked, "Where are the Canadian playwrights? . . . I mean persons of Canadian descent, or adoption, who have written plays the subject matter of which deals with some intrinsic part of Canadian life, past or present, and whose plays are directly artistic representations of Canadian life, or interpretations of Canadian temperament."[35]

Hart House created a stage beyond the reach of the American companies; it now remained for Canadian playwrights—several of whom would be directly inspired by the nationalism of the Group of

Seven—to take up their pens. As Lismer wrote, in 1920 there was a job to be done, in literature no less than in painting.

THE 1920 EXHIBITION at the Art Gallery of Toronto was only the first of numerous Group of Seven ventures. The first aim of the group was, as one Algomaxim affirmed, to make Canadians feel at home in their own country. But members of the group also entertained ambitions of making their name on an international stage. Their art was aimed not merely at the two to three thousand people who attended art exhibitions in downtown Toronto. Hoping to take their vision well beyond the walls of the Art Gallery of Toronto, they wanted to prove to the wider world, not merely to Canadians, that Canadian art was modern, vital and unique—that Canada, as Jackson wrote, could produce artists as well as soldiers.

The United States was the obvious place to stake a claim. Americans remained as blissfully ignorant about Canadian painting as they did about everything else north of their border. Even the most well-intentioned and erudite Americans made fools of themselves whenever they set foot on Canadian soil or pronounced on matters Canadian. Walt Whitman, taking a steamer up the Saguenay in 1880, had sincerely believed himself to be entering, artistically speaking, virgin territory. Wrapped in his grey greatcoat, he stood on deck gaping in wonder at a landscape that, as he related in *Specimen Days,* went "to a further extreme of grimness, of wildness of beauty . . . than perhaps any other on earth." He was astonished that these cliffs and capes should be unpainted, unversed and indeed virtually unknown. "They have stirr'd me more profoundly than anything of the kind I have yet seen. If Europe or Asia had them, we should certainly hear of them in all sorts of sent-back poems, rhapsodies, &c., a dozen times a year through our papers and magazines."[36]

The Saguenay was neither unpainted nor unversed. In 1856 Kingston-born Charles Sangster published his 1,262-line "The St. Lawrence and the Saguenay," with its description of the Saguenay "winding, like a rivulet, / Through the thick woods and reverential hills."[37] These woods and hills were a favourite sketching ground for Quebec artists

at least since Otto Jacobi and C.J. Way worked there in the 1860s, and Lucius O'Brien, in the year of Whitman's voyage, deposited *Sunrise on the Saguenay,* his RCA diploma work, in the National Gallery.

J.E.H. MacDonald, an avid reader of *Specimen Days,* would have noted this irony. Yet Whitman's blind spots about Canadian culture were, he must have realized, the fault of Canadians—who had failed to make themselves heard—at least as much as that of Whitman.

As early as 1918 Eric Brown began making plans to tour Canadian paintings—ones "as modern in character as possible"—through the United States. Asked by the Association of American Art Museum Directors to put together a show, he leapt at the chance. "There is the deepest ignorance across the border of Canadian painting," he wrote to Frank Johnston, "and now they are anxious to see it, I want to startle them as much as possible, and I want to have a specially fine representation from Toronto which includes practically all that is modern and original."[38]

A receptive audience might have been expected for the Group of Seven despite the routine American ignorance about and scorn for Canadian culture. The group's nationalist rhetoric would have struck a familiar and sympathetic chord with many American painters and critics. Although blessed with an immense population and a prolonged independence from colonial rule, Americans for many decades shared with Canadians both feelings of cultural inferiority and aspirations for a culture independent of Europe. American hopes for a national culture were most resonantly expressed in Ralph Waldo Emerson's famous Harvard address in 1837. Americans, he declared, needed to end their "long apprenticeship to the learning of other lands" and create a distinctively American culture.[39]

Whitman duly fulfilled this wish in literature: in "By Blue Ontario's Shore" he described how a "Phantom" appeared to him beside Lake Ontario and urged him to "Chant me the poem . . . that comes from the soul of America"—a task that kept him busy for the next thirty-five years.[40] The visual arts, however, remained in the thrall of European models. The Civil War blighted much American nationalism and patriotism, and convictions that the United States was a cultural backwater sent aspiring young American painters overseas

to train in Parisian ateliers. Once back home, they produced images—like their Canadian counterparts—scarcely distinguishable from their European models. American collectors, happily assured of the superiority of the European product, ignored their work.

American art took a nationalist turn at the end of the nineteenth century. The National Arts Club was founded in New York in 1898 with the aim of weaning collectors from foreign works and persuading them to buy American art. The commonplace that America offered few compelling subjects ("American life is so unpaintable," lamented the Monet disciple Theodore Robinson) was urgently challenged. America was not without subjects to paint, protested one critic in 1894, simply because "she had no castles and donjon keeps." Critics began calling for distinctively American scenes that were, as a Boston newspaper critic demanded, "racy of the soil." Soon American painters were hastily shaking the dust of Europe from their shoes. Theodore Robinson, back from Giverny, discovered that America *did* in fact have subjects to paint: Vermont mountains, canals in upstate New York, sailboats on Long Island Sound. "I am only beginning to see its beauties and possibilities," he wrote in 1895.[41]

By the first decades of the new century, many American painters foreshadowed the Group of Seven's preoccupation with landscape painting and national identity. The country's most famous and successful artist at the turn of the century, Childe Hassam, was renowned for his patriotism. "I am an American!" he once proclaimed. "I would rather have that said of me than anything else."[42] Seeking what he believed were typically American subjects, he often worked in a clapboard shack in Old Lyme, Connecticut, where he painted *en plein air* while stripped to the waist. He was a skilled canoeist and fisherman, and when he embarked on a painting trip to the Oregon desert in 1908, a local newspaper breathlessly reported how the great man had "camped for two months on the Blitzen River, 40 miles from a post-office, hundreds of miles from any railroad ... where he painted 40 canvases."[43] This combination of physical vigour, patriotic fervour and bare-chested depictions of far-flung locations was exactly the formula that the painters in the Studio Building were prescribing for Canadian art.

Hassam further demonstrated his patriotism by painting his famous "flag series" during the Great War. Patriotism was, if anything, even stronger among American artists after the war, as Americans rejected European culture. In New York, Alfred Stieglitz turned from an international avant-gardism to a cultural nationalism in which the land—the "spirit and soil" of America—was supposed to lead to an American art unfettered by European influences. Having introduced Cézanne and Matisse to America, Stieglitz now wanted "America without that damned French flavour."[44] (Following the demise of 291 he would found a new gallery called, tellingly, An American Place.) In the summer of 1918 one of his proteges, Marsden Hartley, set off for New Mexico in search of haunting and austere landscapes that would help him forge a uniquely "American" art. "I am an American discovering America," Hartley wrote (though he took the precaution of studying Courbet and Cézanne for ideas on how to tackle the landscape). He hoped others would follow his trail westward: "There will be an art in America only when there are artists big enough and really interested enough to comprehend the American scene."[45] It was precisely the same kind of journey of artistic inspiration and national discovery, albeit with a Yankee accent, as members of the Group of Seven took to Georgian Bay and Algoma—with similar (often unacknowledged) debts to European predecessors.

Would American sympathies for a more homegrown style of art extend across the border? Complimentary reviews and a few high-profile sales could shame reticent Canadians into a more zealous support for the Group of Seven.

THE *Exhibition of Paintings by the Group of Seven Canadian Artists* opened at the Worcester Art Museum in Massachusetts in the first week of November 1920. A wire-manufacturing city of 150,000 people sixty kilometres west of Boston might have seemed an obscure and unlikely venue for the group to launch themselves in the United States. Under its director Raymond Wyer, however, the Worcester Art Museum provided a congenial home for progressive art. A *New York Times* interview in the summer of 1920 quoted Wyer's ambition to

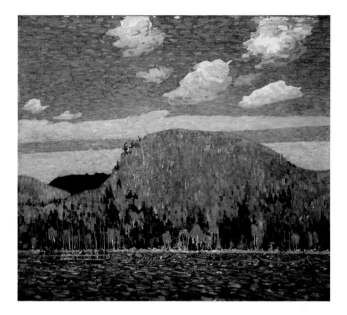

PLATE 24 | TOM THOMSON (Canadian, 1877–1917)
The Pointers (Pageant of the North), 1915
oil on canvas, 102.2 × 116.5 cm

Hart House Permanent Collection, University of Toronto,
Purchased by the Art Committee with the Print Fund, 1928–29

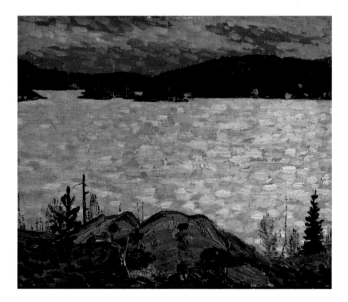

PLATE 25 | TOM THOMSON (Canadian, 1877–1917)
Islands, Canoe Lake, 1916
oil on wood panel, 21.4 × 26.2 cm

McMichael Canadian Art Collection, Gift of the Founders,
Robert and Signe McMichael, 1966.16.73

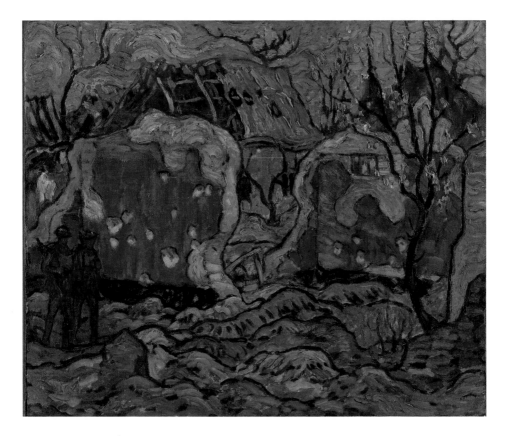

PLATE 26 | A.Y. JACKSON

(Canadian, 1882–1974)

Springtime in Picardy, 1919

oil on canvas, 65.1 × 77.5 cm

Art Gallery of Ontario, Gift from the Albert H. Robson
Memorial Subscription Fund, 1940

PLATE 27 | FRANZ JOHNSTON (1888–1949)
A Northern Night, 1917
tempera over graphite on illustration board
100.3 × 75.3 cm
National Gallery of Canada, Ottawa

PLATE 32 FREDERICK VARLEY (Canadian, 1881–1969)
Portrait of Vincent Massey, 1920
oil on canvas, 120.7 × 141 cm

Hart House Permanent Collection, University of Toronto

Presented to Vincent Massey by his friends in the University of Toronto on the
occasion of the completion of Hart House, 1920

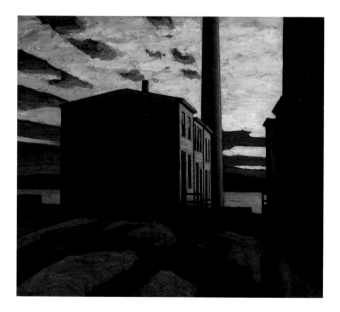

PLATE 33 LAWREN S. HARRIS (Canadian, 1885–1970)
Elevator Court, Halifax, 1921
oil on canvas, 96.5 × 112.1 cm

Art Gallery of Ontario, Gift from the Albert H. Robson Memorial Subscription Fund, 1941

PLATE 34 | ARTHUR LISMER
(Canadian, 1885–1969)
The Big Rock, Bon Echo, 1922
oil on canvas, 91.6 × 101.7 cm
National Gallery of Canada, Ottawa

PLATE 35 | LAWREN S. HARRIS (Canadian, 1885–1970)

Above Lake Superior, c.1922

oil on canvas, 121.9 × 152.4 cm

Art Gallery of Ontario, Gift from the Reuben and Kate Leonard Canadian Fund, 1929

challenge "intellectual stagnation" and appeal to an "unprejudiced and broad-visioned" public by exhibiting paintings that revealed "a combination of strength, subtlety and modern spirit which is indispensable to art of a vital nature."[46] The museum had already hosted a selection of war paintings by Nevinson, Nash and Wyndham Lewis, and its exhibition of contemporary American artists such as John Sloan, a member of The Eight, had closed earlier in the year. The Group of Seven's paintings were to be Wyer's latest offering of the "modern spirit."

The Group of Seven's American tour began well. Much modernist painting in Europe was a response to the disintegration of traditional society in the industrialization and urbanism of the machine age. The loss of social cohesion and spiritual meaning led to alienation, despair and meaninglessness—crises self-consciously reflected in the agitated brushwork and jangling colours of Post-Impressionism. Little of this pessimism and alienation touched the Group of Seven, most of whom (Harris with his urban scenes was the obvious exception) were still marked by the national pride and the infectious optimism of the booming Laurier years. The Canadian painters used expressive brushwork and European innovations in colour perception not to record disintegration and dysphoria but to proclaim their excitement, optimism and wonder—and sometimes their foreboding and disquiet—at the "wildness of beauty" in the northern landscape.

This combination of modernist technical innovation and New World optimism played well with an American audience. The thirty paintings in the exhibition were well received by the critic for the *Worcester Telegram*. What some Toronto critics had deplored as an ugly landscape and an even uglier style of painting was celebrated by the American reviewer as conveying "a splendid feeling of the freshness and the joy of living in this beautiful world of ours." Jackson's *Terre sauvage* was singled out for inspiring in viewers "the feeling of grandeur and solitude in a new world," and Thomson's *The West Wind* was extolled as a "powerful canvas." The reviewer added that the works were painted "in the most modern way"—no mean compliment in view of how the likes of Nash, Nevinson and Sloan had only

recently vacated the museum.[47] The exhibition was due to close at the end of November. From Worcester it would move to Boston, followed by museums in cities such as Rochester, Toledo, Indianapolis and Cleveland.

Meanwhile, another exhibition of art by the Group of Seven was simultaneously beginning its advance through Western Canada. This whistle-stop tour took a collection of their smaller sketches to Fort William, Brandon, Moose Jaw, Calgary and Edmonton. Museumgoers on the Prairies no doubt were puzzled that this "national" school of art purporting to celebrate the Canadian landscape included not a single glimpse of countryside west of Wawa. The serial paintings of the Precambrian Shield would have spoken to the thousands of migrants to Western Canada merely of interminable vistas glimpsed through the windows of the CPR trains that transported them across hardscrabble tracts of forest to the abundant promise of the Prairies. The scrub-and-boulder landscape above Sault Ste. Marie must have been, to most westerners, an unvarying hiatus of economic infeasibility stretching between the factories of southern Ontario and the farmlands of the West. That such an unfertile and underpopulated region was to be celebrated as the quintessence of Canada could have aroused only incredulity. Then, of course, there was the Hot Mush style. A critic in Edmonton, although able to appreciate the beauty of Ontario's rivers and waterfalls, objected to the way the painters were abusing "the talent the Lord gave them" by distorting "His handiwork, making it hideous in the eyes of the people."[48]

The curious and courteous response in Moose Jaw was, however, more typical of the reception in Western Canada. The fifty works by members of the group, including five works by Thomson, went on display in, for want of a gallery, the show rooms of John Bellamy's furniture store (the setting could have been worse: Bellamy also owned a funeral parlour). They were joined by twenty-five works, complete with five sketches by F.M. Bell-Smith and two by Homer Watson, from the collection of William Grayson, a local barrister and landowner. The *Moose Jaw Evening Times* reported Grayson's opening address. After speaking about "the various European schools of art,"

he discussed "the efforts being made by Canadian painters to break away from the older traditions and the methods of their masters and establish a school of art distinctly Canadian that would depict in true-to-nation tints the crystalline atmosphere, vivid colourings of our inimitable sunsets and autumn woods, and the rugged magnificence of our mountains."[49]

The newspaper's correspondent was at least as knowledgeable as Grayson. On the eve of the opening, the *Evening Times* carried a long article introducing the various members of the group. Harris was identified as "the recognized leader," MacDonald "the poet-colourist," Johnston "the foremost painter in tempera in America," and Jackson was known for "sketches made in inaccessible places with the thermometer many degrees below zero." The paper hailed Thomson, who received at least as much publicity as the others, as "the most unique, spontaneous and remarkable of them all." According to the paper's correspondent, he was the group's "martyr, its great genius, its founder, its champion, its dominating influence."

The wide publicity and the newspaper's positive reviews (the group's "splendid works of art" were celebrated as "a great contribution to the artistic life of Canada") brought large numbers of people into Bellamy's; a late-night opening was even required to accommodate the visitors.[50] When the paintings left Moose Jaw, Harris's *The Drive* remained behind, in the lecture room of the public library, as a loan from the National Gallery.

ALONGSIDE THESE TRAVELLING exhibitions, a second Group of Seven show was planned for the Art Gallery of Toronto in the spring of 1921. It and the future of the group as a whole were, however, soon placed in jeopardy. The American and Western Canadian exhibitions siphoned some of the best work from their studios, and by the autumn of 1920 Jackson was fretting about whether the yield of his fellow painters would be enough to warrant a new show in Toronto. "Varley and MacDonald are the non-producers," he complained to Eric Brown. "Lismer is pretty well tied up with the school and has to paint with a rush. Harris and I will be the big contributors."[51]

351

Many of these contributions would come from the Algoma hills. The autumn of 1920 saw Jackson, Harris and Johnston departing on yet another voyage—Harris's fifth—along the ACR tracks, again to Mongoose Lake. They stayed in the same cottage as before and enjoyed remarkable weather. "We only had half a day of rain on our whole Algoma trip... A more wonderful autumn there never was," Jackson reported to Catherine Breithaupt.[52] Johnston was, as usual, the most prolific, managing as many as eight sketches per day.[53] Although he had missed the spring jaunt to Algoma, his presence on this latest expedition indicated a lack of any ill will between him and other members of the group. Events, though, soon led him to distance himself from his colleagues. Jackson later claimed the "bad publicity" over the first exhibition caused Johnston to resign from the Group of Seven: "From an economic standpoint he had difficulty in earning a living from his painting. People were afraid to buy pictures that were the subject of ridicule."[54]

Economic considerations no doubt played a part in Johnston's resignation, though the full story was more nuanced. Not only was there little ridicule over the first Group of Seven exhibition, but also, Johnston suddenly found himself able to sell his work. An invitation to exhibit two hundred of his tempera paintings at the picture gallery in Eaton's in December 1920 resulted in respectable sales. His tempera paintings had a clear appeal to a clientele weaned on the prettified images of painters such as Georges Chavignaud. Toronto buyers proved welcoming to a painter who, as a reviewer observed, was more decorative and pictorial than "his ultra-radical companions."[55] As another critic noted, Johnston's "imaginative temperament that delights in allegories and fairy tales" had rendered him "extremely popular" with the public, and the *Worcester Telegram* praised his "delicately drawn, decorative compositions" with their "very pleasing combinations of colour."[56] Even some of their names—*Rhapsodie, Dream Days, Land o' Dreams*—suggested poetic associations at odds with the more vehement interpretations of the landscape issuing from the ateliers of the Studio Building.

Johnston seems to have worried that further association with a collective billed in some sections of the press as "ultra-radical" might

dent his popularity and jeopardize his commercial prospects among Toronto's skittish picture-buying public. One of his Christian Scientist friends later explained why he left: "It was purely financial. It was because he was supporting his family, and because he felt that he would . . . have to do potboilers, a bit. That he would have to do that in order to support his family. And he knew that there were certain pictures of his that everybody fell for and liked . . . that would sell more."[57]

Whether or not he had anything to fear, much was at stake for Johnston financially by the start of 1921. The last few years had been *anni mirabiles* for him. He enjoyed the active support of Eric Brown and Sir Edmund Walker, he was paid $1,500 for his work for the Canadian War Records Office, he was represented in the National Gallery and he was elected to an associate membership in the RCA. Best of all, much critical praise, and even a little money, had been lavished on his work. In the spring of 1919, around the time of the Algoma exhibition, he left his job as a designer to paint full-time. "I am very glad to hear that you are starting out on your own," wrote Brown, "and I do not think you need have any fear of the future."[58]

Buoyed by his successes, Johnston had ambitious plans for housing his family. After several years of living on Keewatin Avenue, near Yonge and Eglinton, he began designing and building a much larger home. A grand affair on St. Germain Avenue, in an upscale neighbourhood north of Yonge and Lawrence, it would feature a large studio and cathedral windows. With its $22,000 price tag making it nearly fourteen times the cost of the average Toronto house, Johnston evidently reasoned he could not risk alienating the public.[59] He decided to go it alone. The Group of Seven would become a group of six.

4 MULTIPLES OF UGLINESS

ANGING IN THE parlour of Geneva Jackson's Kitchener home was a painting by Cornelius Krieghoff, done about 1847. Called *The Ice Bridge at Longue-Pointe*, it was a classic Quebec scene: toque-wearing habitants in blanket coats crossing a frozen lake in horse-drawn sleighs, with a steepled church and several humble dwellings in the background.

A.Y. Jackson professed a great admiration for Krieghoff, who died in 1872. His grandfather Henry Jackson, a railway engineer who lived at Longueuil, Quebec, seems to have known the Dutch painter. Jackson eulogized him as "the leading pioneer painter of Canada . . . There was something wild in him, something of the coureur-du-bois and of the colonist."[1] This description did little justice to Krieghoff, a velvet-suited, beaver-hatted, flute-playing bohemian whose Quebec scenes owed as much to the sledging and ice-skating paintings of seventeenth-century Dutch artists like Adriaen van de Velde as they did to any real-life toque-and-toboggan excursions along the snowy lanes of rural Quebec. But for Jackson, determined to make Krieghoff in his own image, the Dutchman's work marked the high-water mark in nineteenth-century Canadian art. For many years after his death, in Jackson's view, "painting in this country produced nothing of consequence."[2]

Jackson was dismissive of much Quebec painting apart from Krieghoff. Between 1913 and 1920 he made no secret of his preference for both Toronto's artistic milieu and the Ontario landscape. But by the early 1920s his interest in Quebec suddenly revived. Part of this enthusiasm could have been a simple nostalgia for the vanishing world depicted by Krieghoff in his aunt Geneva's parlour and more recently portrayed with great success in Louis Hémon's novel *Maria Chapdelaine*, published in 1916 with illustrations by Suzor-Coté (Clarence Gagnon would illustrate an even more celebrated edition in 1933). Jackson complained that in rural Quebec "beautiful old types of house architecture are giving way to bungalows and other nondescript forms."[3] Unlike Harris, he showed no interest in Ontario's architecture, but suddenly he was seized with the desire to capture some of these beautiful old habitant dwellings on canvas before the "nondescript forms" of the modern world swept them away.

Jackson's interest in Quebec's artistic scene was further raised by the formation in Montreal of a loose coalition of young (mostly anglophone) painters called the Beaver Hall Group, after the communal studio several of them shared, in self-conscious emulation of the Studio Building, at 350 Beaver Hall Hill. Jackson met some members for the first time in Montreal in the autumn of 1920, a few months after they elected him president. Unhappy circumstances took him back to the city. His sketching holiday in Algoma was cut short when he learned via telegram that his beloved mother—the woman addressed in his letters as "little Marmoo" and "my dear darling little Mater"[4]— was gravely ill. The Beaver Hall Group was led by Jackson's friend Randolph Hewton and included a half-dozen former students of his old teacher William Brymner. Unlike the Group of Seven, this Montreal coalition included a strong contingent of women, including Nora Collyer, Emily Coonan, Prudence Heward, Mabel May, Kathleen Morris, Lilias Torrance Newton, Sarah Robertson and Anne Savage.

An exhibition, planned for early in 1921, was slated to feature the work of eleven men and eight women. Jackson eagerly began conducting interviews on their behalf. "I wish every artist would focus on painting, describing and expressing the region where he lives," he declared in *La Presse*. "In Toronto, seven or eight of us have

endeavoured to depict northern Ontario. I wish they would do the same here in Quebec."[5]

The art-wise people of Montreal must have been taken aback to learn that the landscape of Quebec was not being painted. Horatio Walker had been doing pastoral scenes of the Île d'Orléans since the late 1870s, and Cullen and Suzor-Coté both specialized in scenes of the snow-swathed Quebec countryside. By 1920 the great star of Quebec landscape painting was Gagnon, still only thirty-nine (a year older than Jackson). He had returned to Montreal in May 1919 after living for much of the previous fourteen years in Paris, though he had regularly criss-crossed the Atlantic by steamship to make his studies around his beloved Baie-Saint-Paul. The fact that he moved through Charlevoix country on skis, carrying a gun as well as a palette, should have made him an attractive and sympathetic figure for the painters in the Studio Building. But Gagnon did not meet the house style imposed by the Toronto painters. Although he had long since graduated from the turbid colours of his friend Horatio Walker to a more luminous and high-keyed palette, for Jackson his style was probably still too derivative of French Impressionism.

Jackson's hopes for the Beaver Hall Group doing in Quebec what the Group of Seven were attempting in Ontario ultimately went unfulfilled. His role as president did little to encourage the cultural nationalism or commitment to northern landscapes prevailing in the Studio Building. Heward, Coonan, Newton and Robertson, as well as one of the men, the twenty-eight-year-old Edwin Holgate, were all talented figure painters. The association nonetheless had pleasant repercussions for Jackson since he was immediately attracted to one member, twenty-four-year-old Anne Savage. A former student at the Art Association of Montreal and the Minneapolis School of Art, she had recently begun teaching art at Baron Byng High School in Montreal. It was to be the start of a long and extremely rewarding friendship that would survive, a dozen years later, Savage's rejection of Jackson's rather unconvincing proposal of marriage.

HIS INTEREST IN his home province refreshed, early in February 1921 Jackson set off on a sketching expedition in what he called

Annie Savage sketching at Lake Wonish, c.1917
Private collection

"the French part of Quebec."[6] He went to the village of Cacouna, near Rivière-du-Loup, on the south shore of the St. Lawrence, two hundred kilometres northeast of Quebec City. "A nice cool spot I expect," he wrote to Catherine Breithaupt before departing, "but if Canadians live there, Canadians can paint there."[7]

Although Cacouna was undoubtedly cold in the middle of winter, Jackson was not exactly exploring a rustic and uncharted habitant frontier. Cacouna had been a bustling tourist resort—at least in summer—since the Maison des bains opened in 1845. It was soon followed by other hotels that accommodated the hundreds of tourists who arrived each summer by train and steamboat. William Dean Howells in his 1873 novel *A Chance Acquaintance* described how Cacouna attracted "great numbers of Canadians who flee their cities during the fierce, brief fever of the northern summer."[8] By the end of the nineteenth century, rich Montreal businessmen were building themselves palatial summer homes overlooking the St. Lawrence at Cacouna.

Among them were Sir George Drummond's Gads Hill and Sir Montagu Allan's rambling neoclassical mansion, Montrose. By the 1920s, when Jackson arrived, a six-hundred-room hotel bulked over the river.

Jackson took his ease more simply in the boarding house of a couple named Plourde. By day he roamed the countryside on snowshoes, accompanied by the Plourdes' dog Bustare; evenings were spent playing cards and eating unstinting dinners of chicken, cream and maple syrup. After a few weeks he moved into a small hotel, deserted in the off-season but for its proprietor, M. Lafleur, and his extended family. Bored with their company, Jackson appealed to Albert Robinson, a friend from his days in St. Malo and Carhaix. Robinson enlivened the stilted atmosphere at the Lafleurs by dancing vigorous reels with Lafleur's sister-in-law—"who must at some time have been kicked by a horse, as she had a broken nose and impaired speech"[9]—as one of the daughters bashed the piano.

Jackson and Robinson slogged through the countryside on snowshoes, doing *plein-air* sketches of Cacouna's snow-heaped rooftops. In what seemed an occupational hazard for Canadian landscapists, even after the war, they found themselves mistaken by the locals for spies. Disabused of the notion, the Cacounois nonetheless remained bewildered that the two men should paint old houses and barns rather than Montrose, Gads Hill or the various other villas dotting the area. But Jackson was determined to capture an enchanting Krieghoff world of sleighs, old barns and steepled churches. He returned to Toronto with sketches of Cacouna's brightly painted houses seen from afar and studies of children tobogganing in the shadow of the village church. Lacking the "eerie wilderness" mood of his Ontario paintings, the works show the Quebec landscape as a place of homely comforts and charming domesticity: less a *terre sauvage* than a vision from *Maria Chapdelaine*.

JACKSON'S PREDICTION THAT he and Harris would be the only significant contributors to the 1921 exhibition did not prove entirely true. MacDonald spent part of the winter working on several large Algoma paintings despite the fact that he was hired by Lismer to teach

commercial design at the Ontario College of Art (Lismer later claimed he engaged his friend to "teach artistic lettering with fine artistic insight, quote Whitman, the Bible, and East philosophy").[10] *Gleams on the Hills,* an undulating landscape incandescently green, orange and crimson, he created from sketches done along the Batchawana River in 1918. In another, *Batchawana Rapid,* whitewater in close-up purls over rocks against a background of brilliant autumn colour.

His most remarkable work was *The Solemn Land.* It would be his best effort at expressing his quasi-religious experience in Algoma, the "glimpse of God himself" captured amid the infinity of waters and uprearing eminences of stone. The painting was based on several small sketches done from a vantage point (undoubtedly alongside the ACR tracks) high above a wide expanse of the Montreal River. In the finished work—at 1.5 metres wide by 1.2 metres high, one of his largest—the perspective plummets down a wooded hillside spiked with pinnacles of pine and along the river to a radiant sugarloaf painted by autumn foliage and a revelatory sunlight. He decided to send it to the 1921 OSA exhibition, along with a price tag of $700. It was the most he had ever asked for one of his works.

While MacDonald was painting the paradisal majesty of Algoma, Harris busied himself with more infernal visions. In the spring of 1921 he travelled to what was for him the *terra incognita* of the Maritimes. The poet and fiction writer Charles G.D. Roberts in his 1895 guidebook *The Land of Evangeline and the Gateways Thither* described Nova Scotia as a "wonderland of artists" that offered the painter "subjects which are new both in line and colour."[11] Jackson and Lismer had certainly enjoyed working in this wonderland, producing seascapes and harbour scenes and interesting themselves in quaint Nova Scotia fishing villages. Even the American urban realist George Luks, visiting Nova Scotia in 1919 for a spot of sketching and salmon fishing, was captivated by the coastal landscape and swiftly flowing rivers. In 1920 the Kraushaar Galleries in New York exhibited to great critical applause his series of watercolours featuring the "sparkling radiance" of the moonlight on Lake Rossignol and the rapids gushing past giant boulders at the area called the Screecher.[12] Harris, though, was drawn

to other aspects of Nova Scotia. Typically, he looked for down-at-heel neighbourhoods. What he found in Halifax, in a part of the city not mentioned in Roberts's guidebook, inspired some of his most remarkable urban paintings so far.

Halifax's equivalent of the Ward or Earlscourt was Africville, a group of rundown houses and wooden tenements in the north end of the city, beside Bedford Basin and near the site of the 1917 explosion. The area was settled in the 1830s by descendents of black refugees from the War of 1812 who bought their land from white merchants, including former slave-traders. The inhabitants of the community, soon dubbed Africville, worked as fishermen, stevedores and stonemasons, but by the twentieth century this self-sufficient and hard-working neighbourhood had fallen into a shameful neglect. A railway line cut it in half, a "night soil" disposal pit was situated on its eastern perimeter, and noxious industries—a tar factory, a bone mill, two slaughter-houses—had been allowed to expand into the area. The residents were denied water and sewage, and a 1919 request for fire and police protection was turned down by the Halifax authorities. The result, by the time Harris arrived in 1921, was Canada's worst slum.[13]

Whereas the other members of the Group of Seven saw as their mandate a celebration of Canada's solitary and inhospitable wilderness, only Harris was determined to show brutal and unforgiving urban environments—those corners where Canadians suffered prejudice and economic hardship. He produced two remarkable studies of Africville, *Elevator Court, Halifax* (see plate 33) and *Black Court, Halifax*. The scenes were stark depictions of poverty and neglect. The respectable but weathered-looking clapboard houses planted in fields of mud lack the quirky charm of many of his Toronto neighbourhood scenes. Unlike the Toronto pictures, too, where the buildings are parallel to the picture plane, the Africville paintings feature a spatial recession that draws the viewer into the claustrophobic scene in the same way Skarbina did in paintings such as *The Matthiasstrasse in Hamburg*. Munch-like clouds swim through the background of *Black Court*, and a smokestack looms behind the buildings in *Elevator Court*, an intimidating monolith the omnipotence of which is underscored

by the rays of the setting sun with streaks of cloud and a radiating light whose sharp orthogonals match those of the melting snowbanks and the drab, almost featureless tenements.

Earlier, Harris had celebrated Canadian industry in works such as *The Eaton Manufacturing Building* and *The Gas Works*. A decade on, he was less sanguine about belching chimneys, seeing them as monuments to greed that poisoned both the air and the soul. His poem called "Tall Stark Chimneys," probably written about this time, described "the aspirations of men / going up / in soot and smoke and flame / and God be damned." Another described the "black smoke, poison fumes and mad, intensified fires" of chimney stacks.[14]

The age's most famous painting of tenement life was George Bellows's 1913 *Cliff Dwellers,* a snapshot of bustling immigrants in the slums of the Lower East Side. Harris used the same oblique angles as Bellows but showed none of the laundry-festooned, handbill-plastered, fire-escape-thronged overcrowding that makes *Cliff Dwellers* so enthralling. Harris's Halifax scenes expose a terrible vacuity and stillness from which virtually all animate life is drained (only a few children appear in *Black Court*). Whereas Bellows's painting carried a strong social indictment (it was based on an illustration called *Why Don't They Go to the Country for a Vacation?* done by Bellows for the socialist journal *The Masses*), art historians have been swift— undoubtedly too swift—to discount any reproachful comment in Harris's urban scenes.[15] Although Harris's paintings might not have had the same agenda as the members of The Eight, he clearly wanted his paintings—like his poems—to throw a light on deplorable social conditions in Canada, whether the British immigrants in Earlscourt or the even more impoverished residents of Africville. One of his friends, Doris Mills, claimed such scenes of poverty profoundly distressed Harris, a "wealthy young man" who was "frightfully sensitive." He wanted, she claimed, "to reform the whole world."[16]

Harris's social concerns arose in tandem with his interest in theosophy, whose system of beliefs overlapped with reform movements like socialism and feminism. Their otherworldliness might have made theosophists seem strange bedfellows for radicals and reformers, but in

361

fact many theosophists could be found among the ranks of socialists, suffragettes and other reformers. The socialist and freethinker T. Phillips Thompson joined the Toronto chapter of the Theosophical Society in 1891, firm in the belief that theosophy offered a coherent philosophy for socialism. His magazine *Labour Advocate* published articles with titles such as "Theosophy Considered in Relation to the Great Social Problem."[17] The links were also apparent in the case of the president of the Theosophical Society, Annie Besant, a former worker for the trade union movement and a campaigner against child and female labour. "I do desire to suggest to you," she wrote, "that a profound economic change is absolutely necessary, that unless that change is brought about the civilization cannot last, nor ought it to last with the canker of poverty eating out the very life great masses of our people."[18]

Yet theosophy did not stop at economic change: a job still remained to be done once the canker of poverty was healed. As Besant wrote in a 1912 article called "The Future Socialism," economics alone "are not enough to make a nation prosperous and free. Important as economics may be and are, behind economics lie men and women, and unless these men and women are trained into a noble humanity, economic schemes will fail as hopelessly as any political scheme can possibly do."[19]

The material view of history, for theosophists, was incomplete. They believed human spiritual development—the progress towards a noble humanity—was the true motive force of history. Concerns about the "canker of poverty" led to wider and graver concerns about spiritual impoverishment, or what Harris called "the soul's degradation."

FROM NOVA SCOTIA, Harris went to Newfoundland, its shoreline cliffs and small fishermen's huts the perfect combination for him of rugged scenery and humble domestic architecture. Such views recently drew a number of American painters to Newfoundland. The Post-Impressionist Dodge Macknight (a one-time friend of Van Gogh) painted the huts and fish houses in 1906 and 1909. Then Rockwell Kent, craving "the golden North,"[20] moved to the fishing village of Brigus and created powerful northern seascapes such as *Ice Floes,*

Newfoundland and *Newfoundland Ice* before being deported in 1915 as a suspected German spy.

The fact that Harris went to Newfoundland in springtime suggests he too was hoping to paint icebergs, later to become one of his (as well as Kent's) favourite subjects. Icebergs were prominent in the news in the first months of 1921. A mild winter meant more drifted down to Newfoundland in any year since 1912 when the *Titanic* was sunk. But Harris had no luck sighting icebergs, or at any rate none appeared in his work in 1921. He was awed nonetheless by the majesty of the ocean as seen from Newfoundland's coast. It was around this time that he wrote the poem "The Sea Wind," which contrasted the "soul-stirring voice" of the sea to the crude and ugly civilization built by man, with its "steel and sweat and grime" and the "life plundering rhythm of a billion machines." Not only was the natural world compared favourably to the brutal processes of the machine age, but also the sea was described as the repository "of many bygone, golden ages—/ Wondrous, lost golden ages," that slumbered "beyond the far horizons" and awaited their "radiant resurrections" when men would again become great.

All nationalisms, it has been argued, need the concept of a golden age—a mythical period of heroism and creativity that is key to understanding and recouping a people's "true self."[21] But Harris's poem, with its evocation of a wretched and repulsive civilization turning helplessly to a long-lost golden age, paints a bleak picture of Canada sharply at odds with the optimism and idea of progress underpinning the country's nationalist temper after the Great War.

THE SECOND GROUP of Seven exhibition, which opened on May 6, 1921, featured only eighty-nine works, some fifty fewer than the inaugural show a year earlier. The reviews for the most part were, if unenthusiastic, at least respectful and judicious. Sympathetic critics like Augustus Bridle and Fred Jacob covered the exhibition in, respectively, the *Daily Star* and the *Mail & Empire;* M.O. Hammond wrote it up in the *Globe.* No review appeared in *Saturday Night:* Hector Charlesworth continued to keep his powder dry. The painters were

nonetheless expecting criticism to turn hostile. A few weeks after arriving back from Cacouna, Jackson wrote to Eric Brown that he expected a backlash. "The 7 Group are not loved very much by their confrères," he wrote on April 24, "and it will only be a matter of time before opposition takes a definite form."[22]

Jackson's prediction proved correct, though the first real attack came from a politician rather an artistic colleague. Three days after he wrote his letter to Brown, a Liberal MP from Ottawa named Charles Murphy rose in Parliament to condemn the purchasing policy of the National Gallery. A colleague described the fifty-eight-year-old Murphy as "a fighting Irishman, whose shillelagh very seldom slipped in his hand." To a historian he was a man who "loved, hated and schemed with narrow, provincial intensity."[23] In 1921 his hatred was fixed on Sir Edmund Walker, whom he accused in Parliament of turning the National Gallery into "a haven for special pets" and "a place where genteel graft is handed out."[24]

Murphy objected, like Senator Boyer, to the National Gallery's patronage of the Group of Seven. The three works bought from the 1920 exhibition were merely the latest in a long line of the Gallery's acquisitions from artists in the Studio Building. Brown and Walker were staying true to their word that the gallery would support the younger artists. Four years after Harris made his (unfair) complaint about the gallery ignoring Canadian painting, MacDonald could note with satisfaction that the trustees "have shown themselves keenly interested in the movement."[25]

MacDonald knew whereof he spoke. One of his works had departed for Ottawa each year from 1914 through 1918, and by the time of the first Group of Seven exhibition no fewer than six of his paintings were in the national collection. Every member but Carmichael was represented. Budget constraints and closed doors in 1918 did not prevent the gallery from acquiring Thomson's *The Jack Pine* and *Autumn's Garland* as well as twenty-seven of his sketches. And the patronage was ongoing: MacDonald's *The Solemn Land* was purchased from the 1921 OSA exhibition, along with a portrait by Varley of his son John. It was probably the announcement of these last two purchases—and the

fact that *The Solemn Land* went for $700—that brought the obstreperous Murphy to his feet.

Murphy's complaint, like Harris's in 1914, was unjust. The National Gallery did buy three paintings from the 1920 Group of Seven exhibition, though in the same year it acquired a hundred other works of art. The greatest beneficiary of "genteel graft" was Walter J. Phillips, a thirty-six-year-old English-born painter and printmaker who immigrated to Winnipeg in 1913 (and who would soon become a harsh critic of the Group of Seven's "stark and unfriendly pictures").[26] The gallery purchased a total of twenty-one of his works in 1920, mostly colour woodcuts poetically depicting Manitoba's winter landscape and the area around Lake of the Woods. The English artist Charles W. Bartlett was another artist patronized by the National Gallery in 1920. Sixteen of his woodcuts of India, Pakistan and Japan found their way into the collection. Two habitant scenes by the painter William Raphael (who died in 1914) were bought by the gallery, along with a Krieghoff self-portrait, two works by Mary Cassatt and one by Anders Zorn. Other purchases showed how Brown did not limit himself to the Canadian landscape: scenes of Stonehenge, Derbyshire, Florence, Martigues, a Scottish cathedral, an English inn; all were welcomed into the gallery.

Although the publicity surrounding Murphy's objections failed to usher more visitors through the doors of the Group of Seven's second exhibition (attendance was again under three thousand), it also failed to deter Brown and Walker from further acquisitions. Carmichael's *The Hilltop* was bought for $250, ensuring that he, too, was finally represented in Ottawa. A further two of Jackson's works were bought, *Quebec Village* and *Early Spring, Georgian Bay,* each for $300. The big purchase was Varley's *Stormy Weather, Georgian Bay,* praised in the *Toronto Daily Star* as "a smashing epic in bravura style" and acquired for $750.[27] Its addition ensured that corkscrewed pine trees on granite-bouldered shorelines could vie for space in the gallery with scenes of the Taj Mahal or the Ponte Vecchio.

A fairly typical comment on the 1921 exhibition came from Hammond, a journalist and talented amateur photographer who was once

the *Globe*'s parliamentary correspondent in Ottawa. He believed the small *plein-air* sketches were more convincing—presumably, more "realistic"—than the larger studio-produced canvases, which strove for decorative effects. These little sketches were, he wrote, "full of atmosphere and of poetic stimulus," and the larger works "suggest an imagination running riot in a city studio far away from the sane sway of the out-of-doors."[28] Such were the wages, for Canadian artists, of having a parliamentary correspondent covering their exhibitions. Hammond was even less complimentary in his private diary, complaining that apart from a few paintings such as Varley's *Stormy Weather, Georgian Bay*, he could see little but "multiples of ugliness that weary one."[29]

Most of the visitors seem to have agreed with Hammond. The Toronto collectors remained as reticent as ever towards the painters in the Studio Building. No sales were made apart from those to the National Gallery. The prediction from the foreword to their 1920 catalogue that their work would be accepted only by a "very small group" was holding dismayingly true.

5 BY THE SHINING BIG-SEA-WATER

"WHAT IS A Canadian? Where does one find one? What does he look like; how does he act and react; what is distinctive about him? How does he differ from an American or an Englishman, a Scotsman or Irishman?"[1]

This "puzzling problem," as he called it, was addressed in the spring of 1921 by a twenty-seven-year-old former architecture student from the University of Pennsylvania and an old friend (since their days in Philadelphia and then New York City) of Frank Johnston. Merrill Denison was uniquely placed to tackle the problem. He had been born in the border city of Detroit to a mother who came from Loyalist stock and a father descended from American Revolutionaries. He was also a combination, in what was becoming a typically Canadian mélange, of the backwoods and the boulevards. Recently he had abandoned his architectural practice in New York because office work gave him "a terrible nostalgia for the Ontario backwoods" of his childhood.[2] On his return to Canada he began working with Roy Mitchell at Hart House Theatre, and in April 1921, on the eve of the second Group of Seven exhibition, he presented his play *Brothers in Arms*. A one-act farce set in the Northern Ontario backcountry, it was the theatre's first production of an original Canadian work, and one of the first plays in English Canada to make use of a Canadian setting and characters.

Brothers in Arms was Denison's attempt to probe the all-too-familiar question, "What is a Canadian?" His conclusion was not entirely flattering. The play depicts a young urbanite, Dorothea Browne, whose romantic view of the Canadian wilderness and its handsome frontiersmen has been instilled by American films. In reality, the laconic and unsociable backwoodsmen that she and her time- and money-obsessed husband encounter fall somewhat short of the cinematic ideal. *Brothers in Arms* is a clever satire on the familiar preconceptions of visitors to, and settlers in, the Canadian backwoods. The Wordsworthian nature poetry that inspired (and ultimately failed) the immigrating Susanna Moodies of the nineteenth century is replaced by the enticing illusions of Hollywood—which are, Denison suggests, equally unfaithful to a reality at once harsher and more prosaic.

Brothers in Arms was influenced by Denison's experiences with visitors to his own patch of the Ontario backwoods, the Bon Echo Inn on Mazinaw Lake. Found in the Addington Highlands, 130 kilometres southwest of Ottawa, the inn and its extensive lands were bought in 1910 by his mother, the theosophist and pioneering feminist Flora MacDonald Denison. She and her American husband began billing it (against much competition) as the "most picturesque spot in Canada." Mazinaw Lake's main attraction, Bon Echo Rock, was sublime rather than picturesque: a Gibraltar-like granite cliff, inscribed with prehistoric, red-ochre pictographs, rising one hundred metres above the surface of the lake.[3]

Flora Denison, who died in Toronto during the 1921 Group of Seven exhibition, was a suffragette and a spiritualist, a devotee of both Whitman and Ouija boards. Born in a logger's shanty north of Belleville in the year of Confederation, she was working as dress buyer for Simpsons in the 1880s when a series of visions of her dead sister, Mary—a mathematical prodigy who died at twenty-two—led her onto the misty path of spiritualism. Her curiosity about the supernatural did not stop her from succeeding at more earthly pursuits. She became a columnist for the *Toronto Sunday World,* a member of the Toronto Progressive Thought Club and president of the Canadian

Bon Echo Inn brochure designed by Franklin Carmichael
McMichael Canadian Art Collection Archives

Suffrage Association. In the same year she established the Whitman Club of Bon Echo and then, in 1916, the Whitman Fellowship of Toronto. Three years later, to mark the hundredth anniversary of the poet's birth, she arranged for lines from "Song of Myself"—"My foothold is tenon'd and mortis'd in granite / I laugh at what you call dissolution / And I know the amplitude of time"—to be carved into the face of the cliff above Lake Mazinaw. The massive rock, christened "Old Walt" in the poet's honour, was dedicated to the "Democratic Ideals of Walt Whitman." The inscription even had the posthumous blessing of Whitman himself: the great poet spoke to Denison at a seance in Toronto earlier that year, assuring her that "whatever you do at Bon Echo will be welcomed by me."[4]

Mazinaw Lake's natural beauty and mystical associations made it a natural draw for members of the Group of Seven. Arthur Lismer first met Merrill Denison at Hart House, and the pair worked together, soon

after *Brothers and Arms* was staged, on the set for Shakespeare's *Cymbeline*. The production was commendably avant-garde. Hart House made the first use in North America of the Swiss stage designer Adolphe Appia's neutral screens and projections of coloured light. Denison and Lismer's *Cymbeline* marked the most successful employment of the technique. Influenced by how Gauguin, Van Gogh and other Post-Impressionists used colour to express emotion, Appia experimented with the affective qualities of colour and light. Through the Appia screens, Denison explained, he and Lismer explored "the possibilities of mobile coloured light, which may be changed in chroma, value and hue with the mood of the play, not only on stage but in the auditorium itself."[5] This link between colour and emotion had another source. Besides Appia, they were undoubtedly influenced by theosophical writings such as Annie Besant and C.W. Leadbeater's *Thought-Forms*. First published in 1905, *Thought-Forms* argued that colours expressed emotions or states of being that could be seen projected in "the cloud-like ovoid, or aura, that encompasses all living beings."[6]

In August 1921, little more than a month after *Cymbeline* closed, Lismer and his family were invited by Denison to holiday at the Bon Echo Inn. Flora Denison had worked hard to attract writers and artists, partly in the hope of turning it into a community of like-minded people and partly in the hope of seeing it celebrated in their writings and immortalized on their canvases. Visitors in her time included J.W. Bengough and F.M. Bell-Smith, whose *The Silent Sentinel of the North* had appeared at the 1912 OSA exhibition. Her son hoped to continue the tradition, using his contacts in Hart House and the Arts and Letters Club to lure artists to his Bon Echo retreat. Frank Johnston was already an occasional visitor, sometimes earning his keep by designing the resort's tourist publicity.

370 Lismer and his family took the CPR to Kaladar, where guests were traditionally met by the inn's factotum, an Iroquois named Johnnie Bey. A veteran of the Great War, Bey was "mighty economical of words and hopelessly bankrupt in laughter"[7]—the prototype, perhaps, of the saturnine backwoodsmen of *Brothers in Arms*. A two-hour northward journey was endured before guests were deposited at the log-built inn,

within sight of the granite amplitude of Old Walt. They could fish in Mazinaw Lake, bathe or boat from the wharf, hike in the surrounding hills, berry-pick in the late summer or snowshoe in winter. "Bon Echo is for those who love nature at her best, and who enjoy the great out-of-doors," exclaimed its publicity. Tamer pleasures also awaited. The hotel featured a library (a hollowed-out tree trunk fitted with shelves), a croquet lawn, a tennis court and a crease for quoits. Most of the guests were affluent city dwellers in search of outdoor recreations to enjoy in reasonable comfort. The gentility of the environs was empha-sized by Flora's beloved Cadillac.

Flora once wrote that visitors to Bon Echo were "under no obliga-tion" to join the Whitman Club or read Whitman's poetry.[8] But Lismer, having studied Whitman with the Eclectics and immigrated to Can-ada with a copy of *Leaves of Grass* in his trunk, would not have chafed under such obligations. He was equally well disposed to admire Old Walt. Hardly had he unpacked than Merrill Denison rowed him beneath the enormous cliff. "Arthur Lismer came up today," he wrote to his fiancée, Muriel Goggin, "and I took him out under the Rock . . . a great artist's reaction. He looked and looked and could do nothing but gurgle uneffectual nothings. He is one of the elected because Old Walt silenced his tongue."[9] Silencing the voluble Lismer was indeed a feat.

NO EVIDENCE SUGGESTS that Lismer, Harris or MacDonald, despite their passion for the American poet, ever joined the Whitman Fel-lowship of Toronto. The fellowship boasted a hundred members even though *Leaves of Grass* was banned from the open shelves of the city's libraries, and the booksellers regarded Whitman (so MacDon-ald claimed) as "that smutty old man."[10] But all three painters were highly sympathetic to the Whitmania prevailing in Toronto (and else-where) in the first decades of the twentieth century. The publication in 1902 of the ten-volume *The Complete Writings of Walt Whitman,* a decade after the poet's death, followed by three volumes (1906, 1908, 1914) of Horace Traubel's *With Walt Whitman in Camden,* stimulated exhilarated worship of the sort normally reserved for cult leaders. Flora Denison was far from unique in her belief that Whitman was

a prophet; many regarded him as a demigod offering proof of the evolution of a higher state of consciousness distinctive to the North American continent. Spiritualism met patriotism and nationalism as he became the symbol of a "New America," or what a journal of the day (in an article proclaiming the emergence of a "new spiritual America") called "nothing less than that mystical and spiritual America which centers predominantly about the recognition of the new and hitherto unrecognized powers of Mind."[11]

Since, in Whitman's formulation, America included "Kanada," a number of Canadians regarded their country as part of this new higher consciousness that was sloughing off the outdated European one. One of Whitman's closest friends and most enthusiastic disciples had been the Canadian psychiatrist Richard Maurice Bucke. A graduate of McGill University, Dr. Bucke was a professor of nervous and mental diseases at the University of Western Ontario and subsequently the superintendent of the Asylum for the Insane in London, Ontario. One of the first to hail Whitman's genius, he befriended the poet and ultimately became his biographer and personal physician. Bucke's research into insanity led him to believe humankind was progressing through a "mental evolution" similar to the physiological one described by Darwin. The most perfect example of this progress towards mental and spiritual perfection was, in his opinion, Whitman, herald of a new and heightened phase of perception that Bucke (borrowing a term from his friend and fellow Whitman aficionado Edward Carpenter) called "cosmic consciousness."[12] Dr. Bucke found dedicated readers in the Studio Building. Harris (who was "very, very interested" in Whitman) called Bucke's 1901 magnum opus, *Cosmic Consciousness: A Study in the Evolution of the Human Mind,* the best book ever written by a Canadian.[13]

The painters in the Studio Building might not have held Whitman in the same exaggerated veneration that Bucke did. In a public lecture, however, MacDonald called him "a great specimen of humanity, divinely humane... He draws our attention widely and speaks deeply for all from the soul of Man." As a young man in Toronto he had gone through the ritual of applying to the chief librarian to read *Leaves of*

country north of Superior—and its place in the popular imagination—began to fade. Jackson and Harris therefore encountered the terrain with a freshness and lack of expectation, and with all the evangelical enthusiasm of pioneers and explorers. The terrain astonished them. "I know of no more impressive scenery in Canada for the landscape painter," Jackson later wrote of the North Shore. "There is a sublime order to it, the long curves of the beaches, the sweeping ranges of hills, and headlands that push out into the lake."[20] Harris was equally awed. The pristine skies over Lake Superior possessed a "singing expansiveness and sublimity" that he believed existed nowhere else in Canada.[21] If Algoma was where MacDonald indulged his Edenic fantasies, for Harris the land north of Superior came to hold the deepest spiritual allure, its seemingly primeval purity the flipside of the degradation witnessed several months earlier in Africville.

If the scenery was transcendent, the accommodation, compared with the cozy Algoma excursions, was primitive. "It was a strenuous life," Jackson boasted.[22] That autumn they camped beside frigid lakes, digging a trench in the middle of their tent and filling it with hot embers for warmth. Weasels and whisky jacks invaded the campsites and stole their food. Fortified against the cold and wet by Harris's favourite breakfast cereal, Dr. Jackson's Roman Meal (a mixture of wheat, rye, flaxseed and bran), they plunged into Superior's famously cold waters. Harris remained relentlessly optimistic, even on the many days it rained. "It is clearing in the west" became his catchphrase.[23]

They made numerous sketches, with Harris in particular inspired by the harsh northern landscape. Its stark majesty was imbued, in his eyes, with a numinous significance. Rockwell Kent once wrote that he craved "snow-topped mountains, dreary wastes and the cruel northern sea" because they revealed "wonders . . . a thousand times more eloquent of the eternal mystery than those of softer lands."[24] Doris Mills, a friend to both Harris and Kent, later claimed the two men were "spiritual brothers," and for Harris, too, the North was a place to be celebrated for what he called "mystery and bigness."[25] By the early 1920s he was likewise beginning a quest to uncover the more spiritual dimensions of the snow-capped northern landscape.

Kent's journeys to the rugged continental margins—Newfound-
land, an island off Alaska, Isla Grande de Tierra del Fuego—were
voyages of artistic and personal discovery having little to do with any
kind of nationalism. But for Harris the spiritual was never completely
detached from national or at least geographical considerations. He
believed that viewing a northern Canadian landscape of lakes and
hills allowed an artist to glimpse the universal relations that were the
proper business of the artist. The sight of the Precambrian Shield gave
the Canadian artist "a different outlook from men in other lands." The
clear air, the soil and rocks, the rearing mountains and plummeting
temperatures—these geographical and atmospheric features "move
into a man's whole nature," he wrote, "and evolve a growing, living
response that melts his personal barriers, intensifies his awareness,
and projects his vision through appearance to the underlying reality."

Exactly how and why these unique artistic and spiritual insights
about hidden realities should be vouchsafed to those who made their
way into granite-capped latitudes or onto snowy elevations was not
explained beyond vague references to the "top of the continent" as a
"source of spiritual flow" that radiantly bathed Canadians (or, at least,
the Canadian painter with a CPR ticket and a pair of hiking boots) at
the expense of "the southern teeming of men."[26]

HOW DID ONE paint a physical world that, no matter how alluring,
was merely a surface to be X-rayed by the artist seeking an "underly-
ing hidden reality"?

Back in Toronto, Harris began working in a simpler and more
pared-down style in order to reintegrate form and spirit and discover
the "eternal mysteries" behind the blue-sky-and-basalt natural world.
Sometime in the autumn of 1921 he began work on *Above Lake Supe-
rior,* one of his most important paintings (see plate 35). The flowing
lines and flaming colours that had been the hallmarks of the Hot Mush
painters were replaced by glacial tones and stark forms suggesting—
not the swirling agitation of the earlier canvases—but a magnificent
and revelatory stillness. The expressive energy of his brushwork dis-
appeared as the voluminous shapes of the landscape hardened into

geometric abbreviations. A self-conscious rigour controlled the entire composition. A horizon line split the painting exactly in two, with the top half further sliced into strips of cirrus cloud. In the foreground, bare tree trunks, elongated and alien looking, stretched yearningly upward. Placed with symmetrical precision in the middle of the painting, and dominating the whole, was the mass of a distant hill, a brooding hummock shaped like a truncated pyramid.

Harris's geometrized hill in *Above Lake Superior* was intended as a piece of theosophical symbolism. The sonorous fancies of theosophy had already been translated to the picture plane by Kandinsky and Mondrian, and more recently by Nicholas Roerich, a one-time Ballets Russes set designer (and the man who in the 1930s would persuade Henry A. Wallace to put the pyramid and "all-seeing eye" onto the American one-dollar bill).[27] Pyramids and triangles functioned as important theosophical symbols: the seal of the Theosophical Society featured two interlaced triangles. A series of articles on the "Symbolism of the Triangle" appeared in the *American Theosophist* in 1913, and the opening chapter of Kandinsky's *Concerning the Spiritual in Art* recounted how the triangle represented "the life of the spirit" (and triangles and acute angles are scattered through Kandinsky's compositions). The apex of the triangle marked, for Kandinsky, the "joyful vision" of a spiritual and artistic avant-garde, the base an uncomprehending multitude in need of elevation.[28]

Although not yet a member of the Toronto Theosophical Society, for several years Harris had been, as his friend Doris Mills put it, "studying the masters"—theosophists such as Blavatsky and Besant as well as Rabindranath Tagore and various other "eastern Johnnies." He even stopped smoking and drinking alcohol. "He wanted to be so pure," claimed Mills, "that the wings of God would sweep straight through him and find no obstruction at all."

Theosophy was a source of solace to Harris. Although recovered from his breakdown, he was still deeply troubled. Mills sensed a "great sorrow" beneath his outward cheer. About this time she wrote a poem, "To LSH," catechizing his "exquisite agony of sorrow" and the "pain of the world beating and pulsing" within him. Although the pain was

partly his distress at the economic and spiritual deprivation of places like Earlscourt and Africville, an increasingly anguished personal life also darkened his mood. By the early 1920s he and Trixie had been married for more than a decade. During that time the "nice, gay little thing" (as Mills patronizingly called her) changed little in her outlook and priorities. While Harris went "deeper and deeper and deeper . . . Trixie just stayed where she was," according to Mills. "She didn't grow. She was just a nice, nice woman but she didn't grow, and she couldn't possibly follow him. She couldn't follow what he was doing. She couldn't follow what he was thinking. She couldn't do it, and it meant that at home there was no one very close to him . . . not really close."[29]

Harris found like-minded companionship with Mills and her husband, Gordon, an amateur writer and musician who was a member of the Arts and Letters Club. He also enjoyed the friendship of his old school friend Fred Housser and Housser's beautiful and talented wife, Bess, a painter and journalist. He painted Bess Housser's portrait early in 1920, when she was thirty, and later that year displayed it at the Group of Seven's first exhibition. It was probably as he worked on this portrait, if not earlier, that he fell in love with her. He never sold the portrait or showed it in public again, and his feelings for Bess likewise needed to be concealed from the public gaze: Fred Housser was his friend, after all, and divorce in Toronto in the 1920s was almost unthinkable. Although the divorce rate in Canada had risen slightly since the first three decades of Confederation witnessed fewer than ten cases a year, the number was still statistically minuscule.[30] Often it was necessary to prove adultery or immoral behaviour before a divorce could proceed. Such requirements involved private detectives and, inevitably, journalists. A decade later, these laws resulted in farcical scenes: private detectives wielding flashlights burst into the Toronto apartment of the man with whom Dr. Frederick Banting's wife was having an affair. As a friend of Dr. Banting observed, the unseemly divorce action sent the Nobel laureate, at the time the most famous man in Canada, tumbling from the pinnacle to the gutter.[31]

For Harris, divorce would have been socially awkward and embarrassing; not the least of the victims would have been his ten-year-old

son. And so, as Mills (also a close friend of Bess) wrote in her poem, he carried on with his heart "bleeding within him."

AFTER LEAVING THE Group of Seven, Frank Johnston put geographical as well as artistic distance between himself and his former colleagues. In the summer of 1921 he moved to Winnipeg to become principal of the Winnipeg School of Art, founded eight years earlier. The perceived apostasy of his departure rankled his former colleagues. According to Doris Mills, the other members "were very disgusted about him" because they believed his motives were financial. "It seemed not idealistic enough."[32]

At times, though, it must have seemed that Fred Varley, not Johnston, was the absent member of the Group of Seven. Reviews of their shows sometimes failed to mention his name, and he in no obvious way shared the regnant nationalism of some of his colleagues. *Stormy Weather, Georgian Bay* was an anomaly: since returning from Europe he had been concentrating on portraits, not forests and lakes. Besides his portrait of Vincent Massey, he completed those of Massey's father, Chester, and father-in-law, Sir George Parkin; of Barker Fairley; of Fairley's wife, Margaret; of a woman named Ethel Ely, the wife of a Toronto haberdasher; and of a working-class Yorkshire immigrant named Mrs. Goldthorpe, whom he outfitted in a red kerchief and open-necked red blouse so that she could masquerade as an Augustus John–style gypsy in a work called *Gypsy Blood*.[33]

Regular commissions notwithstanding, Varley's domestic and professional life remained as precarious as ever. No sooner was *Stormy Weather* sold in 1921 than the painter faced turbulent weather of his own. Doris Mills claimed that whereas the rest of the Group of Seven were "angels, morally," Varley "was much more of a libertine."[34] Shortly after Maud Varley gave birth to their fourth child, his libertinism came to light: intercepting a letter from London, Maud discovered her husband's infidelity with Florence Fretton. She was deeply distressed but ultimately powerless (as Harris was discovering in the midst of his own marital unhappiness). Indeed, as a woman with little money, and as an immigrant with few family connections in Canada, she was

379

far more powerless than Harris. Varley confessed his "follies & indulgence," claiming that Florence was the first person with whom he had "besmirched" himself.[35]

The couple resolved to carry on as before. Within the year, using Maud's modest inheritance, they arranged a mortgage on a house on Colin Avenue, a few blocks north of Upper Canada College, on the fringes of Forest Hill. Calm did not descend on the household. Whatever money Varley earned—sometimes sizable amounts from his society portraits—quickly disappeared. Sheets were tacked to the windows for want of curtains, the children ran about "like wild things," and "tremendous parties" at the house witnessed both Varley and Maud drinking heavily despite the fact that Maud was a Christian Scientist.[36]

Varley's artistic career remained thwarted. His champion, Barker Fairley, fretted over his slim chances for success in Canada. "I have come to the conclusion that Varley's prospects as a painter are just as precarious as they were ten years ago," he wrote to Eric Brown, "and that there seems nothing for it but to try to push him out of Canada into London or New York. The support Varley received here in the past two or three years . . . all reduces itself to the enthusiasm of a handful of people, including yourself, whose united efforts do not seem to suffice to carry the man indefinitely." The portraits for the Massey family brought money and acclaim, but Fairley recognized the limited market for his friend's skills since "his work is not unoriginal enough for commissions to come in unsought."[37]

Fairley did manage to find work for him. By the end of 1921 Varley was at work on portraits of such worthies as Irving Heward Cameron, a recently retired professor of surgery at the University of Toronto. Known as the "philosophical surgeon," Dr. Cameron had served overseas with John McCrae, with whom he made translations from Latin and Greek.[38] A more debonair sitter was Huntley Gordon, the Montreal-born star of Hollywood films such as *The Million Dollar Dollies, The Frisky Mrs. Johnson* and *My Lady o' the Pines.* As if to compensate for his folly and indulgence, Varley also began a series of portrait sketches of Maud and the children.

THE GROUP OF Seven's tour of American art museums ended in
January 1922 in Muskegon, Michigan. Once known as the "Lum-
ber Queen of the World," Muskegon made an apt location to conclude
an exhibition featuring so many scenes of Canada's timber-producing
regions. In Muskegon, as elsewhere, from Worcester to Moose Jaw,
the painters earned their reputation as modernists. The reviewer for
the *Muskegon Chronicle* praised the "crudeness" and "ruggedness" of
"these big splotchy things" as evidence that the Group of Seven were
"radical in their methods" and had "seceded from the older schools."
Gratifyingly, he declared that the thirty paintings "make evident with
a loud clear voice that Canada has something to say in the realm of
painting."[1]

The American tour may have been a critical success, but after fif-
teen months of travel, the hoped-for sales to American collectors
and museums failed to materialize, and all but one of the paintings
returned to Toronto. The lack of sales to institutions should not have
been surprising or discouraging. American museums were not yet
committed to buying Post-Impressionist art—even works by Cézanne
or Matisse, or homegrown artists such as Marsden Hartley—in any
quantities. Although the first Cézanne entered an American public

collection (the Metropolitan Museum of Art) in 1913, almost no other examples of European or American modernism were purchased by American museums prior to the early 1920s.[2] It was in fact a rare coup that Lawren Harris's *A Side Street* was bought in 1921 by the Detroit Institute of Arts. But it proved the lone sale (and even it was eventually rejected, repatriated across the Peace Bridge in 1956). Commercial prospects were scarcely better in Canada, apart from those to the National Gallery or a few cognoscenti such as Dr. MacCallum and Vincent Massey.

Casting a cold eye on this dearth of commercial success, Hector Charlesworth pronounced for the first time on the Group of Seven as a collective. The artists had only themselves to blame, he wrote, because "they keep on producing stuff that people will not buy." People did not want to hang on the walls of their homes pictures of swamps and slums: they wanted "horses hitched to a logging sleigh; the familiar old snake fence, with a woods in the distance."[3] In fact, this appraisal was too sanguine about public tastes, since few Canadians wanted images of Canadiana of any kind on their walls. In 1910 Frances Anne Hopkins had lamented, "I have not found Canadians at all anxious hitherto for pictures of their own country."[4] A decade later, little had changed. In the early 1920s, only 2 per cent of all paintings sold in Canada were done by Canadian artists.[5]

LACK OF COMMERCIAL success or international impact failed to bring about a change in tactics. By 1922 the painters had settled into what had become an undeviating routine. In March they showed a small number of works at the OSA exhibition, followed by a larger display for the third Group of Seven exhibition in May. The foreword to their catalogue repeated many now-familiar doctrines about challenges to convention, new methods, the impossibility of a European style capturing the autumn pageantry of our northern woods, and so forth.

Two new invitees appeared at the group's 1922 exhibition, but neither did anything to expand the collective's profile or heighten its aesthetic power or credentials. They were merely made up of two

Catalogue for the third Group of Seven exhibition, 1922
McMichael Canadian Art Collection Archives

friends, the painter and printmaker William J. Wood and the historian and teacher Percy J. Robinson, an amateur painter and a member of the Madawaska Club. Their inclusion was disappointing in view of the calibre of other painters who received no invitations. Florence McGillivray, now living in Ottawa, would have been an inspired choice to enhance the exhibition. Likewise Peter Sheppard, a gifted painter of wilderness landscapes, maritime scenes and majestic Toronto cityscapes. The latter in particular, in works like *The Building of the Bloor Street Viaduct* (1916) and *The Arrival of the Circus* (1919), marked him out as a rare talent, well versed in modern painterly techniques and possessed of a visionary approach to the urban landscape.

Nor were invitations issued to any of the Beaver Hall painters, despite the critic for *La Presse* praising them (the women in particular) as the most exciting and accomplished artists showing work in

Montreal. The approach of these Montreal painters, who eschewed nationalism in favour of individual expression, probably disqualified them from the holy-old-mackinaw tone of the Toronto shows. In any case, no safety rope linked Beaver Hall Hill and the Studio Building. Perhaps unsurprisingly, there was to be no breakthrough for the Group of Seven in 1922. Attendance was much the same as in previous years—some 2,800 people—and no sales were made.

The reviews were equally predictable. The *Mail & Empire* was generous and supportive, stating that the artists "have at least attempted to depict something new in a new manner." Perennial detractors voiced their usual demurrals: "the methods of the theatrical scene painter" (Charlesworth) and "what happened to the fence in the rear of the home of Mr. Two Dimensions during the coal strike" (the *Toronto Telegram*'s description of one of Harris's shack paintings).

The most telling and disturbing complaint came from a longtime ally, Augustus Bridle, who lamented the lack of individuality among members: the painters were, he noted, "becoming rather more alike." Bridle also pointed out the sometimes cursory efforts. With a one-year-old daughter and a new full-time job as a designer at Sampson-Matthews, Carmichael enjoyed none of the same leisure to travel and paint as Jackson or Harris. He exhibited only a single work, *Leaf Pattern,* which showed him to be, Bridle claimed, a "roving poet who has very little time to get the big, serious things." Varley meanwhile "seems moody and impatient," uninterested in "most of the things seen in the north."[6]

Two years into their great adventure, there was already the need for an infusion of fresh blood that the members seemed incapable of administering.

384 THE FOREWORD TO the 1922 Group of Seven catalogue included a wonderful rhetorical flight: "In the midst of discovery and progress, of vast horizons and a beckoning future, Art must take to the road and risk all for the glory of a great adventure." All roads in 1922 led, though, to the familiar destinations, underlining the essential regionalism of the painters. Harris spent the summer of 1922 at his property

in Allandale before returning to the North Shore of Lake Superior, this time with Carmichael. They made their way to Port Coldwell, near the southern edge of Lake Nipigon, where the Prince of Wales camped three years earlier. Lismer returned to the Bon Echo Inn (after continuing his association with Merrill Denison by acting in his most recent play, *From Their Own Place*, staged at the Arts and Letters Club). Jackson painted in Quebec in the early spring and Georgian Bay in the late autumn.

MacDonald went farthest afield, spending six weeks near Petite Rivière, Nova Scotia. He visited his old friend Lewis Smith, the newly appointed head of the Art Department at Acadia Ladies' Seminary in Wolfville. He tried painting seascapes but—unexpectedly for an artist who executed rapids and waterfalls with such dexterity—found the sea hard to capture. "I have been attempting to sketch the waves, but find this very difficult," he wrote to his wife, Joan. He was hoping to find a "heroic subject" but instead, like Jackson in Quebec, concentrated on humbler scenes of human occupation.[7] Different from the forbidding scenes of Africville painted by Harris a year earlier, MacDonald's Nova Scotia paintings showed a quiet habitation and bustling industry: the entrance to the harbour, a bridge spanning the river, a team of oxen hauling a load of hay, a church by the sea. If some of these images seemed to peddle the myths and clichés of Longfellow's *Evangeline*, they did so with good reason: MacDonald was preparing to illustrate Grace McLeod Rogers's *Stories of the Land of Evangeline* for McClelland & Stewart.

Harris was likewise at work on a book illustration for McClelland & Stewart—in his case, the endpapers for a work of his own. The autumn of 1922 saw the publication of his collection *Contrasts: A Book of Verse*. In publishing poetry, he was straying onto ground equally fraught with controversy. In Canadian literature as in Canadian painting, modernists and the old guard were at daggers drawn. Conservative critics abhorred free verse, the first Canadian example of which, Arthur Stringer's *Open Water*, appeared in 1914. In language worthy of a Group of Seven catalogue, Stringer argued in his preface against the "necrophilic regard for . . . established conventions,"

and claimed the purpose of poetry was to "elucidate emotional experience."[8] Unsurprisingly, many critics took a dim view of such developments. *Saturday Night* urged Stringer not to turn his back on metre and rhyme, and elsewhere literary modernism and free verse were indignantly denounced by Canadian critics as "intellectual Bolshevism" and "the foetid breath of decadence."[9]

In *Contrasts* Harris proved to be a modernist in both style—all of the poems are in free verse—and subject matter: most deal with the urban degradation and isolation explored by earlier poets such as Baudelaire and T.S. Eliot. Toronto the Good became, in Harris's poetry, a "pestilential city" ("City Heat"), a place "ever shrouded in smoke" ("A Note of Colour"), where "garbage-reeking lanes" were "littered with ashes, boxes, cans, old rags" ("A Question"). Like Eliot, whose *The Waste Land* was published that same autumn, Harris reveals how the sordid modern metropolis destroys the old rituals and rhythms of the natural world, as the inhabitants—what Harris calls "blind, driven people" who swarm to "the daily grind"—are compelled by irrational machine-age forces they cannot understand. The result is fragmentation, isolation and a spiritual death in the age of the soul's degradation.

Although Harris's paintings of urban poverty were often garishly bright, the colourful swirls and charged brushwork of his canvases gave way in *Contrasts* to a pared-down language of pained but detached observation of urban blight. The critics did not warm to his approach. He received a rebuke in *Canadian Forum*—a publication that usually defended modernism—from none other than Barker Fairley, who lamented the "appalling laxity of the *vers libre* habit, now rife on this continent" that had tempted Harris into publishing "an extremely bad book of verses." Almost as harsh an assessment came from an even more esteemed literary figure, Lucy Maud Montgomery. "I liked a few things in it," she wrote in a letter to her friend Ephraim Weber. "But the straining after originality displayed by so many modern writers often reveals the poverty of their thought . . . *Free* verse strikes me as *laziness*."[10]

Montgomery, in her Anne and then her Emily novels, depicted a Canada—pastoral and picturesque, held together by bonds of family

and community—very different from both Harris's portraits of craggy wilderness solitudes and his scenes of urban isolation. He and the "Queen of Canadian Novelists" (as she was christened in 1923)[11] may well have met a year earlier, when Montgomery—whose own (dutifully rhyming) collection of verse McClelland & Stewart had published in 1916—attended a dinner at the Arts and Letters Club in honour of her fellow PEI novelist Basil King. What she made of Harris's paintings, a world away from the "green, untroubled pastures and still waters" of Avonlea, has not been recorded.[12]

THE FIRST FEW years of the Group of Seven's existence had seen little in the way of offensive and malicious reviews. Jackson's 1921 prophecy that opposition would arise threatened to go unfulfilled. Controversy arose, however, as in September of that year the National Gallery opened its doors for the first time since the war. It moved back into rooms in the Victoria Memorial Museum vacated after the 1916 fire on Parliament Hill. Once again it shared quarters with the dinosaurs from the Canadian Museum of Nature. A few years later, Lismer described the premises as a "pitiful ramshackle," and E. Wyly Grier claimed the building looked "as though it might fall down and bury its own pictures."[13]

Sometime after the reopening, Charlesworth paid a visit to Ottawa. It was not the ramshackle state of the building that offended him so much as the contents. Indignant at what he saw, he wrote an article in *Saturday Night* arguing that the Group of Seven were overrepresented. Eric Brown and Sir Edmund Walker were devoting far too much wall space, he believed, "to experimental pictures of unproven quality."[14]

When Charlesworth's article appeared in early 1922, the National Gallery owned some fifty paintings by Thomson and the Group of Seven. Even more cause for alarm, for opponents like Charlesworth, was the statistic that in the years 1920 and 1921 the Gallery spent $5,400 on paintings by the Group of Seven, compared with only $7,500 by all others.[14] For two consecutive years, that is, almost 42 per cent of the gallery's entire acquisitions budget was devoted to acquiring work by a group of painters who, despite wide and assertive

promotion, had singularly failed to motivate other patrons or muse-ums to reach for their chequebooks.

This "genteel graft" (as Charles Murphy called it) was about to end. Several months before Charlesworth's article appeared, a new regime came to power in Ottawa. In December 1921 Mackenzie King's Liber-als defeated Arthur Meighen's Conservatives and formed a minority government. King was not at all sympathetic to modern art. "The modern art," he later wrote in his diary, "is a perversion . . . Nature robbed of her shades and moods . . . decayed trees made to do duty as works of Art." He had nothing but revulsion for the Group of Seven and their "so-called 'Canadian Art'—futurist impressionist stuff." He found Harris and Thomson especially repellent: their landscapes looked like the work of "a man suffering from leprosy."[15] He much pre-ferred the healthier-looking trees of Homer Watson and Carl Ahrens, both personal friends. Ahrens's landscapes he called a "burst of sunshine."[16]

Coming to power in 1921, King could not help noticing that Ahrens was still unrepresented in the national collection. According to Ahrens's second wife, Madonna, Sir Edmund Walker felt a "bitter enmity" towards the painter, vowing never to allow any of his work through the doors of the National Gallery—possibly as revenge for Ahrens's 1916 attack on MacDonald and Thomson.[17] Despairing of his prospects, Ahrens had even left Toronto a year earlier to live and work at the art colonies in Woodstock, New York, and then on the Massa-chusetts coast at Rockport.

King despised both Walker ("a very vain man, full of himself & what he has done") and Brown ("a conceited ass, a bit of a fool as well").[18] Both remained in their positions, but within a month of King's election three new trustees—Auguste Richard, Newton Mac-Tavish and Warren Y. Soper—were appointed to the board of trustees of the National Gallery. MacTavish, the editor of *Canadian Maga-zine,* was a former member of the Canadian Art Club and a personal friend of King. Soper was an even closer and more long-standing friend. Founder of the Ottawa Electric Railway Company, he lived in a Rockcliffe Park mansion so grand it would in due course become the

residence of the American ambassador. Among his expensive art collection were a number of paintings by Ahrens.

When, therefore, King wrote a familiar litany in his diary in October 1922—"We must follow a plan of encouraging Canadian art"—he was not referring to the "futurist impressionist stuff" produced by the Group of Seven. That same month he personally intervened to force the board of trustees to purchase an Ahrens. "If Sir Edmund Walker doesn't fall in line," he wrote menacingly in his diary, "we will ask his resignation as chairman of the Art Advisory Committee."[19] Walker duly fell in line, and a few weeks later the Gallery took shipment of a woodland scene called *The Road.* The painting cost $2,500, more than double the price ever paid for work by a member of the Group of Seven. Sensing opportunity, Ahrens promptly upped stakes in Rockport and moved back to Toronto.

To King's political muscle was added Charlesworth's continued attacks in *Saturday Night.* In December 1922, eight months after his first swipe, Charlesworth again launched himself at the National Gallery. He reproached Brown for neglecting many "worthy" artists in favour of the "experimental" Group of Seven, producers of "depressing and disappointing" works of art. A few weeks later he accused the gallery's "apparent obsession in favour of one school of Canadian painting" of "destroying the individuality of young artists."[21]

Neither criticism was entirely just (Brown's task of assembling a representative national collection was surely an invidious one). Certainly the Gallery was heavily promoting the Group of Seven across the country and abroad as well as purchasing examples of their work, but it was not, despite its limited budget, neglecting other artists. Soon after reopening it staged an exhibition of the work of the Ottawa-based teacher and painter Peleg Franklin Brownell, and in 1922 works were purchased from established artists such as Suzor-Coté and Ernest Fosbery as well as the timid and reclusive Beaver Hall painter Emily Coonan, recipient of the first National Gallery Travel Grant. It bought the Confederation-era watercolours *Chaudière Falls, Lake Champlain* and *Mouth of the Kaministiquia* by Sir Daniel Wilson, the first president of the University of Toronto. Other landscapes were

389

acquired from painters—Frederick S. Coburn, John Y. Johnstone—who worked in more traditional Tonalist styles that could not have alarmed even Mackenzie King.

Debate did not take a rational turn as the rebarbative Jackson entered the fray. Ignoring the physical travails and cross-country expeditions of his many predecessors, he justified the group's canvases on the basis, as usual, of the pioneer-style get-up-and-go that had supposedly gone into their production. "We have spent weeks in the bush, camping till the snow drove us out; lived in tents and shacks and trailed all over the north country to find out how to interpret our own country in terms of art."[22] Charlesworth reasonably replied, "To hold that artists like the Homer Watson of his prime, Carl Ahrens, Archibald Browne and Suzor-Coté, who interpret with poetic truths the moods of the older and more pastoral sections of Canada, are less worthy and less national in spirit because they do not camp out in the late autumn and paint the wilds in a harsh, strident mood is to talk nonsense and very misleading nonsense at that."[23]

But for Jackson, as ever, latitude and Fahrenheit were the measures of quality and integrity in Canadian painting. And, as ever, his argument was a specious one. Sir Daniel Wilson's luminous watercolours might have looked anodyne fifty years after composition, but they were the products of long canoe trips through territories as yet unopened by the CPR or the ACR: well-appointed cabooses were not transport options when Wilson painted them in the 1860s.

THE STAKES IN this debate between the Group of Seven and their detractors were raised after plans were announced for a 1924 British Empire Exhibition in London. According to its promoters, the exhibition was intended to open new markets, foster trade and make "the different races of the British Empire better known to each other."[24] A 216-acre site was purchased in the North London suburb of Wembley, and work began on palaces of engineering and industry. There was also to be a "Palace of Arts" where the participating dominions and dependencies would display their finest artistic wares. Canada would be allowed to show a total of three hundred paintings, pieces of sculpture and other artifacts.

The task of selecting Canadian works for foreign exhibition was usually, though not always, assumed by the Royal Canadian Academy of Arts. Founded in 1880 at the behest of the Marquess of Lorne, the RCA was meant to be the custodian of the fledgling nation's visual heritage. It held juried exhibitions and drawing classes, it offered prizes, and each newly elected academician was obliged to deposit a diploma work in the National Gallery. Although one president protested that "it is no part of my duties," the RCA usually presided over the selection of works to represent Canada abroad.[25] It took charge of Canada's artistic offerings at the World's Columbian Exposition in Chicago in 1893, at the Pan-American Exposition in Buffalo in 1901 and at the 1904 World's Fair in St. Louis. The Canadian government, however, appointed committees to oversee the Canadian representations at a number of other foreign exhibitions.

In 1923 Eric Brown seized the initiative on behalf of the National Gallery. He contacted the British authorities and asked for the gallery to be given responsibility for Canada's display at Wembley. The British and Canadian governments agreed, funds were set aside for the task, and Brown and his trustees set to work assembling a jury. Realizing they had been outmanoeuvred, the RCA fought back under its new president, the Montreal-based portrait painter George Horne Russell. It passed a motion claiming—not entirely truthfully—that for the previous forty years it alone had exercised the function of choosing paintings, while Horne Russell protested that "laymen" rather than professional artists were arrogating the RCA's powers and privileges.

Charlesworth predictably was aghast at these developments. He published an article in *Saturday Night* fretting that the National Gallery would make predominant "the younger and more freakish schools of landscape." The walls of the Canadian display would be covered, he feared, with "crude cartoons of the Canadian wilds."[26] One of his main objections to the Group of Seven was that they ignored the lyrical subjects traditionally favoured by Canadian landscapists: the misty cascades, the knotty oaks, the sentimental evocations of a vanished or vanishing rural world. Instead they chose to depict, in a hard-edged style, an uncongenial topography of beaver swamps, fire-ravaged hillsides, and icy lakes. Bell-Smith and O'Brien had painted the Rockies to

promote them as a tourist destination, but the works of the Group of Seven would have, Charlesworth believed, quite a different effect. He complained that the freakish landscapes would be a "bad advertisement for this country" and that the Department of Immigration and Colonization should "intervene to prevent such a catastrophe."

Charlesworth was deadly serious. Canada traditionally used world's fairs and other international expositions to lure immigrants into the country.[27] As John Sylvester MacKinnon, director of the Canadian Industrial Exhibits for the Wembley exhibition, declared, "We want to show the people of the world that Canada is a good place in which to live."[28] Mackenzie King expressed hopes in the British press that Canada's display at Wembley would make clear to the world "something of the capacity of Canada, not only to furnish new avenues for profitable trade and investment, but also to provide homes for countless numbers from the Old World."[29] (Jackson once joked that prospective settlers should be "confronted with a Group of Seven show as a means of weeding out the weaklings.")[30]

Brown and Walker were unrepentant. They hoped to stage a display that, liked or loathed by the British (and by potential immigrants), would at least reveal that Canadian art was—as they believed the Group of Seven's paintings to be—distinct from that of other lands. As Walker wrote in his diary, "I feel sure that whether our modernists are liked or not, the existence of a form of plastic art which is distinctly Canadian must be admitted."[31]

The composition of the jury should have reassured Charlesworth and Horne Russell. A number of younger artists were included: Lismer, Randolph Hewton and the American-born sculptor Florence Wyle. But the others, all five of them members of the RCA, were drawn from among the most eminent figures in Canadian art. There was Horatio Walker (winner of numerous international medals), Clarence Gagnon, Franklin Brownell, Frederick Sproston Challener (credited in 1913 with having "perhaps the keenest sense of light and brilliancy of colour of any of the Canadian painters"),[32] and the portrait painter E. Wyly Grier, president of the OSA between 1908 and 1913. Although he painted in a conservative style, Grier was a friend of Brown, a fellow

Christian Scientist who once called him the "wise head of the tribe."[33] Horne Russell himself sulkily refused the offer of a seat on the jury.

As the jury set to work choosing the selection of paintings for Wembley, the members of the Group of Seven must have been apprehensive. They would be prominently featured in the display: there could be no doubt of that. But success at Wembley would be vital for the group. With no new group exhibitions planned for Toronto in either 1923 or 1924, the British Empire Exhibition offered one of the few stages—and a major one at that—on which they might prove themselves.

IN THE MIDST of these debates, the painter who already made his mark in London, however ephemerally, was suffering his habitual difficulties. Augustus Bridle wrote in his review of the 1922 Group of Seven that Varley seemed uninterested in most of the things seen in the north. But one year later, in the summer of 1923, Varley was forced into a sudden and intimate acquaintance with Shield country. Evicted from their Toronto house for missing mortgage payments, he and his family took refuge in a tent in the Kawartha Lakes. Their rescuer—the man who offered the tent—was E.J. Pratt, the endpapers for whose collection of poetry, *Newfoundland Verse,* Varley had illustrated several months earlier.

Varley's financial problems stemmed, according to Sir Edmund Walker, from the fact that he worked "fitfully instead of industriously."[34] But Varley had been more industrious than fitful in 1922 and 1923. With portrait commissions few and far between, he had taught summer school for the OCA and accepted numerous commercial commissions. He also turned his hand to book illustration for The Ryerson Press.

Varley's design work for The Ryerson Press brought him into contact with the kind of cultural nationalism prevailing in the Studio Building. Lorne Pierce, Ryerson's chief editor since 1920, was hoping to do in the realm of literature what the Group of Seven was attempting in the visual arts. An ordained Methodist minister from Ontario, he had taught summer school in Saskatchewan in 1909 and 1910. His experiences on the immigrant mosaic of the Prairies—so different,

E.J. Pratt, *Newfoundland Verse* (Toronto: Ryerson Press, 1923)
Endpapers designed by F.H. Varley
McMichael Canadian Art Collection Library

with its Mennonites, Doukhobors and black farm labourers, from the Anglo-Saxon Ontario of his youth—convinced him of the need for a distinctive Canadian literature to shape a national identity that might encompass and indoctrinate these hundreds of thousands of newcomers. A national literature could further serve, he believed, to heal the rift between English and French Canada. The introduction to his 1922 anthology *Our Canadian Literature* asserted (with sublime optimism) that English and French Canadians "speak two languages, yet we have but one passionate loyalty—Canada!"[35] Inspired by the nationalism of the Group of Seven, he turned, naturally enough, to the painters themselves to design and illustrate his books. With MacDonald busy working on McClelland & Stewart's list (Bliss Carman's *Later Poems* in 1921, Pauline Johnson's *Legends of Vancouver,* Isabel Ecclestone Mackay's *Fires of Driftwood* in 1922 and Rogers's *Stories of the Land of Evangeline* in 1923), Pierce enlisted the services of Varley.

Pratt's poetry captured what Augustus Bridle would have called the "essential virilities" of life in a vital and dangerous northern land by the sea. Like Lampman and Campbell, Pratt was haunted by the harshness and hostility of nature—the fateful animus he glimpsed in the sinking of the *Titanic* off Newfoundland in 1912 (the subject of one of his later poems) and the drowning of his friend and teacher George Blewett four months later at Go Home Bay. The first poem in *Newfoundland Verse*, "The Ice-Floes," grimly imagined a real-life tragedy whose aftermath he witnessed in 1898, when ss *Greenland* steamed into St. John's with its flag at half-mast, its decks stacked with the bodies of twenty-five dead seal hunters, and another twenty-three missing. His poem describes how a day of killing seals ("From the nose to the tail we ripped them, / And laid their quivering carcasses flat / On the ice; then with our knives we stripped them") ended with a shrieking gale, gusts of snow, desperation, madness and, finally, mass death.

Newfoundland Verse appeared to great critical acclaim in the spring of 1923. Calling it a welcome change from the "usual fifth-rate, airy, fairy stuff" that passed for poetry in Canada (presumably, the lyric poetry of Bliss Carman and others), one critic hailed it as "vigorous, red-blooded verse."[36] With one poetic bound, forty-one-year-old Ned Pratt, a lecturer in English with anemia, a heart murmur and a doctoral dissertation on Pauline eschatology, landed four-square among the virile makers of Canadian culture. Like them, he was helped along in his efforts to describe what he called a land "not charactered . . . by History's pen" by an acquaintance with an international avant-garde, in his case the free verse and Imagist poetry of Ezra Pound and T.E. Hulme.[37]

Pratt and Varley already knew each other from the Arts and Letters Club. Varley's ongoing behaviour—his drinking, his temper, his libertinism—"caused a certain amount of estrangement" (according to Mills) from other members of the Group of Seven.[38] He appears to have found in the Newfoundland-born Pratt a more reliable and congenial friend than he had in the group. Pratt came to the rescue, at any rate, when the bailiffs appeared at the door of the Varley home on Colin Avenue. A year earlier, Pratt and his wife had purchased a

cottage in Bobcaygeon, 170 kilometres northeast of Toronto in the Kawartha Lakes, where Pratt enjoyed shooting ducks and playing golf. On one side of his property was his friend, the poet Arthur Phelps, author of *A Bobcaygeon Chapbook* and the man who first introduced him to free verse and Imagism; on the other was a vacant lot in which Varley and his family—consisting now of four children between the ages of two and thirteen—were invited to pitch a tent.

Just as MacDonald, a devotee of Henry David Thoreau, once ended up immersed in a Walden-like world of enforced privation and self-sufficiency, Varley, who idealized gypsies like his hero Augustus John, suddenly found himself leading the impecunious and nomadic life of a Romany. He had been fascinated by gypsies, those romantic symbols of individual freedom and vagabond living, ever since he saw their caravans as a boy in the Peak District outside Sheffield.[39] It is not difficult to see what he identified with in these outcasts who lived hand-to-mouth existences on the margins of society with their broods of children and their proverbial love of music and, when in funds, drink.

Several years after dressing a woman named Goldthorpe in gypsy costume for the expressive portraits *Gypsy Blood* and *Gypsy Head,* Varley painted a scene in Bobcaygeon casting members of his own family as campfire castaways. *Evening in Camp* shows Maud by a campfire with thirteen-year-old Dorothy and the infant Peter, their tent behind them against a twilit sky. The trio is bathed in ruddy firelight, with Maud staring sadly into the fire and swaddling two-year-old Peter on her lap. The scene is almost religious, a modern-dress *Rest on the Flight into Egypt* with Maud cast as a bobhaired Madonna. Most of all, it is a tender family portrait in which Dorothy's awkward pose and Maud's sad meditation sum up the uncertainty faced by the Varleys in the summer of 1923.

VARLEY'S CAMPFIRE IDYLL in the Kawarthas was soon interrupted. Before the summer was out, he was hurrying back to Toronto for an unusual assignment. An Anglican minister, the Reverend Lawrence Skey, had given MacDonald an intriguing commission: the decoration of St. Anne's Anglican Church in the Parkdale district of Toronto.

Unlike several other members of the Group of Seven, MacDonald was not particularly religious (he once claimed that his religion was the Arts and Letters Club).[40] But he took to this task with gusto. He began his designs—twenty-one scenes for the pendentives and apse—and put together a team of painters that included his twenty-two-year-old son, Thoreau, and his students from the OCA (one a promising artist named Carl Schaefer). When the students departed for their summer holidays, Varley and Carmichael were conscripted into service.

A major decorative program in a Protestant church in Canada was an unusual commission. In the 1870s and 1880s the Italian-born Luigi Capello painted murals in many Catholic churches in Quebec; one of his students, Ozias Leduc, went on to decorate thirty others over the course of a long career. But Protestant churches in English Canada generally made do with humbler decorations. MacDonald noted that the working-class Orangemen in the pews of St. Anne's possessed "a restricted idea of colour of display."[41] But he and Reverend Skey envisioned something eye-catching. MacDonald wanted his cycle of paintings to provide "religious vitality"[42]—to inject into the getting-and-spending world of twentieth-century Toronto a much-needed dose of spirituality. What the Orangemen would make of the work of the painter of *The Tangled Garden* remained to be seen, but Skey claimed to be confident that MacDonald would "produce a colour scheme, which would be reverent, harmonious and in keeping with the traditions of the architecture of the church."[43]

Painting the panels took MacDonald and his team through the late summer and autumn of 1923. He and Thoreau worked in the Studio Building, using palettes of crimson, Venetian red, yellow ochre and ultramarine blue. MacDonald took three scenes for himself: *Stopping the Tempest, The Transfiguration,* and *The Crucifixion.* Thoreau tackled *The Raising of Lazarus,* his choice of pigments, because he was colour-blind, no doubt closely supervised by his father. Down the corridor in the Studio Building, Carmichael worked on *The Adoration of the Magi* and *The Entry into Jerusalem.* Some of the panels were almost five metres high, and since Eden Smith had not designed

397

St. Anne's Church
Photograph courtesy of St. Anne's Church, Toronto

the building to accommodate such enormous paintings, getting them through the door and along the narrow corridor to the exit must have been something of a struggle.

Varley's mural was *The Nativity.* Varley the libertine painting an image of the Holy Family was, in many respects, ironic. MacDonald's design called for Mary to be dressed in ultramarine blue with the Christ Child in her lap, two angels flanking her, a lamb at her feet, and two worshippers—one of them presumably Joseph—gazing in adoration. Varley faithfully (and beautifully) executed the design. But he added a small touch of his own: the worshipper on the left is, in the finest Renaissance tradition, a self-portrait of the artist.

PREPARATIONS FOR THE exhibition of Canadian art at Wembley were interrupted by the death of Sir Edmund Walker from pneumonia on March 27, 1924. "A giant oak has fallen and all Canada mourns the loss of a great native son," reported the *Toronto Globe*. His sudden passing robbed the Group of Seven of one of their most powerful supporters. Lawren Harris, writing in *Canadian Bookman*, praised him as someone "of almost incalculable value. He was the first and only man of position to detect that in the modern movement in Canadian art the country had found the beginnings of a distinctive, significant, and bold expression."[1]

A few weeks after Walker's funeral, on April 23, St. George's Day, the British Empire Exhibition opened at Wembley. First proposed in 1913 but delayed more than a decade because of the Great War, the British Empire Exhibition was intended as both an indication of Britain's imperial achievement and a sign of national renewal after the war. Never before had the pink spaces on the world map come together for such a vast display. The official guidebook boasted that the grounds at Wembley would "reproduce in miniature the entire resources of the British Empire. There the visitor will be able to inspect the empire from end to end."[2]

The exhibition presented an eclectic array of attractions against which the paintings in the Palace of Arts—a modest building tucked away in a corner of the 216-acre site and dwarfed by the gigantic ferro-concrete hangars making up the Palace of Industry and Palace of Engineering—would struggle to compete. Besides the national pavilions, there was an amusement park featuring a waterslide, a mile-long scenic railway, a giant aquarium, and a ninety-foot-high Ferris wheel. Also on display was the "Tomb of Tut-Ankh-Amen," a burial chamber filled with wood and plaster replicas of the boy-pharaoh's throne, chariot and sarcophagus. Despite the mockery of literati such as Virginia Woolf and P.G. Wodehouse, and the efforts of the "Won't Go to Wembley Society," 100,000 people a day passed through the turnstiles. Some 17 million people would visit the exhibition during its seven-month run.

Originally the brainchild of a Canadian, Lord Strathcona, the former president of the CPR, the British Empire Exhibition offered Canada yet another opportunity to assert itself on the world stage. Yet Canada's participation in the exhibition had been a matter of some doubt. The nationalism stirred by Canada's successes in the Great War and its quest for diplomatic and political independence were attenuating some of the links—both political and sentimental—with the Mother Country.

The fact that Canada took seriously its new role as an autonomous nation with (as Resolution IX had put it) "an adequate voice in foreign policy" was brought home to the British in September 1922. When Lloyd George called on the dominions for military help against the Turkish nationalists threatening the British garrison on the Dardanelles, Canadians declined to fall smartly into step as they had in 1914. Instead, Mackenzie King insisted that the Canadian Parliament, not the British prime minister, should decide "whether or not we should participate in wars in different parts of the world."[3] This independent stance was affirmed six months later when the Canadian minister of marine and fisheries, Ernest Lapointe, signed an agreement with the United States on the conservation of halibut stocks—the first treaty negotiated by Canada not bearing the signature of the British ambassador.

This emergent nationalism, coupled with the high costs of mounting a display, meant some Canadian politicians and businessmen responded to the idea of Wembley with a notable lack of enthusiasm. Even so, when the curtain finally rose on Wembley, Canada made its presence emphatically known in a 120,000-square-foot pavilion beside the new sports stadium. Although still sheathed in scaffolding and dust wraps on opening day, the pavilion did not fail to impress the first visitors, guarded as it was by what one newspaper hailed as "Canada's finest exhibit": a detachment of Royal Canadian Mounted Police.[4] These six-footers patrolling their turf in black breeches and red serge offered a compelling image of Canadian masculinity. "Six feet of stirring romance," swooned one correspondent.[5]

Inside, the pavilion offered attractions such as a 4,400-pound lump of silver from a mine near Cobalt. The country's vast and varied landscape, with all its beauty and riches, was the keynote. The main corridor was lined with bas-relief panoramas of cornfields, prairies, forests and mountains, all done in kernels of wheat. Travel films of Canadian scenery played alongside a mock-up of Niagara Falls. In what was reputedly among the most popular of all Wembley's attractions, the pavilion featured in a refrigerated glass display case a statue of the Prince of Wales carved from Canadian butter. The sight of so much butter (3,000 pounds were used to depict the life-sized prince standing with a horse before his ranch house in Pekisko) did little to harm Canada's image as a land of plenty. One visiting Londoner told a reporter that one of the prince's ears would "keep us a week."[6]

Lord Burnham, owner of the *Daily Telegraph,* called the Canadian Pavilion "the best piece of national advertising that has ever been attempted."[7] This celebration of butter, wheat and mountains omitted, however, references to certain Canadians, most conspicuously First Nations people. Hitherto "Red Indians" (as the British knew them) were mainstays of both Canadian exhibitions abroad and, in the guise of spectacles such as members of the Stoney Reserve performing ritual dances at strategic points along the CPR line through the Rockies, the Canadian tourist trail.[8] Some sections of the Canadian press, anxious that no one should come away from Wembley with

the "false impression that our country is still largely peopled by savages," did not mourn their absence. As a journalist in the *Montreal Herald* put it, Canada should no longer be advertised "by representations of Indians in war paint."[9] Québécois observers were distressed, though, by the scanty representation of Quebec and the complete lack of French in the pavilion's signage. Some British visitors, meanwhile, were puzzled by the absence of winter scenes.[10] More than a quarter century after Kipling's "Our Lady of the Snows," showing a Canadian landscape under snow was still seen as tactless and unwise.

CANADA'S ADVERTISEMENTS for itself as a beautiful and thoroughly modern nation were continued a few hundred yards away from the Canadian Pavilion, in the Palace of Arts. This building (soundproofed against the hoopla of the crowds beyond its walls) displayed the art of Britain, Canada, Australia, New Zealand, South Africa, India and Burma. According to the man in charge of the British exhibits, the architect Sir Lawrence Weaver, this panoply was intended to showcase not artistic individuality but rather "how the Daughter Nations have developed their art from the English School."[11] The English School was amply represented by six rooms of Hogarth, Gainsborough, Reynolds, Constable, Turner and the Pre-Raphaelites; works by contemporary painters—Paul Nash, Roger Fry, Edward Wadsworth, Augustus John—hung in a separate room.

If some Canadian businessmen were reluctant to expose their wares at Wembley, not so Canadian painters. The Canadian section of the fine arts display, hung by Eric Brown, was made up of 267 pieces of art, including 215 paintings. The exhibition was billed by Brown as "the most important exhibition of Canadian art ever held outside the Dominion."[12] The fact that Canada was the only dominion to issue a catalogue for its fine arts exhibition indicated how seriously Brown took his task. There was even a supplement to the catalogue, *A Portfolio of Pictures from the Canadian Section of Fine Arts,* whose cover (like that of the catalogue) was designed by J.E.H. MacDonald. Unsurprisingly, the distinctiveness of Canadian art was repeatedly stressed, the supplement confidently declaring that "a vigorous and national school of painting" was "springing up" in Canada.[13]

Despite Charlesworth's fears, the Group of Seven's offering of thirty-four paintings made up less than a fifth of the display, to which were added seven paintings by Tom Thomson. The exhibition was widely representative of recent Canadian art. Established international artists such as Cullen, Gagnon, Morrice (who died in Tunisia three months earlier), Watson, Walker and Milne were on show. So too were the Beaver Hall painters Sarah Robertson, Kathleen Moir Morris and Henrietta Mabel May, together with more than two dozen other female artists. The woman whose work Thomson so admired, Florence McGillivray, was represented by *Labrador Fishing Stage*. RCA stalwarts included Horne Russell and Wyly Grier. Suzor-Coté and Ozias Leduc were among the strong Quebec contingent, and from the West came the Saskatchewan painters James Henderson (with First Nations portraits) and the former Prairie homesteader and Slade School alumnus Inglis Sheldon-Williams.

The contributions from the Group of Seven included paintings shown at their 1920 exhibition: Carmichael's *Spring* and *Autumn Hillside,* Harris's *Shacks,* Jackson's *Terre sauvage,* Varley's *Vincent Massey.* The Northern Ontario vignette of a pine tree on a windy lakeshore was a recurring motif, reinforced by Lismer's *A September Gale, Georgian Bay* (shown at the 1921 Group of Seven exhibition), Varley's *Stormy Weather, Georgian Bay* and Thomson's *The West Wind* and *The Jack Pine.* The latter two paintings flanked Thomson's *Northern River,* making up a remarkable triptych.

Although the exhibition did not include critical *casus belli* such as MacDonald's *The Tangled Garden* or Jackson's *Assisi from the Plain,* members of the group could have been forgiven a few trepidations about their reception by British critics. Since 1923 an exhibition of their work, "Modern Canadian Painters," had been doing the rounds of American museums. In contrast to their first American tour, the reviews this time were modest, mixed and, in general, unenthusiastic. At Wembley, though, the painters fared much better: so well, in fact, that the exhibition would eventually be celebrated, in *Saturday Night* of all places, as a "red-letter day in the history of Canada's status among the nations of the world."[14]

This remark was extravagant wishful thinking. But there was no

doubt that many British critics sincerely regarded Canadian painting in general, and the landscapes of the Group of Seven in particular, as among the most vital and exhilarating forces in modern art. A number of British critics praised exactly the qualities in the paintings—the bold simplifications and flamboyant colours—detested by Charlesworth and Ahrens. "Canada, above all other countries," announced the May issue of *The Field*, "has reason to be proud of her contribution, uniting as she does a pronounced love of nature coupled with a vigorous and a definite technique." The critic for the *Morning Post*, a London daily, was equally enthusiastic. He suggested that whereas painters from Australia and New Zealand were content to "follow the ideas and methods of the Mother Country artists," Canadian landscapists (he singled out Gagnon and Morrice as well as Thomson, Jackson, MacDonald and "Alfred" Lismer) were striking out on their own to create "the foundation of what may become one of the greatest schools of landscape painting. In their pictures are signs of new vision and feeling for the physical and spiritual significance of nature in both its static and dynamic moods."[15]

This combination of a passion for nature and a sense of the landscape's moods and spiritual significance led the reviewer for *The Times* to compare the younger Canadians to the visionary Russian painter Nicholas Roerich, then at the zenith of his popularity following a hugely successful American tour that witnessed his celebration as the "Walt Whitman of painting."[16] The *Times* reviewer was impressed by MacDonald's *The Beaver Dam* and—most of all—by Thomson's *The Jack Pine*. He regarded Thomson's elegiac painting as not only the best work in the Canadian section but also the finest painting in the entire Palace of Arts. It was, he wrote, the "most striking work at Wembley."[17]

404

The best review of all came from C. Lewis Hind in the *Daily Chronicle*, a paper whose sales exceeded those of *The Times* and the *Daily Telegraph* put together. The sixty-two-year-old Hind was one of England's most knowledgeable writers on modern art (he claimed to be the only man in London able to discuss Matisse without losing his temper). In 1911 he published *The Post-Impressionists*, an attempt

to explain Cézanne, Gauguin and Van Gogh to the British public. "Expression, not beauty, is the aim of art," he told them in his reasonable and measured tones. Echoing Roger Fry, he went on to describe how art is "always decorative and emotional," and how "rhythm and emotional expression are nearer to the heart of things than representation and photographic realism."[18]

This view of art as decorative and emotional favourably disposed Hind towards the work of the Canadian landscapists. He had nothing but praise for their "bold, decorative landscapes" that emphasized "colour, line, and pattern" in a way that reminded him of work created by "the younger artists of France." But the Canadians were surpassing even the French, producing "the most vital group of paintings produced since the war—indeed, this century."[19] Higher or more gratifying praise would be difficult to imagine.

BACK HOME IN Canada, Hector Charlesworth was appalled at these critical genuflections. "Flub-dub, every word of it," he snorted in *Saturday Night*. In another column, histrionically entitled "Freak Pictures at Wembley," he claimed Hind and other critics had been hoodwinked into complimenting the younger Canadian painters thanks to a "fairly effective lobby" (led, presumably, by the hard-working Eric Brown). The British public was being hoaxed by "insincere and splashy pictures painted to create a sensation rather than to record beauty and emotion." He concluded the column by once again voicing fears about the Group of Seven's deleterious effects on immigration: "The pictures do undoubtedly provide a sensation for jaded palates, but we are quite sure that no stranger to this country having looked on them would ever want to visit our shores. From the standpoint of business they are as bad an advertisement as this country ever received."[20]

Charlesworth betrayed a typically Canadian anxiety about the country's image abroad—the same disquiet behind the absence of First Nations people at Wembley. The reviewer for *The Times*, in his otherwise positive review, called the paintings "a little crude, leaving plenty of room for refinement."[21] The words plunged Charlesworth into a panic that the British were happily confirmed in their

prejudices that Canadians were savages, "crude and commonplace in taste and ideals."[22] In fact, the painters were celebrated by the British (as they had been by Raymond Wyer and a number of American critics) for their modernity in the same way that in 1919 Sir Claude Phillips extolled Varley as an "ultra-modernist." As the reviewer for *The Times* observed: "It is here, of all the Dominions, that the note is what we understand by 'modern.'" Far from letting down themselves (or the country) as uncultured colonials, the painters were, in the eyes of critics like Hind, art-world sophisticates familiar with international trends that they were adapting to their own original ends.

The reviewer for *The Field* predicted that, given the strength of the display, the time would come when the British began buying Canadian paintings for their public collections. Hind even called for the purchase of "two or three for the Tate Gallery," home of Britain's international collection of modern art. *The West Wind* was put forward for consideration by the Tate's trustees, along with Lismer's *A September Gale* and MacDonald's *The Beaver Dam*. In the end, the Tate purchased Jackson's *Entrance to Halifax Harbour* for £88 15s., or almost $450. The choice might have owed as much to the exploits of the Canadian Corps as it did to Jackson's artistic flourishes.[23] Whatever the motive, the work became the first painting by a Canadian to hang on the gallery's walls.

Engaging the gears of the Group of Seven's publicity machine, Eric Brown put together for consumption back home a collection of laudatory press clippings called *Press Comments on the Canadian Section of Fine Arts, British Empire Exhibition*. Harris's friend Fred Housser began writing a book that two years later would see print as *A Canadian Art Movement: The Story of the Group of Seven*. His wife, Bess, meanwhile celebrated the purchase of Jackson's painting in the pages of *Canadian Bookman*. "It is the seal of genuine approval upon the many laudatory comments in the English press since the opening of the exhibition at Wembley," she wrote. "It is a justification of the so-called 'modern' work . . . It means encouragement to all young Canadians who are endeavouring to express something which is truly innate and to find themselves honestly native to their land."[24]

There is, of course, an irony that the seal of approval for an art intended to mark artistic independence and make Canadians feel at home in their own country should have come, not from Canadians themselves, who by and large stubbornly still refused to grant their approval, but from the former colonial masters. Still, this approval perhaps needed to come from beyond Canadian borders. Part of the project of Eric Brown and the Group of Seven had been to dispel the ignorance about Canadian culture that prevailed abroad. Claims for a modern and distinctive style can only be legitimately made—in the case of Canada or any other country—if they are recognized and validated beyond the national borders. Anything less smacks of parochialism.

There might be another reason why the affirmation needed to come from Britain. A prophet is not without honour but in his own country, especially if that country is Canada. Merrill Denison believed Canadians were unwilling to accept other Canadians as artists and writers because of a national inferiority complex, "an intellectual timidity born of a false feeling of inadequacy or inability." More recently a sociologist has argued that Canadians have an "aversion to conspicuous and colourful success."[25] That inferiority complex and aversion to success drove talented artists abroad and forced the ones who stayed to toil in obscurity and subsist on meagre wages. It made Canadians consumers rather than producers of culture, importers rather than exporters, "provincial and imitative" (in the words of C.W. Jefferys) instead of sophisticated and original.[26] The triumph at Wembley was a step, the Group of Seven and their supporters believed, towards overturning this state of affairs.

Besides the positive reviews in the British press, there was another indication that Canadian art was being taken seriously abroad. When the British Empire Exhibition closed in November 1924, the paintings were dispatched on a tour of Britain, first to the Leicester City Art Gallery (in November) and then the Kelvingrove Art Gallery in Glasgow (in December). If in 1913 some visitors to the MacDowell Club in New York were puzzled that Canadian painters seemed to be neglecting the fiercer aspects of their landscape, in 1924 the reviewer for the *Glasgow*

went to Ellesmere Island on board the sealing steamer *Beothic*. The following year, he and Banting went to Great Slave Lake, and in 1930 he returned to the Arctic, this time with Harris, the pair of them hoping, as Jackson later wrote (with a typically patronizing attitude towards Canadians' acquaintance with their own geography), "to give Canadians some idea of the strange beauty of their northern possessions."[2]

Harris, however, was attempting to do more than merely send postcards of the North to his fellow Canadians. Four years after painting *Above Lake Superior,* he portrayed radiant northern tranquility in an even more austere style in another canvas, *North Shore, Lake Superior.* Here the clouds, landforms and even the tree stump itself were reduced almost to the point of abstraction, giving the landscape an otherworldly quality. In 1931 the painting would win the Baltimore Museum of Art Award at the Pan-American Exhibition of Contemporary Painting in Baltimore, confirming Harris's credentials as one of the most important painters on the continent. It would also attest to how he was laying aside the nationalist ethos of the group in favour of explorations of mystical realms.

Besides widening their geographical interest, the group also began encouraging other young Canadian artists, acting as a catalyst for painters in regions beyond Ontario, including many women. As a female journalist observed, the painters encouraged women "whose work indicated the same vigorous attitude, the same frank and untraditional conception of the mission of the painter."[3] The Montreal painter Sarah Robertson was invited to show work at their 1925 exhibition. Prudence Heward, Bess Housser, Mabel May, Pegi Nicol and Sarah Robertson all shared wall space with the men in 1928. Overtures were also made in French Canada. In 1926 the group held their exhibition jointly with a show called *Art in French Canada,* which featured works by young Quebec painters, such as Edwin Holgate and Anne Savage, as well as bringing to the attention of English Canadians well-established artists such as Cullen, Gagnon and Ozias Leduc.

In 1927 the members of the group made their most significant alliance when they met a virtually unknown fifty-five-year-old painter from Victoria named Emily Carr. For many years Carr had dwelt in artistic isolation. The poor receptions given her work in Vancouver

410

in 1912 and 1913 meant she all but gave up painting and spent fifteen years running a Victoria boarding house and breeding bobtail puppies. But in November 1927, on a visit to Toronto, her solitude ended when she met Harris, Lismer, Jackson and MacDonald. She was profoundly affected by her visit to the Studio Building. "Oh, God, what have I seen," she wrote rapturously in her journal. "Where have I been? Something has spoken to the very soul of me . . . Oh, these men, this Group of Seven, what have they created?—a world stripped of earthiness, shorn of fretting details, purged, purified; a naked soul, pure and unashamed; lovely spaces filled with wonderful serenity . . . Jackson, Johnson, Varley, Lismer, Harris—up-up-up-up-up!"[4] Returning to Victoria, she would begin a long and productive period of artistic self-confidence and critical success that would make her one of Canada's most accomplished and beloved artists.

1927 was also the year that the Group of Seven, in the person of Lawren Harris, made another connection: a long-overdue alliance with international modernism. Underwriting some of the costs himself, Harris arranged for the International Exhibition of Modern Art, assembled by the Société Anonyme in New York, to open at the Art Gallery of Toronto. Abstract art predominated, and artists such as Marcel Duchamp, Joseph Stella and Constantin Brancusi were introduced to a Toronto audience. Harris and Lismer, along with Katherine Dreier, president of the Société Anonyme, gave speeches before a crowd of almost four hundred. More than ten thousand people (twice the number who ever attended a Group of Seven show) filed through the exhibition, and no fewer than thirteen features and reviews—surprisingly, most of them positive—appeared in the Toronto papers. If they had in no small way stirred this curiosity about modern art, the Group of Seven was also, suddenly, overshadowed. "It made our paintings, by contrast, seem quite conservative," Jackson later reflected.[5] The writing was on the walls of the Art Gallery of Toronto, inscribed in the languages of Cubism, Surrealism and geometric abstraction.

THE GROUP OF Seven had effectively been a Group of Six since the departure of Frank Johnston in 1921. A seventh member was not added until 1926: twenty-eight-year-old Alfred Joseph Casson,

Frank Carmichael's assistant at the design firm Rous and Mann. A painter who specialized in images of Ontario villages, he was a safe but somewhat uninspired choice. Three years later Edwin Holgate, who had painted with Jackson in both Quebec and British Columbia, was invited to join. His membership took their number to eight and brought into the group a painter, besides Varley, interested in the human form. Holgate's presence nevertheless kept alive the myth of the Canadian painter as a hardy outdoorsman: he claimed to paint *en plein air* in temperatures of –31 degrees Fahrenheit, when "his colours congealed and refused to stay where they were put."[6] Finally, in 1932 the group effectively became a "Group of Nine" when an invitation was extended to the forty-two-year-old Winnipeg artist Lionel LeMoine FitzGerald. The group had therefore included a total of ten painters as well as the shade of Tom Thomson.

Yet the group was fragmenting as it expanded. The first member to leave Toronto was Varley. In 1926, still struggling financially, he accepted an offer to become head of drawing and painting at the Vancouver School of Decorative and Applied Arts. He claimed he wanted to "try out many adventures in paint," and indeed he made more of a mark on the West Coast than he ever did in Toronto, becoming, according to one colleague, "the artist who laid the foundation stone of imaginative and creative painting in British Columbia."[7] His personal life, though, remained badly out of control. His marriage did not survive his tenure in Vancouver, and eventually he left Maud and their four children following affairs with several of his students.

The Group of Seven faced hostile reviews through the 1920s. Their 1928 exhibition was greeted by a headline in the *Toronto Telegram* proclaiming "Junk Clutters Art Gallery Walls." The author complained that the paintings "were not even Canadian, but following in the rut of the so-called 'modernists' who have afflicted the whole world."[8] And as late as 1932 a journalist in Vancouver named J.A. Radford (the man who wanted Canadian art to concentrate on cows and "handsome women") castigated them for their "hideous and unnatural modernism."[9] Increasingly, though, they became the target of those who wished to see Canadian art move beyond nationalism and what were

in danger of becoming visual clichés of the forested wilderness. The Group of Seven style was quickly becoming the "official" one, as much of an orthodoxy as the older artistic styles they had worked so hard to overturn. The British-born painter Bertram Brooker, who exhibited abstract works in Toronto in 1927, wrote of their April 1930 exhibition that it "rings the deathknell of the Group of Seven as a unified and dominant influence in Canadian painting... The experimentation is over, the old aggressiveness has declined."[10]

The last Group of Seven exhibition was staged in December 1931. An impetus for change came a year later, with the death of J.E.H. Mac-Donald at the end of 1932. MacDonald's contribution to Canadian art extended well beyond the controversial *The Tangled Garden* and Algoma masterpieces such as *The Solemn Land*. Unable to earn a living from his painting, he had begun teaching design at the Ontario College of Art in 1921 and then became principal of the school in 1929, influencing a generation of students. Exhausted from years of overwork, he died of a stroke in his office at the college at the age of fifty-nine.

Within several weeks of MacDonald's death, the Group of Seven officially disbanded, its members merging into a larger body of several dozen artists called the Canadian Group of Painters. The emphasis on nationalism remained, but by the 1930s other concerns were coming to govern many Canadian artists. In 1938 the art critic Graham McInnes deplored what he saw as the "excessive nationalism" inspired by the Group of Seven.[11] In the same year, believing the Canadian Group of Painters was failing to provide inspiration or leadership, the Montreal artist John Lyman (having finally returned to Canada in 1931) formed the Eastern Group of Painters. "The talk of the Canadian scene has gone sour," he wrote. "The real Canadian scene is in the consciousness of Canadian painters, whatever the object of their thought."[12]

The Group of Seven—especially Jackson, Varley and Harris, along with Thomson—had all attempted to use the landscape as a vehicle to express emotion, or what Emily Carr perceptively called the "naked soul." But the group's repeated emphasis on national identity and the landscape of the Canadian regions ultimately gave way to more insistent attempts by painters to express what Lyman had called

413

their "consciousness"—interior landscapes of sensation and emotion. Many young painters believed that should not be limited to visual perceptions or the imitation of nature. The riddle that (according to Northrop Frye) had long haunted Canadians—"Where is here?"[13]— became less important than the more introspective "Who am I?"

Harris himself ultimately abandoned both landscapes and urban scenes. In 1930 he wrote to Carr, "I cannot yet feel that abstract painting has greater possibilities of depth and meaning than art based on nature and natural forms . . . I have seen almost no abstract things that have that deep resonance that stirs and answers and satisfies the soul."[14] By the mid-1930s, however, he did turn to abstraction, the move partly precipitated by the emotional and domestic crisis that had been building for more than a decade. In July 1934 he left his wife, Trixie, and, in a ceremony later that summer in Nevada, married Bess Housser, recently abandoned by her husband. The ensuing scandal— which saw Jackson taking the side of Fred Housser—forced Harris and his new wife to leave Toronto for Hanover, New Hampshire, and then for Santa Fe, New Mexico. He would not return to Canada—to Vancouver—until the outbreak of the Second World War.

The 1940s and 1950s would witness the triumph of abstract and nonrepresentational art in Canada, with the Automatistes (led by Paul-Émile Borduas) in Quebec and the Painters Eleven in Toronto. Their art moved away not only from the Canadian landscape but also, in many cases, from the object itself. By this time the nationalistic concerns of the Group of Seven seemed remote. In 1970, on the fiftieth anniversary of their first exhibition, the abstract painter Ron Bloore, a member of the Regina Five, denigrated their "limited accomplishment" as a "provincial, romantic movement" that became a "powerful conservative force in English-speaking Canada." As Jackson complained, the Group of Seven was disparaged as "a mere symptom of nationalism in a backward country."[15]

BLOORE'S ATTACK AND Jackson's lament do not tell the full story. In the same year that Bloore wrote his harsh appraisal, Dennis Reid, at different times a curator at both the Art Gallery of Ontario and the

National Gallery of Canada, was able to observe that the members of the Group of Seven occupied a position in the Canadian cultural pantheon "shared only with a few hockey stars and a handful of beloved politicians."[16]

Indeed, for many decades Tom Thomson and the Group of Seven were celebrated as Canadian icons. Frank Carmichael and Frank Johnston (who in 1927 changed his name to Franz) died during the 1940s, but the members who survived them lived long and productive lives, able to appreciate the affection in which the public held them. By the middle of the century, reproductions of *The Jack Pine, The Solemn Land* and *A September Gale* adorned the walls of virtually every Canadian schoolroom. During the Second World War, silkscreen copies were hung in barracks overseas to boost morale and remind those involved in the war effort of the Canada they were fighting for. In 1967, and then again in 1995 to celebrate the group's seventy-fifth anniversary, stamps were issued featuring their portraits and paintings. Their works have influenced Canadians at a nuclear level. Who can look at a bent pine tree or snow-stooped spruce without thinking of the Group of Seven?

Tom Thomson, in particular, was cherished as an embodiment of the Canadian spirit. As early as 1930 a writer called him the "crystallization of the Canadian consciousness."[17] In 1949 Hugh MacLennan ranked him alongside Champlain, Frontenac and Sir John A. Macdonald in his list of the "Ten Greatest Canadians."[18] Twenty years later, Pierre Berton included him as one of his twenty-five greatest Canadians. He has inspired poetry, plays, novels, films and—in Canada's answer to JFK's assassination—conspiracy theories. *The West Wind* and *The Jack Pine* are probably Canada's most recognizable and beloved paintings, the latter not least because it was featured on Canada Post's ten-cent stamps between 1967 and 1971. Thomson's cairn at Canoe Lake and the shack where he painted—now at the McMichael Canadian Art Collection in Kleinburg, Ontario—have become sites of pilgrimage. Even his smallest panels fetch seven-figure prices. In November 2007 his painting *Winter Thaw* was sold for $1,463,500. Six months later, *Pine Trees at Sunset* was knocked down for $1,957,000.

Yet if hockey stars and politicians have maintained their popularity, by the dawn of the twenty-first century the members of the group were in danger of slipping from the public imagination. Thomson and the Group of Seven failed to make any impression in the CBC's 2004 poll *The Greatest Canadian*. This list of one hundred Canadians found room for fourteen singers, ten hockey players, assorted television actors and comedians, a professional wrestler and a government accountant. The only artist to make the list—well down the rankings at number eighty-five—was Emily Carr.

What is the reason for this eclipse? Undoubtedly the Group of Seven is no longer seen to represent Canada in the way they did even as recently as the 1960s and 1970s. The patriotism and nationalism that they promoted are seen by many as outdated and unattractive ideologies. Peter C. Newman has observed that to be a Canadian nationalist is to be "a goofy thing...like a butterfly collector."[19] And we are told by the experts that we now live in a "post-national" age where our loyalties are not to countries but to various sub- and supranational collectives.[20]

Even the trademark of Thomson and the group, the solitary pine tree, has come under attack. The lone krummholz pine on the edge of a windswept lake supposedly emphasizes the rural pioneer spirit over the urban cultural mosaic. The author of a paper prepared in 2005 for the Department of Canadian Heritage wrote (with no detectable whimsy) that the jack pine from the "xenophobic Canadian Shield" plays up "heroic survival in the face of adversity" at the expense of "the modern verities of Canada's encounter with diasporic identities, ethnic diversities, and transnational linkages." He offered instead a supposedly more encompassing symbol: the "quintessentially mobile goose."[21] The heroic jack pine so beloved of the painters was dismissed by another academic as an unfortunate case of "arborescent territorialization." She put forward an even more pictorially unpromising substitute: a rhizome, a creeping rootstalk that has "uncompromising tubular propagations."[22]

However bizarre at face value, these arguments highlight the way many Canadians no longer identify themselves or their country with the Shield landscape of pine, boulder and lake, or with the age

of lumberjacks and pioneers. As late as 1946 Wyndham Lewis could be firm in his belief that the "monstrous, empty habitat" of the Canadian wilderness—a place "infinitely bigger physically than the small nation that lives in it"—would continue to dominate Canadians both psychologically and culturally.[23] This monstrous habitat was of course already vanquished and vanishing by the time the Group of Seven took up their brushes (Jackson admitted that even the Arctic had been "robbed . . . of much of its terrors" by the time he arrived).[24] But for the group, as for so many other Canadians of earlier generations, our shared ancestor and our common denominator were geography. The land was what held us together, and more specifically a particular attitude to the land as both a dangerous, impregnable wilderness and a place of grace and refuge. Canadians were defined by their day-to-day engagement with this remote and rugged landscape. This encounter was what everyone had in common, from the Bessarabian peasants and Romanian Jews homesteading on the Prairies, to the Doukhobors clearing forests and planting orchards beside the Kootenay, to the Toronto businessmen taking rest cures by paddling the shorelines of Lake Muskoka.

If this shared ancestor now seems remote, the reason is not a matter of ethnicity or immigration: twice as many immigrants came to Canada in 1912 as arrived in 2006. More likely it is because Canada has become largely urban and post-industrial. In sociological terms, it is a *Gesellschaft* where shared values, traditions and beliefs are thin on the ground. For the Group of Seven and their contemporaries, it was self-evident that Canadians were not, historically or typically, an urban people. In 1901, only 40 per cent of the Canadian population lived in urban areas, compared with 2001 when almost 80 per cent lived in cities of ten thousand people or more. As an encyclopedia of world geography notes, Canada is now one of the most urbanized nations on the planet, its northern wilderness "far removed from the everyday life of most Canadians working in office blocks in large urban centres."[25] And with the wilderness criss-crossed by highways, overflown by jet airplanes, harvested or polluted by industry, packaged by tourism and receding before the suburban sprawl, its possibilities for shaping feelings of identity have evidently diminished.

Most Canadians not only fail to identify themselves with their country's hewers-of-wood and drawers-of-water past, but in English Canada at least, they also identify themselves with very little history at all. One of Canada's most eminent historians, Ramsay Cook, has remarked that English Canadians have a severely underdeveloped historical consciousness. One of the problems, he writes, is that Canada does not have an agreed-upon national history, a grand and encompassing narrative of its origins and trajectory.[26] History is a nightmare from which anglophone Canadians—troubled by the complex implications for nationhood of things such as the British Conquest of 1760, the spiriting away of indigenous land rights, the suppression of the Northwest Rebellion, the $500 head tax imposed on Chinese immigrants, the *Komagata Maru* incident—are trying to awake.

The most common attribute of twenty-first-century Canadians is not a confrontation with the rugged wilderness but—as the 2005 report for the Department of Canadian Heritage argued—the experience of immigration and ethnic diversity. This experience is virtually identical to that of every other Western democracy, but as the introduction to the *Encyclopedia of Canada's Peoples* points out, all Canadians share in this "common national founding myth . . . a tradition of migration that began well before the dawn of recorded history and endures to our day."[27] The Group of Seven is certainly judged severely by some as the focus of Canadian identity has turned from the vast landscape to the "small nation" that lives in it. The curator of a recent Group of Seven exhibition, the granddaughter of Frank Carmichael, lamented that the painters made no effort to reflect "the complexity of Canada's multicultural composition."[28] Most common is the accusation that they created images of Canada that are largely empty of people, in particular empty of Aboriginal Canadians.[29]

418 In fact, far more people appear in the group's paintings than is generally acknowledged, including immigrants and Aboriginal Canadians (and Jackson was an early and enthusiastic champion of the Tsimshian artist Frederick Alexei). There is a certain pecksniffery in arguments about the "erasure" of the Aboriginal in the Group of Seven landscapes, given how Edmund Morris, a knowledgeable and

sympathetic painter of First Nations portraits, is today completely ignored and almost utterly forgotten.[30] But the perceived exclusions by the group have been reproached in the Korean-born photographer Jin-me Yoon's *A Group of Sixty-Seven,* created in 1996. This intriguing montage places before one of Lawren Harris's most famous works, *Maligne Lake, Jasper Park,* sixty-seven members of Vancouver's Korean community—a reminder of what Harris, with his attention fixedly on the landscape, failed to include in his canvases.

There may be another reason why the brash nationalism of the Group of Seven resonates so little today. Even the most jingoistic Canadian would have to admit that Laurier's confident prophecy— "Canada shall fill the twentieth century"—went unfulfilled. Few Canadians today can feel Laurier's optimism for their country's place in the world. Canada did not reach a population of 80 million, nor did it become—at least in the eyes of opinion-makers abroad—influential in world politics. Asked why their newspaper offered virtually no coverage of the October 2008 federal election in Canada, editors for *The Times* airily explained that Canada "is not a big player on the world stage." Nor, apparently, is Canada seen by those in developed countries as the "golden land" of a century ago. When Hector Goudreau, Alberta's minister of employment and immigration, arrived in Britain in 2008, in a Clifford Sifton–like quest to lure prospective immigrants to Canada, his mission was greeted with much scoffing in the British press. A journalist for the *Daily Telegraph* claimed that any Briton contemplating a move to Canada was invariably met "with boggle-eyed horror, as if they had unveiled a suicide pact." She added for good measure that "sneering at Canada" was a habit deeply entrenched in the British and American psyches. How such evaluations, with their combination of ignorance and malice, would have pained and infuriated the Canadian nationalists of the 1920s.[31]

WHATEVER THE VALIDITY of the criticisms of the Group of Seven, their achievements were undeniably tremendous. They modernized the landscape idiom in Canada, importing elements of the European avant-garde and helping to end the dominance of the Barbizon and

Dutch schools of atmospheric painting that by the turn of the twenti-
eth century were outdated in most parts of the Western world except
among collectors in Toronto and Montreal. They also awakened an
interest in art, and in Canadian art in particular. In 1928 an exhibi-
tion of Canadian art in Vancouver attracted 65,000 visitors, causing
one astonished observer to remark that if a stranger came to town he
would think the people of Vancouver more passionate about art "than
the citizens of Florence, or Chelsea, or Montmartre."[32]

By mid-century, or even earlier, the art of the Group of Seven might
have seemed (as Jackson noted in comparison with the Société Ano-
nyme) positively tame. But the members of the group, unlike so many
other modern artists, remained dedicated to creating an art that
was widely accessible to the people. Art appreciation was not, for the
group, a private affair that demanded a high level of education or a
special sensibility. They believed art could enhance common expe-
rience. Compare that with how Clement Greenberg, mentor of the
Painters Eleven, railed against the democratization of culture, or how
some modern (and postmodern) art has seemed bent on proving Clive
Bell's snobbish assertion that "the masses of mankind will never be
capable of making delicate aesthetic judgments."[33]

Some of their greatest legacies lay beyond the walls of studios and
art galleries. For many years they were at the forefront of a cultural
awakening in English Canada, a stirring of artistic self-confidence
that could never have developed as quickly or as richly without them.
Many writers, and then later composers and musicians, tried to do in
print and song what the group did in pigment. Self-consciously "Cana-
dian" themes were rendered in vibrant and innovative forms. Much of
the poetry of F.R. Scott and A.J.M. Smith would have been unthink-
able without the pathfinding of the group. Smith's most famous poem,
"The Lonely Land," was inspired by both a colour reproduction of *The
Jack Pine* and works at the group's 1925 exhibition.[34]

Ditto the Group of Seven's influence on the plays of Merrill Deni-
son and Herman Voaden. The latter, a playwright and director who
married his Canadian nationalism to avant-garde literary tech-
niques and experimental stagecraft, saw the painters as the heralds of

far-reaching artistic developments in Canada. They were "the first to strike out boldly," he wrote in 1928. "They carved new materials out of our landscape and evolved a different technique to handle them."[35] Later, in music, came Harry Freedman, Claude Champagne and Violet Archer, all animated by visions of the group's paintings. The architect Arthur Erickson, who designed the Canadian pavilion at Expo 67 and the Canadian Embassy in Washington, acknowledged the influence of Lawren Harris.[36] More conspicuous still was Glenn Gould, who attributed his fascination with the North to their imagery, and who loved what he called the "Group of Seven woebegoneness" of Northern Ontario.[37]

The final judge of their importance should be the paintings themselves. If we forget the group's nationalist agenda, if we forget the political agendas of their critics, and if we look at the canvases and panels themselves, only the most churlish could deny that they produced some works of virtuoso design and emotional intensity that would grace any art museum in the world: Jackson's *The Red Maple*, MacDonald's *The Solemn Land*, Harris's Lake Superior paintings, Varley's portraits and war scenes, Thomson's sketches of Algonquin Park. Like the photograph of Donald A. Smith driving the Last Spike, or Terry Fox's radiant silhouette in the soft-focus coronas of a police car's beacons (another vignette of individual triumph over adversity), their works have become part of the national memory bank. Together, they have given us one of the best responses—however incomplete it must inevitably be in a country so differentiated and so vast—to that most difficult and most Canadian of questions: "Where is here?"

NOTES

BOOK I

CHAPTER 1: A WILD DESERTED SPOT

1. Quoted in Jasen, *Wild Things,* p. 108.
2. "2006 Census Highlights, Fact Sheet 2: Population Counts: Urban and Rural," Ministry of Finance, Government of Ontario, http://www.fin.gov.on.ca/english/economy/demographics/census/cenhio6-2.pdf.
3. *The Times,* 24 May 1911.
4. Mark Robinson, transcript of interview, p. 1, in the Tom Thomson Collection, McMichael Canadian Art Collection Archives (hereafter cited as MCAC Archives). For Harry B. Jackson's recollections of the expedition, see Harry B. Jackson to Blodwen Davies, 5 May 1931, Blodwen Davies Fonds, Vol. 11, MG30 D38, Library and Archives Canada, Ottawa (hereafter cited as LAC).
5. R.P. Little, "Some Recollections of Tom Thomson and Canoe Lake," *Culture* 16 (1955), p. 213.
6. Ottelyn Addison and Elizabeth Harwood, *Tom Thomson: The Algonquin Years* (Toronto: McGraw-Hill, 1969), p. 13.
7. Quoted in Cole, "Artists, Patrons and Public," p. 71. The Torontonian was Taylor Statten, the Secretary of Boys' Work at the Toronto Central YMCA and later the founder of Camp Ahmek.
8. Harry B. Jackson to Blodwen Davies, 29 April 1931, Blodwen Davies Fonds.
9. S.H.F. Kemp, "A Recollection of Tom Thomson," October 1955, typescript in the Tom Thomson Collection, MCAC Archives.
10. Fraser Thomson to Blodwen Davies, 19 May 1930, Blodwen Davies Fonds.
11. Quoted in Andrew C. Holman, "'Cultivation' and the Middle-Class Self: Manners and Morals in Victorian Ontario," in Edgar-André Montigny and Lori Chambers, eds., *Ontario Since Confederation: A Reader* (Toronto: University of Toronto Press, 2000), p. 111.
12. Kemp, "A Recollection of Tom Thomson."
13. Albert H. Robson, *Canadian Landscape Painters* (Toronto: Ryerson, 1932), p. 138.
14. A.Y. Jackson, London, to J.E.H. MacDonald, 26 August 1917, MCAC Archives.
15. Marion Long to Robert and Signe McMichael, undated letter, MCAC Archives.

16. Mark Robinson to Blodwen Davies, 23 March 1930, Blodwen Davies Fonds.

17. Quoted in J. Murray, *Tom Thomson: Design for a Canadian Hero*, p. 36.

18. For Thomson's family background, see Littlefield, *The Thomsons of Durham*.

19. Louise Henry to Blodwen Davies, 11 March 1931, Blodwen Davies Fonds.

20. Ibid.

21. J.E.H. MacDonald, "A Landmark of Canadian Art," *The Rebel* (November 1917), reprinted in Fetherling, *Documents in Canadian Art*, p. 39.

22. Louise Henry to Blodwen Davies, 11 March 1931, Blodwen Davies Fonds.

23. Quoted in Littlefield, *The Thomsons of Durham*, p. 38.

24. As late as the 1920s, almost 70 per cent of Canadian men earned less than $1,000 per year: see Cynthia R. Comacchio, *The Infinite Bonds of Family: Domesticity in Canada, 1850–1940* (Toronto: University of Toronto Press, 1999), p. 72. For Toronto house prices, see R. Harris, *Unplanned Suburbs: Toronto's American Tragedy, 1900–1950* (Baltimore and London: Johns Hopkins University Press, 1996), p. 225. For Canadian farm prices, see Bruno Ramirez, *Crossing the 49th Parallel: Migration from Canada to the United States, 1900–1930* (Ithaca: Cornell University Press, 2001), p. 89.

25. Alan H. Ross to Blodwen Davies, 11 June 1930, Blodwen Davies Fonds.

26. Louise Henry to Blodwen Davies, 11 March 1931, Blodwen Davies Fonds.

27. Alan H. Ross to Blodwen Davies, 11 June 1930, Blodwen Davies Fonds.

28. Alan H. Ross to Blodwen Davies, 1 June 1930, Blodwen Davies Fonds.

29. See Robert Stacey, "Tom Thomson as Applied Artist," in Reid, *Tom Thomson*, pp. 50–51.

30. For the various (improbable) versions of this story, see J. Murray, *Tom Thomson: Design for a Canadian Hero*, pp. 32–33. For a critical eye on the legend, see Sherrill Grace's comments in *Inventing Tom Thomson*, pp. 66–67, 80.

31. Alice Lambert, *Women Are Like That* (New York: Dell, 1934), pp. 20–21.

32. Robson, *Canadian Landscape Painters*, p. 138. Robson, later Thomson's boss at Grip and then Rous and Mann, was at pains to point out that he himself found Thomson "a most diligent, reliable and capable craftsman" (ibid.).

33. J. Murray, *Tom Thomson: Design for a Canadian Hero*, p. 36.

34. William J. Wood, Midland, ON, to Arthur Lismer, 2 January 1925, MCAC Archives.

35. Ibid. Wood specifically mentions "Broadhead, Varley, Thompsons [*sic*], MacLean, Johnson [*sic*], Robson, Carmichael, MacDonald."

CHAPTER 2: THIS WEALTHY PROMISED LAND

1. Quoted in Jarrett Rudy, *The Freedom to Smoke: Tobacco Consumption and Identity* (Montreal and Kingston: McGill-Queen's University Press, 2005), p. 51. For Thomson's fondness for tobacco, see Harry B. Jackson to Blodwen Davies, 5 May 1931, Blodwen Davies Fonds.

2. Quoted in Stacey and Bishop, *J.E.H. MacDonald, Designer*, p. 1. The visitor was MacDonald's son, Thoreau.

3. Typescript of Thoreau MacDonald's recollections, Tom Thomson Collection, MCAC Archives, p. 2.

4. William Smithson Broadhead, Correspondence addressed to members of the Broadhead family, LD 1980/29 and 32, Sheffield Archives, Sheffield, South Yorkshire.

5. Quoted in R. Cook, *The Regenerators*, p. 124. On Bengough's career and platforms, see ibid., pp. 123–51. See also Christina Burr, "Gender, Sexuality and Nationalism in J.W. Bengough's Verses and Political Cartoons," *Canadian Historical Review* 83 (December 2002), pp. 505–54.

6. Quoted in Michele H. Bogart, *Artists, Advertising and the Borders of Art* (Chicago: University of Chicago Press, 1995), p. 114.

7. William Broadhead to the Broadhead family, LD 1980/28, Sheffield Archives.

8. Rupert Brooke, *Letters from America* (London: Sidgwick & Jackson, 1916), pp. 79, 80, 82.

9. *Toronto Globe*, 16 March 1900.

10. Quoted in P.G. Mackintosh, "'The Development of Higher Urban Life' and the Geographic Imagination: Beauty, Art, and Moral Environmentalism in Toronto, 1900–1920," *Journal of Historical Geography* 31 (October 2005), p. 697.

11. Quoted in Norman Hillmer and Adam Chapnick, eds., "Introduction: An Abundance of Nationalisms," in *Canadas of the Mind: The Making and Unmaking of Canadian Nationalisms in the Twentieth Century* (Montreal and Kingston: McGill-Queen's University Press, 2007), p. 3.

12. Quoted in R. Douglas Francis and Chris Kitzan, eds., "Introduction," in *The Prairie West as Promised Land* (Calgary: University of Calgary Press, 2007), p. ix.

13. *Montreal Daily Star*, 16 September 1911.

14. J.M. Bumstead, *Canada's Diverse Peoples: A Reference Sourcebook* (Santa Barbara: ABC-CLIO, 2003), p. 162; and Paul Robert Magocsi, ed., *Encyclopedia of Canada's Peoples*, (Toronto: University of Toronto Press, 1999), pp. 144, 1093.

15. J. Burgon Bickersteth, *Land of Open Doors: Being Letters from Western Canada* (London: Wells Gardner, Darton & Co., 1914), p. x.

16. Quoted in Brown and R. Cook, *Canada, 1896–1921*, p. 73.

17. *Strangers within Our Gates: Or, Coming Canadians* (1909), reprinted with an introduction by Marilyn Barber (Toronto: University of Toronto Press, 1972), pp. 9, 244. The author was the Methodist social gospeller J.S. Woodsworth, who would later adopt a more tolerant attitude towards immigrants to the Prairies.

18. Quoted in Brown and R. Cook, *Canada, 1896–1921*, p. 165.

19. Émile Durkheim, *The Elementary Forms of Religious Life*, trans. K.E. Fields (New York: Free Press, 1995). For the lack of heroes in (English) Canada, see Ramsay Cook, *Watching Quebec: Selected Essays* (Montreal and Kingston: McGill-Queen's University Press, 2005), pp. 98–100. Cook points out that early Canadian heroes—he cites Brébeuf and Dollard des Ormeaux—"are nearly all French" (ibid., p. 99).

20. Richard Hakluyt, *Voyages and Discoveries*, ed. Jack Beeching (London: Penguin, 1972), p. 191.

21. *Speculations: Essays on Humanism and the Philosophy of Art*, ed. Herbert Read (London: Routledge & Kegan Paul, 1949), p. 73. This work was first published (posthumously) in 1924.

22. *Criterion*, April 1924.

23. *The Collected Writings of T.E. Hulme*, ed. Karen Csengeri (Oxford: Oxford University Press, 1994), p. 53.

24. Sir John Douglas Sutherland Campbell, the Marquess of Lorne, *Memories of Canada and Scotland: Speeches and Verse* (London: Sampson Low, Marston, Searle & Rivington, 1894), p. 220.

25. *The Canadian Magazine*, November 1908.

26. Quoted in Reid, *A Concise History of Canadian Painting*, p. 124.

27. The young art student was A.Y. Jackson: A.Y. Jackson, Berlin, ON, to Georgina Jackson, Montreal, 1 June 1910, Naomi Jackson Grove Fonds, LAC, MG30 D351, Container 96, File 12.

28. Quoted in Harper, *Painting in Canada*, pp. 215–16.

29. *Morning Post,* 4 July 1910.

30. Quoted in Hunter, "Mapping Tom," in Reid, *Tom Thomson,* p. 45.

31. For an Algonquin Provincial Park example, see Gaye I. Clemson,
 Gertrude Baskerville, the Lady of Algonquin Park (Capitola, CA: Globalinkage, 2001), p. 1.

32. P.L. Simmons, *Franklin and the Arctic Regions* (London: George Routledge
 & Co., 1853), pp. 44–46.

33. Quoted in Whiteman, *J.E.H. MacDonald,* pp. 14, 66.

34. C. Barry Cleveland to Joan MacDonald, 27 November 1932, MCAC Archives.

35. J.E.H. MacDonald, 40 Duggan Ave., Toronto, to F.B. Housser, unsent letter,
 20 December 1926, MCAC Archives.

36. J.E.H. MacDonald, London, to Joan MacDonald, 15 July 1906, MCAC Archives.
 MacDonald states that the painting was in the South Kensington Museum
 (now the Victoria & Albert Museum).

37. *The Canadian Magazine,* May 1908.

38. Augustus Bridle, *The Story of the Club* (Toronto: Arts and Letters Club, 1945), p. 10.

39. Quoted in Karen A. Finlay, *The Force of Culture: Vincent Massey and Canadian
 Sovereignty* (Toronto: University of Toronto Press, 2004), p. 95.

40. Quoted in Nasgaard, *The Mystic North,* p. 161. Jefferys's comments come from a
 speech delivered in London, Ontario, in May 1944 and subsequently in Toronto in
 March 1945.

41. *The Lamps,* November 1911.

42. Hamlin Garland, "Impressionism," in Charles Harrison, Paul Wood, and Jason
 Gaiger, eds., *Art in Theory, 1815–1900: An Anthology of Changing Ideas* (Oxford: Blackwell,
 1998), p. 930.

43. Quoted in Kelly, *J.E.H. MacDonald, Lewis Smith, Edith Smith,* p. 12.

CHAPTER 3: EIN TORONTO REALIST

1. Lawren Harris, "The Group of Seven in Canadian History," *The Canadian Historical
 Association: Report of the Annual Meeting Held at Victoria and Vancouver, June 16–19, 1948*
 (Toronto: University of Toronto Press, 1948), p. 31.

2. A.J. Casson, "Group Portrait," in Fetherling, *Documents in Canadian Art,* p. 59.

3. *Hamilton Spectator,* 11 February 1897.

4. *Canadian Bookman,* February 1924. For Harris's early years, see Larisey,
 "The Landscape Painting of Lawren Stewart Harris," pp. 1–22.

5. Arthur Shadwell, *Industrial Efficiency: A Comparative Study of Industrial Life in England,
 Germany and America* (London: Longmans, Green and Co., 1906), p. 159.

6. "The Beauty of Form and Decorative Art," in Charles Harrison and Paul Wood, eds.,
 Art in Theory, 1900–1990: An Anthology of Changing Ideas (Oxford: Blackwell, 1992), p. 62.

7. Quoted in Sue Prideaux, *Edvard Munch: Behind the Scream* (New Haven: Yale
 University Press, 2006), p. 136.

8. Quoted in ibid., p. 138.

9. Quoted in Marion F. Deshmukh, "Max Liebermann: Observations on the
 Politics of Painting in Imperial Germany, 1870–1914," *German Studies Review* 3
 (May 1980), p. 171.

10. Quoted in Peter Paret, *The Berlin Secession: Modernism and Its Enemies in Imperial
 Germany* (Cambridge, MA: Belknap Press of Harvard University Press, 1980), p. 38.

11. Quoted in Larisey, "The Landscape Painting of Lawren Stewart Harris," p. 23.

12. Ibid., pp. 39, 44.

13. Quoted in Bess Harris and R.G.P Colgrove, *Lawren Harris* (Toronto: Macmillan, 1969), p. 219.

14. Emily Carr, *Growing Pains,* with an introduction by Robin Laurence and a foreword by Ira Dilworth (Vancouver: Douglas & McIntyre, 2005), p. 263. *Growing Pains* was originally published in 1946.

15. Shadwell, *Industrial Efficiency,* p. 159.

16. Ferdinand Tönnies, *Community and Civil Society,* ed. José Harris, trans. Margaret Hollis (Cambridge: Cambridge University Press, 2001); and Émile Durkheim, *The Division of Labor in Society,* trans. George Simpson (New York: Free Press, 1964).

17. Quoted in Larisey, "The Landscape Painting of Lawren Stewart Harris," p. 29. On this urban aspect of Skarbina's work, see Ralf Roth, "Interactions between Railways and Cities in Nineteenth-Century Germany: Some Case Studies," in Ralf Roth and Marie-Noëlle Polino, *The City and the Railway in Europe* (Aldershot, Hants: Ashgate, 2003), pp. 17–20; John Czaplicka, "Pictures of a City at Work, Berlin 1890–1930: Visual Reflections on Social Structures and Technology in the Modern Urban Construct," in Charles W. Haxthausen and Heidrun Suhr, eds., *Berlin: Culture and Metropolis* (Minneapolis: University of Minnesota Press, 1990), pp. 4–17; and Shearer West, *The Visual Arts in Germany, 1890–1940: Utopia and Despair* (Manchester: Manchester University Press, 2001), p. 41.

18. Quoted in Roth, "Interactions," p. 16.

19. Quoted in Larisey, "The Landscape Painting of Lawren Stewart Harris," p. 26. For Wille and the notion of *Heimatkunst* in Germany at this time, see ibid., pp. 24–26.

20. Quoted in Adamson, *Lawren S. Harris,* p. 21.

21. Quoted in ibid., p. 22. For speculation that the unorthodoxy was theosophy, see Davis, *The Logic of Ecstasy,* p. 22.

22. *The Studio,* 15 November 1907. This exhibition, at the Fritz Gurlitt Gallery in Berlin, was probably seen by Harris.

23. For the 1906 *Ausstellung Deutscher Kunst aus der Zeit von 1775–1875* and its probable influence on Harris, see Larisey, "The Landscape Painting of Lawren Stewart Harris," pp. 50–52.

24. Quoted in Larisey, "The Landscape Painting of Lawren Stewart Harris," p. 48.

25. Quoted in Adamson, *Lawren S. Harris,* p. 51. The letter in which Harris makes this claim dates from 1948.

26. Quoted in Housser, *A Canadian Art Movement,* p. 36.

27. This statement was made in an April 1954 talk delivered at the Vancouver Art Gallery and broadcast on the Vancouver radio station CBU in September 1954.

28. Quoted in Housser, *A Canadian Art Movement,* p. 36.

29. Doris Speirs (formerly Mills), interview with Charles Hill, 15 October 1973, *Canadian Painting in the Thirties* Exhibition Records, National Gallery of Canada Fonds, National Gallery of Canada Library and Archives.

30. Quoted in Mackintosh, "The Development of Higher Urban Life," p. 698.

31. *The Canadian Magazine,* November 1909; *Toronto Daily Star,* 28 February 1914.

32. Quoted in Gregory Betts, ed., *Lawren Harris: In the Ward* (Holstein, ON: Exile Editions, 2007), p. 94.

33. Quoted in Adamson, *Lawren S. Harris,* p. 33.

34. See Paul Duval, *Canadian Impressionism* (Toronto: McClelland and Stewart, 1990); and Lowrey, *Visions of Light and Air.*

35. Quoted in Hunter Bishop, "MacDonald and the Club," in Stacey and Bishop, *J.E.H. MacDonald, Designer,* p. 113.

36. *The Saturday Review,* 31 December 1910.

37. Gregory S. Kealey, *Toronto's Workers Respond to Industrial Capitalism, 1867–1892*
(Toronto: University of Toronto Press, 1980), p. 13; and Robert N. Pripps and Andrew
Morland, *The Big Book of Massey Tractors* (St. Paul, M N: Voyageur Press, 2006,), p. 12.

38. R. Harris, *Unplanned Suburbs,* pp. 116–17.

39. For the growth of industry in Toronto between 1901 and 1911, see J.M.S. Careless,
Toronto to 1918: An Illustrated History (Toronto: James Lorimer and Co., 1984), pp. 154–55.

40. See Stacey and Bishop, *J.E.H. MacDonald, Designer,* p. 42.

41. *Toronto Mail & Empire,* 20 February 1911; and *Toronto Mail & Empire,* 15 August 1911.
For a full account of the campaign, see Paul Stevens, *The 1911 General Election:
A Study in Canadian Politics* (Toronto: Copp Clark, 1970).

42. For the term "tinted steam," applied to Turner's work by John Constable,
see K. Clark, *Landscape into Art,* p. 103.

43. For examples, see Roth, "Interactions," pp. 18–19.

44. See Czaplicka, "Pictures of a City at Work," pp. 15–16.

CHAPTER 4: EERIE WILDERNESSES

1. Quoted in Carl Berger, "The True North Strong and Free," in Elspeth Cameron, ed.,
Canadian Culture: An Introductory Reader (Toronto: Canadian Scholars' Press, 1997), p. 91.

2. Robyn Roslak, *Neo-Impressionism and Anarchism in Fin-de-Siècle France: Painting,
Politics and Landscape* (Aldershot, Hants: Ashgate, 2007), pp. 141–71.

3. *The Men of the Last Frontier* (Toronto: Macmillan, 1976), p. 76. This work was originally
published in 1931.

4. J. Macdonald Oxley, *The Young Woodsman, or Life in the Forests of Canada* (London and
New York: T. Nelson & Sons, 1897), p. 8. On the Portuguese lament, see A. Marshall Elliott,
"Origin of the Name 'Canada,'" *Modern Language Notes* 3 (June 1888), pp. 164–73; and
Alan Rayburn, *Naming Canada: Stories about Canadian Place Names,* rev. ed. (Toronto:
University of Toronto Press, 2001), pp. 13–14. For studies of Canadian literature's fearful
responses to the landscape, see Northrop Frye's "Canada and Its Poetry," originally published
in 1943 as a review of A.J.M. Smith's *The Book of Canadian Poetry* and reprinted in *The
Bush Garden: Essays on the Canadian Imagination* (Toronto: House of Anansi Press, 1971),
pp. 129–43. Frye's observations that the Canadian landscape "is consistently sinister and
menacing in Canadian poetry" (p. 142) has been adopted and explored by a number of
other critics. See especially D.G. Jones, *Butterfly on Rock: A Study of Themes and Images in
Canadian Literature* (Toronto: University of Toronto Press, 1970); Marcia B. Kline, *Beyond
the Land Itself: Views of Nature in Canada and the United States* (Harvard University
Press: Cambridge, M A, 1970); Margaret Atwood, *Survival: A Thematic Guide to Canadian
Literature* (Toronto: House of Anansi, 1972); idem., *Strange Things: The Malevolent North
in Canadian Literature* (Oxford: Oxford University Press, 1995; London: Virago, 2004);
John Moss, *Patterns of Isolation in English Canadian Fiction* (Toronto: McClelland &
Stewart, 1974); and Gaile McGregor, *The Wacousta Syndrome: Explorations in the Canadian
Landscape* (Toronto: University of Toronto Press, 1985). A number of critics dissent from
this view. For a stern corrective to McGregor, see I.S. McLaren, "The McGregor Syndrome;
or, the Survival of Patterns of Isolated Butterflies on Rocks in the Haunted Wilderness of
the Unnamed Bush Garden Beyond the Land Itself," *Canadian Poetry* 18 (1986), pp. 118–30.
Others critics have claimed that nineteenth-century Canadians regarded the forest and
wilderness in more positive light: see M.L. MacDonald, "Literature and Society in the
Canadas, 1830–1850" (PhD dissertation, Carleton University, 1984); and Susan Glickman,

The Picturesque and the Sublime: A Poetics of the Canadian Landscape (Montreal and Kingston: McGill-Queen's University Press, 1998). Glickman argues that the supposed menace and hostility of the Canadian landscape can be read in terms of British aesthetic categories of the sublime and the picturesque. Allan Smith argues, however, that those who saw the Canadian landscape in a positive light tended to be those who concentrated on the land's ability to sustain agricultural activity: see "Farms, Forests and Cities: The Image of the Land and the Rise of the Metropolis in Old Ontario, 1860–1914," in David Keane and Colin Reade, eds., *Old Ontario: Essays in Honour of J.M.S. Careless* (Toronto: Dundurn Press, 1990), pp. 71–94.

5. *Farmer's Advocate*, 25 May 1905. Campbell's article was entitled "Back to the Land."

6. Catharine Parr Traill, *The Canadian Settler's Guide*, 7th ed. (Toronto: Office of the *Toronto Times*, 1857), p. 217.

7. *James Bay Treaty: Treaty No. 9 (Made in 1905 and 1906) Adhesions Made in 1929 and 1930* (Ottawa: Printer and Controller of Stationery, 1931; 1964), p. 1; Bruce W. Hodgins and Kerry A. Cannon, "The Aboriginal Presence in Ontario Parks and Other Protected Places," in John Marsh and Bruce W. Hodgins, eds., *Changing Parks: The History, Future and Cultural Context of Parks and Heritage Landscapes* (Toronto: Dundurn Press, 1998), p. 52.

8. Stephen Leacock, *Adventurers of the Far North* (Toronto: Hunter-Ross Co., 1914), p. 2.

9. *The Times*, 24 May 1911.

10. Quoted in Ragna Stang, *Edvard Munch: The Man and His Art*, trans. Geoffrey Culverwell (New York: Abbeville Press, 1977), p. 90.

11. Jasen, *Wild Things*, p. 104.

12. Ada Kinton, quoted in Astrid Taim, *Almaguin: A Highland History* (Toronto: Dundurn Press, 1998), p. 45.

13. Norman Duncan, *Going Down from Jerusalem: The Narrative of a Sentimental Traveller* (New York and London: Harper & Brothers, 1909), p. 4.

14. On Henry Ward Ranger's reputation at the time, see Clara Ruge, "The Tonal School of America," *International Studio* 27 (1906), pp. 57–68.

15. See the full-page advertisements by Eaton's and Simpsons in the *Toronto Daily Star*, 9 February 1912, 12 April 1913, and 17 November 1915. A.Y. Jackson lampoons these works and the practice by which they are sold in an unpublished article (written c. 1918 for *The Rebel*) called "Buckeyes": see J.E.H. MacDonald Fonds, MG30 D111, Container 1, File 14, LAC.

16. "Prefatory Note," *Catalogue of the Thirty-eighth Annual Exhibition* (Toronto: Ontario Society of Artists, 1910), unpaginated.

17. In the 1915 OSA exhibition Manly offered two landscapes for $300 each and Chavignaud one *(In the Land of Evangeline)* for $400.

18. *Catalogue of the Thirty-ninth Annual Exhibition* (Toronto: Ontario Society of Artists, 1911).

19. *The Canadian Magazine*, May 1904, December 1893.

20. Quoted in Joyce Henri Robinson, "'Honey, I'm Home': Weary (Neurasthenic) Businessmen and the Formulation of a Serenely Modern Aesthetic," in Andrew Ballantyne, ed., *What is Architecture?* (Abingdon, Oxon: Routledge, 2002), p. 118. For the studies of Jean-Martin Charcot and Hippolyte Bernheim and their application to the arts, see Debora L. Silverman, *Art Nouveau in Fin-de-Siècle France: Politics, Psychology and Style* (Berkeley: University of California Press, 1989), pp. 79–88.

21. Quoted in Housser, *A Canadian Art Movement*, p. 48.

22. *The Studio*, 14 December 1912.

23. Quoted in Adamson, *Lawren S. Harris*, p. 44. This statement, a retrospective one, comes from a 1954 address at the Vancouver Art Gallery.

24. *The Canadian Magazine*, November 1908.

CHAPTER 5: LIFE ON THE MISSISSAGI

1. William Broadhead to the Broadhead family, L D 1980/11, 32 and 26, Sheffield Archives.

2. Grey Owl, *Tales of an Empty Cabin* (Toronto: Macmillan, 1936), p. 172.

3. Quoted in Lovat Dickson, *Wilderness Man: The Strange Story of Grey Owl* (London: Macmillan, 1974), p. 92.

4. This information comes from a *Toronto Mail & Empire* article by William Arthur Deacon. Entitled "Famed Canvases Found in Cabin," it describes how Beaver Lodge was decorated with three Thomson sketches that Grey Owl acquired from a mysterious doughnut-making fire ranger on Lake Minisinakwa. I am grateful to Christine Lynett for allowing me to see this clipping, which is in her collection of the Tweedale family papers. Undated, it is undoubtedly from 1936, the year of publication for *Tales of an Empty Cabin*, the book that Grey Owl was promoting in Toronto at the time of his interview with Deacon.

5. *James Bay Treaty*, p. 16.

6. William Broadhead to the Broadhead family, L D 1980/21, Sheffield Archives.

7. *Toronto Globe*, 29 June 1904.

8. Quoted in Harold A. Innis, *The Fur Trade in Canada: An Introduction to Canadian Economic History*, rev. ed. (Toronto: University of Toronto Press, 1956), p. 20. For a study of the canoe in Canadian history and mythology, see Daniel Francis, *National Dreams: Myth, Memory and Canadian History* (Vancouver: Arsenal Pulp Press, 1997), pp. 128–51.

9. Addison and Harwood, *Tom Thomson*, p. 19.

10. Tom Thomson, Toronto, to Dr. J. M. McRuer, Huntsville, postmarked 17 October 1912, M C A C Archives.

11. *Man: A Canadian Home Magazine* (December 1885).

12. Izaak Walton, *The Compleat Angler, or The Contemplative Man's Recreation* (New York: Dodd, Mead & Co., 1897), p. 33. The description of angling as a "pleasant labour" is found in Walton's dedication to John Offley. For a discussion of Thomson's interest in Walton, see Hunter, "Mapping Tom," in Reid, *Tom Thomson*, pp. 26–27.

13. Tom Thomson, Toronto, to Dr. J. M. McRuer, Huntsville, postmarked 17 October 1912, M C A C Archives.

14. Ibid.

15. Grey Owl, *Tales of an Empty Cabin*, p. 172.

16. Tom Thomson, Toronto, to Dr. J. M. McRuer, Huntsville, 17 October 1912, M C A C Archives. Presumably he meant that two rolls of a dozen exposures were salvaged from a total of fourteen rolls. A copy of McRuer's wedding certificate, dated 16 February 1909, with Thomson as a signatory, can be seen in the Tom Thomson Collection, Box No. 1, Series I V, File 1, M C A C Archives. For Seton's mishap, see *The Arctic Prairies: A Canoe Journey of 2,000 Miles in Search of the Caribou* (New York: Charles Scribner's Sons, 1911), pp. 81–91.

17. Louise Henry to Blodwen Davies, 11 March 1931, Blodwen Davies Fonds.

18. Dr. J.M. McRuer, Huntsville, to Tom Thomson, Toronto, 1 November 1912, Tom Thomson Papers, M G30 D284, Vol. 1, The Thomson Correspondence, 1912–1917, L A C.

19. *Canadian Journal of Medicine and Surgery* 3 (1898).

20. Quoted in Hill, "Tom Thomson, Painter," in Reid, *Tom Thomson*, p. 119.

21. Quoted in Landry, *The MacCallum-Jackman Cottage Mural Paintings*, p. 20.

22. This story is told in Housser, *A Canadian Art Movement*, pp. 61–62.

23. William Broadhead to the Broadhead family, L D 1980/24, 26, 2/1, 10, and 23, Sheffield Archives.

24. Jackson, *A Painter's Country*, p. 94.

25. Quoted in Bridges, *A Border of Beauty*, p. 11.

26. *The Studio*, July 1893.

27. Lois Darroch, *Bright Land: A Warm Look at Arthur Lismer* (Toronto: Merritt Publishing Co., 1981), p. 8.

28. Quoted in Bridges, *A Border of Beauty*, p. 12.

29. Quoted in Tippett, *Stormy Weather*, p. 56.

30. Quoted in Tooby, *Our Home and Native Land*, unpaginated.

31. Quoted in Tippett, *Stormy Weather*, p. 47.

32. Kemp, "A Recollection of Tom Thomson." The Lismer quote is taken from Addison and Harwood, *Tom Thomson*, p. 7.

33. Minnie Henry to Blodwen Davies, 2 February 1931, Blodwen Davies Fonds.

34. Quoted in Tippett, *Stormy Weather*, p. 64.

35. Quoted in Tippett, *Stormy Weather*, pp. 70–71.

CHAPTER 6: WILD MEN OF THE NORTH

1. *New York Times*, 26 November 1911.

2. A.Y. Jackson, "Lawren Harris, A Biographical Sketch," in *Lawren Harris: Paintings* (Toronto: Art Gallery of Ontario, 1948), p. 6.

3. Quoted in Stacey, "A Contact in Context," p. 40.

4. Quoted in *Academy Notes* 8 (January 1913), p. 22.

5. Christian Brinton, "Introduction," *Exhibition of Contemporary Scandinavian Art* (Stockholm: Nationalmuseum Library, 1912), p. 15.

6. See Kirk Varnedoe, *Northern Light: Nordic Art at the Turn of the Century* (New Haven: Yale University Press, 1988); as well as Reinhold Heller's review of Varnedoe, *New York Times*, 21 August 1988.

7. *Academy Notes* 8 (January 1913), p. 1.

8. J. Nilsen Laurvik, "Intolerance in Art," *The American Scandinavian Review* (March 1913), p. 17.

9. Quoted in Berger, "The True North Strong and Free," in E. Cameron, *Canadian Culture*, pp. 84, 85.

10. *Academy Notes* 8 (January 1913), p. 20.

11. Torsten Gunnarsson, *Nordic Landscape Painting in the Nineteenth Century*, trans. Nancy Adler (New Haven: Yale University Press, 1998), pp. 104–6, 206–8. For National Romanticism in Scandinavia, see also Michelle Facos, *Nationalism and the Nordic Imagination: Swedish Art of the 1890s* (Berkeley and Los Angeles: University of California Press, 1998).

12. Harris, "The Group of Seven in Canadian History," p. 31.

13. Gunnarsson, *Nordic Landscape Painting in the Nineteenth Century*, pp. 252–53.

14. Lawren Harris, *The Story of the Group of Seven* (Toronto: Rous and Mann, 1964), p. 10.

15. J.E.H. MacDonald, "Scandinavian Art," *Northward Journal* 18/19 (1980), p. 9. This lecture was originally delivered at the Art Gallery of Toronto in April 1931.

16. *The Letters of Vincent Van Gogh*, ed. Ronald de Leeuw, trans. Arnold Pomerans (London: Allen Lane, Penguin Press, 1996), p. 390.

17. Quoted in Nasgaard, *The Mystic North*, p. 40.

18. Laurvik, "Intolerance in Art," p. 13.

19. *Academy Notes* 8 (January 1913), p. 20.

20. Quoted in Stang, *Edvard Munch*, p. 15.

21. Quoted in Frederick B. Deknatel, *Edvard Munch* (London: Max Parrish & Co., 1950), p. 54.

22. *Academy Notes* 8 (January 1913), p. 19.

23. Laurvik, "Intolerance in Art," p. 17.

24. W.G.C. Byvanck, *Un Hollandais à Paris en 1891* (Paris: Perrin, 1892), p. 176.

25. Fry, "The Philosophy of Impressionism," in *A Roger Fry Reader,* ed. Christopher Reed (Chicago: University of Chicago Press, 1996), p. 13.

26. Quoted in Helmut Friedel, "'To Sense the Invisible and to Be Able to Create It—That is Art,'" in Helmut Friedel and Tina Dickey, *Hans Hofmann* (Manchester, Vermont: Hudson Hills Press, 1998), p. 8.

27. Quoted in Reinhold Heller, *Munch: His Life and Work* (Chicago: University of Chicago Press, 1984), p. 64.

28. Henry Reuterdahl, "Scandinavian Painting and Its National Significance," *The Craftsman* 23 (December 1912).

29. Brinton, *Exhibition of Contemporary Scandinavian Art,* p. 23.

30. MacDonald, "Scandinavian Art," p.24.

31. Ibid., p. 25.

32. Ibid.

33. *Academy Notes* 8 (January 1913), p. 4.

34. MacDonald, "Scandinavian Art," p. 17.

35. Ibid.

36. Quoted in Stefan Tschudi Madsen, *The Art Nouveau Style: A Comprehensive Guide with 264 Illustrations,* trans. Ragnar Christophersen (Mineola, N Y: Dover Publications, 2002), p. 246.

37. See Stacey and Bishop, *J.E.H. MacDonald, Designer,* p. 1, figure B.3.

38. MacDonald, "Scandinavian Art," pp. 17, 18.

39. Harris, "The Group of Seven in Canadian History," p. 31.

40. *New York Times,* 14 May 1911.

41. Brooke, *Letters from America,* p. 49.

42. Ibid., p. 83.

43. *New York Sun,* 13 March 1913.

CHAPTER 7: THE INFANTICIST SCHOOL

1. Laurvik, "Intolerance in Art," p. 17.

2. Quoted in Milton W. Brown, *The Story of the Armory Show* (New York: Abbeville Press, 1988), p. 43.

3. Roger Fry, "The Post-Impressionists," in *Manet and the Post-Impressionists* (London: Grafton Galleries, 1910).

4. For these responses, see J.B. Bullen, ed., *Post-Impressionists in England: The Critical Reception* (London: Routledge, 1988), pp. 111, 115, 119–20, 137, 210; as well as *The Moraine Post,* 19 November 1910; and *The Nation,* December 1910.

5. *Century,* April 1913.

6. See Schapiro, *Modern Art,* pp. 146, 171.

7. *Montreal Daily Witness,* 26 March 1913.

8. *Montreal Daily Herald,* 26 March 1913.

9. Casson, "Group Portrait," in Fetherling, *Documents in Canadian Art,* p. 60.

10. Jackson, *A Painter's Country,* p. 3.

11. G. Blair Laing, *Memoirs of an Art Dealer,* 2 vols. (Toronto: McClelland & Stewart, 1979), vol. 1, p. 109.

12. Anne McDougall, *Anne Savage: The Story of a Canadian Painter* (Montreal: Harvester House, 1977), p. 37.

13. A.Y. Jackson, Chicago, to Georgina Jackson, Montreal, 18 September 1906, Naomi Jackson Groves Fonds, Container 96, File 2.

14. For Jackson's positive reactions to Mucha's art and lectures, see his letters to his mother of 28 October and 4 November 1906, Naomi Jackson Groves Fonds, Container 96, Files 2 and 3. An exhibition of Mucha's work was staged at the Art Institute of Chicago in October and November 1906.

15. A.Y. Jackson, Chicago, to Georgina Jackson, Montreal, 2 March 1907, Naomi Jackson Groves Fonds, Container 96, File 5. The catalogue for the exhibition (listing two paintings by Skarbina, including *On the Canal, Berlin*) was published as *Catalogue of an Exhibition of Contemporary German Paintings* (Chicago: Art Institute of Chicago, 1907).

16. A.Y. Jackson, Chicago, to Isabel Jackson, 11 November 1906, Naomi Jackson Grove Fonds, Container 96, File 3.

17. On the Académie Julian, see H. Barbara Weinberg, *The Lure of Paris: Nineteenth-Century American Painters and Their French Teachers* (New York: Abbeville Press, 1991), pp. 221–62.

18. Jackson, *A Painter's Country*, p. 8.

19. A.Y. Jackson, c/o American Art Association of Paris, 74 rue Notre-Dame-des-Champs, Paris, to Georgina Jackson, 69 Hallowell Avenue, Montreal, 5 March 1908, Naomi Jackson Grove Fonds, Box 96, File 6.

20. C.R.W. Nevinson, *Paint and Prejudice* (New York: Harcourt, Brace and Co., 1938), p. 60.

21. Quoted in Dominique Lobstein, "Paris 1907: The Only Salon of Italian Divisionists," in Vivienne Greene, ed., *Arcadia & Anarchy: Divisionism/Neo-Impressionism* (New York: Guggenheim Museum, 2007), p. 60. For Jackson's visit to the exhibition, see A.Y. Jackson, Paris, to Georgina Jackson, Montreal, 12 December 1907, Naomi Jackson Grove Fonds, Box 96, File 6.

22. A.Y. Jackson, Paris, to Georgina Jackson, Montreal, 5 March 1908, Naomi Jackson Grove Fonds, Box 96, File 6.

23. A.Y. Jackson, Amsterdam, to Georgina Jackson, Montreal, 12 July 1909, Naomi Jackson Grove Fonds, Box 96, File 11. For Jackson's time in the Low Countries, see Tovell, "A.Y. Jackson in France, Belgium and Holland," pp. 31–51.

24. A.Y. Jackson, Montreal, to Catherine Briethaupt, Boston, 17 January 1921, Catherine Breithaupt Bennett Papers.

25. For Van Gogh's influence in the first dozen years of the twentieth century, see Jill Lloyd, *Van Gogh and Expressionism* (Ostfildern, Germany: Hatje Cantz Verlag, 2007).

26. Leo Stein, *Appreciation: Painting, Poetry and Prose* (New York: Crown, 1947), p. 174.

27. *The Saturday Review*, 12 November 1910.

28. Schapiro, *Modern Art*, pp. 137–38.

29. Quoted in Townsend Ludington, *Marsden Hartley: The Biography of an American Artist* (Ithaca: Cornell University Press, 1998), p. 79. Hartley arrived in Paris several months after Jackson in April 1912. Jackson's address is given as 26 rue de Fleurus in the catalogue for the 1912 Canadian National Exhibition and in a letter to his mother of 1 June 1912: Naomi Jackson Grove Fonds, Box 96, File 16. For a description of 27 rue de Fleurus, with its numerous visitors and its drawings by Matisse and Picasso tacked to the doors, see Gertrude Stein, *The Autobiography of Alice B. Toklas* (London: Bodley Head, 1935), pp. 7–8.

30. James R. Mellow, *Charmed Circle: Gertrude Stein & Company* (New York: Praeger, 1974), pp. 3–4.

31. Louise Dompierre, *John Lyman, 1886–1967* (Kingston: Agnes Etherington Art Centre, 1986), p. 29.

32. Jackson, *A Painter's Country*, p. 23.

33. *Montreal Herald*, 27 May 1912.

34. A.Y. Jackson, Étaples-sur-mer, to Georgina Jackson, Montreal, 11 June 1912, Naomi Jackson Grove Fonds, Container 96, File 16.

35. Quoted in Hill, *The Group of Seven*, p. 38.

36. Jackson, *A Painter's Country*, p. 23.

37. Jackson and MacDonald had already corresponded regarding staging an exhibition together in Montreal with Randolph Hewton: see A.Y. Jackson, Assisi, to Georgina Jackson, Montreal, 4 December 1912, Naomi Jackson Grove Fonds, Box 96, File 17. Jackson writes that he and Hewton have contacted "a Toronto man named MacDonald."

38. A.Y. Jackson, Sweetsburg, QC, to Georgina Jackson, Montreal, 7 March 1910, Naomi Jackson Grove Fonds, Box 96, File 12.

39. Quoted in Housser, *A Canadian Art Movement*, pp. 79–80.

40. *New York Times*, 14 September 1910.

41. Quoted in Tippett, *Stormy Weather*, p. 80.

42. *Canadian National Problems*, ed. Ellery C. Stowell (Philadelphia: Annals of the American Academy of Political and Social Science, 1913), pp. 171–76.

43. *Toronto Daily Star*, 12 April 1913.

44. *Toronto Daily Mail & Empire*, 5 April 1913.

45. Quoted in Stacey, "Tom Thomson as Applied Artist," in Reid, *Tom Thomson*, p. 51.

46. Quoted in Hill, "Tom Thomson, Painter," in Reid, *Tom Thomson*, p. 117.

47. Gail Dexter, "Tom Thomson's Dollar-a-Month Shack Becomes a Group of Seven Shrine," *Toronto Daily Star*, 1 June 1968. I am grateful to Christine Lynett for allowing me to see this clipping, which is in her archive of the Tweedale family papers. The "middle-aged woman" who related the story to Dexter at the McMichael Conservation Collection of Art in 1968 is not identified.

CHAPTER 8: THE HAPPY ISLES

1. Quoted in Bridges, *A Border of Beauty*, p. 15.

2. Quoted in Grigor, *Arthur Lismer*, p. 8.

3. Quoted in McLeish, *September Gale*, p. 48.

4. Quoted in ibid., p. 29.

5. Quoted in ibid., p. 22.

6. Parr Traill, *The Canadian Settler's Guide*, p. 217.

7. Quoted in Brown and R. Cook, *Canada, 1896–1921*, p. 79.

8. Walt Whitman, *Leaves of Grass*, 2nd ed. (Philadelphia: David McKay, 1891–92), p. 173.

9. Edward Carpenter, *The Art of Creation* (New York: Cosimo Classics, 2005). My quotations all come from Chapter Two, "The Art of Creation."

10. Edward Carpenter, *Civilisation: Its Cause and Cure* (London: George Allen & Unwin, 1921), p. 58. This work was originally published in 1889.

11. McLeish, *September Gale*, p. 9. See also Grigor, *Arthur Lismer*, p. 16.

12. McLeish, *September Gale*, p. 30.

13. Liz Lundell, *Old Muskoka: Century Cottages & Summer Estates* (Erin, ON: Boston Mills Press, 2003), pp. 80, 103–5.

14. Quoted in Grigor, *Arthur Lismer*, p. 62.

15. William Velores Uttley, *A History of Kitchener, Ontario* (Waterloo: Chronicle Press, 1937), p. 87.

16. Jackson, *A Painter's Country*, p. 67.

17. See the following of Jackson's letters to his mother, Naomi Jackson Grove Fonds:

April 1909 (Box 96, File 11); 25 March 1908 (Box 96, File 10); 5 June 1909 (Box 96, File 11); 8 December 1906 (Box 96, File 3).

18. See Rosa M. Breithaupt, interview with H. Spencer Clark, 21 August 1978, Breithaupt Hewetson Clark Collection, University of Waterloo. For the location of the Clement cottage, see "Note for Portage Point Log," Florence Clement Papers, Clement Bowlby Family Fonds, University of Waterloo.

19. Rosa M. Breithaupt, interview with H. Spencer Clark.

20. See the Florence Clement Papers, Clement Bowlby Family Fonds. For Jackson's reference to the "happy isles," see A.Y. Jackson, Murray Bay, QC, to Florence Clement, Toronto, 14 March 1926, Clement Bowlby Family Fonds.

21. Quoted in Reid, *The Group of Seven*, p. 34.

22. Quoted in Housser, *A Canadian Art Movement*, pp. 85–86.

23. William Broadhead to the Broadhead family, LD 1980/15b, Sheffield Archives.

24. Quoted in Lynda Jessup, "Prospectors, Bushwhackers, Painters: Antimodernism and the Group of Seven," *International Journal of Canadian Studies* 17 (Spring 1998), p. 193.

25. Quoted in Lamb, *The Canadian Art Club*, p. 6.

26. Quoted in Harper, *Painting in Canada*, p. 229.

27. *Canadian Art*, Winter 1955.

28. Corinne Lyman, "Avant Propos," *Exhibition of Paintings and Drawings by John G. Lyman* (Montreal: Art Association of Montreal, 1913).

29. *Montreal Daily Star*, 25 May 1913.

30. *Montreal Daily Star*, 23 May 1913.

31. *Montreal Daily Star*, 10 May 1913.

32. "Growing Pains," in *The Complete Writings of Emily Carr*, ed. Doris Shadbolt (Vancouver: Douglas & McIntyre, 1997), p. 437.

33. *Toronto Globe*, 4 June 1914.

34. Quoted in Ord, *The National Gallery of Canada*, p. 77.

35. David R. Spencer, "Fact, Fiction or Fantasy: Canada and the War to End All Wars," in Bonnie Brennen and Hanno Hardt, eds., *Picturing the Past: Media, History and Photography* (Urbana and Chicago: University of Illinois, 1999), p. 191.

36. *Toronto Daily Star*, 12 December 1913. The entirety of the article is reprinted in Fetherling, *Documents in Canadian Art*, pp. 43–48.

37. Fry, *Vision and Design*, p. 27.

38. Quoted in J.B. Bullen, ed., *Post-Impressionists in England*, p. 99.

39. *Toronto Daily Star*, 18 December 1913.

40. *Emerson's Literary Criticism*, ed. Eric W. Carlson (Lincoln: University of Nebraska Press, 1995), p. 19.

41. Quoted in Colleen Denney, *At the Temple of Art: The Grosvenor Gallery, 1877–1890* (Madison, NJ: Fairleigh Dickinson University Press, 2000), p. 220.

42. For this neglected aspect of modernism, see Richard R. Brettell, *Modern Art 1851–1929: Capitalism and Representation* (Oxford: Oxford University Press, 1999), pp. 197–210; and especially Walter L. Adamson, *Embattled Avant-Gardes: Modernism's Resistance to Commodity Culture in Europe* (Berkeley and Los Angeles: University of California Press, 2007).

43. I take the term "ethno-scape" from Athena S. Leoussi, ed., *Encyclopaedia of Nationalism* (New Brunswick, NJ: Transaction Books, 2001), p. 10.

44. Quoted in Nina Maria Athanassoglou-Kallmyer, *Cézanne and Provence: The Painter in His Culture* (Chicago: University of Chicago Press, 2003), p. 2.

45. For Picasso's Catalan nationalism at this time, see Christopher Green, *Picasso: Architecture and Vertigo* (New Haven: Yale University Press, 2005), pp. 136–47. Although born in Málaga in Andalusia, Picasso regarded Catalonia as his true home: see Lael Wertenbaker, *The World of Picasso, 1881–1973* (New York: Time-Life Books, 1967), p. 13. For Stein's comments on Picasso's work, see Brenda Wineapple, *Sister Brother: Gertrude & Leo Stein* (Lincoln: University of Nebraska Press, 2008), p. 306.

46. Quoted in W.L. Adamson, *Embattled Avant-Gardes,* p. 139.

47. This term was originally the motto of *The Nation,* the short-lived paper of Young Ireland in the 1840s: "To create and foster public opinion in Ireland and to make it racy of the soil." By the 1890s the phrase was frequently used in Canada, especially with regard to poetry: see D.M.R. Bentley, *The Confederation Group of Canadian Poets, 1880–1897* (Toronto: University of Toronto Press, 2004), p. 28.

CHAPTER 9: RITES OF *PAYSAGE*

1. The Thoreau MacDonald Collection, The Papers of L. Bruce Pierce, Binder 1, File 25, MCAC Archives. For the average house price in Toronto, see R. Harris, *Unplanned Suburbs,* p. 162.

2. See W. Douglas Brown, "The Arts and Crafts Architecture of Eden Smith," in David Latham, ed., *Scarlet Hunters: Pre-Raphaelitism in Canada* (Toronto: Archives of Canadian Art and Design, 1998), pp. 144–53.

3. *Toronto Daily Star,* 28 February 1914.

4. Dennis Reid has written that the Studio Building was an "essentially Arts and Crafts utopia of a non-hierarchical community of artist-craftsmen living in a totally aestheticized environment in healthy accord with nature" ("Tom Thomson and the Arts and Crafts Movement," in Reid, *Tom Thomson,* p. 79).

5. Lawren Harris, 4760 Belmont Ave., Vancouver, to A.Y. Jackson, Toronto, 14 January 1955, MCAC Archives.

6. Jackson, *A Painter's Country,* p. 27.

7. Quoted in Adamson, *Lawren S. Harris,* p. 49.

8. Eric Brown, quoted in Dorothy M. Farr, *J.W. Beatty, 1869–1941* (Kingston: Agnes Etherington Art Centre, 1981), p. 28.

9. *Toronto Globe,* 13 April 1912. For Heming's biography, see his entry in Henry James Morgan, ed., *Canadian Men and Women of the Time* (Toronto: William Briggs, 1912), p. 521.

10. Floyd S. Chalmers, "Arthur Heming," 5 August 1941, p. 1, Arthur Heming Collection, Box 1, File 1, National Gallery of Canada Archives; Laing, *Memoirs of an Art Dealer,* vol. 2, p. 40.

11. Chalmers, "Arthur Heming," p. 11.

12. *The Lamps,* October 1911.

13. Jackson, *A Painter's Country,* p. 33.

14. Quoted in Stacey, "A Contact in Context," p. 44.

15. *Toronto Daily Star,* 28 February 1914.

16. Ibid.

17. Quoted in Hunter, "Mapping Tom," in Reid, *Tom Thomson,* p. 45.

18. *Toronto Globe,* 29 June 1904.

19. See Jeffrey W. Andersen, "The Art Colony at Old Lyme," in *Connecticut and American Impressionism* (Storrs, CT: University of Connecticut, 1980), pp. 114–37; and Arthur Heming, *Miss Florence and the Artists of Old Lyme* (Old Lyme: Lyme Historical Society, 1971).

20. Naomi Jackson Grove Fonds: 20 November 1908, Container 96, File 7; 20 November 1908, Container 96, File 7; 4 November 1906, Container 96, File 2; and 11 November 1906, Container 96, File 3.

21. Naomi Jackson Grove Fonds: 26 September 1907, Container 96, File 6; 14 November 1907, Container 96, File 6; 26 July 1908, Container 96, File 7; 12 December 1907, Container 96, File 6; 26 June and 2 July 1908, Container 96, File 9; and 1 June 1912, Container 96, File 16.

22. Jackson, *A Painter's Country*, p. 34.

23. Christina Bertram was a friend of Jackson's cousin Florence Clement: see the many references to her in the Florence Clement Papers, Clement Bowlby Family Fonds. For the information on Christina Bertram's interactions with the painters, I am grateful to Mary Gordon for passing on to me the recollections of Christina's late granddaughter Ruth Hamilton Upjohn (personal communication, 6 June 2007).

24. Quoted in Joan Murray, "Tom Thomson," in Morrin et al., *The Advent of Modernism*, p. 167. Murray repeats the story in *The Birth of the Modern: Post-Impressionism in Canadian Art, c. 1900–1920* (Oshawa: Robert McLaughlin Gallery, 2002), p. 78. Jackson made this claim in an interview with Murray on 4 March 1971.

25. Paul Signac, quoted in Floyd Ratliff, *Paul Signac and Color in Neo-Impressionism* (New York: Rockefeller University Press, 1992), p. 262; and D.S. MacColl, quoted in Kate Flint, ed., *The Impressionists in England: The Critical Reception* (London: Routledge & Kegan Paul, 1984), p. 174.

26. For this second phase of Neo-Impressionism, see John Sillevis, *A Feast of Colour: Post-Impressionists from Private Collections* (Zwolle: Waanders Publishers, 1990), pp. 72, 202.

27. Quoted in ibid., p. 198.

28. *La Grande Revue*, 10 October 1907. For an excellent study of this process, see Roger Benjamin, "The Decorative Landscape, Fauvism and the Arabesque of Observation," *The Art Bulletin* 75 (June 1993), pp. 295–316.

29. Quoted in Adamson, *Lawren S. Harris*, p. 49.

30. Quoted in ibid.

31. For Segantini's al fresco painting expeditions, see Luigi Villari, *Giovanni Segantini* (London: T. Fisher Unwin, 1901), p. 152. For his reputation and influence in the years after his death, see Annie-Paule Quinsac, *Segantini: Catalogo generale*, 2 vols. (Milan: Electa, 1982). The first person to note Segantini's influence on Harris appears to have been Jeremy Adamson: see *Lawren S. Harris*, p. 50.

32. Housser, *A Canadian Art Movement*, p. 91.

33. *The Studio*, 15 September 1914.

34. *The Studio*, 15 July 1914.

35. *Toronto Daily Star*, 14 March 1914.

36. *The Studio*, 15 July 1914.

37. Jackson, "Foreword," *Catalogue of an Exhibition of Paintings by the Late Tom Thomson, March 1 to March 21, 1919* (Montreal: The Arts Club, 1919).

38. A.Y. Jackson, Canoe Lake, to J.E.H. MacDonald, Studio Building, 14 February 1914, J.E.H. MacDonald Fonds, Container 1, File 2.

39. Ibid.

40. Quoted in Hill, "Tom Thomson, Painter," in Reid, *Tom Thomson*, pp. 123–24.

41. Quoted in Nasgaard, *The Mystic North*, p. 166.

42. Quoted in Hill, *The Group of Seven*, p. 51.

43. Brooke, *Letters from America*, p. 76.
44. J.E.H. MacDonald, "A Landmark of Canadian Art," in Fetherling, *Documents in Canadian Art*, p. 40.
45. R.P. Little, "Some Recollections of Tom Thomson," p. 213.
46. Saunders, *Algonquin Story*, p. 167.
47. A.Y. Jackson, Canoe Lake, to J.E.H. MacDonald, Studio Building, 14 February 1914, J.E.H. MacDonald Fonds, Container 1, File 2.
48. Saunders, *Algonquin Story*, pp. 129–30, 179.
49. Mark Robinson, transcript of interview, pp. 2, 3.
50. Kemp, "A Recollection of Tom Thomson."
51. Mark Robinson, transcript of interview, pp. 6–7.
52. *Toronto Daily Star*, 28 February 1914.
53. Gaye I. Clemson, *Algonquin Voices: Selected Stories of Canoe Lake Women* (Victoria: Trafford, 2002), pp. 41, 43.
54. Quoted in Hill, "Tom Thomson, Painter," in Reid, *Tom Thomson*, p. 124.
55. Lismer, "Tom Thomson (1877–1917), Canadian Painter," *Educational Record of the Province of Quebec* 80 (1954), p. 171.

CHAPTER 10: THE YOUNG SCHOOL
1. Quoted in Ord, *The National Gallery of Canada*, p. 68.
2. *Toronto Globe*, 4 June 1914.
3. *The Studio*, February 1913.
4. Quoted in Davis, "The Wembley Controversy," p. 55.
5. *Toronto Daily Star*, 28 February 1914.
6. Quoted in Tippett, *Art at the Service of War*, p. 40.
7. Jackson, *A Painter's Country*, p. 27.
8. Wilfred Campbell, *The Beauty, History, Romance and Mystery of the Canadian Lake Region* (Toronto: Musson Book Co., 1910), p. 99.
9. Jackson, *A Painter's Country*, p. 85.
10. *Globe and Mail*, 16 May 2003. This painting was sold in 2003 by Helen MacCallum Dodd's granddaughter.
11. Jackson, *A Painter's Country*, p. 25.
12. Quoted in Joan Murray, "Tom Thomson's Letters," in Reid, *Tom Thomson*, p. 298.
13. Franklin Carmichael reported in a letter of 27 May 1915 that Thomson had told him that "last summer he could not do anything for nearly two months." Letter of Franklin Carmichael to Ada Went, 27 May 1915, MCAC Archives.
14. J. Murray, "Tom Thomson's Letters," in Reid, *Tom Thomson*, p. 297.
15. For some of the logistics of Thomson's voyage, see Wadland, "Tom Thomson's Places," in Reid, *Tom Thomson*, p. 105; and Hill, "Tom Thomson, Painter," in Reid, *Tom Thomson*, p. 126. Wadland suggests that much of the journey was made via steamship and rail, whereas Hill believes that Thomson canoed the entire distance between Go Home Bay, Lake Nipissing and Canoe Lake.
16. Brooke, *Letters from America*, p. 118.
17. W. Campbell, *The Beauty, History, Romance and Mystery of the Canadian Lake Region*, p. 107.
18. See Landry, *The MacCallum-Jackman Cottage Mural Paintings*, p. 32.
19. Alexander Henry, *Travels and Adventures in Canada and the Indian Territories between the Years 1760 and 1776* (New York: I. Riley, 1809), p. 32.

20. Jennet Roy, *The History of Canada* (Montreal: Armour and Ramsay, 1850), p. 202.

21. Kathryn Hume, *Fantasy and Mimesis: Responses to Reality in Western Literature* (London: Methuen, 1984), p. 177. Northrop Frye argues that the quest myth is the one from which "all literary genres are derived": see "The Archetypes of Literature," in *Fables of Identity: Studies in Poetic Mythology* (New York: Harcourt, Brace, 1963), p. 17.

22. For the quest myth's application to America in the Age of Discovery, see Richard Slotkin, *Regeneration through Violence: The Mythology of the American Frontier, 1680–1860* (Norman: University of Oklahoma Press, 1973), pp. 28–29.

23. For the classic statement of this myth, see Joseph Campbell, *The Hero with a Thousand Faces,* 2nd ed. (Princeton: Princeton University Press, 1972), first published in 1949. For Canadian versions, with specific reference to the canoe (but only a passing mention of Thomson), see William C. James, "The Quest Pattern and the Canoe Trip," in Bruce W. Hodgins and Margaret Hobbs, eds., *Nastawgan: The Canadian North by Canoe & Snowshoe* (Willowdale, ON: Betelgeuse Books, 1987), pp. 9–23.

24. A.Y. Jackson to Dr. James MacCallum, A.Y. Jackson manuscripts, MG30 D 259, LAC.

25. Wyndham Lewis, "Canadian Nature and Its Painters," in Fetherling, *Documents in Canadian Art,* p. 111. Lewis's article was first published in *The Listener* in 1946.

26. Jackson, *A Painter's Country,* p. 37.

27. A.Y. Jackson, Canoe Lake, to J.E.H. MacDonald, Studio Building, 5 October 1914, J.E.H. MacDonald Fonds, Container 1, File 2.

28. Carl Schaefer, interview with Charles Hill, 11–12 October 1973, *Canadian Painting in the Thirties* Exhibition Records, National Gallery of Canada Fonds, National Gallery of Canada Library and Archives.

29. Quoted in Naomi Jackson Groves, *A.Y.'s Canada* (Toronto: Clarke Irwin, 1968), p. 148.

30. Kemp, "A Recollection of Tom Thomson."

31. Jackson, *A Painter's Country,* p. 38.

32. Quoted in Hill, "Tom Thomson, Painter," in Reid, *Tom Thomson,* p. 126.

33. A.Y. Jackson, Canoe Lake, to J.E.H. MacDonald, Studio Building, 5 October 1914, J.E.H. MacDonald Fonds, Container 1, File 2.

34. Quoted in Hill, "Tom Thomson, Painter," in Reid, *Tom Thomson,* p. 126.

35. Jackson, *A Painter's Country,* p. 38. See also Housser, *A Canadian Art Movement,* p. 96.

36. A.Y. Jackson, Canoe Lake, to J.E.H. MacDonald, Studio Building, 5 October 1914, J.E.H. MacDonald Fonds, Container 1, File 2.

37. Quoted in Colonel G.W.L. Nicholson, *Canadian Expeditionary Force, 1914–1919* (Ottawa: Queen's Printer and Controller of Stationery, 1964), p. 4.

38. *Toronto Daily Star,* 25 August 1914.

39. *Toronto Daily Star,* 5 August 1914.

40. *Toronto Daily Star,* 25 August 1914.

41. A.Y. Jackson, Canoe Lake, to J.E.H. MacDonald, Studio Building, 5 October 1914, J.E.H. MacDonald Fonds, Container 1, File 2.

42. Saunders, *Algonquin Story,* p. 169.

43. *Toronto Daily Star,* 28 February 1914.

44. Quoted in Tippett, *Stormy Weather,* pp. 59, 70.

45. A.Y. Jackson, Canoe Lake, to J.E.H. MacDonald, Studio Building, 5 October 1914, J.E.H. MacDonald Fonds, Container 1, File 2.

46. A.Y. Jackson to Dr. James M. MacCallum, 13 October 1914, Dr. James M. MacCallum Papers, National Gallery of Canada Archives, Ottawa.

47. F.H. Varley to Dr. James M. MacCallum, c. 31 October 1914, Dr. James M. MacCallum Papers.

48. Arthur Lismer to Dr. James M. MacCallum, 11 October 1914, Dr. James M. MacCallum Papers.

49. Quoted in Tippett, *Stormy Weather*, p. 70.

50. See Richard R. Brettell, *Modern Art, 1851–1929: Capitalism and Representation* (Oxford: Oxford University Press, 1999), p. 83.

51. Quoted in Duval, *Canadian Impressionism*, p. 124. Lismer made this claim in 1942.

52. A.Y. Jackson, Canoe Lake, to J.E.H. MacDonald, Studio Building, 5 October 1914, J.E.H. MacDonald Fonds, Container 1, File 2. For the difficulties of commercial designers at this time, see William Colgate, *Two Letters of Tom Thomson, 1915 & 1916* (Weston, ON: The Old Rectory Press, 1946), p. 10.

53. *Montreal Daily Star*, 29 May 1913; *The Studio*, 15 February 1914 and 15 September 1914.

54. A.Y. Jackson to Dr. James M. MacCallum, 13 October 1914, Dr. James M. MacCallum Papers.

55. Tippett, *Stormy Weather*, p. 85.

56. Norman Angell, *The Great Illusion: A Study of the Relation of Military Power in Nations to Their Economic and Social Advantage* (London: William Heinemann, 1912), p. 26.

57. Ibid., p. v.

58. Kemp, "A Recollection of Tom Thomson."

BOOK II
CHAPTER 1: MEN WITH GOOD RED BLOOD IN THEIR VEINS

1. Megan Bice, *Sunlight & Shadow: The Work of Franklin Carmichael* (Kleinburg: MCAC, 1990), p. 10.

2. Franklin Carmichael to Ada Went, 1 February 1915, MCAC Archives.

3. A.Y. Jackson, Canoe Lake, to J.E.H. MacDonald, Studio Building, 5 October 1914, J.E.H. MacDonald Fonds, Container 1, File 2.

4. Quoted in R. Harris, *Unplanned Suburbs*, p. 152.

5. For these details of Thomson's life in the shack, see the typescript of Thoreau MacDonald's recollections held in the Tom Thomson Collection, MCAC Archives; Housser, *A Canadian Art Movement*, pp. 115–16; and Jackson, *A Painter's Country*, p. 52. Peter Mellen states that Thomson moved into the shack only at the end of 1915 in *The Group of Seven*, p. 49. However, a May 1915 letter from Franklin Carmichael to Ada Went (in the MCAC Archives) indicates that Thomson had moved in by that date. As well, a drawing by Arthur Lismer in the National Gallery of Canada, entitled "Frank Johnston in T.T.'s Shack" and dated 1914, shows Thomson in his shack. Johnston was studying in Philadelphia and New York between 1912 and 1915, and so it is likely that Lismer drew the sketch at Christmas 1914. Against this latter evidence it must be allowed, as Charles Hill has pointed out to me, that Lismer sometimes made dating errors in his sketches (personal email communication, 17 September 2009).

6. Bice, *Sunlight & Shadow*, pp. 8, 24.

7. William Broadhead to the Broadhead family, LD 1980/8, Sheffield Archives.

8. Franklin Carmichael to Ada Went, 1 February 1915, MCAC Archives; Thoreau MacDonald's recollections, Tom Thomson Collection, MCAC Archives.

9. Laing, *Memoirs of an Art Dealer*, vol. 1, pp. 24–25. For Heming's abstemious and retiring nature, see Chalmers, "Arthur Heming."

10. Franklin Carmichael to Ada Went, 6 February 1915, MCAC Archives.

11. *Toronto Daily Star*, 28 February 1914.

12. *Toronto Globe*, 13 April 1912.

13. Terry Chapman, "'An Oscar Wilde Type': 'The abominable crime of buggery' in Western Canada, 1890–1920." *Criminal Justice History* 4 (1983), pp. 97–118.

14. On Baden-Powell, see Allen Warren, "Popular Manliness: Baden-Powell, Scouting and the Development of Manly Character," in J.A. Mangan and James Walvin, eds., *Manliness and Morality: Middle-Class Masculinity in Britain and America, 1800–1940* (Manchester: Manchester University Press 1987), pp. 199–219. On schoolmasters: Richard Holt, *Sport and the British: A Modern History* (Oxford: Oxford University Press, 1989), p. 89. On Robert Henri: Rebecca Zurier, *Picturing the City: Urban Vision and the Ashcan School* (Berkeley: University of California Press, 2006), pp. 109–20. On the artistic search for "masculine vigour": Ysanne Holt, *British Artists and the Modernist Landscape* (Aldershot, Hants: Ashgate, 2003), pp. 49–50. And for John's red-blooded behaviour: Michael Holroyd, *Augustus John* (London: Chatto & Windus, 1996), pp. 79–81.

15. *Harper's Weekly*, 16 September 1911.

16. Franklin Carmichael to Ada Went, 23 March 1915, MCAC Archives.

17. *Toronto Daily Star*, 22 March 1915.

18. See Brian H. Peterson, ed., *Pennsylvania Impressionism* (Philadelphia: University of Pennsylvania Press, 2002).

19. This similarity is noted in Town and Silcox, *Tom Thomson*, p. 44.

20. The influence of this design on Thomson seems to have been noted first in Hubbard, *The Development of Canadian Art*, pp. 88–89.

21. Arthur Lismer, Halifax, undated and unfinished letter on stationery headed "Victoria School of Art & Design," MCAC Archives.

22. William Broadhead to the Broadhead family, LD 1980/36 and 32, Sheffield Archives.

23. *The Diaries of Northrop Frye, 1942–1955*, ed. Robert D. Denham (Toronto: University of Toronto Press, 2001), p. 736. See also the numerous references to Stanley Kemp in *The Correspondence of Northrop Frye and Helen Kemp, 1932–1939*, ed. Robert D. Denham (Toronto: University of Toronto Press, 1996).

24. Quoted in Littlefield, *The Thomsons of Durham*, p. 35.

25. For Richard Hovey, see D.M.R. Bentley, "'The Thing Is Found to Be Symbolic': *Symboliste* Elements in the Early Short Stories of Gilbert Parker, Charles G.D. Roberts, and Duncan Campbell Scott," in Gerald Lynch and Angela Arnold Robbeson, eds., *Dominant Impressions: Essays on the Canadian Short Story* (Ottawa: University of Ottawa Press, 1999), p. 27. For Duncan Campbell Scott, see *More Letters*, ed. Arthur S. Bourinot (Ottawa: Arthur S. Bourinot, 1960), p. 24. Scott's letter (to Pelham Edgar) dates from June 1904. For the influence of Maeterlinck on Scott, see D.M.R. Bentley, "A Deep Influx of Spirit: Maurice Maeterlinck and Duncan Campbell Scott," *Studies in Canadian Literature* 21 (1996), pp. 104–19. Robert Stacey has argued that Thomson's illustration of Maeterlinck might have been a trial piece he executed in order to get his job at Grip: see "Tom Thomson as Applied Artist," in Reid, *Tom Thomson*, pp. 53–54.

26. Wassily Kandinsky, *Concerning the Spiritual in Art*, trans. M.T.H. Sadler (New York: Dover, 1977), pp. 14–15, 55.

27. On Maeterlinck and Carpenter, see Linda Dalrymple Henderson, "Mysticism as the 'Tie that Binds': The Case of Edward Carpenter and Modernism," *Art Journal* 46 (Spring 1987), p. 32. Carpenter wrote about Maeterlinck in his 1920 work *Pagan and Christian Creeds*.

28. *Ontario Society of Artists: Catalogue of the Forty-Third Annual Exhibition* (Toronto: Ontario Society of Artists, 1915).

29. *The Studio*, 14 December 1918; Voltaire, *Candide,* trans. Roger Pearson (Oxford: Oxford University Press, 2006), p. 65; and Jefferys, quoted in Stacey, "A Contact in Context," p. 43.

30. *Toronto Daily Mail & Empire*, 13 March 1915; *Saturday Night,* 20 March 1915.

31. Minnie Henry to Blodwen Davies, 2 February 1931, Blodwen Davies Fonds, MG30 D38, LAC. For the costs of pigments, see Frank Johnston's account scribbled on the back of a letter from George Wilson, 30 May 1922, Mary Bishop Rodrik and Franz Johnston Collection, R320, Volume 1, File 10, LAC. Johnston records paying $24 for twenty-one tubes of paint.

32. *The Studio,* February 1915.

33. Franklin Carmichael to Ada Went, 23 March 1915, MCAC Archives.

34. F.H. Varley to Dr. James M. MacCallum, October 1914, Dr. James M. MacCallum Papers.

35. Chalmers, "Arthur Heming," pp. 9–10.

36. William Broadhead to the Broadhead family, LD 1980/6 and 34, Sheffield Archives.

37. Comacchio, *The Infinite Bonds of Family,* p. 72

38. Franklin Carmichael, Bolton, ON, to Ada Went, 25 May 1915, MCAC Archives.

CHAPTER 2: THE GREAT EXPLOSION

1. Quoted in Nicholson, *Canadian Expeditionary Force, 1914–1919,* p. 62.

2. Colonel A. Fortescue Duguid, *Official History of the Canadian Forces in The Great War, 1914–1919,* 2 vols. (Ottawa: King's Printer, 1938), vol. 1, app. 851.

3. *The Times,* 15 May 1915.

4. Martin Gilbert, *The First World War* (London: Weidenfeld & Nicolson, 1994), p. 162. The veracity of the crucifixion story, disputed by the Germans at the time, has never been established. For a discussion of the episode, see Paul Fussell, *The Great War and Modern Memory* (Oxford: Oxford University Press, 1975), pp. 117–18, where it is described as a "fiction."

5. A.Y. Jackson, 69 Hallowell Ave., Westmount, Montreal, to Arthur Lismer, 4 February 1915, MCAC Archives.

6. Ibid.

7. Jackson, *A Painter's Country,* p. 41.

8. Terry Copp, "The Military Effort, 1914–1918," in David MacKenzie, ed., *Canada and the First World War: Essays in Honour of Robert Craig Brown* (Toronto: University of Toronto Press, 2005), p. 59, note 32.

9. Jackson, *A Painter's Country,* p. 41.

10. Franklin Carmichael to Ada Went, February 1915, MCAC Archives.

11. Darroch, *Bright Land,* p. 25.

12. Stacey and Bishop, *J.E.H. MacDonald, Designer,* p. 119.

13. Thoreau MacDonald Collection, The Papers of L. Bruce Pierce, Binder 1, File 25, MCAC Archives.

14. Albert H. Robson, *J.E.H. MacDonald* (Toronto: Ryerson Press, 1937), p.4.

15. *Canadian Courier,* 22 July 1916. MacDonald's poster design for *Belgium* was printed in this issue as a black and white illustration to a poem by Sidney Low, "From the Body of This Death."

16. Quoted in J. Murray, "Tom Thomson's Letters," in Reid, *Tom Thomson,* p. 301.

17. R.P. Little, "Some Recollections of Tom Thomson," p. 218.

18. Mark Robinson, transcript of interview, p. 7.

19. Minnie Henry to Blodwen Davies, 2 February 1931, Blodwen Davies Fonds.

20. Ian Hugh Maclean Miller, *Our Glory and Our Grief: Torontonians and the Great War* (Toronto: University of Toronto Press, 2002), pp. 71, 79. On Carmichael's rejection, see Bice, *Sunlight & Shadow*, p. 17.

21. Percy Ghent, "Tom Thomson at Island Camp, Round Lake, November 1915," *Toronto Evening Telegram*, 8 November 1949.

22. E.E. Godin to Blodwen Davies, 15 June 1931, Blodwen Davies Fonds. Godin was with Thomson in the summer of 1916 and insisted, "I know up until that time he had not tried to enlist."

23. *Toronto Daily Star*, 13 October 1914.

24. Winnifred Trainor to George Thomson, 17 September 1917, Tom Thomson Collection, Vol. 1, File 5, MG30 D284, LAC.

25. Quoted in J. Murray, "Tom Thomson's Letters," in Reid, *Tom Thomson*, p. 300.

26. See, for example, the *Toronto Daily Star*, 12 July 1916.

27. Mark Robinson, transcript of interview, p. 9.

28. Quoted in J. Murray, "Tom Thomson's Letters," in Reid, *Tom Thomson*, p. 302.

29. Louise Henry to Blodwen Davies, 11 March 1931, Blodwen Davies Fonds.

30. Hill, "Tom Thomson, Painter," in Reid, *Tom Thomson*, p. 131.

31. Dr. James M. MacCallum Papers, National Gallery of Canada Archives, quoted in J. Murray, "Tom Thomson's Letters," in Reid, *Tom Thomson*, p. 302.

32. Ibid., p. 301.

33. Henry, *Travels and Adventures in Canada and the Indian Territories*, p. 29.

34. L. George Thomas, *Edward Thomas: A Portrait* (Oxford: Oxford University Press, 1985), pp. 242, 248; and *The Life and Letters of Edward Thomas*, ed. John Moore (London: Heinemann, 1939), p. vii.

35. Tom Thomson, Mowat Lodge, Canoe Lake, to J.E.H. MacDonald, 22 July 1915, Tom Thomson Collection, MCAC Archives.

36. *Water Flowers* and *Wildflowers* (MCAC); *Marguerites, Wood Lilies and Vetch* (Art Gallery of Ontario); *Canadian Wildflowers* (National Gallery of Canada).

37. "Krakatoa Provided Backdrop to Munch's *Scream*," *The Age*, 11 December 2003; "*The Scream*, East of Krakatoa," *New York Times*, 8 February 2004; "How Old Masters Are Helping Study of Global Warming," *The Guardian*, 1 October 2007. The theory about Munch and Krakatoa was first put forward by Texas State University professors Don Olson, Marilynn Olson and Russell Doescher. For reports of the 1915 earthquake in California, see the *New York Times*, 22 and 23 May 1915.

38. David Lee, *Lumber Kings and Shantymen: Logging, Lumber and Timber in the Ottawa Valley* (Toronto: James Lorimer & Co., 2006), p. 179.

39. Oxley, *The Young Woodsman*, p. 87.

40. Lee, *Lumber Kings and Shantymen*, pp. 48–49.

41. This image has been noted by Andrew Hunter, who notes that the cross "seems so obvious and perfectly positioned that it is hard to believe it wasn't intentional" ("Mapping Tom," in Reid, *Tom Thomson*, p. 34).

42. Quoted in Jonathan Vance, *Death So Noble: Memory, Meaning, and the First World War* (Vancouver: University of British Columbia Press, 1997), p. 51.

43. *Toronto Daily Star*, 1 May 1915. See also the front-page report on 1 June 1915, which describes "little wooden crosses on which is rudely painted the man's name, number, and the regiment."

44. Leonard V. Smith, Stéphane Audoin-Rouzeau, and Annette Becker,
 France and the Great War, 1914–1918 (Cambridge: Cambridge University Press, 2003),
 p. 169; and Fussell, *The Great War and Modern Memory*, p. 118.

45. Jay Winter, *Sites of Memory, Sites of Mourning: The Great War in European Cultural
 History* (Cambridge: Cambridge University Press, 1995), p. 92; and Alan Gordon,
 Making Public Pasts: The Contested Terrain of Montreal's Public Memories, 1891–1930
 (Montreal and Kingston: McGill-Queen's University Press, 2001), p. 99.

CHAPTER 3: WHITE FEATHERS AND TANGLED GARDENS

1. Jackson, *A Painter's Country*, p. 42.

2. Ibid.

3. L.C. Giles, *Liphook, Bramshott and the Canadians* (Liphook, Hants: Bramshott
 and Liphook Preservation Society, 1986).

4. A.Y. Jackson, letter postmarked 27 January 1916, Bramshott, Hants, to
 Georgina Jackson, Naomi Jackson Grove Fonds, Box 96, File 19.

5. A.Y. Jackson, Bramshott Camp, Hants, to J.E.H. MacDonald, Studio Building,
 J.E.H. MacDonald Fonds, Container 1, File 2,.

6. Quoted in Alexander John Watson, *Marginal Man: The Dark Vision of Harold Innis*
 (Toronto: University of Toronto Press, 2006), p. 86.

7. A.Y. Jackson, undated letter, "Somewhere in France," to Georgina Jackson,
 Naomi Jackson Grove Fonds, Box 96, File 19.

8. *The Studio,* 15 June 1917.

9. M.O. Hammond, "Journal, 1903–1934," 10 December 1915, M.O. Hammond Fonds,
 Archives of Ontario. I am grateful to Scott James for this source.

10. Quoted in Ian E. Wilson, "Creating the Future: Canada and Its Provinces,"
 in Yvan Lamonde, Patricia Lockhart Fleming, and Fiona A. Black, eds., *The History of the
 Book in Canada, vol. 2, 1840–1914* (Toronto: University of Toronto Press, 2005), p. 175.

11. Hammond, "Journal, 1903–1934," 10 December 1915. For speculation that the lumberjack is
 modelled on Thomson, see Landry, *The MacCallum-Jackman Cottage Mural Paintings*, p. 33.

12. Quoted in Madsen, *The Art Nouveau Style*, p. 246. The term "cloisonné" refers to the line of
 metal surrounding the coloured areas in medieval enamel techniques.

13. Quoted in Philip Ball, *Bright Earth: The Invention of Colour* (London: Viking, 2001), p. 153.

14. Quoted in Charles A. Riley 11, *Color Codes: Modern Theories of Color in Philosophy,
 Painting and Architecture, Literature, Music and Psychology* (Lebanon, NH: University
 Press of New England, 1995), p. 73.

15. Quoted in Robinson, "Honey, I'm Home," in Ballantyne, *What is Architecture?*, p. 122.

16. *Toronto Daily Mail & Empire,* 11 March 1916.

17. *Toronto Daily Star,* 11 March 1916.

18. *Saturday Night,* 18 March 1916. Ruskin's attack on Whistler was published in
 Fors Clavigera, July 1877.

19. Quoted in Bishop, "MacDonald and the Club," in Stacey and Bishop,
 J.E.H. MacDonald, Designer, p. 113.

20. *Saturday Night,* September 1906, April 1911, August 1915. These articles are
 reprinted in Thomas Thorner and Thor Frohn-Nielsen, eds., *A Country Nourished
 on Self-Doubt: Documents in Post-Confederation Canadian History*
 (Peterborough: Broadview Press, 2003), pp. 124–25, 218.

21. *Toronto Daily Star,* 16 March 1916. Ahrens's article, on p. 3, is entitled "The New Schools
 of Art."

22. For biographical information on Ahrens, I am indebted to Kim Bullock.

23. Madonna Ahrens, "Carl Ahrens: His Life and Work," unpublished manuscript in the archival collection of Kim Bullock.

24. *The Lamps*, December 1911.

25. Madonna Ahrens, "Carl Ahrens: His Life and Work."

26. See G.S. Simes, "Slang Terms for Homosexuals in English," in Wayne Dynes, ed., *Encyclopedia of Homosexuality* (New York: Garland, 1990), p. 1202; and Richard A. Spears, "On the Etymology of Dike," *American Speech* 60 (Winter 1985), p. 318.

27. Quoted in S.K. Tillyard, *The Impact of Modernism: The Visual Arts in Edwardian England* (London: Routledge, 1988), p. 121. For "greenery-yallery," see Miranda B. Hickman, *The Geometry of Modernism: The Vorticist Idiom in Lewis, Pound, H.D. and Yeats* (Austin: University of Texas Press, 2005), p. 266, note 38. The term was first used to mock aesthetes in Gilbert and Sullivan's *Patience* (1881).

28. *Saturday Night*, 8 April 1916.

29. Kafka, *Letter to His Father*, trans. Ernst Kaiser and Eithne Wilkins (New York: Schocken Books, 1953), p. 99.

30. *Toronto Daily Star*, 10 August 1915.

31. *Toronto Daily Star*, 28 September 1914. See also the report in the *Daily Star* on 12 September 1914.

32. *Toronto Daily Star*, 28 December 1915.

33. Quoted in Jeffrey A. Keshen, *Propaganda and Censhorship during Canada's Great War* (Edmonton: University of Alberta Press, 1996), p. 21.

34. W.R. Chadwick, *The Battle for Berlin, Ontario: An Historical Drama* (Waterloo: Wilfrid Laurier University Press, 1992), p. 68.

35. Quoted in Brown and R. Cook, *Canada, 1896–1921*, p. 219.

36. Quoted in Miller, *Our Glory and Our Grief*, p. 112.

37. Quoted in Brown and R. Cook, *Canada, 1896–1921*, p. 219.

38. Quoted in Tippett, *Stormy Weather*, p. 85.

39. J.E.H. MacDonald, Studio Building, Toronto, to the editor, *Toronto Daily Star*, 17 March 1916, MCAC Archives.

40. Uttley, *A History of Kitchener*, pp. 85–86.

41. For the Breithaupts' experiences in Berlin (and then Kitchener) during the Great War, see Chadwick, *The Battle for Berlin*, pp. 60–73.

42. *Toronto Globe*, 27 March 1916.

43. *Exhibition of Contemporary Scandinavian Art*, p. 58.

44. MacDonald's inscription can be seen on p. 130 of the copy of the Albright catalogue held in the MCAC Archives.

45. *Canadian Magazine*, April 1912; *The Studio*, December 1918.

46. For information on the Battle of Mount Sorrel, see Nicholson, *Canadian Expeditionary Force*, pp. 131–37.

47. A.Y. Jackson, "in a dugout somewhere in Flanders," to Georgina Jackson, Montreal, 10 April 1916, Naomi Jackson Grove Fonds, Box 96, File 19; and A.Y. Jackson, 457316 Signal Station, 60th Canadian Battalion, to J.E.H. MacDonald, Studio Building, 31 May 1916, J.E.H. MacDonald Fonds, Container 1, File 2.

48. Quoted in Watson, *Marginal Man*, p. 92.

49. The following details are found in a letter Jackson wrote to MacDonald: A.Y. Jackson, 247 Lees Road, Oldham, to J.E.H. MacDonald, Studio Building, 10 September 1916, J.E.H. MacDonald Fonds, Container 1, File 2.

50. A description of the No. 1 Canadian General Hospital can be found in the Sophie
 Hoerner Fonds, Letters 1915–1917, MG30 E290, LAC.

CHAPTER 4: THE LINE OF BEAUTY

1. Bruce Cane, ed., *It Made You Think of Home: The Haunting Journal of Deward Barnes,*
 Canadian Expeditionary Force, 1916–1919 (Toronto: Dundurn, 2004), p. 32.

2. Keshen, *Propaganda and Censorship during Canada's Great War,* pp. 32–33; and
 Toronto Daily Star, 11 July 1916.

3. Accounts of Thomson painting the sketch are found in Harris, *The Story of the Group*
 of Seven, p. 19, and two letters written by Dr. MacCallum in 1921, quoted in Hill,
 "Tom Thomson, Painter," in Reid, *Tom Thomson,* p. 137. For Turner's adventures on board
 the *Ariel,* see Kenneth Clark, *The Romantic Rebellion: Romantic versus Classic Art*
 (London: John Murray, 1973), p. 243.

4. Dr. James M. MacCallum Papers, National Gallery of Canada Archives, quoted in J. Murray,
 "Tom Thomson's Letters," in Reid, *Tom Thomson,* p. 302.

5. Ed Godin to Blodwen Davies, 17 November 1930, Blodwen Davies Fonds.

6. Dr. James M. MacCallum Papers, National Gallery of Canada Archives, quoted in J. Murray,
 "Tom Thomson's Letters," in Reid, *Tom Thomson,* p. 302.

7. Thomson wrote to MacDonald on the bottom of a letter he received from Eric Brown:
 Eric Brown, Ottawa, to Tom Thomson, 28 June 1916, MCAC Archives.

8. Quoted in Kelly, *J.E.H. MacDonald, Lewis Smith, Edith Smith,* p. 9.

9. Quoted in ibid., p. 16.

10. Quoted in Grigor, *Arthur Lismer,* p. 36.

11. Darroch, *Bright Land,* p. 37.

12. Quoted in McLeish, *September Gale,* pp. 57–58.

13. Quoted in Tooby, *Our Home and Native Land,* unpaginated.

14. E.T. Cook and Alexander Wedderburn, eds., *The Works of John Ruskin,* 39 vols.
 (London: George Allen, 1903–12), vol. 11, p. 263.

15. E.T. Cook and Wedderburn, *The Works of John Ruskin,* vol. 27, p. 96.

16. Grigor, *Arthur Lismer,* p. 9.

17. Arthur Lismer, Bedford, NS, to Dr. James M. MacCallum, 20 December 1916, MCAC Archives.

18. J.E.H. MacDonald, Studio Building, to Arthur Lismer, Bedford, NS, 21 December 1916,
 MCAC Archives.

19. Jackson, *A Painter's Country,* p. 52.

20. Brian Winter, *Chronicles of a County Town: Whitby Past and Present*
 (self-published, 1999), p. 299.

21. Mark Robinson, letter to Blodwen Davies, 11 May 1930, Blodwen Davies Fonds.
 For a good overview of McGillivray's career, see J. Murray, *Tom Thomson:*
 Design for a Canadian Hero, p. 77; and idem., *The Birth of the Modern,* pp. 96–97.

22. Mark Robinson, letter to Blodwen Davies, 11 May 1930, Blodwen Davies Fonds.

23. P.G. Hamerton, quoted in Flint, *The Impressionists in England,* p. 95.

24. *Burlington Magazine,* January 1910, reprinted in Reed, *A Roger Fry Reader,* p. 76.

25. *Gil Blas,* 20 March 1906; and *L'Aurore,* 22 March 1906. For much of the following
 information on Fauves, the decorative landscape and the arabesque, I am indebted
 to Roger Benjamin, "The Decorative Landscape, Fauvism and the Arabesque
 of Observation," *The Art Bulletin* 75 (June 1993), pp. 295–316.

26. Paul Signac, *D'Eugène Delacroix au néo-impressionisme* (Paris: H. Floury, 1911), p. 89.
 This work was first published in 1899.

27. Maurice Denis, *Théories, 1890–1910: Du symbolisme et de Gauguin vers un nouvel ordre classique* (Paris: L. Rouart et J. Watelin, 1920), p. 170.

28. A.Y. Jackson, Canoe Lake, to J.E.H. MacDonald, Studio Building, 14 February 1914, J.E.H. MacDonald Fonds, Container 1, File 2.

29. *The International Studio*, 31 September 1919.

30. *Gil Blas*, 20 March 1906.

31. André Lhote, *La Peinture, le coeur et l'esprit: Correspondance inédite (1907–1924)*, 2 vols., ed. Alain Rivière, Jean-Georges Morgenthaler and Françoise Garcia (Bordeaux: Musée des beaux-arts de Bordeaux, 1986), vol. 1, pp. 29–30.

32. See Sandra Nadaff, *Arabesque: Narrative Structure and the Aesthetics of Repetition in the 1001 Nights* (Evanston, IL: Northwestern University Press, 1991), p. 113.

33. Félix Fénéon, *Oeuvres plus que complètes*, ed. Joan U. Halperin (Geneva: Librairie Droz, 1970), vol. 1, p. 177. On Signac's use of the arabesque, see Roslak, *Neo-Impressionism and Anarchism in Fin-de-Siècle France*, pp. 162–66.

34. Jack Flam, ed., *Matisse on Art* (Berkeley and Los Angeles: University of California Press, 1995), p. 210.

35. Quoted in Christopher Butler, *Early Modernism: Literature, Music, and Painting in Europe, 1900–1916* (Oxford: Clarendon Press, 1994), p. 35. For Matisse's expression of abstract ideas through the arabesque, see also Flam's "Introduction: A Life in Words and Pictures," *Matisse on Art*, pp. 17–1.

36. Quoted in Miller, *Our Glory and Our Grief*, p. 56.

37. *Ottawa Evening Journal*, 18 November 1916.

38. Miller, *Our Glory and Our Grief*, pp. 53, 57.

39. Quoted in Keshen, *Propaganda and Censorship during Canada's Great War*, pp. 12–13.

40. Quoted in Robin Prior and Trevor Wilson, *The Somme* (New Haven: Yale University Press, 2005), p. 314; and Martin Gilbert, *The Somme: Heroism and Horror in the First World War* (New York: Henry Holt, 2006), p. 243.

41. Edward A. Johnson, *Fire and Vegetation Dynamics: Studies from the North American Boreal Forest* (Cambridge: Cambridge University Press, 1992), p. 100.

42. For the classic statement of this idea, see Margaret Atwood, *Survival: A Thematic Guide to Canadian Literature*.

43. Jaroslav Folda, *Crusader Art in the Holy Land: From the Third Crusade to the Fall of Acre* (Cambridge: Cambridge University Press, 2005), p. 297.

44. Quoted in J. Murray, "Tom Thomson's Letters," in Reid, *Tom Thomson*, pp. 303–4.

45. *Saturday Night*, 25 December 1926. On John Sloan Gordon's career, see D. Grace Inglis, "John Sloan Gordon," in *Dictionary of Hamilton Biography*, vol. 3 (1925–1939) (W.L. Griffin: Hamilton, 1992), pp. 78–79. For his interactions with Thomson, see Paul Duval, *Canadian Water Colour Painting* (Toronto: Burns & MacEachern, 1954), p. 297.

46. *Owen Sound Sun*, 10 April 1917.

CHAPTER 5: IMPERISHABLE SPLENDOUR

1. A.Y. Jackson, Brundall House Hospital, Brundall, Norfolk, to Arthur Lismer, 25 June 1916, MCAC Archives.

2. A.Y. Jackson, Lakenham Military Hospital, Norwich, to Georgina Jackson, 14 June 1916, Naomi Jackson Grove Fonds, Box 96, File 18.

3. Quoted in Watson, *Marginal Man*, p. 77.

4. Quoted in Watson, *Marginal Man*, p. 92. For Watson's discussion of Harold Innis's psychological scars and reticence to speak of his experiences, see pp. 77–79.

5. Quoted in Eric J. Leed, *No Man's Land: Combat and Identity in World War I* (Cambridge: Cambridge University Press, 1979), p. 171.

6. A.Y. Jackson, Brundall House Hospital, Brundall, Norfolk, to Arthur Lismer, 25 June 1916, MCAC Archives. For Jackson's reunion with Baker-Clack, see Jackson, *A Painter's Country*, p. 43.

7. Jackson, *A Painter's Country*, pp. 43–44.

8. A.Y. Jackson, Brundall House Hospital, Brundall, Norfolk, to Arthur Lismer, 25 June 1916, MCAC Archives.

9. A.Y. Jackson, St. Leonard's, East Sussex, to Catherine Breithaupt, 9 April 1917, Catherine Breithaupt Bennett Papers.

10. See Rosa M. Breithaupt, diary entry, 21 May 1913, Breithaupt Hewetson Clark Collection, University of Waterloo Library; and Rosa M. Breithaupt, interview with H. Spencer Clark.

11. A.Y. Jackson, to Catherine Breithaupt, 9 April 1917, Catherine Breithaupt Bennett Papers.

12. *The Times*, 10 April 1917.

13. Brown and R. Cook, *Canada, 1896–1921*, p. 218.

14. *The Times*, 3 July 1917.

15. *Ottawa Citizen*, 3 July 1917.

16. J.L. Granatstein, "Conscription in the Great War," in MacKenzie, *Canada and the First World War*, p. 67.

17. See *The Times*, 10 August 1917.

18. *Toronto Daily Star*, 7 July 1917.

19. *Toronto Daily Star*, 4 July 1917.

20. *The Times*, 10 August 1917.

CHAPTER 6: SHADES OF GREY

1. Tom Thomson to John Thomson, letter postmarked 16 April 1917, quoted in J. Murray, "Tom Thomson's Letters," in Reid, *Tom Thomson*, p. 303.

2. Tom Thomson to Tom Harkness, letter postmarked 23 April 1917, quoted in J. Murray, "Tom Thomson's Letters," in Reid, *Tom Thomson*, p. 305.

3. This claim is made by Mark Robinson: see the transcript of interview, p. 10. The *Toronto Daily Star* reported the death of Charles L. Scrim at the age of thirty-two in its 10 February 1921 edition.

4. R.P. Little, "Some Recollections of Tom Thomson," p. 216.

5. Mark Robinson, letter to Blodwen Davies, 23 March 1930, Blodwen Davies Fonds.

6. Quoted in Joan Murray, *Tom Thomson: The Last Spring* (Toronto: Dundurn Press, 1994), p. 95.

7. R.P. Little, "Some Recollections of Tom Thomson," p. 212.

8. Clemson, *Algonquin Voices*, p. 165.

9. Addison and Harwood, *Tom Thomson*, p.59.

10. Laing, *Memoirs of an Art Dealer*, vol. 1, p. 82.

11. These photographs have been published in Reid, "Photographs by Tom Thomson," nos. 38 and 39. Reid notes that these rings "have not been explained" (ibid., p. 10, note 35).

12. Addison and Harwood, *Tom Thomson*, p. 93.

13. Margaret Thomson, Timmins, ON, to Dr. James M. MacCallum, 9 September 1917, Dr. James M. MacCallum Papers.

14. Mark Robinson to Blodwen Davies, 4 September 1930, Blodwen Davies Fonds.

15. Mark Robinson, transcript of interview, p. 17.

16. William T. Little, *The Tom Thomson Mystery* (Toronto: McGraw-Hill, 1970), p. 30.

17. William Broadhead to the Broadhead family, LD 1980/34, Sheffield Archives.

18. Tom Thomson to John Thomson, postmarked 16 April 1917, Tom Thomson Papers, National Archives of Canada, Ottawa, MG30-D284.

19. Daphne Crombie, quoted in J. Murray, *Tom Thomson: The Last Spring*, p. 96; R.P. Little, "Some Recollections of Tom Thomson," p. 219.

20. Mark Robinson, transcript of interview, p. 13.

21. *The Complete Letters of Vincent van Gogh*, ed. and trans. Mrs. Robert Amussen et al., vol. 3 (London: Thames & Hudson, 1978), p. 28.

22. Mark Robinson, transcript of interview, pp. 12–13.

23. Charles F. Plewman, "Reflections on the Passing of Tom Thomson," *Canadian Camping Magazine* (Winter 1972), p. 9.

24. Quoted in J. Murray, "Tom Thomson's Letters," in Reid, *Tom Thomson*, p. 306.

25. Alan H. Ross to Blodwen Davies, 1 June 1930, Blodwen Davies Fonds.

26. Quoted in J. Murray, *Tom Thomson: The Last Spring*, p. 94.

27. W.T. Little, *The Tom Thomson Mystery*, pp. 41–42.

28. Noble Sharpe, "The Canoe Lake Mystery," *Canadian Society of Forensic Science Journal* 3 (June 31, 1970), p. 34.

29. Quoted in Watson, *Marginal Man*, p. 85.

30. Paul Litt, "Canada Invaded! The Great War, Mass Culture, and Canadian Cultural Nationalism," in MacKenzie, *Canada and the First World War*, p. 339.

31. Mark Robinson, Daily Journal, 14 May 1917, Addison Family Fonds, 97-011, Trent University Archives, Peterborough Ontario.

32. See Grant W. Grams, "Karl Respa and German Espionage in Canada during World War One," *Journal of Military and Strategic Studies* 8 (Fall 2005), available online at http://www.jmss.org/jmss/index.php/jmss/article/view/157/179.

33. George Thomson to Blodwen Davies, 8 June 1931, Blodwen Davies Fonds.

34. W.T. Little, *The Tom Thomson Mystery*, p. 40.

35. Mark Robinson, transcript of interview, p. 14. There are numerous (often varying and contradictory) accounts of what transpired on 8 July 1917. I have assembled the following pages using mainly these sources: George Thomson to Blodwen Davies, 8 June 1931, Blodwen Davies Fonds; Mark Robinson to Blodwen Davies, March 23, 1930, Blodwen Davies Fonds; Mark Robinson, transcript of interview, pp. 114–20; R.P. Little, "Some Recollections of Tom Thomson," pp. 219–20; Saunders, *Algonquin Story*, pp. 183–85; Addison and Harwood, *Tom Thomson*, pp. 68–74; and W.T. Little, *The Tom Thomson Mystery*, pp. 40–57.

36. Winnifred Trainor to George Thomson, 17 September 1917, Tom Thomson Collection, Vol. 1, File 5, MG30 D284, LAC.

37. Mark Robinson, transcript of interview, p. 16.

38. *Owen Sound Sun*, 13 July 1917.

39. Mark Robinson to Dr. James M. MacCallum, 12 July 1917, Dr. James M. MacCallum Papers.

40. *Toronto Daily Star*, 7 July 1917 and 10 July 1917.

41. *Toronto Globe*, 13 July 1917.

42. Plewman, "Reflections on the Passing of Tom Thomson," p. 6.

43. *Owen Sound Sun*, 17 July 1917.

44. *Toronto Daily Star*, 16 and 17 August 1912.

45. Dr. A.E. Ranney to Blodwen Davies, 7 May 1931, Blodwen Davies Fonds.

46. Copy of entry for Tom Thomson in Burial Register of Knox United Church, Owen Sound, 20 July 1931, Blodwen Davies Fonds.

47. Mark Robinson, transcript of interview, p. 4.

48. Arthur Lismer, Bedford, NS, to Dr. James M. MacCallum, 21 July 1917, MCAC Archives.

49. Extracts from the Daily Journal of Mark Robinson, p. 2.

50. Plewman, "Reflections on the Passing of Tom Thomson," p. 8.

51. Ibid.

52. J.S. Fraser, letter to Dr. J.M. MacCallum, 24 July 1917, Tom Thomson Collection, Vol. 1, File 3, MG30 D284, LAC.

53. Plewman, "Reflections on the Passing of Tom Thomson," p. 8.

54. J.S. Fraser, letter to George Thomson, 29 December 1917, Tom Thomson Collection, Vol. 1, File 6, MG30 D284, LAC.

55. Franklin Carmichael to Arthur Lismer, 19 July 1917, MCAC Archives.

56. Winnifred Trainor to George Thomson, 17 September 1917, Tom Thomson Collection, Vol. 1, File 5, MG30 D284, LAC.

57. Margaret Thomson to Dr. James M. MacCallum, 9 September 1917, Dr. James M. MacCallum Papers. For the accusations of Shannon Fraser's sharp practice, see T.J. Harkness to J.S. Fraser, 12 September 1917, Tom Thomson Collection, Vol. 1, File 5, MG30 D284, LAC; and Winnifred Trainor to George Thomson, 17 September 1917, Tom Thomson Collection, Vol. 1 File 5, MG30 D284, LAC. For Fraser's account of the two canoes, see J.S. Fraser to T.J. Harkness, 6 August 1917, Tom Thomson Collection, Vol. 1, File 4, MG30 D284, LAC.

58. R.P. Little, "Some Recollections of Tom Thomson," p. 217; Plewman, "Reflections on the Passing of Tom Thomson," p. 9.

59. For these two interviews, see Ronald Pittaway, interview with Daphne Crombie, in J. Murray, *Tom Thomson: The Last Spring*, pp. 94–96; and Roy MacGregor, "Author's Note," *Canoe Lake* (Toronto: McClelland & Stewart, 2002), pp. 285–89. MacGregor first published details of his interview with Crombie in *The Canadian*, 15 October 1977.

60. Sharpe, "The Canoe Lake Mystery," p. 34.

61. Mark Robinson, transcript of interview, p. 18.

62. Ibid.

63. William B. Wright, "Drowning: Is There a Fixed Period at Which a Drowned Body Will Float?" *The American Journal of the Medical Sciences* 51 (July 1853), p. 264. These observations from the mid-nineteenth century correspond with the "body float information" provided in 2005 by John Sanders, Dr. John Whittington and Mark Williams of the National Underwater Rescue-Recovery Institute in Circleville, Ohio. See http://www.twinquarries.com/nurri/body_float_info.pdf.

64. Blodwen Davies, *A Study of Tom Thomson* (Toronto: Discus Press, 1935), p. 123.

65. For a general account of dry drowning in the context of canoeing, see Charlie Walbridge, "Accident Summary: January–June 2007," *American Whitewater* (September–October 2007), p. 57. For medical literature, see L.K. DeNicola, J.L. Falk, and M.E. Swanson, "Submersion Injuries in Children and Adults," *Critical Care Clinics* 13 (July 1997), pp. 477–502; D.L. Levin, F.C. Morriss, L.O. Toro, L.W. Brink, and G.R. Turner, "Drowning and Near-Drowning," *Pediatric Clinics of North America* 40 (April 1993), pp. 321–36; and C.J. McNamee, D.L. Modry, D. Lien, and A. Alan Conlan, "Drowned Donor Lung for Bilateral Lung Transplantation," *Journal of Thoracic and Cardiovascular Surgery* 126 (September 2003), pp. 910–12.

66. *Toronto Globe*, 18 July 1917.

67. Arthur Lismer, Bedford, NS, to Dr. James M. MacCallum, 21 July 1917, MCAC Archives.

68. On this connection, see the discussion in Hunter, "Mapping Tom," in Reid, *Tom Thomson*, pp. 41–42.

69. For these details of the cairn's construction, see MacDonald's letter of 13 October 1917 to John Thomson, J.E.H. MacDonald Fonds, Container 1, File 4.

70. Quoted in Hunter, "Mapping Tom," in Reid, *Tom Thomson*, p. 44. Hunter includes a photograph of the grave, with its plaque and cross, in figure 18.

71. *The Rebel*, November 1919. As Andrew Hunter has shown, although the published version of the poem makes no mention of McKechnie, the handwritten drafts show the dedication. See "Mapping Tom," in Reid, *Tom Thomson*, p. 43, p. 322, endnote 99.

72. A.Y. Jackson, London, to J.E.H. MacDonald, Studio Building, 26 August 1917, J.E.H. MacDonald Fonds, Container 1, File 2a.

73. Quoted in Stacey and Bishop, *J.E.H. MacDonald, Designer*, p. 3.

CHAPTER 7: THE VORTEX OF WAR

1. For these activities, see Grigor, *Arthur Lismer*, pp. 35–38.

2. Arthur Lismer, Bedford, NS, to J.E.H. MacDonald, York Mills, 28 February 1918, J.E.H. MacDonald Fonds, Container 1, File 1.

3. Quoted in Grigor, *Arthur Lismer*, p. 40. Lismer's daughter Marjorie would claim, in contrast to Lismer himself, that he did not miss his train and in fact had no intention of travelling to Halifax that morning: "Because of his Saturday morning classes he generally kept a free day during the week. On this particular morning he had no plans to go to work. We had not yet had breakfast when we heard the noise and saw the smoke in the distance. In our house, nearly twelve miles from the disaster, the damage was not serious—soot all over the breakfast table and a number of shattered windows" (Bridges, *A Border of Beauty*, p. 27).

4. Grigor, *Arthur Lismer*, p. 40.

5. Quoted in Hill, *The Group of Seven*, p. 66.

6. *Daily Mirror*, 4 December 1916; the billing of the no man's land photo quoted in Tippett, *Art at the Service of War*, p. 27.

7. Quoted in M.T. Jolly, "Fake Photographs: Making Truth in Photography" (PhD dissertation, University of Sydney, 2003), p. 33.

8. *Manchester Guardian*, 23 December 1919.

9. *The Letters of Rudyard Kipling, 1911–1919*, ed. Thomas Pinney (Iowa City: University of Iowa Press, 1999), p. 299.

10. For the complete history of the CWRO and the CWMF, see Tippett, *Art at the Service of War*.

11. Quoted in Tippett, *Art at the Service of War*, p. 29.

12. A.Y. Jackson, London, to Georgina Jackson, Montreal, 19 August 1917, Naomi Jackson Grove Fonds, Box 96, File 15.

13. Henry Cheal, *The Story of Shoreham* (Hove, Sussex: Cambridges, 1921), pp. 162, 262.

14. A.Y. Jackson, Shoreham-by-Sea, Sussex, to J.E.H. MacDonald, 4 August 1917, MCAC Archives.

15. Ibid.

16. A.Y. Jackson, Shoreham, to Georgina Jackson, Montreal, 4 August 1917, Naomi Jackson Grove Fonds, Box 96, File 20.

17. *The Studio*, 15 September 1914.

18. Jackson, *A Painter's Country*, p. 45.

19. A.Y. Jackson, London, to J.E.H. MacDonald, 26 August 1917, MCAC Archives. See Jackson's account of his trepidations in Jackson, *A Painter's Country*, p. 47.

20. *Kitchener-Waterloo Record,* 27 November 1999. I am grateful to Susan Mavor for bringing this article to my attention.

21. A.Y. Jackson, London, to Georgina Jackson, Montreal, 22 September 1917, Naomi Jackson Grove Fonds, Box 96, File 15.

22. Ibid.

23. Jackson, *A Painter's Country,* p. 47.

24. A.Y. Jackson, London, to Georgina Jackson, Montreal, 9 November 1917, Naomi Jackson Grove Fonds, Box 96, File 15.

25. Jackson, *A Painter's Country,* p. 49.

26. *New York Times,* 8 June 1919.

27. A.Y. Jackson, London, to Georgina Jackson, Montreal, 25 June 1918, Naomi Jackson Grove Fonds, Box 96, File 21.

28. A.Y. Jackson, 457316 Signal Station, 60th Canadian Battalion, to J.E.H. MacDonald, Studio Building, J.E.H. MacDonald Fonds, Container 1, File 2.

29. Jackson, *A Painter's Country,* pp. 45–48.

30. A.Y. Jackson, London, to J.E.H. MacDonald, York Mills, 6 April 1918, J.E.H. MacDonald Fonds, Container 1, File 2a.

31. Jackson, *A Painter's Country,* p. 48.

32. Ibid.

33. This painting, which Varley would later rename *Stormy Weather, Georgian Bay,* is usually dated to 1920. However, Maria Tippett argues convincingly in favour of the earlier date: see *Stormy Weather,* pp. 77–78. Further evidence in support of Tippett's dating of the painting is the fact that the OSA catalogue for 1917 shows that Varley exhibited *Squally Weather, Georgian Bay* in March 1917. However, no 1917 review specifically naming *Squally Weather* exists, making comparisons with *Stormy Weather* impossible.

34. For a recent study, see Alejandro Vergara, ed., *Patinir* (Madrid: Museo Nacional del Prado, 2007).

35. The term "northern expressionist" comes from Kenneth Clark. See *Landscape into Art,* pp. 73–107. For his discussion of Van Gogh in this context, see ibid., pp. 197–202.

36. *Canadian Courier,* 16 February 1918.

37. Tippett, *Art at the Service of War,* p. 45.

38. Tippett, *Stormy Weather,* p. 85.

39. *The Times,* 7 September 1909.

40. Quoted in Tippett, *Stormy Weather,* p. 90.

41. Ibid.

42. Quoted in Sir Alfred Munnings, *The Second Burst* (London: Museum Press, 1951), p. 30. Munnings was probably the composer of the verses.

43. Quoted in Butler, *Early Modernism,* p. 230. The Futurist Manifesto was first published in *Le Figaro* on 20 February 1909.

44. Quoted in Butler, *Early Modernism,* p. 147.

45. Quoted in Roberto Baronti Marchiò, "The Vortex in the Machine: Futurism in England," in Günter Berghaus, ed., *International Futurism in Arts and Literature* (Berlin and New York: de Gruyter, 2000), p. 102. The member of the audience was Wyndham Lewis.

46. Quoted in Marchiò, "The Vortex in the Machine," p. 105.

47. Guillaume Apollinaire, *Caligrammes: Poems of War and Peace (1913–1916),* introduction by S.I. Lockerbie (Los Angeles and Berkeley: University of California Press, 1980), p. 221.

48. *The Times,* 30 April 1915.

49. *New York Times*, 8 June 1919.

50. Quoted in Tippett, *Art at the Service of War*, p. 31.

51. Frank Rutter, *Some Contemporary Artists* (London: Leonard Parsons, 1922), p. 212.

52. Andrew Causey, ed., *Poet and Painter: Letters between Gordon Bottomley and Paul Nash, 1910–1946* (Bristol: Redcliffe, 1990), pp. 42–43.

53. Margot Eates, *Paul Nash: Master of the Image, 1889–1946* (London: John Murray, 1973), p. 21; *The Times*, 25 May 1918.

54. *The Observer*, 15 June 1914.

55. *Daily Express*, 25 February 1915.

56. Quoted in Tippett, *Art at the Service of War*, p. 62.

57. *New York Times*, 25 May 1919.

58. *The Times*, 2 March 1918.

59. C.R.W. Nevinson, *Paint and Prejudice*, p. 148; and *The Times*, 2 March 1918. For Nevinson's war art, see Michael Walsh, "C.R.W. Nevinson: the Modern Artist of Modern War," *Apollo* (July 2004), pp. 52–57. For his early years as a Futurist, see idem., "Vital English Art: Futurism and the Vortex of London, 1910–14," *Apollo* (February 2005), pp. 64–71.

60. Quoted in Tippett, *Stormy Weather*, p. 95.

61. Jackson, *A Painter's Country*, p. 49.

62. Apollinaire, *Caligrammes: Poems of War and Peace*, p. 257.

63. Jackson, *A Painter's Country*, p. 49.

64. For a discussion of this reversion to the pastoral in Great War writings, see Fussell, *The Great War and Modern Memory*, p. 135.

65. Varley, quoted in Tippett, *Stormy Weather*, pp. 92, 93, 95, 100.

CHAPTER 8: THE DWELLER ON THE THRESHOLD

1. Quoted in Cane, *It Made You Think of Home*, p. 32.

2. Quoted in Adamson, *Lawren S. Harris*, p. 69.

3. *Saturday Night*, 24 March 1917.

4. Lawren Harris, Woodend, Allandale, ON, to J.E.H. MacDonald, York Mills, August 1918, MCAC Archives.

5. See Betts, *Lawren Harris in the Ward*.

6. Kandinsky, *Concerning the Spiritual in Art*, p. 2. On Christian Science in Canada, see Patricia Jasen, "Mind, Medicine and the Christian Science Controversy in Canada, 1888–1910," *Journal of Canadian Studies* 32 (Winter 1998), pp. 5–20.

7. *New York Times*, 13 January 1918.

8. The name Ashcan School was not coined until a 1934 article in *Art in America*.

9. Quoted in Bennard B. Perlman, *The Lives, Loves, and Art of Arthur B. Davies* (Albany, NY: SUNY Press, 1998), p. 164. For The Eight's self-promotion and commercial success, see Zurier, *Picturing the City*, pp. 36–37.

10. Quoted in Zurier, *Picturing the City*, p. 37. Henri made this comment in 1916.

11. *New York Times*, 6 January 1918.

12. Quoted in Perlman, *The Lives, Loves, and Art of Arthur B. Davies*, p. 165.

13. Ibid., pp. 63–64.

14. H.P. Blavatsky, *The Key to Theosophy* (Pasadena, CA: Theosophical University Press, 1989), p. 63.

15. Salem Bland, quoted in Richard Allen, *The View from the Murney Tower: Salem Bland, the Late-Victorian Controversies, and the Search for a New Christianity* (Toronto: University of Toronto Press, 2008), p. 191.

16. See Christopher Bamford, ed., *Spiritualism, Madame Blavatsky & Theosophy: An Eyewitness View of Occult History: Lectures by Rudolf Steiner* (Herndon, VA: Steiner Books, 2002), p. 31.

17. For Reid's involvement in the Theosophical Society, see Heather Murray, *Come, Bright Improvement! The Literary Societies of Nineteenth-Century Ontario* (Toronto: University of Toronto Press, 2002), p. 116.

18. *New York Times*, 8 January and 13 January 1918.

19. *University of Toronto Roll of Service, 1914–1918* (Toronto: University of Toronto Press, 1921), p. 62.

20. Lawren Harris, Woodend, Allandale, ON, to J.E.H. MacDonald, 7 August 1919, MCAC Archives.

21. Quoted in Adamson, *Lawren S. Harris*, p. 99.

22. *Saturday Night*, 3 January 1914. For information on Earlscourt, see R. Harris, *Unplanned Suburbs*, pp. 1–3 passim.

23. *The Times*, 29 August 1919.

24. Eates, *Paul Nash*, p. 21.

25. *Canadian Theosophist*, 15 July 1926.

26. W. Campbell, *The Beauty, History, Romance and Mystery of the Canadian Lake Region*, p. 93.

27. Housser, *A Canadian Art Movement*, p. 138.

28. Lawren Harris, Woodend, Allandale, ON, to J.E.H. MacDonald, August 1918, MCAC Archives.

29. Brooke, *Letters from America*, pp. 99–100.

30. Lawren Harris, Woodend, Allandale, ON, to J.E.H. MacDonald, York Mills, undated letter [summer 1918], J.E.H. MacDonald Fonds, Container 1, File 3.

31. Ibid.

32. Lawren Harris, Woodend, Allandale, ON, to MacDonald, York Mills, 31 August 1918, J.E.H. MacDonald Fonds, Container 1, File 3.

33. *The Rebel*, March 1918.

34. Lawren Harris, undated letter [summer 1918] to Frank Johnston, Mary Bishop Rodrik and Franz Johnston Collection, R320, Volume 1, File 7, LAC.

35. Lawren Harris, Woodend, Allandale, ON, to J.E.H. MacDonald, York Mills, August 1918, MCAC Archives.

36. Mason, *A Grand Eye for Glory*, p. 17.

37. Casson, "Group Portrait," in Fetherling, *Documents in Canadian Art*, p. 60.

38. Doris Speirs, interview with Charles Hill.

39. Sir Edmund Walker to Frank Johnston, 3 September 1918, Mary Bishop Rodrik and Franz Johnston Collection, R320, Volume 1, File 7, LAC.

40. *The Lamps*, November 1919.

41. Harris, "The Group of Seven in Canadian History," p. 34.

42. Quoted in Duval, *The Tangled Garden*, pp. 86–87.

43. Quoted in Robert Rosenblum, *Modern Painting and the Northern Romantic Tradition: Friedrich to Rothko* (London: Thames & Hudson, 1975), p. 19.

44. E.T. Cook and Wedderburn, *The Works of John Ruskin*, vol. 3, p. 630, and vol. 26, p. 115.

45. Naomi E. Maurer, *The Pursuit of Spiritual Wisdom: The Thought and Art of Vincent Van Gogh and Paul Gauguin* (Cranbury, NJ:Associated University Press, 1998), p. 60; Michael Robertson, *Worshipping Walt: The Whitman Disciples* (Princeton, NJ: Princeton University Press, 2008), pp. 43–44; T.E. Hulme, "Romanticism and Classicism," in Herbert Read, ed.,

Speculations: Essays on Humanism and the Philosophy of Art (London: Routledge & Kegan Paul, 1949), p. 118; Davis, *The Logic of Ecstasy*, p. 48; and Whitman, *Leaves of Grass*, pp. 125, 167. For Whitman's influence on Gauguin and Van Gogh, see Maurer, *The Pursuit of Spiritual Wisdom*, pp. 3, 16. Whitman mentions "Kanada"—often in relation to lakes and snow—in poems such as "Me Imperturbe," "Our Old Feuillage," "From Paumanok Starting I Fly Like a Bird," and "By Blue Ontario's Shore."

46. Quoted in Duval, *The Tangled Garden*, p. 87.

CHAPTER 9: THE GREAT KONODIAN ARMY

1. Quoted in Tippett, *Stormy Weather*, p. 96.
2. Quoted in ibid., pp. 95, 97.
3. Ibid., p. 97.
4. Ibid., p. 98.
5. *Daily News*, 13 August 1918.
6. Quoted in Hill, *The Group of Seven*, p. 65.
7. F.H. Varley, Camblain l'Abbé, to Arthur Lismer, 2 May 1919, photocopy in the MCAC Archives.
8. Quoted in Tippett, *Stormy Weather*, p. 105.
9. Ibid., p. 109.
10. *The Times*, 12 and 15 November 1917, and 5 December 1917.
11. *The Times*, 30 July and 8 October 1917.
12. Quoted in Tippett, *Stormy Weather*, p. 106.
13. Quoted in Davis, *The Logic of Ecstasy*, p. 31.
14. Quoted in Tippett, *Stormy Weather*, p. 107.
15. *The Observer*, 5 January 1919.
16. Quoted in Holroyd, *Augustus John*, p. 435.
17. For John's ignominious career with the CWMF, see Holroyd, *Augustus John*, pp. 430–36.
18. *The Times*, 6 May 1924.
19. *Christian Science Monitor*, 10 February 1919.
20. *Canadian Magazine*, November 1919.
21. *The Observer*, 19 January 1919; *The Nation*, 11 January 1919; and Sir Claude Phillips, quoted in *The Rebel*, March 1919.
22. Quoted in Tippett, *Stormy Weather*, p. 110.
23. Quoted in ibid., p. 113.
24. *The Rebel*, March 1919.
25. Quoted in Susan Butlin, "Landscape as Memorial: A.Y. Jackson and the Landscape of the Western Front, 1917–1918," *Canadian Military History* 5 (Autumn 1996), p. 68.
26. Quoted in Alex Danchev, *Georges Braque: A Life* (New York: Arcade, 2005), p. 140.
27. *The Studio*, September 1919.
28. Michael L. Hadley and Roger Flynn Sarty, *Tin-pots and Pirate Ships: Canadian Naval Forces and German Sea Raiders, 1880–1918* (Montreal and Kingston: McGill-Queen's University Press, 1991), p. 190.
29. *Toronto Globe*, 11 October 1918.
30. Arthur Lismer, Bedford, NS, to J.E.H. MacDonald, Studio Building, 21 March 1919, J.E.H. MacDonald Fonds, Container 1, File 1, LAC.
31. Jackson, *A Painter's Country*, p. 51.
32. Arthur Lismer, Bedford, NS, to J.E.H. MacDonald, Studio Building, 21 March 1919, J.E.H. MacDonald Fonds, Container 1, File 1, LAC.

33. Jackson, *A Painter's Country*, p. 51.

34. Quoted in Hill, *The Group of Seven*, p. 85.

35. A.Y. Jackson, London, to J.E.H. MacDonald, York Mills, 6 April 1918, J.E.H. MacDonald Fonds, Container 1, File 2a, LAC.

BOOK III

CHAPTER 1: THE SPIRIT OF YOUNG CANADA

1. Dan Franck, *Bohemian Paris: Picasso, Modigliani, Matisse and the Birth of Modern Art,* trans. Cynthia Liebow (New York: Grove Press, 2003), p. 136.

2. A.Y. Jackson, 247 Lees Road, Oldham, to Arthur Lismer, 22 May 1918, MCAC Archives.

3. Quoted in Hill, *The Group of Seven*, p. 43.

4. *Toronto Daily Star,* 26 March 1919.

5. A.Y. Jackson, undated letter to the editor of the *Montreal Daily Star,* c. 1919, J.E.H. MacDonald Fonds, Container 1, File 2a.

6. Quoted in Adamson, *Lawren S. Harris*, p. 76.

7. *Toronto Telegram,* 8 March 1919; *The Weekly Sun,* 26 March 1919.

8. Quoted in Zurier, *Picturing the City*, pp. 121–22.

9. Quoted in Hill, *The Group of Seven*, p. 83.

10. Quoted in ibid., p. 81.

11. *Saturday Night,* May 1919; *Mail & Empire,* 10 May 1919.

12. A.Y. Jackson, Shoreham-by-Sea, to Mrs. J.E.H. MacDonald, 18 November 1916, J.E.H. MacDonald Fonds, Container 1, File 2a.

13. Laing, *Memoirs of an Art Dealer,* vol. 1, p. 24.

14. Quoted in McLeish, *September Gale*, p. 65.

15. Arthur Lismer, Bedford, NS, to J.E.H. MacDonald, Studio Building, J.E.H. MacDonald Fonds, Container 1, File 1.

16. Quoted in McLeish, *September Gale*, p. 69.

17. Tippett, *Art at the Service of War,* p. 94.

18. F.H. Varley, Camblain l'Abbé, to Arthur Lismer, 2 May 1919, MCAC Archives.

19. Tippett, *Stormy Weather*, pp. 46–47.

20. Quoted in ibid., p. 120.

21. Quoted in ibid., pp. 145–46.

22. *Toronto Daily Star,* 23 August 1919.

23. *New York Times,* 15 June 1919.

24. Nevinson, quoted in Michael J.K. Walsh, "'A Veiled and Virgin Shore': C.R.W. Nevinson and the (end of an) American Dream," in Michael J.K. Walsh, ed., *A Dilemma of English Modernism: Visual and Verbal Politics in the Life and Work of C.R.W. Nevinson (1889–1949)* (Cranbury, NJ: Associated University Presses, 2007), p. 92.

25. *New York Times,* 8 June 1919.

26. Quoted in Holroyd, *Augustus John*, p. 433.

27. Quoted in Tippett, *Art at the Service of War,* p. 80.

28. *Toronto Globe,* 8 September 1919; *Saturday Night,* 13 September 1919.

29. Quoted in Tippett, *Art at the Service of War,* p. 88.

30. *The Lamps,* December 1919; *The Rebel,* October 1919.

31. Quoted in David P. Silcox, *Painting Place: The Life and Work of David B. Milne* (Toronto: University of Toronto Press, 1996), p. 7. For details of Milne's early life, see pp. 3–12.

32. Quoted in Morrin et al., *The Advent of Modernism*, p. 131.

33. Quoted in Francis M. Naumann, *Conversion to Modernism: The Early Work of Man Ray* (New Brunswick, NJ: Rutgers University Press, 2003), p. 123.

34. *Christian Science Monitor*, 24 February 1913; *New York Times*, 3 November 1913.

35. Quoted in Silcox, *Painting Place*, p. 92. For Milne's military service and work with the CWRO office, see ibid., pp. 89–116; and R.F. Wodehouse, "David Milne: 1918–19," *National Gallery of Canada Bulletin* 2 (1963), pp. 18–27.

36. Quoted in Silcox, *Painting Place*, p. 96.

37. *New York Times*, 3 November 1912.

38. Ibid.

39. Quoted in Silcox, *Painting Place*, p. 69. For Milne's peregrinations through the Taconics, see his essay in the *New York Evening Post* entitled "One-Day Trip to the Taconic Wilds," 28 April 1922.

CHAPTER 2: A SEPTENARY FATALITY

1. Quoted in Owen Dudley Edwards and Jennifer H. Litster, "The End of Canadian Innocence: L.M. Montgomery and the First World War," in Irene Gammel and Elizabeth Epperly, eds., *L.M. Montgomery and Canadian Culture* (Toronto: University of Toronto Press, 1999), p. 45, note 5.

2. Papineau's famous open letter to his cousin Henri Bourassa, an opponent of French-Canadian participation in the war, was first published in the *Montreal Gazette* on 28 July 1916, and then reprinted in *The Times* on 22 August 1916. It has been included (with Bourassa's response) in Thorner and Frohn-Nielsen, *A Country Nourished on Self-Doubt*, pp. 218–25.

3. Brown and R. Cook, *Canada, 1896–1921*, p. 287.

4. Quoted in ibid., p. 338.

5. Quoted in Craig Heron, "Introduction," *The Workers' Revolt in Canada, 1917–1925* (Toronto: University of Toronto Press, 1998), p. 5.

6. *Montreal Gazette*, 1 April 1918, *The Times*, 2, 3, 4 April 1918.

7. Quoted in Philip Ziegler, *King Edward VIII: The Official Biography* (London: Collins, 1990), p. 119. For the report of the Prince's visit to Fort William, see *The Times*, 10 September 1919.

8. *Canadian Courier*, 30 August 1919.

9. Ibid.

10. Quoted in Mackintosh, "The Development of Higher Urban Life," p. 704.

11. Quoted in Zurier, *Picturing the City*, p. 41.

12. MacDonald regarded Reid as one of the "pioneers and encouragers" of Canadian art, and he admired his City Hall murals: see J.E.H. MacDonald, 40 Duggan Ave., Toronto, to F.B. Housser, unsent letter dated 20 December 1926, MCAC Archives.

13. Quoted in Marylin Jean McKay, *A National Soul: Canadian Mural Painting, 1860s–1930s* (Montreal and Kingston: McGill-Queen's University Press, 2002), p. 49.

14. Quoted in McKay, *A National Soul*, p. 49. For Reid's murals in Toronto, see ibid., pp. 39–41, 159–61.

15. Quoted in J.M. Bumstead, "Making Culture," *Canadian Historical Review* 72 (1991), p. 265.

16. *The Statesman*, 22 March 1919; *The Rebel*, November 1919.

17. MacDonald described this journey in an article in the December 1919 issue of *The Lamps* entitled "ACR 10557."

18. *The Times*, 19 September 1919; and Dan Douglas, *Northern Algoma: A People's History* (Toronto: Dundurn Press, 1995), p. 94.

19. Frank Johnston, Hubert, ACR, to Florence Johnston, Toronto, 29 September, 1 October, 6 October 1919, Mary Bishop Rodrik and Franz Johnston Collection, R320, Volume 1, File 8, LAC.

20. *New York Times*, 9 September 1919; *The Times*, 10 September 1919.

21. John Taliaferro, *Charles M. Russell: The Life and Legend of America's Cowboy Artist* (Boston: Little, Brown, 1996; reprinted, Norman, Oklahoma: University of Oklahoma Press, 2003),p. 216. The painting given to the Prince of Wales was *When Law Dulls the Edge of Chance*.

22. Hill, *The Group of Seven*, p. 84.

23. Quoted in Hill, *The Group of Seven*, p. 88.

24. Quoted in Farr, *J.W. Beatty*, p. 26.

25. Carl Schaefer, interview with Charles Hill.

26. Lawren Harris, Woodend, Allandale, ON, to J.E.H. MacDonald, the Studio Building, Toronto, 7 August 1919, J.E.H. MacDonald Fonds, Container 1, File 3.

27. H.P. Blavatsky, *The Secret Doctrine: The Synthesis of Science, Religion and Philosophy* (London: Theosophical Publishing Co., 1888), vol. 1, p. 158.

28. H.P. Blavatsky, "The Number Seven and Our Society," *Theosophist* (September 1880); and AE, "The Hour of Twilight," *Irish Theosophist*, 15 February 1893, "The Element Language," *Irish Theosophist*, 15 October 1893, and "The Ascending Cycle," *Irish Theosophist*, 15 November 1893.

29. Quoted in Mason, *A Grand Eye for Glory*, p. 38.

CHAPTER 3: ARE THESE NEW CANADIAN PAINTERS CRAZY?

1. Jackson, *A Painter's Country*, p. 55.

2. *Canadian Magazine*, December 1916.

3. Quoted in Milton A. Cohen, *Movement, Manifesto, Melee: The Modernist Group, 1910–1914* (Lanham, MD: Lexington Books, 2004), p. 299.

4. Peter Howard Selz, Harold Joachim, and Perry T. Rathbone, *Max Beckmann* (New York: Museum of Modern Art, 1964), p. 23.

5. Alasdair Alpin MacGregor, *Percyval Tudor-Hart, 1873–1954: Portrait of an Artist* (London: P.R. Macmillan, 1961), p. 115.

6. *Toronto Globe*, 2 September 1920.

7. Percy Wyndham Lewis, *Rude Assignment: An Intellectual Biography* (London: Hutchinson, 1950), p. 129.

8. Quoted in Cohen, *Movement, Manifesto, Melee*, p. 180. For Cohen's discussion of how modernism became a casualty of the war, see pp. 180–82.

9. Quoted in Robin Walz, *Modernism: A Short History of a Big Idea* (Harlow, Essex: Pearson, 2008), p. 77.

10. A.J. Casson, "Reminiscences of the Group of Seven," *The Empire Club of Canada Speeches, 1982–1983*, ed. A. Carlyle Dunbar and Douglas L. Derry (Toronto: Empire Club Foundation, 1984) p. 52.

11. See Hill, *The Group of Seven*, p. 88, figure 33. William Colgate claimed that Harris was the author of the piece: see *Canadian Art: Its Origin & Development* (Toronto: Ryerson Press, 1967), p. 82.

12. Quoted in Tippett, *Stormy Weather*, p. 134.

13. Quoted in Tooby, "Orienting the True North," in Tooby, *The True North*, p. 24–25.

14. *Canadian Courier*, 22 May 1920.

15. *Christian Science Monitor*, 7 June 1920.

16. *Canadian Courier*, 22 May 1920.

17. Quoted in Tippett, *Stormy Weather*, p. 128.

18. *The Rebel* 3, no. 5, 1919.

19. A.Y. Jackson, Toronto, to Georgina Jackson, Montreal, 11 May 1920, Naomi Jackson Grove Fonds, Box 96, File 22.

20. *Toronto Daily Star*, 7 May 1920; *Mail & Empire*, 10 May 1920.

21. Quoted in Finlay, *The Force of Culture*, p. 29.

22. Quoted in ibid., p. 128.

23. F.H. Varley, Thornhill, to Eric Brown, 29 November 1919, photocopy of original held in Christopher Varley Curatorial Papers, Series 11, File 1, MCAC.

24. For the contemporary appreciation of this painting, see Mellen, *The Group of Seven*, p. 96.

25. A.Y. Jackson, Toronto, to Georgina Jackson, Montreal, 11 May 1920, Naomi Jackson Grove Fonds, Box 96, File 22.

26. *Mail & Empire*, 10 May 1920; *Canadian Courier*, 22 May 1920.

27. Quoted in Hill, *The Group of Seven*, p. 95.

28. Jackson, *A Painter's Country*, p. 65.

29. *Canadian Courier*, 30 August 1919.

30. For MacDonald's ex libris, see Stacey and Bishop, *J.E.H. MacDonald, Designer*, pp. 100–103. For Jackson's mural, see Jackson, *A Painter's Country*, pp. 65–66. Some of Jackson's drawings for the mural are in the Firestone Collection at the Ottawa Art Gallery. I am grateful to Chris Finn for information on tracking down (via fire plans) information on the Kent-McClain factory and the fate of the mural, which seems to have been destroyed in the 1930s.

31. Quoted in Hill, *The Group of Seven*, p. 125.

32. *The Ubyssey*, 18 November 1920.

33. *Canadian Bookman*, December 1920.

34. For this article and the responses to it, see Anton Wagner, "Saving the Nation's Aesthetic Soul: B.K. Sandwell at the *Montreal Herald*, 1900–1914, and *Saturday Night*, 1932–1951," in Anton Wagner, ed., *Establishing Our Boundaries: English-Canadian Theatre Criticism* (Toronto: University of Toronto Press, 1999), pp. 188–89.

35. *Canadian Bookman*, April 1919.

36. Walt Whitman, *Specimen Days* (Philadelphia: David McKay, 1882), pp. 164–65.

37. Charles Sangster, "The St. Lawrence and the Saguenay," in *The St. Lawrence and the Saguenay, and Other Poems* (Auburn, NY: Miller Orton & Mulligan, 1956), lines 1066–67.

38. Eric Brown, Ottawa, to Francis H. Johnston, 96 Keewatin Avenue, Toronto, 21 August 1918, Mary Bishop Rodrik and Franz Johnston Collection, R320, Volume 1, File 7, LAC.

39. Ralph Waldo Emerson, "The American Scholar," in Joel Porte, ed., *Essays and Lectures* (New York: The Library of America 1983), pp. 70, 53.

40. Walt Whitman, "By Blue Ontario's Shore," in Francis Murphy ed., *Walt Whitman: The Complete Poems* (London: Penguin, 1996), lines 3–4.

41. Quoted in H. Barbara Weinberg, Doreen Bolger and David Park Curry, "Introduction," *American Impressionism and Realism: The Painting of Modern Life, 1885–1915* (New York: Metropolitan Museum of Art, 1994), pp. 30, 31, 58.

42. Quoted in Susan G. Larkin, "Hassam in New England, 1889–1918," in H. Barbara Weinberg, ed., *Childe Hassam: American Impressionist* (New Haven: Yale University Press, 2004), p. 119.

43. Quoted in H. Barbara Weinberg, "Hassam's Travels, 1892–1914," in Weinberg, *Childe Hassam*, pp. 188–89.

44. Quoted in Donna M. Cassidy, *Marsden Hartley: Race, Region, and Nation* (Lebanon, NH: University Press of New England, 2005), p. 20. For Stieglitz and nationalism after the First World War, see Matthew Baigell, "American Landscape Painting and National Identity: The Stieglitz Circle and Emerson," *Art Criticism* 4 (1987), pp. 27–47.

45. Quoted in Emily Ballew Neff, *The Modern West: American Landscapes, 1890–1950* (Houston: Museum of Fine Arts, 2006), p. 159. On Hartley's work in New Mexico and its nationalist implications, see also Heather Hole and Barbara B. Lynes, *Marsden Hartley and the West: The Search for an American Modernism* (New Haven: Yale University Press, 2007).

46. *New York Times*, 1 August 1920. In 1922 Wyer changed his name to Raymond Henniker-Heaton.

47. *Worcester Telegram*, 8 November 1920.

48. *Edmonton Journal*, 2 April 1921.

49. *Moose Jaw Evening Times*, 13 May 1921.

50. *Moose Jaw Evening Times*, 11, 13 May 1921.

51. Quoted in Hill, *The Group of Seven*, p. 100.

52. A.Y. Jackson to Catherine Breithaupt, 17 January 1921, Catherine Breithaupt Bennett Papers.

53. William J. Wood, Midland, ON, to Arthur Lismer, 3 November 1920, MCAC Archives. Wood has just been visited in Midland by Jackson—who "looked particularly fit"— and so was able to report Jackson's comments about the trip.

54. Jackson, *A Painter's Country*, p. 65.

55. *Toronto Daily Mail & Empire*, 18 December 1920.

56. *Moose Jaw Evening Times*, 11 May 1921; *Worcester Telegram*, 8 November 1920.

57. Doris Speirs, interview with Charles Hill.

58. Eric Brown, Ottawa, to Frank Johnston, Toronto, 13 March 1919, Mary Bishop Rodrik and Franz Johnston Collection, R320, Volume 1, File 7, LAC.

59. For the price of the house, see Harold R. Watson, Toronto, to Mrs. F.H. Johnston, 96 Keewatin Avenue, Toronto, 28 September 1920, Mary Bishop Rodrik and Franz Johnston Collection, R320, Volume 1, File 35, LAC.

CHAPTER 4: MULTIPLES OF UGLINESS

1. Quoted in Marius Barbeau, "On Krieghoff," in Fetherling, *Documents in Canadian Art*, p. 21. Jackson claimed that it was "probable" that his grandfather knew Krieghoff (*A Painter's Country*, p. 1). On this count, see also J. Russell Harper, *Krieghoff* (Toronto: University of Toronto Press, 1979), p. 29.

2. Quoted in Barbeau, "On Krieghoff," in Fetherling, *Documents in Canadian Art*, pp. 21–22.

3. Quoted in Hill, *The Group of Seven*, p. 290.

4. A.Y. Jackson, 4149 Michigan Ave., Chicago, to Georgina Jackson, Montreal, 11 November 1906, Naomi Jackson Groves Fonds, Container 96, File 3; and A.Y. Jackson, London, to Georgina Jackson, Montreal, 18 June 1905, ibid., Container 96, File 1.

5. Quoted in Wayne Larsen, *A.Y. Jackson: A Love for the Land* (Montreal: XYZ Publishing, 2003), pp. 81–82.

6. Jackson, *A Painter's Country*, p. 71.

7. A.Y. Jackson, Montreal, to Catherine Briethaupt, Boston, 17 January 1921, Catherine Breithaupt Bennett Papers.

8. William Dean Howells, *A Chance Acquaintance* (Boston: James R. Osgood & Co., 1873), pp. 18–19.

9. Jackson, *A Painter's Country*, p. 70.

10. Quoted in Whiteman, *J.E.H. MacDonald*, p. 66.

11. Charles G.D. Roberts, *The Land of Evangeline and the Gateways Thither* (Kentville: Dominion Atlantic Railway, 1895), p. 2. The phrase "wonderland of artists" appears in an advertisement for the Dominion Atlantic Railway on the book's inside cover.

12. *New York Times*, 11 January 1920.

13. Jennifer J. Nelson, *Razing Africville: A Geography of Racism* (Toronto: University of Toronto Press, 2008), pp. 9–12. See also Donald H. Clairmont and Dennis William Magill, *Africville: The Life and Death of a Canadian Black Community* (Toronto: Canadian Scholars' Press, 1999).

14. Betts, *Lawren Harris in the Ward*, pp. 79, 70.

15. Mellen argues that these paintings offer no social commentary; rather they are simply formal experiments in which Harris concentrated on "deep, three-dimensional space. He uses space, form and colour to create a mood of timelessness and mystery" (*The Group of Seven*, p. 112). Jeremy Adamson likewise agrees that there is no political activism in the works: "While he was deeply moved by the material poverty he witnessed in Toronto and several Maritime cities, it was the idea rather than reality that attracted his attention. Harris was not committed to social change or to leftist political ideologies" (*Lawren S. Harris*, p. 106). Elsewhere in his study Adamson reassures us that "there are no overt Marxist overtones" in Harris's work (ibid., p. 25). Inexplicably, neither Mellen nor Adamson mentions Africville by name, despite the fact that their studies were completed within a decade of the neighbourhood's controversial destruction in the 1960s.

16. Doris Speirs, interview with Charles Hill.

17. For theosophy and social reform in Canada with reference to Phillips Thompson, see R. Cook, *The Regenerators*, pp. 167–68; and Richard Allen, *The View from the Murney Tower*, p. 191. For theosophy and feminism, see H. Murray, *Come, Bright Improvement!* p. 116; and Joy Dixon, *Divine Feminine: Theosophy and Feminism in England* (Baltimore: Johns Hopkins University Press, 2001), p. 123.

18. Quoted in Rohit Mehta, *Theosophical Socialism* (Ahmedabad: R. Mehta, 1937), p. 1.

19. Quoted in ibid., p. 19.

20. Rockwell Kent, *It's Me, O Lord* (New York: Dodd Mead & Co., 1955), p. 204.

21. See Anthony D. Smith, *Chosen Peoples: Sacred Sources of National Identity* (Oxford: Oxford University Press, 2003), pp. 190–217.

22. Quoted in Hill, *The Group of Seven*, p. 134.

23. Gratton O'Leary, "The Right Honourable Arthur Meighen," *Manitoba Historical Society Transactions* 3 (1970–71), available online at http://www.mhs.mb.ca/docs/transactions/3/meighen_a.shtml; and Henry Ferns and Bernard Ostry, *The Age of Mackenzie King* (Toronto: James Lorimer & Co., 1976), p. 174.

24. Quoted in Davis, "The Wembley Controversy," p. 65.

25. *The Rebel*, March 1918.

26. Douglas Cole and Maria Tippett, eds., *Phillips in Print: The Selected Writings of Walter J. Phillips on Canadian Nature and Art* (Winnipeg: Manitoba Record Society, 1982), p. 66.

27. *Toronto Daily Star*, 7 May 1921.

28. *Toronto Globe*, 9 May 1921.

29. Quoted in Hill, *The Group of Seven*, p. 105.

CHAPTER 5: BY THE SHINING BIG-SEA-WATER

1. Merrill Denison, "That Inferiority Complex," *The Empire Club of Canada Speeches, 1948–1949* (Toronto: Empire Club of Canada, 1949), p. 260.

2. Ibid., p. 256.

3. For histories of the Denisons and Bon Echo, see Lacombe, "Songs of the Open Road," pp. 152–67; Robert Stacey and Stan McMullin, *Massanoga: The Art of Bon Echo* (Ottawa: Penumbra Press, 1998); and John Campbell, *The Mazinaw Experience: Bon Echo and Beyond* (Toronto: Dundurn Press, 2000).

4. Flora MacDonald Denison, "A Dedication and a Death," in Cyril Greenland and John Robert Colombo, eds., *Walt Whitman's Canada* (Willowdale, ON: Hounslow, 1992), pp. 196–200.

5. *Canadian Bookman*, March 1923.

6. Annie Besant and C.W. Leadbeater, *Thought-Forms* (London: Theosophical Publishing Society 1905), p. 4.

7. *The Sunset of Bon Echo*, April 1920.

8. *The Sunset of Bon Echo*, Summer 1919.

9. Quoted in Stacey and McMullin, *Massanoga*, p. 58.

10. "An Artist's View of Whitman," J.E.H. MacDonald Fonds, Container 3, File 28. This is the (undated) draft copy of a paper read before the English Association at the Toronto Central Reference Library. An incomplete version of a later draft (which does not include the "smutty old man" reference) is found in Container 3, File 29.

11. *Current Literature*, February 1909.

12. See R.M. Bucke, *Cosmic Consciousness: A Study in the Evolution of the Human Mind* (Philadelphia: Innes & Sons, 1905).

13. Doris Speirs, interview with Charles Hill; Davis, *The Logic of Ecstasy*, p. 46.

14. "An Artist's View of Whitman," J.E.H. MacDonald Fonds, Container 3, Files 28 and 29.

15. Quoted in Hole and Lynes, *Marsden Hartley and the West*, p. 44. For Whitman's influence on Hartley, see Ruth L. Bohan, *Looking into Walt Whitman: American Art, 1850–1920* (University Park, PA: Pennsylvania State University Press, 2006), pp. 143–64.

16. On Whitman and American modernism, see Bohan, *Looking into Walt Whitman*, p. 5; and Alan Trachtenberg, *Reading American Photographs: Images as History, Mathew Brady to Walker Evans* (New York: Hill and Wang, 1989), pp. 62–63. For Whitman's admiration of Millet, see Bohan, pp. 76–77. "I nourish active rebellion" is found at line 211 of "Song of the Open Road," in Murphy, *The Complete Poems*. For his discussion of the absorption of Canada into the United States, see *Specimen Days* (Philadelphia: David McKay, 1882), p. 142.

17. Jackson, *A Painter's Country*, p. 57.

18. Scott L. Cameron, *The Frances Smith: Palace Steamer of the Upper Great Lakes, 1867–1896* (Toronto: National Heritage Books, 2005). For Lake Superior tourism at the end of the nineteenth century, see Jasen, *Wild Things*, pp. 80–104.

19. Quoted in Peter Morris, *Embattled Shadows: A History of Canadian Cinema, 1895–1939* (Montreal and Kingston: McGill-Queen's University Press, 1978), p. 36.

20. Jackson, *A Painter's Country*, p. 57.

21. Harris, "The Group of Seven in Canadian History," p. 34.

22. Jackson, *A Painter's Country*, p. 58.

23. Ibid.

24. Quoted in Constance Martin, "Rockwell Kent's Distant Shores: The Story of an Exhibition," *Arctic* 55 (March 2002), p. 104.

25. Doris Speirs, interview with Charles Hill; *The Lamps*, October 1911.

26. *Canadian Theosophist*, 15 July 1926.

27. On Roerich and the American dollar, see Robert Chadwell Williams, *Russian Art and American Money, 1900–1940* (Cambridge, MA: Harvard University Press, 1980), p. 111.

28. *American Theosophist* (January, February, March 1913); Kandinsky, *Concerning the Spiritual in Art*, pp. 6–9.

29. Doris Speirs, interview with Charles Hill. Doris dated her poem 7 September 1922.

30. Comacchio, *The Infinite Bonds of Family*, p. 61.

31. Quoted in Michael Bliss, *Banting: A Biography* (Toronto: University of Toronto Press), p. 203.

32. Doris Speirs, interview with Charles Hill.

33. For a discussion of this latter work, see Atanassova, *F.H. Varley*, pp. 44–47.
 For Varley's society portraits in the early 1920s, see ibid., pp. 49–59.

34. Doris Speirs, interview with Charles Hill.

35. Quoted in Tippett, *Stormy Weather*, pp. 146–47.

36. Quoted in ibid., p. 144.

37. Quoted in Hill, *The Group of Seven*, p. 154.

38. *Historical Bulletin* 6 (May 1941), pp. 3–4.

CHAPTER 6: GYPSIES, LEPERS AND FREAKS

1. *Muskegon Chronicle*, 11 January and 14 January 1922.

2. See Judith Zilczer, "The Dissemination of Post-Impressionism in North America,"
 in *The Advent of Modernism*, pp. 36–39.

3. *Saturday Night*, 24 December 1921.

4. Frances Anne Hopkins, 95 Fitzjohns Ave., London, to David Ross McCord,
 12 July 1910, File 5031, McCord Family Papers, McCord Museum, Montreal.

5. *Canadian Bookman*, September 1924.

6. *Toronto Daily Mail & Empire*, 6 May 1922; *Saturday Night*, 1 April 1922; *Toronto Telegram*,
 6 April 1922.

7. Quoted in Kelly, *J.E.H. MacDonald, Lewis Smith, Edith Smith*, p. 21.

8. Quoted in Paul Poplawski, *Encylopedia of Literary Modernism* (Westport, CT: Greenwood
 Press, 2003), p. 36.

9. For these critiques, as well as the attack on literary modernism in Canada in the 1920s,
 see Don Precosky, "'Back to the Woods Ye Muse of Canada': Conservative Response to the
 Beginnings of Modernism," *Canadian Poetry* 12 (Spring/Summer 1983), pp. 40–45.

10. *Canadian Forum*, January 1923; and Hildi Froese Tiessen and Paul Gerard Tiessen, eds.,
 After Green Gables: L.M. Montgomery's Letters to Ephraim Weber, 1916–1941
 (Toronto: University of Toronto Press, 2006), p. 110.

11. Quoted in E. Holly Pike, "(Re)Producing Canadian Literature: L.M. Montgomery's Emily
 Novels," in Gammel and Epperly, *L.M. Montgomery and Canadian Culture*, p. 66.

12. *The Selected Journals of L.M. Montgomery, Volume 2: 1910–1921*, ed. Mary Rubio and
 Elizabeth Waterston (Toronto: Oxford University Press, 1987), p. 309.

13. Quoted in Ord, *The National Gallery*, pp. 102–3.

14. *Saturday Night*, 1 April 1922.

15. Hill, *The Group of Seven*, p. 139.

16. "The Diaries of William Lyon Mackenzie King," 11 January 1927, 14 April 1934,
 LAC, Ottawa, available online at http://king.collectionscanada.ca/EN/default.asp.

17. Ibid., 14 May 1935.

18. Madonna Ahrens, "Carl Ahrens: His Life and Work."

19. "The Diaries of William Lyon Mackenzie King," 21 November 1922, and 14 April 1926.

20. Ibid., 20 October 1922.

21. *Saturday Night*, 9 December and 23 December 1922.

22. Quoted in McLeish, *September Gale*, pp. 79–80.

23. *Saturday Night*, 30 December 1922.

24. Quoted in Judith M. Brown and William Roger Lewis, *The Oxford History of the
 British Empire* (Oxford: Oxford University Press, 1998), p. 214.

25. Quoted in Davis, "The Wembley Controversy," p. 67.

26. *Saturday Night*, 15 September 1923.

27. See E.A. Heaman, *The Inglorious Arts of Peace: Exhibitions in Canadian Society during the Nineteenth Century* (Toronto: University of Toronto Press, 1999); and Stuart Murray, "Canadian Participation and National Representation at the 1851 London Great Exhibition and the 1855 Paris *Exposition Universelle*," *Histoire sociale / Social History* 32 (May 1999), pp. 1–22.

28. Quoted in Anne Clendinning, "Exhibiting a Nation: Canada at the British Empire Exhibition, 1924–1925," *Histoire sociale / Social History* 39 (May 2006), p. 83

29. *The Times*, 23 April 1924.

30. "Two Views of Canadian Art: Addresses by Mr. Wyly Grier, RCA, OSA, and A.Y. Jackson, RCA, OSA, before the Empire Club of Canada, Toronto, February 26, 1925," *The Empire Club of Canada Speeches, 1925* (Toronto: Empire Club of Canada, 1926), p. 113.

31. Quoted in Davis, "A Study in Modernism," p. 108.

32. E.F.B. Johnson, "Painting and Sculpture in Canada," in *Canada and its Provinces*, vol. 11 (Toronto: Publishers' Association of Canada, 1913), p. 623.

33. Quoted in Ord, *The National Gallery*, p. 94.

34. Quoted in Tippett, *Stormy Weather*, p. 142.

35. Lorne Pierce and Albert Durrant Watson, eds., *Our Canadian Literature: Representative Prose and Verse* (Toronto: Ryerson, 1922), p. 124.

36. Quoted in Roza, "Towards a Modern Canadian Art," p. 62.

37. Quoted in *E.J. Pratt: Selected Poems*, ed. Sandra Djwa, W.J. Keith, and Zailig Pollock (Toronto: University of Toronto Press, 2000), p. xii. For the influence of Imagism on Pratt, see ibid., pp. xii and xiii.

38. Doris Speirs, interview with Charles Hill.

39. On Varley and the gypsy tradition, see Atanassova, *F.H. Varley*, pp. 43–45.

40. Quoted in Duval, *The Tangled Garden*, p. 148.

41. Quoted in McKay, *A National Soul*, p. 83.

42. Quoted in ibid., p. 91.

43. Quoted in ibid., pp. 91–92.

CHAPTER 7: WEMBLEY

1. *Toronto Globe*, 28 March 1924; *Canadian Bookman*, May 1924.

2. Quoted in Robert W. Rydell, *World of Fairs: The Century-of-Progress Exhibitions* (Chicago: University of Chicago Press, 1993), p. 65. The most comprehensive study of the exhibition is found in Donald R. Knight and Alan D. Sabey, *The Lion Roars at Wembley: British Empire Exhibition* (London: Barnard & Westwood, 1984).

3. Quoted in R.M. Dawson, ed. *The Development of Dominion Status, 1900–1936* (London: Oxford University Press, 1937), p. 239.

4. *Daily Graphic*, 29 March 1924.

5. Quoted in Anne Clendinning, "Exhibiting a Nation," pp. 96–97.

6. Quoted in ibid., p. 95. For Canada's contribution, see William Beinart and Lotte Hughes, *Environment and Empire* (Oxford: Oxford University Press, 2007), p. 226; Andrew Stuart Thompson, *The Empire Strikes Back? The Impact of Imperialism on Britain from the Mid-Nineteenth Century* (Harlow, Essex: Pearson Education, 2005), p. 86; John Allwood, *The Great Exhibitions* (London: Studio Vista, 1977), pp. 128–29; and especially Clendinning, "Exhibiting a Nation," pp. 79–107, to which I am indebted for information on the Canadian display. The butter sculpture was carved by George D. Kent and Beauchamp Hawkins (*Illustrated London News*, 24 May 1924).

7. Quoted in S.R. Parsons, "The British Empire Exhibition: A Study in Geography, Resources, and Citizenship of the British Empire," *The Empire Club of Canada Speeches, 1924* (Toronto: Empire Club of Canada, 1924), p. 293.

8. On the latter, see Pauline Wakeham, *Taxidermic Signs: Reconstructing Aboriginality* (Minneapolis: University of Minnesota Press, 2008), pp. 46–47.

9. *Montreal Gazette,* 28 May 1925 (reporting on responses in the French-language newspaper *Le Canada*); *Montreal Herald,* 15 July 1925.

10. See Clendinning, "Exhibiting a Nation," pp. 92–93, 105.

11. Quoted in Tom August, "Art and Empire—Wembley, 1924," *History Today* 43 (October 1993), p. 44.

12. *Press Comments on the Canadian Section of Fine Arts, British Empire Exhibition* (London, 1924–25), unpaginated.

13. *A Portfolio of Pictures from the Canadian Section of Fine Arts, British Empire Exhibition* (Toronto: Rous and Mann, 1924), unpaginated.

14. Quoted in Christine Boyanoski, "Selective Memory: The British Empire Exhibition and National Histories of Art," in Annie E. Coombes, ed., *Rethinking Settler Colonialism: History and Memory in Australia, Canada, Aotearoa New Zealand and South Africa* (Manchester: Manchester University Press, 2006), p. 167. The *Saturday Night* article is from 1933.

15. *Morning Post,* 28 May 1924.

16. Quoted in Ruth A. Drayer, *Nicholas and Helena Roerich: The Spiritual Journey of Two Great Artists and Peacemakers* (Wheaton, IL: Quest Books, 2005), p. 49.

17. *The Times,* 6 May 1924.

18. C. Lewis Hind, *The Post-Impressionists* (London: Methuen, 1911), pp. 2, 18. His remarks about his unique tolerance of Matisse are found on p. 12.

19. *Daily Chronicle,* 30 April 1924.

20. *Saturday Night,* 17 May and 13 December 1924.

21. *The Times,* 28 May 1924.

22. *Saturday Night,* 13 December 1924.

23. This point is made in Hill, *The Group of Seven,* p. 145. For information on the purchase price I am grateful to Lisa Cole, Assistant Curator, Gallery Records, at the Tate.

24. *Canadian Bookman,* November 1924.

25. Edgar Z. Friedenberg, "Culture in Canadian Context," in Michael Rosenberg, William B. Shaffir, Allan Turowetz, and Morton Weinfeld, eds., *Introduction to Sociology* (Agincourt, ON: Methuen, 1983), p. 123.

26. *The Lamps,* December 1911.

27. *Glasgow Herald,* 26 December 1924.

EPILOGUE: THE END OF THE TRAIL

1. Quoted in Tippett, *Stormy Weather,* p. 150.

2. Jackson, *A Painter's Country,* p. 135.

3. Blodwen Davies in *American Magazine of Art* (July 1932).

4. *Hundreds and Thousands: The Journals of Emily Carr,* introduction by Gerta Moray (Vancouver: Douglas & McIntyre, 2006), pp. 25–26.

5. Jackson, *A Painter's Country,* pp. 139–40. For an account of the International Exhibition of Modern Art, see Roald Nasgaard, *Abstract Painting in Canada* (Vancouver: Douglas & McIntyre, 2007), p. 27.

6. Cole and Tippett, *Phillips in Print*, p. 86.

7. Varley, quoted in Tippett, *Stormy Weather*, p. 150; and Jock Macdonald, quoted in Nasgaard, *Abstract Painting in Canada*, p. 38.

8. *Toronto Telegram*, 18 February 1928.

9. *Vancouver Sun*, 20 December 1932.

10. Quoted in Hill, *The Group of Seven*, p. 264.

11. Quoted in David P. Silcox, "Tom Thomson's Art," in Town and Silcox, *Tom Thomson*, p. 102.

12. Reid, *A Concise History of Canadian Painting*, pp. 211–12.

13. Frye, *The Bush Garden*, p. 220.

14. Quoted in Peter Larisey, *Light for a Cold Land: Lawren Harris's Work and Life* (Toronto: Dundurn Press, 1993), p. 50.

15. *artscanada*, August 1970; Jackson, "Introduction," *A Painter's Country*, unpaginated.

16. "Introduction," *The Group of Seven* (Ottawa: National Gallery of Canada, 1970), p. 10.

17. *The New Outlook*, 27 August 1930. The writer was Blodwen Davies.

18. *New Liberty*, November 1949. MacLennan's other choices were Joseph Howe, Mackenzie King, Donald McKay, Sir William Osler, Sir Wilfrid Laurier and Sir Frederick Banting.

19. Quoted in Stephen Azzi, *Walter Gordon and the Rise of Canadian Nationalism* (Montreal and Kingston: McGill-Queen's University Press, 1999), p. 188.

20. For a summary of this argument, see A.D. Smith, *Chosen Peoples*, pp. 1–2. Smith argues, to the contrary, that it is equally possible that nations, "far from ceasing to possess meaning and relevance in a global epoch, take on new meanings and a different, but equally powerful, relevance" (ibid., p. 2).

21. Brian S. Osborne, "From Native Pines to Diasporic Geese: Placing Culture, Setting Our Sites, Locating Identity in a Transnational Canada," *Canadian Journal of Communication* 31 (2006), pp. 147–75.

22. Erin Manning, *Ephemeral Territories: Representing Nation, Home, and Identity in Canada* (Minneapolis: University of Minnesota Press, 2003), pp. xx–xxi.

23. Quoted in Fetherling, *Documents in Canadian Art*, p. 109.

24. Jackson, *A Painter's Country*, p. 128.

25. Peter Haggett, ed. *Encyclopedia of World Geography: Canada, the Arctic* (Abindon, Oxon: Andromeda, 2002), p. 392. For urban vs. rural statistics in 1901 and 2001, see http://atlas.nrcan.gc.ca/site/english/aboutus/100anniversary/carto_exhibit/pop_1901_1911.html.

26. R. Cook, *Watching Quebec*, pp. 98–99.

27. Harold Troper, quoted in Magocsi, *Encyclopedia of Canada's Peoples*, p. vii.

28. Mastin, *The Group of Seven in Western Canada*, p. 28.

29. The first and most emphatic of these condemnations is found in Bordo, "Jack Pine," pp. 98–128.

30. For a discussion of Morris's career as a portraitist among the Aboriginal people, see Daniel Francis, *The Imaginary Indian: The Image of the Indian in Canadian Culture* (Vancouver: Arsenal Pulp Press, 1992), pp. 26–30.

31. *The Times*, 27 September 2008; *The Daily Telegraph*, 6 July 2008.

32. Quoted in Hill, *The Group of Seven*, p. 215.

33. "Society and Art," in *Art* (New York: Capricorn Books, 1958), p. 172.

34. Sandra Djwa, "'Who Is This Man Smith?': Second and Third Thoughts on Canadian Modernism," in W.H. New, ed., *Inside the Poem: Essays and Poems in Honour of Donald Stephens* (Toronto: Oxford University Press, 1992), p. 208. Smith's poem, first published in

The *McGill Fortnightly Review* on 9 January 1926, was originally subtitled "The Group of Seven." It was published in a revised form in *Canadian Forum* in July 1927.

35. *Canadian Forum*, December 1928.
36. Larisey, *Light for a Cold Land,* p. 151.
37. Kevin Bazzana, *Wondrous Strange: The Life and Art of Glenn Gould* (Oxford: Oxford University Press, 2004), p. 327.

SELECTED BIBLIOGRAPHY

Adamson, Jeremy. *Lawren S. Harris: Urban Scenes and Wilderness Landscapes, 1906–1930*. Toronto: Art Gallery of Ontario, 1978.

Atanassova, Katerina. *F.H. Varley: Portraits into the Light*. Toronto: Dundurn, 2007.

Bordo, Jonathan. "Jack Pine—Wilderness Sublime, or the Erasure of the Aboriginal Presence from the Landscape." *Journal of Canadian Studies* 27 (Winter 1992–93): pp. 98–128.

Bridges, Marjorie Lismer. *A Border of Beauty: Arthur Lismer's Pen and Pencil*. Toronto: Red Rock, 1977.

Brown, Robert Craig, and Ramsay Cook. *Canada, 1896–1921: A Nation Transformed*. Toronto: McClelland & Stewart, 1976.

Cameron, Ross D. "Tom Thomson, Antimodernism and the Ideal of Manhood." *Journal of the Canadian Historical Association* 10 (1999): pp. 185–208.

Campbell, Claire. "'Our Dear North Country': Regional Identity and National Meaning in Ontario's Georgian Bay." *Journal of Canadian Studies* (Winter 2003): pp. 68–91.

Clark, Kenneth. *Landscape into Art*. London: John Murray, 1976.

Cole, Douglas. "Artists, Patrons and Public: An Inquiry into the Success of the Group of Seven." *Revue d'études canadiennes / Journal of Canadian Studies* 13 (1978): pp. 69–78.

Cook, Ramsay. *The Regenerators: Social Criticism in Late Victorian English Canada*. Toronto: University of Toronto Press, 1985.

———. "Spiritualism, Science of the Earthly Paradise." *Canadian Historical Review* 65 (March 1984): pp. 4–27.

Davis, Ann. *The Logic of Ecstasy: Canadian Mystical Painting, 1920–1940*. Toronto: University of Toronto Press, 1992.

——. "A Study in Modernism: The Group of Seven as an Unexpectedly Typical Case." *Journal of Canadian Studies* 33 (Spring 1998): pp. 108–20.

——. "The Wembley Controversy in Canadian Art." *Canadian Historical Review* 54 (March 1973): pp. 48–74.

Duval, Paul. *The Tangled Garden*. Toronto: Cerebrus / Prentice-Hall, 1978.

Fetherling, Douglas. *Documents in Canadian Art*. Peterborough, ON: Broadview Press, 1987.

Fry, Roger. *Vision and Design*. Edited by J.B. Bullen. Oxford: Oxford University Press, 1981.

Grace, Sherrill E. *Canada and the Idea of North*. Montreal and Kingston: McGill-Queen's University Press, 2001.

——. *Inventing Tom Thomson: From Biographical Fictions to Fictional Autobiographies and Reproductions*. Montreal and Kingston: McGill-Queen's University Press, 2004.

Grigor, Angela Nairne. *Arthur Lismer, Visionary Art Educator*. Montreal and Kingston: McGill-Queen's University Press, 2002.

Harper, J. Russell. *Painting in Canada: A History*, 2nd ed. Toronto: University of Toronto Press, 1977.

Hill, Charles C. *The Group of Seven: Art for a Nation*. Ottawa: National Gallery of Canada, 1995.

——. "The National Gallery: A National Art, Critical Judgment and the State." In Tooby, *The True North*, pp. 64–83.

——. "Tom Thomson, Painter." In Reid, *Tom Thomson*, pp. 111–43.

Housser, F.B. *A Canadian Art Movement: The Story of the Group of Seven*. Toronto: Macmillan, 1926.

Hubbard, Robert H. *The Development of Canadian Art*. Ottawa: National Gallery of Canada, 1963.

Hunter, Andrew. "Mapping Tom." In Reid, *Tom Thomson*, pp. 19–45.

Jackson, A.Y. *A Painter's Country: The Autobiography of A.Y. Jackson*. Toronto: Clarke Irwin, 1958.

Jasen, Patricia. *Wild Things: Nature, Culture, and Tourism in Ontario, 1790–1914*. Toronto: University of Toronto Press, 1995.

Jessup, Lynda. "Bushwhackers in the Gallery: Antimodernism and the Group of Seven." In *Antimodernism and Artistic Experience: Policing the Boundaries of Modernity*, edited by Lynda Jessup, pp. 130–52. Toronto: University of Toronto Press, 2001.

——. "The Group of Seven and the Tourist Landscape in Western Canada." *Journal of Canadian Studies* 37 (Spring 2002): pp. 144–77.

Kaufmann, Eric. "'Naturalizing the Nation': The Rise of Naturalistic Nationalism in the United States and Canada." *Comparative Studies in Society and History* 40 (October 1998): pp. 666–95.

Kelly, Gemey. *J.E.H. MacDonald, Lewis Smith, Edith Smith: Nova Scotia*. Halifax: Dalhousie Art Gallery, 1990.

Lacombe, Michele. "Songs of the Open Road: Bon Echo, Urban Utopians, and the Cult of Nature." *Journal of Canadian Studies* 33 (Summer 1998): pp. 152–67.

Lamb, Robert J. *The Canadian Art Club, 1907–1915*. Edmonton: Edmonton Art Gallery, 1988.

Landry, Pierre B. *The MacCallum-Jackman Cottage Mural Paintings*. Ottawa: National Gallery of Canada, 1990.

Larisey, Peter Daniel. "The Landscape Painting of Lawren Stewart Harris." PhD diss., Columbia University, 1982.

———. "Nationalist Aspects of Lawren S. Harris's Aesthetics." *National Gallery of Art Bulletin* 23 (1974): pp. 3–9, 31.

Linsley, Robert. "Landscapes in Motion: Lawren Harris, Emily Carr and the Heterogeneous Modern Nation." *Oxford Art Journal* 19 (1996): pp. 80–95.

Littlefield, Angie. *The Thomsons of Durham: Tom Thomson's Family Heritage*. Ajax, ON: Durham West Arts Centre, 2005.

———. *"Two of the Talented Thomsons": George Thomson O.S.A., 1868–1965, Margaret Thomson, 1884–1979*. Toronto: John A. Libby Fine Art, 2006.

Lord, Barry. *A History of Painting in Canada: Toward a People's Art*. Toronto: N.C. Press, 1974.

Lowrey, Carol, ed. *Visions of Light and Air: Canadian Impressionism, 1885–1920*. New York: Americas Society Art Gallery, 1995.

Mason, Roger Burford. *A Grand Eye for Glory: A Life of Franz Johnston*. Toronto: Dundurn Press, 1998.

Mastin, Catharine M., ed. *The Group of Seven in Western Canada*. Toronto: Key Porter Books, 2002.

McLeish, J.A.B. *September Gale: A Life of Arthur Lismer*, 2nd ed. Toronto: J.M. Dent & Sons, 1973.

Mellen, Peter. *The Group of Seven*. Toronto: McClelland & Stewart, 1970.

Morrin, Peter, Judith Zilczer, and William C. Agee. *The Advent of Modernism: Post-Impressionism and North American Art, 1900–1918*. Atlanta: High Museum of Art, 1986.

Murray, Joan. *The Birth of the Modern: Post-Impressionism in Canadian Art, c. 1900–1920*. Oshawa: Robert McLaughlin Gallery, 2002.

———. *Canadian Art in the Twentieth Century*. Toronto: Dundurn Press, 1999.

———. *Lawren Harris: An Introduction to His Life and Art*. Toronto: Firefly Books, 2003.

———. *Tom Thomson: Design for a Canadian Hero*. Toronto: Dundurn Press, 1998.

Nasgaard, Roald. *The Mystic North: Symbolist Landscape Painting in Northern Europe and North America, 1890–1940*. Toronto: Art Gallery of Ontario / University of Toronto Press, 1984.

O'Brian, John, and Peter White. *Beyond Wilderness: The Group of Seven, Canadian Identity and Contemporary Art*. Montreal and Kingston: McGill-Queen's University Press, 2007.

Ord, Douglas. *The National Gallery of Canada: Ideas, Art, Architecture*. Montreal and Kingston: McGill-Queen's University Press, 2003.

Pantazzi, Sybille. "Foreign Art at the Canadian National Exhibition, 1905–1938." *National Gallery of Art Bulletin* 22 (1973): pp. 21–41, 43.

Reid, Dennis. *A Concise History of Canadian Painting*, 2nd ed. Oxford: Oxford University Press, 1988.

———. *The Group of Seven*. Ottawa: National Gallery of Canada, 1970.

———. "Photographs by Tom Thomson." *National Gallery of Canada Bulletin* 16 (1970): pp. 2–16.

———, ed. *Tom Thomson*. Toronto and Ottawa: Art Gallery of Ontario and National Gallery of Canada, 2002.

———. "Tom Thomson and the Arts and Crafts Movement in Toronto." In Reid, *Tom Thomson*, pp. 65–83.

Roza, Alexandra. "Towards a Modern Canadian Art, 1910–1936: The Group of Seven, A.J.M. Smith and F.R. Scott." Master's thesis, McGill University, 1997.

Saunders, Audrey. *Algonquin Story*. Toronto: Department of Lands and Forests, 1963.

Schapiro, Meyer. *Modern Art: 19th and 20th Centuries*. New York: George Braziller, 1982.

Silcox, David P. *The Group of Seven and Tom Thomson*. Toronto: Firefly Books, 2003.

———. *Tom Thomson: An Introduction to His Life and Art*. Toronto: Firefly Books, 2002.

Stacey, Robert. "A Contact in Context: The Influence of Scandinavian Landscape Painting on Canadian Artists Before and After 1913." *Northward Journal* 18/19 (1980): pp. 36–55.

———. "Harmonizing 'Means and Purpose': The Influence of Ruskin, Morris, and Crane on J.E.H. MacDonald." In *Scarlet Hunters: Pre-Raphaelitism in Canada*, edited by David Latham, pp. 93–128. Toronto: Archives of Canadian Art and Design, 1998.

———. "The Myth—and Truth—of the True North." In Tooby, *The True North*, pp. 36–63.

———. "Tom Thomson as Applied Artist." In Reid, *Tom Thomson*, pp. 47–63.

Stacey, Robert, and Hunter Bishop. *J.E.H. MacDonald, Designer: An Anthology of Graphic Design, Illustration and Lettering*. Ottawa: Carleton University Press, 1996.

Staines, David. "Introduction," *The Canadian Imagination: Dimensions of a Literary Culture*. Edited by David Staines. Cambridge, MA: Harvard University Press, 1977.

Sullivan, Rosemary. "The Dark Pines of the Mind: The Symbol of the Forest in Canadian Literature." *Études canadiennes / Canadian Studies* 23 (1987): pp. 173–82.

Tippett, Maria. *Art at the Service of War: Canada, Art and the Great War*. Toronto: University of Toronto Press, 1984.

———. *Stormy Weather: F.H. Varley, A Biography*. Toronto: McClelland & Stewart, 1998.

Tooby, Michael. *Our Home and Native Land: Sheffield's Canadian Artists*. Sheffield: Mappin Art Gallery, 1991.

——, ed. *The True North: Canadian Landscape Painting, 1896–1939*. London: Lund Humphries, 1991.

Tovell, Rosemarie L. "A.Y. Jackson in France, Belgium and Holland: A 1909 Sketchbook." *National Gallery of Art Annual Bulletin / Bulletin annuel* 2 (1978–79): pp. 31–51.

Town, Harold, and David P. Silcox. *Tom Thomson: The Silence and the Storm*. Toronto: McClelland & Stewart, 1977.

Vipond, Mary. "The Nationalist Network: English Canada's Intellectuals and Artists in the 1920s." *Canadian Review of Studies in Nationalism* 7 (1980): pp. 32–52.

Wadland, John. "Tom Thomson's Places." In Reid, *Tom Thomson*, pp. 85–109.

Walton, Paul H. "The Group of Seven and Northern Development." *RACAR* 17 (1990): pp. 171–79.

Whiteman, Bruce. *J.E.H. MacDonald*. Kingston, ON: Quarry Press, 1995.

Wilson, Barbara M., ed. *Ontario and the First World War, 1914–1918: A Collection of Documents*. Toronto: Champlain Society, 1977.

INDEX

Italicized page numbers indicate illustrations within the text. Plate numbers are boldface. Notes are indicated by "n" following the page number. To provide chronology for the extensive biographical information on the major artists, their main entries are divided into time periods. Subheadings within these entries are alphabetical.